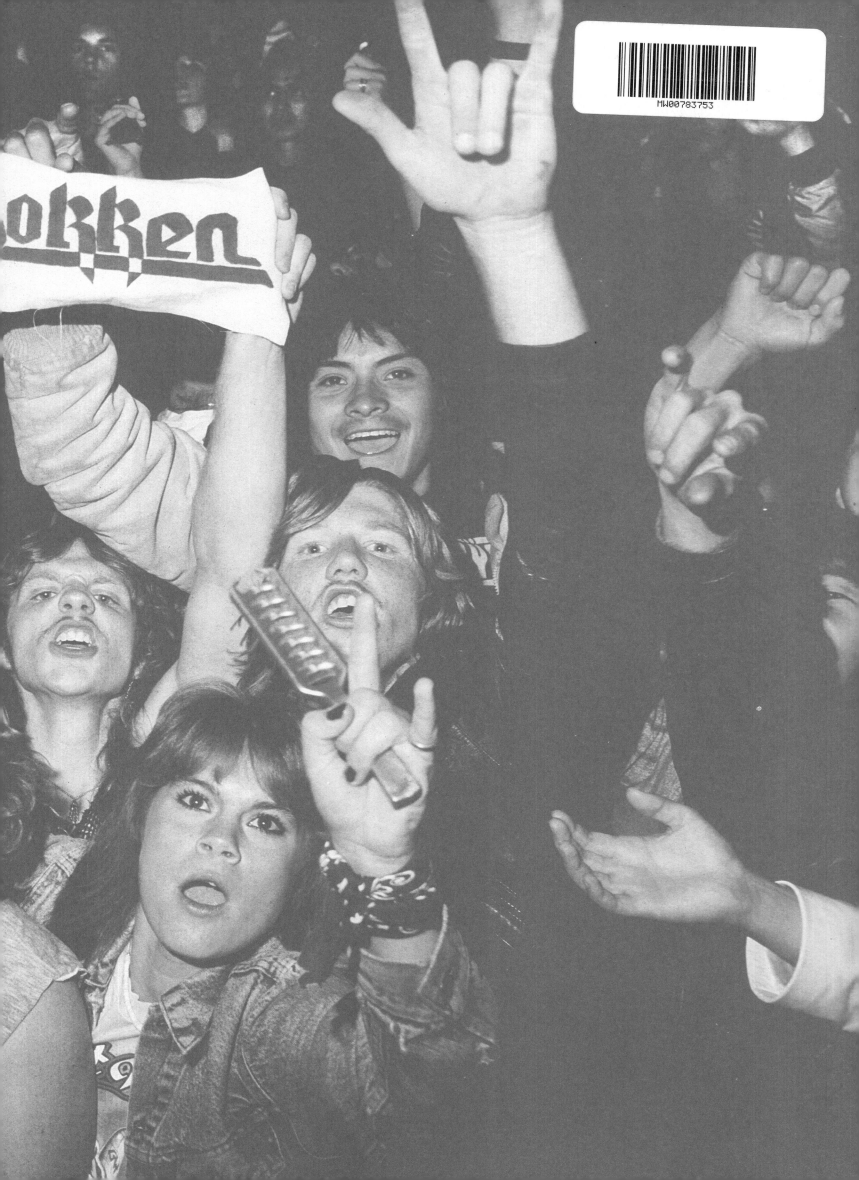

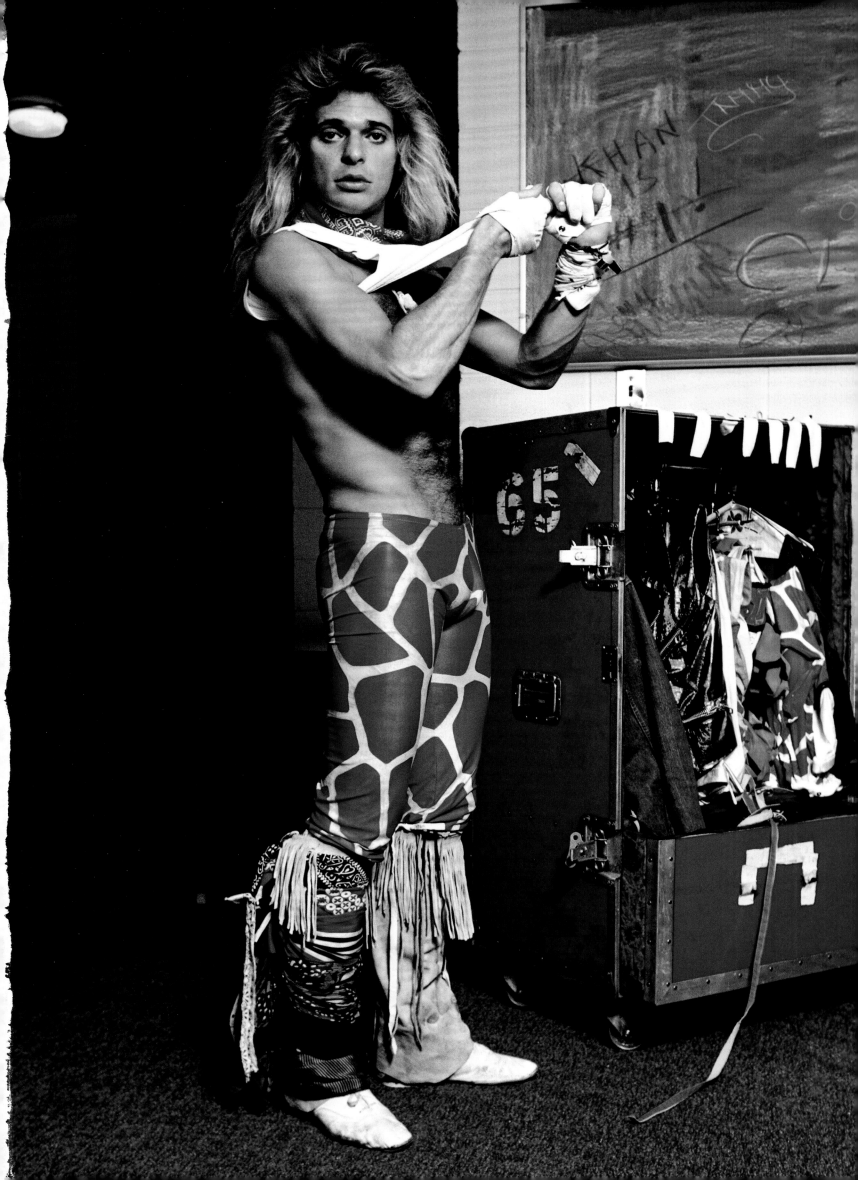

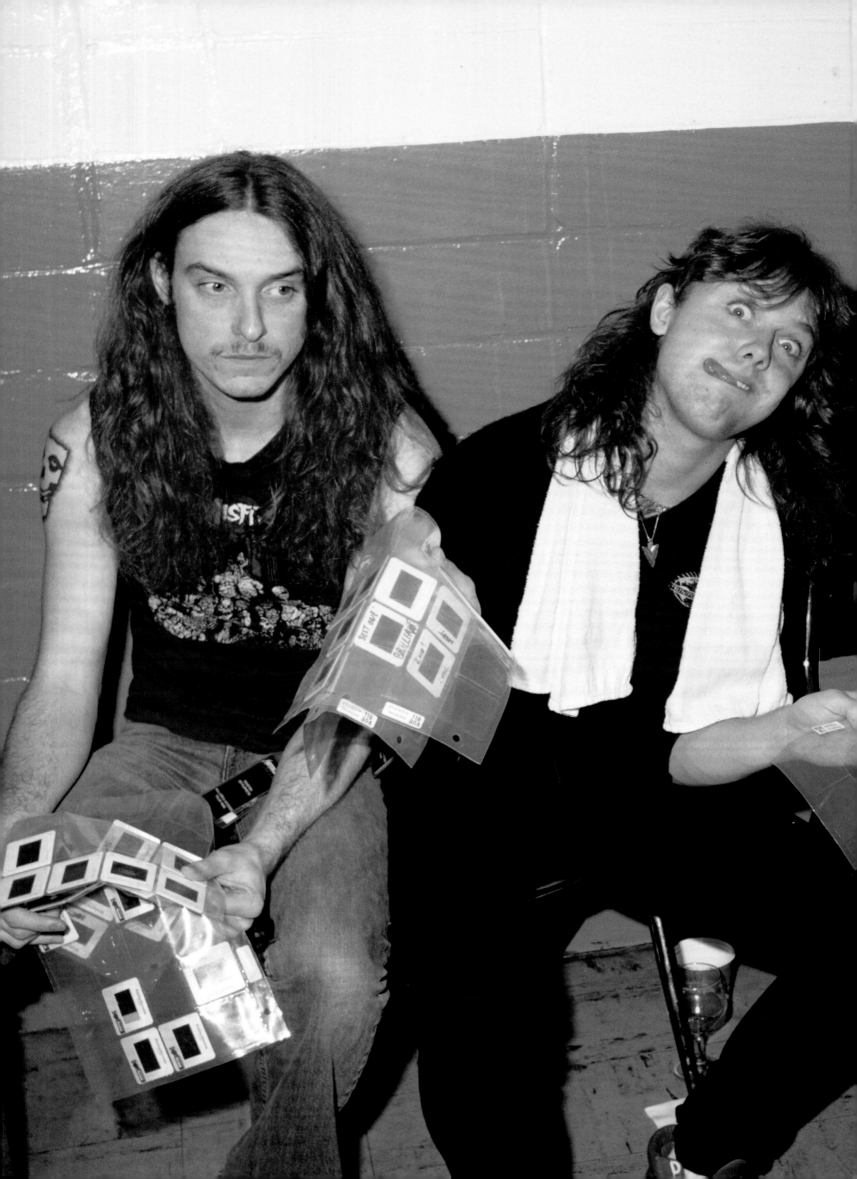

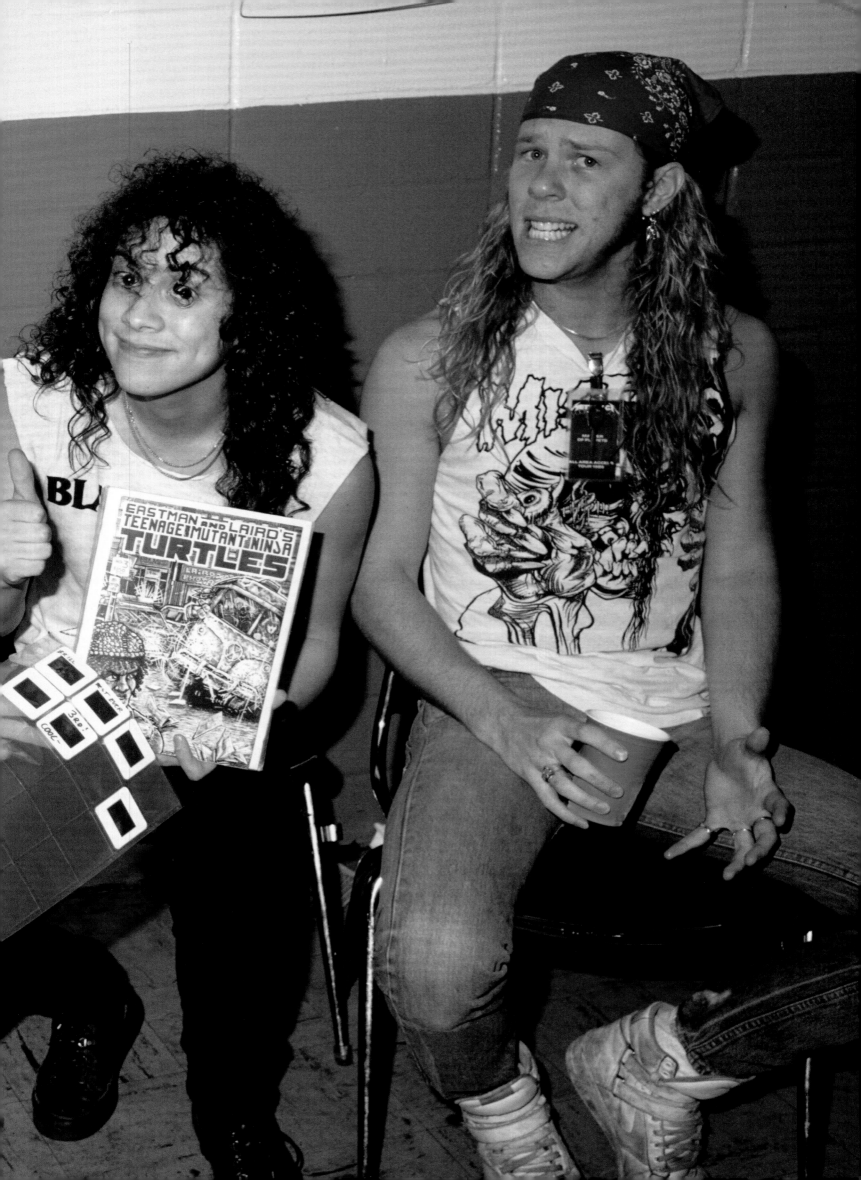

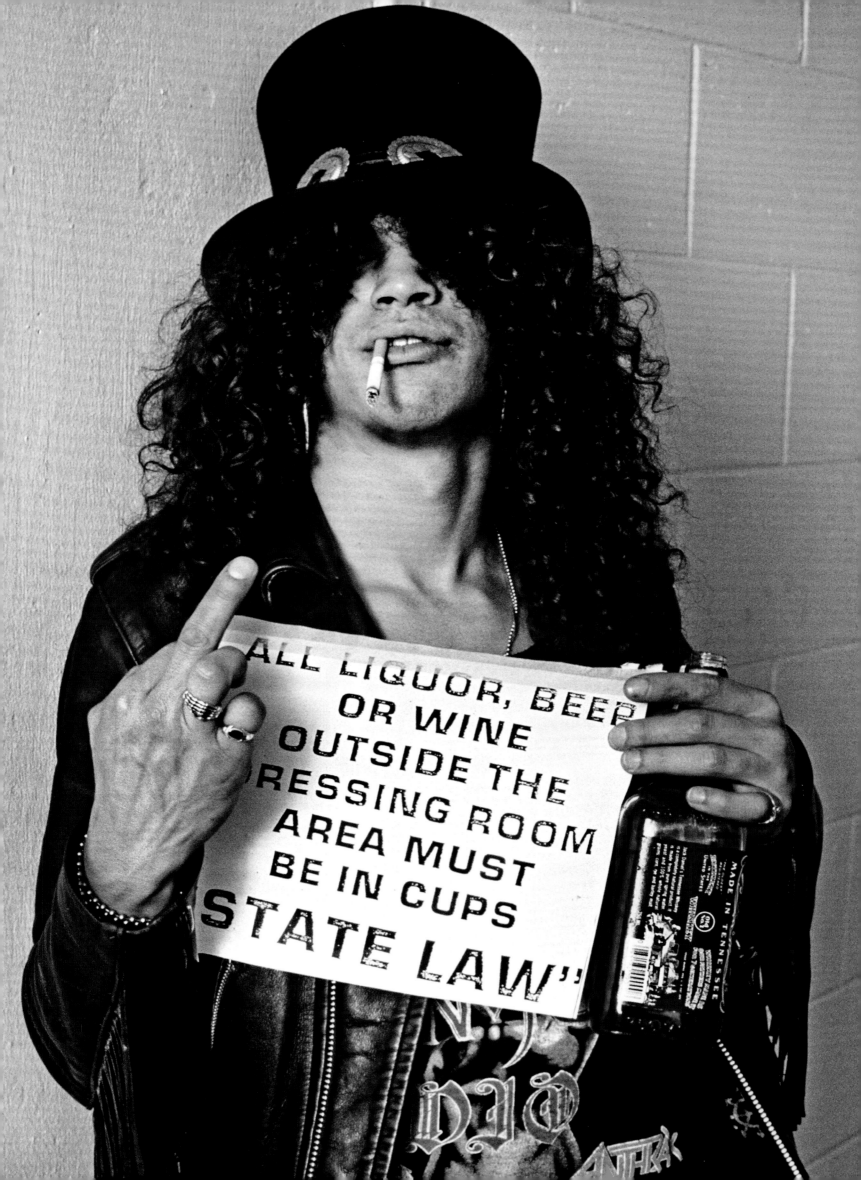

THE DECADE THAT ROCKED

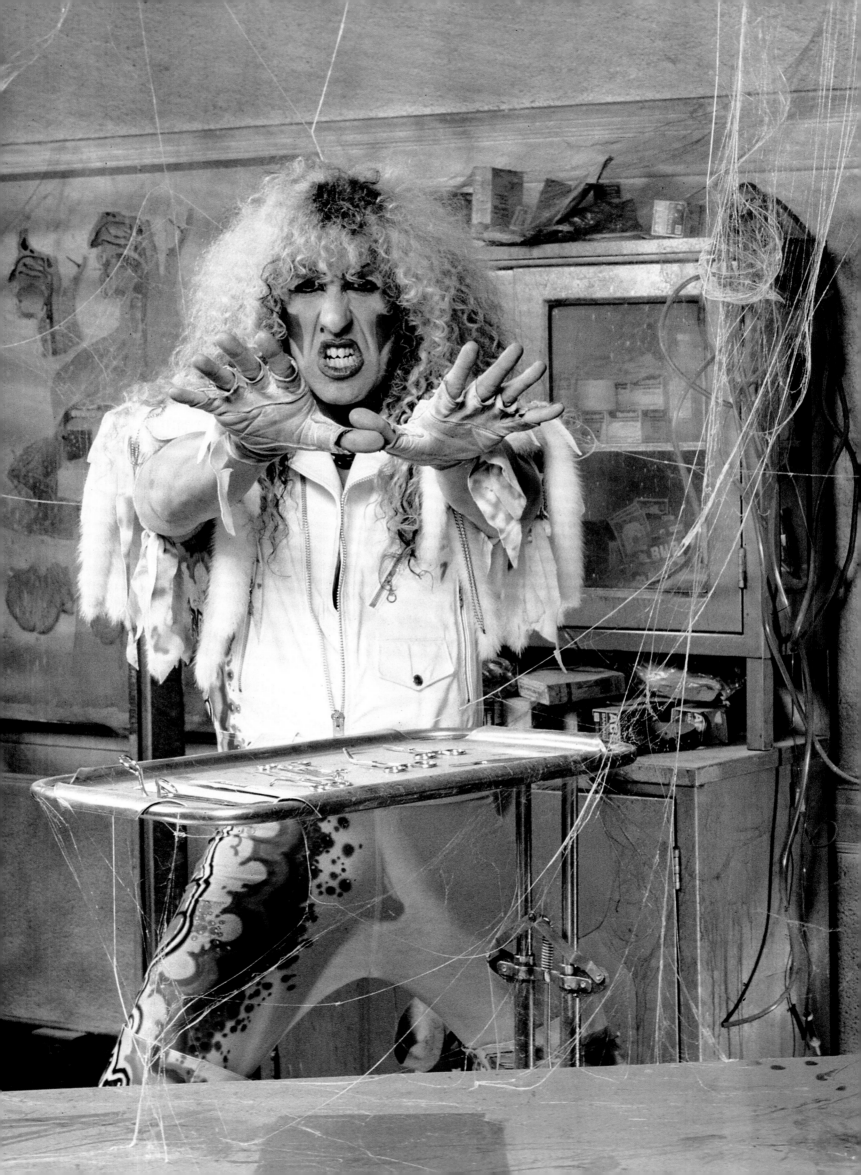

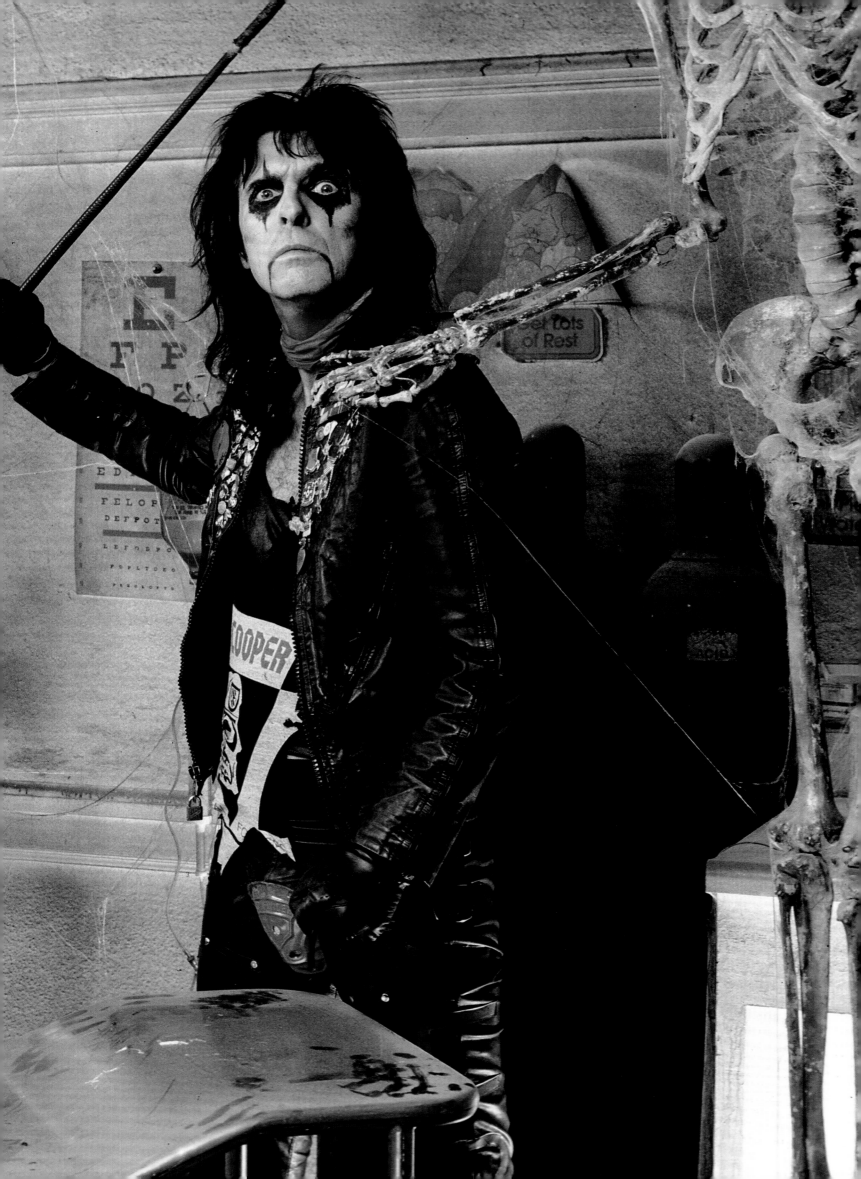

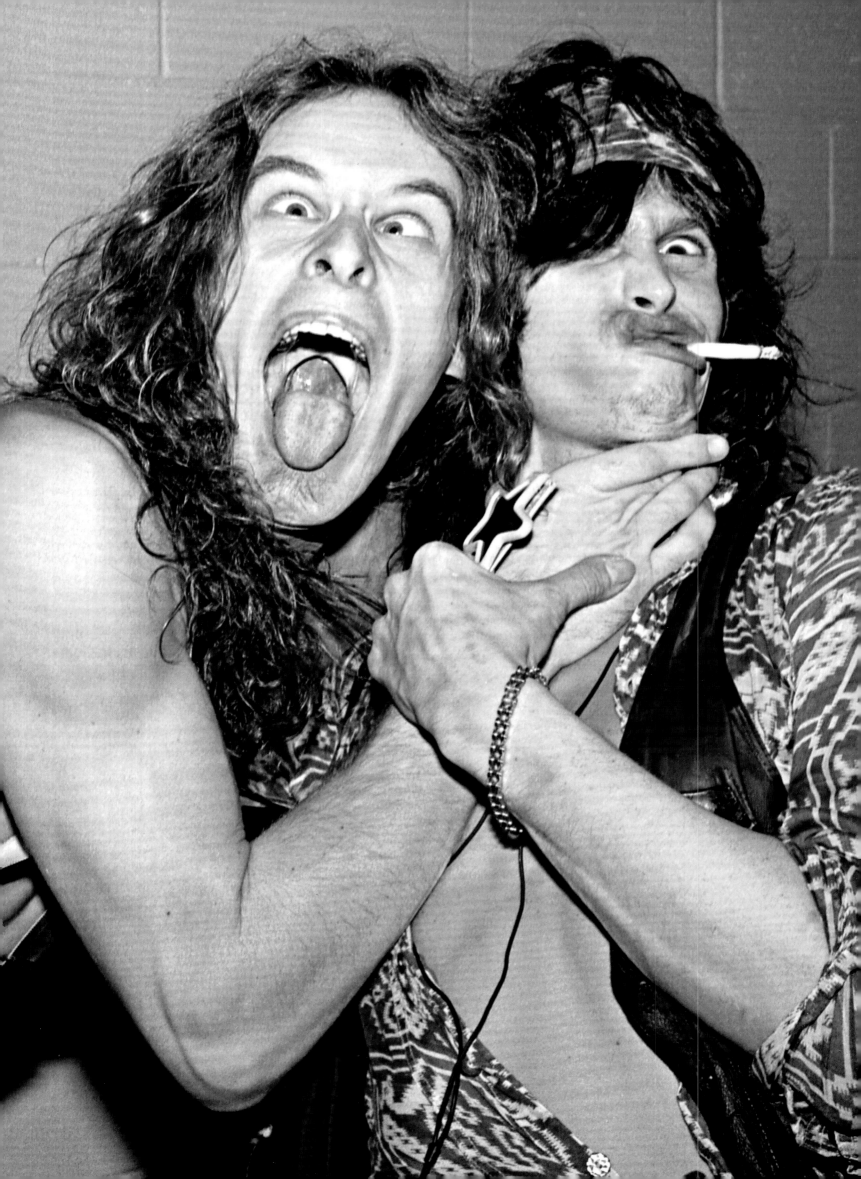

THE DECADE THAT ROCKED

THE PHOTOGRAPHY OF

MARK "WEISSGUY" WEISS

WRITTEN BY
RICHARD BIENSTOCK

FOREWORD BY
ROB HALFORD

AFTERWORD BY
EDDIE TRUNK

CONTRIBUTIONS BY
DANIEL SIWEK

INSIGHT EDITIONS

San Rafael | Los Angeles | London

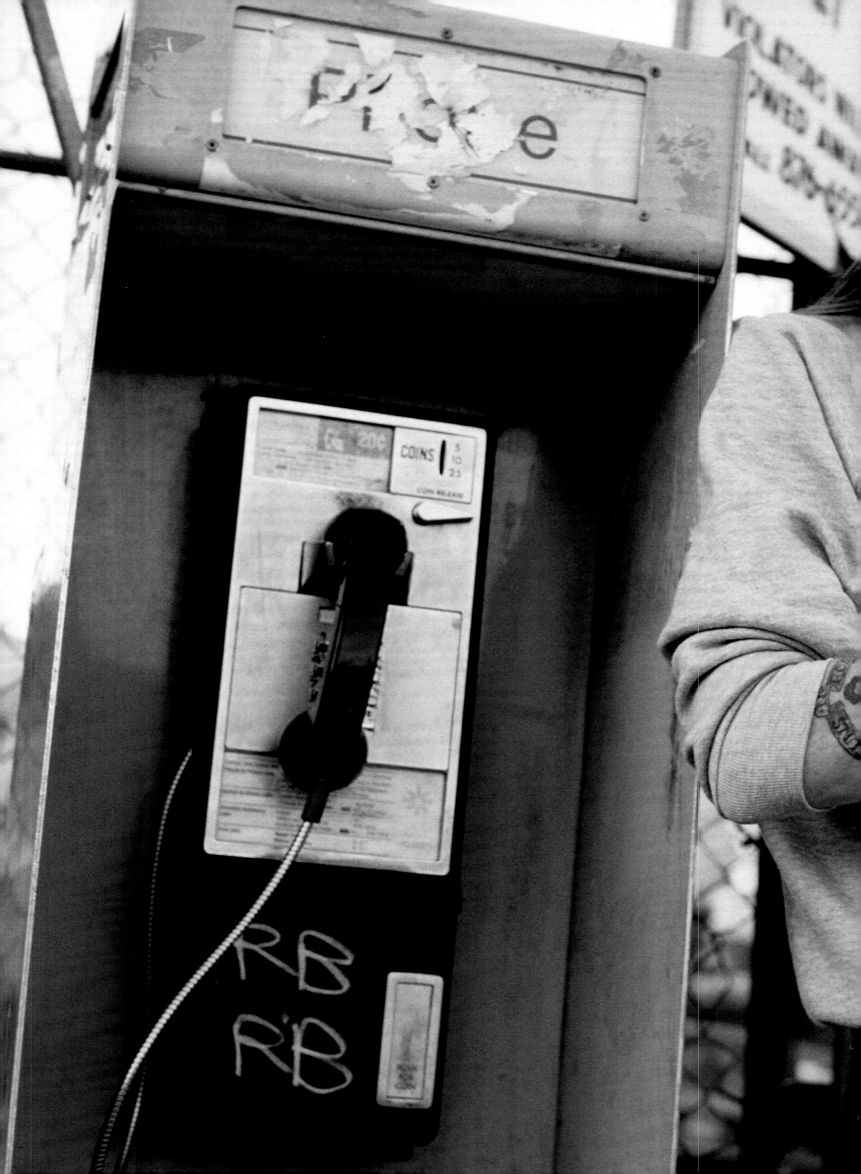

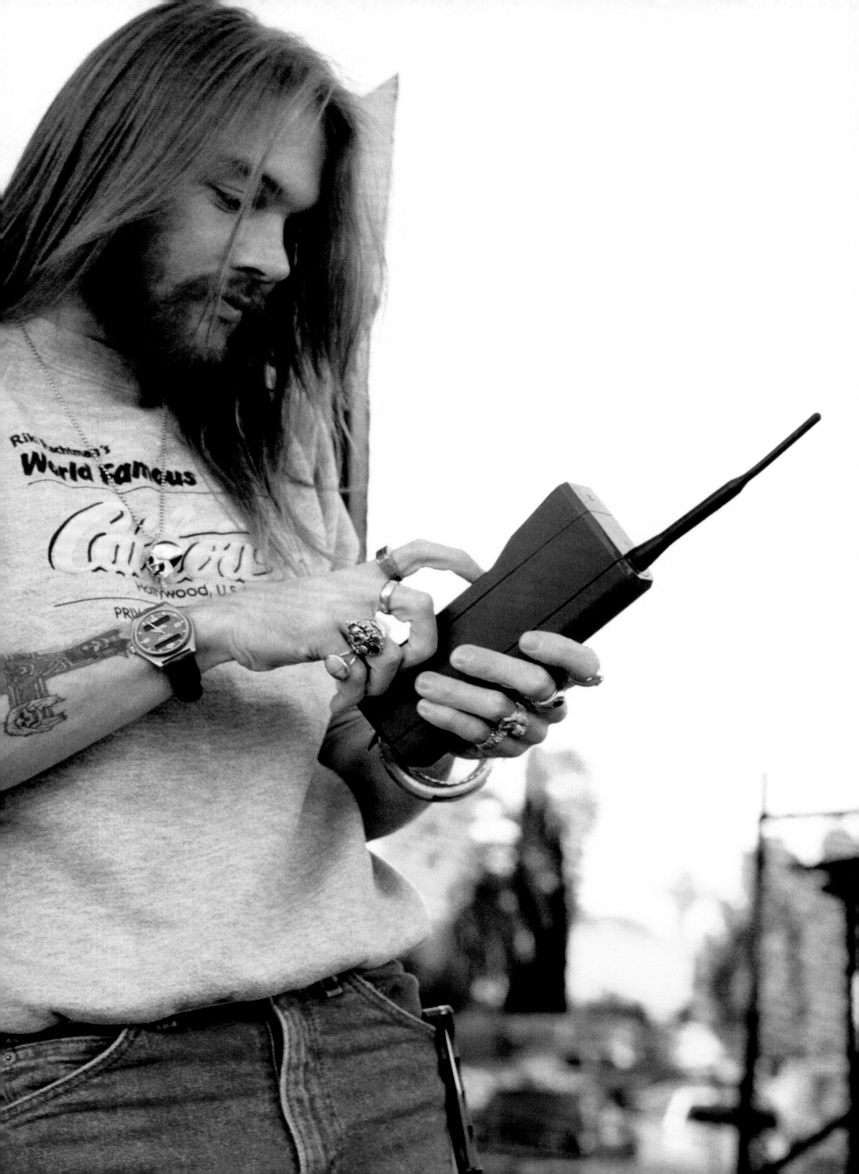

I don't remember Mark being there, but I don't remember Mark not being there. He was an extension of our troop. Mark was our photographer. It is his energy, his creativity, his drive, his positive attitude and his enthusiasm that makes Mark Weiss one of the legends of rock photography. It's why his work—both old and new—is still so in demand today. And from our first life-changing photo shoot to this day, Mark Weiss and I have worked together professionally and remained friends. Mark Weiss inspires greatness in all he turns his camera lens on. But don't take my word for it. Just look at the pictures in this book.

—Dee Snider

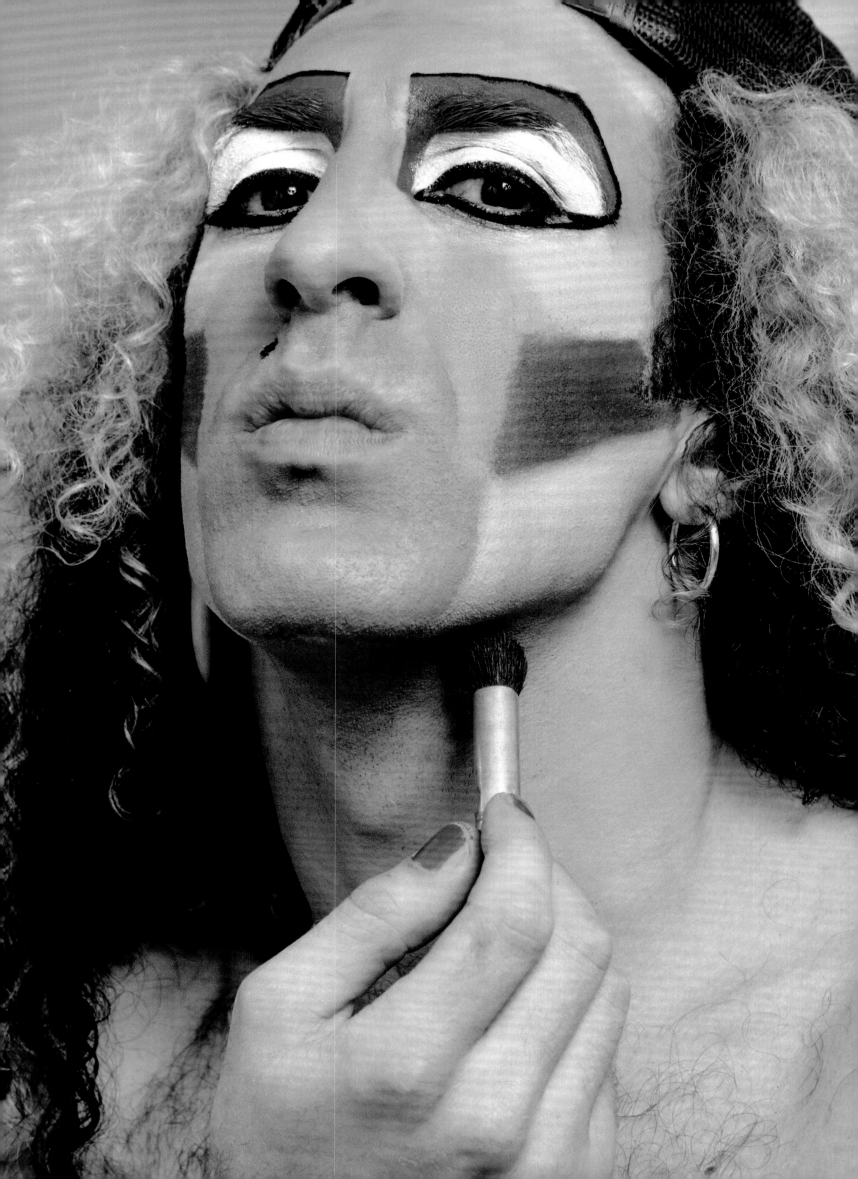

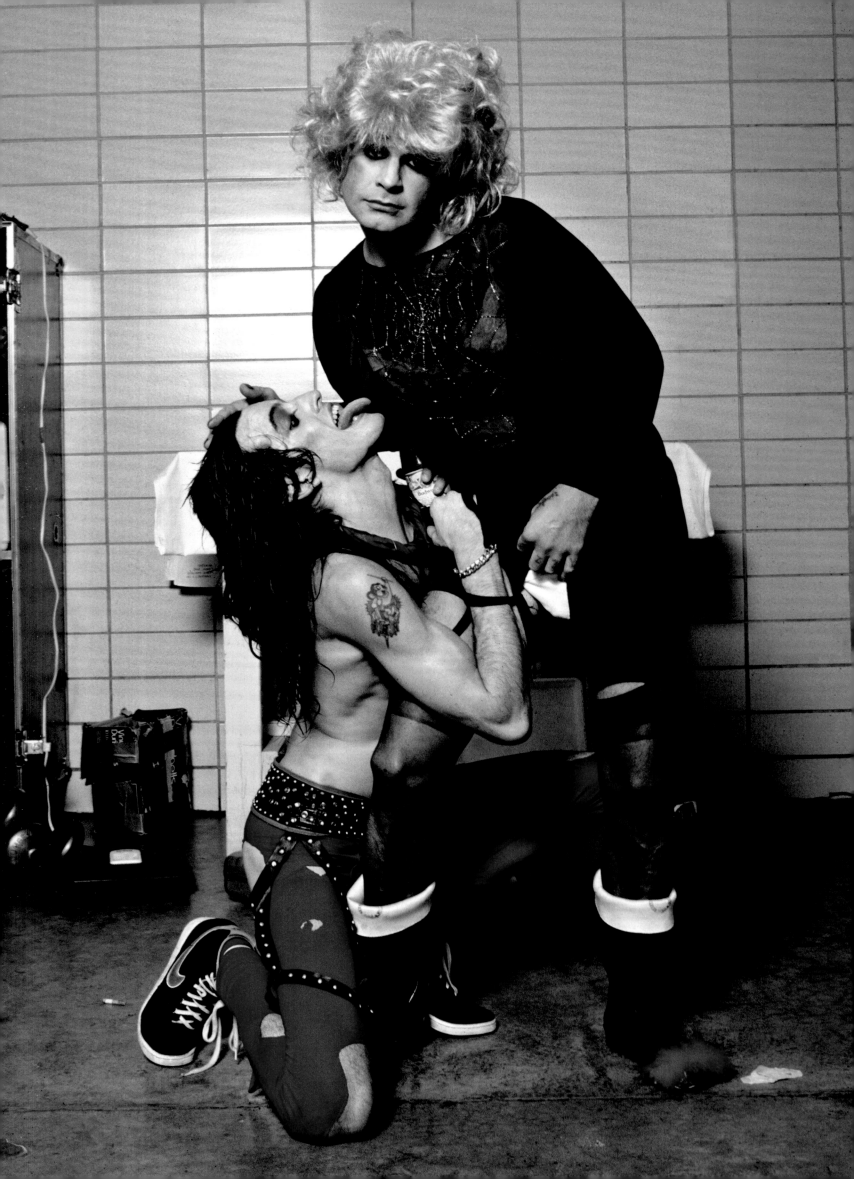

CONTENTS

The '80s were an exciting time. They were an important time—a time to be celebrated. In the '80s, we had things like MTV and rock radio that were really flourishing. We were in an economic moment where people were in a good way financially, where they could afford to go to concerts and buy the albums and really get engrossed in the bands that they loved. It felt like a time on the planet when people were celebrating. Wherever you went—and remember, Mötley Crüe went everywhere, to every single city and state and country—there were people having a good time. It was over the top. It was everything. Whatever we did, Mark was the perfect guy to have hanging around with us and be a fly on the wall. He was one of the boys. That's why he did so well with so many artists. We didn't feel like he was a company man or a corporate guy; he was someone that loved music and loved the lifestyle. He was one of us. He's still there with us, as he should be.

—Nikki Sixx

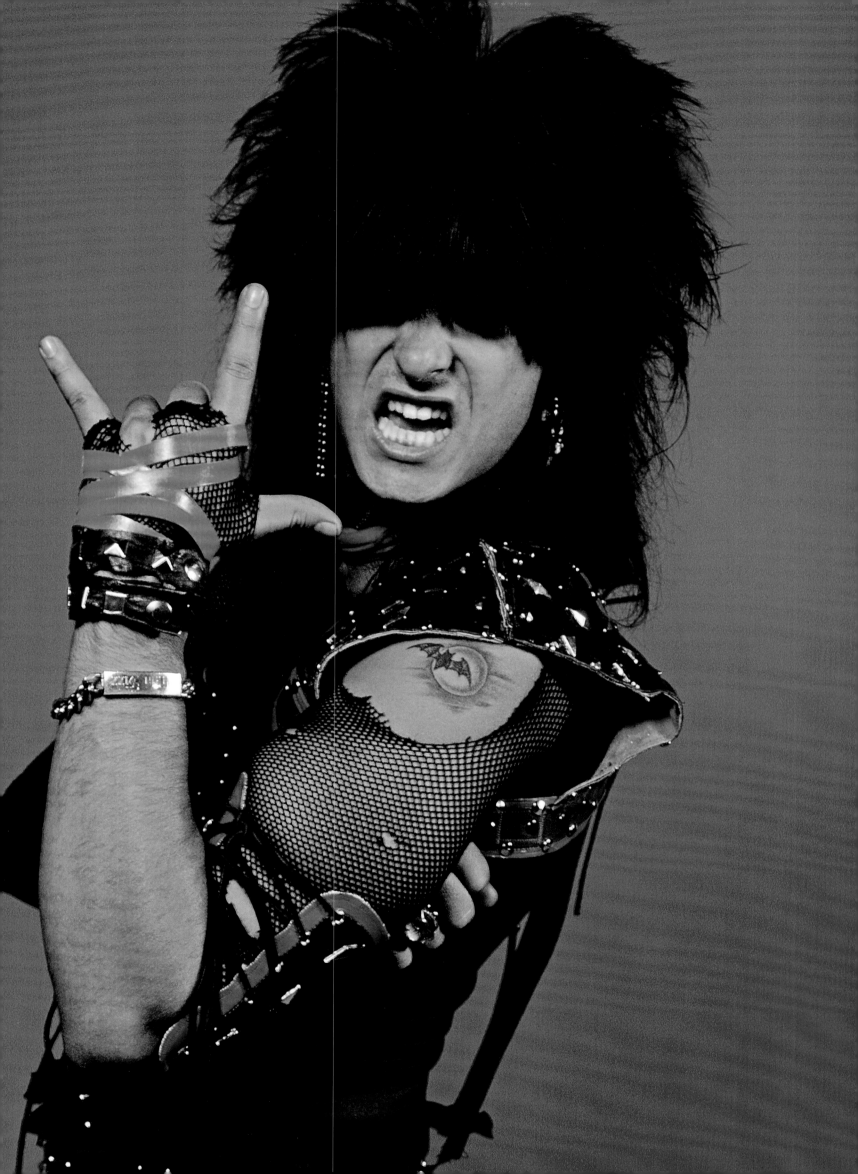

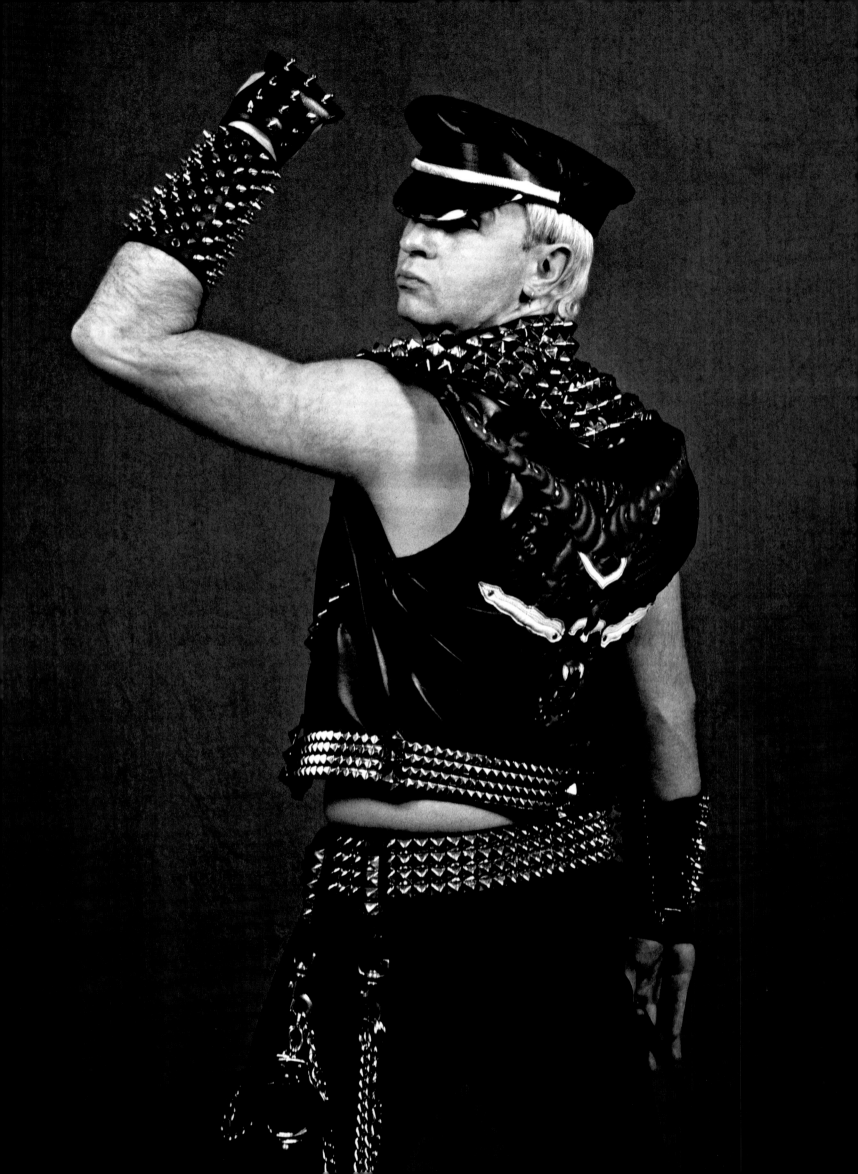

FOREWORD

There's a well-known expression: "A picture is worth a thousand words." Mark Weiss has reinforced that expression time and time again in his rock 'n' roll photos.

So I'll try to be efficient in my words here.

People talk about the fact that at least ten thousand hours of practice is required before one can truly claim to be a master of any craft. In Mark's world, this doesn't necessarily hold true, as he proved to be a master craftsman well before those hours were up. And for recent confirmation of his expertise, I need look no further back than the few preshow moments we had together before I took the stage with Priest not long ago. In very limited space, Mark set up a backdrop and proceeded to complete a shoot. In less than two minutes' time, he had "nailed it," as we say. That's real professionalism.

That said, I believe that it is in his live work where Mark truly shines. As a performer or a band does their stuff, you must have the eye and the instinct to capture what will become a timeless picture. I've lost count of the number of shows where, looking down, I've seen Mark in the pit, running around like a metal maniac and snapping away like a man possessed. It's that kind of fervor and passion, which Mark has to this day, that creates exciting and mesmerizing photographs.

One other thing I feel is important to say here is that, whether live or static, a photograph must convey the personality and character of the subject. And Mark has a sixth sense when it comes to bringing that out. Admittedly, we musicians can be difficult creatures, even in the best of times. To be able to encourage and capture those traits during a session with one of us is a talent and skill that comes from years of clicking that shutter on photographs that must run into the hundreds of thousands.

All in all, whether you look at his formal, live, or candid work, Mark is a legend in the world of rock 'n' roll photography.

—Rob Halford

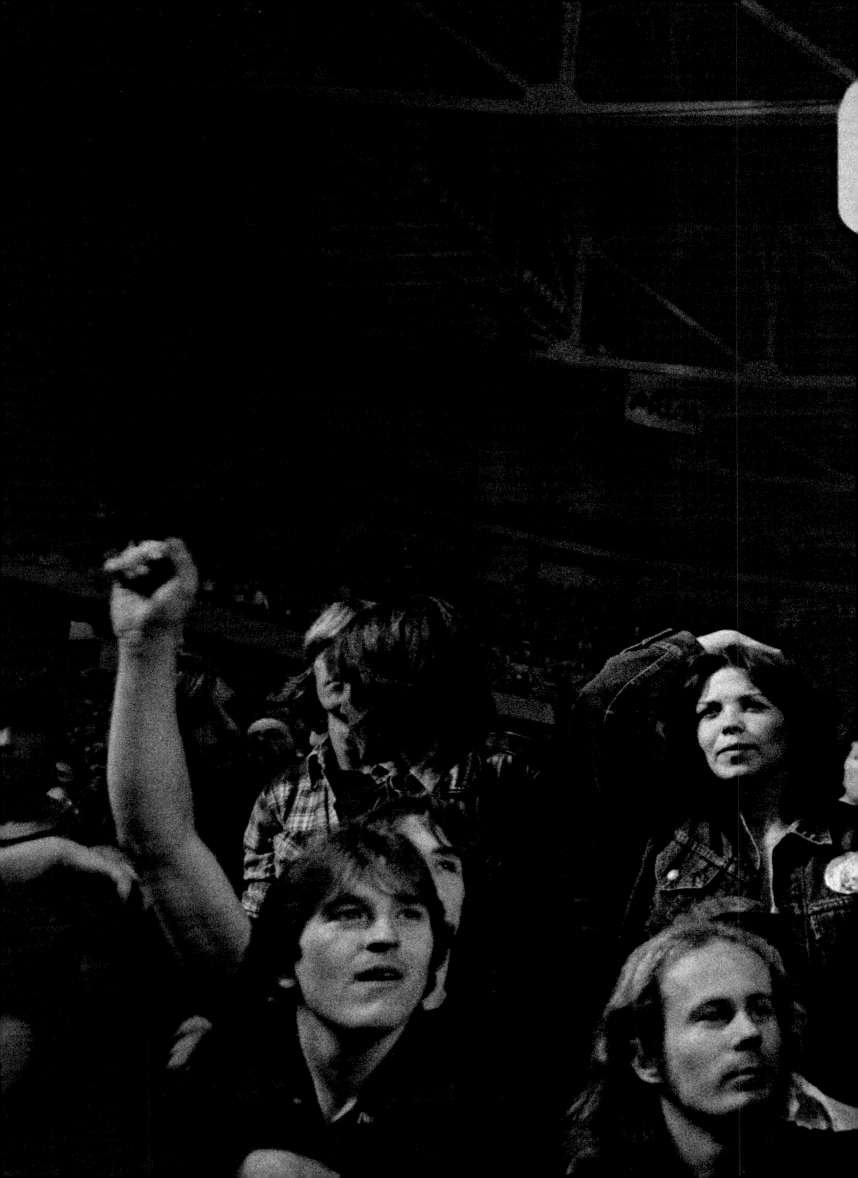

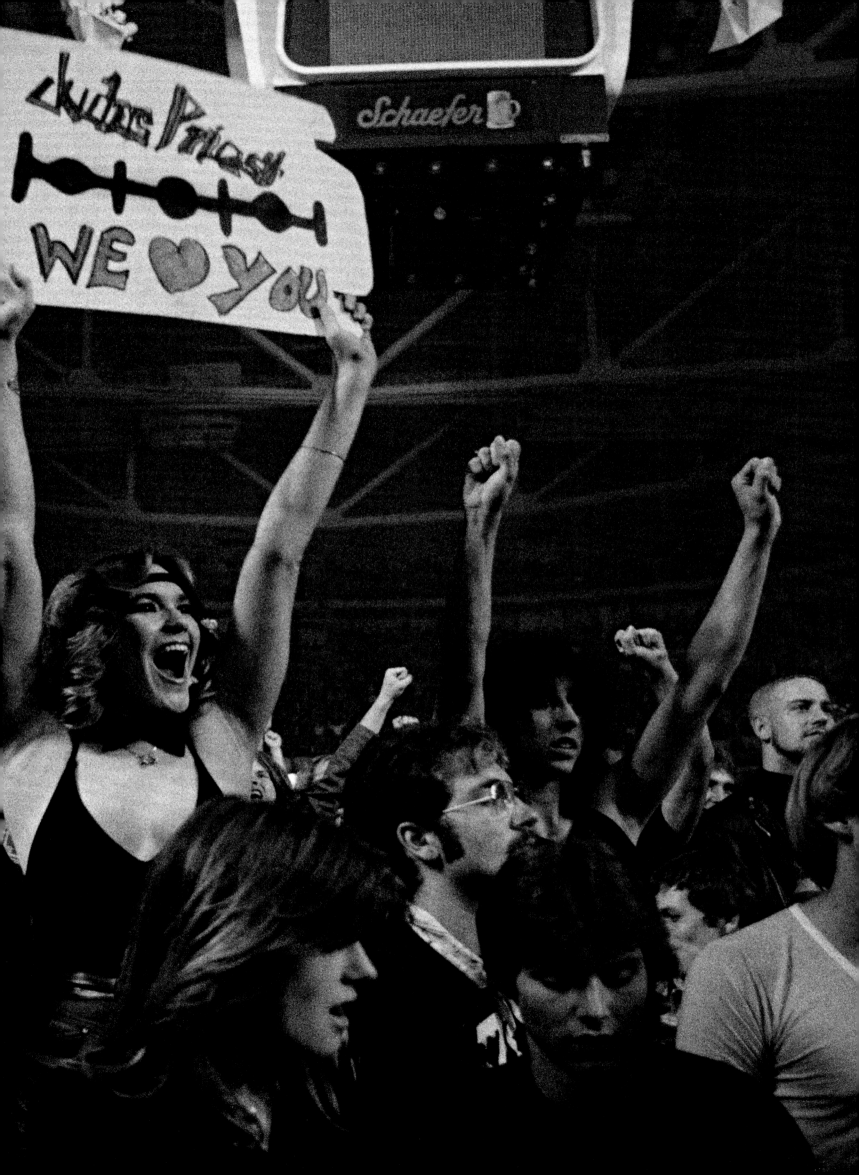

THE EARLY DAYS

I was thirteen years old when I got my first camera. Being a photographer was not something that had ever crossed my mind.

At the time, I was just trying to make a few extra bucks mowing lawns. It was 1973. I was a kid growing up in Matawan, New Jersey, a suburb an hour outside New York City. We were a middle-class family—my mother worked in public relations, and my father was a door-to-door salesman selling aluminum siding. It was my dad's experience that helped me in my lawn-mowing business. He told me, "Make them like you. When they open the door, connect with their eyes; then introduce yourself and be sincere. Always let them think you're there to help make their lives better."

Soon, I had a steady list of five customers a week. Still, I was always looking for more. One day, I knocked on the door of a neighbor with a seriously unkempt lawn: "Hi, my name is Mark. I live down the street. I noticed your lawn is a bit long. Can I help you by cutting it?" The man told

me that he cut his own lawn. I quickly responded, with a smirk, "It doesn't look like it. Is your mower not working?" He smiled and told me if I mowed his yard for the season, he'd give me a camera. Then he went back inside and came out holding a Bell & Howell Canon FP. It looked to me like it was worth a million bucks. I said, "Sure," and after a few cuts, he gave me the camera.

Now that I had the camera, I wanted to learn as much as I could about how to use it. My eighth grade year was ending. There was a photography class with a darkroom at my school, and I asked the teacher if he could give me a crash course in developing film and printing. Everything looked so cool to me in that darkroom. Entering through the cylinder-like door, it felt like I was being transported into another dimension amid red lights, trays filled with chemicals, and glow-in-the-dark timers. I watched in disbelief as a piece of blank paper transformed into an image before my eyes. The whole process was magical.

ABOVE: Mark's darkroom at the back of his garage, Matawan, New Jersey, 1978 **OPPOSITE TOP:** Mark's brother, Jay, and father, Mike, at home, 1973 **OPPOSITE BOTTOM:** Mark's Suzuki 50, 1973

Once the school year ended, I was bummed that I wouldn't have a place to develop and print photos anymore. Then, on my fourteenth birthday—June 15, 1973—my dad took me to Fishkin Brothers in Perth Amboy. It was half hobby shop and half camera store; I used to go there to buy model cars. This time, I was looking at studio strobe lights and cameras displayed in the glass cabinets. It felt like Fort Knox to me. My dad bought me an enlarger, and with the money I had saved from cutting lawns, I bought the trays, chemicals, and paper. At home, I used the bathroom as a darkroom. I had a new hobby.

Around the same time, my older brother, Jay, began exposing me to music. He would take me to rehearsals to watch his band play. Like most of the other kids in my neighborhood, we were into dirt bikes. But by eighth grade, I was already done with riding. A year earlier, I had gone out to ride with a friend of mine, when we collided head-on at a dead man's turn. I was thrown from my minibike. Jay rode up and found me lifeless on the ground. I was out cold for two days with a concussion. My memory was never the same after that.

High school began, and, in time, I started to lose interest in photography. The thrill wore off, and aside from shooting a few family events, my camera took its place on my shelf as a paperweight. But everything changed on August 8, 1974, when my brother took me to Roosevelt Stadium in Jersey City to see Crosby, Stills, Nash & Young. We were finding a spot on the field when I ran into a family friend, Kenny Reff. Kenny was a few years older than me. He was on the way to the stage with two hot girls and a camera around his neck. He told me he was going up close to take photos. That's when I knew that this was what I wanted to do.

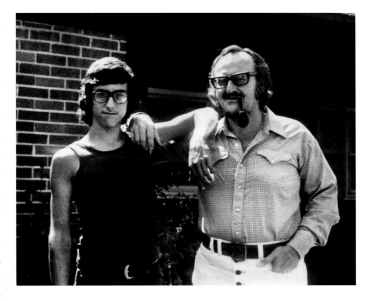

That day wasn't just a big deal for me. It was also a big day for the country, because it was the day Richard Nixon resigned. Graham Nash came out and announced that it had happened, and everyone cheered. There was a certain "Woodstock" feeling in the air. Fifty thousand of us were experiencing an important political moment in history, and it was taking place within the atmosphere of a rock concert, with loud music, girls, and the smell of pot in the air. I felt like I was a part of something big, and I understood at that moment that music was such a huge part of our pop culture—and also my life.

Another thing I understood was that no matter what history had been made that night, what had affected me more than anything was the image of my friend Kenny with his camera and those two girls.

A few months later, I decided to bring my camera to an Elton John concert. I was nervous having my camera on me as I got in line to go into Madison Square Garden. But I managed to sneak it in under my coat without a hitch. Even though I was far from the stage, I shot a roll of film from my seat. Toward the end of the show, John Lennon came out and performed three songs with Elton John. The only problem was, I was completely out of film. But that missed opportunity taught me a lesson: Always have one more roll of film on you. In fact, in the next decade I would end all my photo shoots by yelling, "One more roll!" I also knew that I would have to get closer to the stage.

Not long after, I was back at Madison Square Garden, sneaking my camera in to shoot Peter Frampton. This time, I was going to shoot with black-and-white film so I could develop the photos on my own. The only problem was, my ticket for the show was in the "nosebleeds," all the way at the top of the arena. From my seat, I could barely make out Peter down on the stage,

but I figured I would just develop the negatives, use my enlarger, and blow up the photos. Little did I know that photography didn't quite work that way. After I was all done, I looked at my photos. Peter was bigger . . . but also completely unrecognizable because of the grain in the film.

Next up was Aerosmith at the Garden—only it was sold out. But at a late-night card game, I overheard my brother's friend talking about getting into concerts without tickets: "You just go up to the security guy and quickly flash him a fake ticket, slide him a few bucks under the table, and he'll wave you through." It worked like a charm.

I used the same fake ticket trick when Kiss came to Madison Square Garden on their *Rock and Roll Over* tour. But I still needed to get closer and figure out a way to not get thrown out. When the lights went down, I jumped over the barricade and made my way up front. Then, when I was about ten rows back, I stopped—and began dismantling the seats. I closed off an area so that the ushers couldn't get down to me. Just like that, I had my own little space to shoot from for the entire show. From then on, that's what I did for years until I started getting proper credentials to be in the pit with the other photographers.

After the Kiss show, I couldn't wait to get home to develop the film and print from the negatives. Later that week, I brought the photos to school to show to a few friends. Word got out that I had these cool shots

of Kiss, and I began selling prints out of my locker. Pretty soon, I became known as the "kid with the pics." I loved the attention. I made up business cards and hung up a sign at school: "Concert Photos Available. See Mark Weiss." I was selling 5×7s for seventy-five cents apiece, and 8×10s for a buck and a quarter. My hustling days had begun.

That year, while other kids were figuring out what colleges they wanted to go to, I was off shooting concerts and selling my photographs. I had made a deal with my dad that I would go to college if he built me a darkroom in the back of the garage. Up until then, I had been printing hundreds of photos in my makeshift darkroom—the family bathroom.

I closed out my high school years by shooting Led Zeppelin, who sold out six concerts at Madison Square Garden. I shot the first one on June 7. While my schoolmates were all home getting dressed for the prom, I was photographing the mighty Zeppelin and selling my shots for a buck apiece.

After graduating high school, I got a summer job as a lifeguard at Cheesequake State Park, but when a show came to the area, I would be right back in the photo business. Around this time, I also got more and more into music as a retreat from the stress of what was happening in my family life. Jay was diagnosed with mental illness, and my house was a roller coaster of emotions. I wrapped myself up in music and my photography. It helped me get through a very tough time at home. September came, and I went off to school at Ramapo College. But I was quickly bored there and just felt like I was back in high school. The only good thing that came out of it was that, during my first week there, a band called the Stars Rock N Roll Show performed. I took some photos during their show, and afterward the singer, Cheri, came up to me and asked if she could see the pictures. The following week, we got together and became good friends. I started doing the band's promo photos.

```
                -k
TODAY IS AN IMPORTANT DAY FOR ME.

I didn't think today would come because
of my father's illness and my accident.
   But now that my Bar Mitzvah has come,

I am prepared to take on the responsibilit
                                       ies
of a man.

   Because of the many things that have

been taught to me by my parents and my
teachers, I feel that I can use good
judgement in making important decisions.
```

TOP: First self-portrait, 1973 BOTTOM: Bar mitzvah speech, 1972
OPPOSITE TOP: Mark and Pat Shallis at Rockages—It's Only Rock & Roll Flea Market at the Pennsylvania Hotel, New York City, 1978 OPPOSITE BOTTOM: Self-portrait, Haunted Mansion, Long Branch, New Jersey, 1978

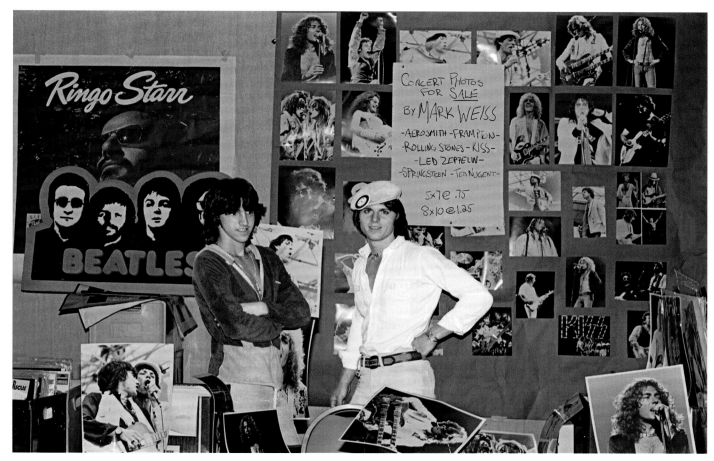

Everything really changed for me toward the end of 1977. That December, Kiss was back in New York City to play three sold-out dates at Madison Square Garden. I printed up a few hundred photos from the MSG gig I had shot earlier in the year and headed down to the venue for the first show. Outside the Garden, my pics were selling like hotcakes. Then I snuck in and got a few shots of Kiss before I got kicked out. I waited for the crowd to come out after the show, and then I started selling photos. Things were going great . . . until I was arrested by the cops for selling my photos. I spent the night in jail.

After I got out, I spent the next few days putting together a portfolio of my work and then took it over to the offices of *Circus* magazine in Manhattan. As luck would have it, the art director was off deadline, and so he and the publisher, Gerald Rothberg, welcomed me into his office. They liked my photographs and told me to stay in touch and let them know what concerts I would be shooting. He told me if I wanted to submit photos I needed to shoot with a flash and use Kodachrome 64—the photos would be sharper and the colors more vibrant.

Not long after that, I dropped out of college and moved into the Stars Rock N Roll Show's band house. I didn't even tell my parents that I stopped going to school. Cheri and the guys took me on the road as their lighting guy. It was my first experience on tour.

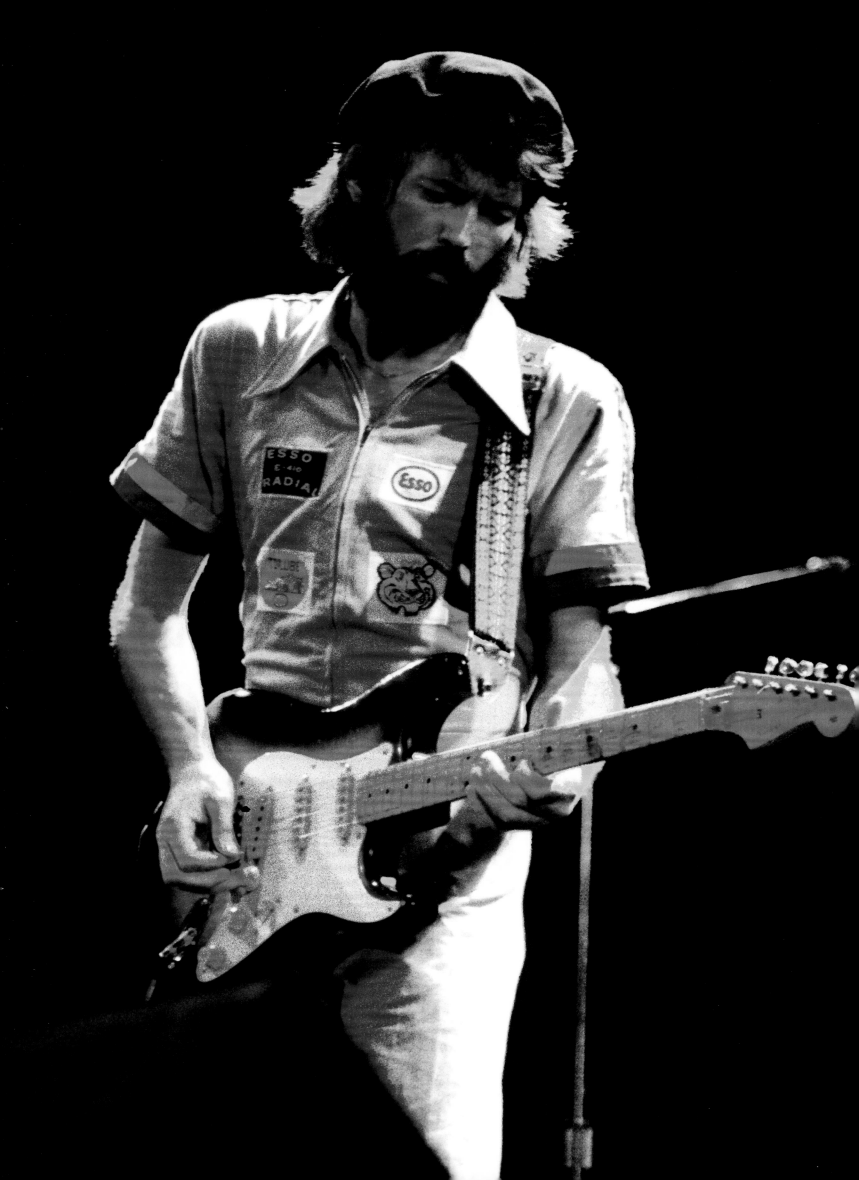

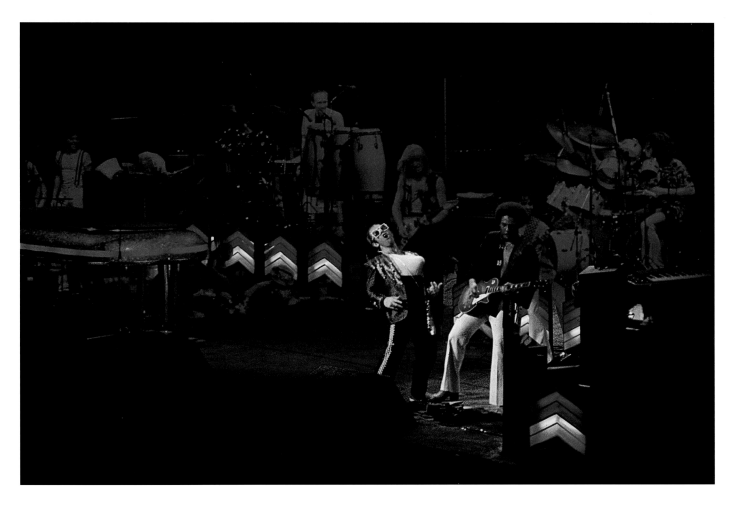

One day, I decided to pop into my old high school to say hi to a couple of teachers I had stayed in touch with. My media arts teacher, a man named Walter Hatton, wrote a film column for an entertainment paper called the *Spectrum*. He passed my number along to George Dassinger, another writer who was also the music editor of the paper.

George called me up and asked if I would be available to photograph a few bands in the area. We hit it off, and I saw my photos in print for the first time. He would write the reviews, and I would take the snaps. I didn't get paid for shooting, but it got me into the pit with a photo pass, and I loved seeing my name in print.

That May, the *Spectrum* set me up with photo passes for a few shows: Blondie, Cheap Trick, David Bowie, and Bruce Springsteen. I decided to call up *Circus* and see if they might need anything. Gerry told me that one of his writers was reviewing Bruce's new album, *Darkness on the Edge of Town*, and if I got any good photos—with Kodachrome—he would use one in the magazine. On Gerry's advice, I also shot with a flash for the first time ever. I dropped off the photos later in the week—mission accomplished! At the end of that summer, my first photo in *Circus* magazine was published. It was a small picture of Bruce Springsteen.

As soon as I got the magazine I went back home to show my parents. I figured it would be a good way to break the news that I had dropped out of college and was traveling with a band I met there, taking photos and doing lights on their tour.

At the end of the summer, on August 6, 1978, I shot Aerosmith, Ted Nugent, and Journey at Giants Stadium in New Jersey. After I got my photos back from the lab, I called *Circus* to tell them what I had. They told me they were looking for photos from that show and to drop them off at the office. Two months later I was flipping through the October 1978 issue of the magazine, with the Beatles on the cover. And there it was: a centerfold shot of Steven Tyler . . . with MARK WEISS in small type on the page. It was the biggest photo in the magazine. It was the photo you ripped out and hung up on your wall.

Even with my success at *Circus*, my parents insisted I go back to school, so I enrolled at the School of Visual Arts in Manhattan. I moved in with my mom's aunt and her family to be closer to my classes. I was living in New York City! On September 30, 1978, I set up a booth at the Rockages—It's Only Rock & Roll Flea Market at the Pennsylvania Hotel in the city. I had a substantial collection of photographs. I also put together a slideshow that featured my photography.

OPPOSITE: Eric Clapton, *There's One in Every Crowd* tour, Nassau Coliseum, Uniondale, New York, 1975 **ABOVE:** Elton John, *Caribou* tour, Madison Square Garden, 1974

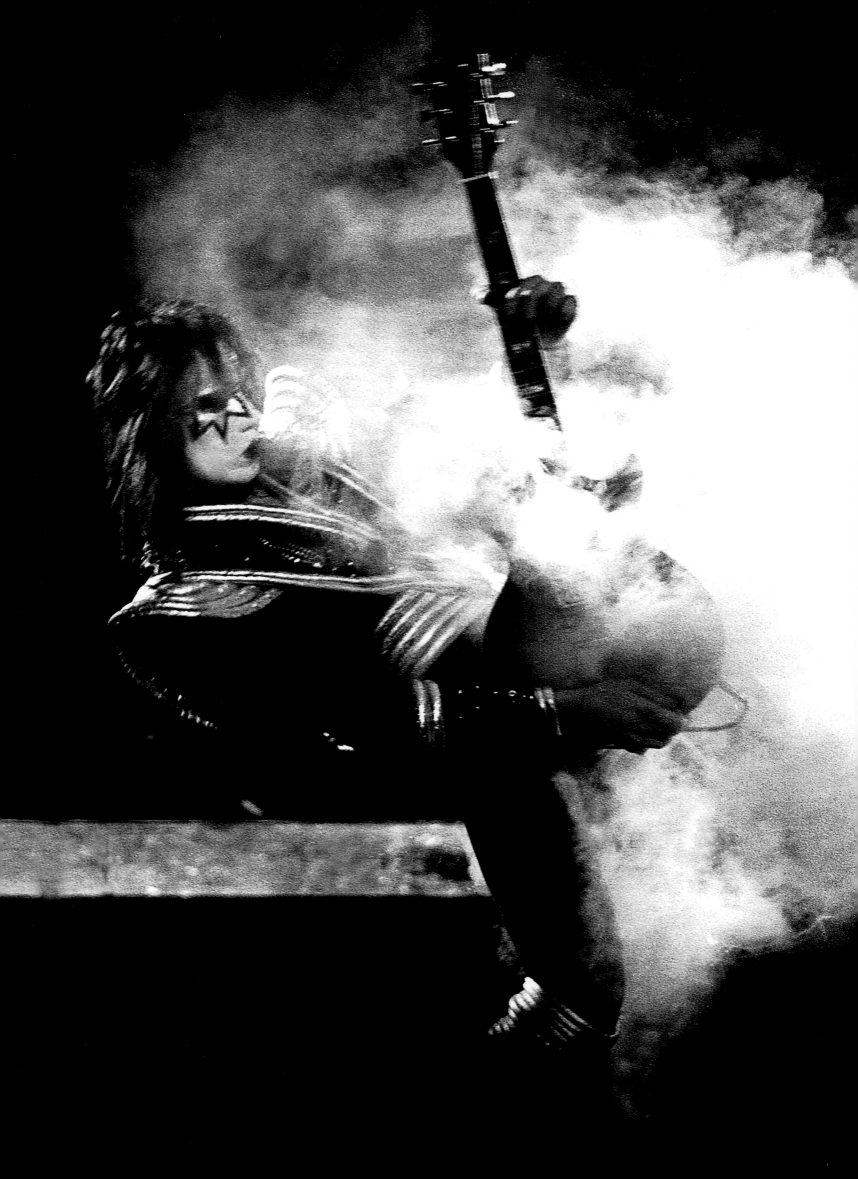

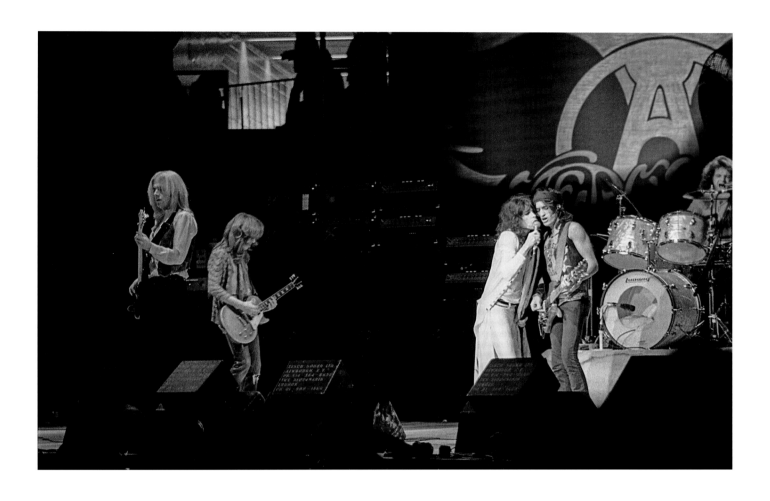

"Mark photographed me several times and always did a top-notch job and made me feel relaxed. Great photography with an excellent eye for composition." —**Ace Frehley (guitarist, Kiss)**

OPPOSITE: Kiss's Ace Frehley, *Rock and Roll Over* tour, Madison Square Garden, 1977 **ABOVE:** Aerosmith, *Rocks* tour, Madison Square Garden, 1976

At this point, I knew that I was going to answer my calling and devote my life to my passion—I was going to be a rock 'n' roll photographer.

Soon enough, *Circus* started calling with paid assignments. On January 9, 1979, they asked me to cover the Music for UNICEF Concert, with the Bee Gees, Rod Stewart, Elton John, and other mainstream acts. When I found out Rogers & Cowan was the publicity firm handling the event, I called up my good friend George Dassinger, who was now working there. George hooked me up with credentials to shoot the sound check and a run-through of the show. *Circus* ran a cover and a spread in the magazine, and it was the first time I saw my name credited alongside the writer's byline, in bold print: PHOTOGRAPHS BY MARK WEISS.

After I came through with the Bee Gees cover, *Circus* started sending me out on more assignments. I shot the Babys, who played the Bottom Line. A few weeks later, I was back at the club for the Police. My pay was $125 per job, with the condition that the magazine would own the photos and could use them as much as they wanted.

In the spring of '79, Rogers & Cowan had me shoot the promo photos for Peter Frampton's new album, *Where I Should Be*, at his house in Westchester, New York. It was Peter's first photo session since a near-fatal motorcycle accident; he was fortunate to have survived with just a broken arm and a few cracked ribs. George pulled me in for the shoot, and we took some very casual photos around Peter's home, including some with his dog, Rocky, the inspiration behind his 1977 song "Rocky's Hot Club." He wound up using one of those shots for the press photo that the record label used to promote the album, with his name printed underneath my picture along with the record company logo. It was another first for me.

I started going into New York City regularly to shoot trade photos for PR and record companies. Riding home to Jersey on the bus one day, I met a girl named Denise, whom I began dating. She introduced me to the Max's Kansas City crowd, which was how I met a musician named Neon Leon.

Neon Leon was getting popular in the scene—he had been asked to write a tune to be used as the theme song for New York rock station WNEW. The song, "Rock & Roll Is Alive," started being played 24/7 on the radio, and his band decided to put it out as a single. Leon asked me to do the cover photo. After the shoot, he told me he wanted to introduce me to someone named Rusty Hamilton, who worked for a men's magazine called *Cheri*. She was a redhead, and her nickname was

Cherry Bomb. I met her at Max's Kansas City a few days later. She told me that *Cheri* was starting a music section, and that she could get me into shows to shoot bands for the magazine. We went to Florida to shoot and interview the Village People. It wasn't my kind of music, but it was an assignment for the magazine, and I got to hang out with Cherry Bomb. I eventually shot wet T-shirt contests, girl pictorials, and covers all around the world.

I was starting to feel like I had made it—in July I had the opportunity to shoot Kiss from the photo pit at Madison Square Garden. At the Kiss show two years earlier, I ended up sitting in a jail cell after getting arrested for selling my photos outside the venue.

The theatrics were amazing. I was so excited to get the film back. Much to my disappointment, when I looked at the film after getting it developed, I noticed that the flash had made the background almost completely black. And the band members' black hair disappeared into the background. It had all looked so bright and colorful when I shot it. But it was what *Circus* required in order to get published in the magazine, so I did what I had to do. I also did a little research for the next show I photographed. I learned about dragging the shutter—letting in the backlight by shooting on a

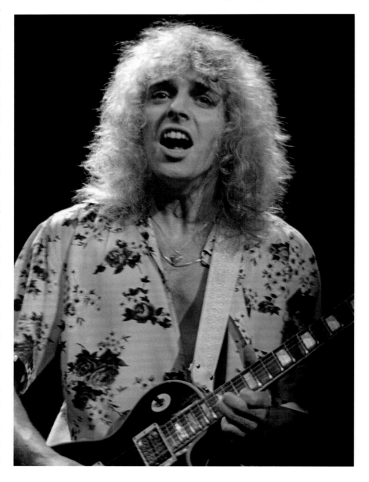

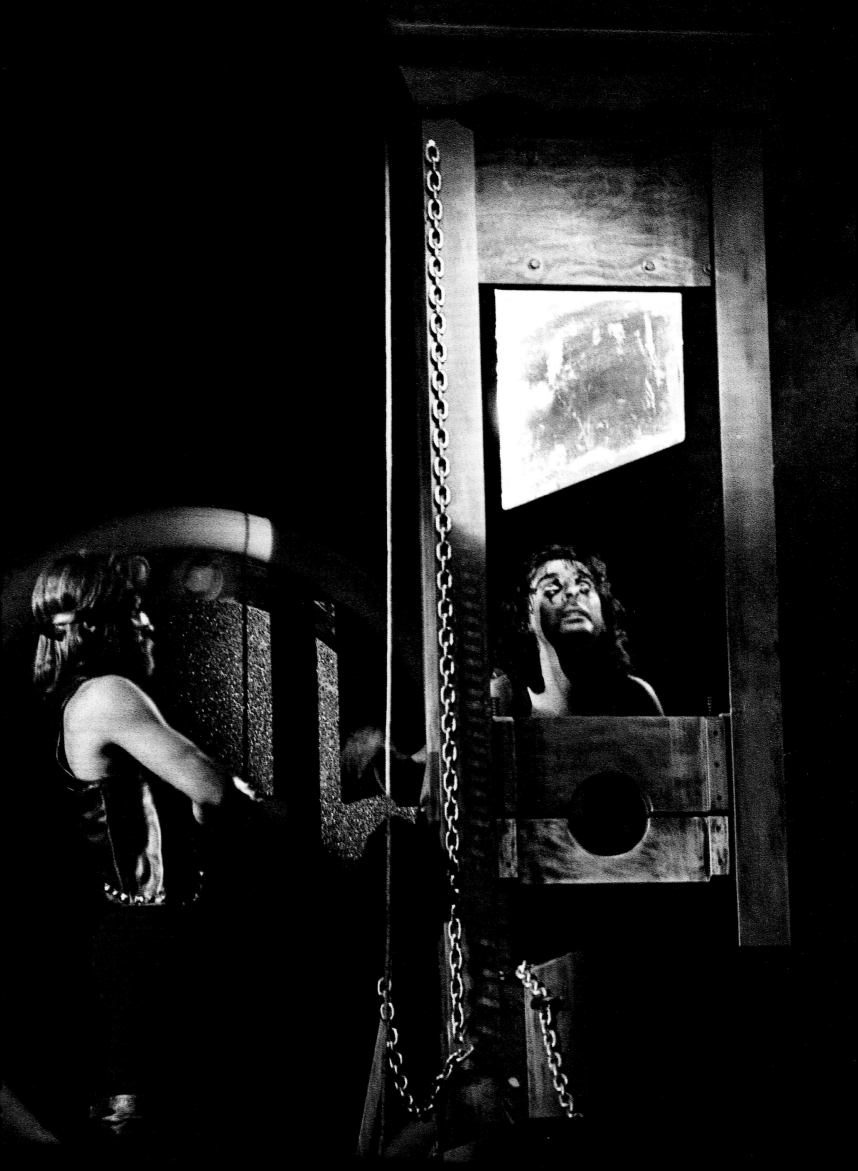

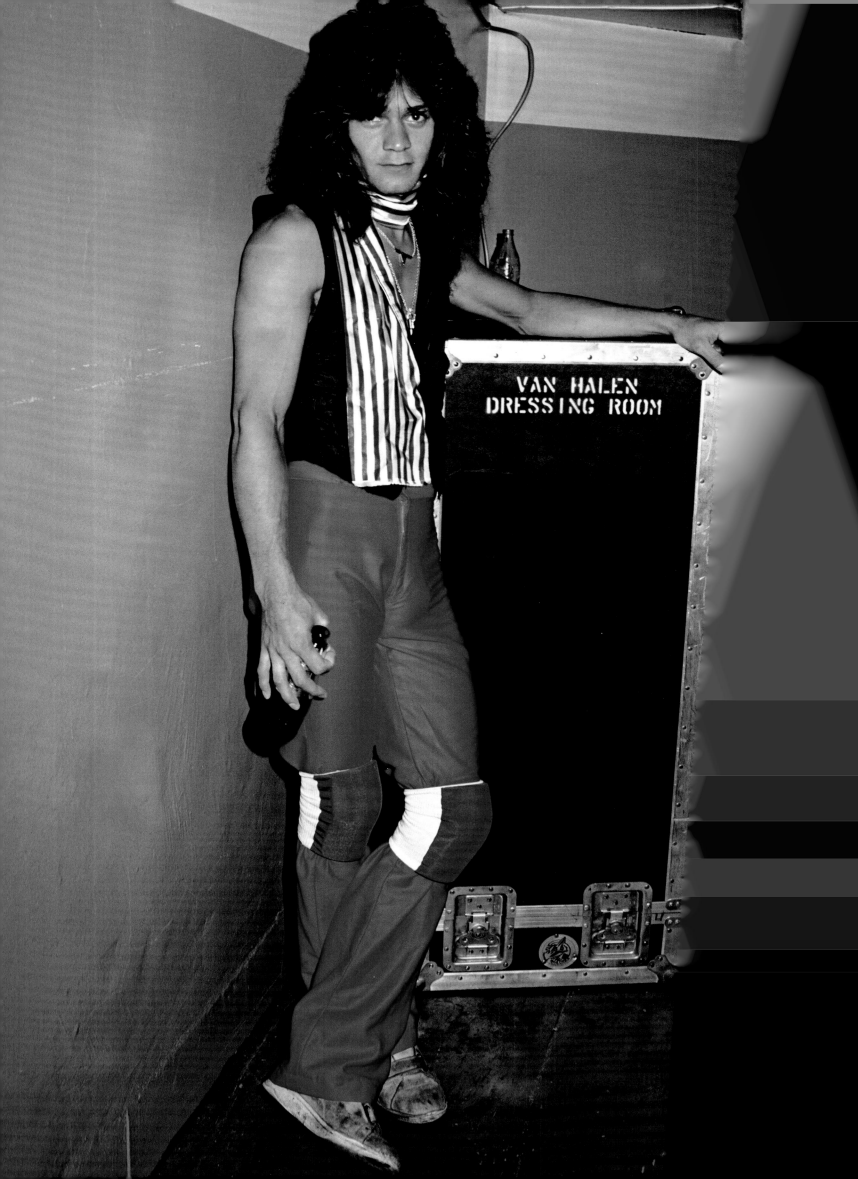

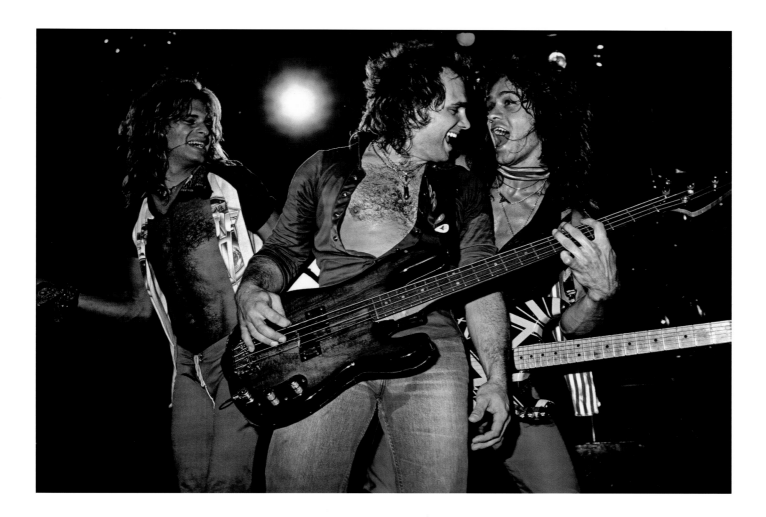

slow shutter. It was all trial and error; I was learning as I was shooting.

The next month I was hired to shoot AC/DC and Ted Nugent at the Spectrum in Philadelphia. It was my first job for Leber-Krebs, the management team that handled Aerosmith, the Scorpions, AC/DC, and Ted Nugent. Laura Kaufman, the publicist at Leber-Krebs, had seen my photos in *Circus* and asked me to shoot both bands that night.

On the way to the show, my foot slipped off the brake at a stoplight, and I rolled into the car in front of me. The guy got out of the driver's seat. As he was walking over to me, I opened up my door to step out and see what the damage was. Before I could even put my foot on the ground, he slammed the door on my leg and sucker-punched me, splitting my lip. Before driving to the Spectrum, I had to make a stop at the hospital to get stitched up.

After shooting AC/DC, I went to find Laura to tell her what had happened. She led me to an empty dressing room, locked the door, rolled up a bill, and poured some coke on the table. "Here ya go, you'll feel better," she said. It was my first line. After that, I felt like

nothing had happened to me—I was ready to go, and off to the photo pit I went. She then brought me in to see Ted. After she told him about my detour, he called me a "true rock warrior."

At the end of the '70s, a lot of people thought rock 'n' roll was on its way out. People were listening to disco and punk. New wave was on the rise. The big acts of the decade—Aerosmith, Zeppelin, the Stones—were all in a period of transition with no major tours planned. This created a void that new bands could step into. Once I saw bands like Van Halen, AC/DC, Judas Priest, and the Scorpions, I knew there was a new generation moving in. They were the new breed, and I was drawn in by their heavier, guitar-driven sound. In the '70s, I was the kid with the camera sneaking into shows and shooting bands from the audience. In the '80s, I was shooting bands from the photo pit, backstage, and on tour. I had the access and the ability to work with rock 'n' roll icons on their rise to stardom. The decade was one big party. It was the decade of MTV, when the visuals were just as important as the music. It was the perfect time to be a photographer. It was the decade that rocked!

OPPOSITE: Eddie Van Halen backstage, *World Vacation* tour, Asbury Park Convention Hall, Asbury Park, New Jersey, 1979 ABOVE: Van Halen, World Vacation tour, 1979

"We weren't into politics or any of that stuff. We were just into party rock. Shit, we just wanted to have a good time, and we happened to love making music." —Michael Anthony (bassist, Van Halen)

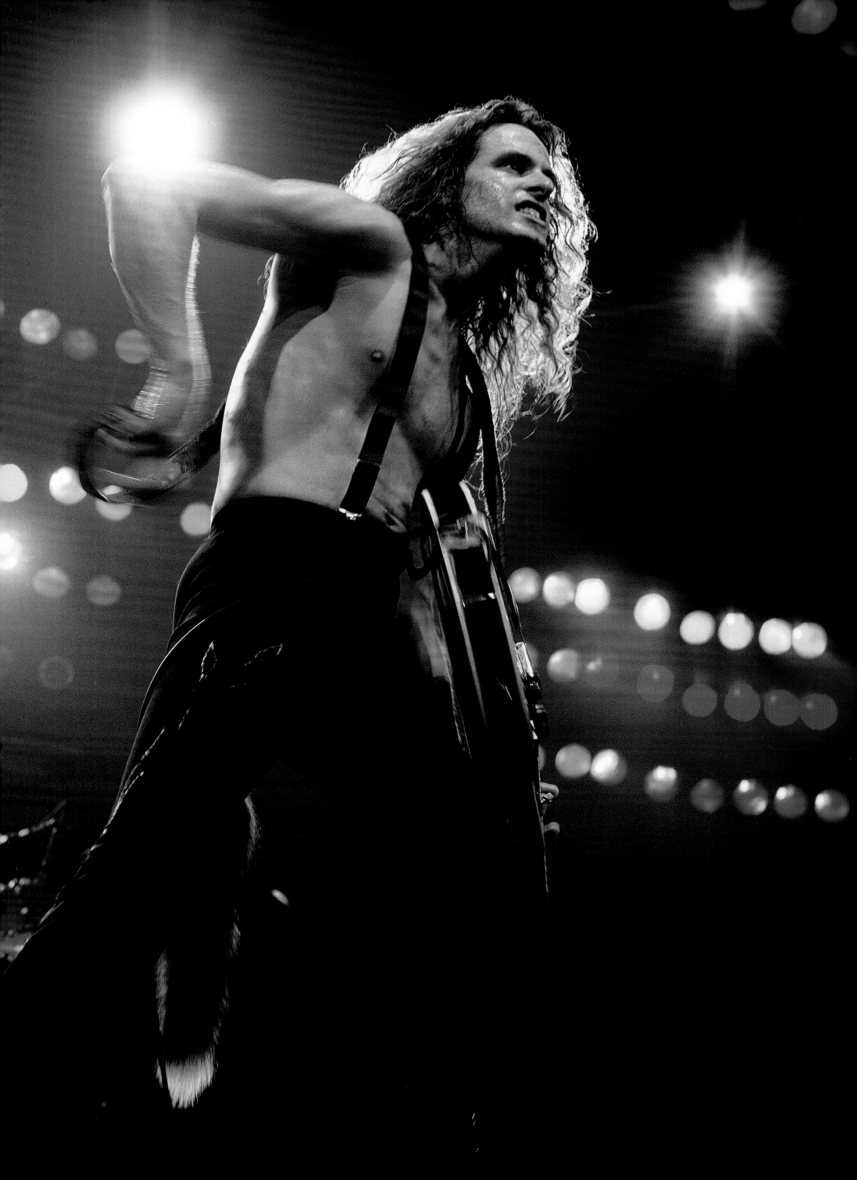

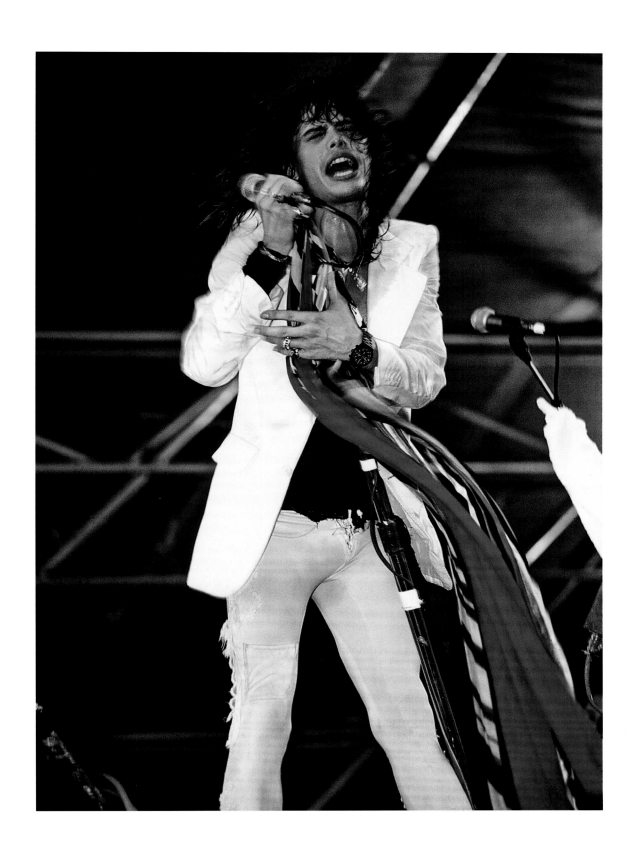

"Mark's got a great work ethic. A great ear. A great eye. I'm very fortunate to have always been surrounded by people who are driven by the spirit and the attitude and the energy and the freedom that American rhythm and blues and rock 'n' roll represents. People like Mark. We consider ourselves a brotherhood." —**Ted Nugent**

OPPOSITE: Ted Nugent, *State of Shock* tour, the Spectrum, Philadelphia, 1979
ABOVE: Aerosmith's Steven Tyler, *Draw the Line* tour, Giants Stadium, 1978

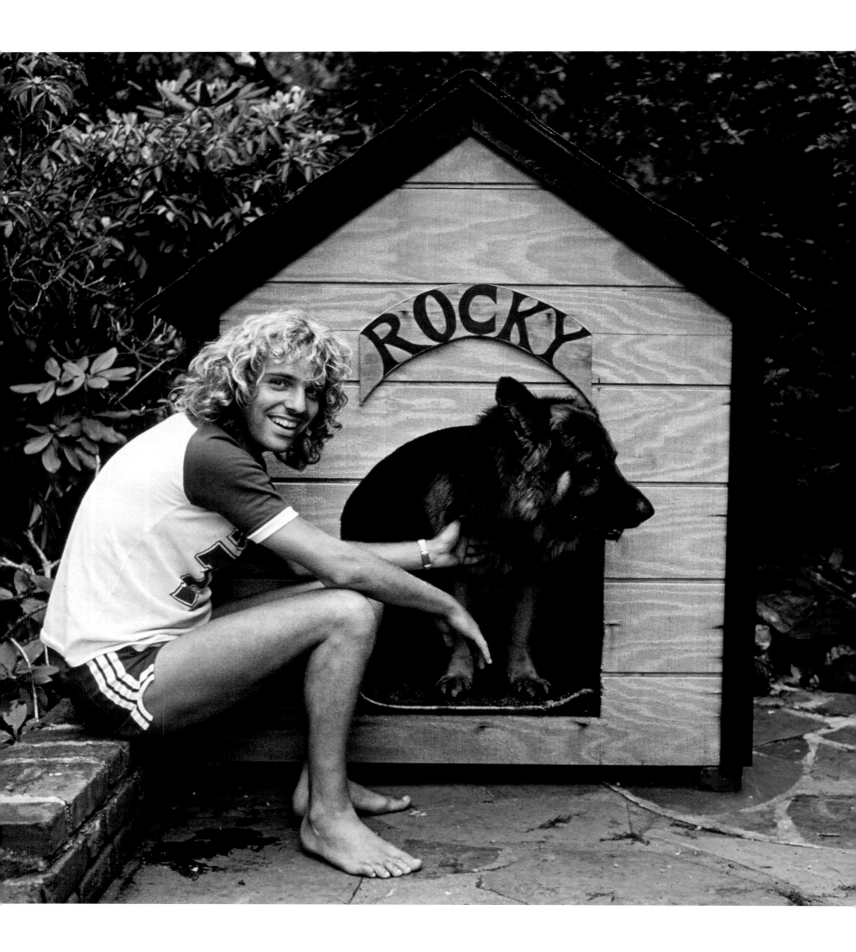

ABOVE: Peter Frampton at home with his dog, Rocky, Westchester, New York, 1979
OPPOSITE: Peter in his recording studio, 1979

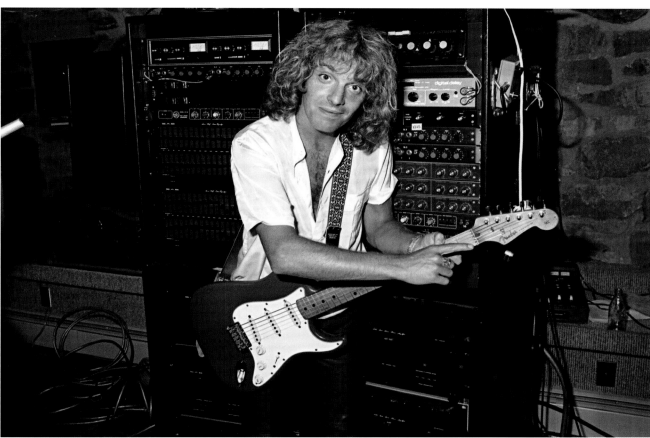

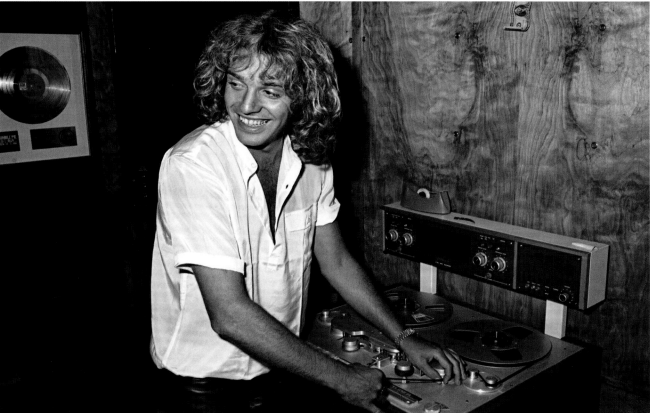

"Mark's taken some timeless photographs, and he was lucky enough to be there in the '70s and '80s when things were really happening as far as rock 'n' roll. It wasn't so much of a business; it was more that we were inventing how to do it at that point. He was there at the beginning of it, and I think he's lasted this long because of his talent." —**Peter Frampton**

ABOVE: Sammy Hagar, Madison Square Garden, 1978 **OPPOSITE:** Judas
Priest's K. K. Downing and Rob Halford, *Killing Machine* tour, the Capitol
Theatre, Passaic, New Jersey, 1979 **PAGES 40–41:** Led Zeppelin, Madison
Square Garden, 1977

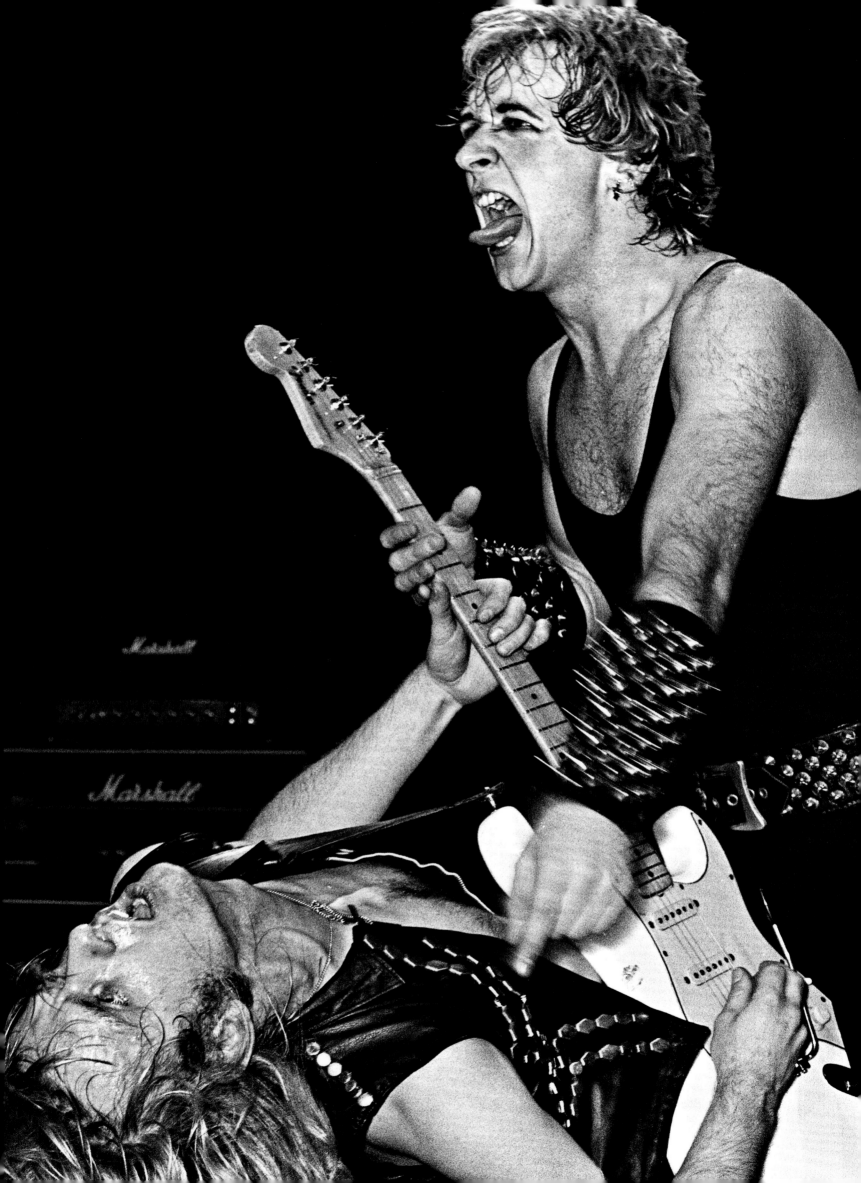

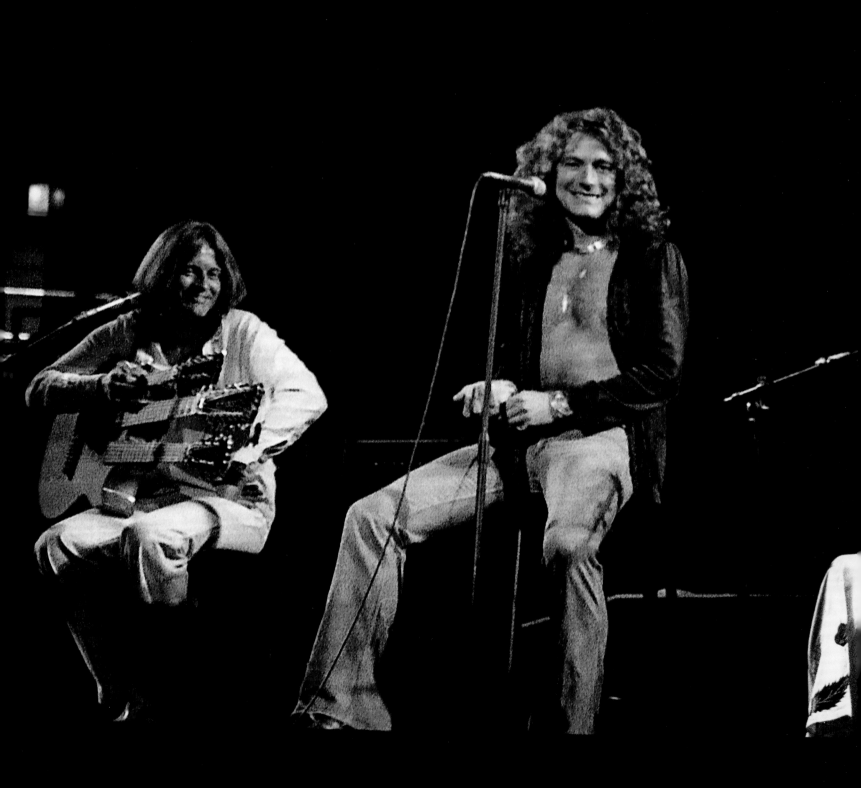

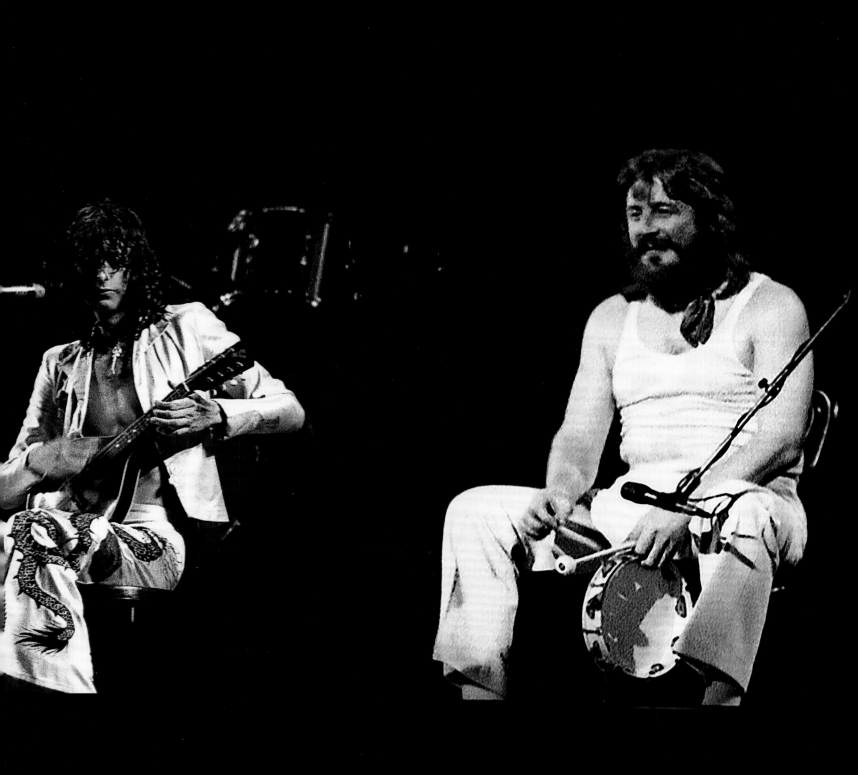

ASINO

THURS JULY 3

WHITE
TIGER
FREE ADMISSION

MARK WEISS
Photographed at the Capitol Theater

MARK WEISS
B 00826
April 1979

THE HITS

ALL THE GIRLS
(WANNA BE IN GANGS)
AND
COUNT ON YOU

PRINTED & PRESSED BY PRI RECORD PRESSING
WYANDANCH, N.Y.

ROCK
SCENE
party

What is it about a signature that attracts a fan? Is it
the performer, or a ha venir? k, for the ca
Mark Weiss to a shop
answers.

LOOKS

AT ALL TICKETRON OU
Call Club F
Tickets Avail
566-9660 50 RT
RKWAY EXIT 117

ENTER TOWER GATE
C 4
0 24 4
SEC. ROW SEAT
ORCHESTRA $10.50
QUEEN MON. EVE.
 SEPT. 29
8:00 P.M. 1980

Not to be outdone, Ian also obliges Trisha in cheeky

MARK WEISS
38 4460

AC/DC
North American Tour 1980
STAGE ACCESS

ENTER TOWER
C 2
45A B 2
LOGE ROW SEAT
BLACK
SABBATH & BLUE
8:00 P.M. SAT. EVE.
 OCT. 18
 1980
LODGE $11.50

E FO

GSTEEN
BAND

MARK WEISS
DEC 1980
36
02598

CIRCUS

NE ON NO LEON

NE ON NO LE

CIRCUS
Steven Tyler
of Aerosmith

THE ALL-TRUE
SEX NEWS MAGAZINE
cher
DEC. $3.50
Cherry
CHRISTMAS!
THE
Bomb
IS BACK
NEW
CENTERSPREAD
AND X-PLOSIVE
PHOTOS
INSIDE!!!

+PHOTO BY MARK WEISS
14
LYNN GOLDSMITH INC. © 1980
241 W. 36th ST. N.Y.C. 10018
MARK WEISS

ARTIST GUEST
PHOTO
AEROSMITH
UNLIMITED

1980

BLACK SABBATH
HEAVEN AND HELL

BLACK SABBATH

HEAVEN AND HELL

ALL AREA
ACCESS

OCT 80N4
PHOTO BY M. SNAKE
LYNN GOLDSMITH INC. © 19
241 W. 36th ST. N.Y.C. 100
25
05814

ADMIT ONE THIS DATE
APR 27 1980
MARK PUMA
PRESENTS
AEROSMITH
FOUNTAIN
CASINO
ASBURY PARK
NEW JERSEY
APR 27 1980
SUN 10 00PM
REFUNDS PRICE NO EXCHANGES
$9.00
SEC ROW SEAT
2004
GEN. ADM.

KODAK SAFETY FILM 5063

S 00188 1980

Weiss

NEW YORK CITY

GOODBYE
NOWHERE MAN

FILM 5063 28 28A 29
KODAK SAFETY

FOR THOSE ABOUT TO ROCK

In October 1980, I saw AC/DC play Nassau Coliseum on their *Back in Black* tour. The last time I had seen them was when they opened for Ted Nugent the year before in Philly; now, Brian Johnson was fronting the group and they were headlining arenas. It was their first tour since the death of Bon Scott, and this was a new beginning for them. Their label threw a party for them at a bar in upper Manhattan called Privates. It was a small get-together to celebrate the release of *Back in Black*. David Coverdale and the guys from Whitesnake came to the party as they were in town for their own gig, opening for Jethro Tull at the Garden.

I loved all music that rocked and always had my eyes open for shows in the area to shoot. On July 5, 1980, Southside Johnny & the Asbury Jukes were playing a show at Freehold Raceway, fifteen minutes from my home. Daryl Hall & John Oates were on the bill, as was Willie Nile. I arrived early in the afternoon and

spotted Southside at the side of the stage, which was set up in the middle of the track where they usually had horse races. I began photographing him as he watched the first band—a bunch of guys right out of high school. Southside said to me, "You should be shooting that kid." I went to the stage to have a closer look. The band, called the Rest, was led by an eighteen-year-old kid named John Bongiovi.

The Rest were playing small clubs on the Jersey circuit, while local bands like White Tiger and Twisted Sister were dominating the scene, packing in as many fans as the national acts. White Tiger played hard rock and heavy metal cover songs at their best. It was all spandex and long hair. They moved better than any band out there, and the girls came out in droves. I befriended the guys, and they asked me if I would do a photo session. It was my first shoot with a heavy metal band.

OPPOSITE: Brian Johnson of AC/DC at Privates, New York City **ABOVE:** Whitesnake's David Coverdale at Privates

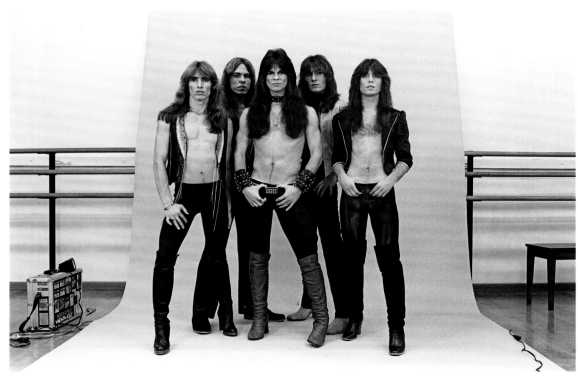

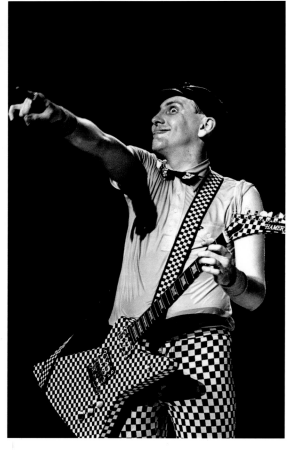

"Mark used to come and shoot our shows. What really struck me about him was his dedication and desire to be a 'rock photographer.' So when we needed a new promo photo I thought I'd give him a crack at it. Needless to say, he got the shot we needed. We used it to promote our upcoming show at the Fountain Casino in the *Aquarian Weekly* newspaper. Soon after, I took Mark with me backstage to a Twisted Sister show and introduced him to Dee Snider."
—**Neil Thomas (singer, White Tiger)**

TOP: White Tiger **BOTTOM LEFT AND RIGHT:** Cheap Trick's Robin Zander and Rick Nielsen on the *Dream Police* tour, Capitol Theatre, Passaic, New Jersey **OPPOSITE:** John Bongiovi with the Rest, Freehold Raceway, New Jersey

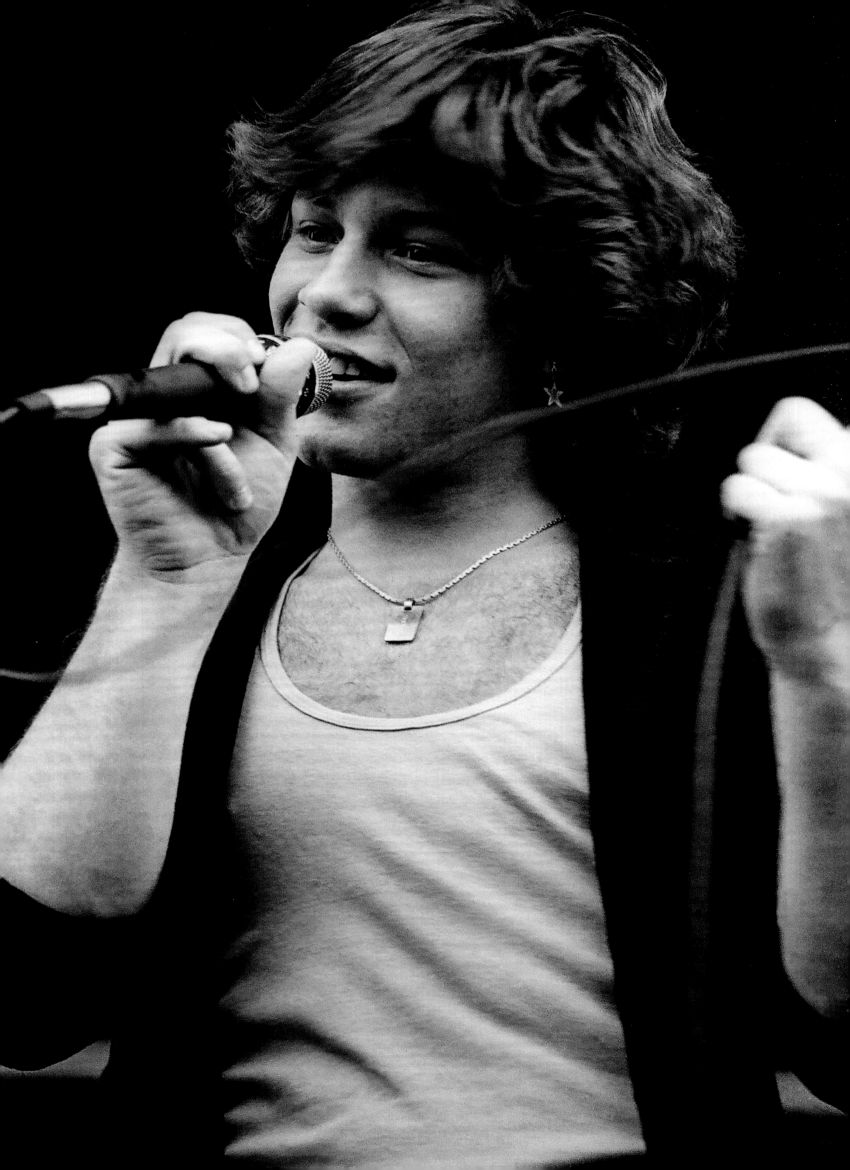

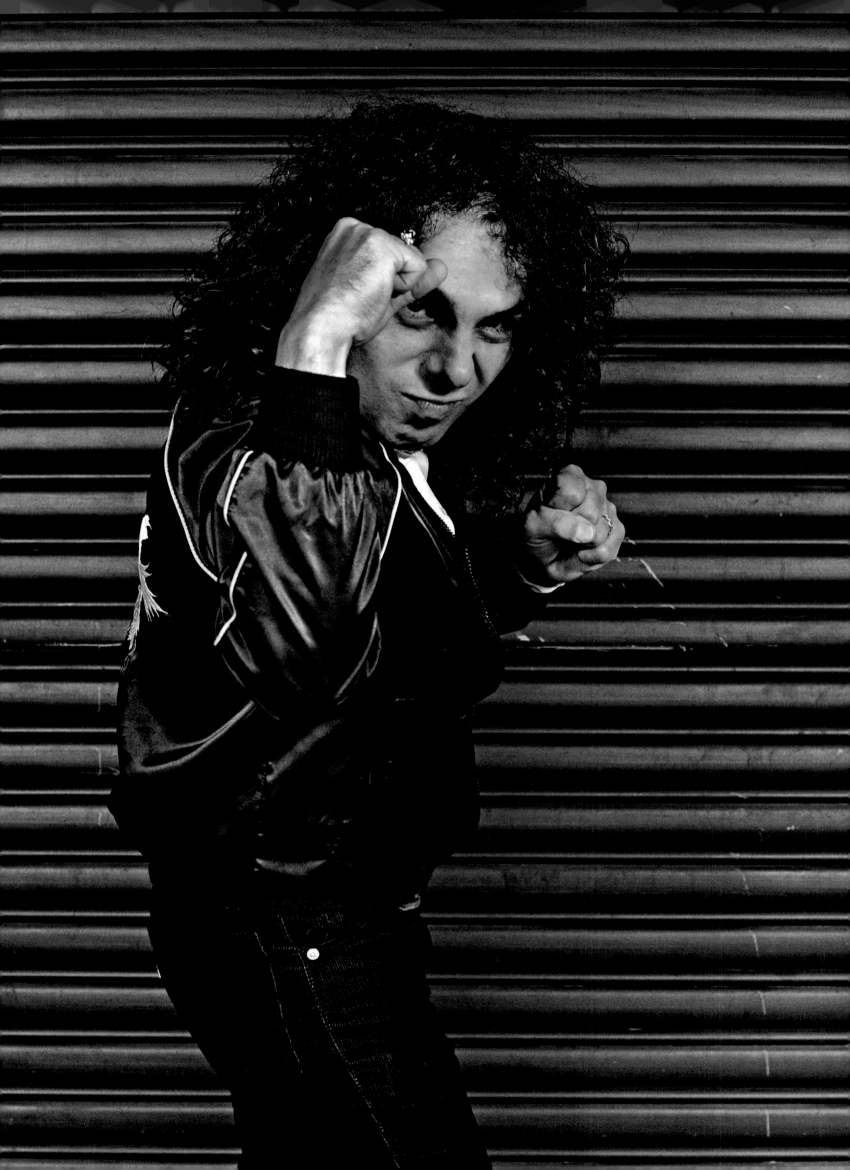

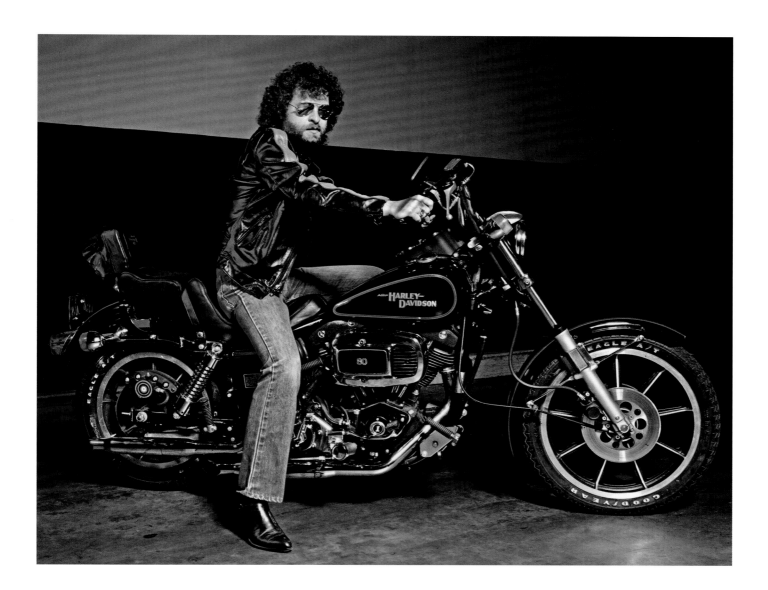

The Capitol Theatre in Passaic, New Jersey, had been an old movie house before promoter John Scher took it over for rock concerts. It was a great place to shoot because there was an aisle in the middle that let us photographers get where we needed to be for the best pictures. I caught Cheap Trick there on their *Dream Police* tour in March, when they were riding the wave of their *Cheap Trick at Budokan* success.

Around this time, Kiss were planning to do a warm-up show at the Palladium in Manhattan with their new drummer, Eric Carr. It was their only gig in the US that year, it was a smaller venue, and it was the first time ever that they'd be playing with a new member. For Kiss fans, it was a big event. By that point, I could get almost any photo pass I requested, and this show was one I wasn't going to miss out on.

I got a call from photographer Lynn Goldsmith, who complimented my photos and asked if I wanted to make extra money syndicating them worldwide through her photo agency, LGI. I told her that I couldn't sell my photos because *Circus* got me the passes to shoot the bands and owned them. She talked me into using an alias so *Circus* wouldn't know about it. She also told me she could get me photo shoots and access. I began submitting through her and earning extra money. She was true to her word and set up a shoot for me with Blue Öyster Cult front man Eric Bloom and his Harley-Davidson at Madison Square Garden, when they coheadlined with Black Sabbath on the Black and Blue tour.

Black Sabbath headlined that night; I had never seen them live, much less with Ronnie James Dio. After the shoot with Eric, I introduced myself to Sabbath's tour manager to see if they would do some quick photos. They agreed, and after we were done with the group photos, Ronnie asked if I wanted to take some solo shots. We immediately bonded. It was the beginning of a working relationship that continued until he passed away in 2010.

OPPOSITE: Black Sabbath's Ronnie James Dio on the Black and Blue tour
ABOVE: Blue Öyster Cult's Eric Bloom on the Black and Blue tour, Madison Square Garden

"I rode it up for the encore on 'Born to Be Wild'—I personally was calling dealers and saying, 'Is there anyone there I can borrow a bike from?,' and I would get them a backstage pass. I'd been doing this for a couple years and then in 1980 I corralled Harley to give me a bike. It's a 1980 Low Rider."
—Eric Bloom (singer, Blue Öyster Cult)

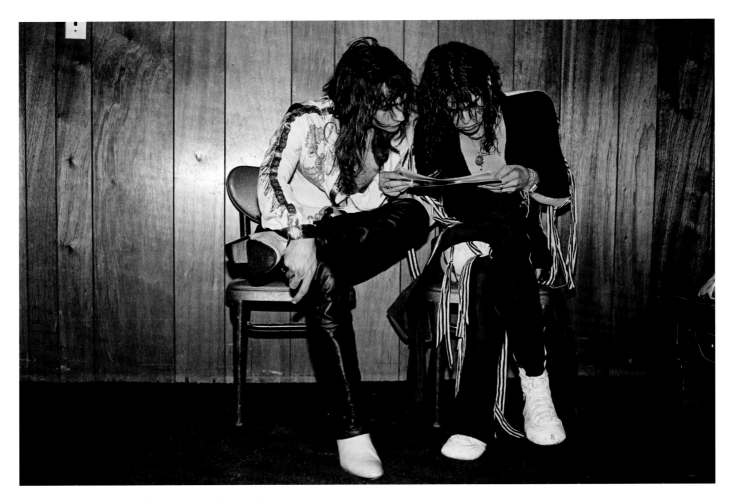

ROCK AND A HARD PLACE

In April, Aerosmith came to the Fountain Casino in Aberdeen, New Jersey. It was a smaller venue for them; they were back in the clubs because Joe Perry had left the band and Jimmy Crespo was brought in. But it was a special show for me. I was on assignment for *Circus*, and I took a copy of that 1978 issue to sound check and also made a few prints to give to Steven. He dug the centerfold and prints, and he gave me an all-access pass to shoot the show. It was the beginning of a long relationship with Aerosmith that continues today.

Around the same time, Joe was out on the road with his new band, the Joe Perry Project. They were promoting their debut album, *Let the Music Do the Talking*. While Aerosmith was playing at the Fountain Casino, Joe came to Jersey for a gig at Alexander's, a place that had previously been a go-go bar. Joe was playing in front of only a couple of hundred people, but to him it didn't seem to matter. He was very humble and seemed happy to be starting over, outside of Aerosmith. We hung out a bit backstage before the show, and I shot some photos of him holding up his album cover.

Rusty Hamilton, now the music editor for *Cheri*, asked me if I could come up with a rock band to interview in the magazine. I knew Ted Nugent was rehearsing at SIR in New York City, so I asked his publicist if he would do it. Ted wasn't shy about anything, really—it was a no-holds-barred interview about sex, drugs, and rock 'n' roll.

Toward the end of the year, I went to Connecticut to shoot Pat Benatar for the cover of *Circus*'s annual Awards Issue. Pat and Robert Plant were being honored as "Woman of the Year" and "Man of the Year." We did a five-minute session backstage at the University of Hartford before she went on.

In December, I went to Central Park a week after John Lennon was assassinated. Fans came together to mourn him. I remember seeing Bob Gruen's iconic photo of John center stage; it showed me the impact a photograph could have. Huge changes were taking place. Bon Scott and John Bonham died, and John Lennon was murdered. At the same time, there was all this great new hard rock and metal music coming out from bands like Van Halen, the Scorpions, and Judas Priest. AC/DC began to flourish with their new lead singer, while the mighty Led Zeppelin had reached their peak. A new decade was beginning to take shape.

ABOVE: Aerosmith's Jimmy Crespo and Steven Tyler backstage, *Night in the Ruts* tour **OPPOSITE:** Joe Perry on the *Let the Music Do the Talking* tour, Alexander's, New Jersey

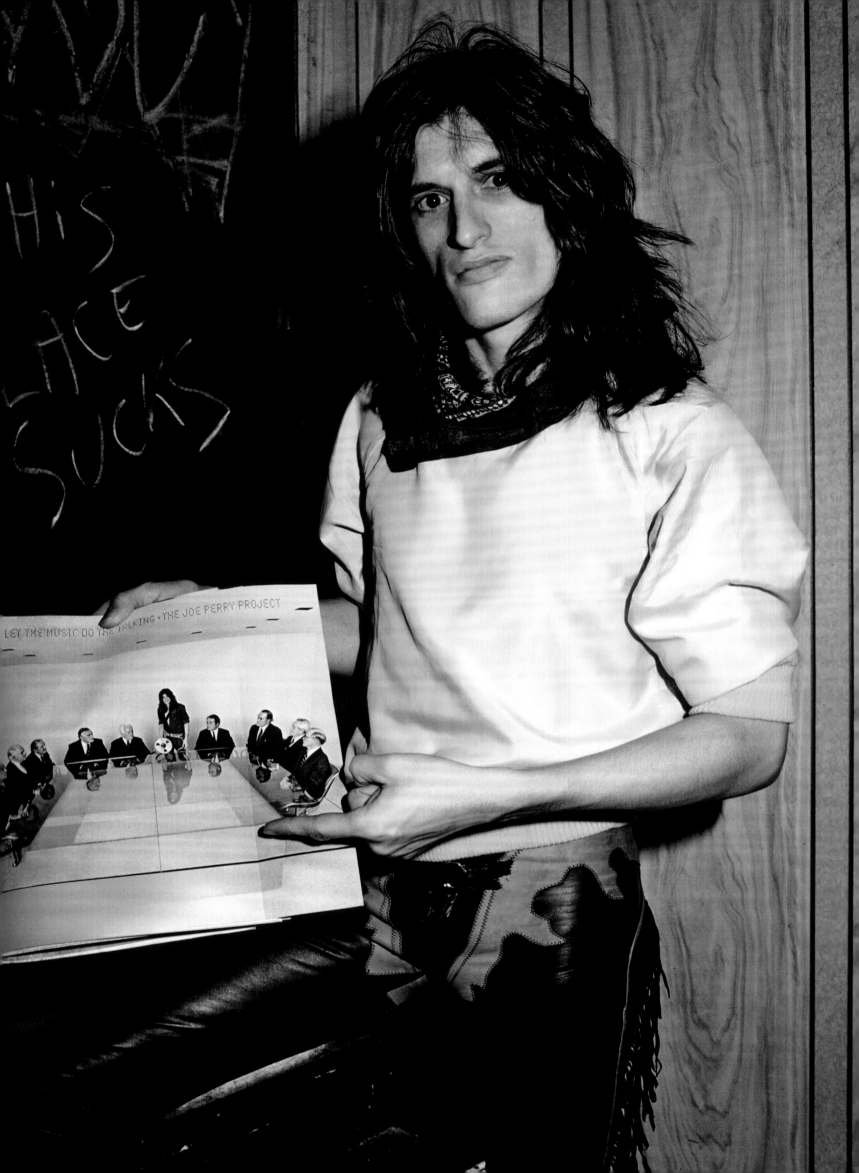

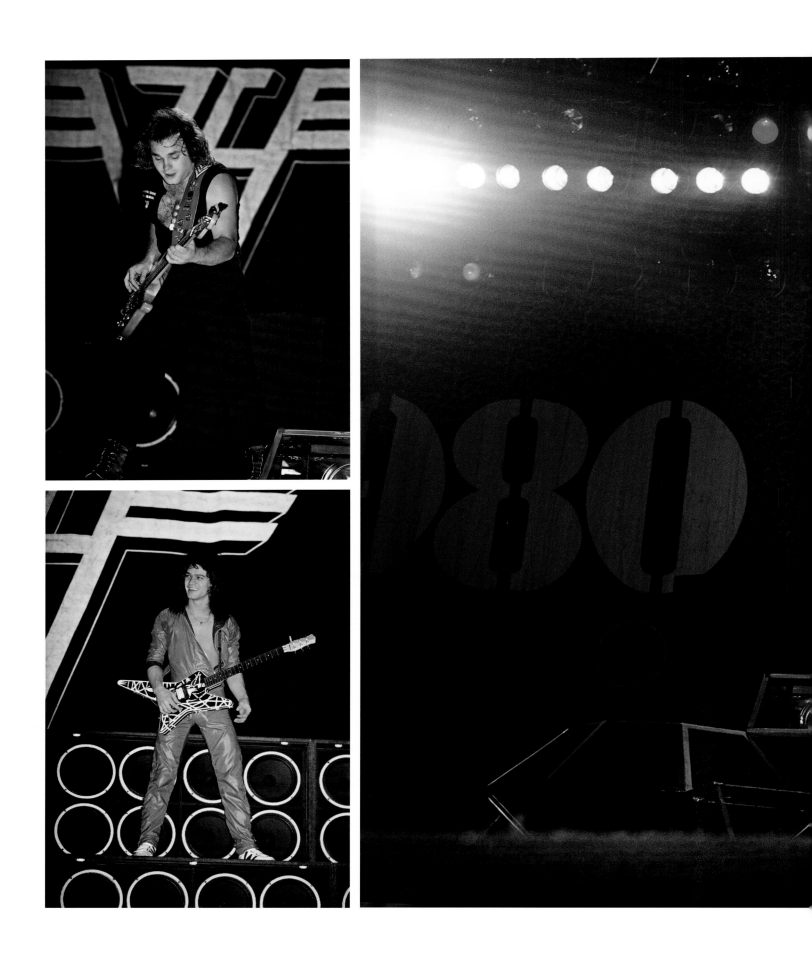

OPPOSITE AND ABOVE: Van Halen, World Invasion tour

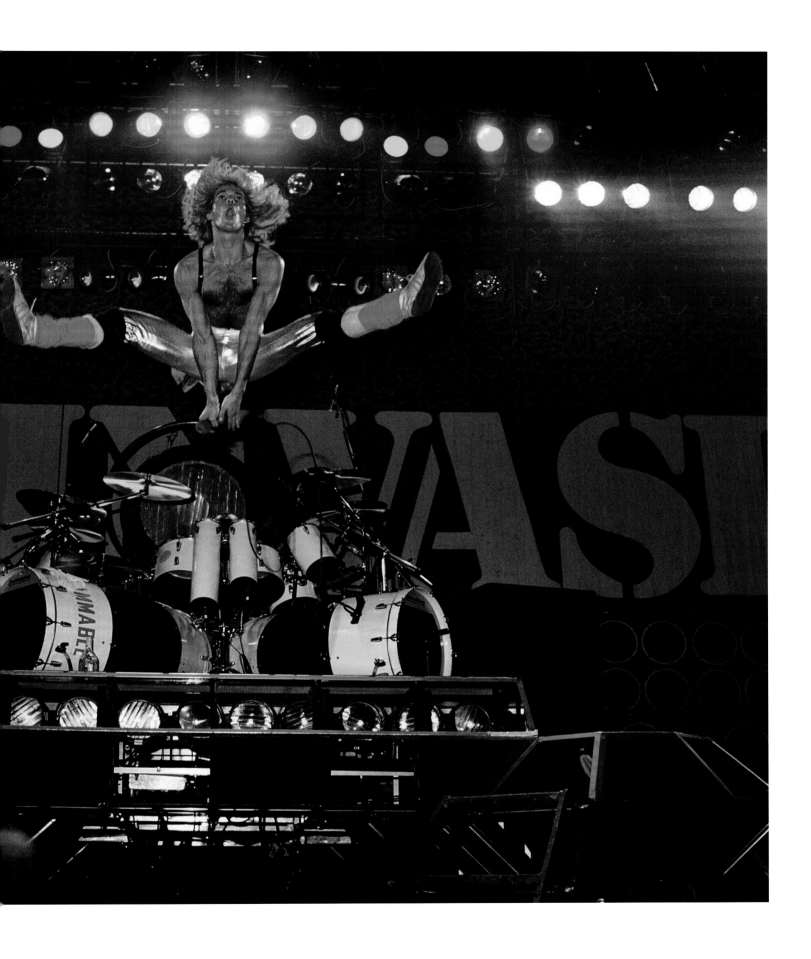

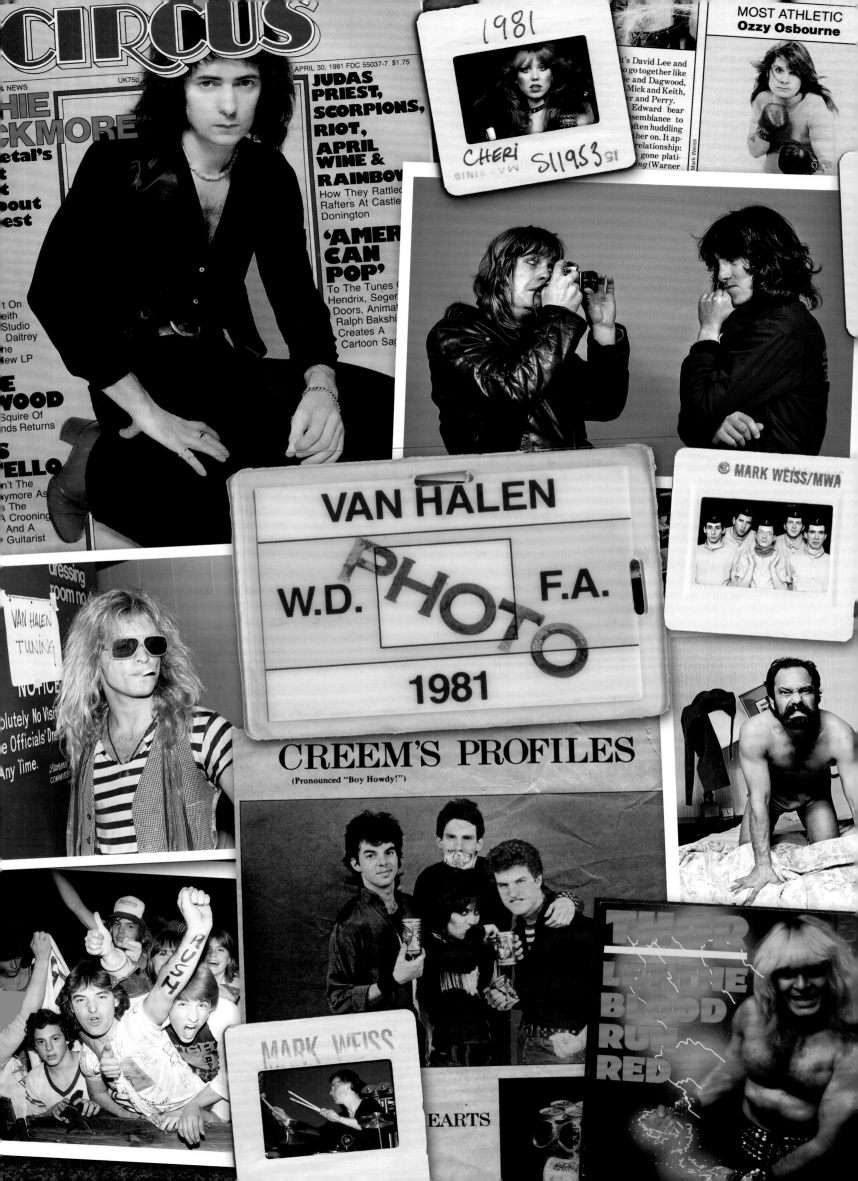

CIRCUS

UK75p

NEWS

HIE
CKMORE

etal's
t
out
est

On
eith
Studio
Daltrey
he
New LP

E
WOOD
Squire Of
nds Returns

S
ELLO
n't The
ymore As
s The
Crooning
And A
Guitarist

APRIL 30, 1981 FDC 55037-7 $1.75

JUDAS
PRIEST,
SCORPIONS,
RIOT,
APRIL
WINE &
RAINBOW
How They Rattled
Rafters At Castle
Donington

'AMERI
CAN
POP'
To The Tunes
Hendrix, Seger,
Doors, Animal
Ralph Bakshi
Creates A
Cartoon Saga

1981
CHERI S11953

MOST ATHLETIC
Ozzy Osbourne

t's David Lee and
o go together like
ie and Dagwood,
Mick and Keith,
er and Perry.
Edward bear
semblance to
often huddling
her on. It ap-
relationship—
gone plati-
ng (Warner

Mark Weiss

© MARK WEISS/MWA

dressing
room no.4

VAN HALEN
TUNING

NOTICE
lutely No Visit
e Officials' Dre
Any Time.

Lawrence
COMMISS

VAN HALEN
W.D. PHOTO F.A.
1981

CREEM'S PROFILES
(Pronounced "Boy Howdy!")

RUSH

MARK WEISS

THOR
LITTLE
BLOOD
RUN
RED

EARTS

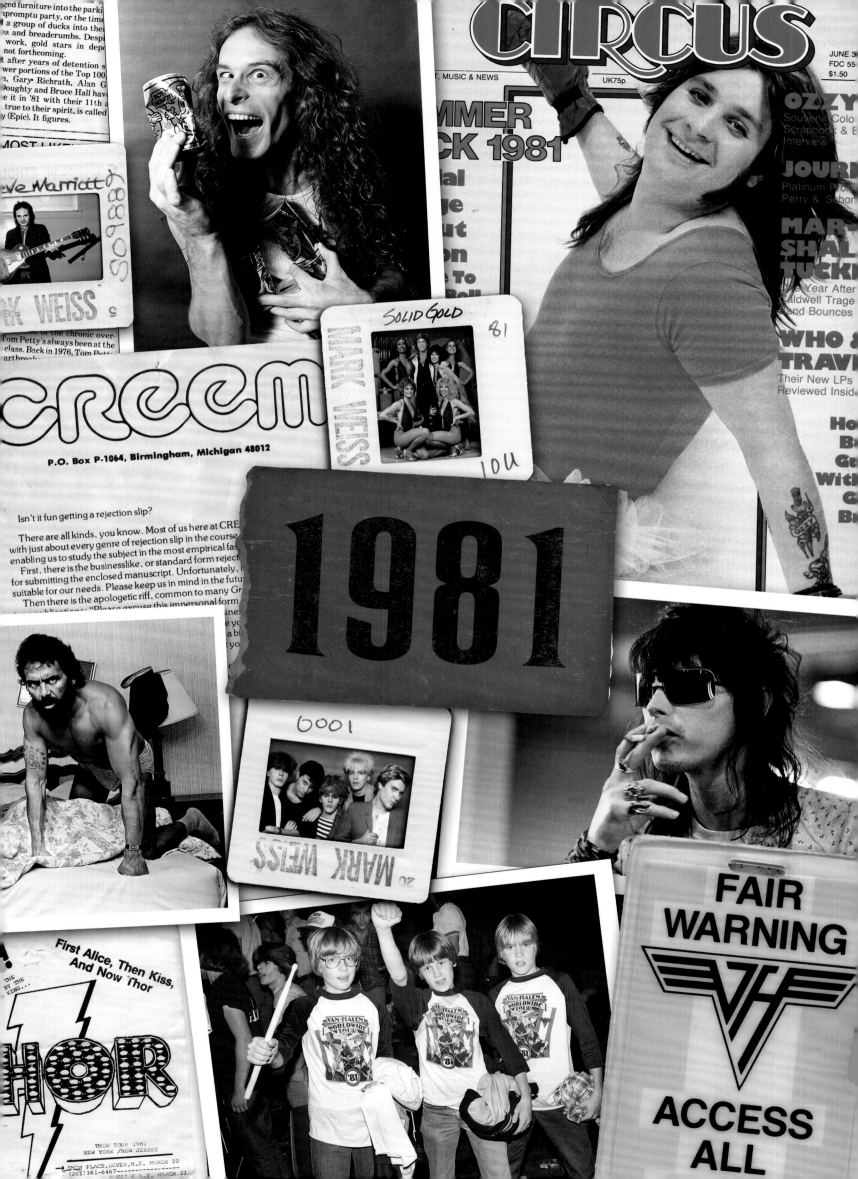

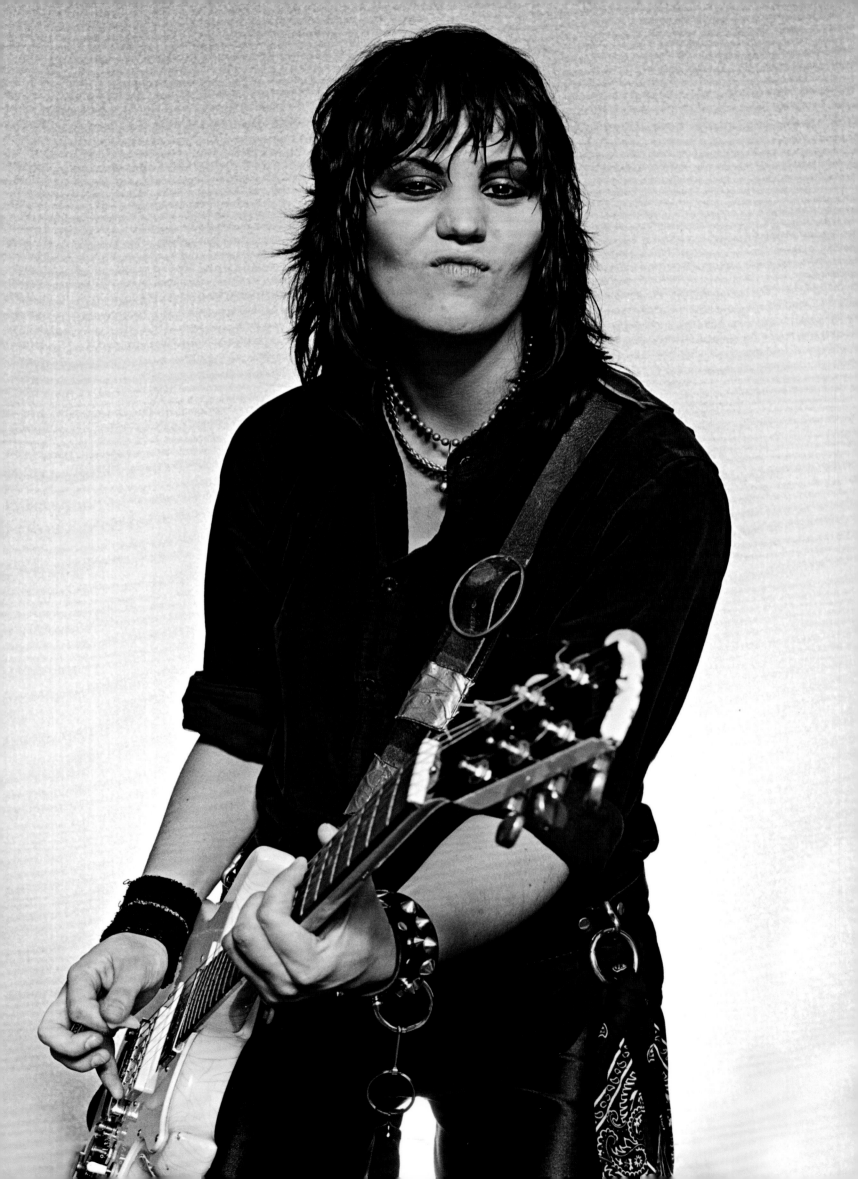

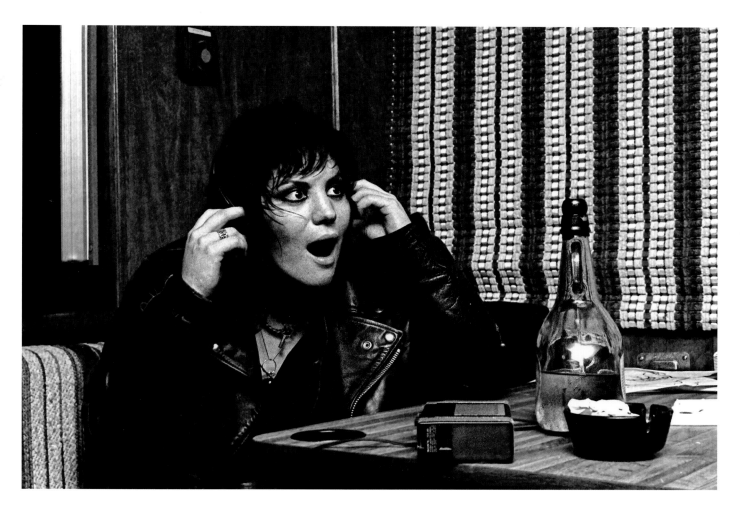

I LOVE ROCK 'N' ROLL

By this time, my photos were being published in almost every issue of *Circus*. The magazine mostly used live photos, but I wanted to do more backstage and posed photo shoots, so I figured I would branch out. I knew that *Creem* magazine published backstage photos, so I sent some of my work to their offices in Detroit. I followed up with a phone call to one of the editors, and he told me the bands I was shooting were too metal for *Creem*. I told him I had been shooting Joan Jett at some shows around New York and asked if he would be interested in seeing the photographs. He said, "If you can get her to hold a Boy Howdy can, I'll get you a full page." He sent me some labels, which I could then put on some cans. "Boy Howdy" was the name of a fictitious beer, and the idea was to shoot the artist holding the can, and then under the photo there would be text poking fun at the band—good rock 'n' roll fun, Lester Bangs style. The challenge was on. (A few years later, I came in second in *Creem*'s 1985 Readers Poll for Photographer of the Year.)

I was in high school when I first saw the Runaways on the cover of *Circus*. I thought, how cool would it be to go on tour and shoot that band? In 1979, the girls broke up and Joan Jett pursued a solo career. Soon after, I met Joan at the offices of Leber-Krebs, who were interested in managing her. I would spend a lot of time at Leber-Krebs, as they were managing Aerosmith and Ted Nugent. Whenever I had something to do in the city, I would be there making follow-up calls, and I became good friends with Carol Kaye, who did publicity for their bands. It was my unofficial office. That's when I began working with Joan and documenting her early days as a solo artist.

I felt I was part of a team. Joan had newfound success after releasing her *Bad Reputation* album and I was there to capture it with my camera. She played a few shows around New York, and felt comfortable enough around me to let me shoot her behind the scenes.

When Joan was about to release her second solo album, *I Love Rock 'n Roll*, Carol called me to shoot the press photos. I needed a place to do a shoot, so I rented a studio in New York City. After that I knew that my next goal would be to get my own space.

Plus, at the end of the shoot I brought out the "Boy Howdy" cans. Mission accomplished—*Creem* published a full page of Joan and the band.

OPPOSITE AND ABOVE: Joan Jett, New York City

"Mark was shooting around the time that we were going from being a really struggling band to having a little bit more success, and being able to document that was really special. And those photos were great." —**Joan Jett**

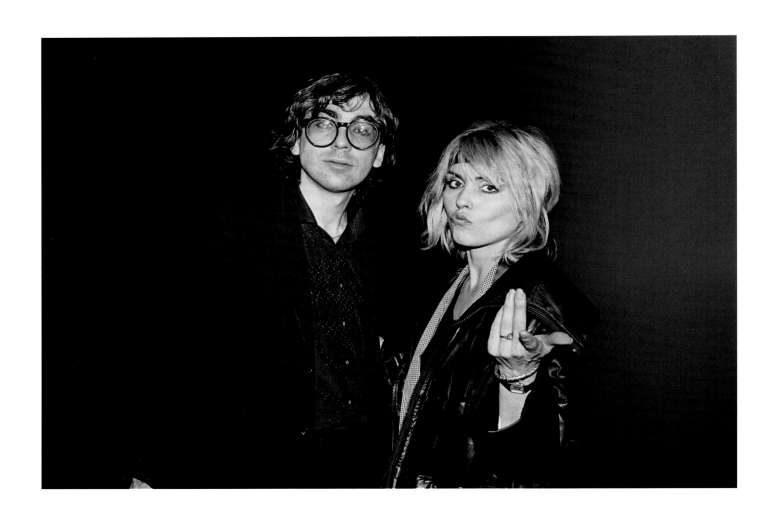

"Mark has a way of putting everyone at ease and getting five or six people to all look good at the same moment, which isn't easy. He's just a great rock photographer. What more could a girl like me ask for?" —**Debbie Harry (singer, Blondie)**

ABOVE: Blondie's Chris Stein and Debbie Harry, New York City
OPPOSITE: Debbie Harry

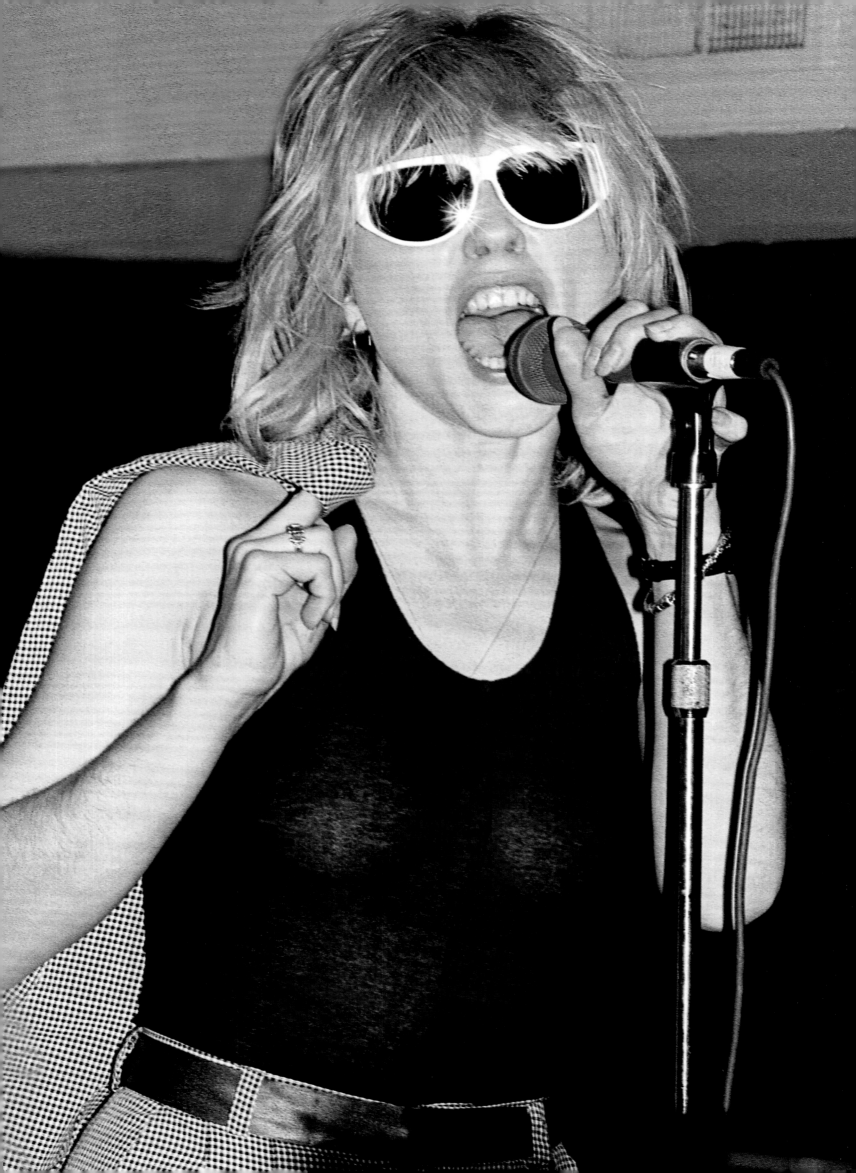

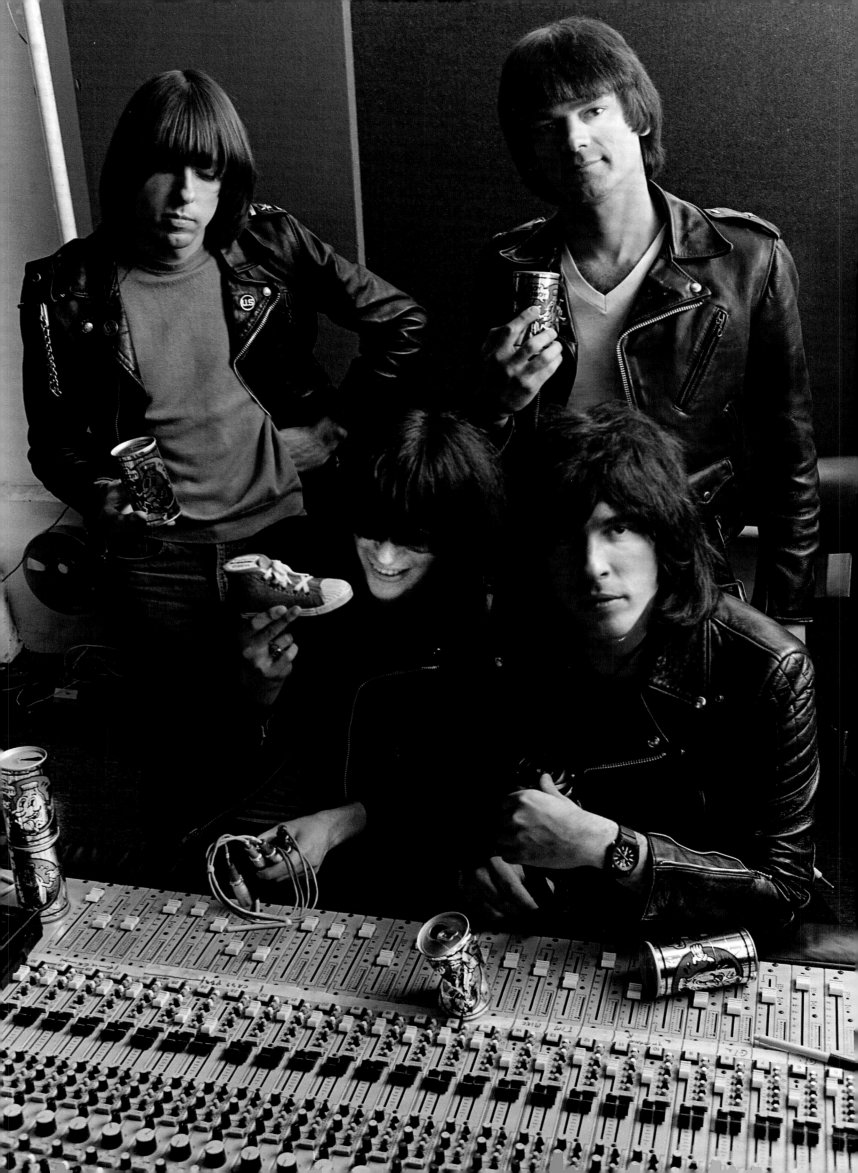

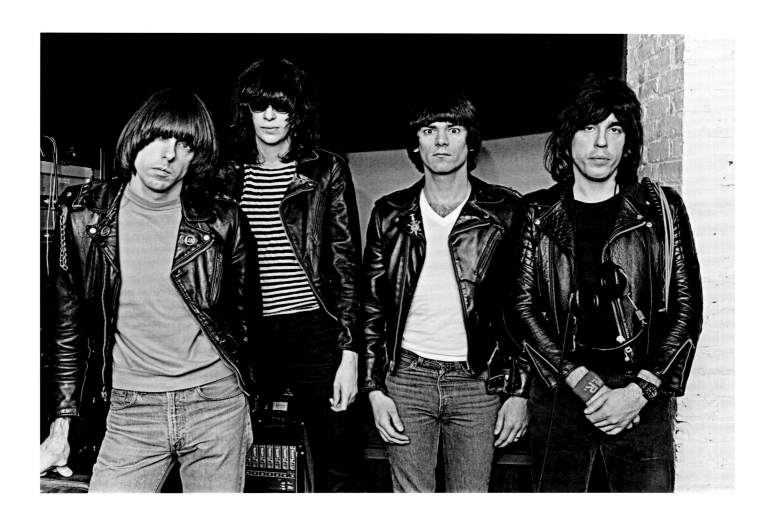

"We were not really posing—we were standing. The Ramones never posed, like sticking our asses out or puckering our lips. We weren't into that shit. We just stood there, and you got what you got. Mark really captured us. Look at Dee Dee's eyes. And there's John, looking like a typical drill sergeant, and I'm there, holding my beer. I don't know what Joey's doing!" —**Marky Ramone (drummer, the Ramones)**

OPPOSITE AND ABOVE: The Ramones, Media Sound Studio, New York City

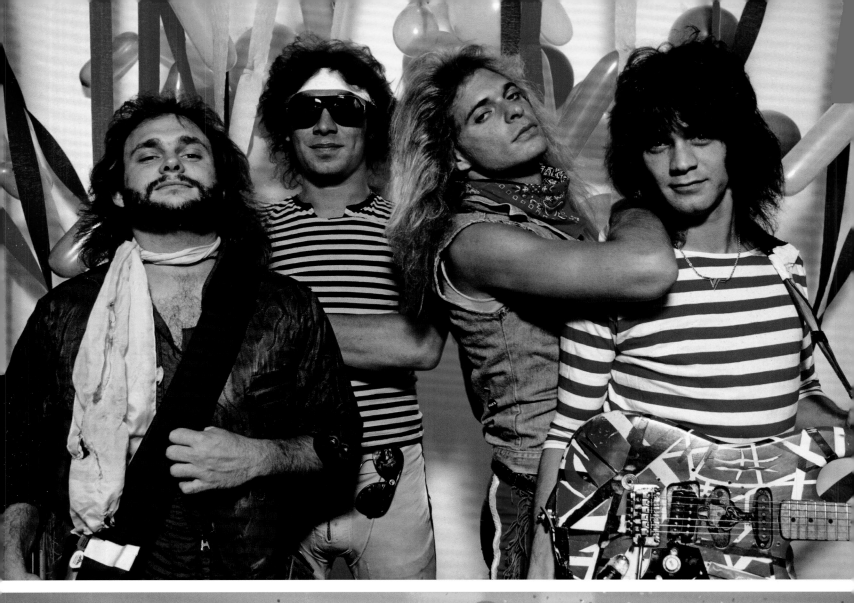
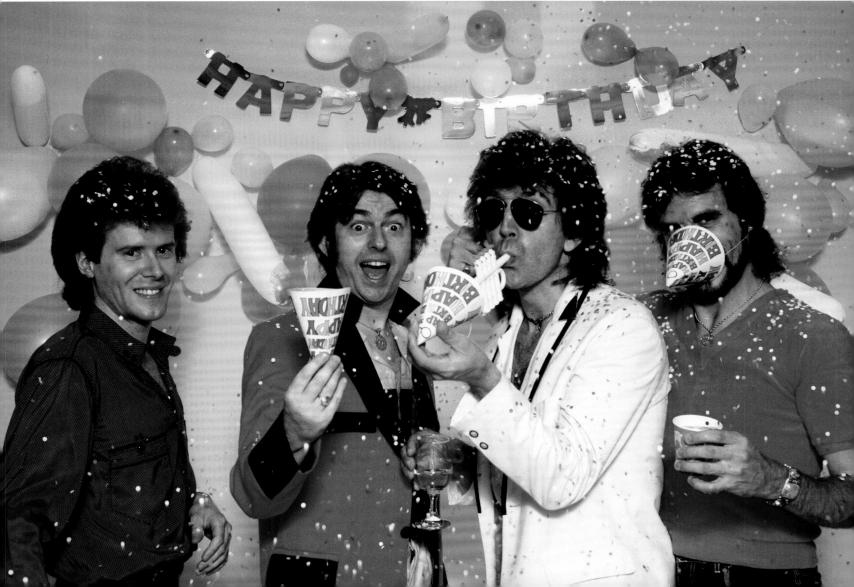

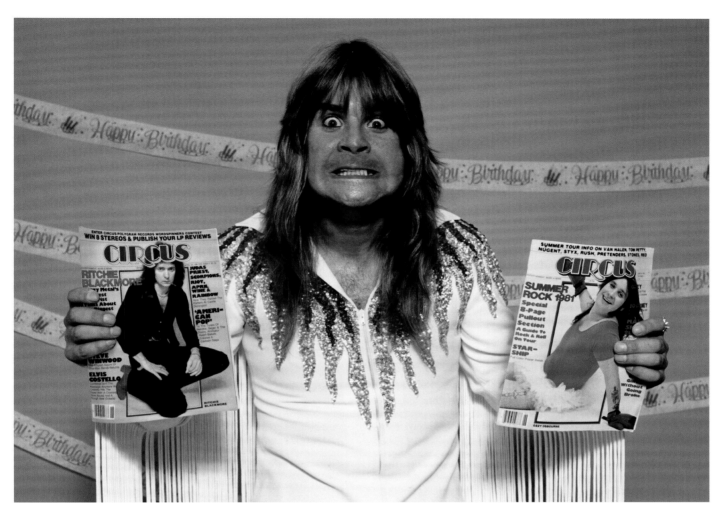

JOINING THE CIRCUS

As a teenager reading *Circus*, I had always dreamed about having a studio portrait on the cover. Ritchie Blackmore was my first photo to get the full cover. I knew he always wore black, and so I talked with the art director, Lon Heller, about using a yellow background, a nice contrast that would pop on the newsstands. They also wanted a photo without his guitar on the cover. He would always pose with his guitar and was reluctant to pose without it, so I had my work cut out for me. I set up a makeshift studio in the conference room at a Holiday Inn near Ritchie's home on Long Island. Ritchie seemed reserved, and at the beginning of the shoot there wasn't much conversation between us. I like to give artists their space. I know when to push and when to lay back. Once I had him pose with his guitar, he relaxed a bit and was more at ease.

Circus was celebrating twelve years of publishing, and they asked me to come up with bands to shoot for their anniversary issue. Van Halen was at the top of that list. When they headlined the Philly Spectrum that summer, I brought along some balloons and party props and shot them backstage. I used similar backdrops for Def Leppard, Ozzy, Foghat, the Tubes, and Billy Squier in the same issue.

In September of '81, the Rolling Stones kicked off their *Tattoo You* tour at JFK Stadium in Philadelphia. The chance to shoot the Stones on assignment for *Circus* was a dream come true. Just before the Stones went on, I saw Journey, the opening band, walking around backstage. I approached them and told them I was working for *Circus* and asked if they would take a few photos. The colored wall behind them was part of the Stones's backdrop. It was perfect. I've always been inspired by textures and colors. Whenever I would go on tour with a band, I would look for a beat-up brick wall, an abandoned building. To me, that shows character.

THESE PAGES: Photographs taken for the *Circus* anniversary issue: Van Halen (*opposite top*); Foghat (*opposite bottom*); Ozzy Osbourne (*above*)

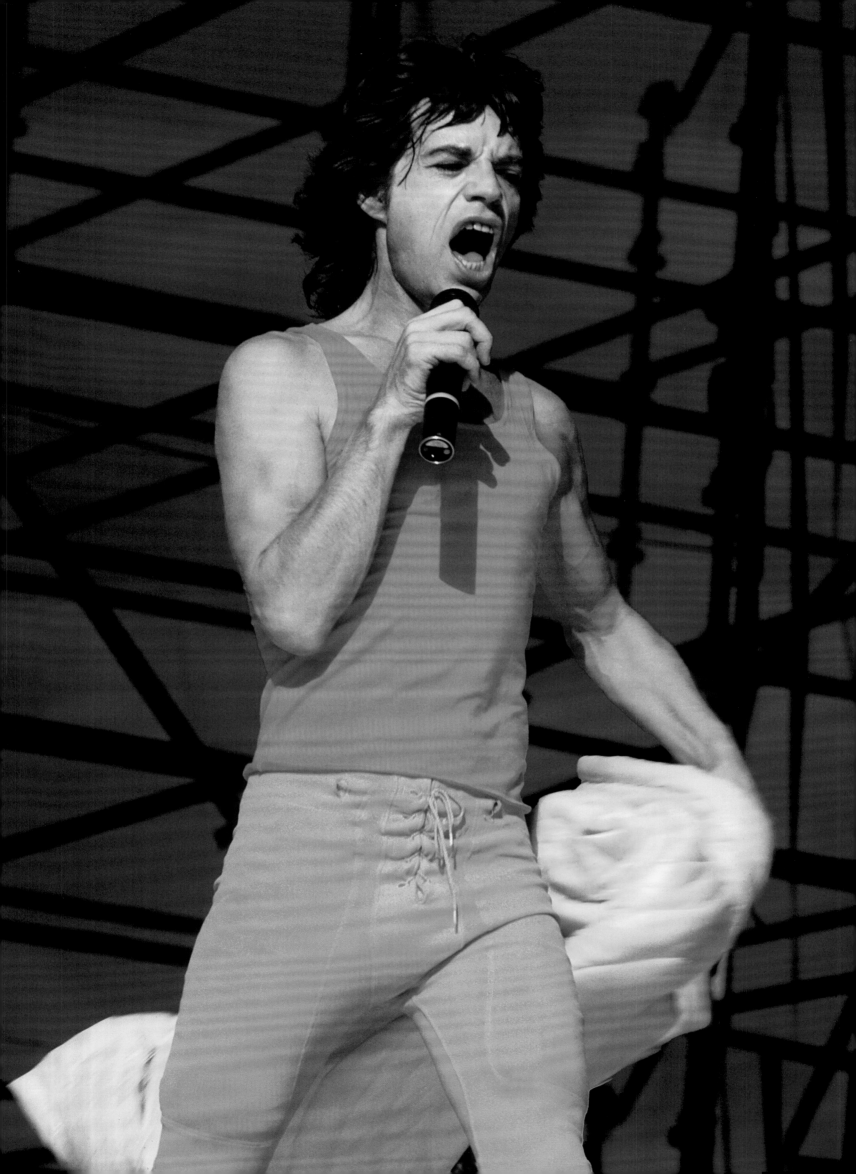

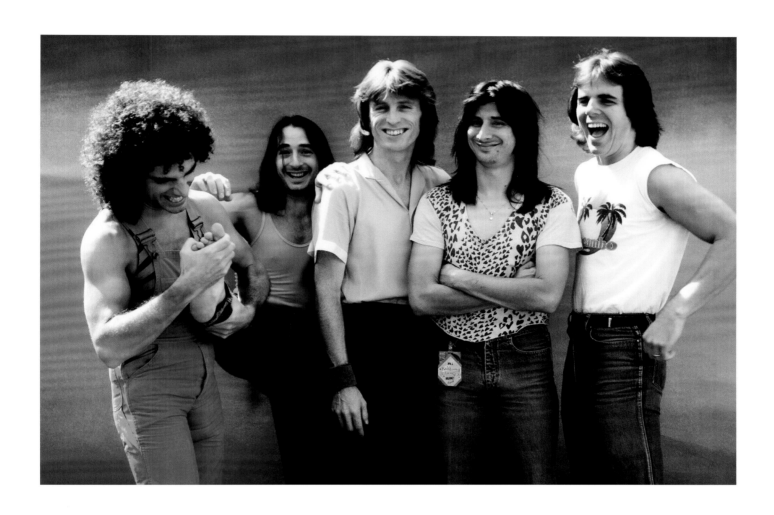

OPPOSITE: Mick Jagger, *Tattoo You* tour, JFK Stadium, Philadelphia
ABOVE: Journey, *Escape* tour, JFK Stadium

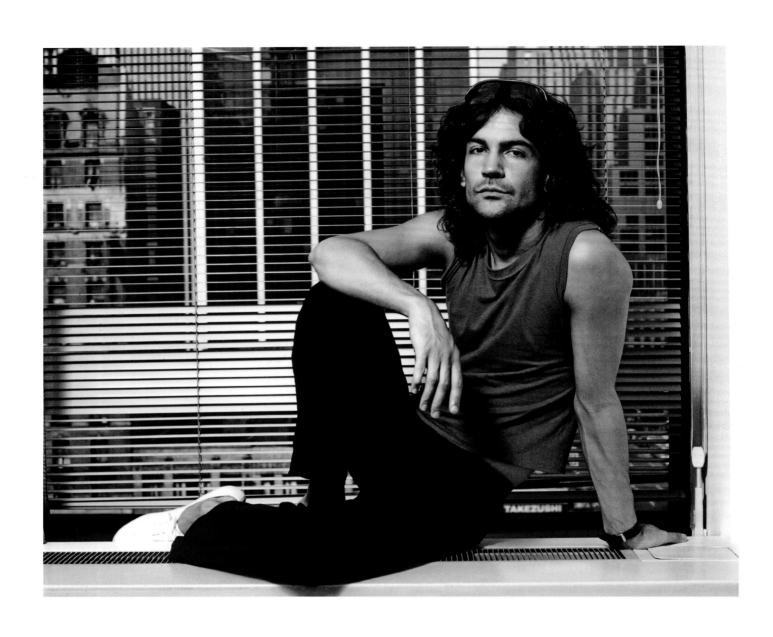

"Mark was a big presence in my camp. He's a great photographer—aggressive, and I don't mean that in a negative way. He's a fan, too, and he always gets the shot."
—Billy Squier

ABOVE: Billy Squier at the *Circus* offices, New York City
OPPOSITE: Rainbow's Ritchie Blackmore, Long Island, New York

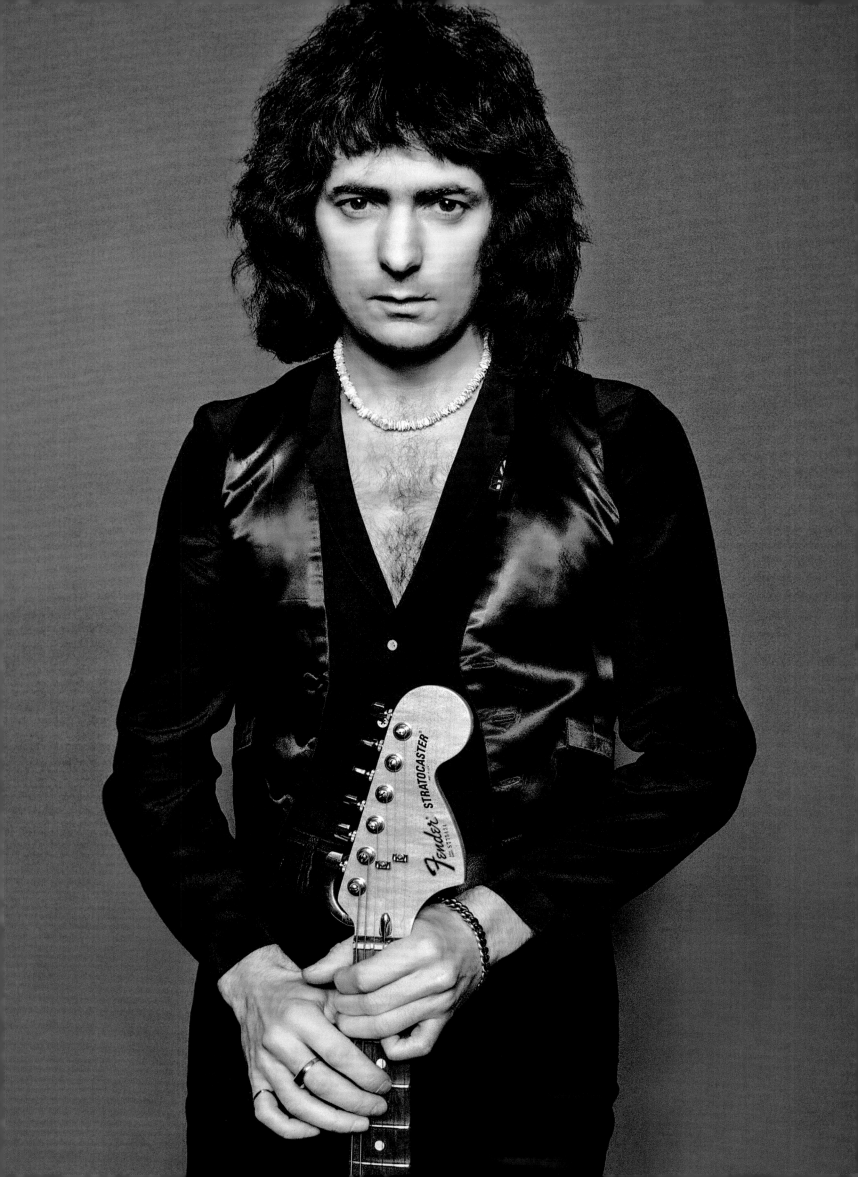

THE OZZMAN COMETH

August 1 was the official launch date of MTV. With the rise of music videos in rock and new wave, the visuals were more important than ever.

Record labels were hiring me to shoot their acts coming in from England. Capitol had me come up to their offices for a session with Duran Duran, who had just put out their first album. Adam Ant's label rented a boat near the South Street Seaport in downtown Manhattan to drum up some publicity. As we sailed along the East River, I photographed Adam with the New York City skyline behind him.

In April, I was assigned to shoot with Ozzy Osbourne for a cover and feature. I knew this one would be a blast; the news had just come out that Ozzy had bit the head off a dove at a record company meeting the month before. He was in NYC promoting his first solo album, *Blizzard of Ozz*. I spent a few days with Ozzy, shooting him around the city and at his hotel room at the Plaza, where I set up a background for the cover shoot. *Circus* was planning to use his image on a few covers as well as in multiple spreads, so we tried a few different looks during the session.

Ozzy was a great subject. When I asked him to try something, he would always do it, and more. At the time, I didn't always speak up. One of the things I kept telling him was to lean his head forward, because he had a bit of a double chin when his head was relaxed. He couldn't understand my direction, but instinctively he would lean his head forward to hear me better. Ozzy would keep saying, "What? I can't hear you, Mark!" So I would yell, "Yes, that's it!" He would answer, "*What's* it? What the fuck are you *saying*?" It was like an Abbott and Costello routine. We had a good laugh about that. After the shoot, I showed him my portfolio. Then we took some photos together. We were like two kids having fun. I finally felt like I was coming into my own.

One of the features that he was going to be in was titled "Rock & Roll Yearbook: Class of '81." Onstage, Ozzy used to run all over the place, so *Circus* awarded him "Most Athletic." I figured I'd take some sports-themed shots, so when I went over to the Plaza to do the shoot, I brought a pair of boxing gloves. Ozzy came out dressed in a pink tutu. He was playing off the same theme, but with a twist. I spotted a pair of boots nearby, and I had him put those on, too, for a sort of play on Sabbath's "Fairies Wear Boots." It was a bizarre scene, for sure.

When I handed over the photos to *Circus*, I didn't think much of it. To my surprise, they used one of the tutu shots for the cover of the issue. After it came out, I got a call from Sharon Arden, Ozzy's manager. She was not happy. And I could understand the way she felt. I mean, here was the Prince of Darkness . . . in a pink tutu on the cover. It had been intended to be a small black-and-white image inside the magazine. For a few months after it came out, Ozzy's camp didn't want anything to do with me. Someone even called in to a live radio broadcast and asked him why he had done it. Ozzy replied, reluctantly, "It was an accident." But then the cover started getting a lot of attention, and they came around. That was the beginning of Ozzy doing more crazy stuff in his photos. Later on, I dressed him up in a lot of outrageous outfits.

One of the days we were shooting, I mentioned to Sharon that I was friends with Thor. Jon Mikl Thor, "the Legendary Rock Warrior," was a championship-winning Canadian bodybuilder. Thor was known for bending steel with his teeth and blowing up a hot water bottle during live shows. I suggested bringing him by the hotel. I was always trying to help Thor out with publicity, and I figured Ozzy was up for anything. I knew Sharon would get a kick out of it too.

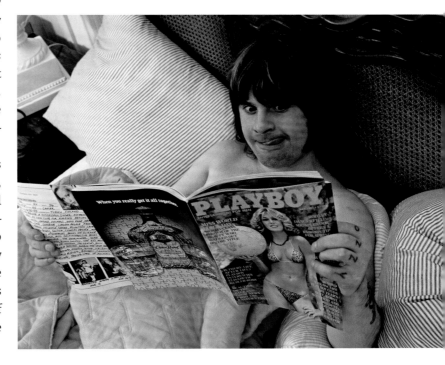

OPPOSITE AND ABOVE: Ozzy Osbourne, the Plaza Hotel, New York City

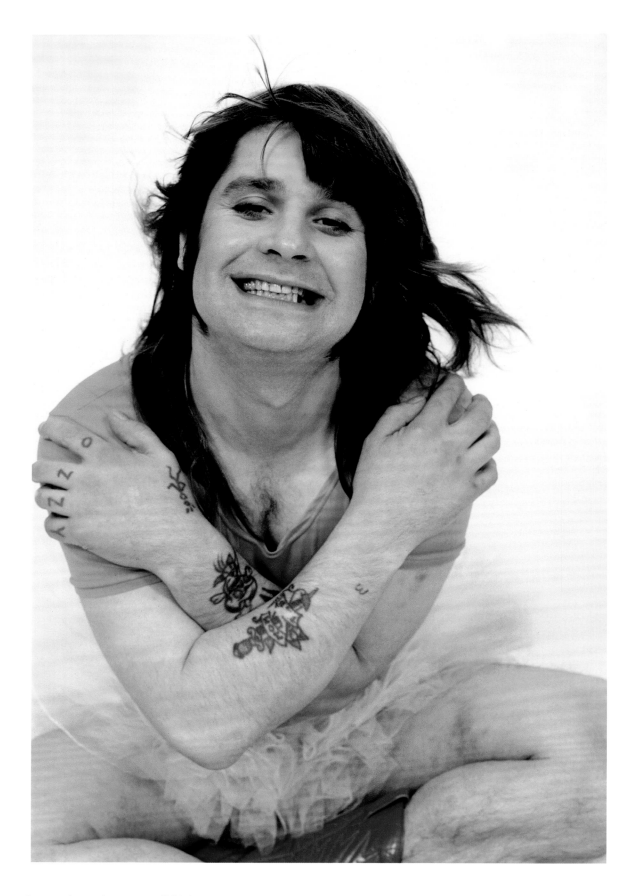

"Mark was always such a cool guy to me. He'd give me opportunities to get together with the bigger artists. The picture he took of me and Ozzy is one of my favorite shots. At the time, Black Sabbath was one of my favorite bands, and now here I was, boxing with Ozzy Osbourne." —**Thor**

ABOVE: Ozzy Osbourne, photographed for *Circus* magazine **OPPOSITE:** Ozzy Osbourne and Thor throwing punches at the Plaza Hotel **PAGES 72–73:** Ozzy Osbourne, *Blizzard of Ozz* tour, Asbury Park Convention Hall, Asbury Park, New Jersey

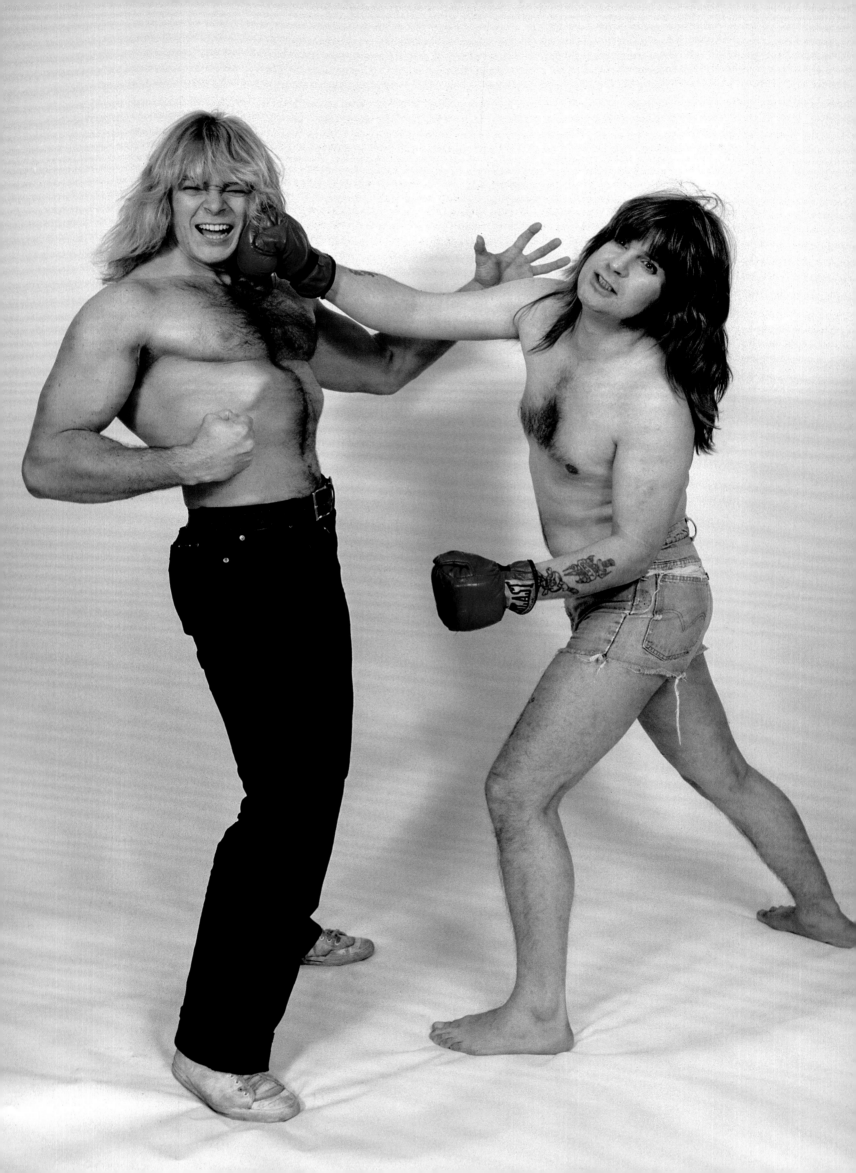

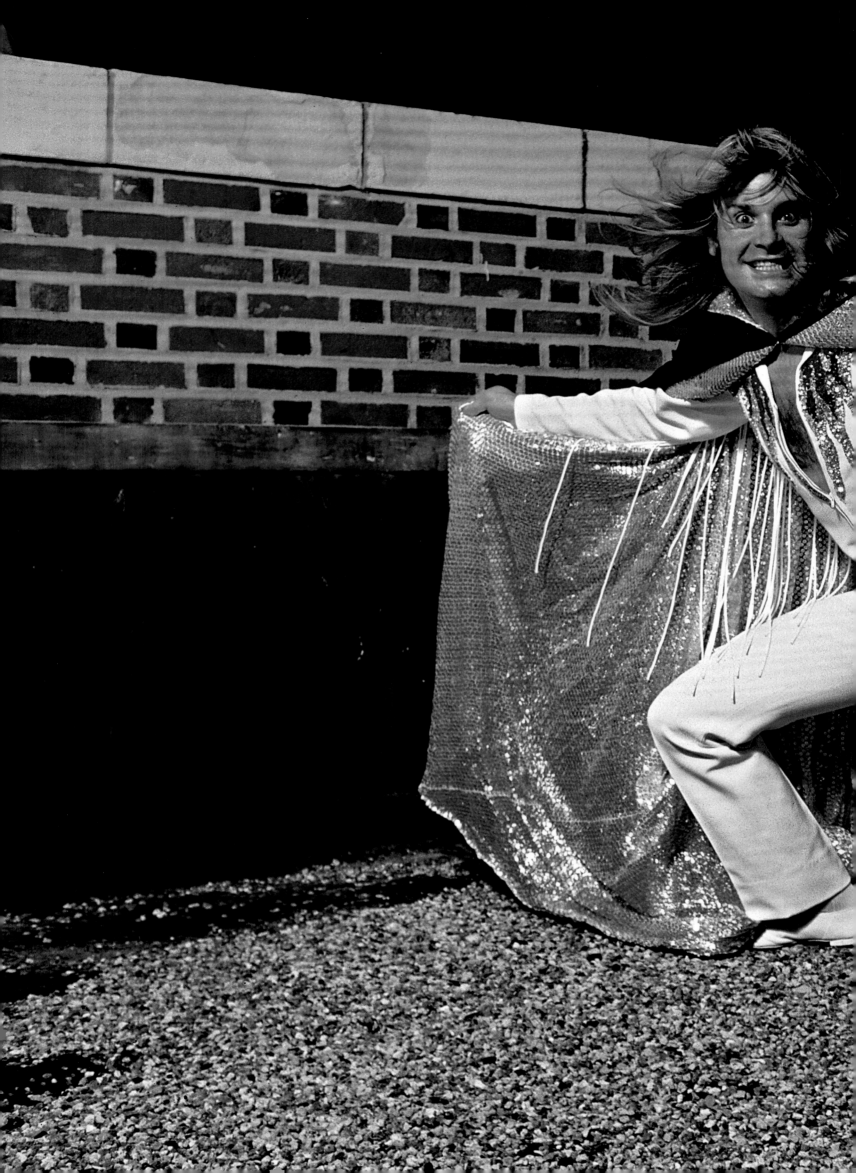

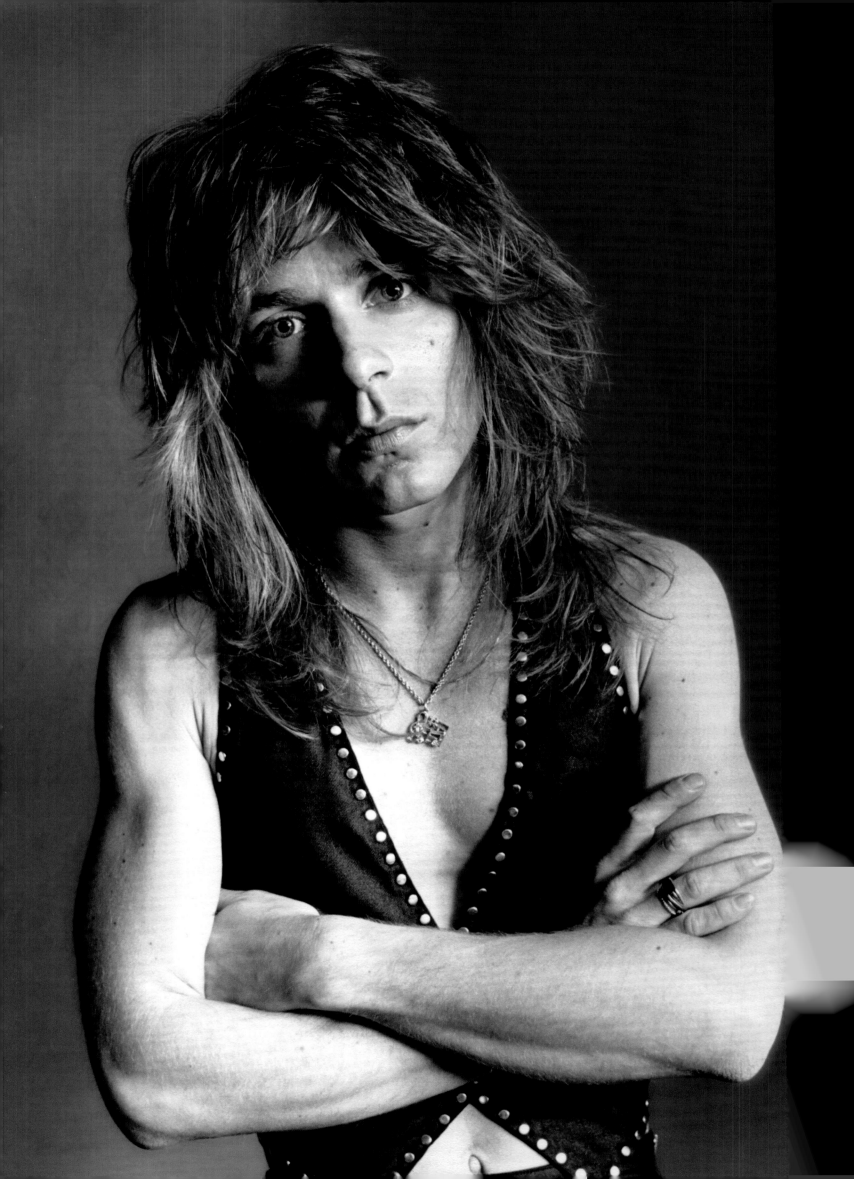

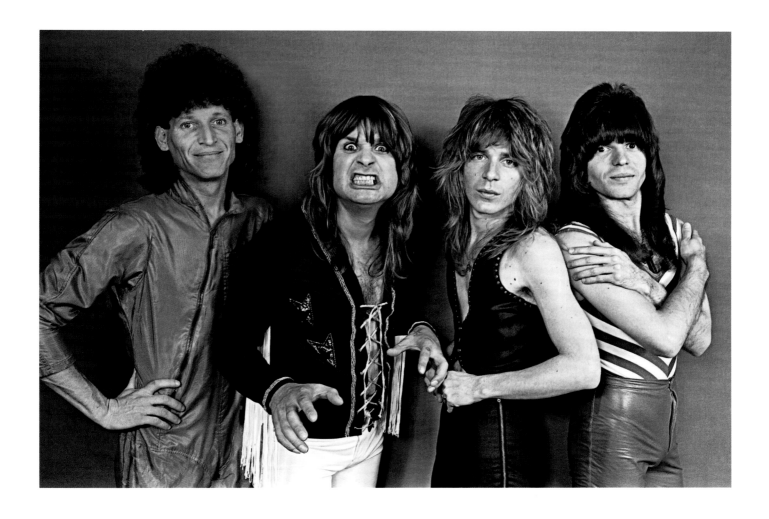

"I would say trust is the most important factor that Mark has brought to his work. And that's why he was a major part of our lives through all those years. We never lost trust in Mark—not only in his work but also as an individual. Because when you're on the road, the people on the bus with you are your family. My memories with Dio and Ozzy and Quiet Riot, that was my family. And Mark Weiss became my family." —**Rudy Sarzo (bassist, Ozzy Osbourne, Quiet Riot, Dio)**

OPPOSITE: Randy Rhoads, *Blizzard of Ozz* tour, the Capitol Theatre **ABOVE:** The Ozzy Osbourne band, the Capitol Theatre **PAGES 76–77:** Ozzy Osbourne, shot for *Circus* magazine, the Plaza Hotel, New York City

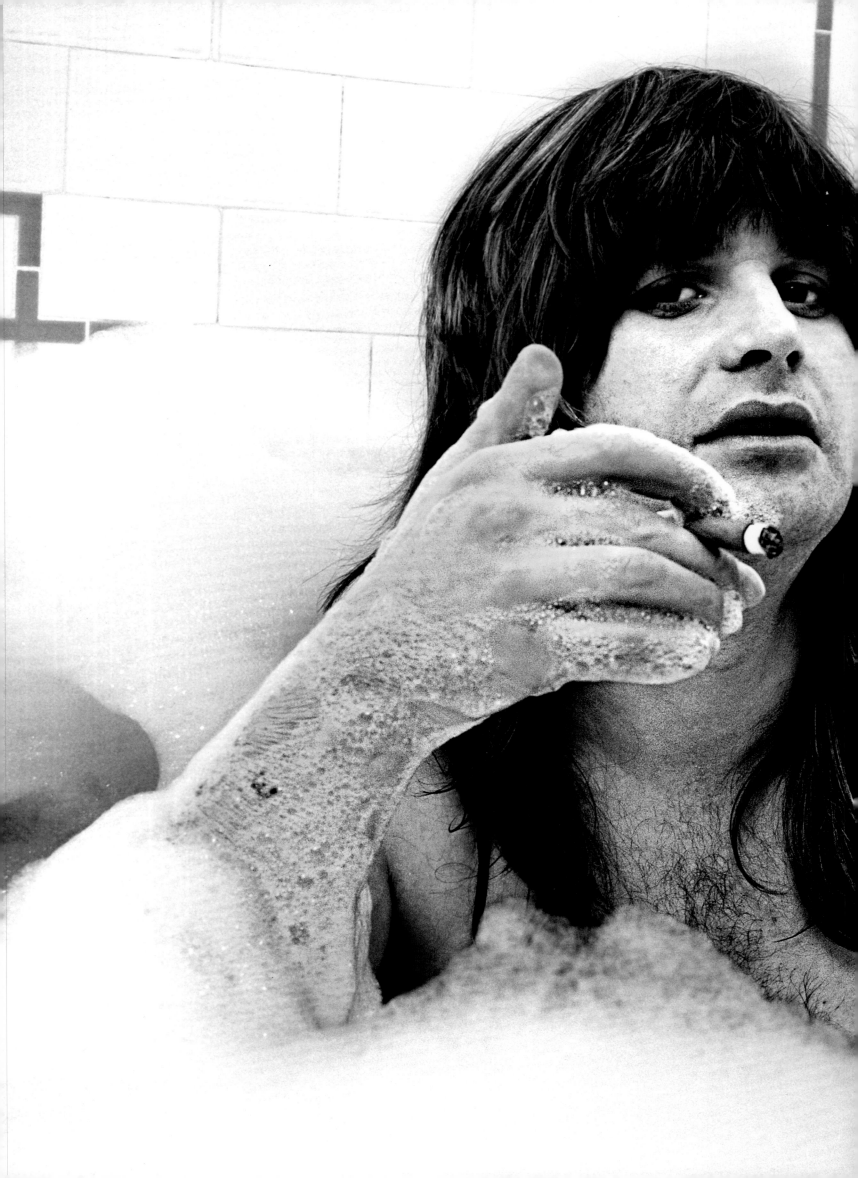

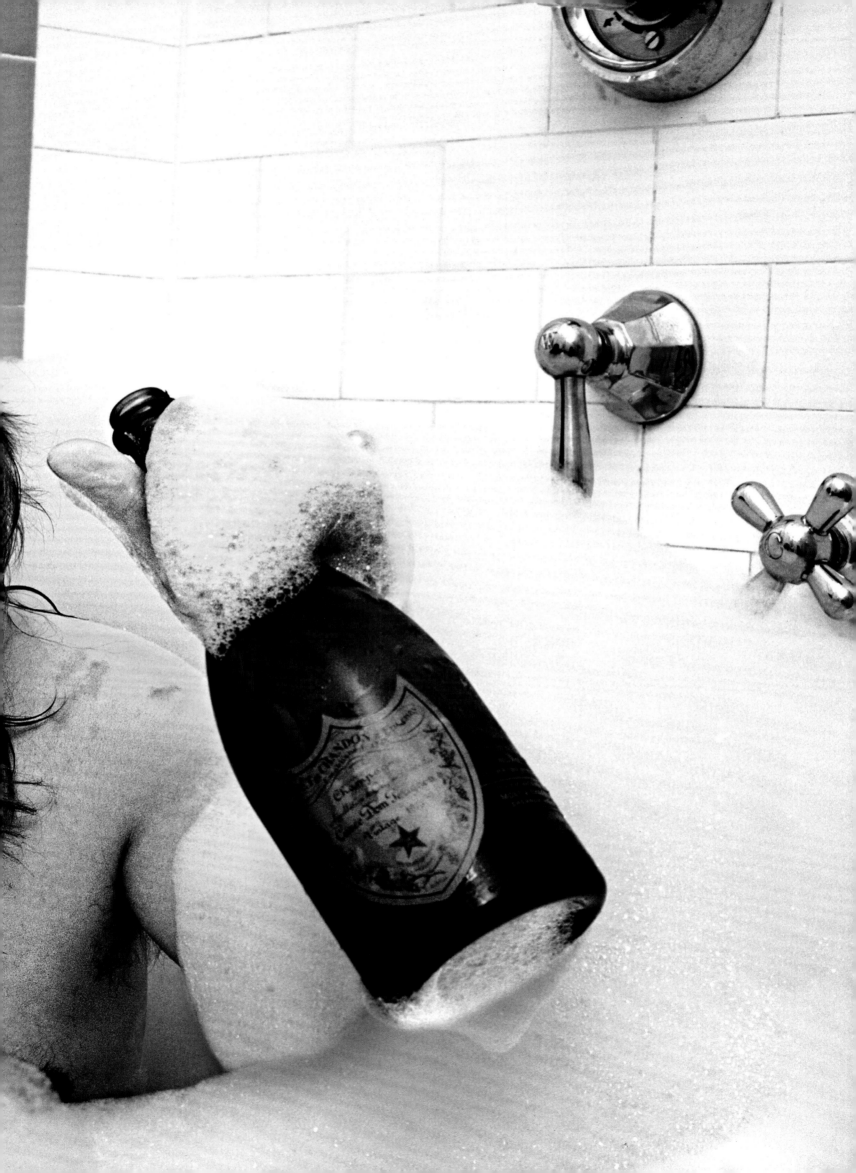

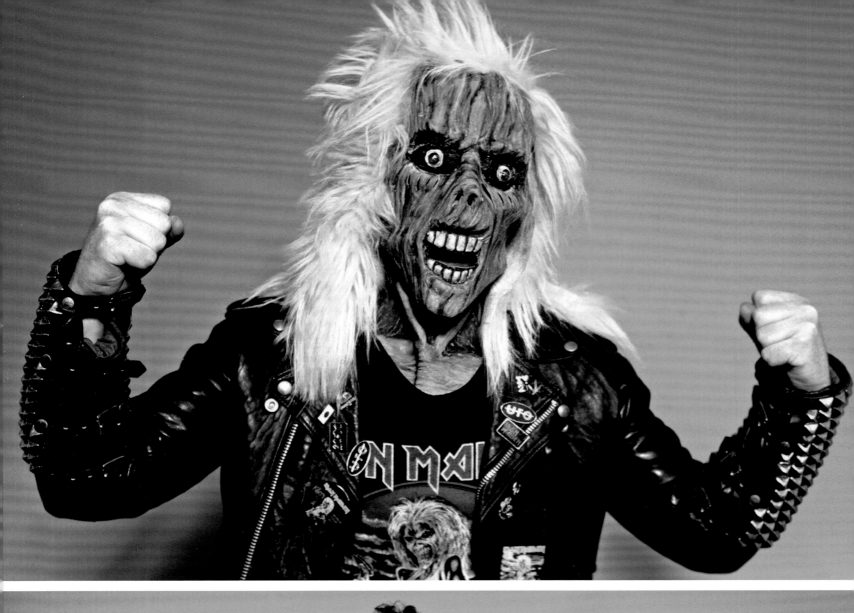
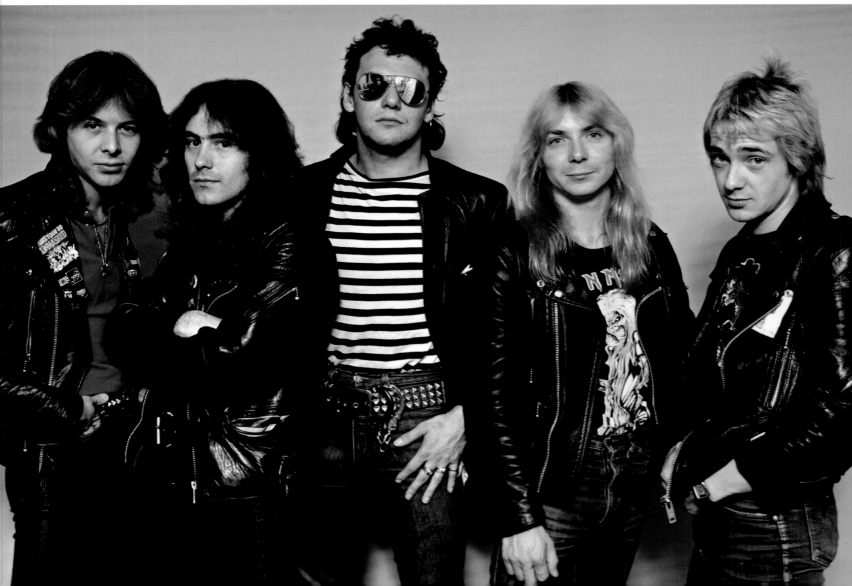

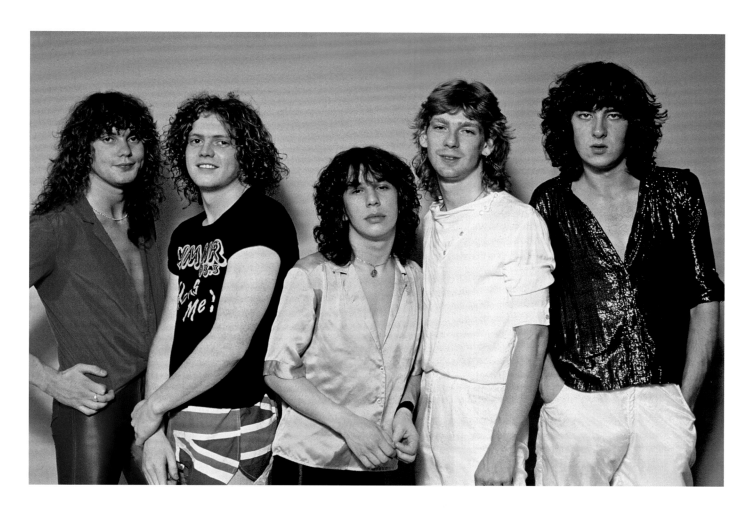

THE NEW WAVE OF BRITISH HEAVY METAL COMES TO AMERICA

I shot Judas Priest at Convention Hall in Asbury Park that July. Opening for the band was a young New Wave of British Heavy Metal act named Iron Maiden. I didn't have a clue who they were, but *Circus* told me to shoot both bands. Maiden were great, and after the show, I went backstage to see if I could do a quick session with them. Their manager, Rod Smallwood, suggested we go back to their hotel and do it there. It was a real seedy place, but I drove over, brought up a backdrop and went up to the band's room. We moved all the furniture to one side and did the shoot right there. Rod also put on the Eddie mask—in the early days, he played the part of the Maiden mascot.

Later that summer, Ozzy played Convention Hall, and, just as Priest had, he had a young New Wave of British Heavy Metal band opening for him. It was Def Leppard. I had no idea who they were, but again, *Circus* had me shoot both bands. The night of the show, I took Ozzy up to the roof of the venue and photographed him in his cape and stage clothes. Then, backstage, I saw the Leppard guys walking around. I told them I was on assignment to shoot Ozzy for *Circus* and asked if they would do a quick shoot.

All of that happened in the span of a year. At the end of 1981, I took my first trip to the West Coast. Things were beginning to rock even harder.

OPPOSITE TOP: Iron Maiden's manager, Rod Smallwood as mascot Eddie, *Killers* world tour, Asbury Park Convention Hall, Asbury Park, New Jersey
OPPOSITE BOTTOM: Iron Maiden **ABOVE:** Def Leppard, *High 'n' Dry* tour, Asbury Park Convention Hall **PAGES 80–81:** Van Halen, *Fair Warning* tour

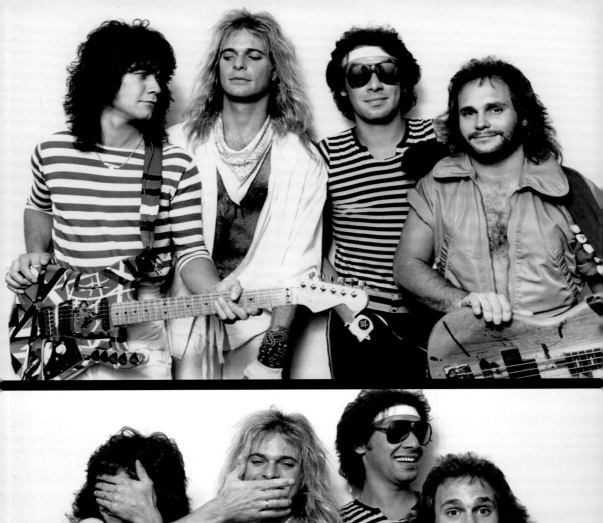
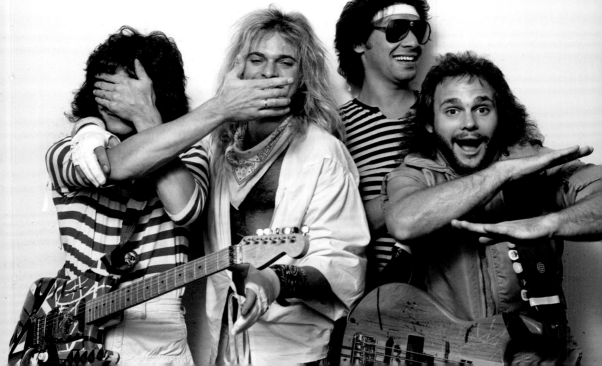

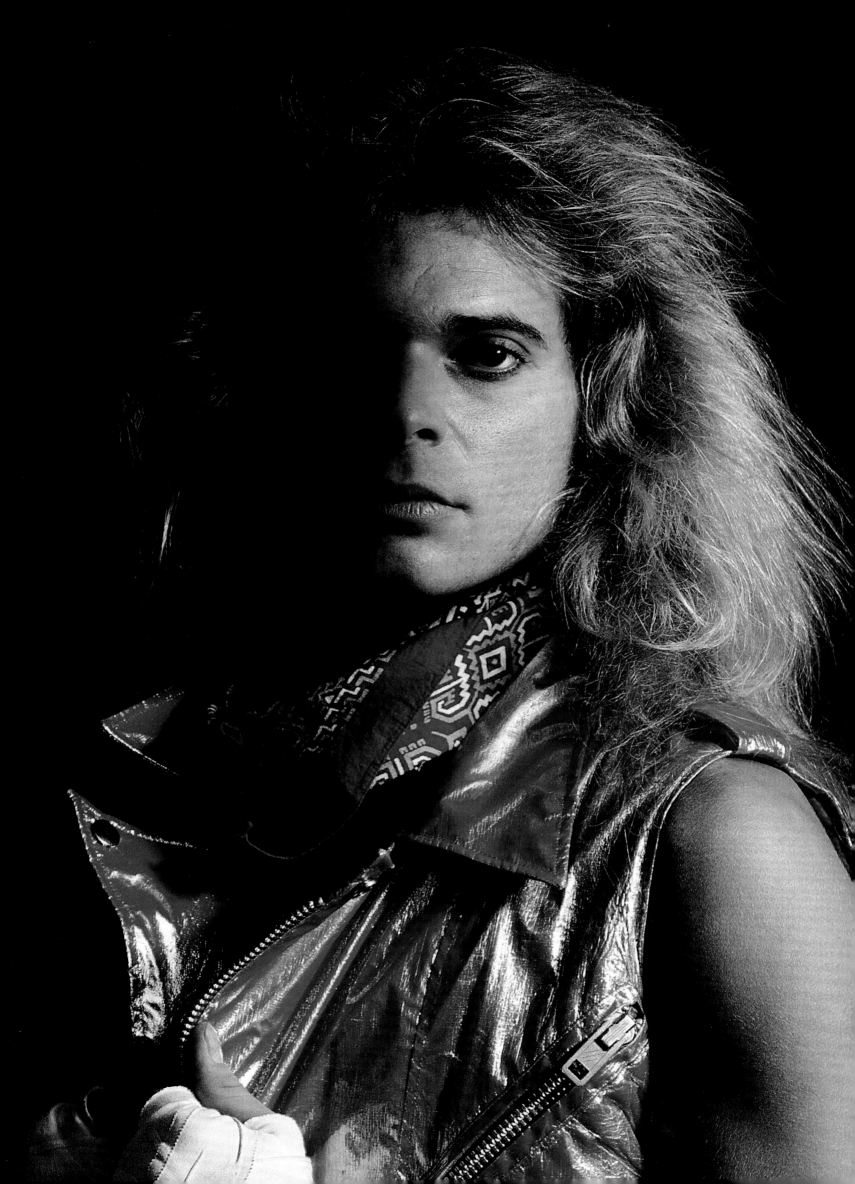

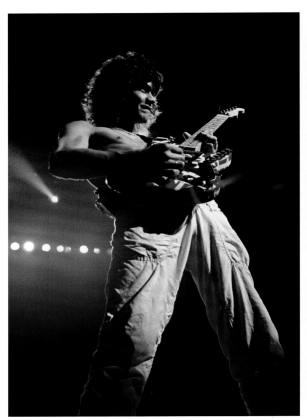

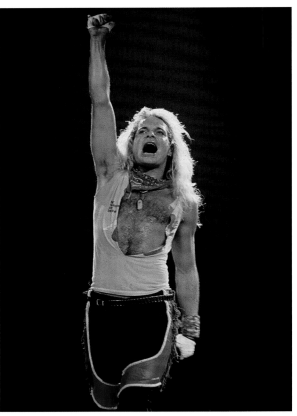

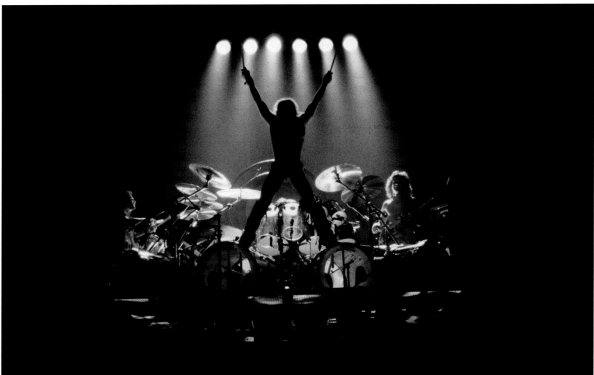

"Mark Weiss was one of the chosen few that was in the trenches with Van Halen. He was one of the insiders, and pretty much lived the lifestyle of a rock star on the road. Mark was one of the very few guys that actually befriended the band and came and hung out with us." —**Michael Anthony (bassist, Van Halen)**

THESE PAGES AND PAGES 84–85: Various images of Van Halen live, *Fair Warning* tour

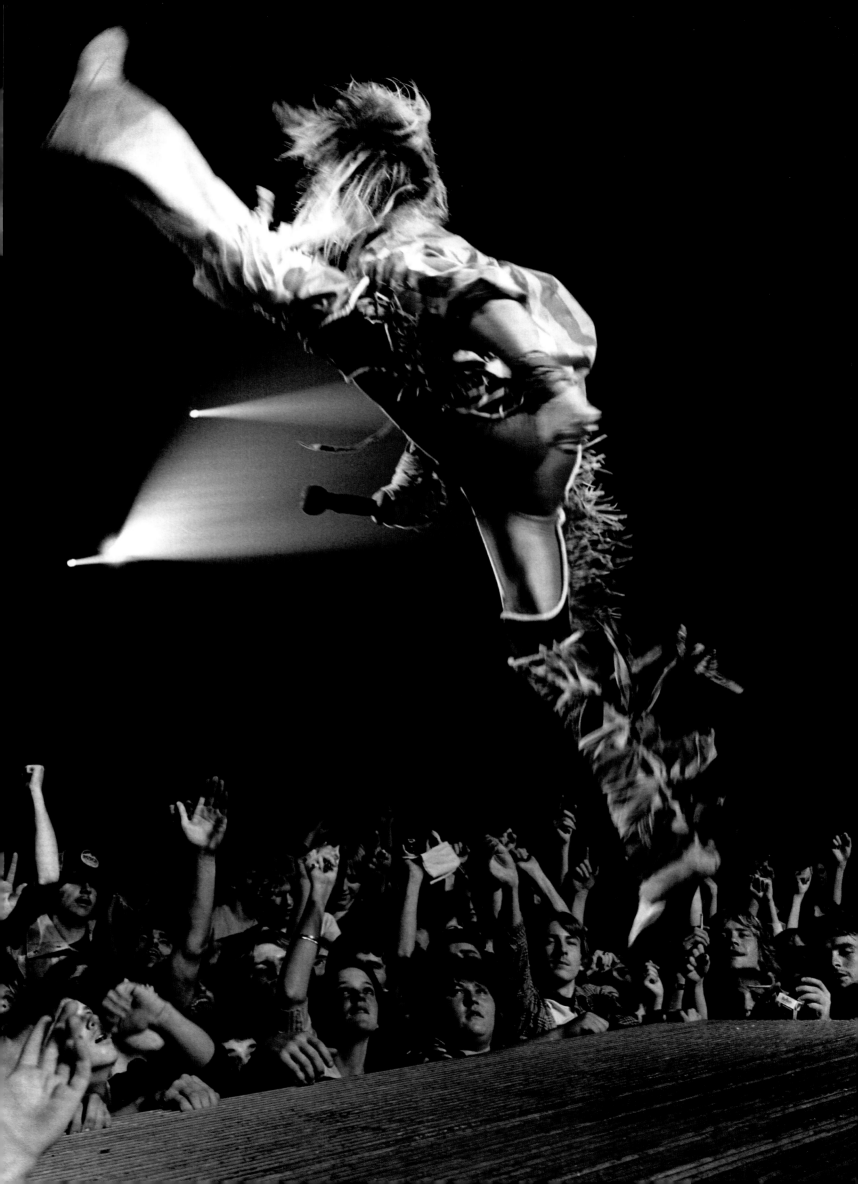

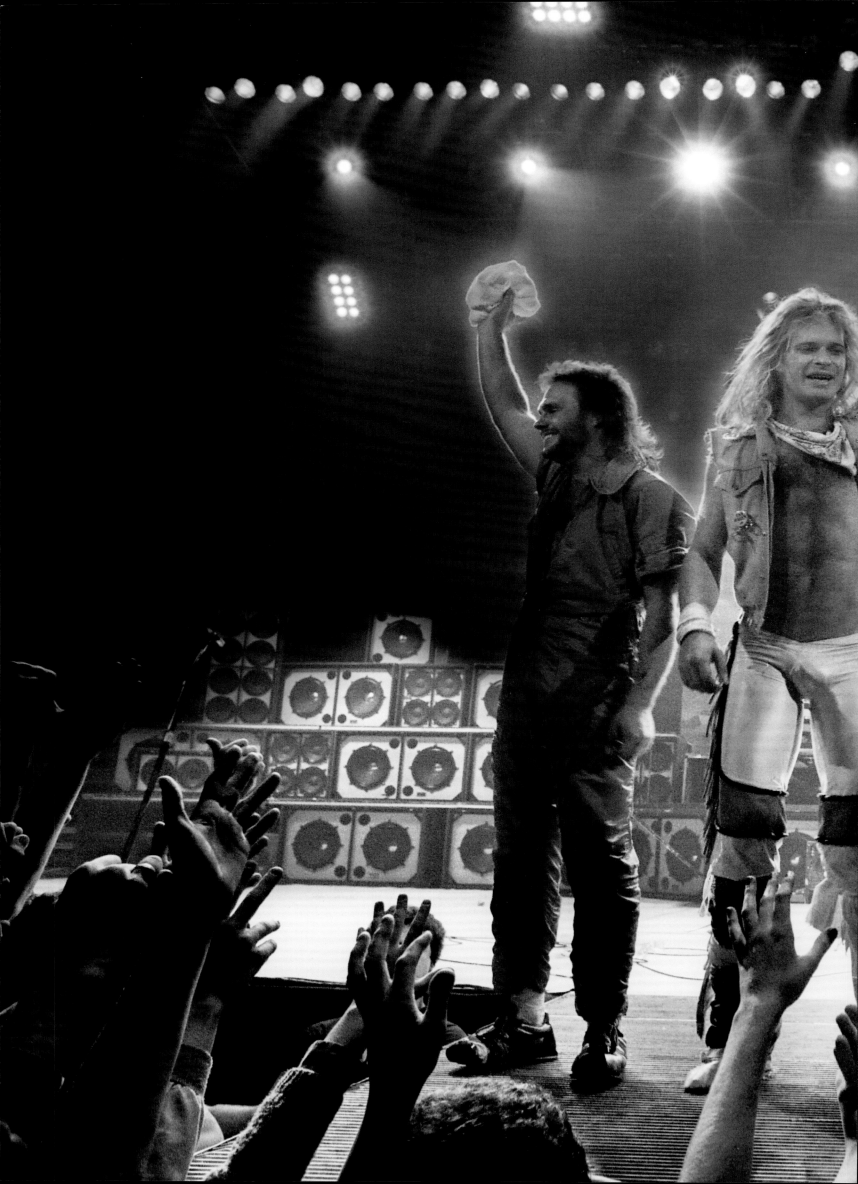

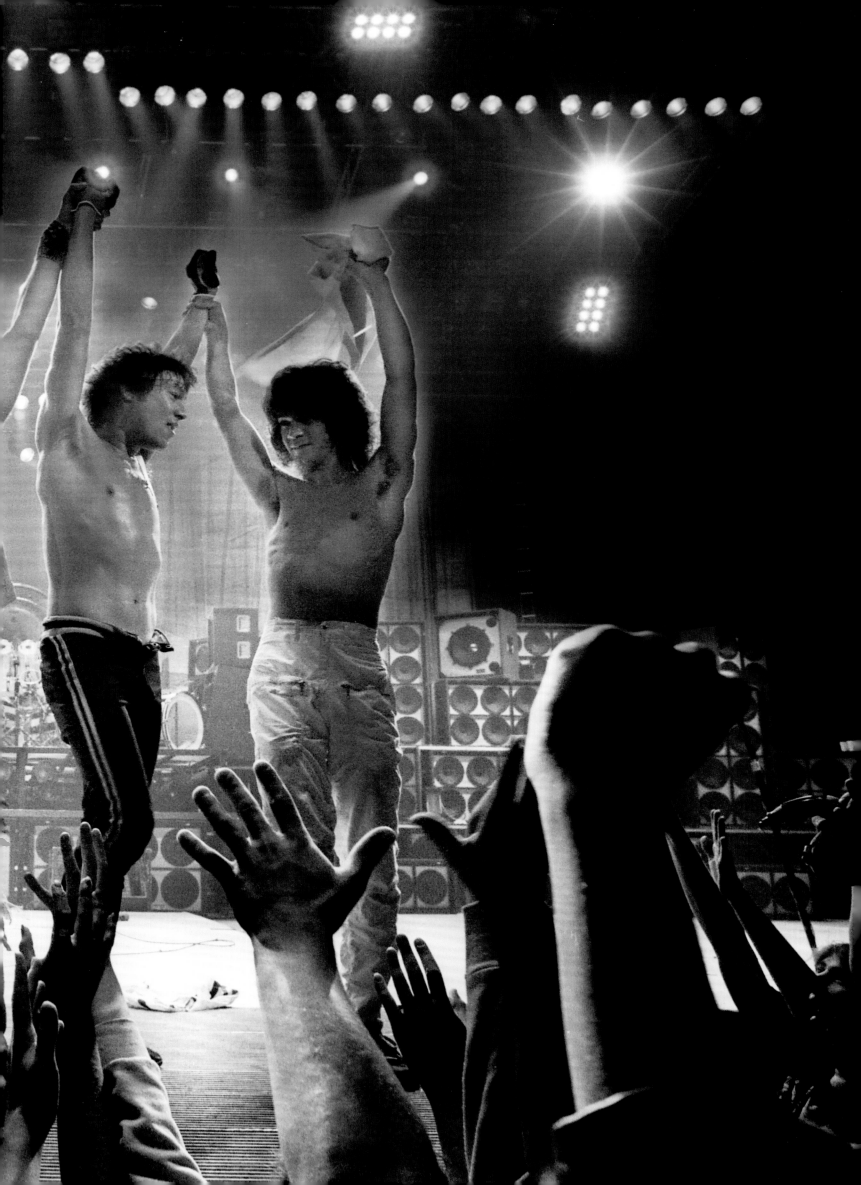

Carmine Appice's ROCK CONFESSIONS

including THE INTERNATIONAL MUSICIAN'S GUIDE TO HOTEL WRECKING!

starring **ROBERT PLANT** in MUDSHARK MAYHEM! THE MOVIE!
THE MOTHERS! THE INSIDE STORY!

JEFF BECK AND THE GREAT SEMEN RACE OF '72

RIOT AT THE HYATT! **HOW TO TRASH A TV**

THE ENVELOPE... LIMO LE...

ALL AREA ACCESS

BLACK SABBATH / MOB RULES

MÖTLEY CRÜE

Giving Glitter A Good Name

Mix heavy glitter with heavy metal, throw in some skulls, pentagrams, and smoke bombs, and against all odds, you get the surprisingly good music of L.A.'s best show band.

Interview by Mikael Kirke and Joe Bivona
Photography by Mark Weiss

249 Cannon R...
Rt. 520 East
Marlboro, New Jersey 07746

Dear Mark:

Per our conversation, this letter confirms your employment to
photograph Van Halen in Chicago and Cleveland on August 19th
and 21st, respectively. As we discussed, the group would like
you to be available to photograph them at their discretion
during your time with them.

It is our understanding that your fee is $400.00 per day plus
expenses-travel, hotel accomodations, film and processing to
be billed to Van Halen Productions, 6525 Sunset Boulevard, Los
Angeles, California 90028.

Van Halen Productions will have exclusive use of all transparen
cies and negatives for publicity use only. You may retain all
rights to the photos with regard to use of the photos for mer-
chandising, with payment for such use to be negotiated.

Please let me know if you have any questions. I'll speak with
you regarding travel arrangements.

Best,

Steven Mandel

Steven Mandel

cc: Noel Monk

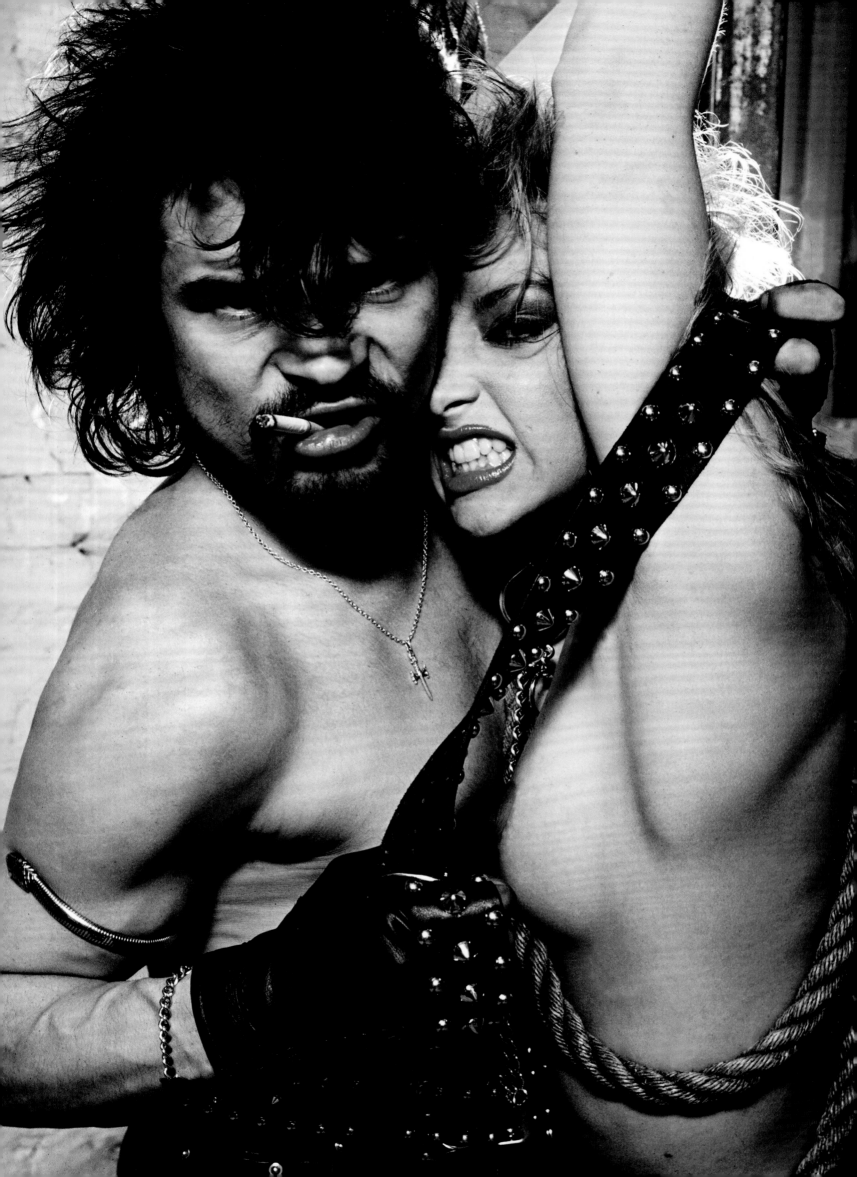

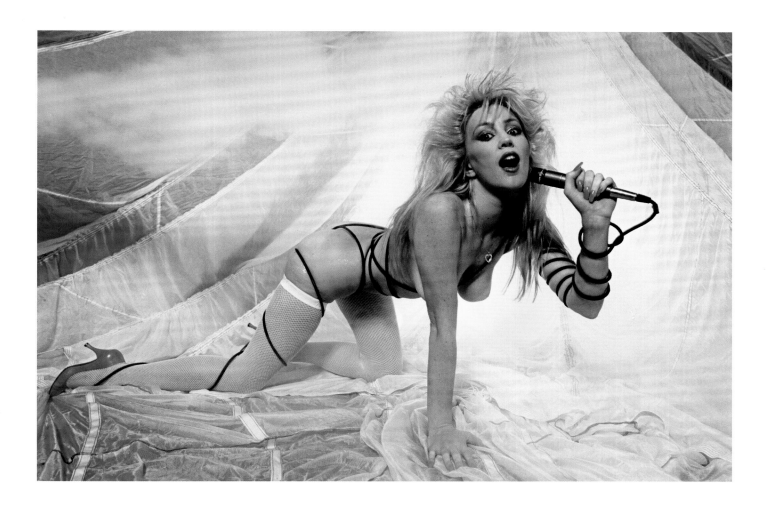

GIRLS ON FILM

I was doing steady work for *Cheri*, and the publishing company that owned it bought the men's magazine *Oui* from its parent publication, *Playboy*. At the same time, Rusty Hamilton, who had been working as the music editor at *Oui*, relinquished her duties to my good friend and "partner in crime" Mikael Kirke. And who else would he take along for the ride but yours truly?

At the end of 1981, Mikael suggested to Peter Wolff, the new editor-in-chief of *Oui* magazine, that we go to California to do an interview and shoot with Andy Gibb, who was cohosting *Solid Gold* at the time. The only stipulation was we needed to line up a couple of shoots to justify the expenses. We photographed Andy at the season finale wrap party on a soundstage in Hollywood, then went to Phoenix to shoot daredevil Evel Knievel's son Robbie, who was following in his dad's footsteps.

Mikael and I had a blast while we were in LA. On the way to the infamous Rainbow on the Sunset Strip, we went to a strip club to see Kitten Natividad, a famous exotic dancer noted for her work with director Russ Meyer. He flashed his *Oui* credentials and got front-row seats to the show. Afterward, we introduced ourselves to Kitten and told her we were staying with Raven De La Croix, who was also featured in Russ Meyer films and was a close friend of Peter's, while we were in town. We were meeting new friends with benefits.

When we turned in the photos from our trip to Peter, he was enraged. He said, "Why do the girls have clothes on?" He told us that if we wanted to continue working for *Oui*, the music section would have to have nudity. We were up for the challenge. In December of '81 we shot our first rock star, just as Peter had

"The shoot was in Daytona, Florida, at a Holiday Inn. We decided that we would do it on the road and that we would talk about road stories in the article. Mark was an awesome photographer; he knew how to get a good picture, how to talk to you—how to pose, how to get good background, good scenery. It's an art form, you know? The concept was that we would make the room look destroyed, like the hotel wrecking that we used to do. And that's what we did. As for the girls, I was on a drum clinic tour at the time, and during a stop in Jacksonville, Florida, we set up a contest. We got local radio stations involved and did a search for models. Then we had an audience judge the winners, who would appear in the magazine with me." —**Carmine Appice (drummer)**

OPPOSITE: Motörhead's Phil "Philthy Animal" Taylor, photographed for *Oui*, New York City **ABOVE:** Cheryl Rixon for *Oui*, New York City

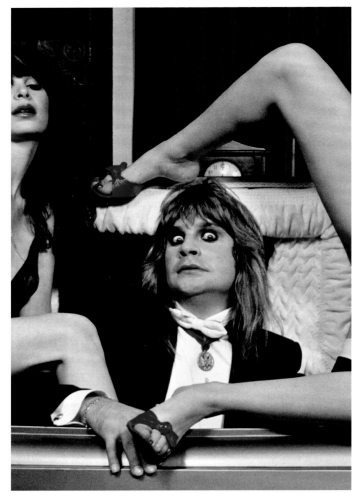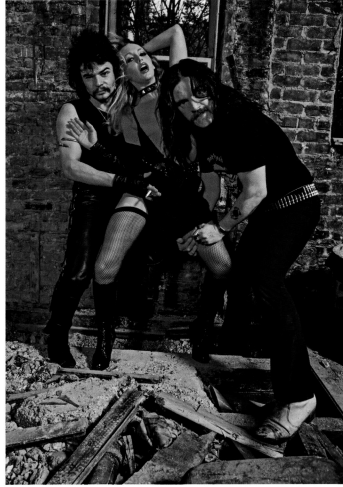

insisted. We did the shoot with none other than Ozzy Osbourne, at a church in LA where horror movies were often filmed. It was the perfect location to photograph him. Then, we went to the Jim South modeling agency in Sherman Oaks to find girls for the shoot. Jim South was a larger-than-life character. He handed each of us books full of pictures of naked women—some of them looked like porn stars, some like your girl next door. We told him who we thought we'd like for the shoot, and then he called them into the room. We were like two kids in a candy shop. After that, whenever we'd come out to California for a *Oui* or a *Cheri* shoot, Jim South would be our first stop—even if we didn't have a job. We were always scouting.

While the models were getting ready, I shot some portraits with Ozzy. Things were going great . . . until the girls came in. Ozzy looked up at me, and there was fear in his eyes. He appeared to be shaking. I asked him what was wrong, and he said to me, "You'd be nervous, too, if your fiancée was watching you!" That's how I found out Ozzy and Sharon were engaged.

Just as Mikael and I had hoped, the Ozzy shoot proved to be just what was needed in order to get other rockers on board with *Oui*. At this point in 1982, the rock scene was just about ready to explode into what would become the decade of decadence.

Next we shot Carmine Appice, who was the former drummer for Vanilla Fudge and had also played with Cactus and Rod Stewart.

I saw Carmine the following year when he played drums for Ozzy on his *Bark at the Moon* tour. He told me that he had lost his endorsement with Ludwig Drums because of our shoot.

After that was Joe Perry at my house in Marlboro, New Jersey. Joe was looking to gain a little attention outside Aerosmith, so I had him pose with my friend's motorcycle and '67 Mustang—as well as my girlfriend, Denise.

Next up was Motörhead. They had a reputation for being a raunchy band, so Mikael and I thought maybe they'd be up for a bit of an S&M theme. The location was pretty sketchy—a townhouse under renovation on Manhattan's Upper West Side; we had to climb through broken windows to get in, and we plugged my lights into a generator because there was no electricity in the building.

ABOVE LEFT: Ozzy Osbourne, *Oui*, Los Angeles, 1981 **ABOVE RIGHT:** Phil "Philthy Animal" Taylor and Ian "Lemmy" Kilmister of Motörhead, *Oui* **OPPOSITE:** Carmine Appice for *Oui*, Daytona Beach, Florida

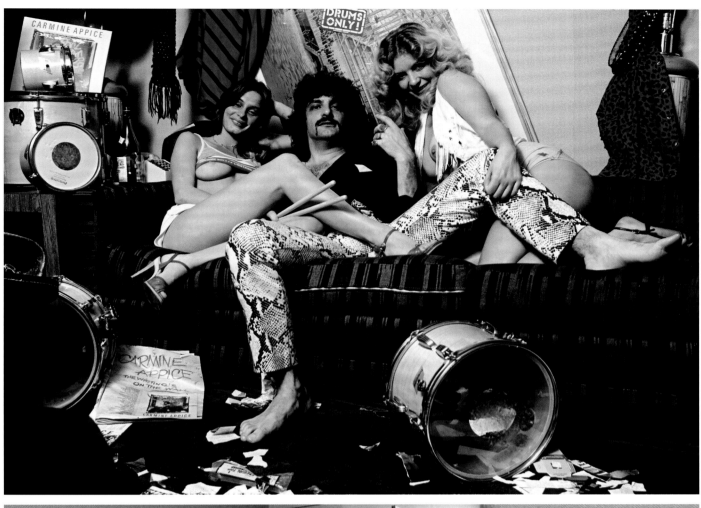

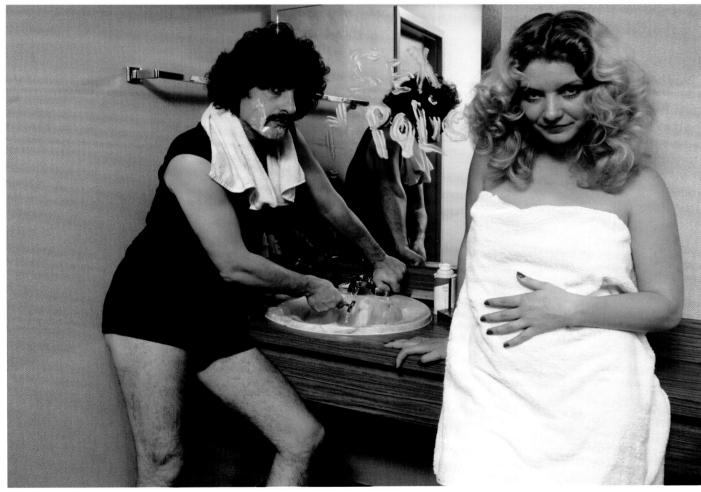

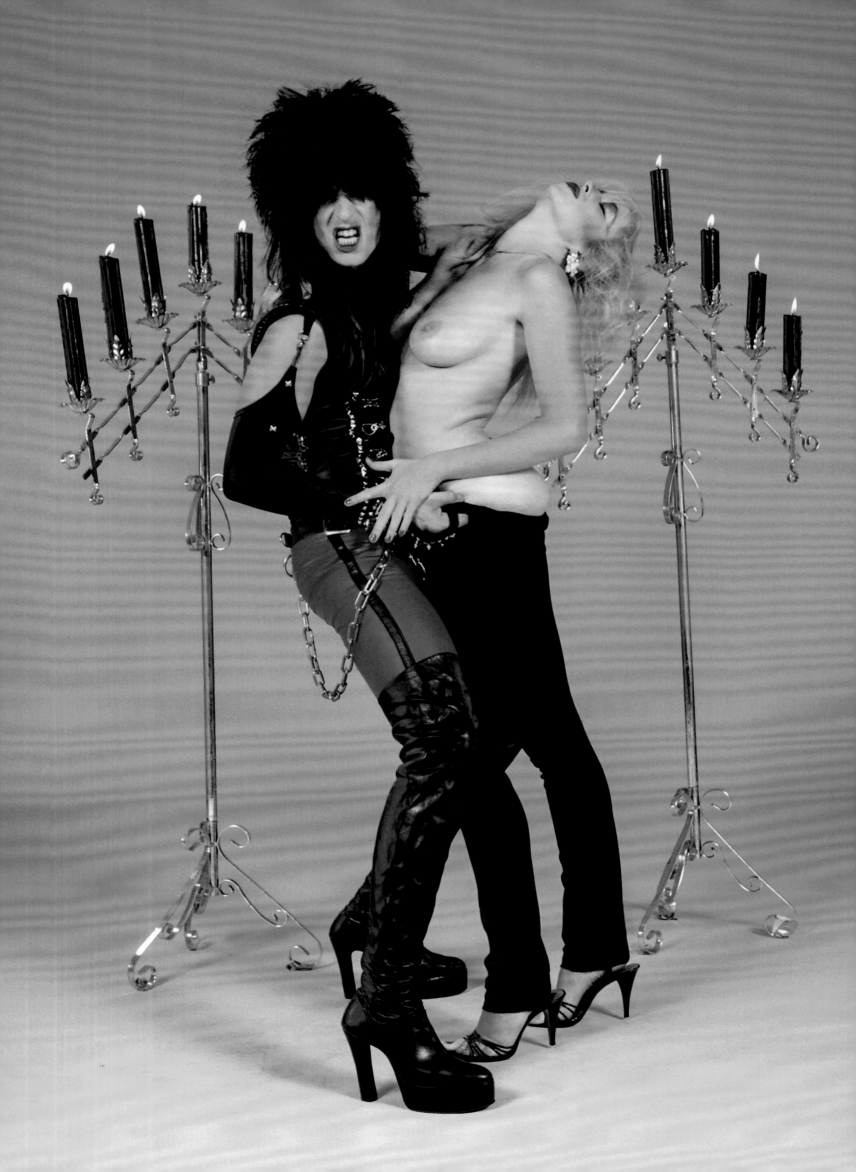

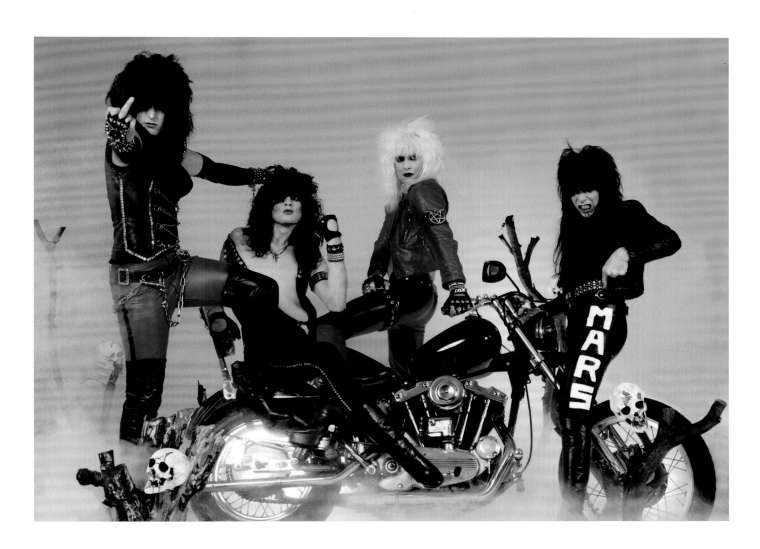

TAKE ME TO THE TOP

We were looking for bands that would be up for anything. In LA, we met with Bryn Bridenthal, the head of publicity at Elektra Records. The label had a new band on its roster that she thought might fit the bill. That band was Mötley Crüe. We met at the Rainbow, and to a kid from the East Coast, the Rainbow was an eye-opener. Every single guy there looked like he was in a band. And the girls . . . well, they all looked like they wanted to be *with* the band.

That August, Elektra released Mötley's debut, *Too Fast for Love*, and we went back out to LA and did a session and interview for *Oui*. It was the band's first shoot to garner them national attention.

After the shoot we went to a Mexican restaurant and then back to the Rainbow with the models. We were in the infamous back corner booth where there was some under-the-table action happening. It was a night to remember.

"Bring the motorcycles, bring the girls, bring the blood, bring everything! For me it was, 'How far can we push it?' There was a nice synergy between the artist and photographer, because Mark seemed to be one of us. At the time—and, actually, still—we had a problem with 'non-artists.' If a real conservative cat came in, a professional photographer with his four assistants and that whole thing, it felt like you were shooting a box of soap. And we're not a box of soap— we're a fucking caged animal! But with Mark, we felt like, 'Here's a kindred spirit.' In fact, I know that afterwards we went to a Mexican restaurant and got so drunk—the band, all the models, Mark, the whole entourage—that we all got thrown out of the restaurant." —**Nikki Sixx (bassist, Mötley Crüe)**

OPPOSITE: Nikki Sixx **ABOVE:** Mötley Crüe, *Oui*, Los Angeles

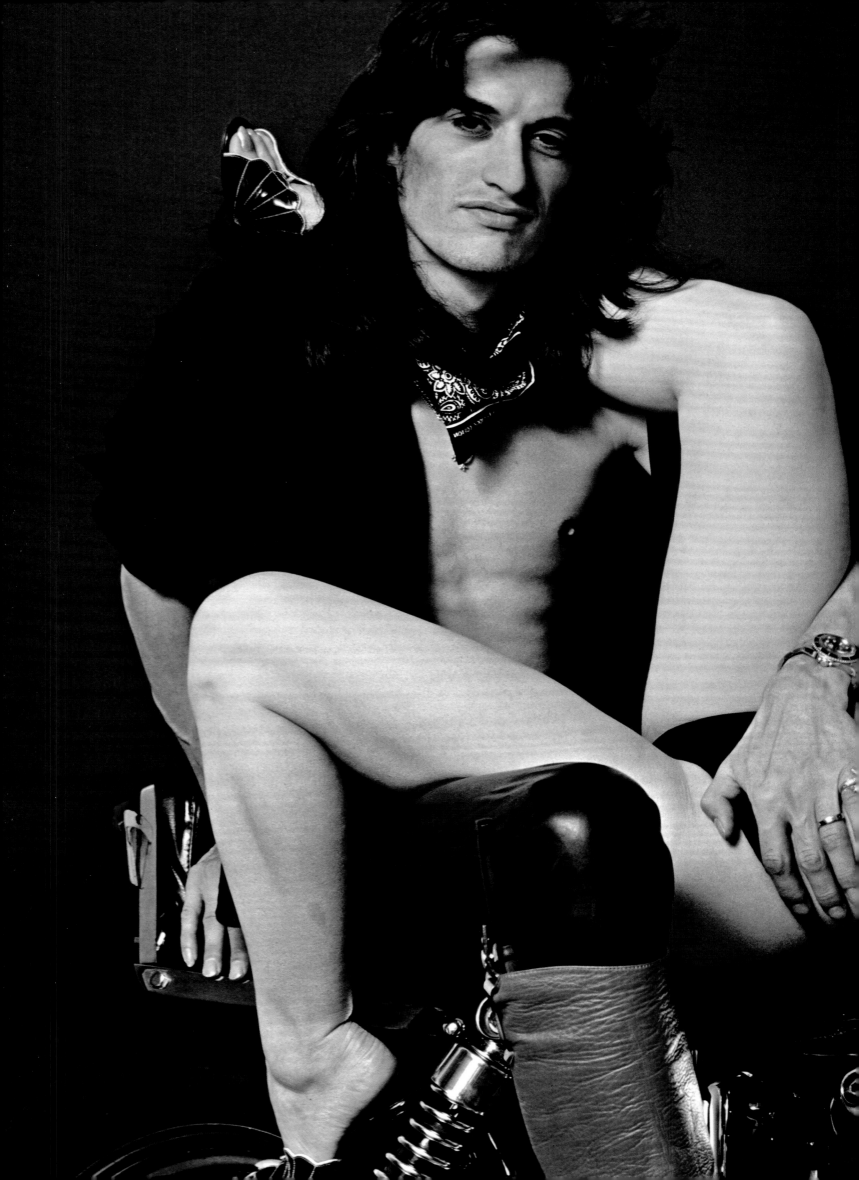

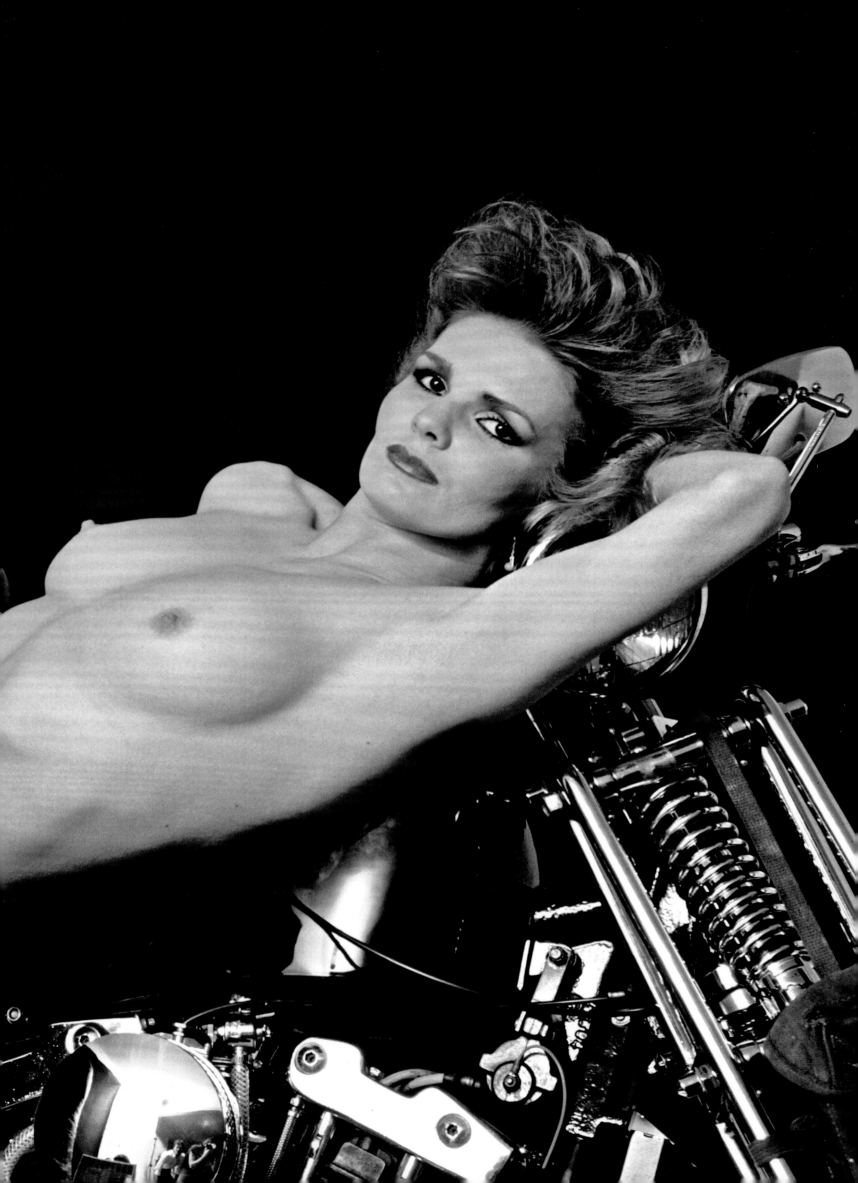

"One of the reasons I left Aerosmith was because I felt that it had become a machine that we had lost control over. So I said, "I just want to get in a van and play rock 'n' roll. I'll play anywhere, I'll open for somebody, whatever we can do." I didn't want all the hubbub that comes along with being in a big thing. So I started the Project, and Mark was one of the guys who was there for it. He would come and take pictures, and it was never, 'Oh, I need this much money.' He would just shoot. He knew where I was coming from and supported what I was doing." —**Joe Perry (guitarist, Aerosmith)**

PAGES 94–95: Joe Perry for *Oui* **OPPOSITE:** Mark's house, Marlboro, New Jersey **ABOVE:** Joe Perry, backstage, Joe Perry Project tour

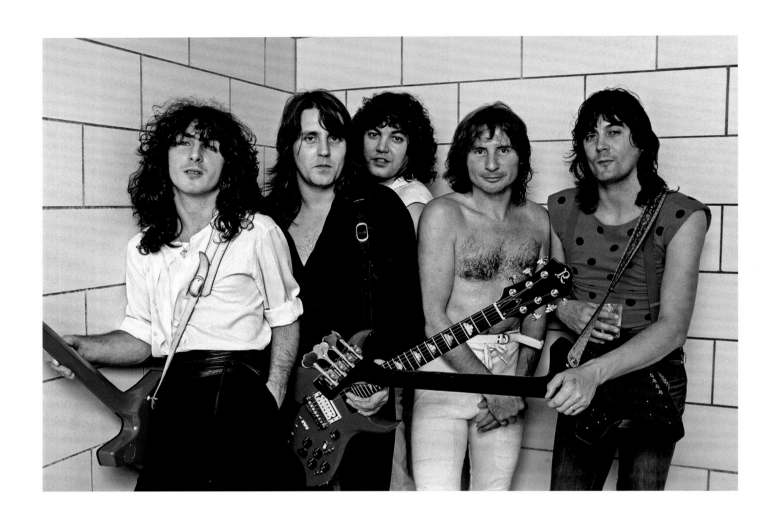

ABOVE: UFO, *Mechanix* tour, Madison Square Garden **OPPOSITE:** Iron
Maiden's Bruce Dickinson. Iron Maiden opened for Judas Priest during their
Beast on the Road tour, Brendan Byrne Arena, East Rutherford, New Jersey

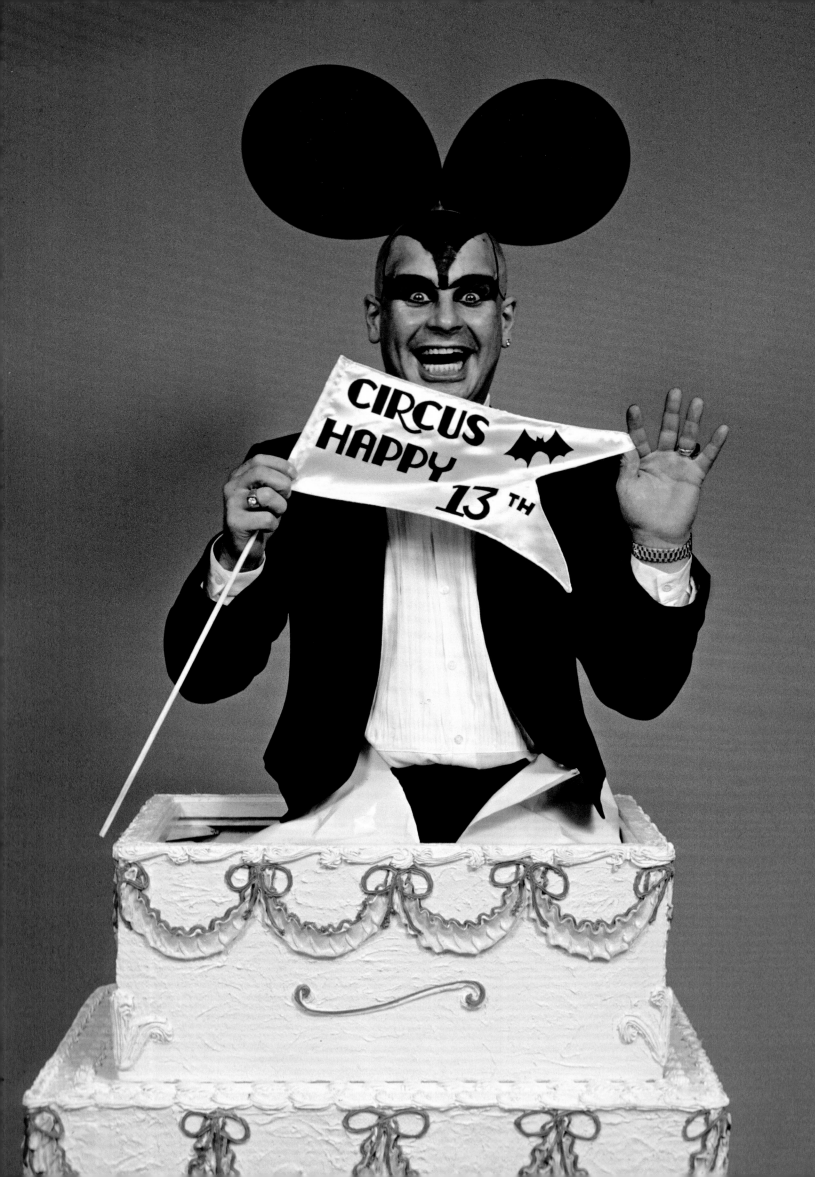

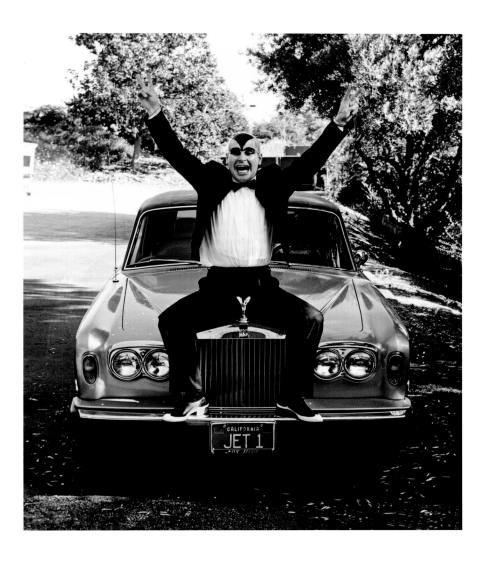

OZZY BUZZED

Later that summer, *Circus* asked me to shoot the cover of their thirteenth anniversary issue. They asked if I had any ideas, and immediately I thought of Ozzy. I called Sharon, and the next thing I knew I was on a flight out to LA. Earlier in the year, Ozzy had bitten the head off a live bat onstage, which landed him in the hospital to get rabies shots. So I had a flag made with a picture of a bat on it and arranged for him to hold it while popping out of a cake. When I arrived at Ozzy's, the house-keeper told me to set up in the garage.

Once I was ready to go, I waited. And waited. Several hours went by. Then Sharon came out with a con-cerned look on her face. "Ozzy shaved his head last night." I must have looked like I had seen a ghost. I thought to myself, I'm done. *Circus* will be pissed at me for spending all this money on the shoot and returning without a cover. Then Sharon gave me that Sharon smile and said, "But he's gonna do it." We put our heads together and came up with an idea. Sharon took out some black makeup and began applying it. Then, I taped a couple of black balloons I had for the birthday theme to his head. I think we topped the tutu cover. I knew then that we were off to a lifelong adventure of shenanigans.

OPPOSITE AND ABOVE: Ozzy Osbourne, photographed for the cover of *Circus*'s thirteenth anniversary issue; above, on the car of Don Arden, Sharon's father, at Arden's house on Beverly Grove Drive, Los Angeles

"I did that [shaving his head] because I didn't want to go back on the road. I just wanted to get off the road for a bit." —**Ozzy Osbourne**

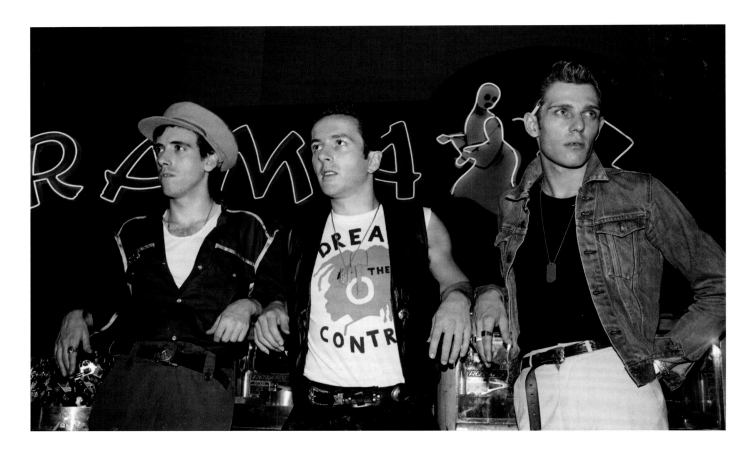

A NEW LEVEL

The hard rock crowd was growing. You could feel that in a very short time the music would take over the '80s. By the end of 1982, even Kiss could sense a change in the air. When Gerry Rothberg went to interview Gene Simmons and Paul Stanley for *Circus* about their possible unmasking, he had me join him at their manager Bill Aucoin's office to shoot some pics. The guys still weren't completely ready to show their faces to the world, but within a year, *Lick It Up* would be out and the makeup would come off. It was a new era.

The Clash opened their *Combat Rock* tour with three shows at Asbury Park's Convention Hall. After the third gig, they threw a party at the Asbury Park Palace, a funhouse with a merry-go-round, a hall of mirrors, and lots of boardwalk games. They called it the "Boardwalk Bash." The guys rode bumper cars and had a good time.

The Van Halen guys liked my photos of them that had been appearing in magazines from their last two tours, so they decided to hire me for a few shows on the Hide Your Sheep tour in support of their *Diver Down* album. It was the last time I photographed all four band members together, and it was difficult to get them in one place at the same time. I shot them right before they went onstage and had only a few minutes before they got antsy and dispersed. It was like pulling teeth to get the guys to stand together. It seemed like they all had their own agendas. Earlier that day, I had shot David outside the hotel in an open field. I had an agreement with Van Halen management saying I would take photos "at their discretion." David's security guy called me and told me to grab my camera, because "David wants you to take photos of him flying a kite." Like most of the opportunities I got that year, I didn't hesitate to take the shot. I was beginning to feel like I was a rock star, too. Jet-setting back and forth between New York and LA; being chauffeured around; staying in Hollywood mansions—I didn't think it could get much better. I was wrong. It did.

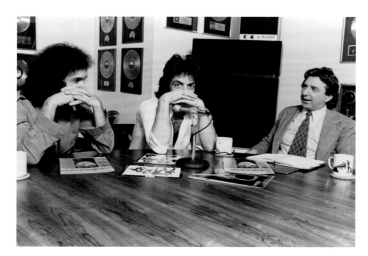

TOP: The Clash, *Combat Rock* tour, Asbury Park Palace, New Jersey
BOTTOM: Kiss's Gene Simmons and Paul Stanley interviewed by *Circus* magazine's Gerry Rothberg OPPOSITE: David Lee Roth flies a kite during Van Halen's Hide Your Sheep tour PAGE 104: Eddie Van Halen

"[Mark] clearly does love the music, and it's certainly a component of what he does. But that's never a substitute for talent. It just makes his photos that much more spirited." —**Paul Stanley (singer and guitarist, Kiss)**

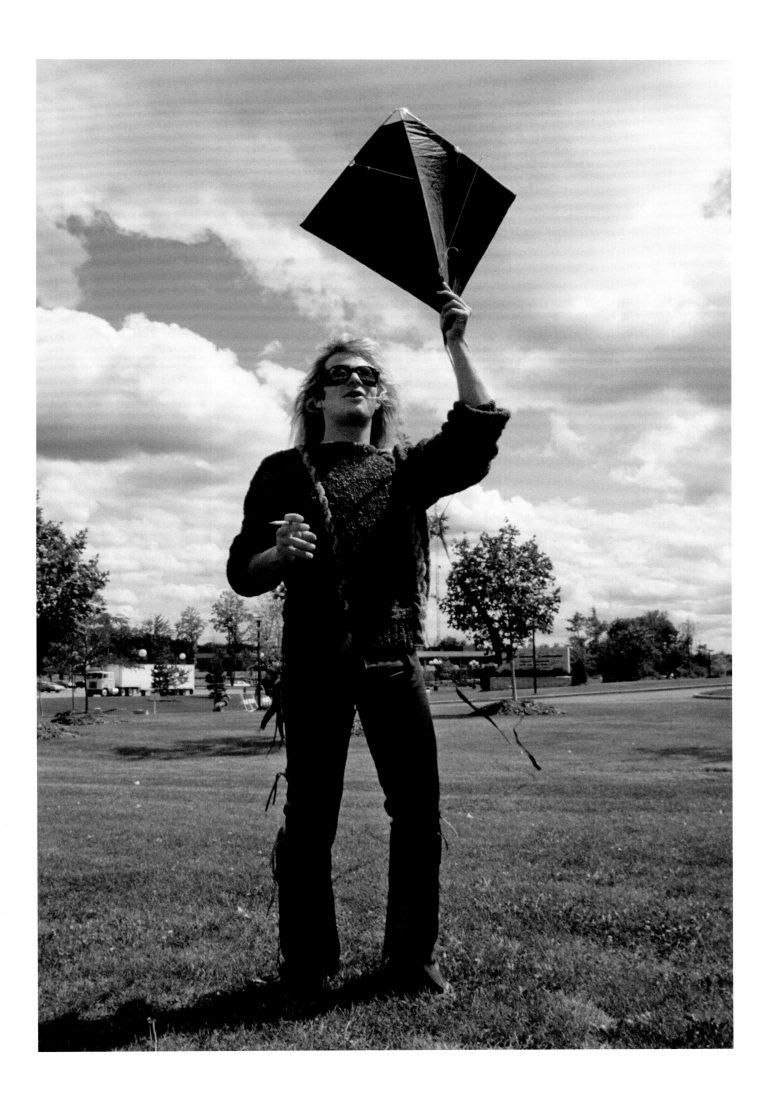

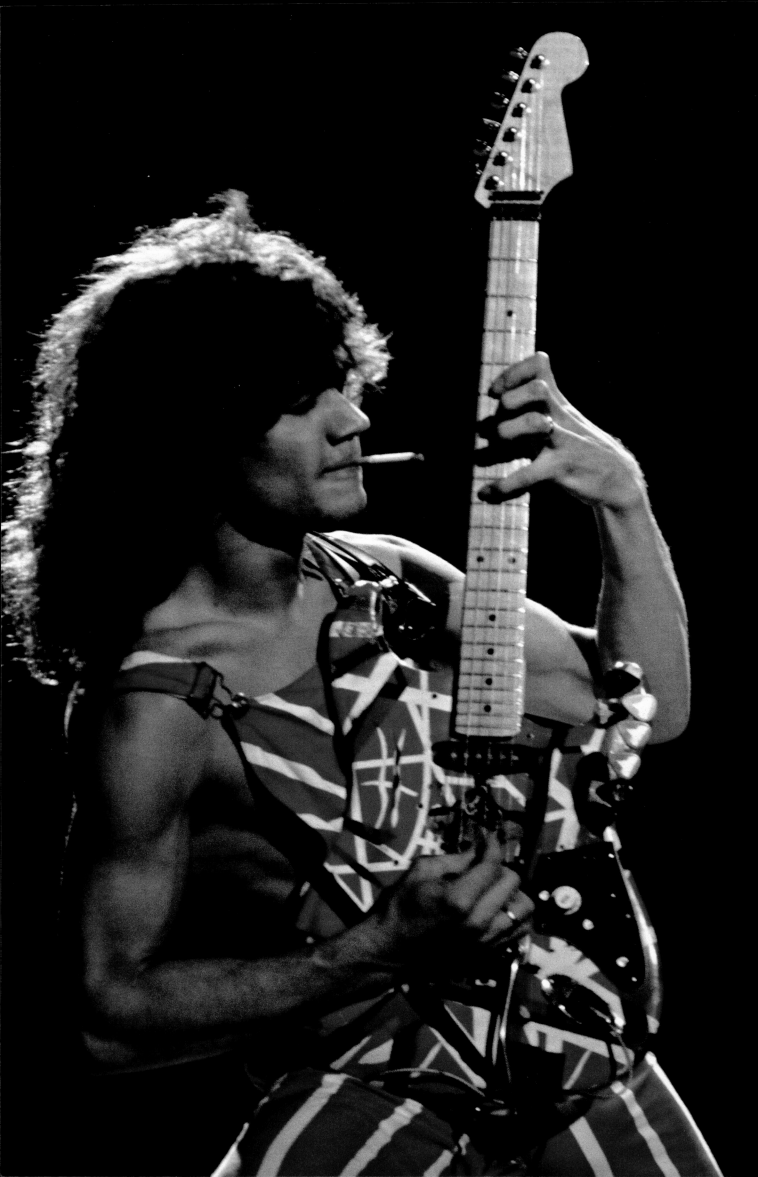

ABOVE: David Lee Roth, Hide Your Sheep tour, 1982 **PAGE 106:** Van Halen, Hide Your Sheep tour, 1982
PAGES 107–108: David Lee Roth, Hide Your Sheep tour, 1982 **PAGE 109:** David Lee Roth, Hide Your
Sheep tour, 1982 **PAGE 110:** Ronnie James Dio and Tony Iommi of Black Sabbath, *Mob Rules* tour, 1982
PAGE 111: Rob Halford of Judas Priest, *World Vengeance* tour in support of *Screaming for Vengeance*,
Meadowlands, East Rutherford, New Jersey, 1982

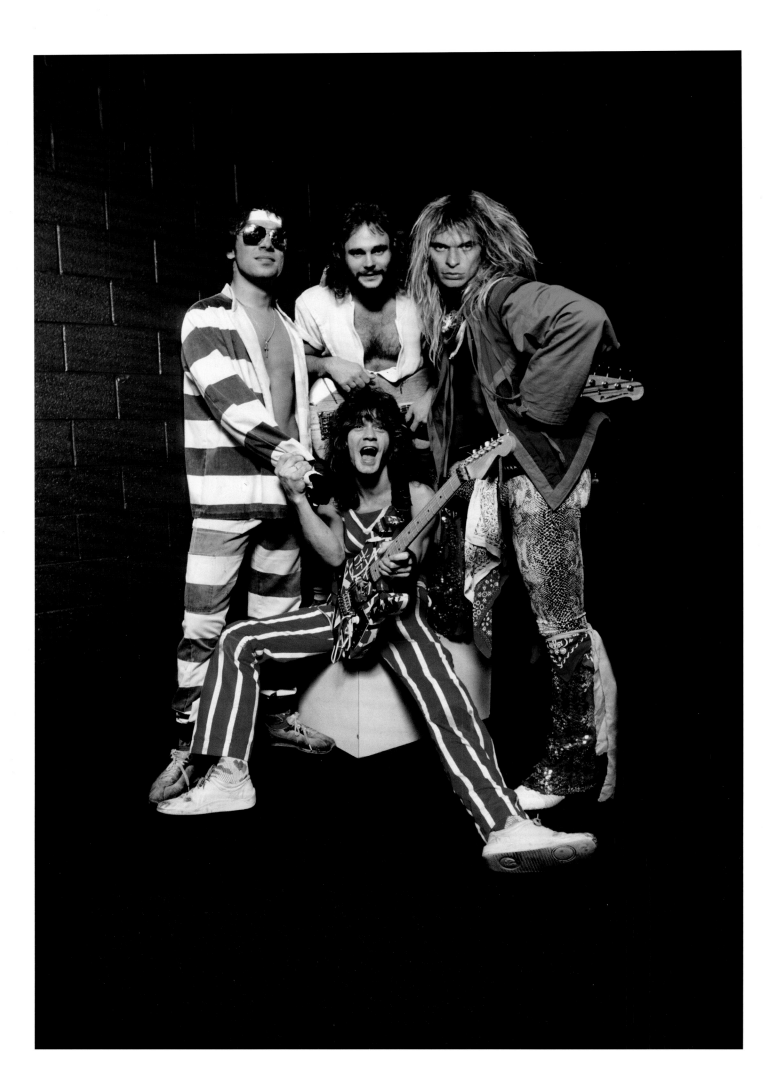

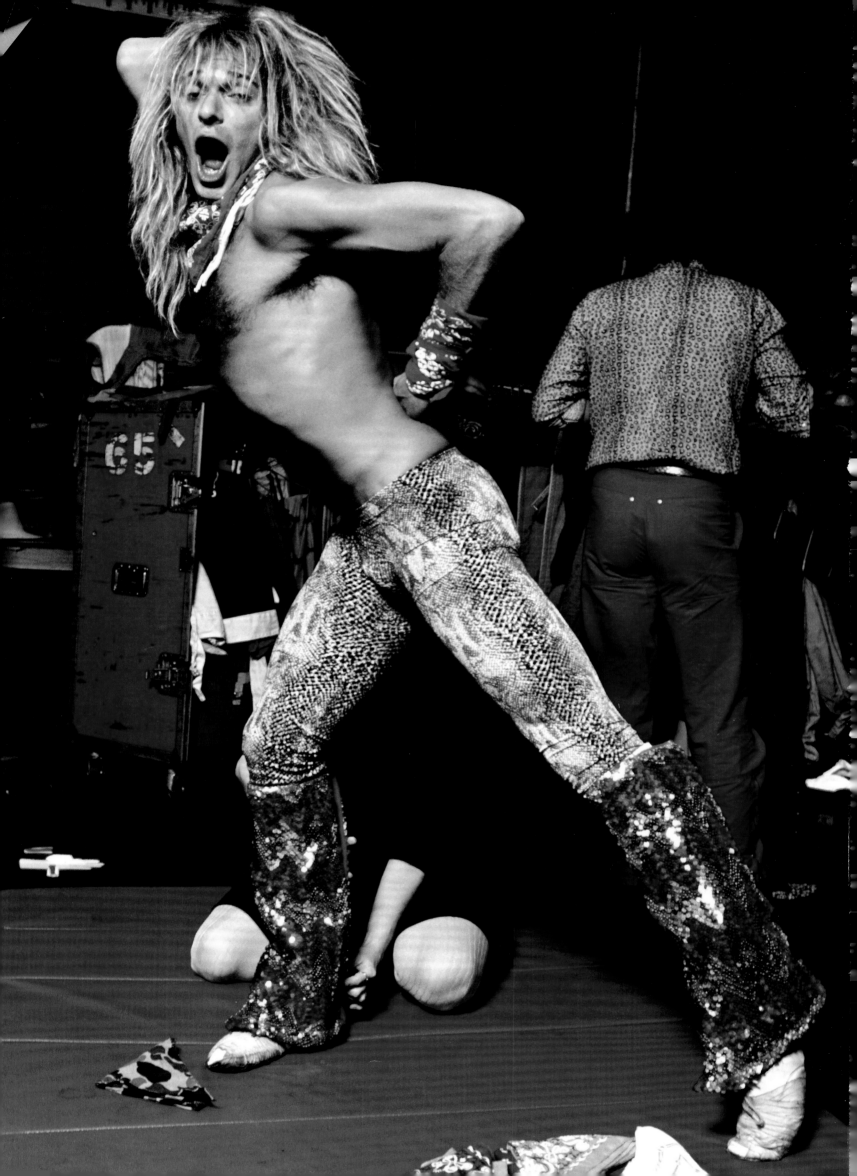

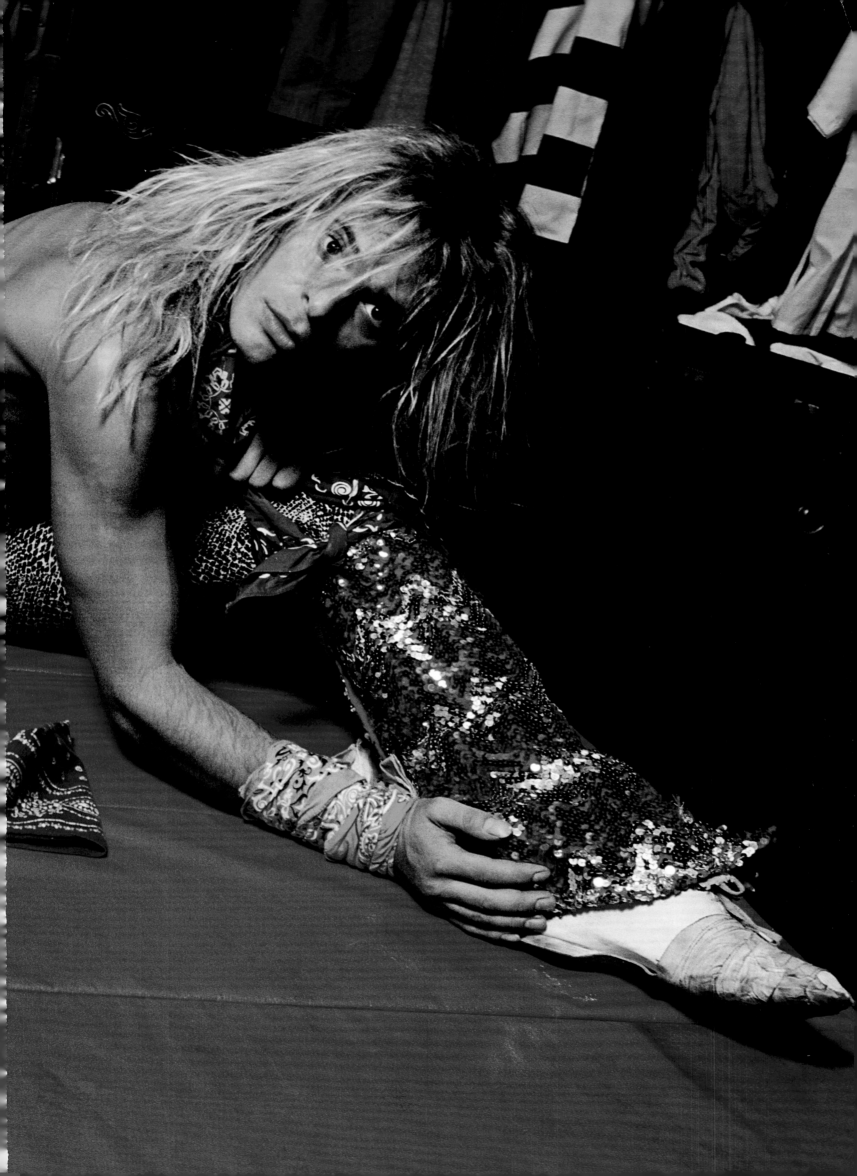

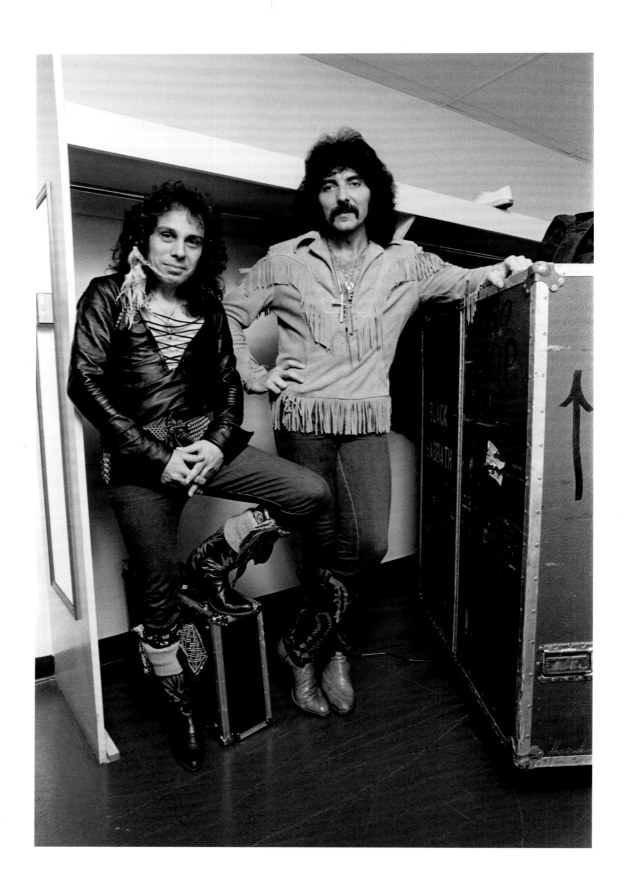

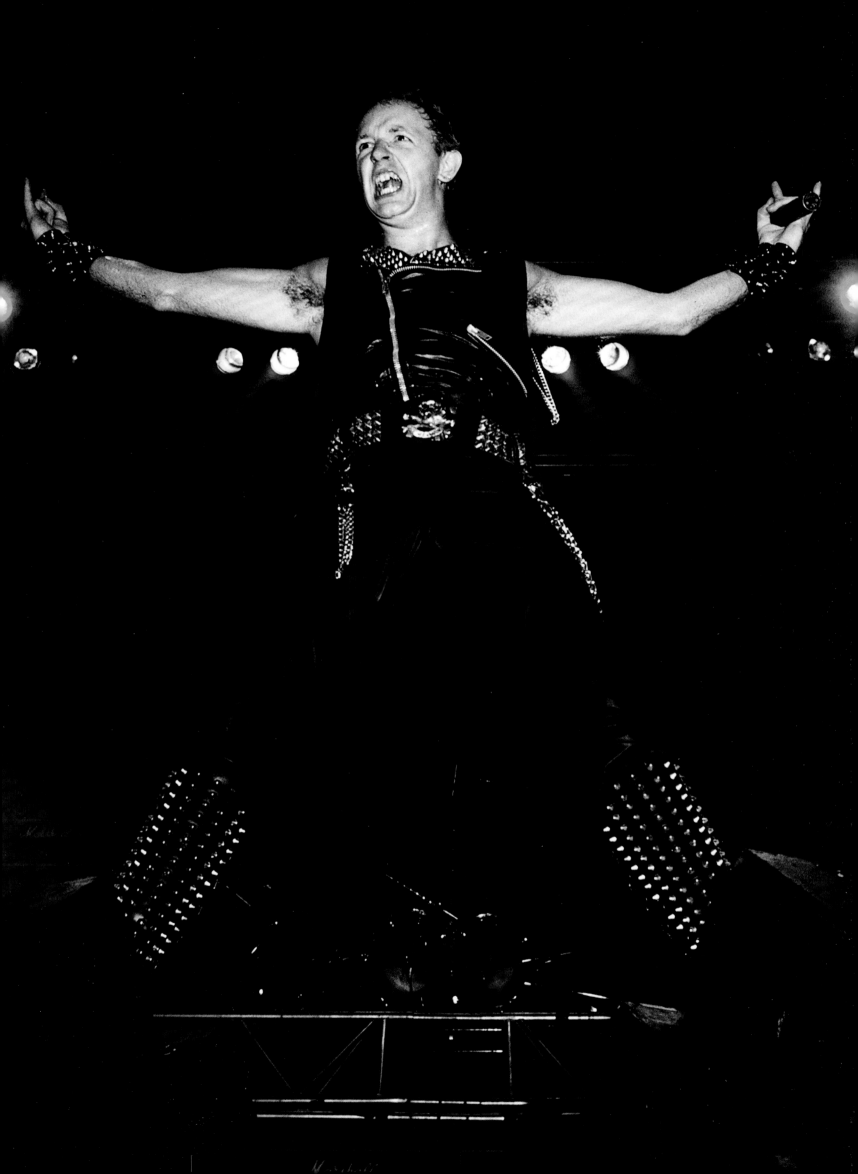

MTV
MUSIC TELEVISION

QUIET RIOT

V.I.P.

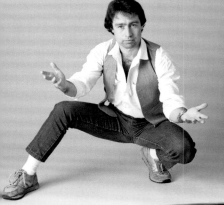

AUL RODGERS

UT LOOS

01753

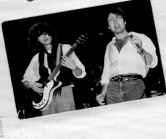

1983

KISS

UNITED
STATES

PHOTO

ALL ACCESS

OTTO

SEP S00823

'83 MARK WEISS/

MARK WEISS/ANGLES

0660-2444-001 BLACK SABBATH

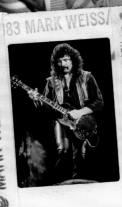

STARCH
00

MARK WEISS

© 1983, MARK WEISS PHOTOGRAPHY Photographer

N.Y., N.Y. 10001

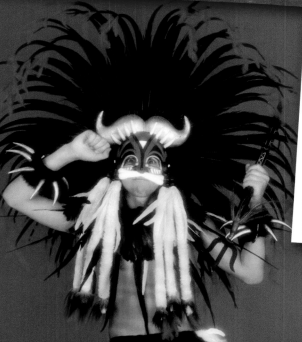

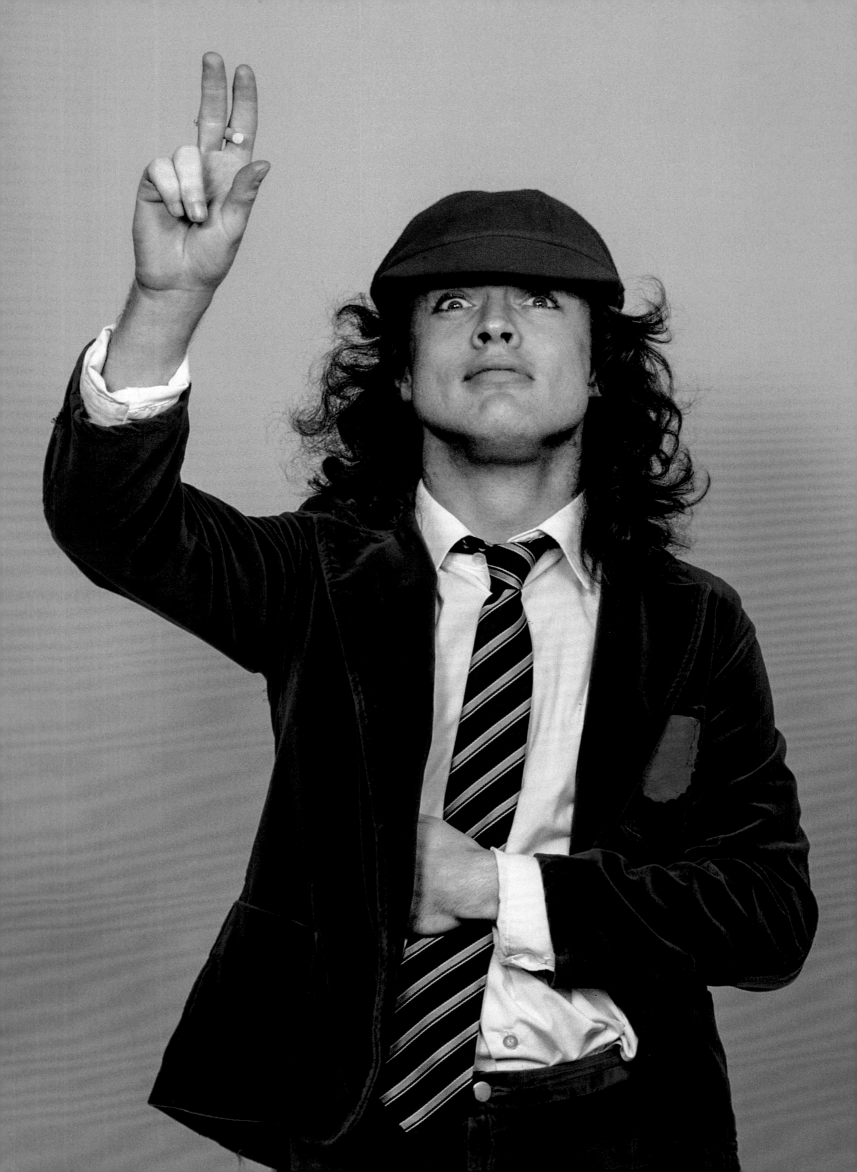

FACES IN THE BIG CITY

I moved to New York City in February. It was a dream come true—I now had a studio in Manhattan, located just one block from Madison Square Garden. It was a small loft—five hundred square feet with tall ceilings, and the width was just about the size of a nine-foot roll of seamless paper. But I felt I had finally come into my own. While I was moving in, I bumped into Jean Beauvoir from the Plasmatics, who lived in the building and asked me if I would shoot a new band he was in with Rascals drummer Dino Dinelli called Little Steven and the Disciples of Soul. It ended up being my first photo shoot in the studio. Lita Ford, Dio, and Kiss—with their new guitar player, Vinnie Vincent—soon would follow. Once I got set up there, one of the first people I reached out to was Carol Kaye at Leber-Krebs, the company that was managing Aerosmith at the time. I asked if Steven would be interested in doing a shoot. He was up for it and came to my studio. I loved the rock 'n' roll attitude on his face when he lifted up his sleeve to show me his tat. It gave me the idea to do a series of photos on rock 'n' roll tattoos.

Paul Rodgers was another one of the first shoots at my studio. After more than a decade with Free and Bad

Company, he released his debut solo album, *Cut Loose*, in 1983. I was excited when Atlantic Records hired me to shoot promo photos. One of my shots appeared on the cover of *Cashbox*, a trade magazine, and was also used for the promotional poster that hung in record stores. I would see it every day when I walked by the Sam Goody down the street from my studio.

Mikael Kirke had received an offer to create a new rock publication called *Faces*, and so we began setting up photo shoots and interviews at my new studio. The first issue of *Faces* featured Ronnie James Dio, Ozzy Osbourne, and a scantily clad Lita Ford. Mikael also arranged to have me shoot MTV's VJs and created a monthly feature where we'd showcase artists who were

OPPOSITE: AC/DC's Angus Young, *Flick of the Switch* tour, the Hollywood Sportatorium, Hollywood, Florida **TOP:** Ronnie James Dio, photographed at Mark's studio, New York City **BOTTOM:** Dino Danelli, Little Steven Van Zandt, and Jean Beauvoir of Little Steven and the Disciples of Soul, Mark's studio, New York City

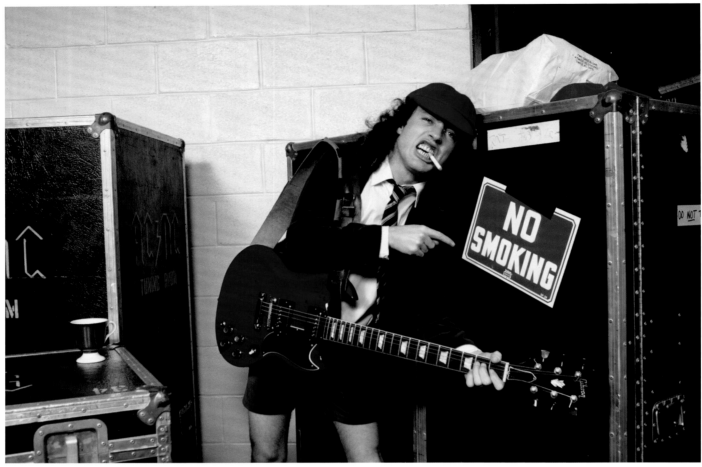

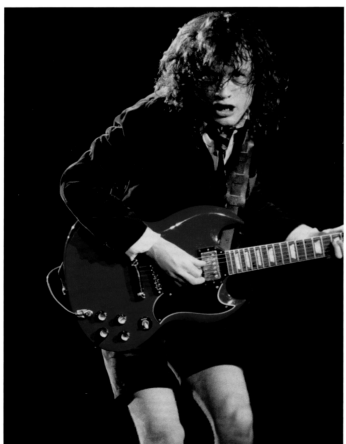

ABOVE: Angus Young, the Hollywood Sportatorium **OPPOSITE:** Brian Johnson of AC/DC **PAGES 118–119:** Lita Ford, photographed at Mark's studio

on the set. Shortly after, MTV's publicist, Doreen Lauer, hired me to shoot the guests who came into the studio. Now, in addition to working with the magazines, I was an official MTV photographer.

The *Faces* premiere issue couldn't have come at a better time. Rock 'n' roll mags had begun phasing out their coverage of new wave and mainstream rock. I was getting bored of just shooting bands in front of seamless paper. It seemed like a chore for the bands, too—they knew they had to be there to promote the music, but they were not having fun and neither was I. I wanted to be more creative with my photo shoots. The word was out that *Faces* was the new magazine that would deliver just that with a focus on rock and metal.

AC/DC was once again headlining arenas on their *Flick of the Switch* tour, and they gave me fifteen minutes before their show at the Sportatorium in Hollywood, Florida, to pull off a cover shoot for *Faces*. I set up a backdrop and lights backstage. Angus Young, the band's guitarist, came in. He didn't say much beyond, "Okay, whatcha want?" What I wanted was his classic Gibson SG, and as we waited for the guitar to arrive, my fifteen minutes were starting to run out. Finally, he said that if we wanted to shoot him with his guitar, we would need to go to the tuning room. And so off we went. On the way over, I saw a NO SMOKING sign in the hall; I grabbed it and taped it to his trap case. Then Angus started mugging for the camera.

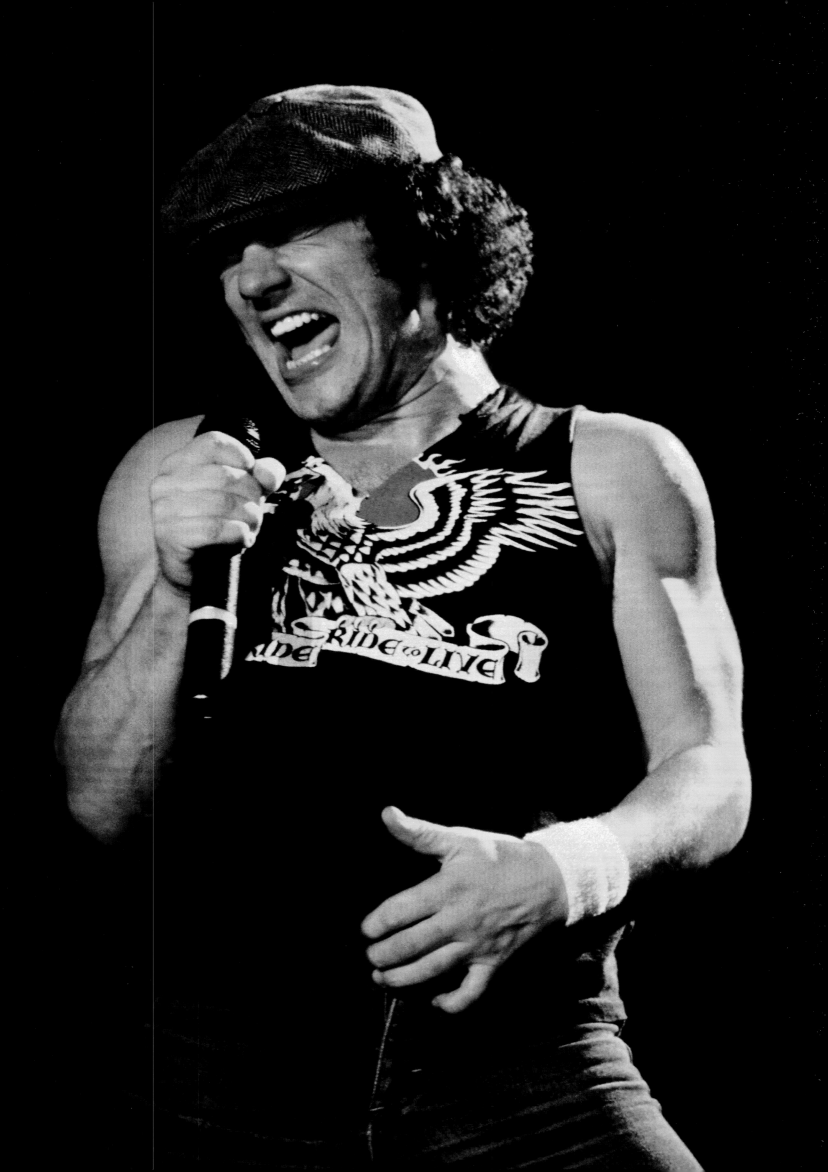

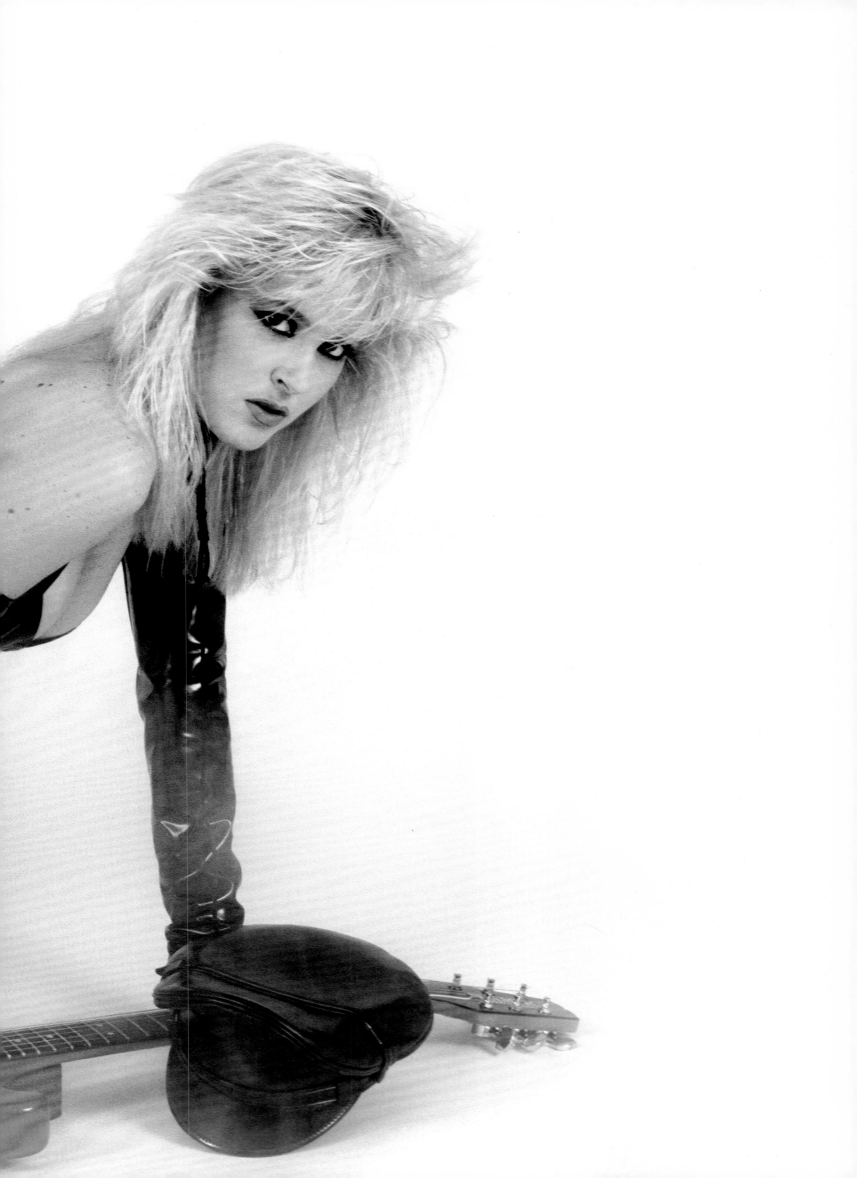

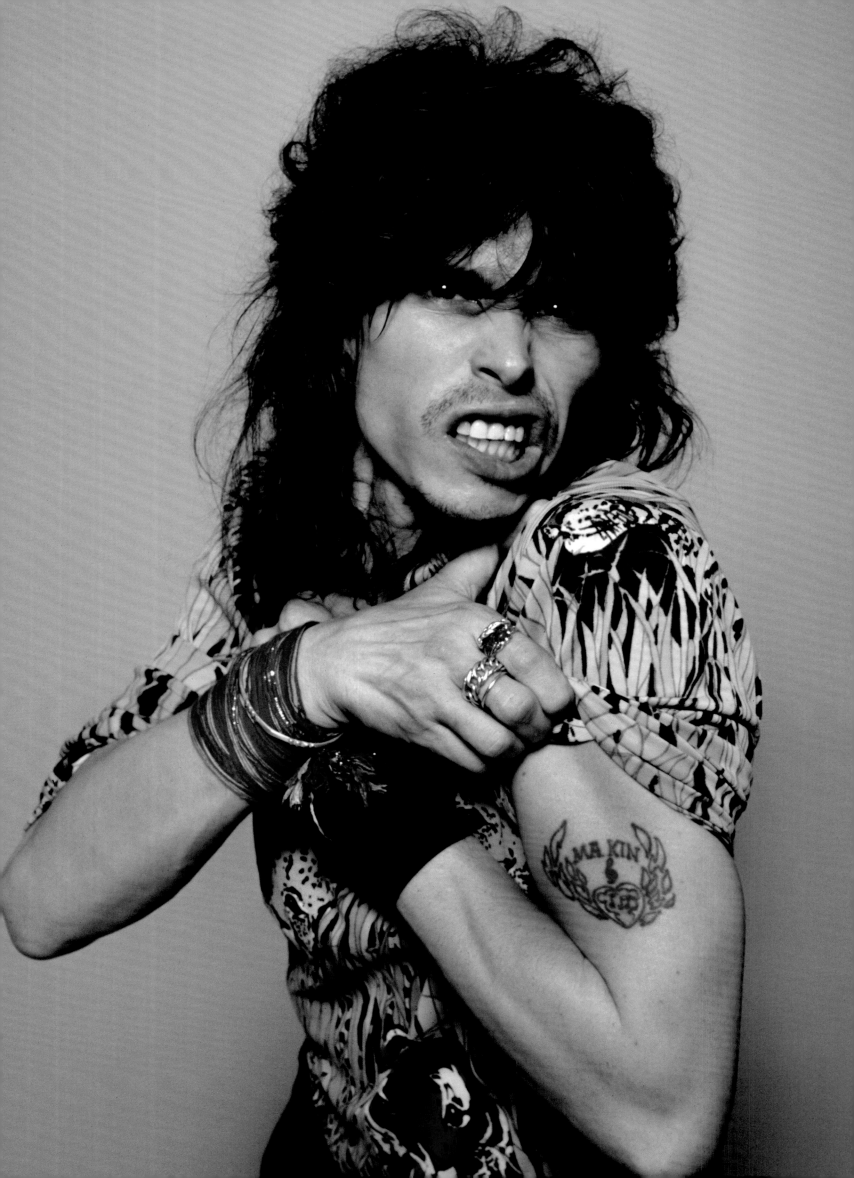

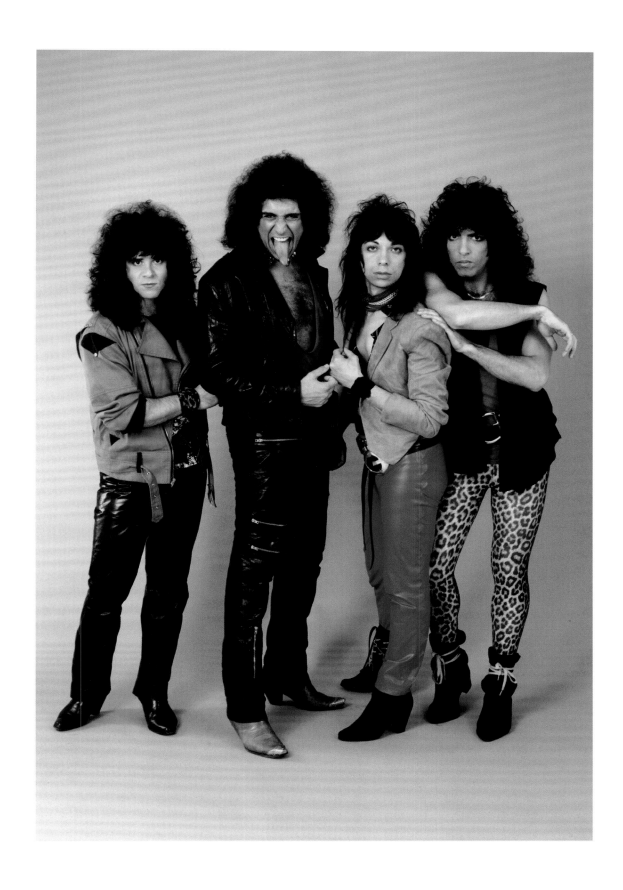

"He'll just tell you, 'Turn your face this way or that way.' 'Do that.' 'Do this.' He'll guide you and direct you. Mark can make the littlest things look very creative."
—Lita Ford

OPPOSITE: Aerosmith's Steven Tyler **ABOVE:** Kiss at Mark's studio, New York City

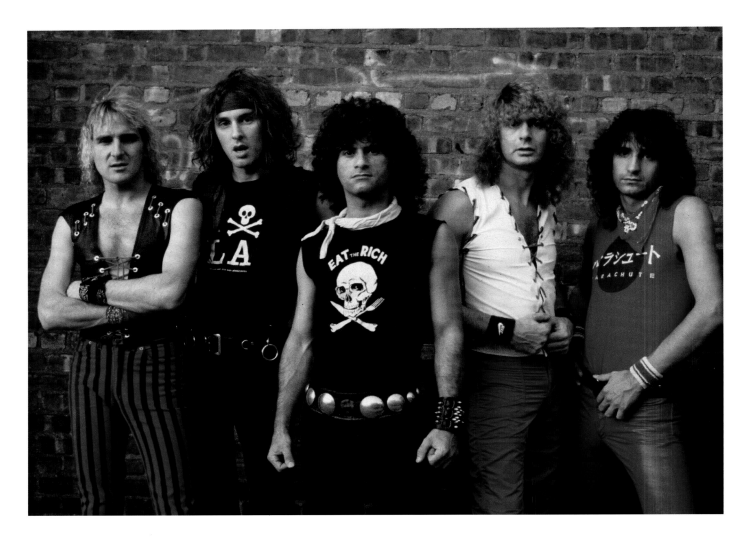

LOVE IN AN ELEVATOR

Meeting with Kiss's former manager Bill Aucoin, who was now representing Billy Idol, proved to be monumental in my life. Billy's publicist, Ellen Zoe Golden, had me bring my portfolio to Olympic Tower in Midtown Manhattan to discuss setting up a shoot. It was a quick meeting; Bill and I had met the previous year when I had shot Gene Simmons and Paul Stanley as they were being interviewed by Gerry Rothberg for *Circus*. Bill was no longer managing Kiss, and now all his attention was focused on his new client.

I left Bill's office with a big smile on my face. I walked out into the hallway and hit the button for the elevator. As the doors opened, I got on and noticed an attractive woman eyeing me. We were the only two on the elevator. Finally, she turned to me and said, "What band are you in?" I responded, "What makes you think I'm in a band?" Maybe it was the long hair and black leather pants. As we descended the thirty-four flights to the ground floor, we started talking. She introduced herself to me. "My name is Suzanne. I used to work for Bill back in the '70s when he

managed Kiss." I told her I was a photographer, and that when Kiss played the Garden in '77 I had been arrested outside for selling my photos. That got a laugh out of her. We had dinner that evening, and within the year, I moved into her apartment in the city. Four years later, Suzanne and I were married. We have two beautiful kids together, Guy and Adele, and a grandson, Jax.

Krokus were touring behind *Headhunter*, their seventh album and their first to go gold in the United States. They were also having success with singles such as "Eat the Rich." I would always keep an eye on the *Billboard* charts and would go after whatever acts seemed promising. In 1983, Krokus was one of those acts. I arranged a photo shoot when they played in the area at the Capitol Theatre. When they released their next album, *The Blitz*, they called me in to do their new promo photos. I met them on the set of their "Midnite Maniac" video and then became their tour photographer. One shoot basically led to another—my contacts were building, and the doors were opening.

ABOVE: Krokus, *Headhunter* tour, the Capitol Theatre **OPPOSITE:** Billy Idol showing off his tattoo of a Russian comic superheroine named Octobriana, Mark's studio, New York City

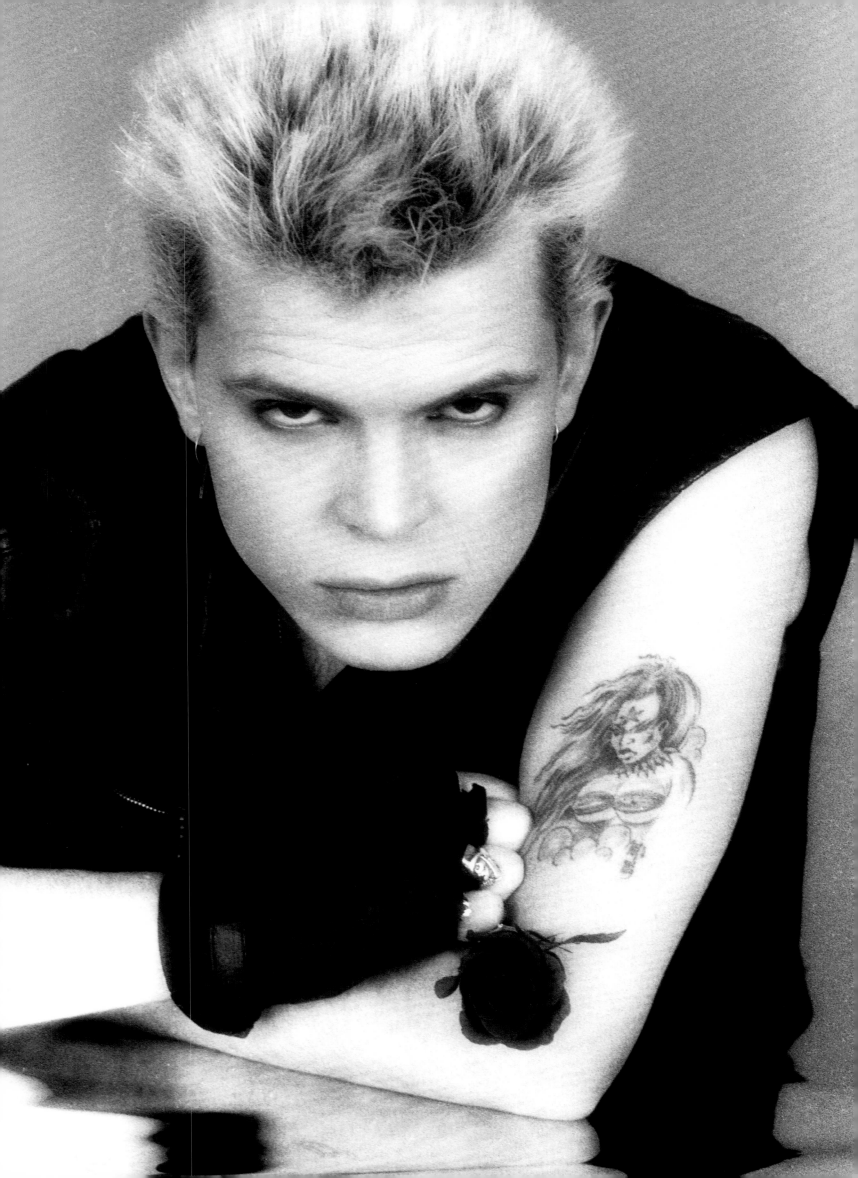

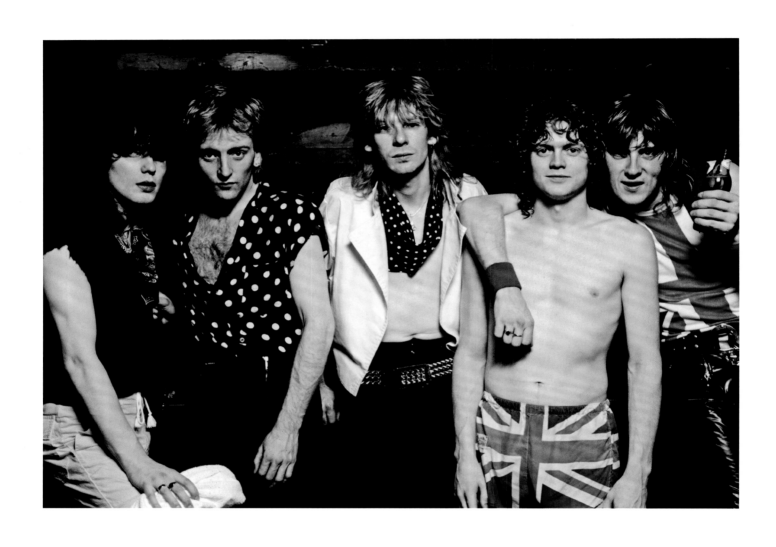

ABOVE: Def Leppard, *Pyromania* world tour, Nassau Coliseum
OPPOSITE: Joe Elliott of Def Leppard

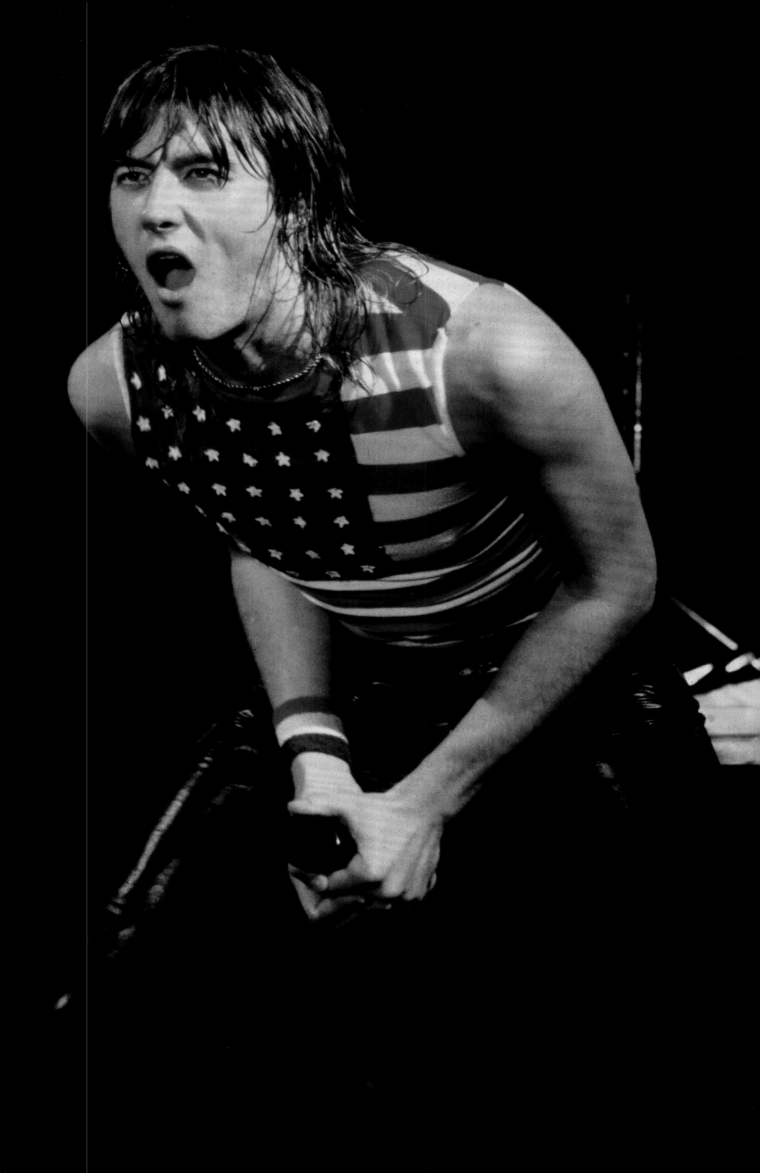

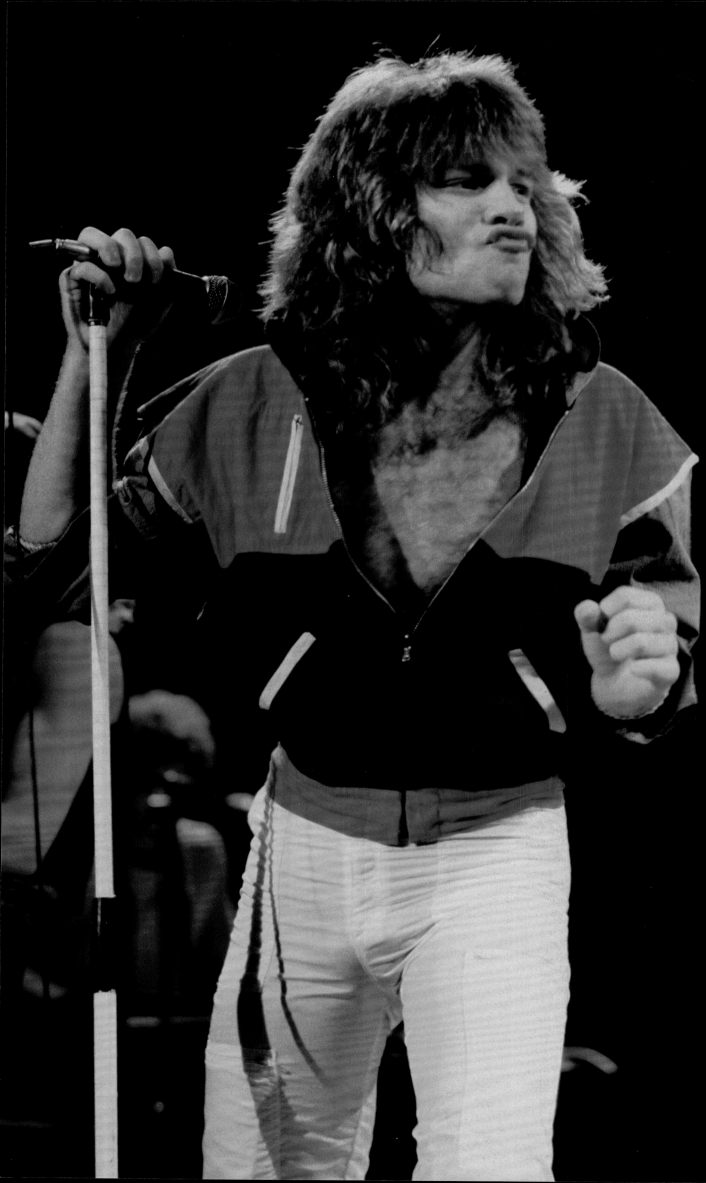

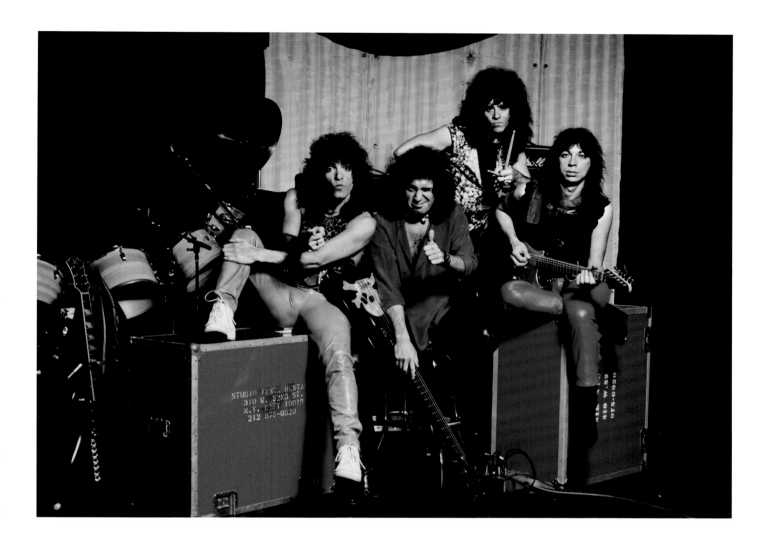

UNMASKED

I got a call from George Dassinger, who was now working for Rogers & Cowan. He hired me to shoot ZZ Top at Madison Square Garden. One night, I went early to check out the opening act for ZZ Top at the Garden—if they were opening for the headliner, they must be on the rise. The singer looked familiar. They were called Bon Jovi, and they had won a contest on WAPP radio to open the show. I got to the photo pit just in time to take a few pics as they were finishing up their set. Later on, I realized I had shot Jon Bon Jovi in his old band, the Rest, a few years earlier. At the time of the ZZ Top gig, Bon Jovi hadn't even released their first album. Two years later, I would be hired to shoot the press photos for their second record, *7800° Fahrenheit*.

I had shot Kiss without their makeup, but they were still covering their faces with their hands, not quite ready to show the world their unmasking. Kiss hired me to take photos at SIR on West 52nd Street, where they were rehearsing for their first album and tour without makeup.

These were some of the first shots of the band where they showed their faces. On September 18, they appeared on MTV and unveiled their new look. Two weeks later, they came to my studio on 31st Street—just two blocks from where I had gotten arrested for selling Kiss photos.

In his autobiography, *Kiss and Make-Up*, Gene revealed how Paul, Kiss's other remaining founding member, convinced him it was time for a big change when they were recording *Lick It Up*, their eleventh studio album:

"'Let's prove something to the fans,' Paul said. 'Let's go and be a real band without makeup.' I reluctantly agreed. I didn't know if it was going to work, but I heard what Paul was saying—there was nowhere else for us to go. We did a photo session just to see what it would look like. We looked straight into the camera lens. We were defiant. I made one small concession to the fans: I stuck out my tongue, to try to keep something that connected us with the past."

OPPOSITE: Jon Bon Jovi opening for ZZ Top at Madison Square Garden
ABOVE: Kiss, photographed at SIR, New York City PAGES 128–129: Rainbow's Ritchie Blackmore, *Bent Out of Shape* tour, the Spectrum

"Mark is the real deal. Mark actually loves what he does. So, Mark may not play guitar, but that camera of his, that's his guitar. In that way, he's a rock star."
—Gene Simmons (bassist, Kiss)

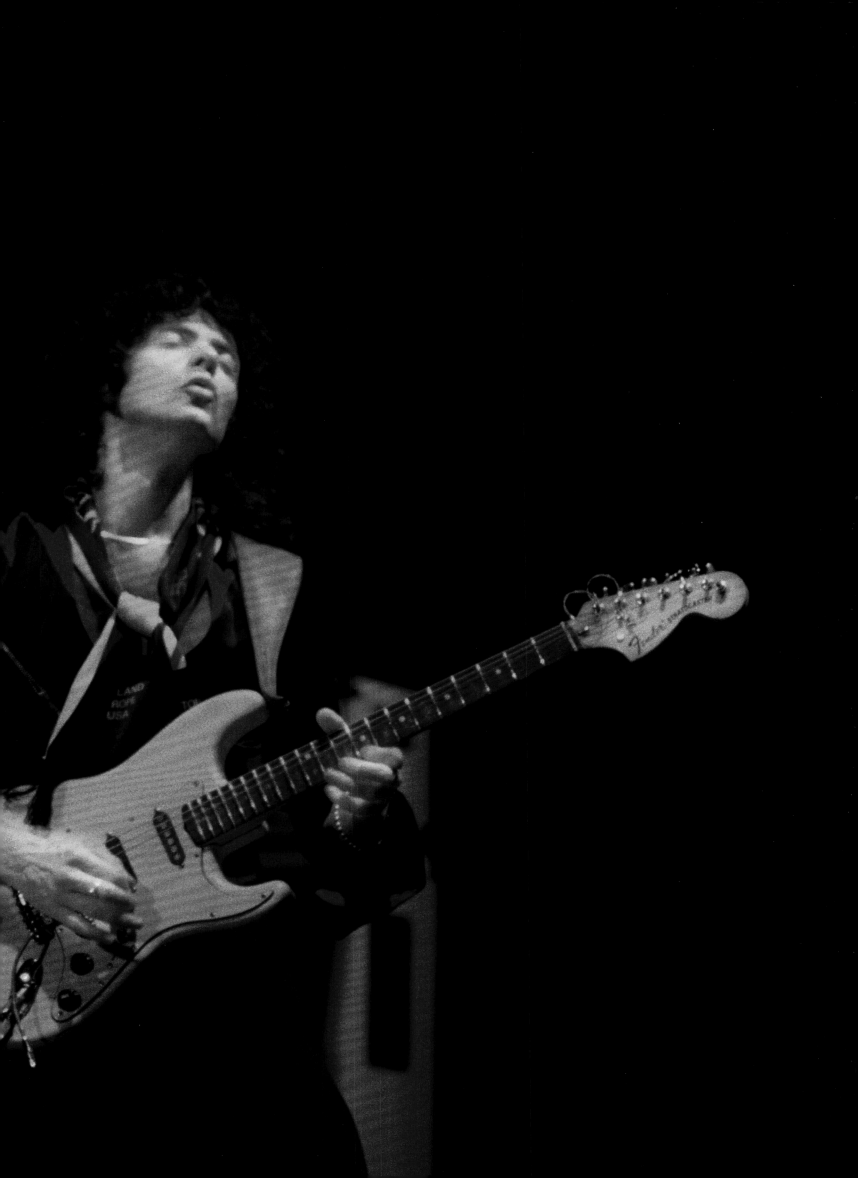

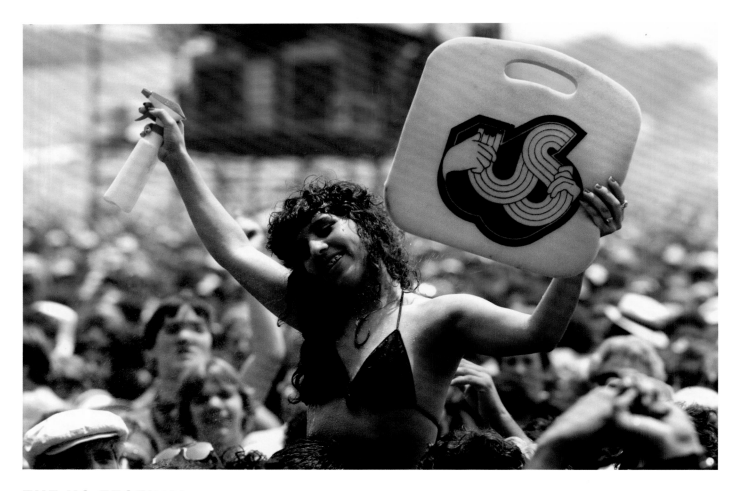

THE US FESTIVAL

Apple cofounder Steve Wozniak put on the first US Festival in San Bernardino, California, in 1982, with performances over three days from acts such as Tom Petty, the Police, and Talking Heads. The crowd was almost half a million people. The next year, Wozniak and his team did a second US Fest—only this time it was a four-day event starting on Memorial Day weekend, and attendance reached almost seven hundred thousand.

What's more, the organizers tipped their hat to the new sounds of the era, dubbing the second day Heavy Metal Day, with performances from Quiet Riot, Mötley Crüe, Ozzy, Priest, Triumph, the Scorpions, and the night's headliners, Van Halen. Was I gonna be there? Hell yeah, I was. And what's more, I was going with Ozzy. Sharon Osbourne called me up a month before the show and asked if I would do a shoot with Ozzy in the new outfit that he was going to wear during the US Festival. She had the costume shipped to my studio; it arrived in a huge wooden box that she told me not to open until they got there. On the day of the shoot, I waited for Ozzy and Sharon, but they never showed up. Eventually, Sharon called and apologized; they weren't going to make it, and she needed to have the box shipped out to California. By this point, I

was more than a bit curious to see what was inside. When I opened the box, I wasn't disappointed. I had to laugh when I saw the outrageous costume; I had to try it on.

The day of the US Festival was a good one. When I look back on it, I remember everyone—the bands, the fans, the crews—having these big ear-to-ear grins on their faces.

After shooting the scene backstage, I got out front and placed myself in the photo pit, ready to shoot the first band: Quiet Riot. I was looking forward to seeing them. *Metal Health* had been released a few months earlier, and the band was starting to get airplay.

One week earlier, Mötley Crüe had been playing two-hundred-seaters in Hollywood. Now, they were in front of a sea of people. They performed songs from their upcoming album, *Shout at the Devil*. Even though Mötley were still a relatively unknown band, the crowd chanted, "Shout! Shout! Shout at the devil!"

Ozzy came out onstage for his set wearing the whole getup that Sharon had shipped to my studio a few weeks earlier. I have to say, it looked better on Ozzy than it had on me. It lasted only a minute or two; he ripped it all off during his opening song, "Over the Mountain."

ABOVE: Fans at the US Festival, San Bernardino, California **OPPOSITE:** Mötley Crüe's Tommy Lee

"That was an unforgettable moment, sitting behind the drums and looking out at my band, looking out at the crowd. We called it the Dust Festival instead of the US Festival because there were so many people, just out in the middle of the fucking desert. You couldn't see where it ended. It was insane."
—**Tommy Lee (drummer, Mötley Crüe)**

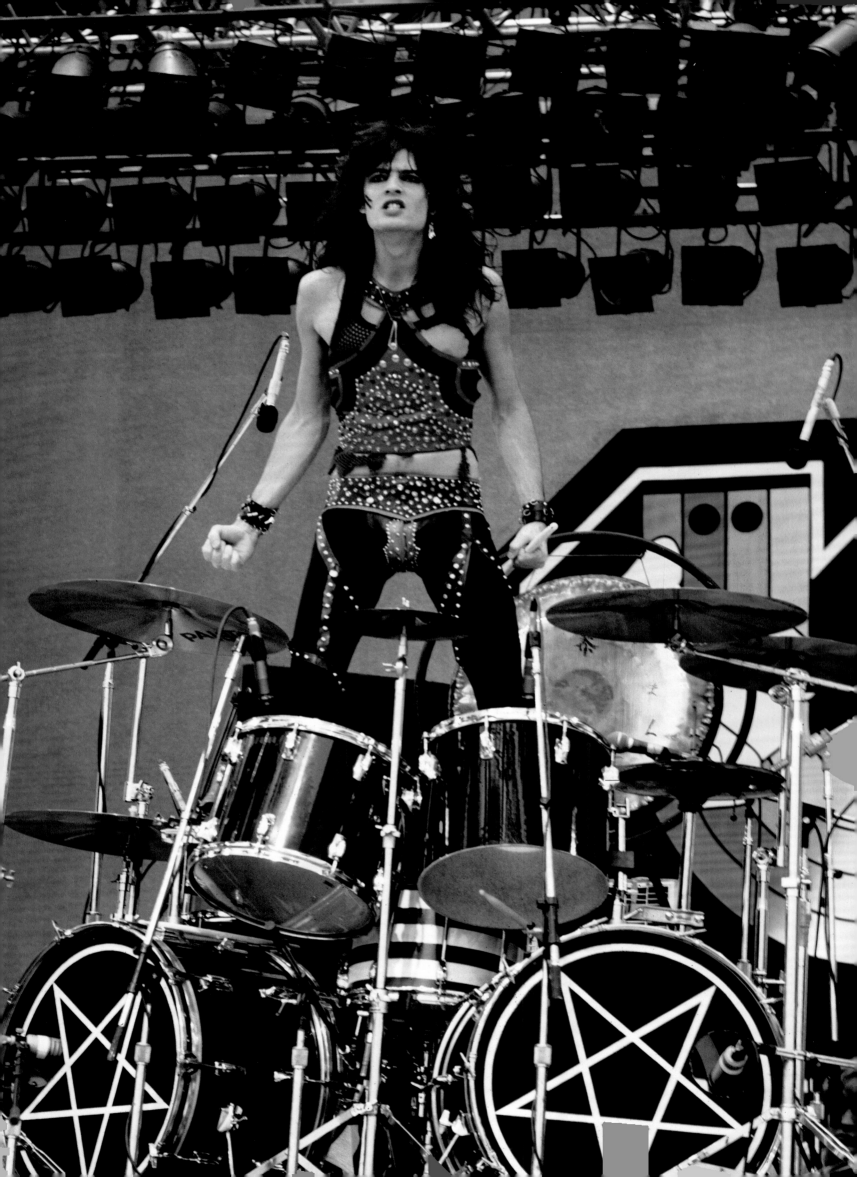

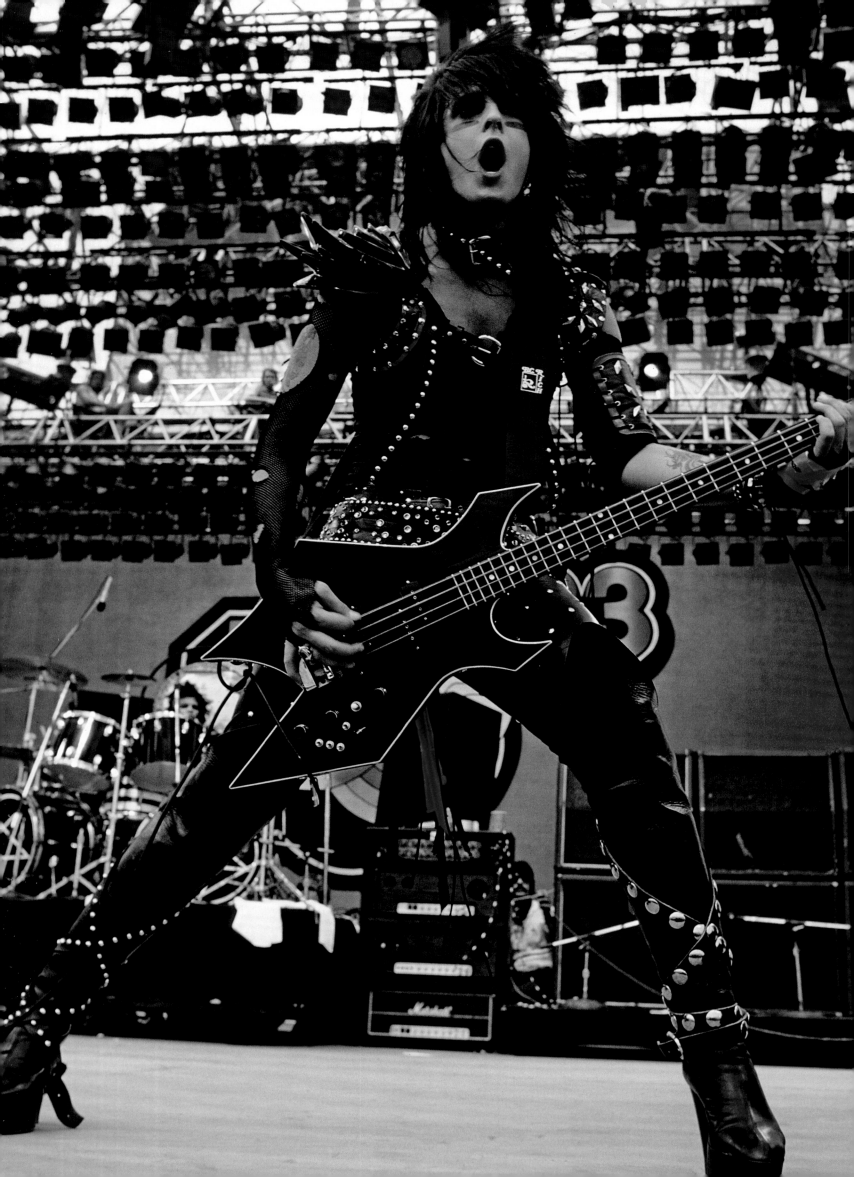

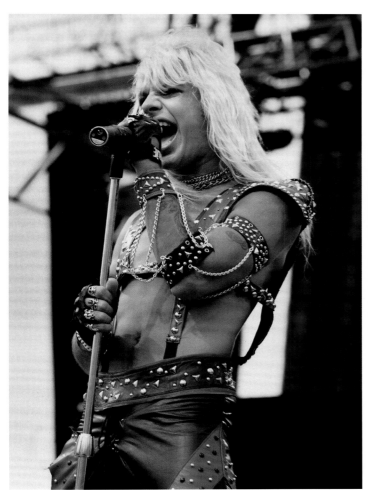
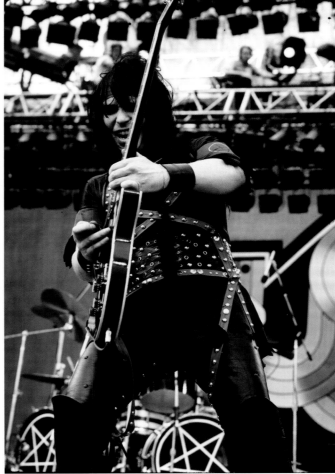

"I remember being on the side of the stage as we were getting ready. I looked at the guys, and we all looked at each other and we just all put our fists together and didn't say a word. Because we knew. We just knew that we were going to do what we do, but we didn't know what was going to happen. I didn't know that we were going to step on that stage and that we were going to play songs that no one had ever heard before and 350,000 people were all gonna go, 'Shout! Shout!' with us. We didn't know what the hell was going to happen. It blew our minds." —**Nikki Sixx**

THESE PAGES: Mötley Crüe live at the US Festival: Nikki Sixx (*opposite*); Vince Neil and Mick Mars (*above*)

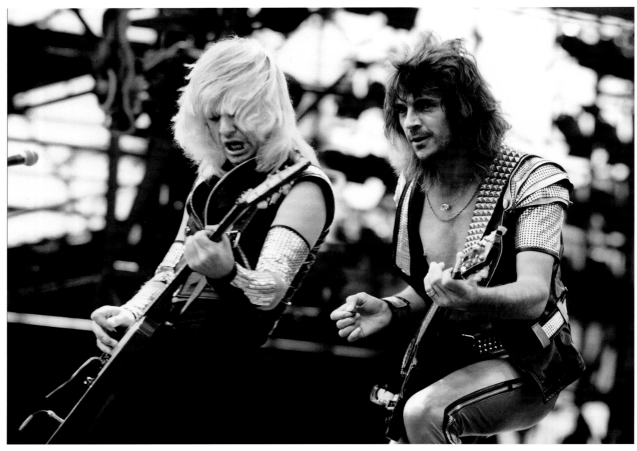

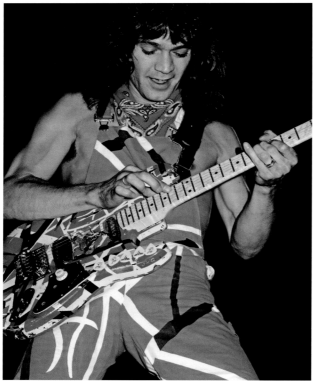

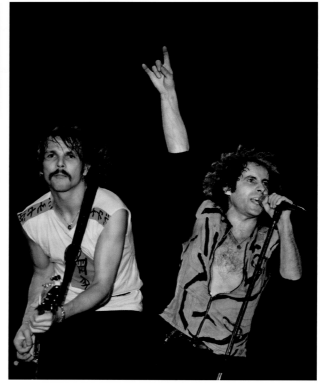

THESE PAGES: Various shots of live performances from the US Festival: K. K. Downing and Glenn Tipton of Judas Priest (*top*); Eddie Van Halen (*bottom left*); Rudolf Schenker and Klaus Meine of Scorpions (*bottom right*); Quiet Riot's Kevin DuBrow and Rudy Sarzo (*opposite*)

"We started to play in front of three hundred thousand totally freaking out rock fans. Going totally nuts. When the sun came down it was a wonderful moment. We came up with the idea to hire five jets to fly over the stage and over the crowd. All of a sudden there were five jets right at the moment that we came out and started playing. It was just the biggest special effect you could imagine, you know?" —**Klaus Meine (singer, Scorpions)**

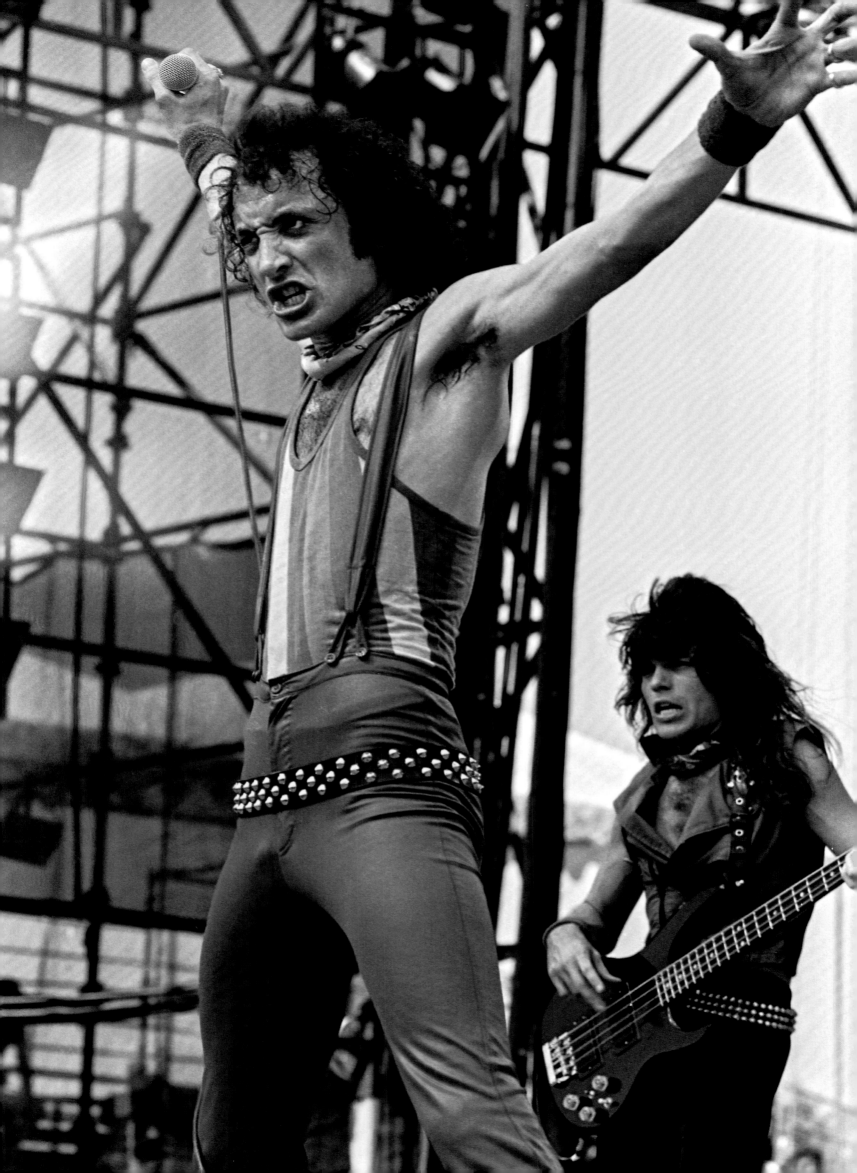

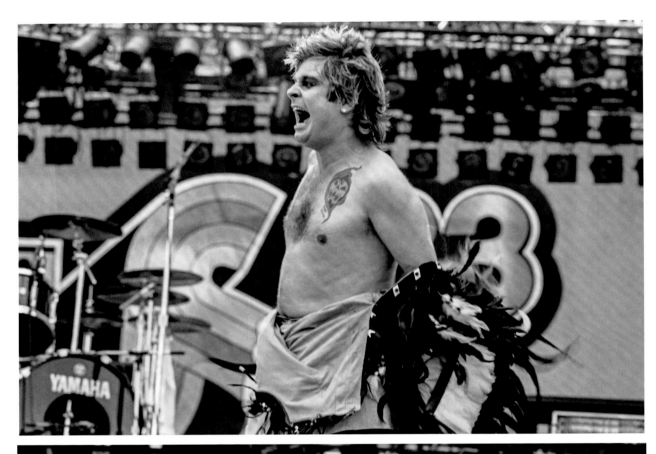

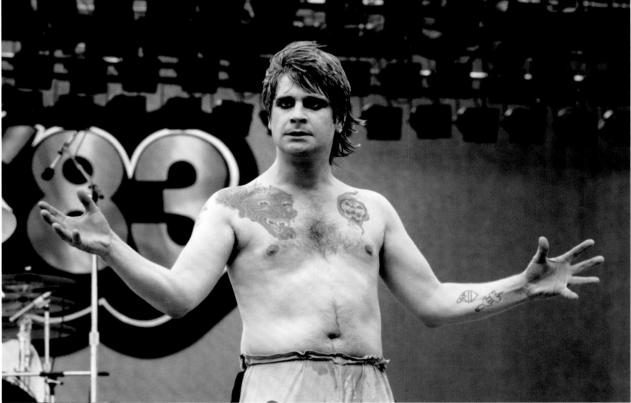

ABOVE AND OPPOSITE: Ozzy Osbourne live at the US Festival

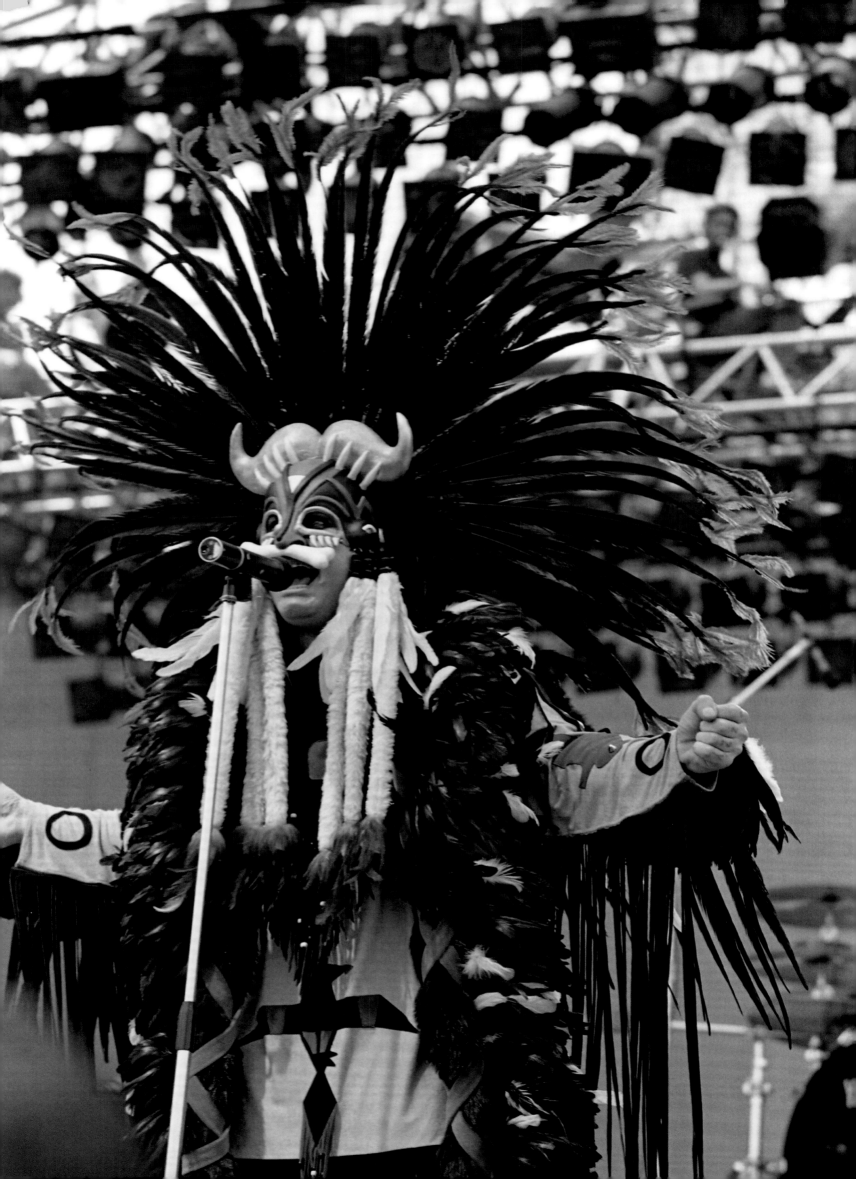

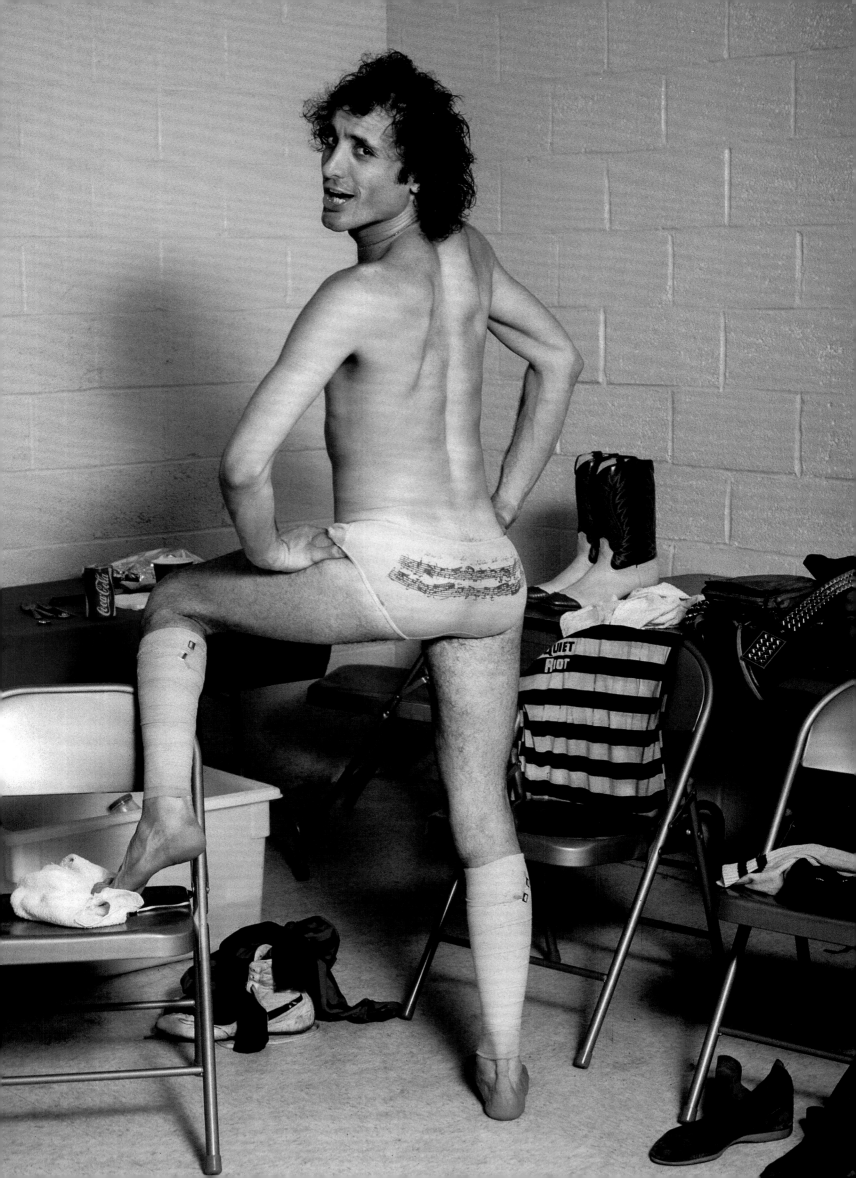

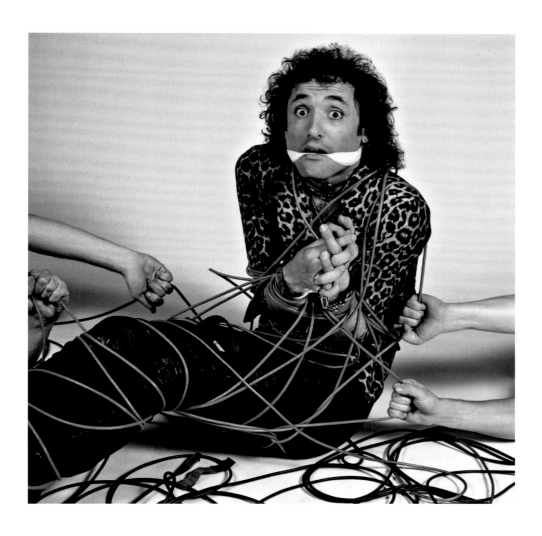

THE MOUTH THAT ROARED

When a new band came out that I liked, I would make it my business to arrange a shoot with them. It was a way to make new friends and have some fun on the road. Quiet Riot was no exception. I shot the cover for the single sleeve for Quiet Riot's "Bang Your Head (Metal Health)" backstage at Madison Square Garden on October 8, when the band was in town opening for Iron Maiden. They had released *Metal Health* back in March. After the success of "Cum on Feel the Noize" and "Bang Your Head," *Metal Health* pushed the Police's *Synchronicity* out of the top spot on the *Billboard* album chart, becoming the first heavy metal album to hit number one. It was a game changer moment for metal in the 1980s.

I became very good friends with the guys in the band. After the success of *Metal Health*, Kevin DuBrow, the lead singer, bought a house in Beverly Hills and let me stay there when I was in town. He had a great sense of humor. He also had a big mouth. He wasn't shy about

expressing his feelings. He had many opinions, especially when it came to other bands that were beginning to have success, too. Whenever I would go to LA and was asked where I was staying, I would say, "DuBrow's house." People looked at me as if I were crazy. They would always question our friendship. But Kevin was a one-of-a-kind guy. I always envied his brazenness. In a cover story in *Faces* titled "The Big Mouth," Kevin said: "I've been called hostile and provocative but I prefer the term rebellious. I have my opinions about other bands, and I say what I feel. If people don't want to know what I feel, why ask? People ask me if I mind seeing all our imitators now around Los Angeles. I used to be very annoyed with them, because they were getting signed while we were on the road working our asses off. Now I could care less, because their fate is up to the public. Five years ago people were busy telling me Quiet Riot would never make it—yeah, a hot guitar player but the singer couldn't sing. And I'll tell you, there were a lot of times I believed 'em!"

OPPOSITE: Kevin DuBrow of Quiet Riot, *Metal Health* tour, Madison Square Garden ABOVE: Kevin DuBrow, Los Angeles, 1984 PAGES 140–141: Quiet Riot, Madison Square Garden

"That photo session in Madison Square Garden will always be special to me. Mark took some very iconic pictures of a very iconic band, from the very beginning and through the rest of our career. He was always in the trenches with us, figuratively and also literally—he was down in the pit taking the photos. He was part of Quiet Riot and always will be." —**Frankie Banali (drummer, Quiet Riot)**

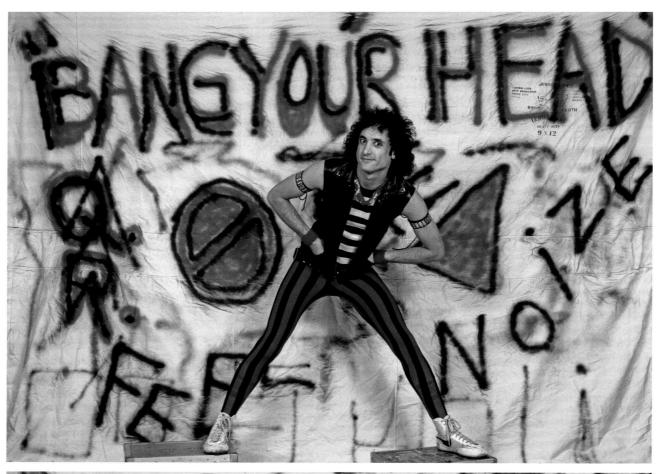
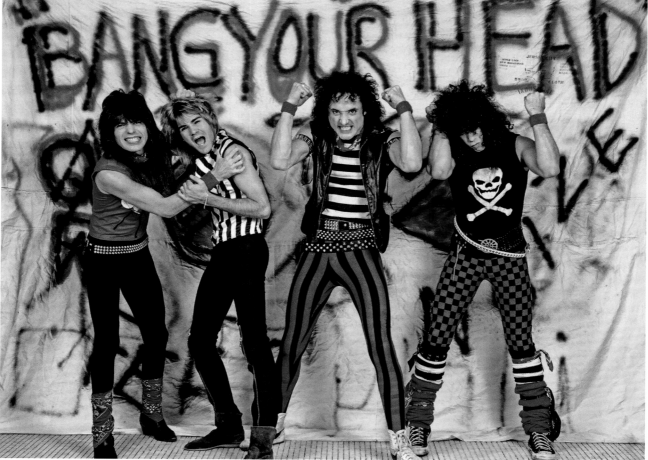

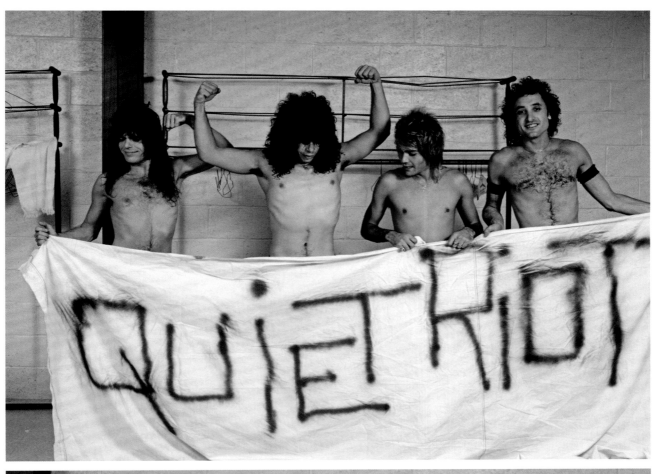

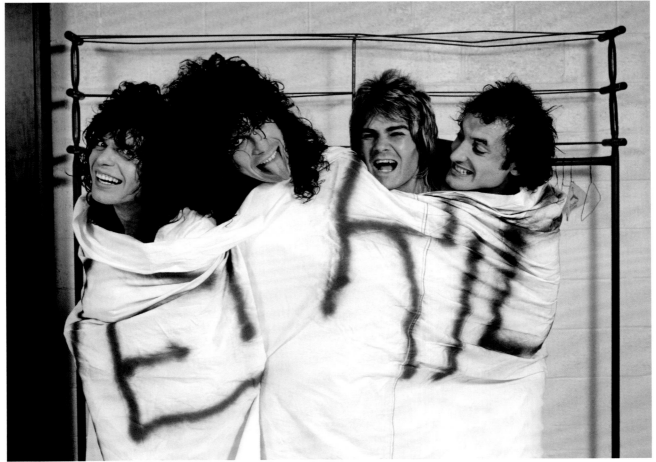

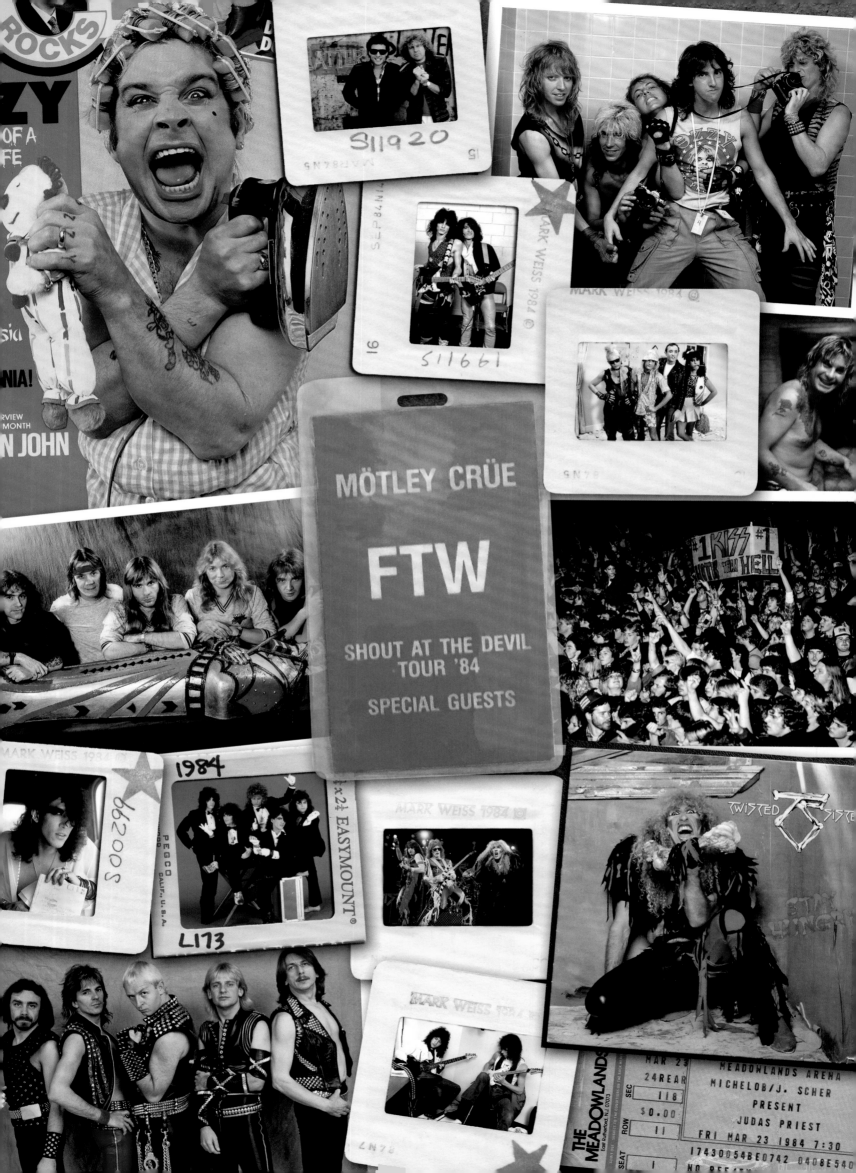

MÖTLEY CRÜE

FTW

SHOUT AT THE DEVIL
TOUR '84

SPECIAL GUESTS

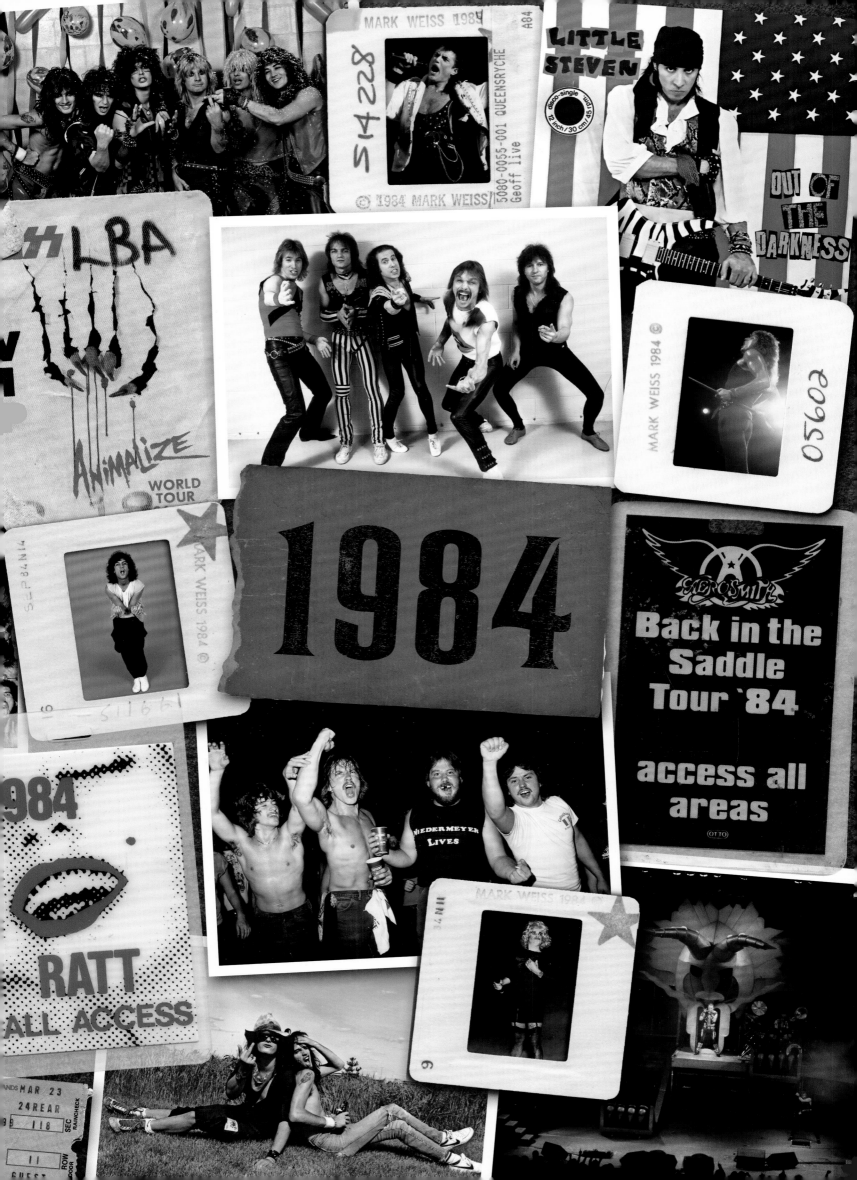

MARK WEISS 1984

S14228 QUEENSRŸCHE A84
Geoff live
© 1984 MARK WEISS

LITTLE STEVEN
disco-single 12 inch / 30 cm / 45 rpm
5080-0055-001

OUT OF THE DARKNESS

LBA
ANiMALiZE
WORLD TOUR

MARK WEISS 1984 ©
05603

1984

MARK WEISS 1984 ©
SEP84N14

AEROSMITH
Back in the Saddle Tour '84
access all areas
OTTO

1984
RATT
ALL ACCESS

WIEDERMEYER LIVES

MARK WEISS 1984 ©

MAR 23
24 REAR
118
SEC RAINCHECK
ROW
11
GUEST DOOR

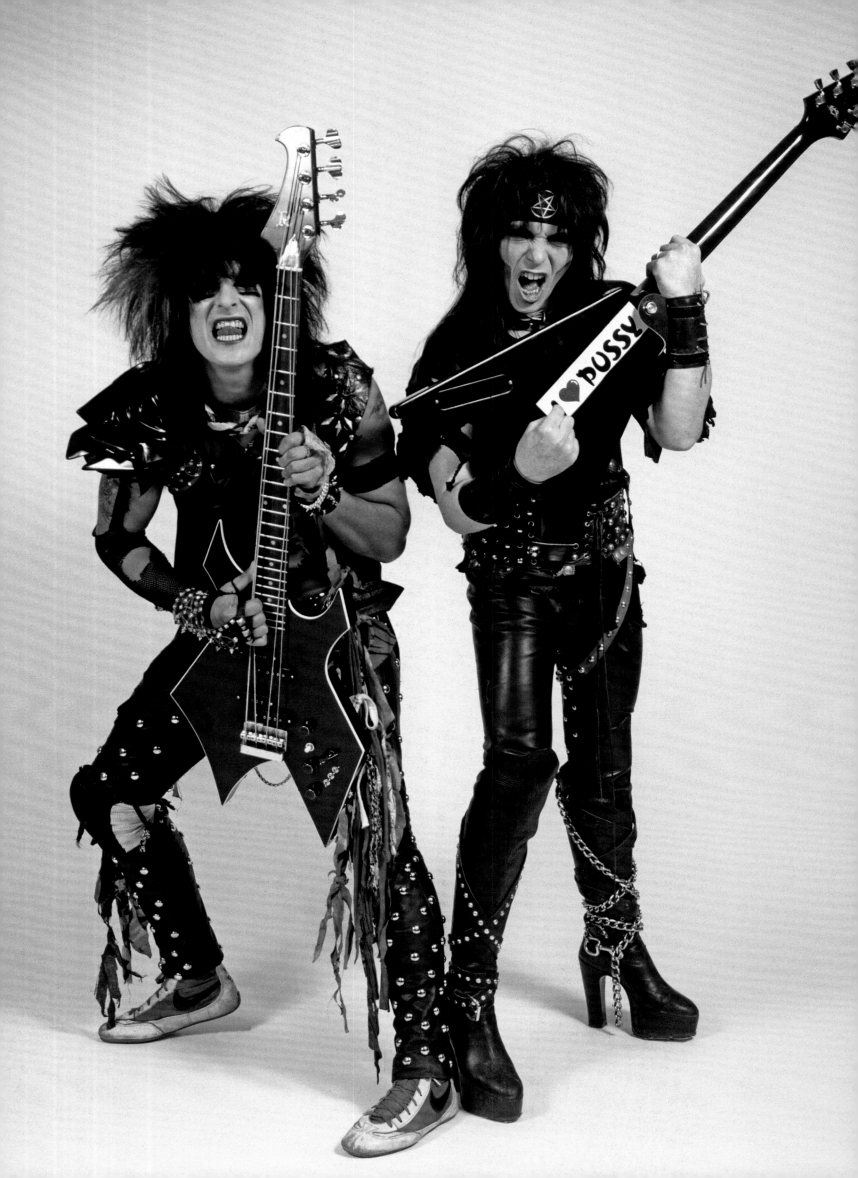

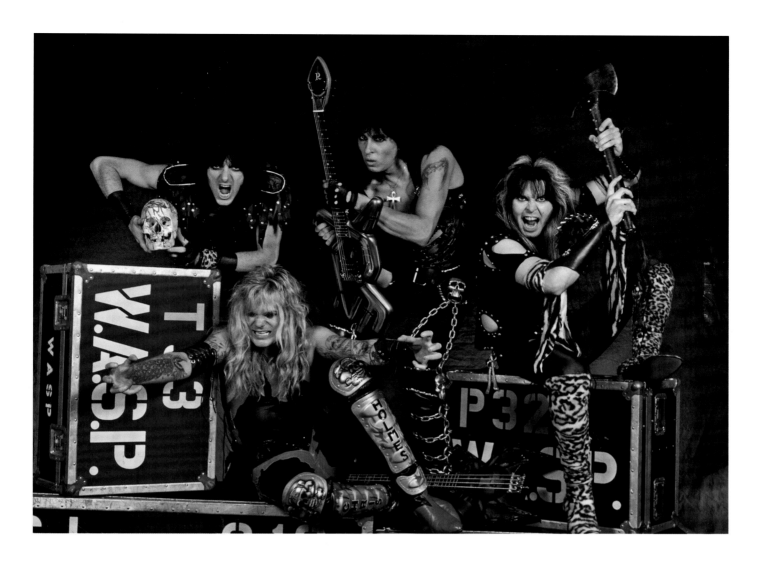

IT'S A MADHOUSE

LA was the new breeding ground for anyone looking to get signed, and the Sunset Strip was the place to be if you were in a band—or even just *looked* like you were in a band. A new rock 'n' roll lifestyle was beginning to take shape, with Quiet Riot, Mötley Crüe, and Ratt starting to sell records and pack venues all over the world. The record companies were on a shopping spree to find the next big band. Bryn Bridenthal, with whom I had developed a good relationship through my *Oui* shoot with Mötley Crüe, was now a VP for Elektra Records and flew me out to photograph Dokken that August, a month before the release of their second album, *Tooth and Nail*. I was warned they might not be the easiest guys to work with, but they were my buds right from the start. Don Dokken let me stay at his house in Manhattan Beach when he was on tour. He had a hot tub in the back and a revolving door of women. Not a bad place to hang out.

By 1984, I had a steady stream of jobs with MTV. I shot Spinal Tap on set while they were there for a walk-on interview. As we waited for David St. Hubbins, Derek Smalls, and Nigel Tufnel to arrive, the monitors played clips from *This Is Spinal Tap*—the only thing was, no one had told us they were a fictitious band. I thought they were an obscure act from England who were huge in their day and had never made it in the States. Once they arrived, I quickly introduced myself and took some pics around the studio. They were in full character. I told Nigel (Christopher Guest) that I could get them in *Circus* magazine. In true Tufnel fashion, he said, "We're not in the circus." I couldn't believe that David St. Hubbins was the guy who had played Lenny on *Laverne & Shirley*. They definitely got one over on me.

OPPOSITE: Nikki Sixx and Mick Mars of Mötley Crüe ABOVE: W.A.S.P.

"I remember we did the first tour and we were sitting on some road cases. Mark was one of the first photographers that I noticed that used a light behind you. I never saw him take a bad picture of me." —Chris Holmes (guitarist, W.A.S.P.)

"When MTV started all of a sudden, it was more about style over substance, and everybody's like, 'Oh man, you guys are decent-looking guys. You should do what these guys are doing.' We were pressured. We always dressed like we should have onstage but we weren't dressing like some other bands that had came up and sort of kicked everybody's ass when MTV started."
—Dave Meniketti (singer, Y&T)

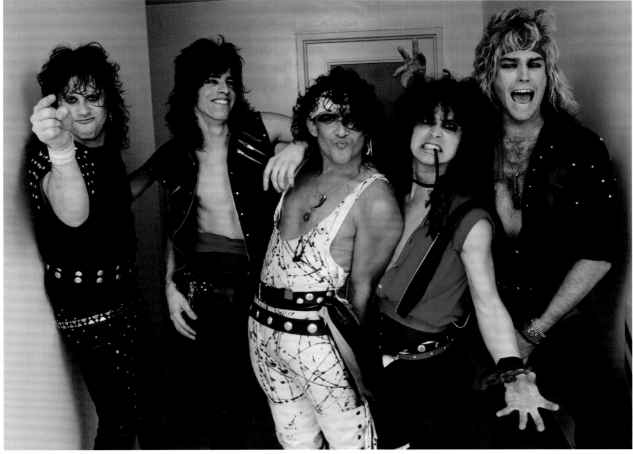

OPPOSITE TOP: Y&T, *In Rock We Trust* tour **OPPOSITE BOTTOM:** Queensrÿche, *The Warning* tour **TOP:** Dokken **BOTTOM:** Ratt, *Out of the Cellar* tour

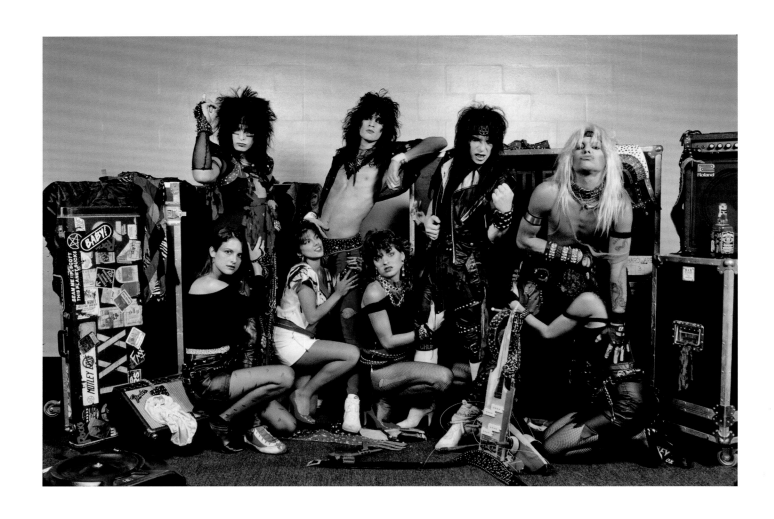

"There was a time before sobriety, before marriage, before family, before things changed, when we were in our innocent, adolescent, decadent bubble. When the only goal for the day was trouble. You go onstage and you destroy, and you come offstage and continue to destroy. Mark had full access to Mötley Crüe during that time." —**Nikki Sixx**

ABOVE: Mötley Crüe, *Shout at the Devil* tour **OPPOSITE:** Dokken, *Tooth and Nail* tour

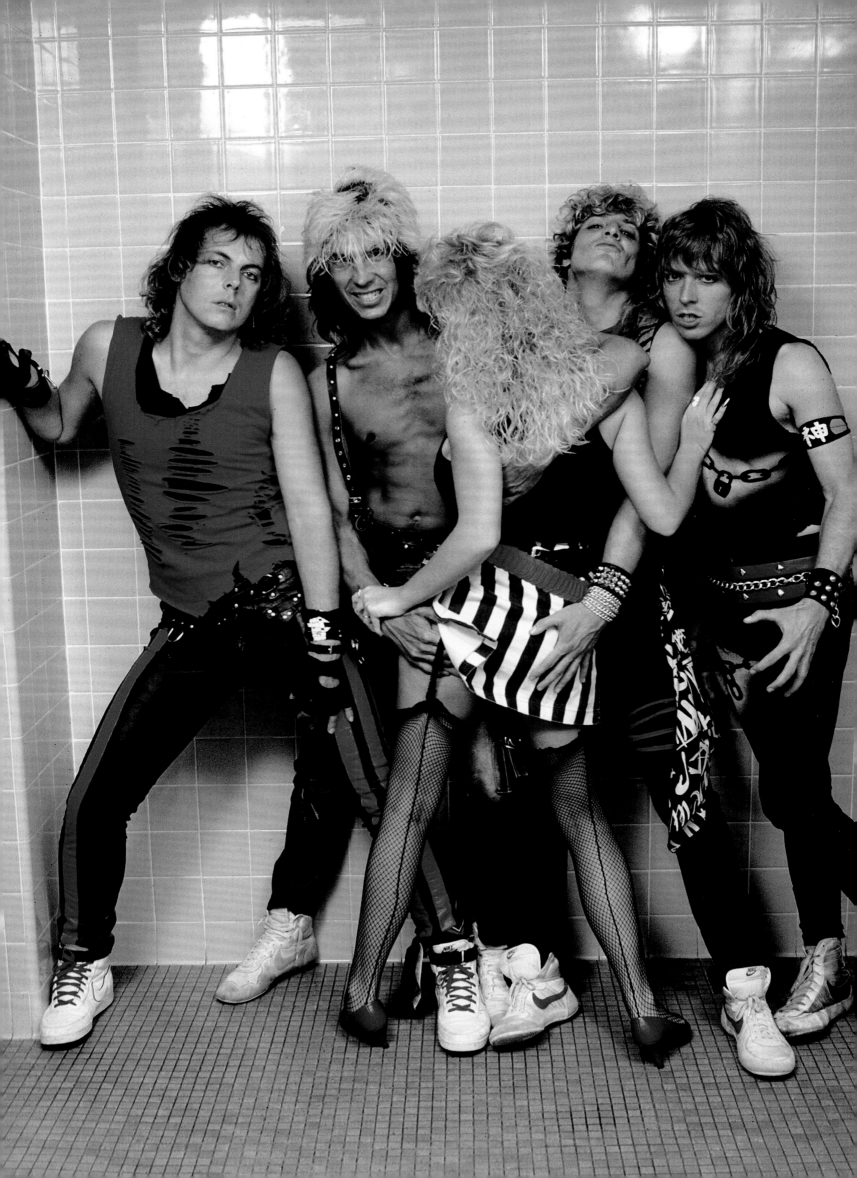

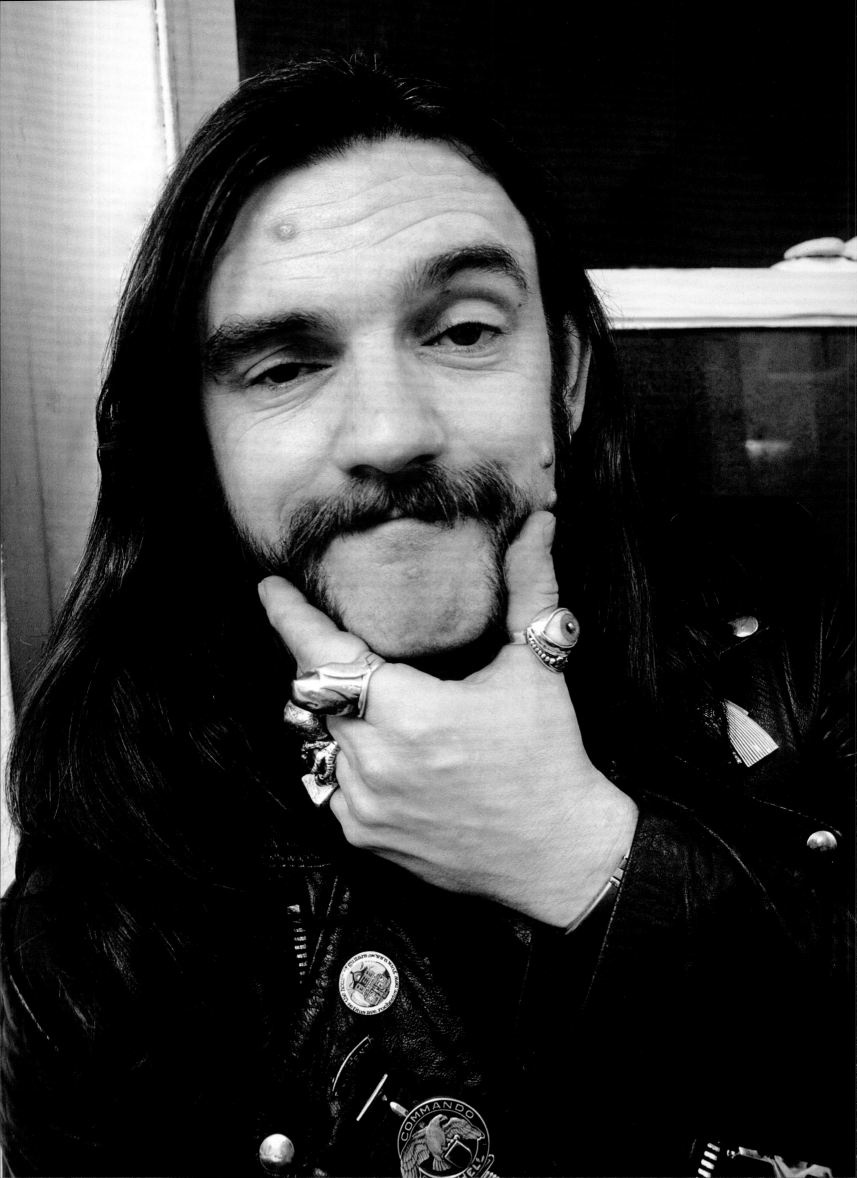

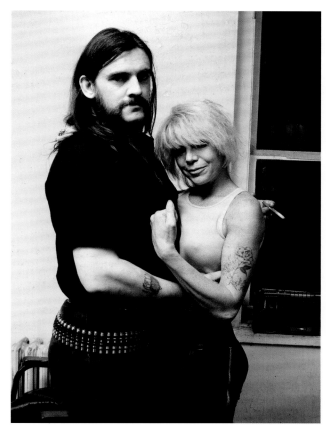

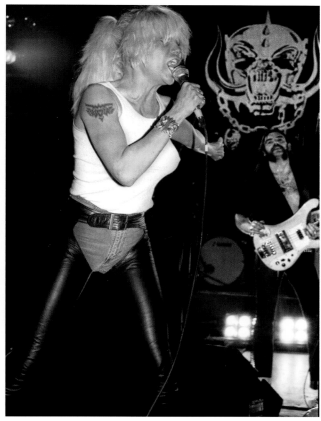

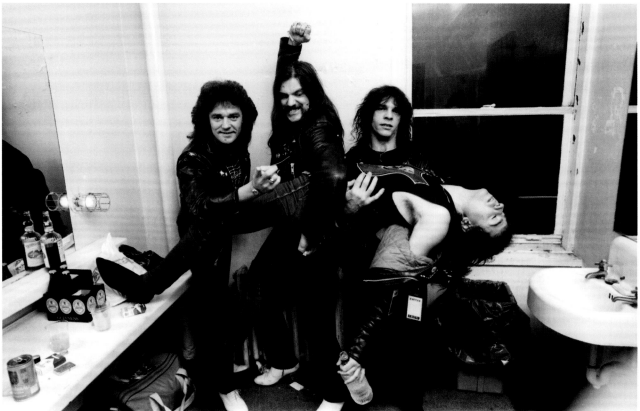

OPPOSITE: Ian "Lemmy" Kilmister of Motörhead, *No Remorse* tour **TOP LEFT:** Motörhead's Kilmister and Wendy O. Williams, backstage at the Beacon Theatre, New York City **TOP RIGHT:** Wendy O. Williams onstage **BOTTOM:** Motörhead **PAGES 152–153:** Mötley Crüe, *Shout at the Devil* tour

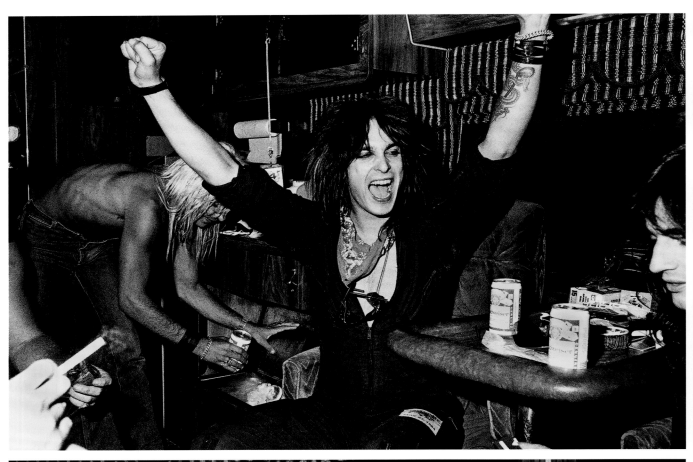

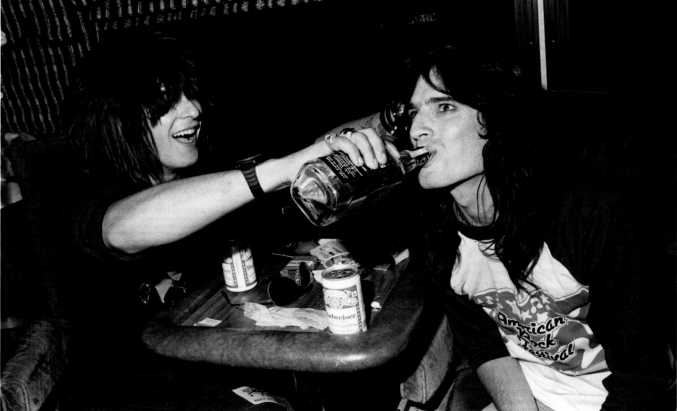

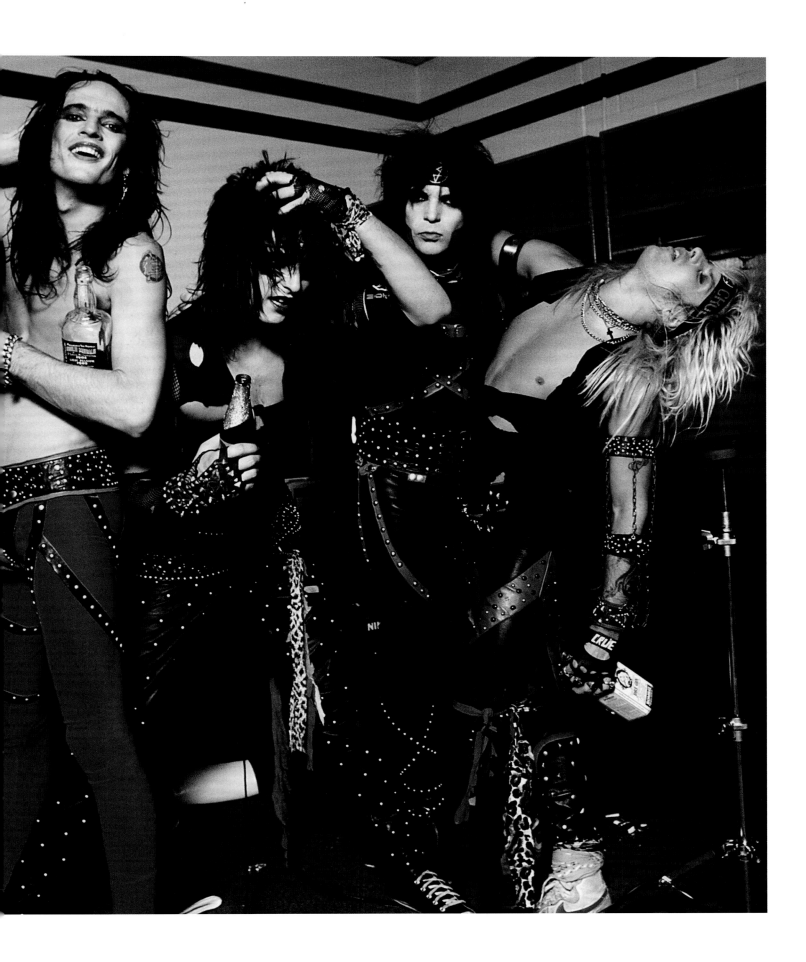

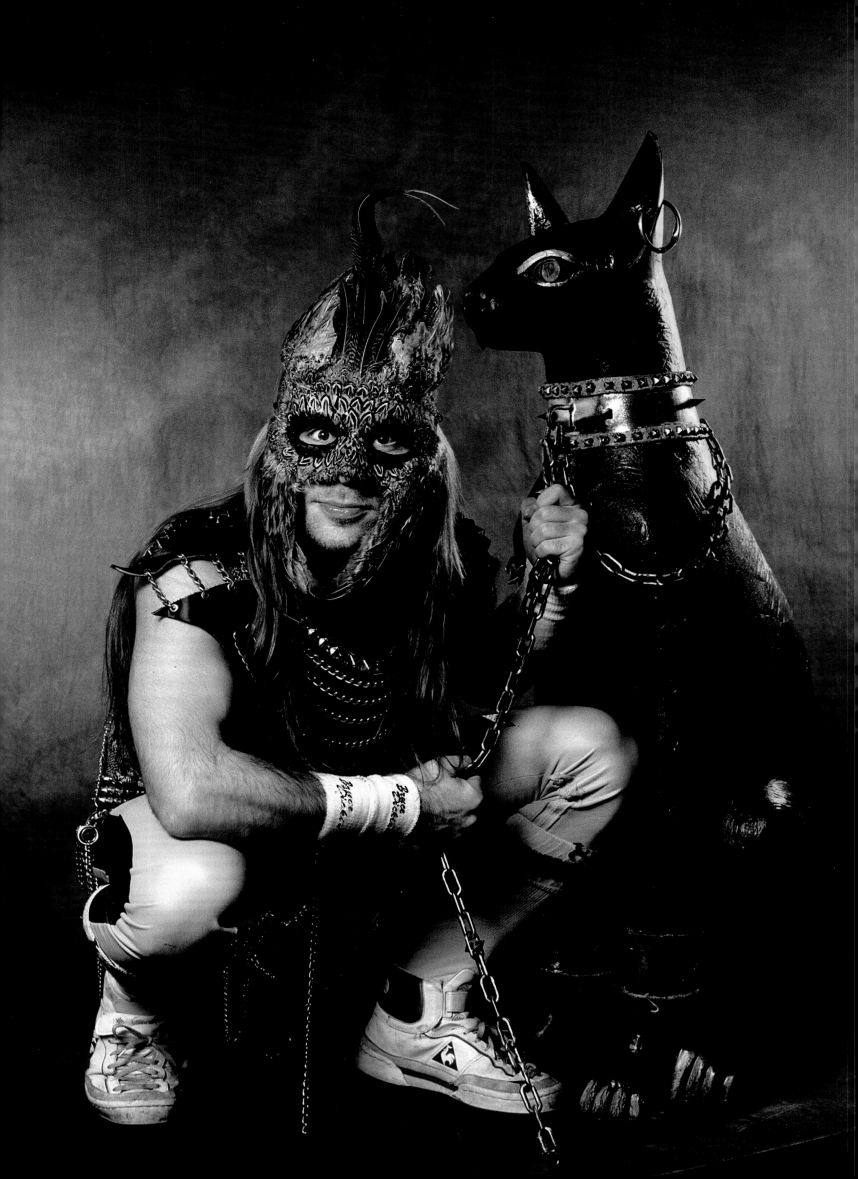

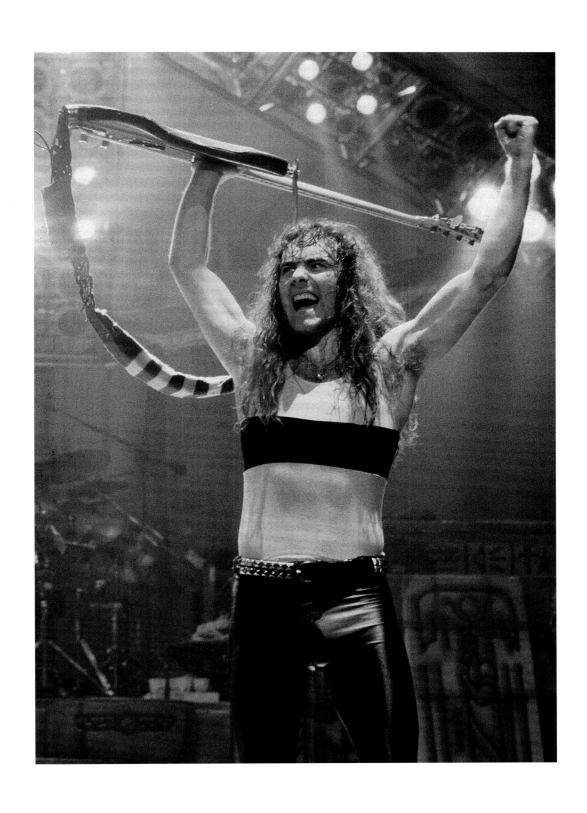

OPPOSITE: Bruce Dickinson of Iron Maiden on their World Slavery tour, Ottawa, Ontario **ABOVE:** Steve Harris of Iron Maiden **PAGES 156–157:** Aerosmith live, Back in the Saddle tour

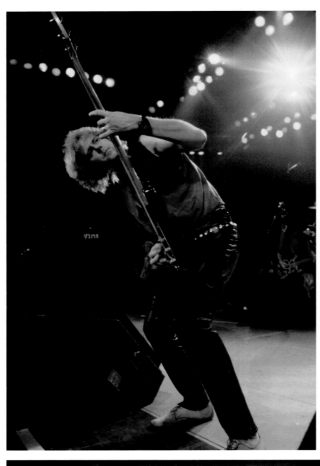

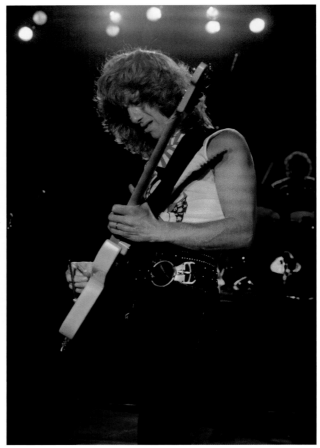

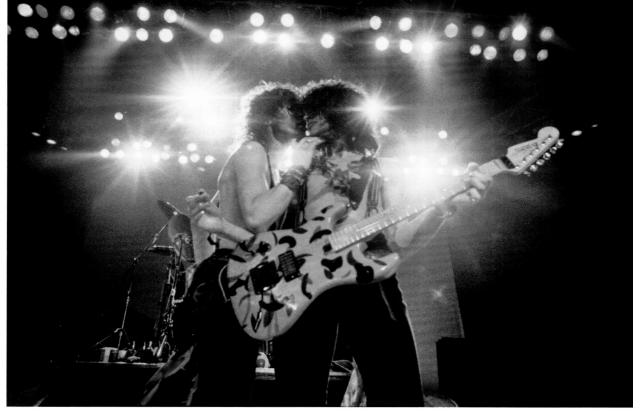

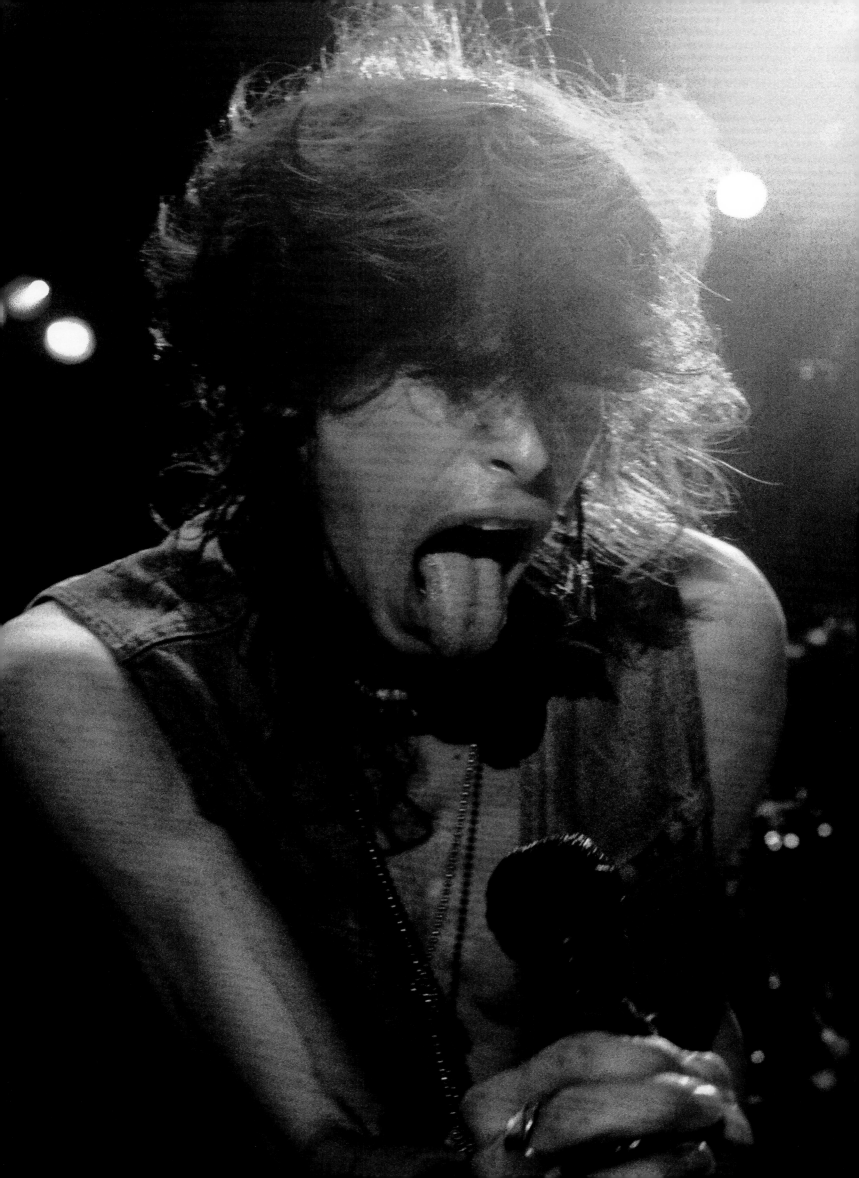

DIARY OF A MAD HOUSEWIFE

I had just moved in with Suzanne on the Upper East Side of New York City. I felt my place was a bit small, so I found a studio share on West 20th Street with a commercial photographer. It was six times the size of my previous one. Ozzy would be my first shoot in my new place. He had just released *Bark at the Moon*, and Sharon wanted me to do a photo session that would get him in the magazines. I approached *Faces*. They were all up for putting Ozzy on the cover, but it had to be different. Mikael and I came up with a spin on Ozzy's last studio album, *Diary of a Madman*. It was the May issue, so we thought, Mother's Day—let's dress Ozzy up like a *mad* housewife.

I explained the idea to Sharon. She laughed and said, "Sure, let's do it." She came with Ozzy and dropped off a bunch of outfits for him to wear. We were going to start the shoot with some cool rock shots of Ozzy in his stage clothes and then take some pics of him in drag for the cover. While I was setting up, Ozzy said to me, "What's that, Mark?" I looked to where he was pointing and saw an Easter bunny outfit and white flowered trestle. I realized it had been left over from a shoot the photographer I shared the studio with had been doing. I gave Sharon a quick smirk and then proceeded to tell Ozzy, "What do you mean, 'What's that?' It's your costume—we're doing an Easter theme for the cover of the magazine. Let's hop to it and get started!" Sharon laughed and said, "Have fun, boys! I'm going shopping." That's when I first heard Ozzy scream, "*Sharrrrron!*" She came back a few hours

later with baby Aimee and a dress for Ozzy to wear for the shoot.

I showed the May cover to Ozzy, and he laughed. He loved it. This was during the second leg of the *Bark at the Moon* tour with Mötley Crüe. I think we were somewhere in the southern United States. It's a bit of blur, honestly—though I remember the shoot! Mikael Kirke and I went to say hi to the Crüe over by their bus. While we were there, Tommy Lee threw something into the trunk where they kept their "trophies" from the night before. A light bulb went off in my head. Mikael and I looked at each other and then grabbed some lingerie from the trophy trunk, and another classic Ozzy photo shoot was born. As we were shooting, Tommy and lead singer Vince Neil came in to see what we had done with their collection. They joined in on the fun. Ozzy then went onstage and ripped off his clothes and wig.

The next visitor to my new studio was none other than David Lee Roth. Van Halen had released their *1984* album, and David's publicist called and asked if I was available to do a shoot with him. Things were looking very good. I had Diamond Dave asking me to do a shoot in my studio in New York City. Not long after, I flew to Detroit to shoot the band with the winners of MTV's "Lost Weekend with Van Halen" contest. While all the craziness was going on around us, I ducked backstage to take some photos of Eddie and caught an affectionate moment between him and his wife, Valerie Bertinelli.

THESE PAGES AND GATEFOLD: Ozzy Osbourne, photo shoot for *Faces* magazine

"Mark always kept a very low profile. He was very out of the way, if you like—very quiet. He wasn't a pushy guy at all. That's what was very nice about him. He would turn up and do his thing and go. He's fantastic, he's always been a good friend and he always comes up with brilliant stuff. May he be there forever."
—**TONY IOMMI** (guitarist, Black Sabbath)

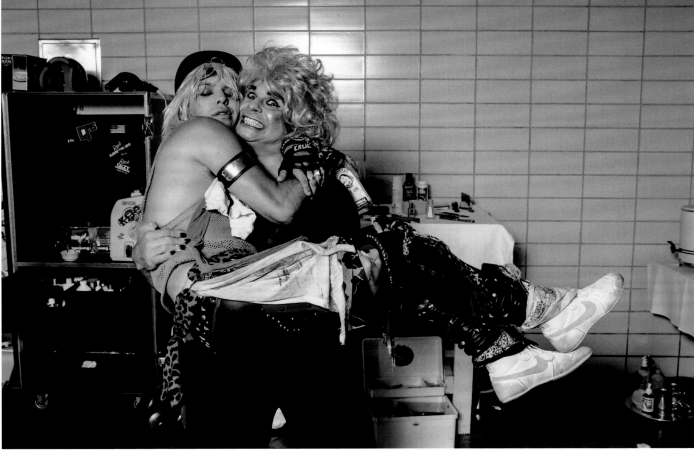

OPPPOSITE: Ozzy Osbourne TOP: Ozzy Osbourne and drummer Tommy Aldridge, *Bark at the Moon* tour BOTTOM: Ozzy Osbourne and Mötley Crüe's Vince Neil PAGES 166–167: David Lee Roth, photographed at Mark's studio, New York City

"Mark always used to bring along this, like, kid's dress-up bag. You never knew what he'd have in it. He was a young kid who loved music and loved what he did, and he was so enthusiastic. Ozzy would go along with it because he was a fun guy. Even though it was a complete contradiction to his persona."
—**Sharon Osbourne (manager and wife of Ozzy Osbourne)**

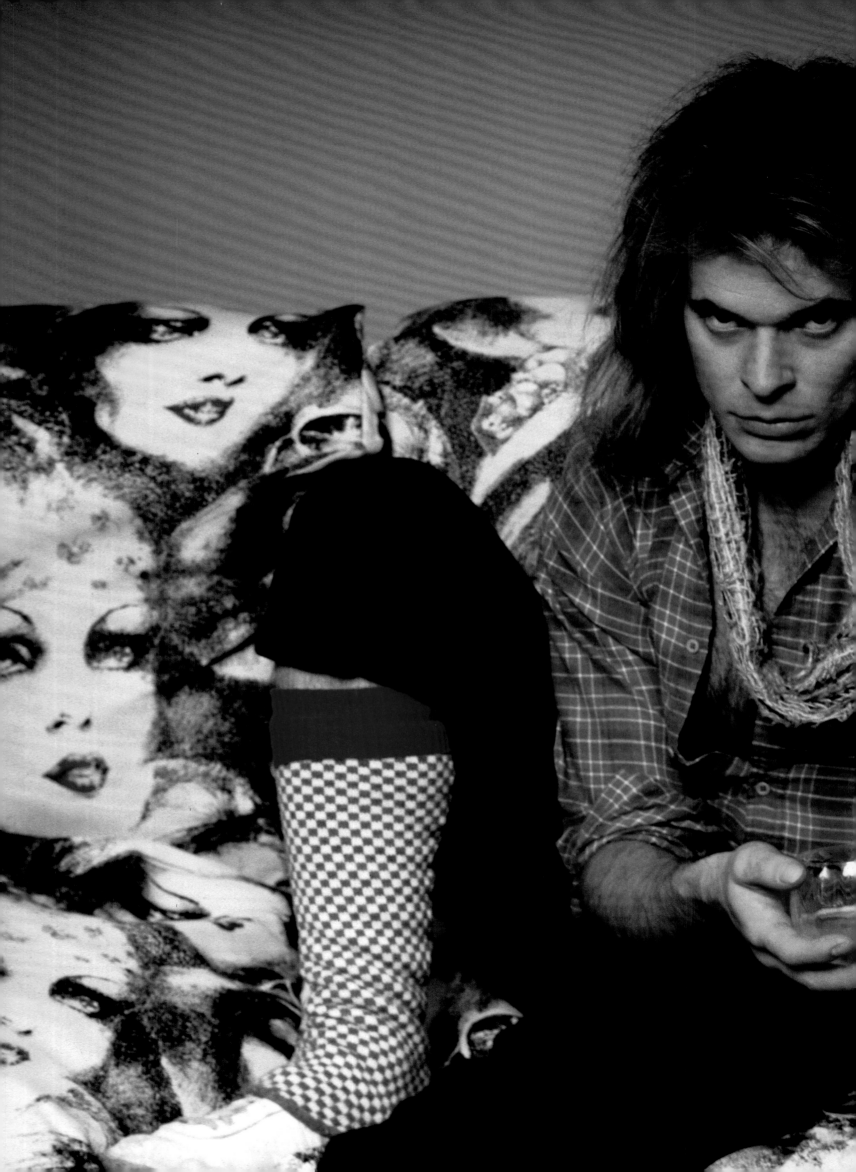

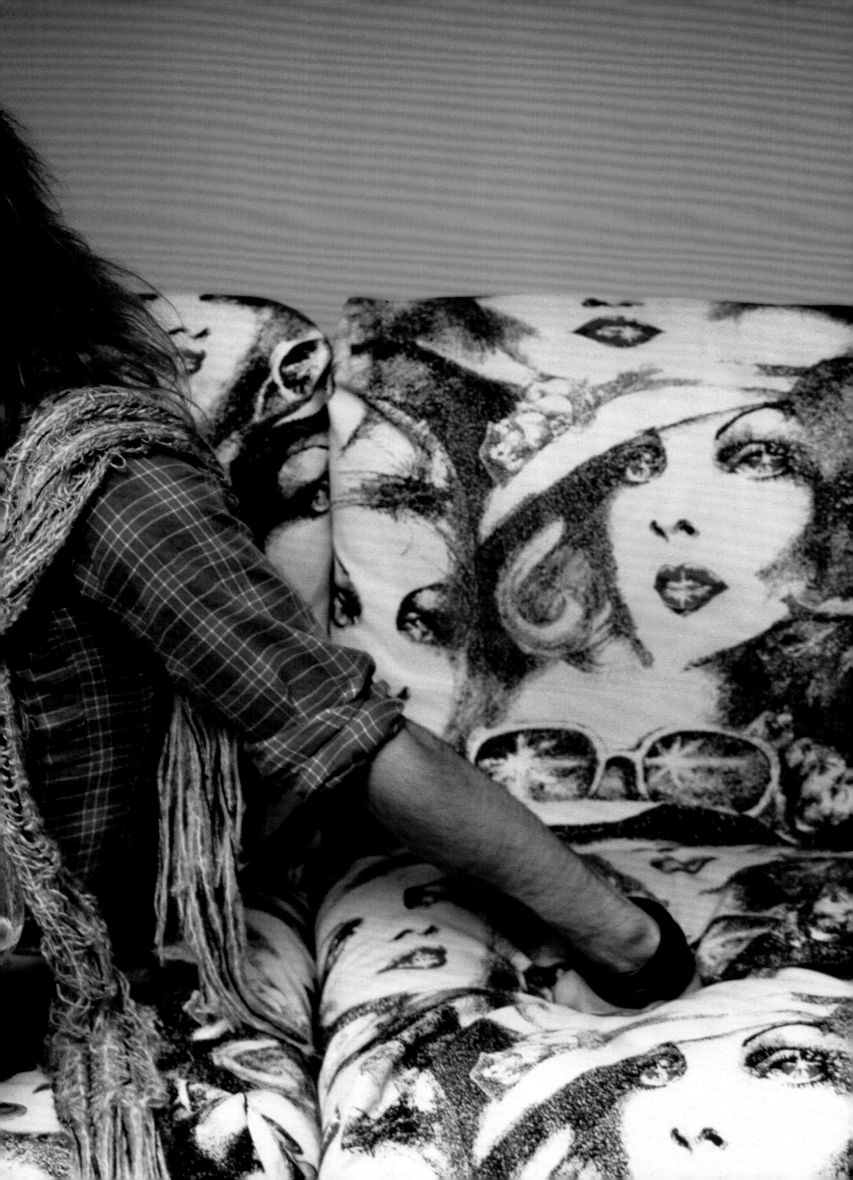

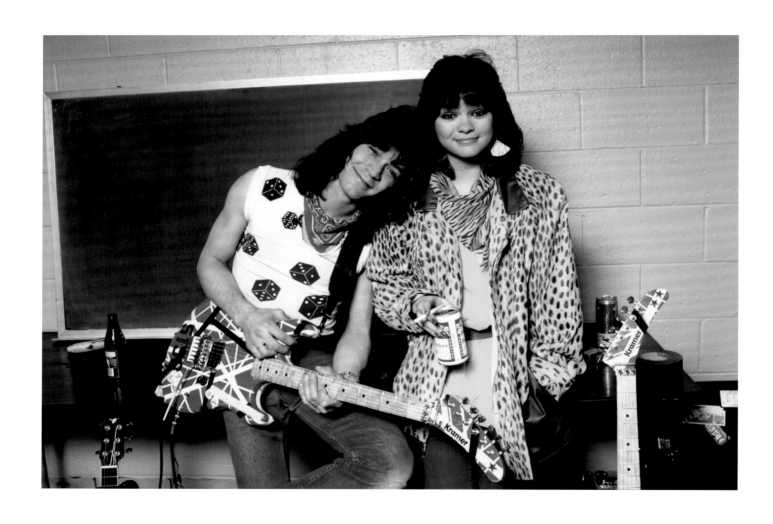

ABOVE AND OPPOSITE: Eddie Van Halen and Valerie Bertinelli (*above*),
MTV's "Lost Weekend," backstage on the *1984* tour at Cobo Hall, Detroit

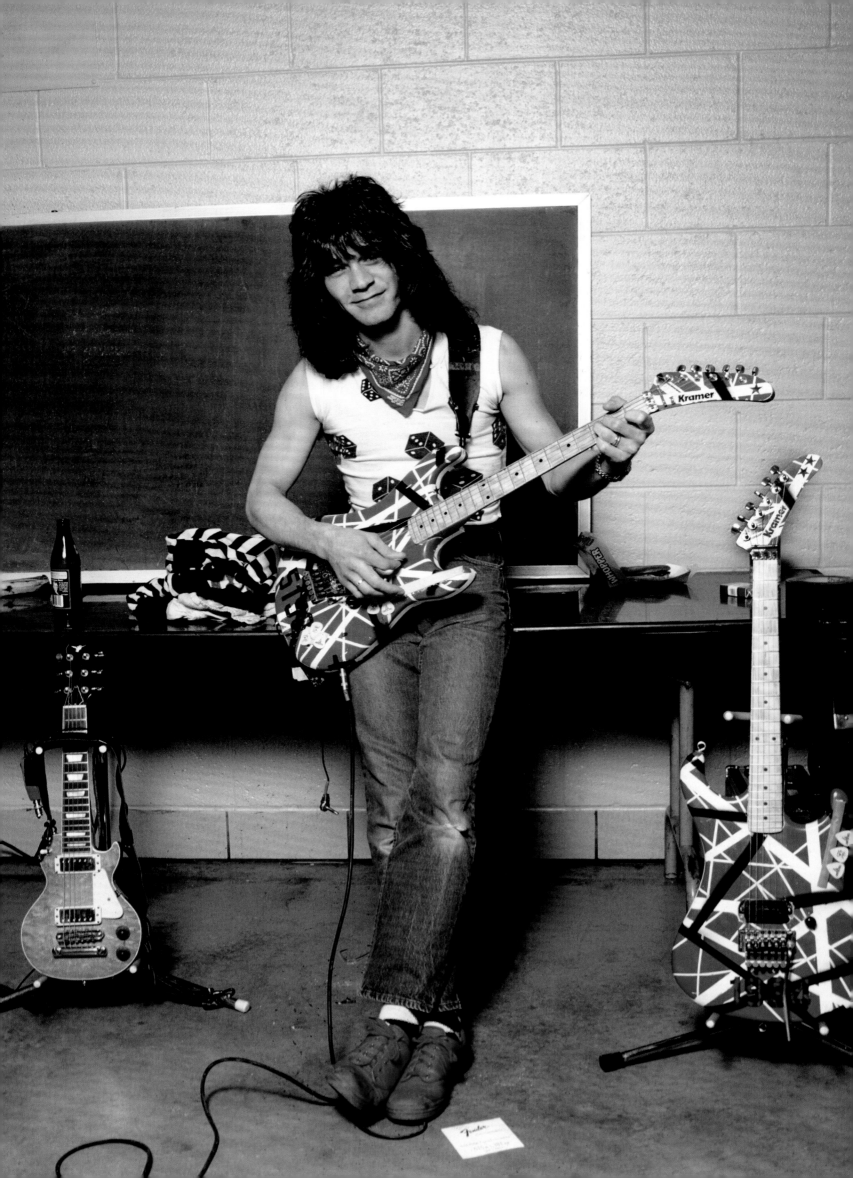

GETTING TWISTED

By 1984, I had made a name for myself in the publishing world. The infamous *Oui* shoots gave me some notoriety—I was the guy who shot half-naked girls with rock bands. Plus, I was being published in almost every issue of *Circus*, *Hit Parader*, and now *Faces*.

I started thinking about what it would be like to have a photograph of mine on an album cover. I loved seeing my pictures in magazines, but after a month, the issue was off the stands. I treasured my albums from the '70s and always visualized having one of my photos on a cover.

In February, I got a call that would be a game changer for me. It came from tour promoter Mark Puma, who was now managing Twisted Sister. He asked if I was available to talk to one of the guys in the band about a concept they had for a shoot. "They've been seeing your photos in magazines," Puma explained, "and they want to use you to shoot the photos for their new album, *Stay Hungry*." The record company wanted the band to go with one of their guys, but the band insisted on having a seasoned rock photographer do the cover. I passed the audition and began talking to Mark Mendoza, Twisted's bassist, about a concept he had in mind.

On the day of the shoot, I had everything set and ready to go. But after a twenty-two-hour session, I still didn't feel that we had "the shot." A couple of the guys in the band hadn't been taking it seriously.

I didn't think we had gotten the magic image, so as everyone was packing up to leave, I asked Dee to stick around for one more roll of film. I really wanted Dee to be more animated—I felt he was frustrated during the shoot and didn't give me what he wanted to give me with the other guys around. I didn't think he wanted to upstage them. As soon as everyone left, I told him to think of himself as a caged animal hungrily devouring the bone I had brought to the set.

Dee was looking at this bone on the table that nobody wanted to touch because it was so disgusting. And he said, "Oh, fuck it, I'll just burn the glove." He grabbed the slimy, rotting piece of flesh and started posing with it. We did thirty-six photos and then Dee took off his outfit and left.

In the end, we got the shot. I found out years later that the single image of Dee on the cover was almost the demise of the band. It was the beginning of Dee being the face of metal and of Twisted Sister. The band started feeling like they were in Dee's shadows.

"We were going through the pictures, and that picture came up—the last shot that we took of me crouched in the corner, trapped like an animal. That's what was in my mind: I was this trapped rat, cornered, ready to fight for whatever is left on this piece of bone. That says *Stay Hungry*. That represents Twisted Sister. That's the image. And, bam! That became the cover, and that just put the icing on the cake of making the band more anonymous than ever and me becoming the focal point, the front man, the face, the image, and everything else." —**Dee Snider (singer, Twisted Sister)**

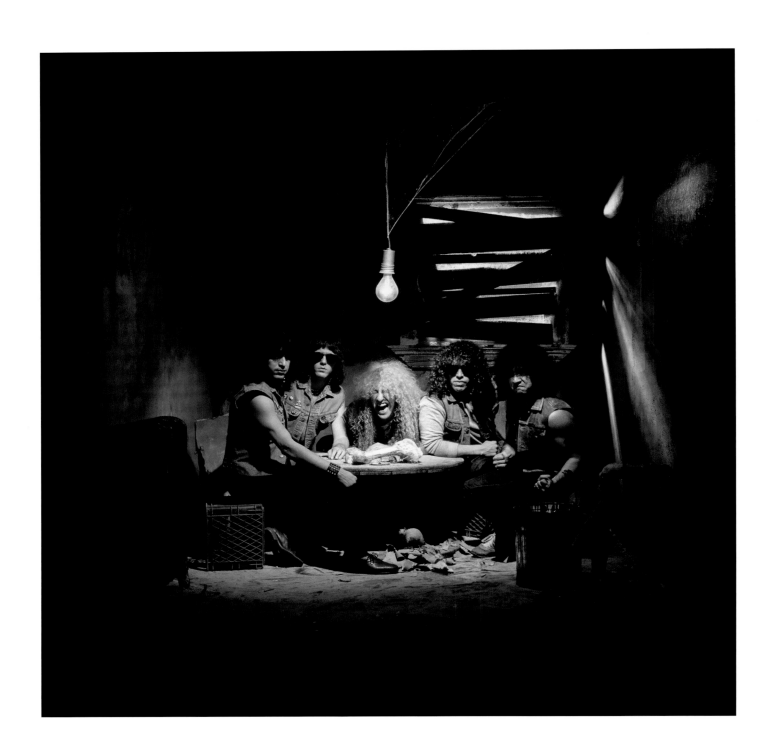

"We never had a discussion about it being the cover. And by not having a discussion, there was an awful lot of resentment. It caused big problems in the band. But Mark took one of the most iconic photos in the history of '80s rock. It was seared into the brains of every kid who grew up in the decade."
—Jay Jay French (guitarist, Twisted Sister)

PAGES 170–171, ABOVE, AND OPPOSITE: Twisted Sister, *Stay Hungry* album cover shoot, Mark's studio, New York City **PAGES 174–175:** Dee Snider, *Stay Hungry* album cover shoot, Mark's studio, New York City

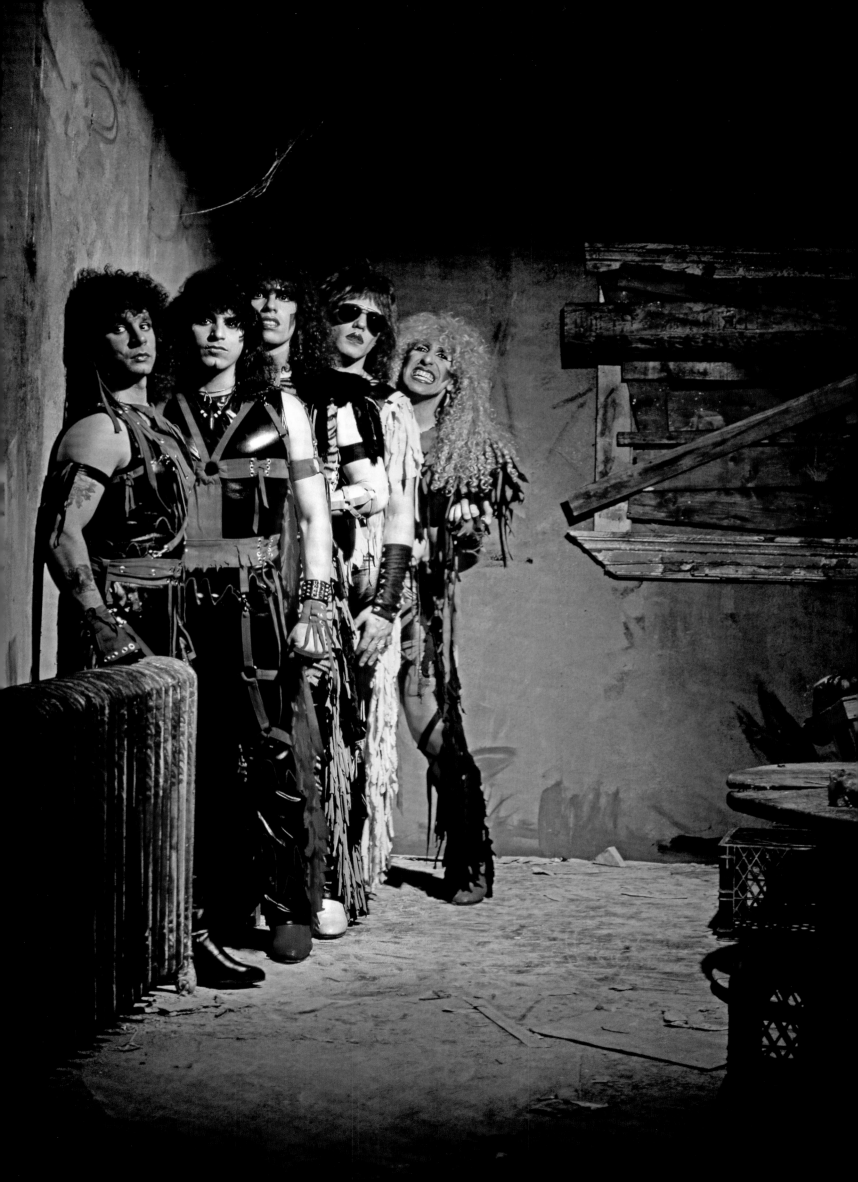

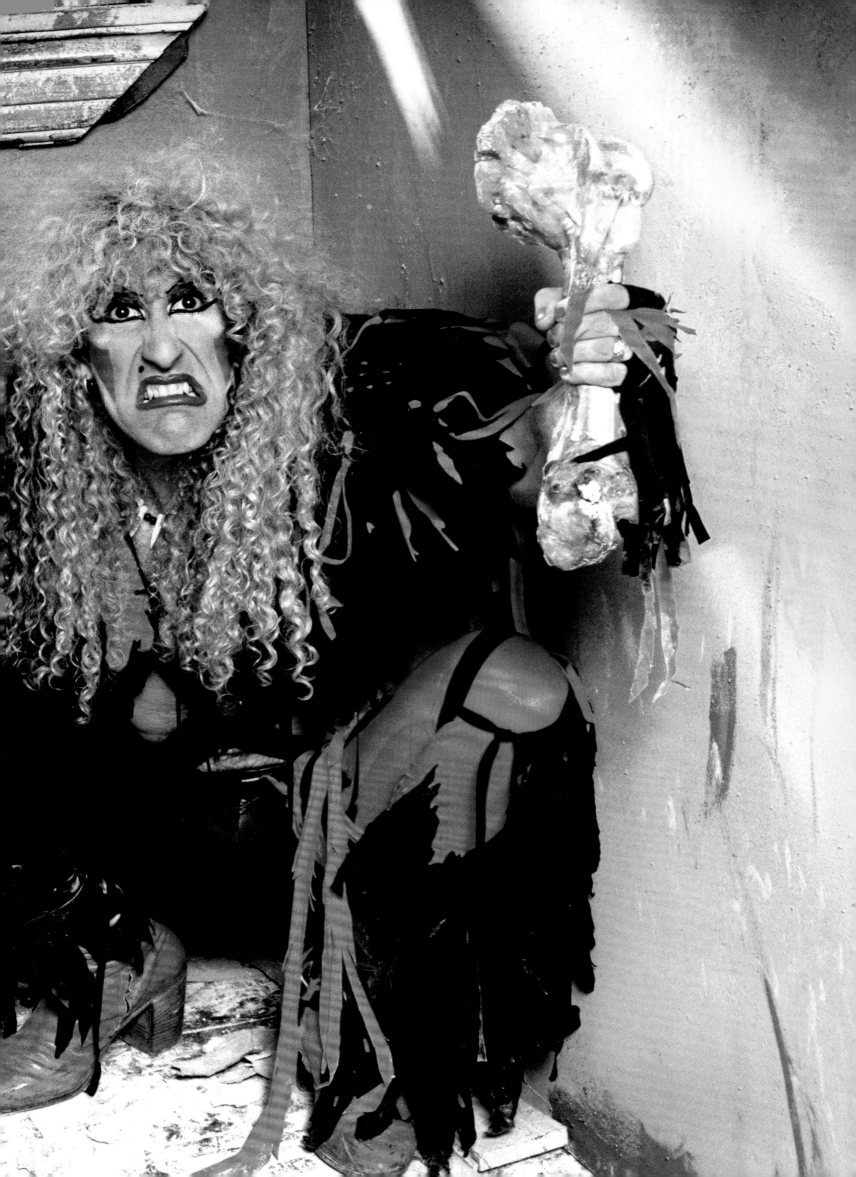

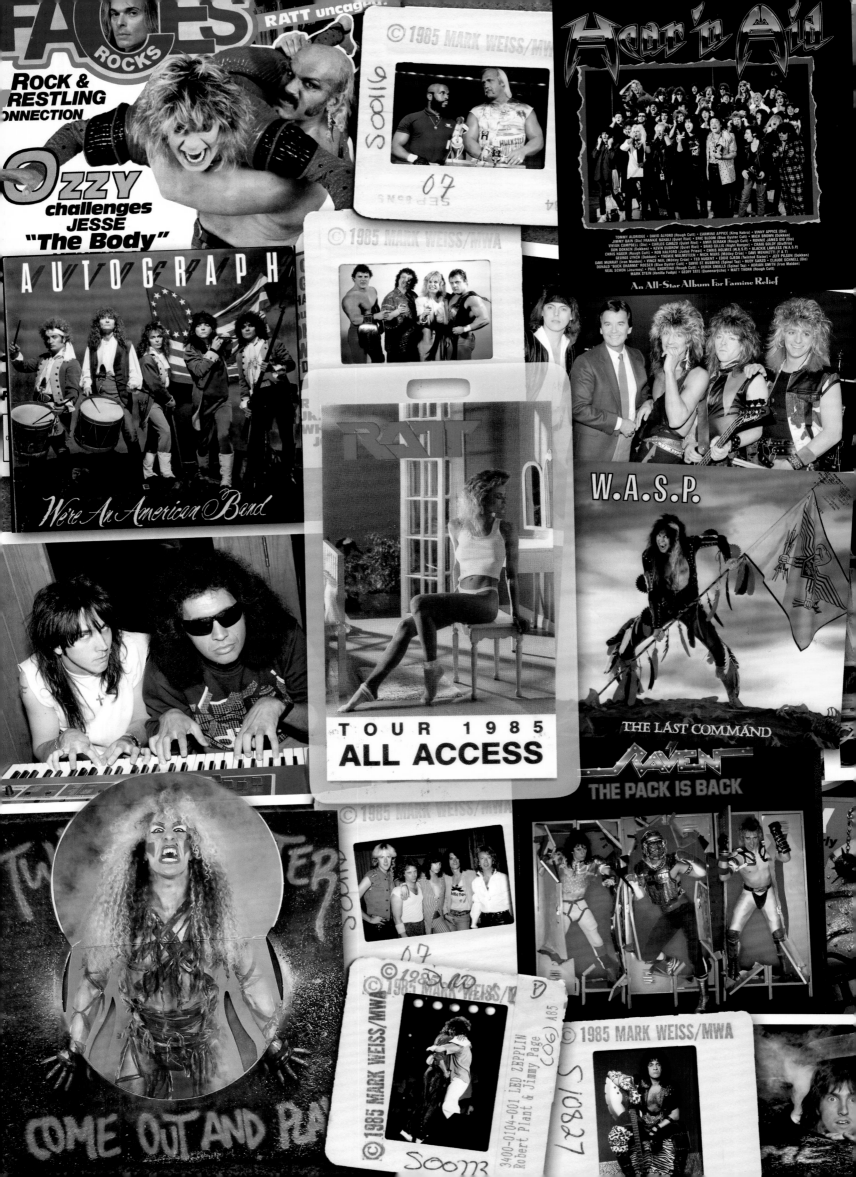

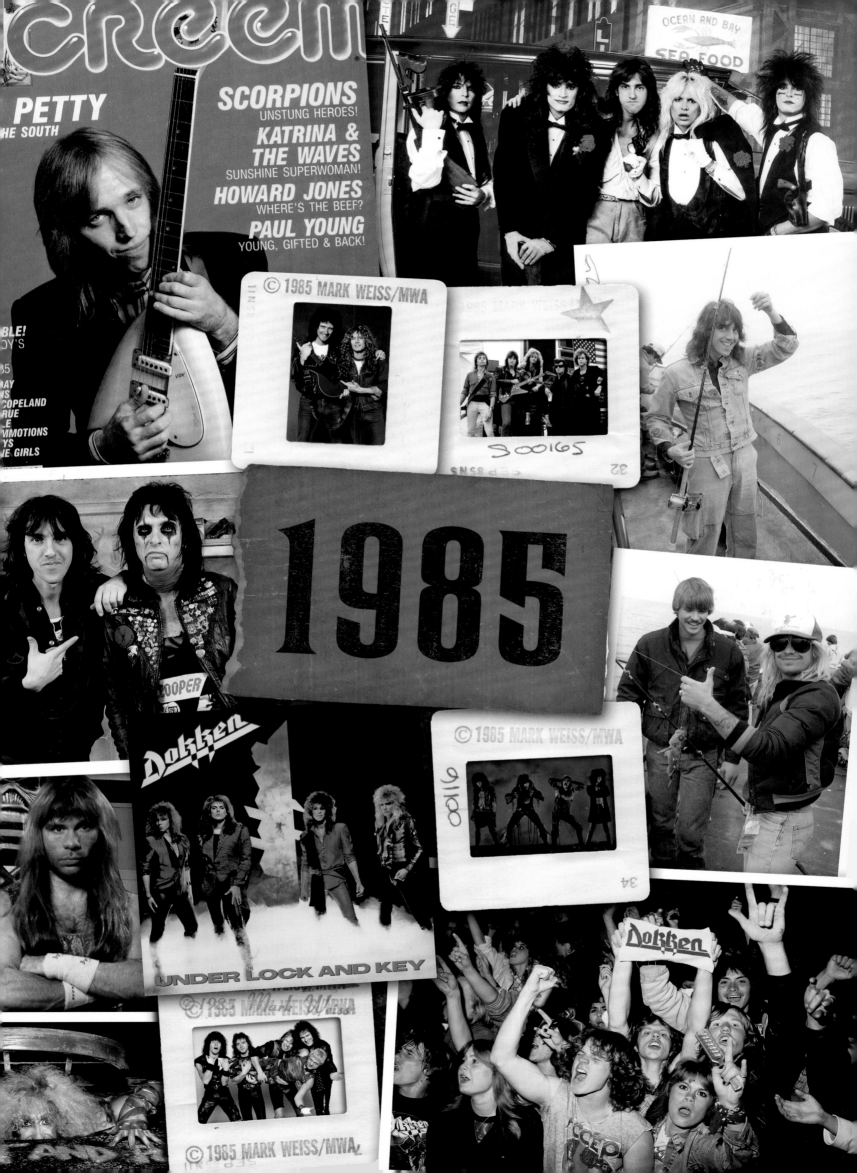

CREEM

PETTY
THE SOUTH

SCORPIONS
UNSTUNG HEROES!

KATRINA &
THE WAVES
SUNSHINE SUPERWOMAN!

HOWARD JONES
WHERE'S THE BEEF?

PAUL YOUNG
YOUNG, GIFTED & BACK!

OCEAN AND BAY
SEA FOOD

1985

COOPER

Dokken

UNDER LOCK AND KEY

Dokken

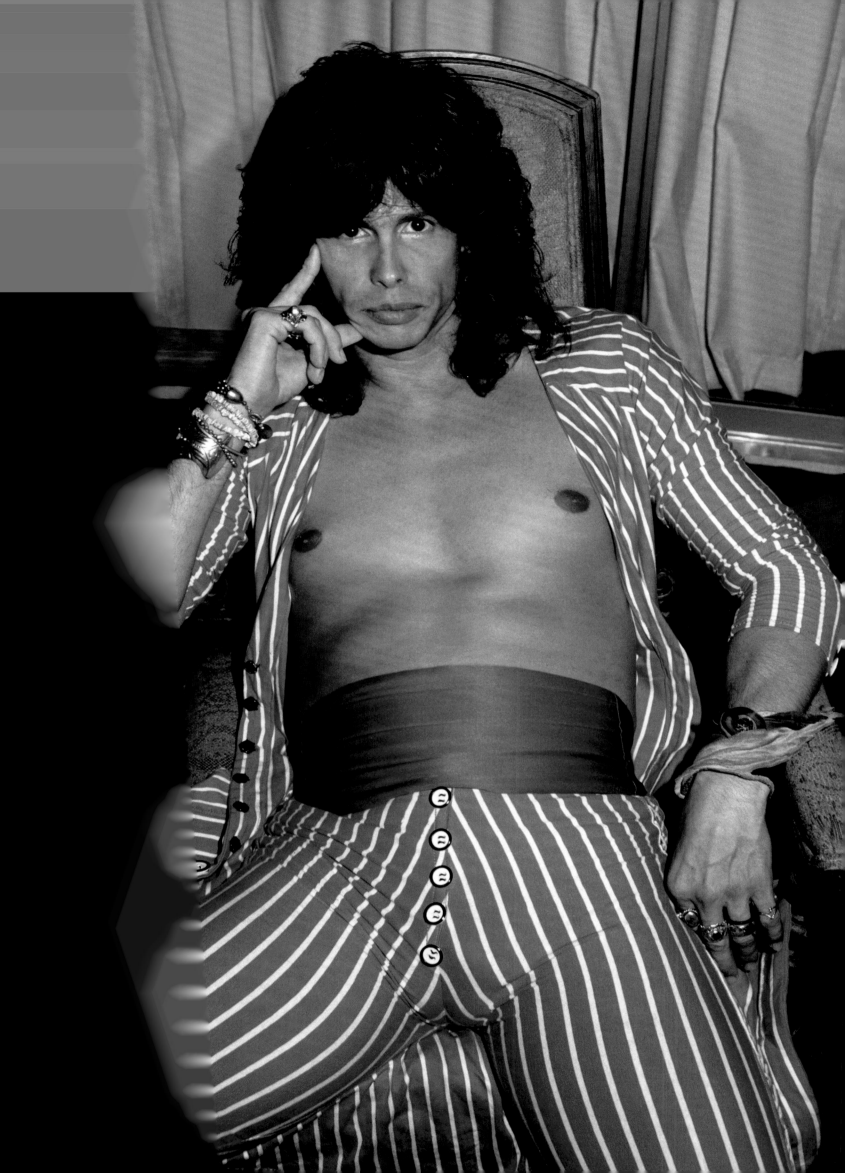

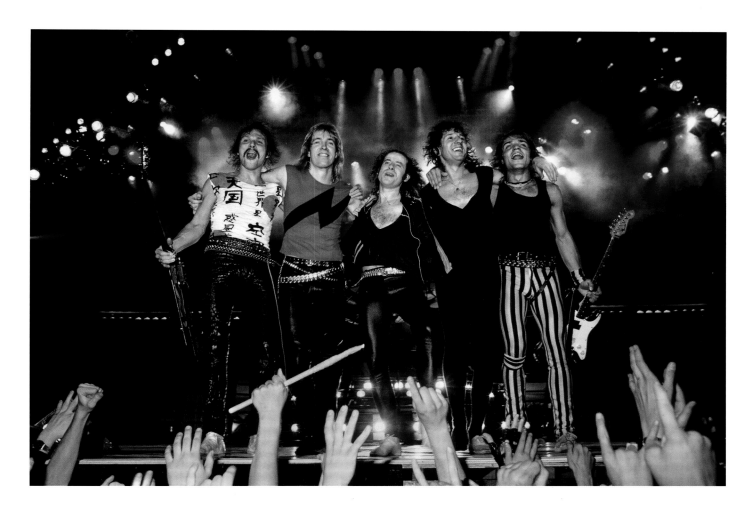

DRAW THE LINE

I was excited that Aerosmith were making a comeback. When Joe Perry and Brad Whitford rejoined the band in the summer of '84 for the Back in the Saddle tour, I tried to set up shoots, but the best I got was a pass to take photos for a few songs during the show, with no backstage access. Tim Collins was now managing the band; I had met him at the *Oui* shoot in 1982 when he had been managing the Joe Perry Project. But now he wasn't being responsive to my requests. He was trying to get them all clean, and I found out later that his main goal was to get rid of all the people who had been in their lives back in the drug days. Now it was a year later and they were no longer a headliner. Aerosmith was on tour opening up for the Scorpions. In September, they had a show in Arizona, and the Scorpions hired me to shoot it.

I figured it was a perfect opportunity to talk to Steven and find out why I was being shut out. I went over to Tim at soundcheck and asked if I could shoot Aerosmith's show as well as some backstage photos of the band. He told me he would have to think about it. Minutes before the show, I had no response from him.

He seemed to be avoiding me. I saw Steven backstage and gave him a hug. He asked me where I'd been for the last couple of years. I was about to tell him, and then Tim walked in. I asked him in front of Steven if it was okay to shoot the show. He said sure. I asked him if I could get a pass. He told me he didn't have any but not to worry about it. I insisted, and then Steven just took his laminate and put it around my neck. Tim did not seem pleased by this. I was starting to figure out that Tim had been the roadblock to my access the previous year.

Steven called in the other guys for some quick shots. It would be my last photo shoot with Aerosmith for more than a decade. After shooting the first few songs of the show, I was pulled out by a security guard. I was enraged. I confronted Tim, who told me I shouldn't have asked to shoot the show in front of Steven and that it would be the last time I would shoot the band. He told me I was in "memory lane." I was banned from the Aerosmith camp until Tim was fired in 1996.

OPPOSITE: Steven Tyler, *Done with Mirrors* tour at Compton Terrace, Chandler, Arizona **ABOVE:** Scorpions, *Love at First Sting* tour, 1984
PAGES 180–181: Steven Tyler

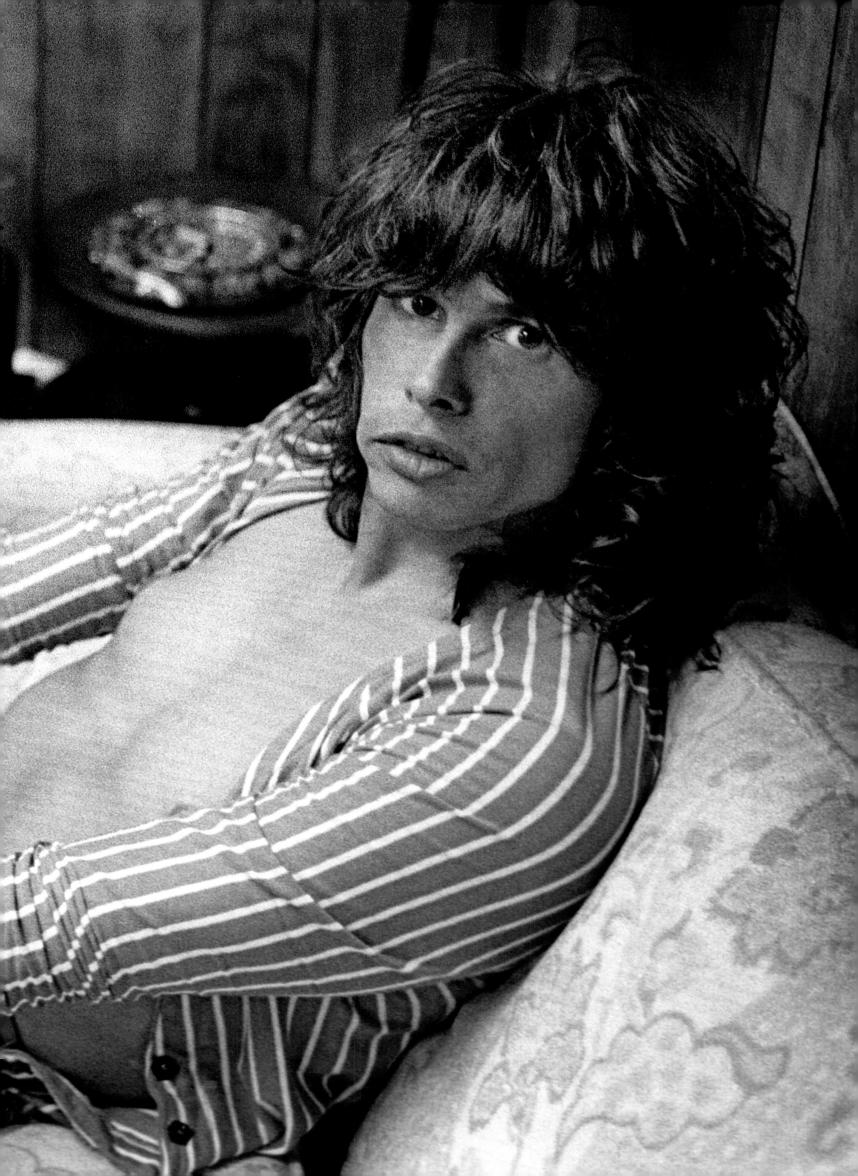

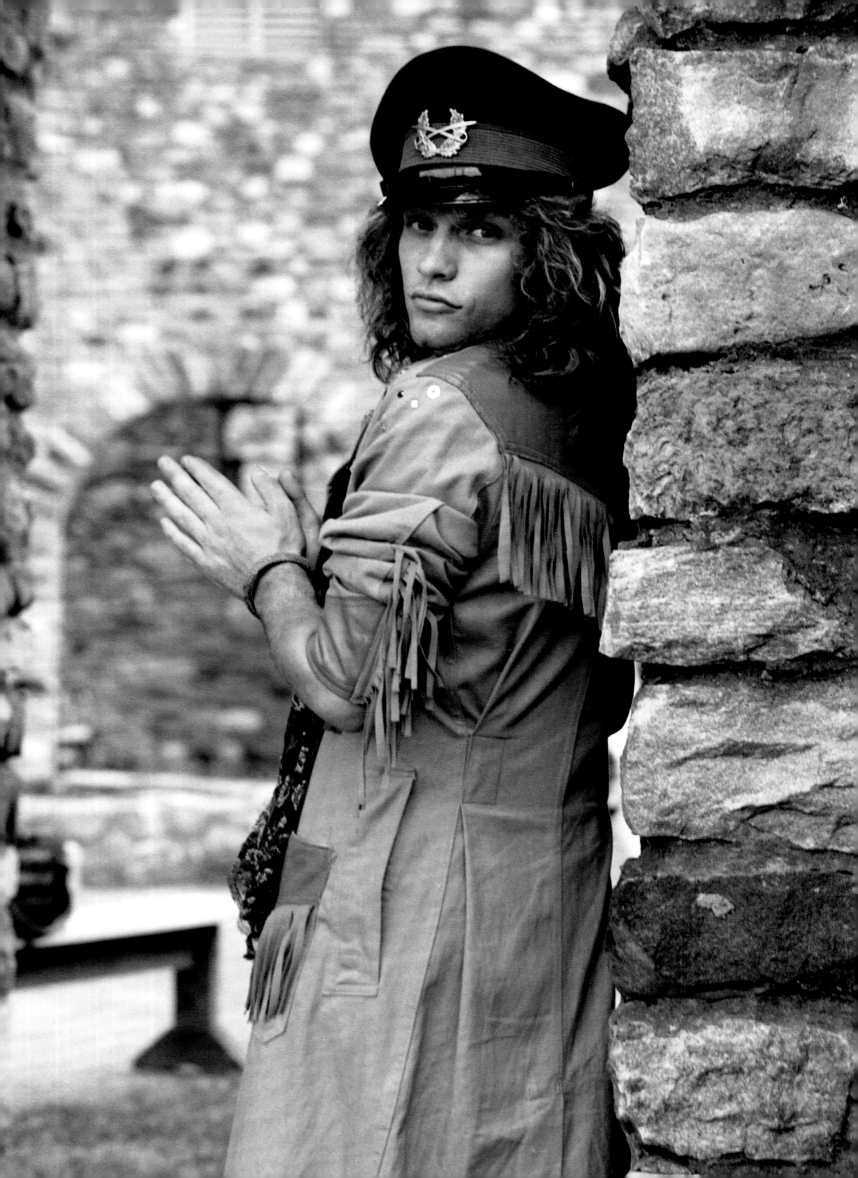

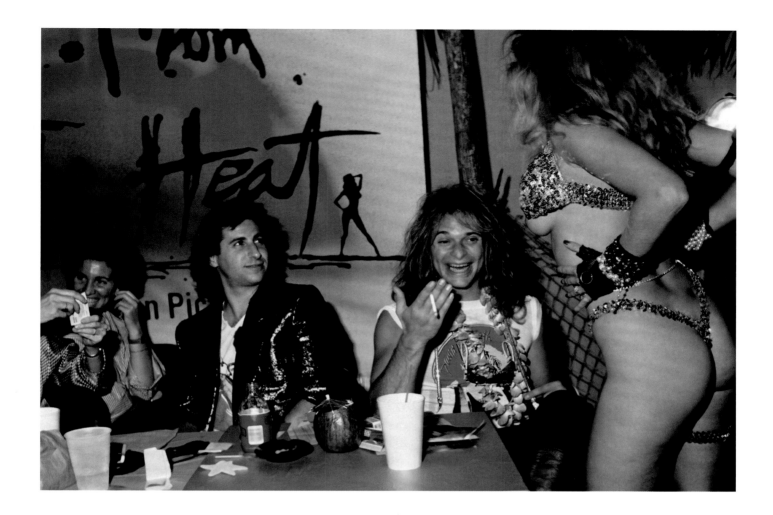

CALIFORNIA DREAMING

David Lee Roth released his first solo record, *Crazy from the Heat*, and in classic Dave style he went on the hunt for pretty girls to star in the videos. He held an open casting call at the Palace in Hollywood, and women were lined up all the way down North Vine Street.

I went on the road with Cinderella when they were opening for David Lee Roth. I was shooting the band but I also made arrangements to take photos of David. He was glad to see me and told me to talk to Eddie, his security guy, and come backstage after the show to the band party. Eddie gave me passes to hand out to girls in the audience. He wrote my initials on each one and told me if one of the girls ended up with Dave, I would get a little something from Dave. I didn't have to go far to find hot women—they always managed to get up to the front row, right by the photo pit. Dave would point to a girl from the stage while I was shooting and gesture to me to give her a pass.

Two months later, *International Musician and Recording World* magazine sent me to Tom Petty's house in the Valley to shoot him at his home studio. They wanted photos of Tom with his guitars and by his recording board. I set up a background and lights in his garage for the cover shot, but then I realized that the photo shop where I rented the equipment had left out the umbrellas, which I needed to reflect the light. I saw drumheads in the corner of the studio. I told Tom my predicament and asked if I could borrow one to diffuse the light. He was more than happy to oblige. *Creem* ended up using one of the photos for the cover of its October 1985 issue.

After the Tom Petty shoot, I decided to head out to the Rainbow. I bumped into Stephen Pearcy and Tawny Kitaen, the model on the cover of Ratt's *Out of the Cellar* album. Vince Neil was there as well. The last time I had seen him, he was serving time for a DUI that had resulted in the death of his good friend Razzle, from Hanoi Rocks. I had gone to visit him while he was incarcerated, and he told me then that he wanted to take me fishing when he got out.

OPPOSITE: Jon Bon Jovi, *7800° Fahrenheit* tour **ABOVE:** David Lee Roth, video auditions at the Palace, Los Angeles **PAGES 184–185:** Ratt's Warren DeMartini, Bobby Blotzer, and Stephen Pearcy, *Invasion of Your Privacy* tour

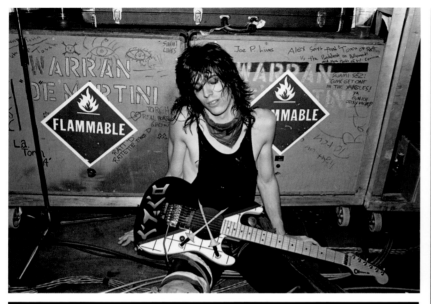

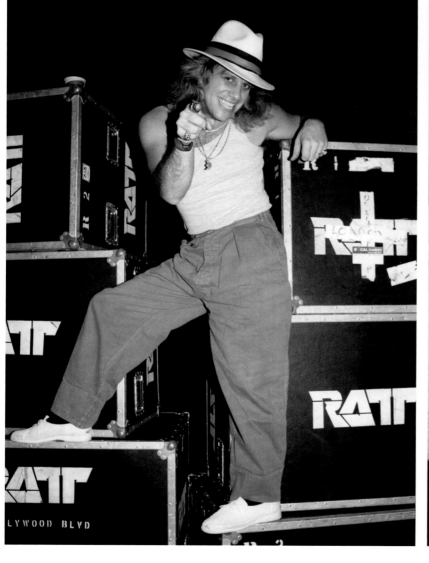

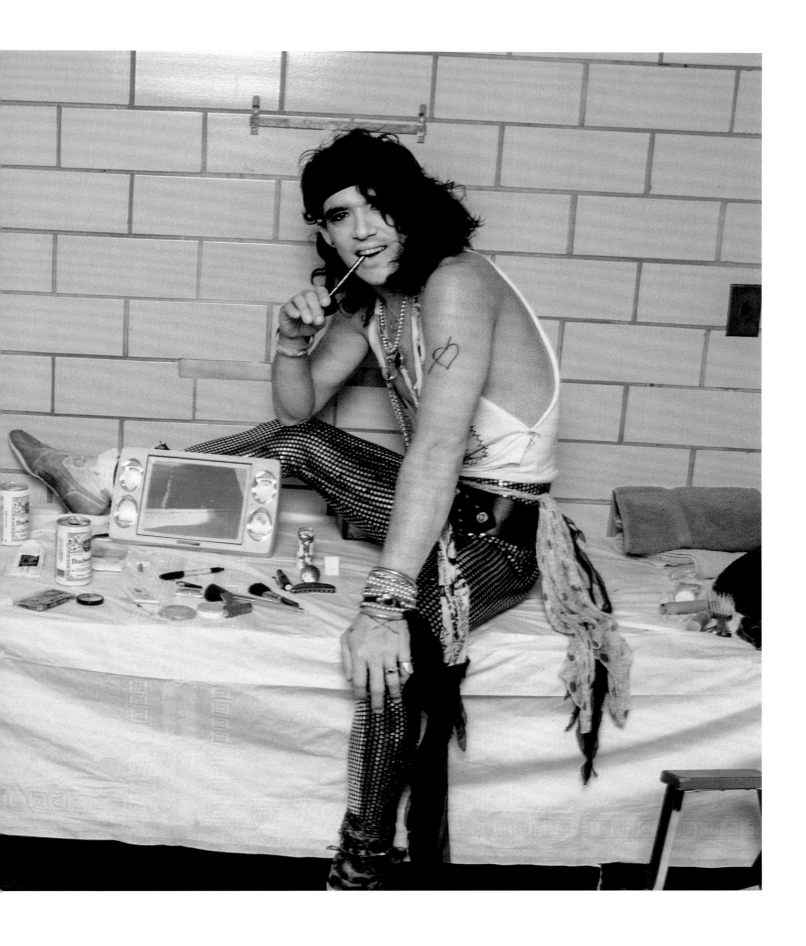

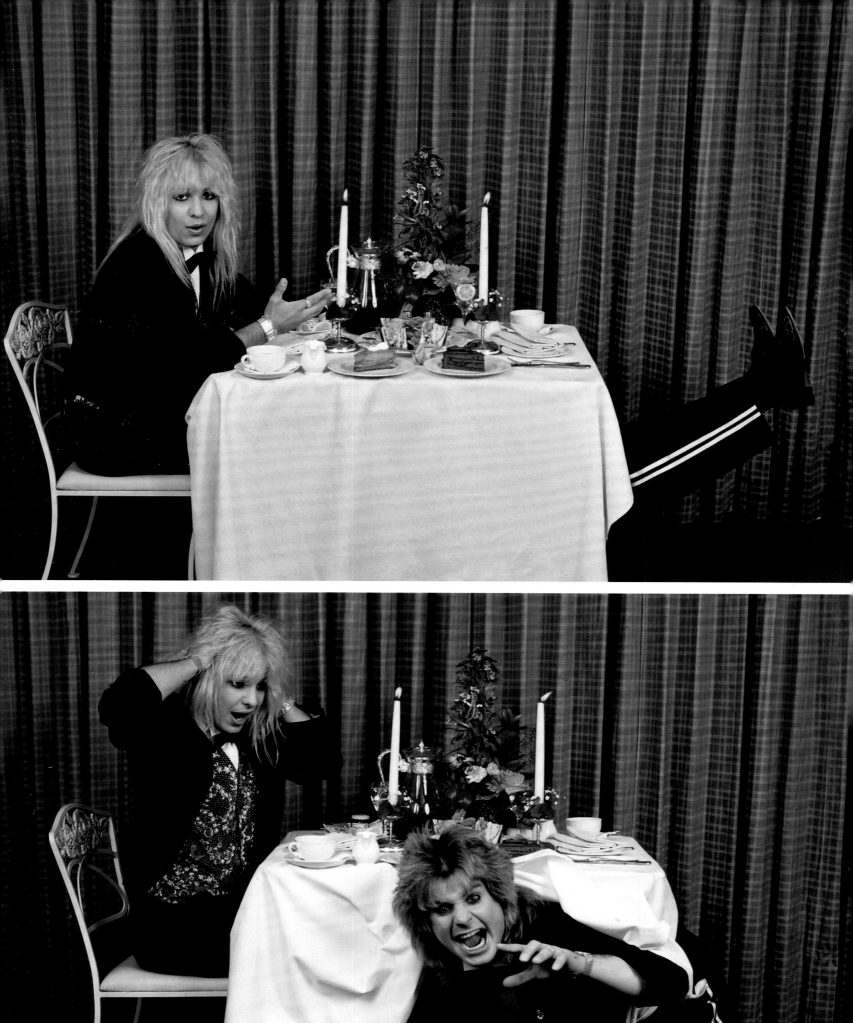

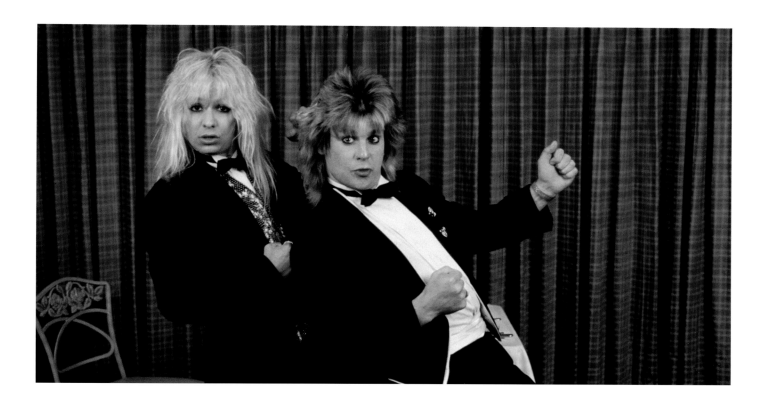

ALL ABOARD THE CRAZY TRAIN

Vince and I did end up fishing! We were cracking up when I reeled in a fish that was smaller than my bait. Vince grabbed my camera and took a photo of me with my big catch. I put down the fish, and Vince continued to snap away. Later that year, the portrait he took of me was used in *Metal Edge* magazine in a story titled "The Great Photographers of Rock," with the credit reading PHOTO BY VINCE NEIL. When I told him about it, he laughed and said he wanted to get paid. Sure enough, Vince received a check for twenty-five dollars from *Metal Edge*.

After the fishing trip, I came back and did a shoot with Vince around his house. I think that after being incarcerated, he wanted to show the world that he was okay. We did some portrait shots in his house and by the beach, and afterward I tagged along while he went to a martial arts class. Vince also invited me to the Record Plant West studio in Hollywood to take some photos while Mötley Crüe were finishing up the recording of *Theatre of Pain* with producer Tom Werman. Nikki and I also discussed an upcoming shoot with a "gangster" theme. From that day on I was the main guy they went to when they needed photos—I was Mötley Crüe's photographer.

While I was in LA, I reached out to Sharon to see what Ozzy was up to and asked if he would be interested in doing a shoot. She said, "Sure, but let's do something different." I told her I had just spent the last week shooting Vince. She replied, "Let's have Vince over for a tea party!"

After I finished shooting Nikki and Vince at the Record Plant, I asked Vince if he wanted to do a photo shoot with Ozzy. His exact words were, "Fuck yeah!" I told him, "Bring a tux and don't ask questions." When he walked into Ozzy's hotel room, I already had my studio lights up, surrounding a table set for two. Vince saw what was going on and just laughed. While we waited for Ozzy to get his tuxedo on, we sat and watched MTV. David Lee Roth's "California Girls" came on. Vince looked at it and commented, "I'm next!" Mötley were definitely on their way up, and they were about to head out on their first arena headlining tour. It seemed like the time had come for Van Halen to make some room for Mötley Crüe.

Finally, Ozzy came out, and we got to work. The tea party setup proved to be a bit anticlimactic—the two of them made a few smirky faces, but that was it. After five minutes, they both gave me a look that said, Now what? I told Ozzy to go underneath the table. He looked at me and said, "Fuck off!" But I told him to trust me. And that's when the fun began. Soon enough, they were goofing around like two little kids.

Change was definitely in the air in 1985. A new wave of glam bands was just starting to get signed. Out west, Poison, glammed out from head to toe, were flyering the Sunset Strip, while Mötley were getting ready to unveil their new look, bringing glam back to the mainstream in a very big way.

OPPOSITE AND ABOVE: Vince Neil and Ozzy Osbourne, Los Angeles

"Mark Weiss is a Hall of Fame photographer. He has taken some iconic photos of me and the band and also me and others, like this one with Ozzy. The best!"
—Vince Neil (singer, Mötley Crüe)

TOP: *From left:* Nikki Sixx, Vince Neil, and producer Tom Werman, *Theatre of Pain* recording sessions, Record Plant, Los Angeles **BOTTOM:** Nikki Sixx during the *Theatre of Pain* recording sessions **OPPOSITE:** Vince Neil, Los Angeles **PAGES 190–191:** (*top left*) Mötley Crüe onstage, *Theatre of Pain* tour; (*bottom left*) Tommy Lee performing upside down; (*right*) Mötley Crüe pose for a *Godfather*-themed photo shoot: "Nikki had the idea to shoot the band in gangster outfits like in the movie *The Godfather*. It became another classic Weissguy shoot. I ran around Hollywood to the prop houses in search of Tommy guns for the shoot. I then went to a place that rented scenic backdrops. I mentioned to Nikki that we needed something they could play off of on the set. He told me he had it covered, which ending up being an understatement. When I got to the studio to set up, there, featured, was a classic Rolls-Royce for me to work around. It was fuckin' perfect!"—**Mark Weiss**

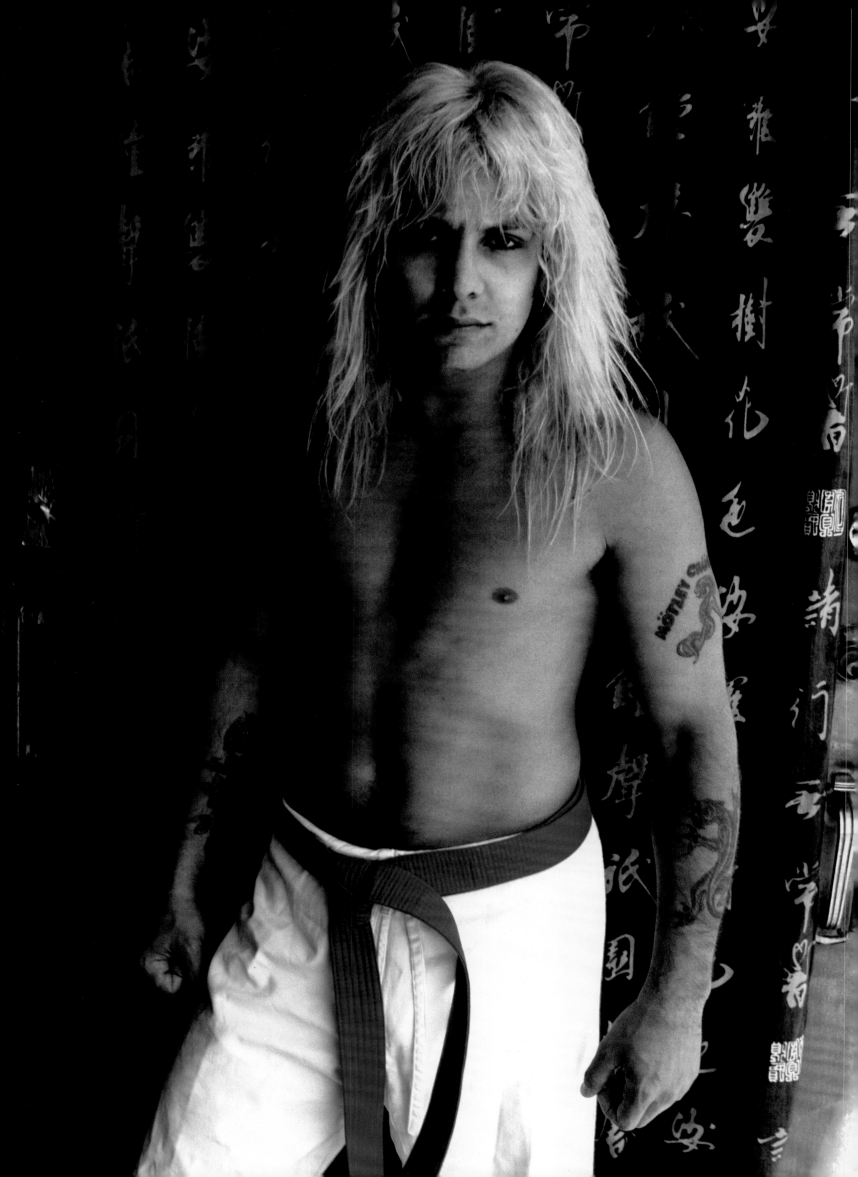

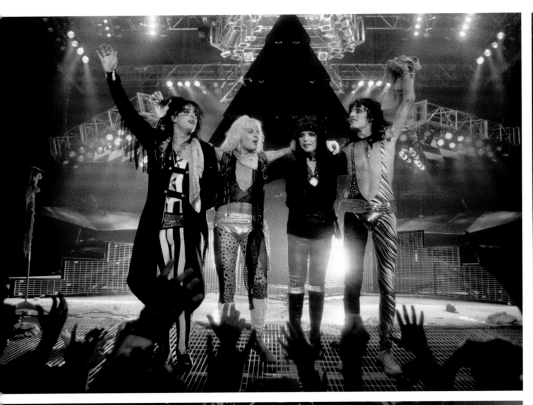

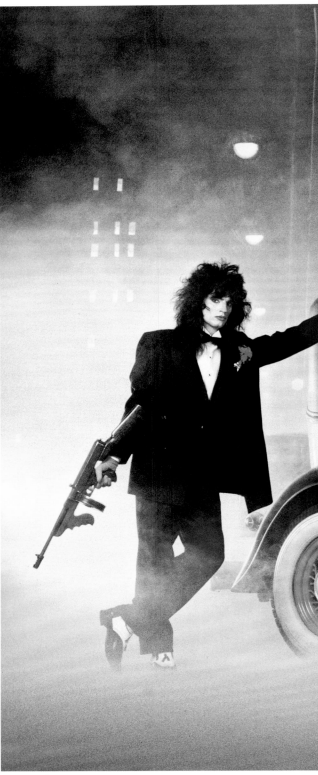

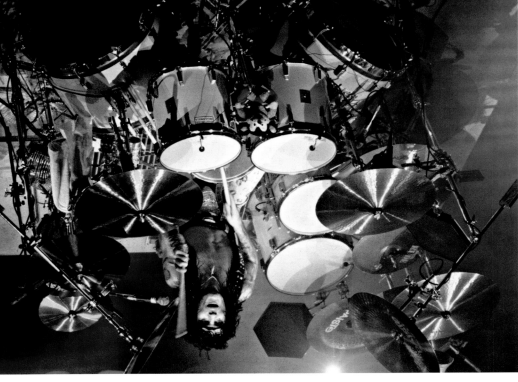

"*Theatre of Pain* . . . that was definitely some of our glam roots coming out. We were probably at the peak of our indulgence. We barely finished that record. That was at a time for us when we were flooring it." —**Tommy Lee**

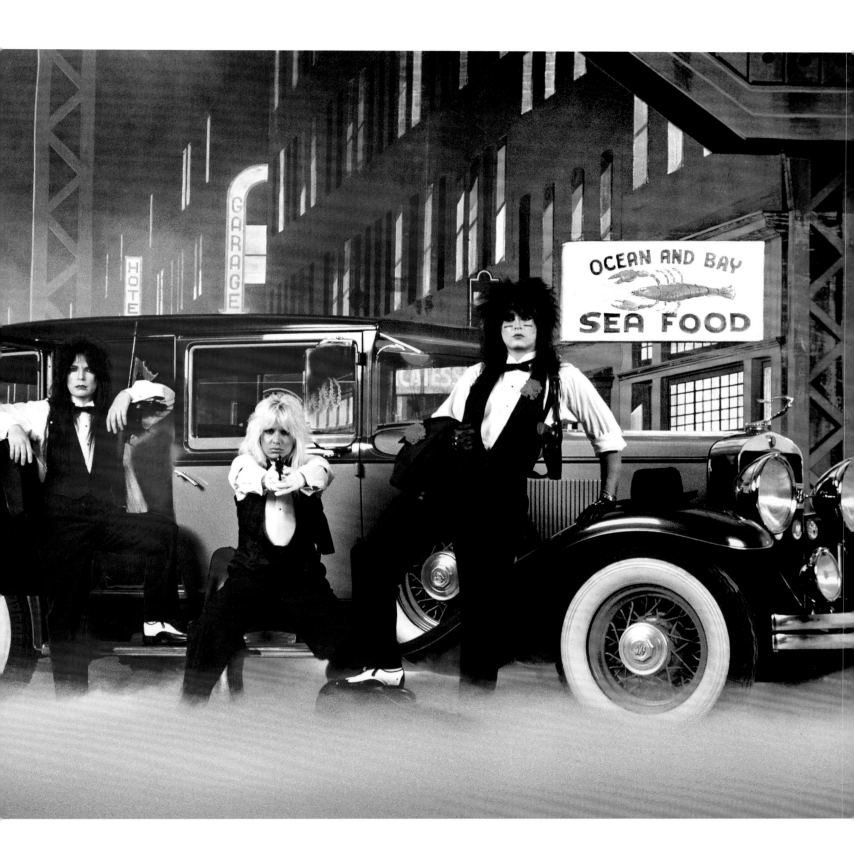

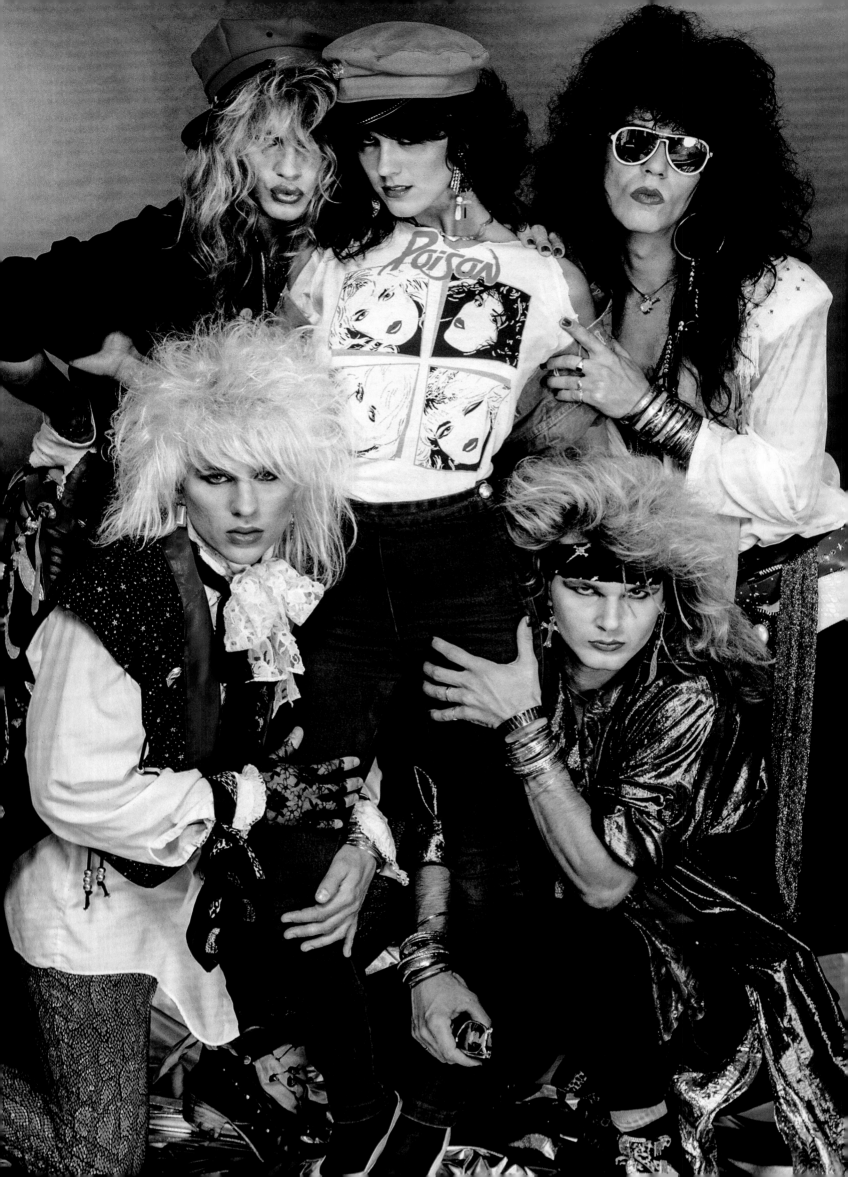

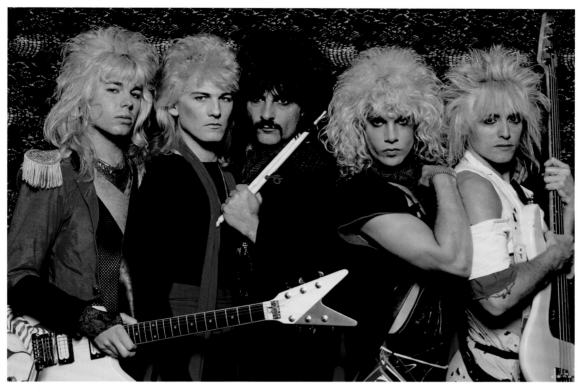

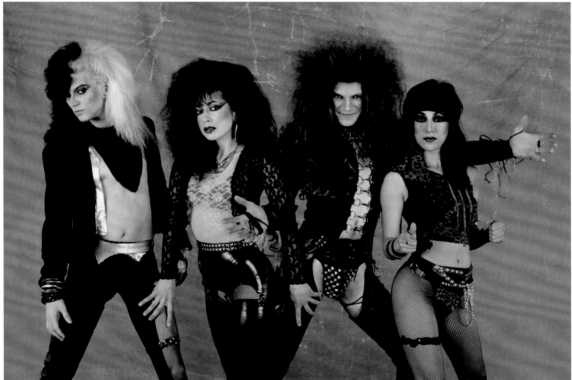

"Mark's artistic eye, talent, and perfection captured the larger-than-life, rock 'n' roll attitude that helped launch the career of my band, the outrageous Madame X. He got the look, feel, sound, and energy of the band in a single shot."
—MAXINE PETRUCCI (guitarist, Madam X)

OPPOSITE: Poison with clothing designer Jacqui King, 1986 **TOP:** King Kobra, Los Angeles **BOTTOM:** Madam X, Los Angeles **PAGES 194–195:** (*left*) D'Molls, Los Angeles 1986; (*right*) Smashed Gladys, Mark's studio, New York City

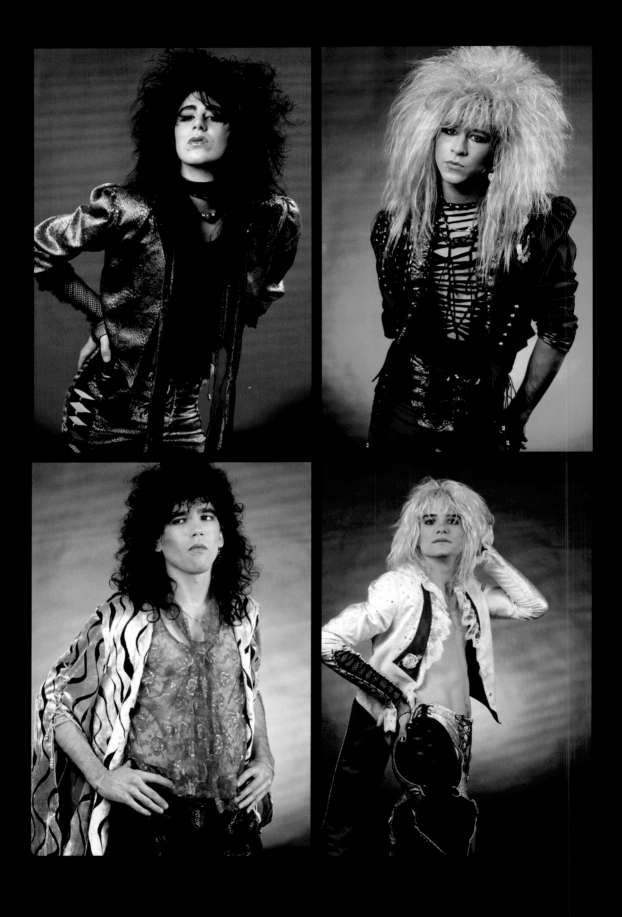

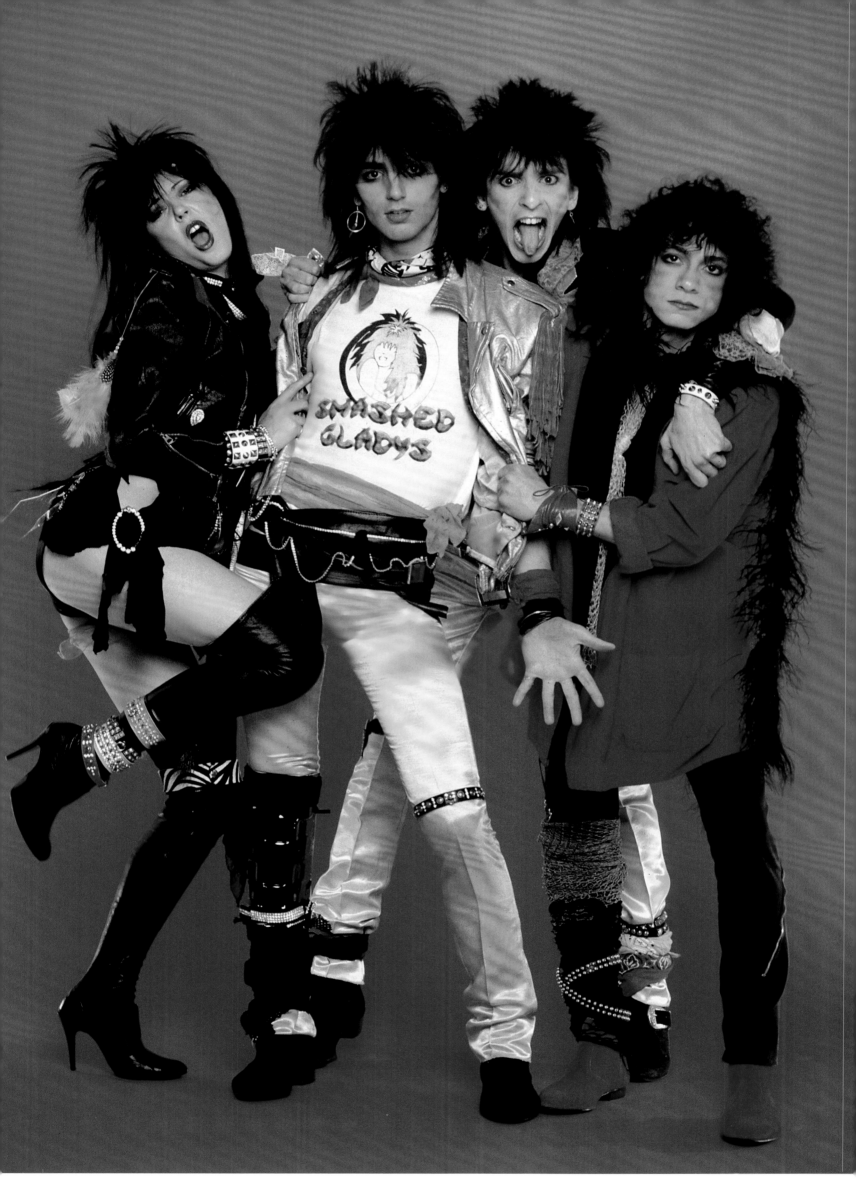

"A great photographer, like a great record producer, takes the band's idea and tries to realize their vision—or even make it better. Our album was going to be called *The Pack Is Back*, which was an old expression from the Green Bay Packers. We were like a gang at the time and that phrase kept coming up, so we went with it. The idea was to have us basically bursting out of lockers like these crazed, steroid-ridden football player–musicians. And these costumes literally turned up the day of the shoot. It's a famous album cover of ours, that people either love or hate. And isn't that the essence of great art?"—**John Gallagher (singer, Raven)**

OPPOSITE AND ABOVE: Raven, *The Pack Is Back* album shoot, Mark's studio, New York City

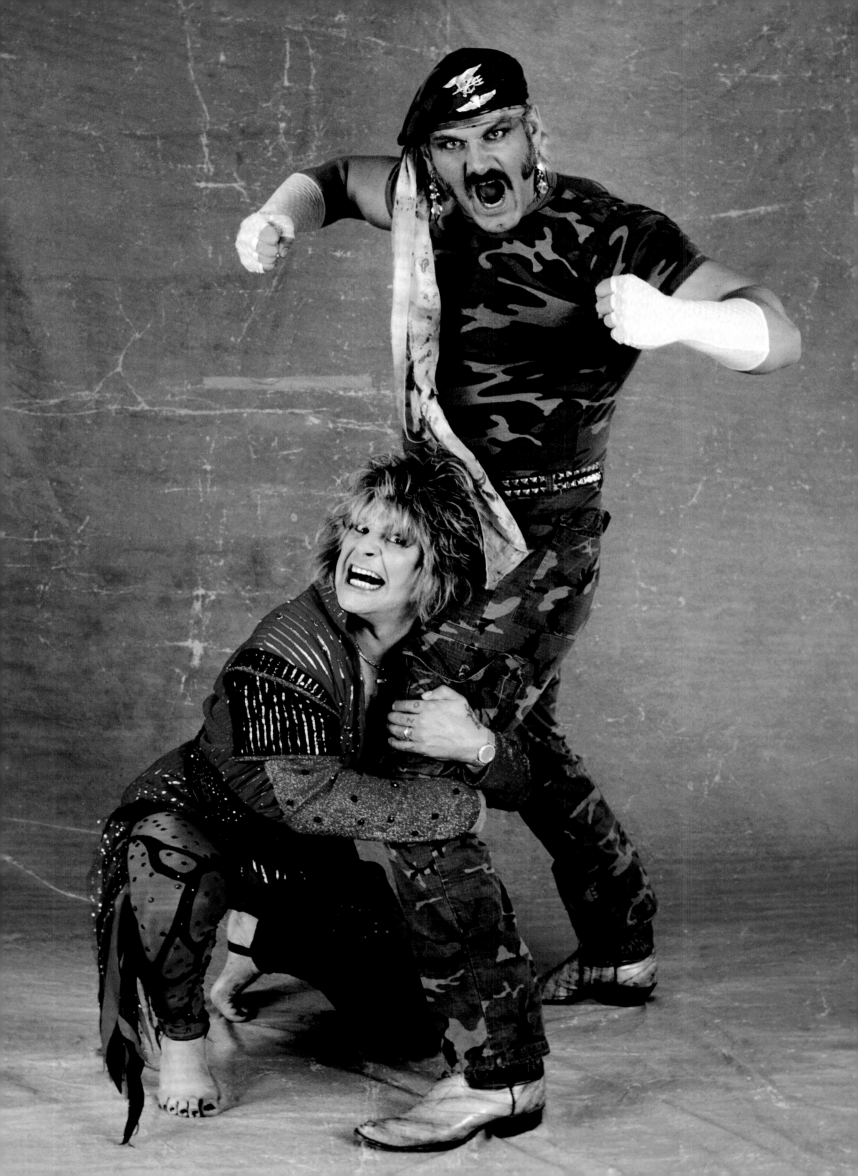

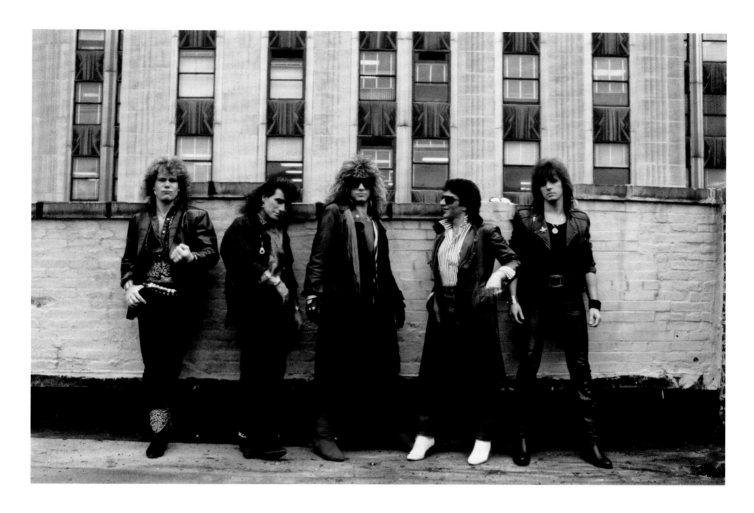

THE BOYS ARE BACK IN TOWN

In the spring of 1985, I moved into my new studio in New York on West 33rd Street, directly across from the Empire State Building. I had the penthouse suite and was excited to christen the space with a band from Sayreville, New Jersey. That band was Bon Jovi. The session came together when I was in Hollywood with Mötley. Their manager, Doc McGhee, had told me he wanted me to shoot a new band he was working with. The record company needed press photos for their new release, *7800° Fahrenheit*. During my shoot with the Bon Jovi guys, I remember Jon saying that he couldn't believe they were shooting with me. He told me he was a fan of my work. I replied, "One of these days you're gonna tell me, 'Get that damn camera out of my face!'" We both laughed.

7800° Fahrenheit was released in the United States on March 27, 1985. We did the shoot the following week, before the band took off to Japan to start a world tour. The rock magazines began to embrace Jon's good looks, touting him as the new poster child for hard rock.

Bon Jovi played alongside everyone from Johnny Cash to Tom Petty to Bob Dylan during the inaugural Farm Aid concert—organized by Willie Nelson, John Mellencamp, and Neil Young—on September 22, in Champaign, Illinois. It was a great event, with a superstar lineup and a cause—proceeds went to American farmers in danger of losing their farms because of mortgage debt—that Jon was behind. He seemed to be coming into his own at that time and wanted a photo with the other stars who were around that day. I was Jon's shadow, and whenever I saw an opportunity, I set up a shot.

WrestleMania's debut also took place in the spring of that year, on March 31, 1985. After that, a lot of rockers started to look like wrestlers—King Kobra being one such example. Maybe it had something to do with record companies recognizing the potential crossover between the young demographics. Whatever the case, rock and wrestling were a match made in heaven, and both sides benefited.

OPPOSITE: Ozzy Osbourne and Jesse "The Body" Ventura, Los Angeles
ABOVE: Bon Jovi on the roof of Mark's studio in front of the Empire State Building

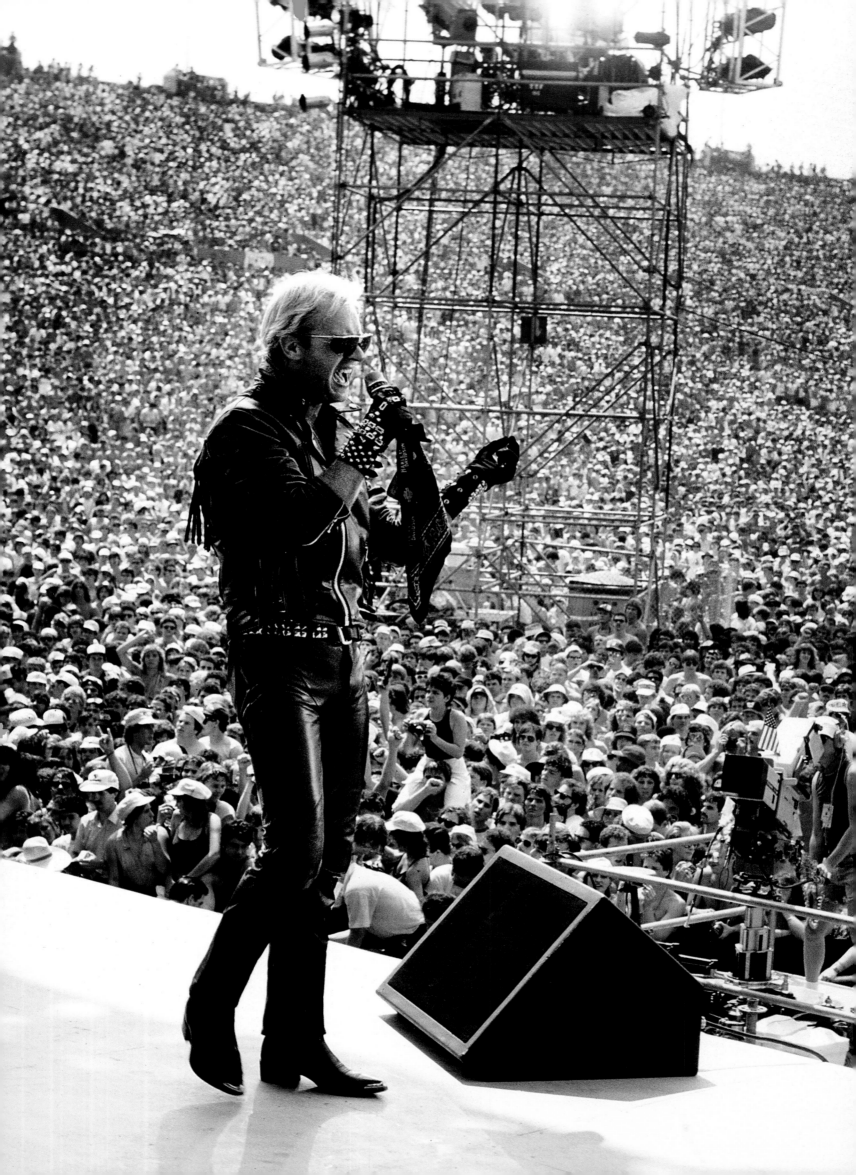

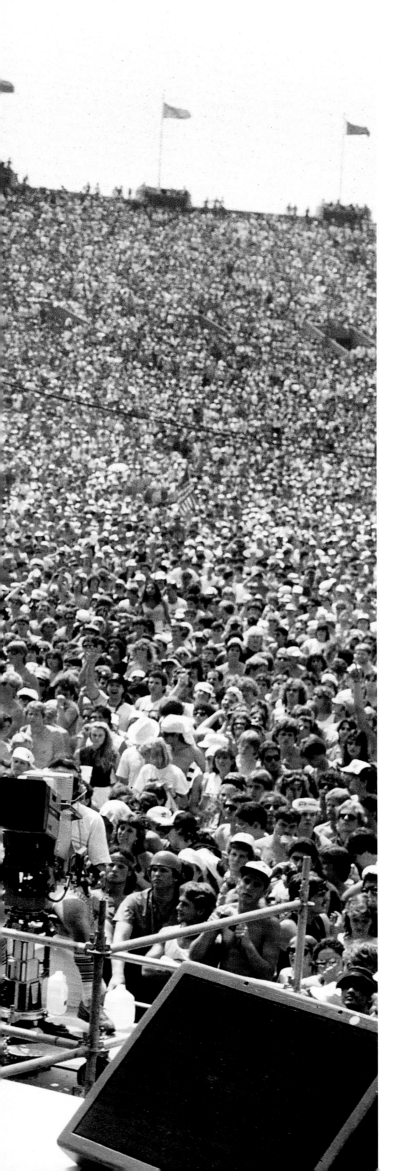

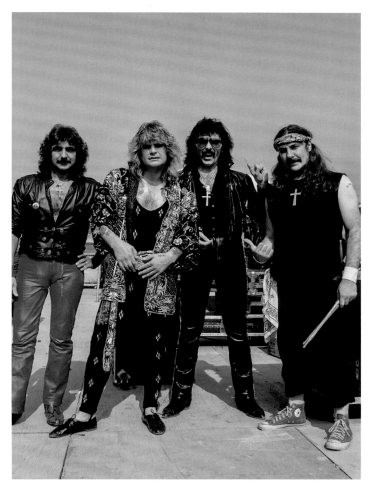

SAVING THE WORLD WITH ROCK 'N' ROLL

On July 13, the historic Live Aid benefit concert took place simultaneously at London's Wembley Stadium and Philadelphia's John F. Kennedy Stadium. I was at JFK, along with more than one hundred thousand fans. It was a special moment to see Ozzy back with Black Sabbath; he hadn't performed with the band in almost a decade.

That wasn't the only big charity event to happen that year. When Wendy Dio, Ronnie James Dio's manager, told me what was going to take place at A&M Records' studios in Hollywood that May, I knew I had to be there. The project was Hear 'n Aid, which brought together dozens of metal legends and up-and-comers to record a "We Are the World"–style charity single, "Stars," to raise money for famine relief in Ethiopia. I wanted to donate my time and document the moment.

OPPOSITE: Judas Priest's Rob Halford onstage at Live Aid, JFK Stadium
ABOVE: Black Sabbath at Live Aid

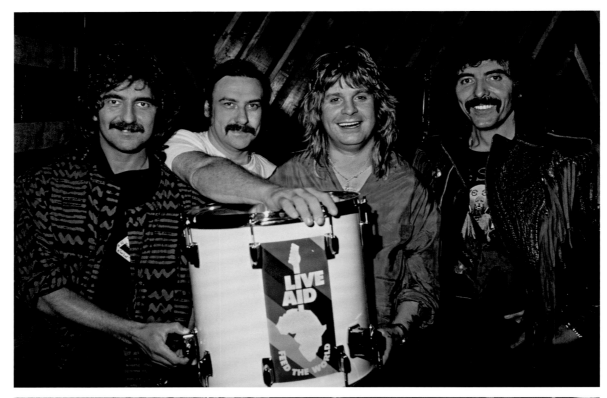

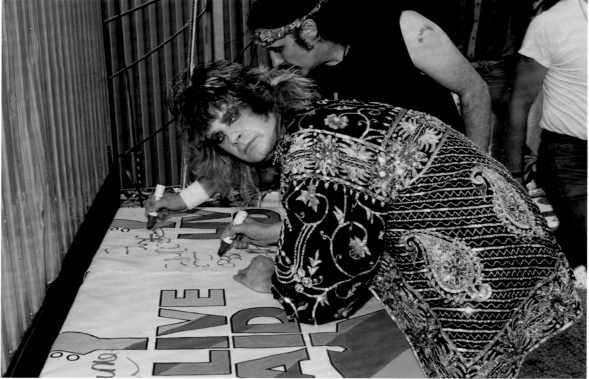

ABOVE AND OPPOSITE: Black Sabbath, backstage at Live Aid
PAGES 206–207: *Hear 'n Aid* recording sessions, A&M Studios, Los Angeles
PAGE 208, TOP: Queensrÿche's Geoff Tate **PAGE 208, BOTTOM:** Don Dokken
PAGE 209, TOP: Rob Halford **PAGE 209, BOTTOM:** Kevin DuBrow

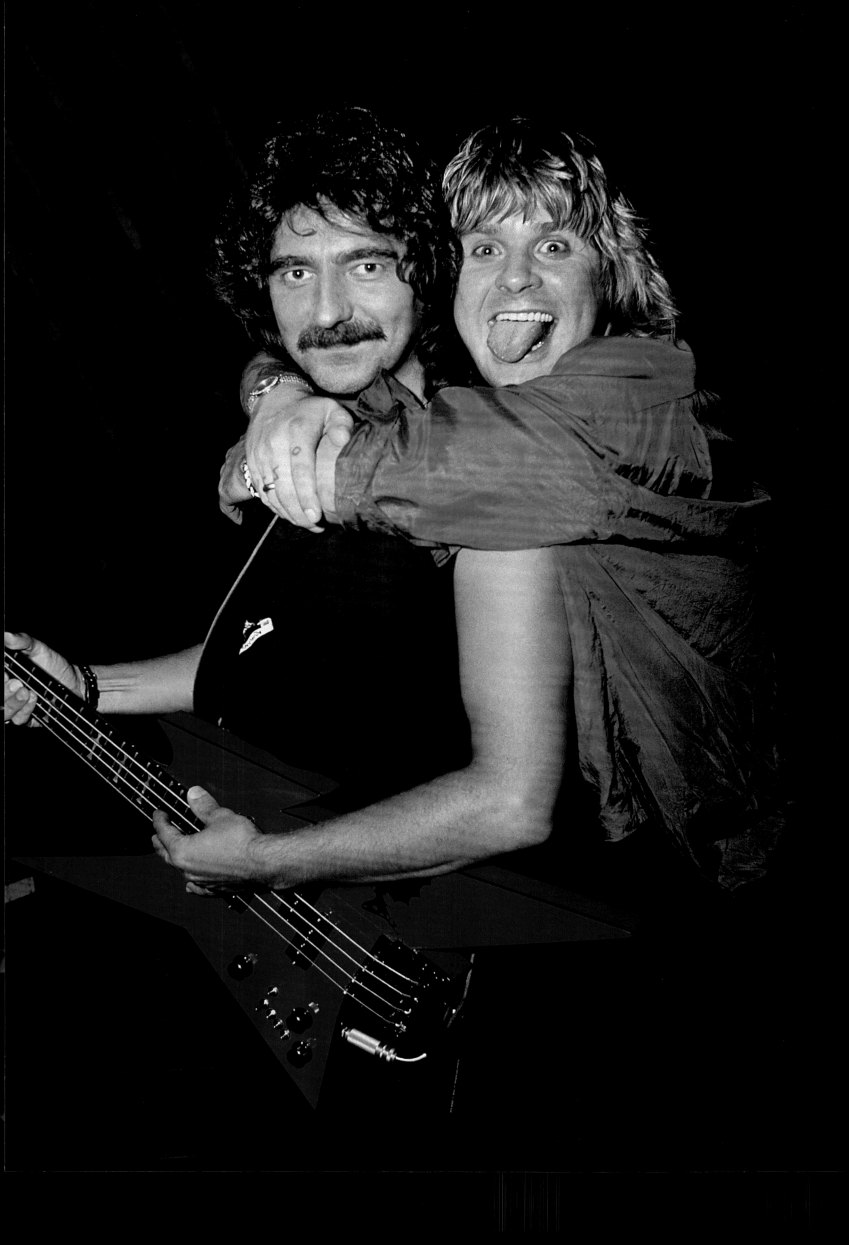

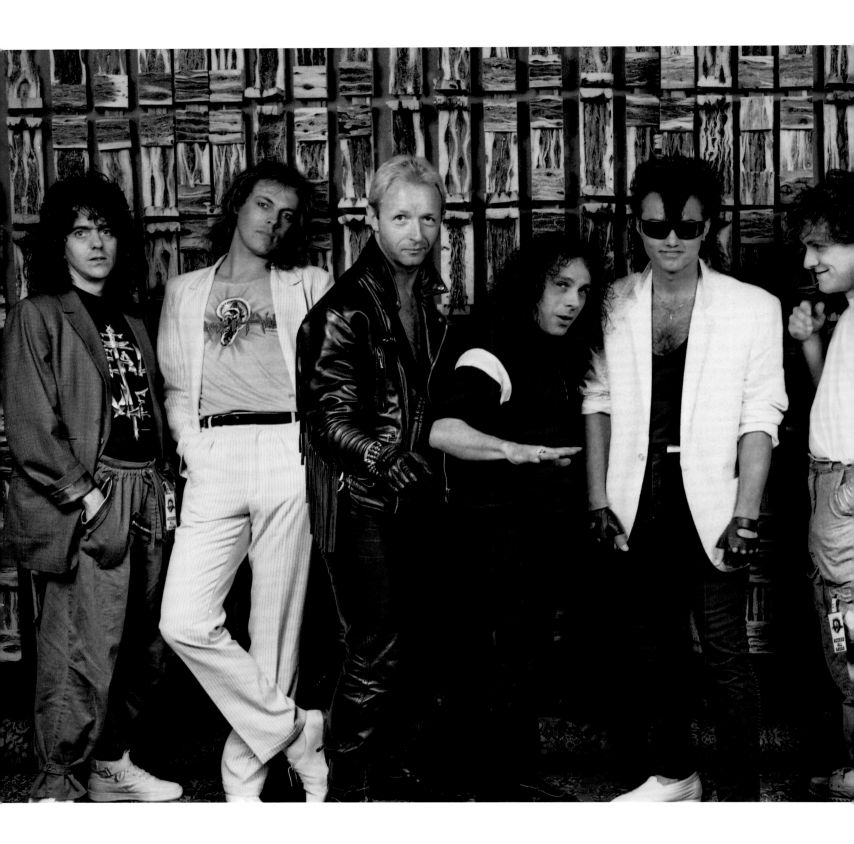

"Mark was hanging around that particular day, taking pictures all the time. It was a tremendous day. Then the final moment, when we all sang together, was the icing on the cake, so to speak. So it was just a memorable, vivid occurrence in rock 'n' roll history. When you look at that picture and you see everybody standing there having a great time, you know, it'll never happen again." —**Rob Halford (singer, Judas Priest)**

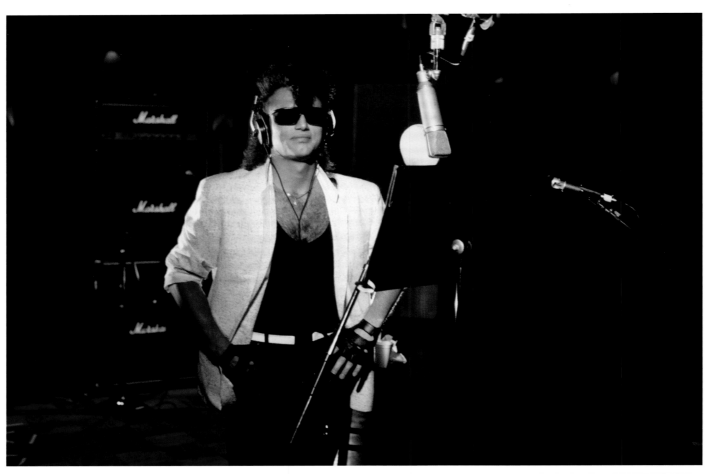

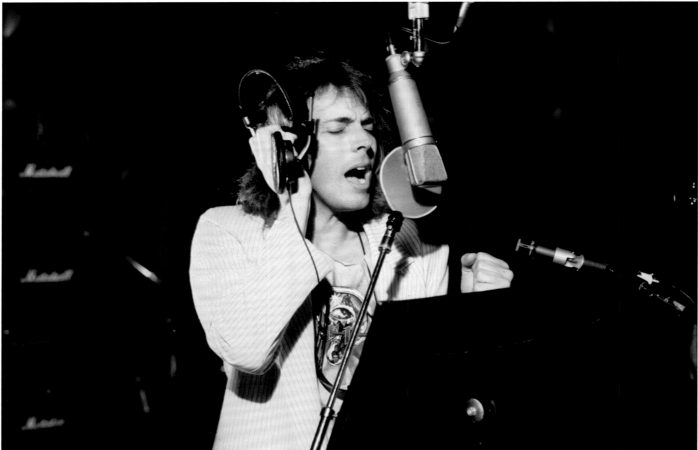

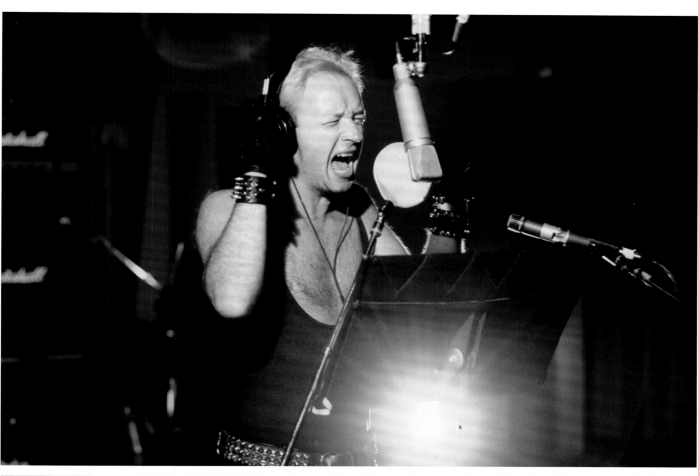
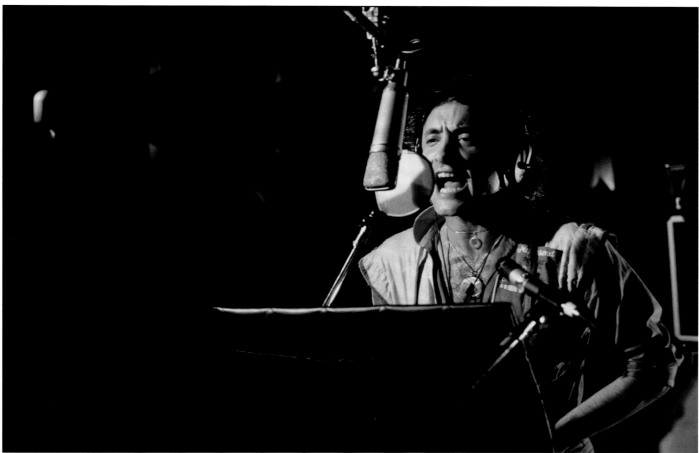

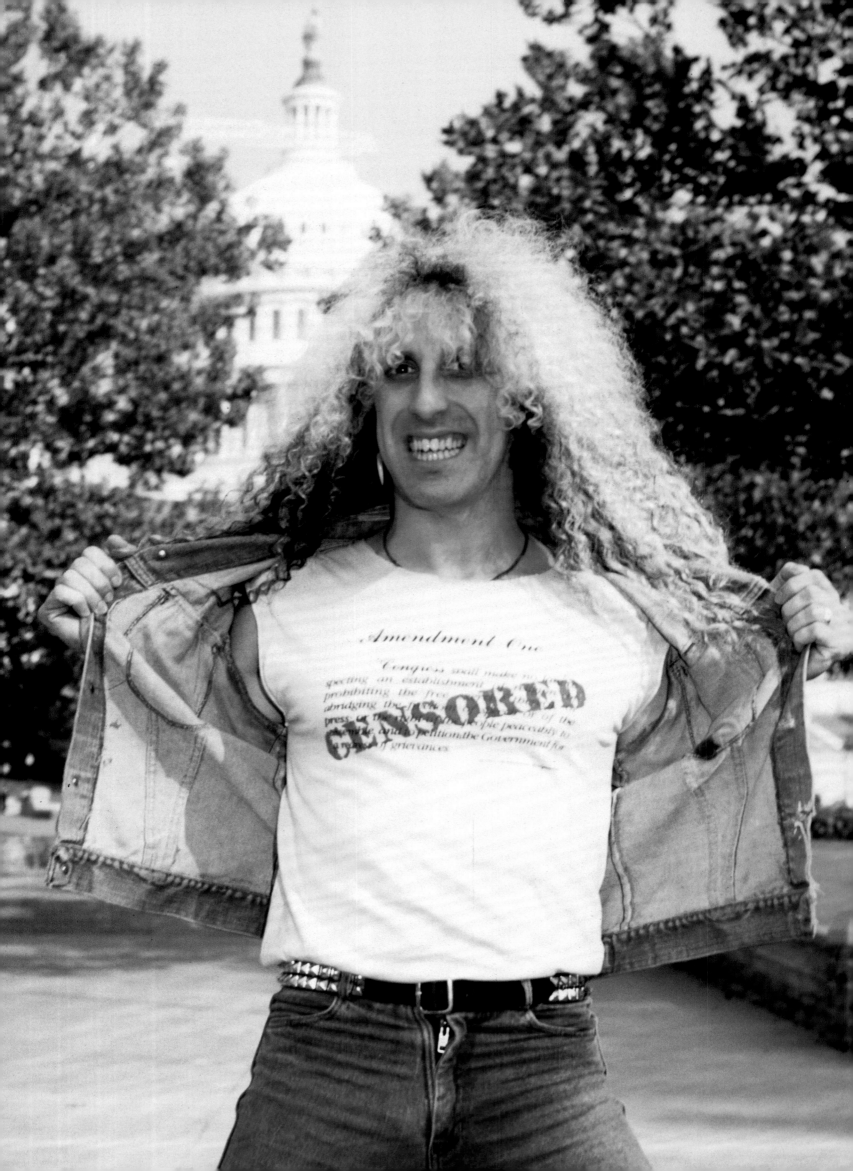

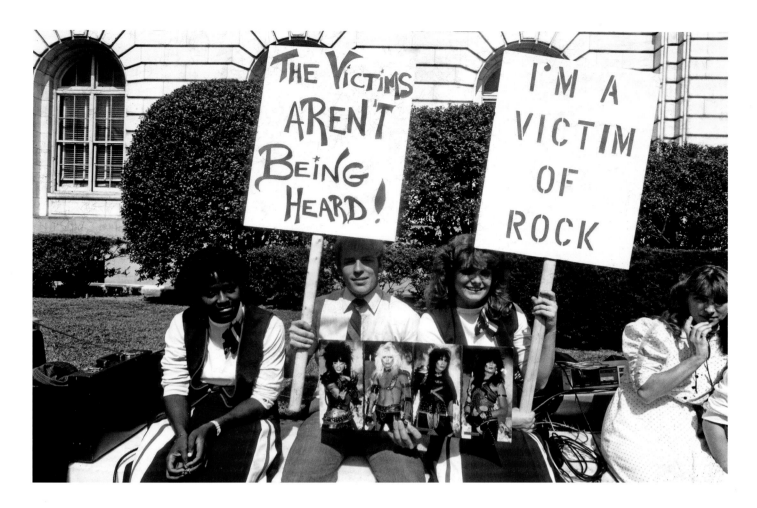

SHOUT AT THE SENATE

On September 19, 1985, I got a call from Dee Snider, asking me to go with him to Washington, DC, to document the Parents Music Resource Center (PMRC) Senate hearings. He would be there testifying on behalf of his fellow musicians' right to freedom of speech and artistic expression in their music. Dee entered the Senate—a room full of suits—as if he owned it. Wearing a cut-off T-shirt with one of my photos on it, he was articulate and passionate as he defended his position. I felt like he was speaking for me and for my freedom to choose the music I wanted to listen to.

Dee kept a tight bunch of soldiers around him, and I was one of them. When it was time to shoot the album cover for the follow-up to *Stay Hungry*, he asked me to art direct it as well. Art direction was a new endeavor for me, but I was up for the challenge. To top it off, the album, *Come Out and Play*, would have a pop-up cover with a raised texture with Dee peeking through the street manhole. We did the shoot that September, two months before the record's release, in my studio. My dad was in the construction business, and had a section of a street

made, along with a manhole cover. The whole thing must have weighed a thousand pounds. (Dee also took a stab at the PMRC by putting his own label on the back cover: "This record contains some words and phrases that require a sense of humor. If you don't have one, don't listen.")

Elektra Records hired me to shoot the cover for Dokken's new album, *Under Lock and Key*. They also asked me to art direct it. Looking back, I would have to say we took the shoot a little too far. They spent a ton of money on costumes that were custom-made by Ray Brown, and I had this silly idea to construct a keyhole in the background with smoke coming out of it. This was a Spinal Tap moment for sure.

The word was getting out that if you were a heavy metal band with a concept, I was your guy. Twisted Sister label mates Raven were releasing a new album, *The Pack Is Back*, and when I saw their costumes, I came up with the idea to have them bust out of lockers. I knew high school kids would identify with the image.

OPPOSITE: Dee Snider of Twisted Sister, Washington, DC **ABOVE:** Protesters outside the PMRC hearings, Washington, DC **PAGES 212–213:** Dee Snider, Twisted Sister, *Come Out and Play* album cover shoot, Mark's studio, New York City; (*gatefold*) Twisted Sister

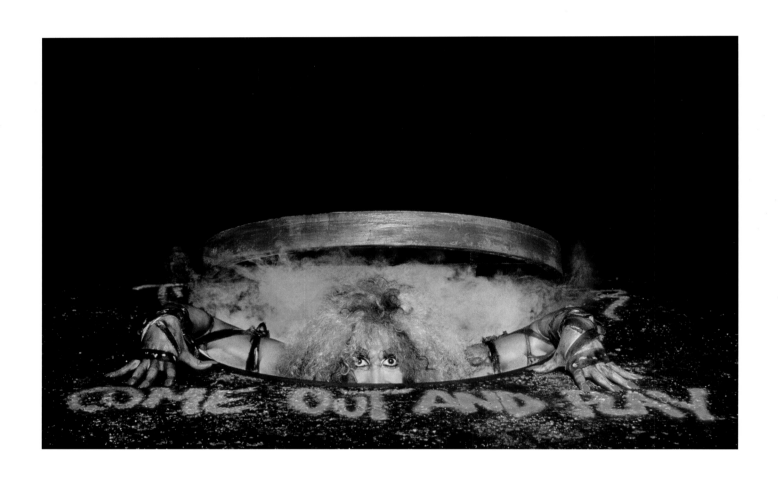

"It was Mark and me working together; we got it correct. I didn't watch the step-by-step, but I told Mark what I wanted, and he was given a budget to do it. And he went out and made it happen. I walked in and there was a fucking piece of street with a manhole cover, and I was like, 'Yes! That's what I'm fucking talking about!' And the cover was real heavy. Hundreds and hundreds of pounds. I remember when they had it propped open for me to peer out of, I was like, 'Is this thing secure?' Because I had a friend who had a manhole cover drop on his fingers, and it mushed them. And he forever had mushed fingers." —**Dee Snider**

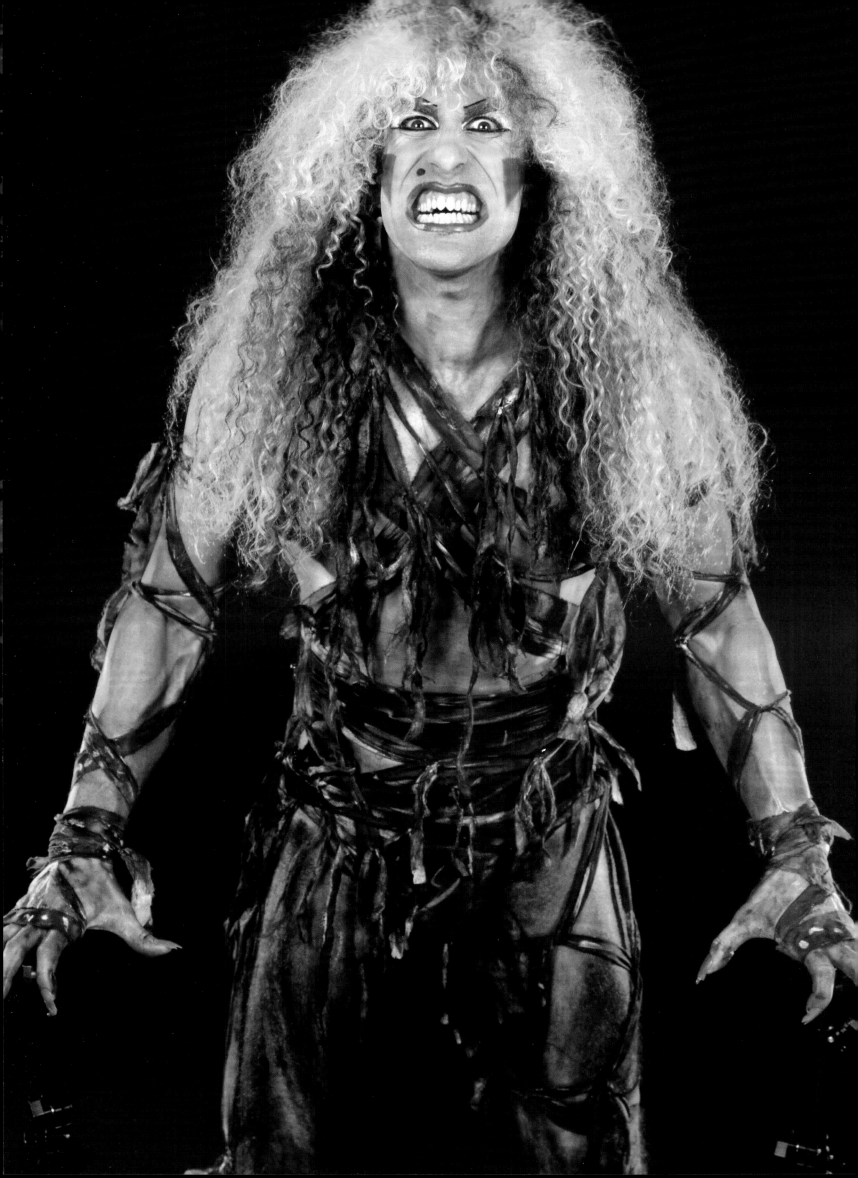

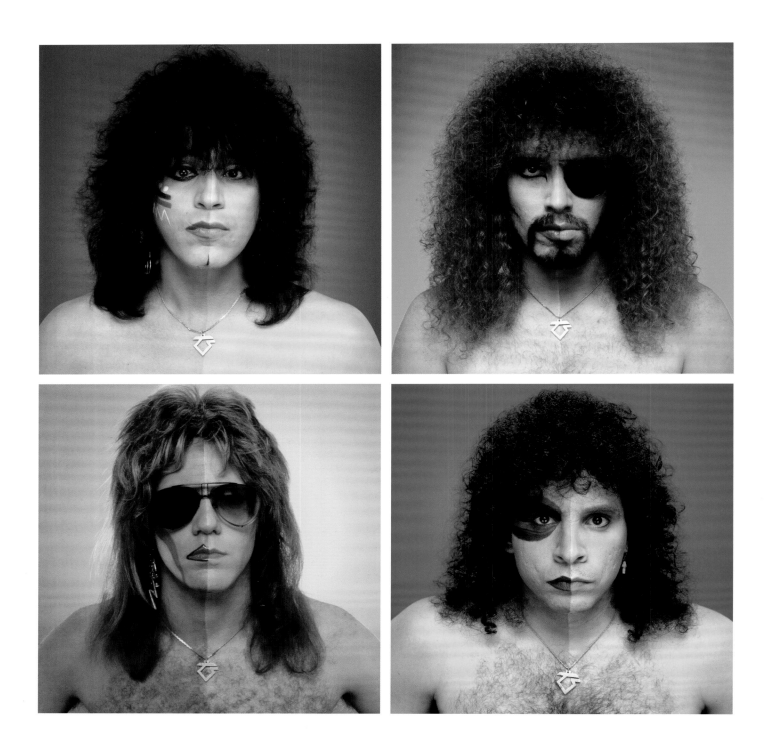

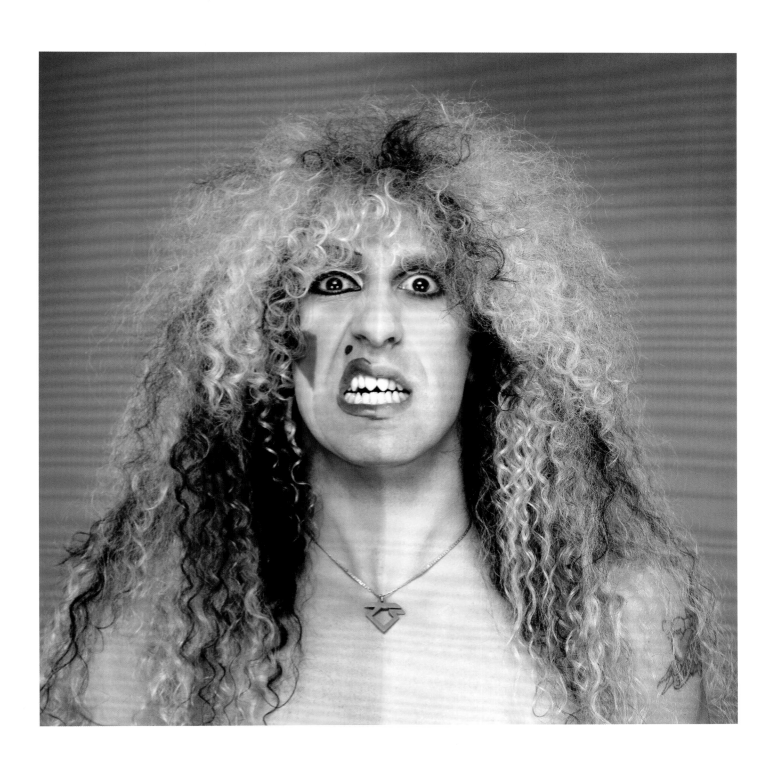

ROCKS

TRAGEDY STRIKES!

DAVID LEE ROTH

Showbiz es The e!

al man rmed?

OZZY OSBOURNE

ON IDEN'S RUCE CKINSON PS IT UP!

04

MÖTLEY CRÜE & DEF LEPPARD

PAT BENATAR
MOTORHEAD
TINA TURNER

CREEM READERS POLL WINNERS

PHOTOGRAPHER Of
The Year

1. Lynn Goldsmith
2. Mark Weiss
3. Neil Zlozower
4. Ross Marino
5. Neal Preston
6. Bob Alford
7. Ebet Roberts
8. Robert Matheu
9. Laura Levine
10. Ross Halfin

This may come as a shock to some of you but that little, teeny-tiny printing usually lodged somewhere along the border of a picture in this and other magazines is actually the name of the photographer. It's not nearly as... this almost... average-... you've ac-... with the... y near-... for.

...ortance... ce over-... em tell... e like... these... g down... as ex-... about... per on... North-... pages... gued... in the... g like... oovy... hink... y by... do?... as to the list (no we haven't forgot-ten). Winner **Lynn Goldsmith**, re-capturing 1st after a brief hiatus is an old CREEM fave—well, not *old*, like in the sense of having a lot of gray hair and wrinkles and stuff but you know, we've all known and respected her work for so long that we can't even remember...oh, forget it. As for the rest of the... all repeats fr...

© Mark Weiss/ANGLES 1986

YNGWIE

NEIL ZLOZOWER & FRIENDS

ROSS

1986 MARK W

DEC 1991

OZZY OSBOURNE
The Ultimate Sin
WORLD TOUR 1986

ACCESS ALL AREAS

OZZY OSBOURNE

© 1986 MARK WEISS/MWA

S07969

SN99 AON

© 1986 MARK WEISS/MWA'

© Mark Weiss/ANGLES

4920-1281-001 POISON
Group (video)

M86

ROCKS

AUTOM K

ASP UE!

ELECTRIC CIRCUS
WORLD TOUR
'86 - '87

CINDERELLA

NIGHT SONGS

© 1986 MARK WEISS/MWA'
04414
APR 86NII
33

© 1986 MARK WEISS/MWA
NOV 86NIO

ME CRAWLING FASTER
METALLICA
MASTER

© 1986 MARK WE 33
509618
5 × 7 SH

METALLICA

MASTER
OF PUPPETS

ALL AREA ACCESS
TOUR 1986

1986

KNAC PURE ROCK 105.5

Slippery When Wet

Bon Jovi

© 1986 MARK WEISS/MWA
WANTED
BON JOVI
GANGA

BON JOVI

Slippery
When
Wet

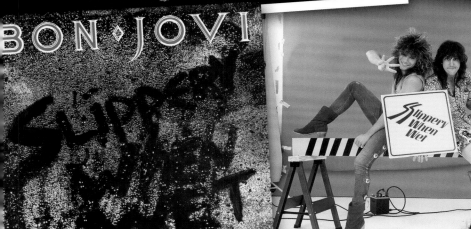

BON·JOVI

Slippery When Wet

BON JOVI
WANTED
DEAD OR
ALIVE

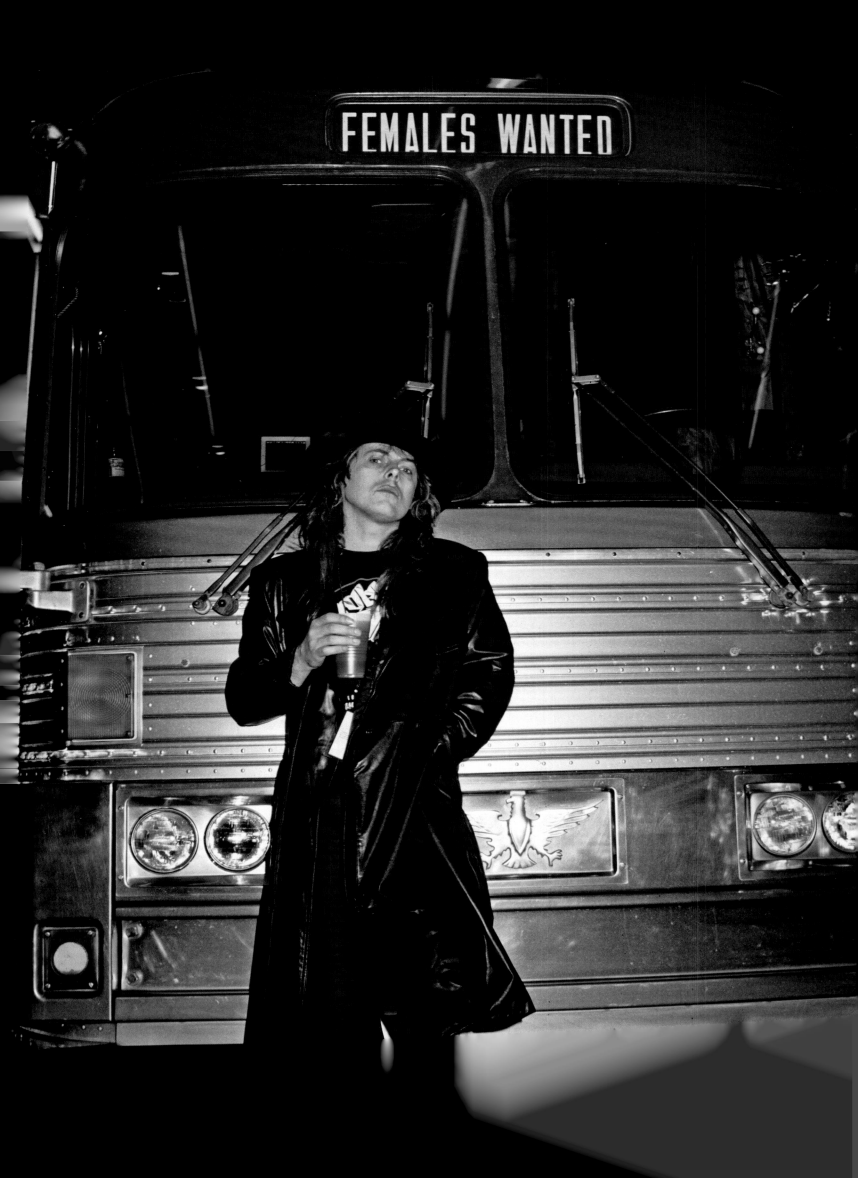

ALL I WANT IS YOUR PHOTOGRAPH

This was the year I felt my work was truly becoming part of the visual imagery that would define '80s rock and metal music. With the success of Quiet Riot's *Metal Health* back in 1983, record companies were sinking big money into bands, from Bon Jovi, Ratt, Lita Ford, and Stryper, to W.A.S.P., Great White, Dokken, and Twisted Sister. Even Kiss were back on top—now without their makeup, they were selling out arenas and appearing on the covers of magazines again. Big hair, tight and shiny custom-made costumes, melodic songs, power chords, power ballads, a charismatic lead singer, and a kick-ass photo shoot seemed to be the formula for a hit album. Image was at the forefront, and exposure on MTV and in the rock mags was what the bands needed to sell records.

I went out on the road with Dokken that year. The band would clear out the extra bunk for me. *Under Lock and Key* was selling well, and they were on the way to becoming an arena act. They even appeared on *Ameri-*can Bandstand. We had lots of good times traveling from town to town. We didn't get out much—just straight to the hotel, then to the show, and then back on the bus to the next gig. We were like traveling gypsies. The guys would also rely on me to bring some hot girls back after the show.

Videos were usually filmed before the release of a single, so it was a great opportunity to get some new posed photos of a band as well as some candid pictures on set. When it came to Ozzy, Sharon was someone who understood the value of publicity, and so she counted on me to get him in the magazines. Video sets were perfect for that because he dressed up in so many different out-fits, and we could provide each magazine with a unique shot. For the "Ultimate Sin" video shoot, the director cast a model who looked like the girl from the *Ultimate Sin* album cover. The scene didn't make it into the final video, but it was another photo for the scrapbook.

OPPOSITE: Don Dokken in front of the Dokken tour bus, *Under Lock and Key* tour ABOVE: Ozzy Osbourne shooting the music video for "The Ultimate Sin"

"George [Lynch] was famous for saying 'Why don't you come on the bus and ride with us?' You get on a tour bus with a famous band and it sounds exciting, and if you're having fun you're not thinking about how you're going to get home."
—**Don Dokken**

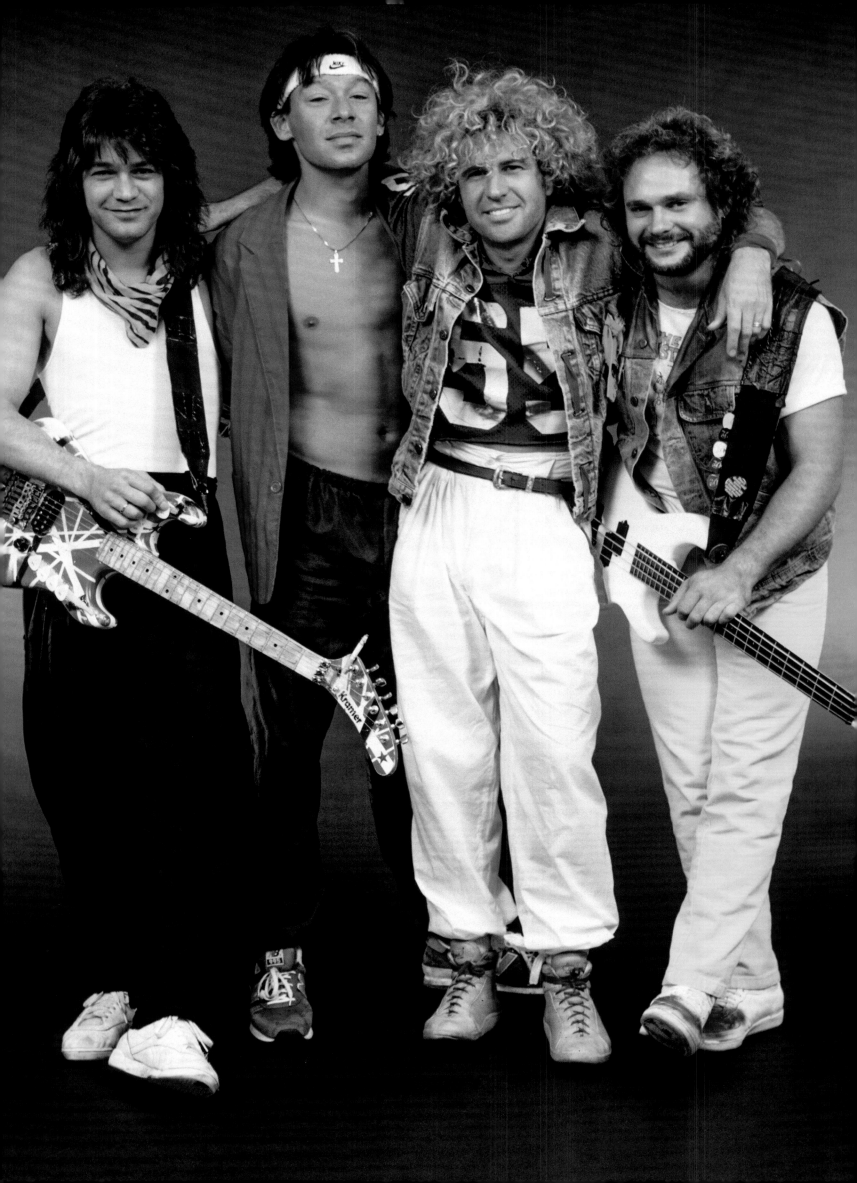

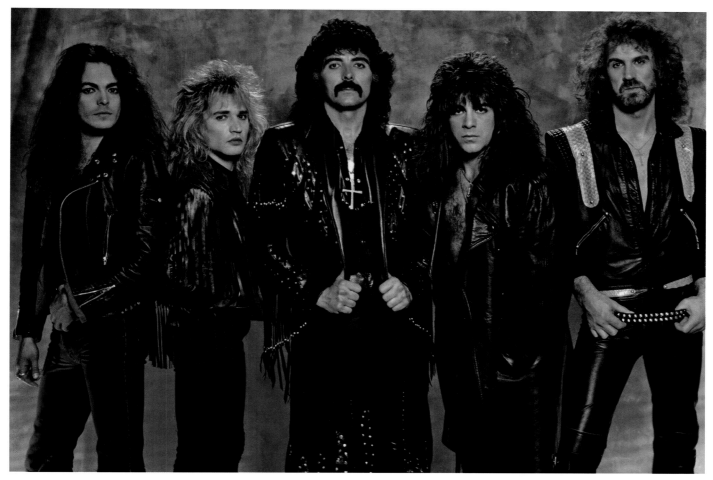

WHY CAN'T THIS BE LOVE?

I was the go-to guy when a band went through a member change. This was the case with two major bands that year, when Tony Iommi put together a new lineup of the legendary Black Sabbath, and Van Halen came back with Sammy Hagar in place of Diamond Dave. Publicists would need photos of the new lineups, and I was the guy they called. I would also get the photographs in the magazines. It worked out well for me, too, because I would be collecting from both sides—the magazine and the record company.

In the '80s, there was camaraderie among bands. If one could help out the other by opening up their show, it just meant having more buddies to hang out with. This couldn't have been truer for Cinderella. Jon Bon Jovi was in Philadelphia working on songs when he saw Tom Keifer and his band play in a nearby club. Jon liked what he saw and brought the PolyGram A&R guy, Derek Shulman, to see them. Soon enough, Cinderella had a record deal.

In August, David Lee Roth went out on the road for *Eat 'Em and Smile*, his first full-scale tour playing arenas since leaving Van Halen. His new band was rounded out by an amazing group of players: guitarist Steve Vai, bassist Billy Sheehan, and drummer Gregg Bissonette. Cinderella opened for some of the dates on the tour.

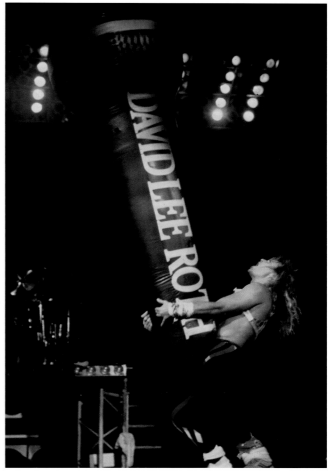

OPPOSITE: Van Halen, *5150* tour **TOP:** Black Sabbath, Canada
BOTTOM: David Lee Roth on the *Eat 'Em and Smile* tour

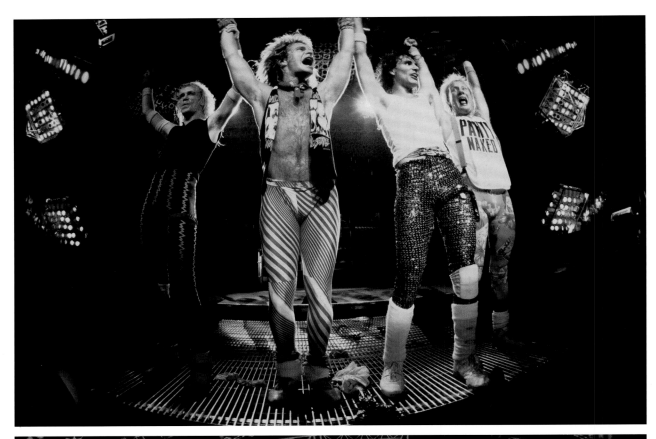

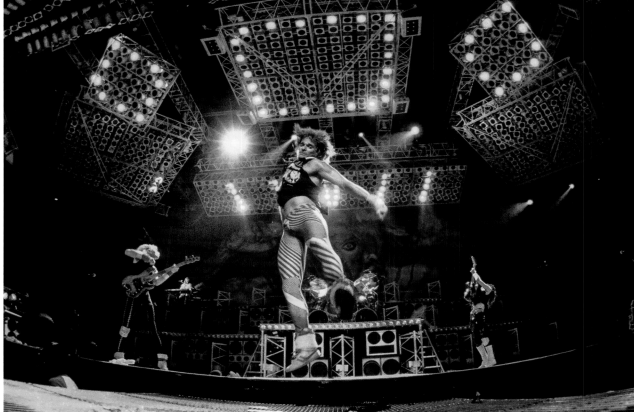

ABOVE AND OPPOSITE: David Lee Roth performing during the *Eat 'Em and Smile* tour

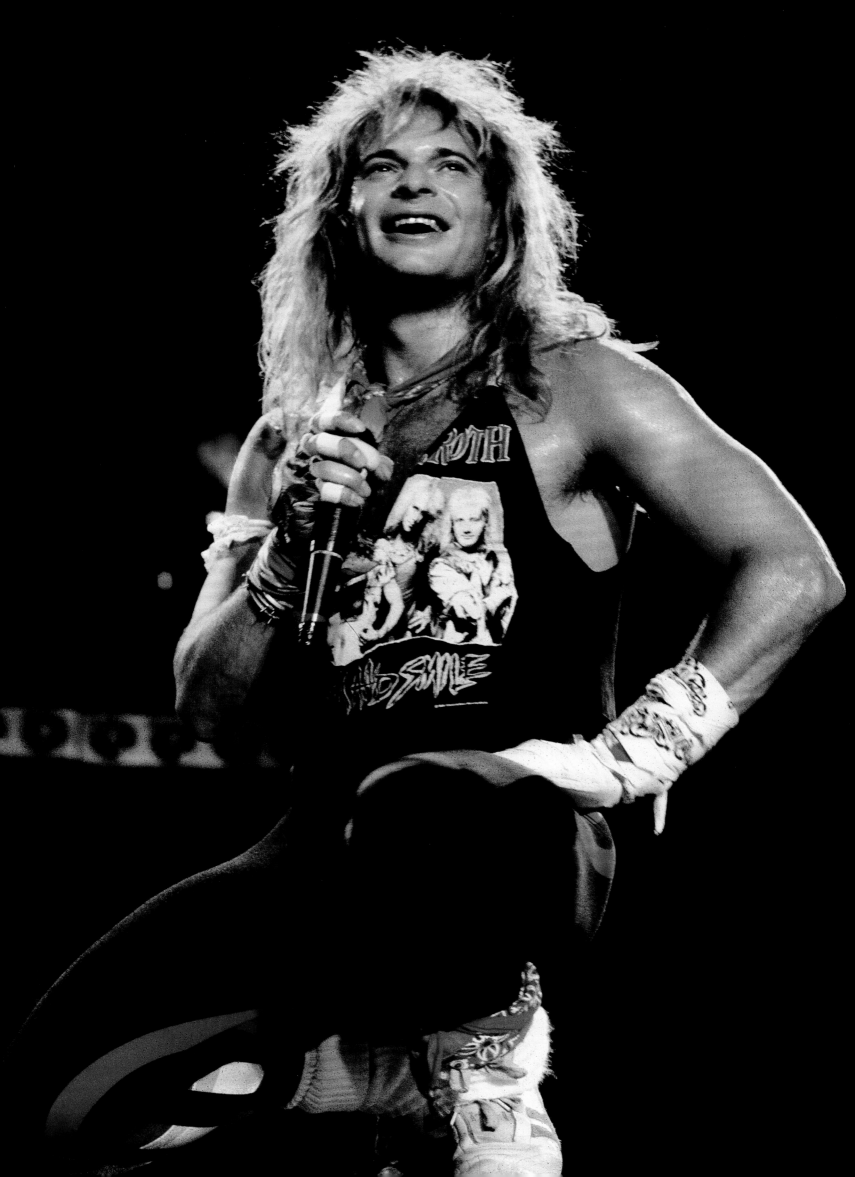

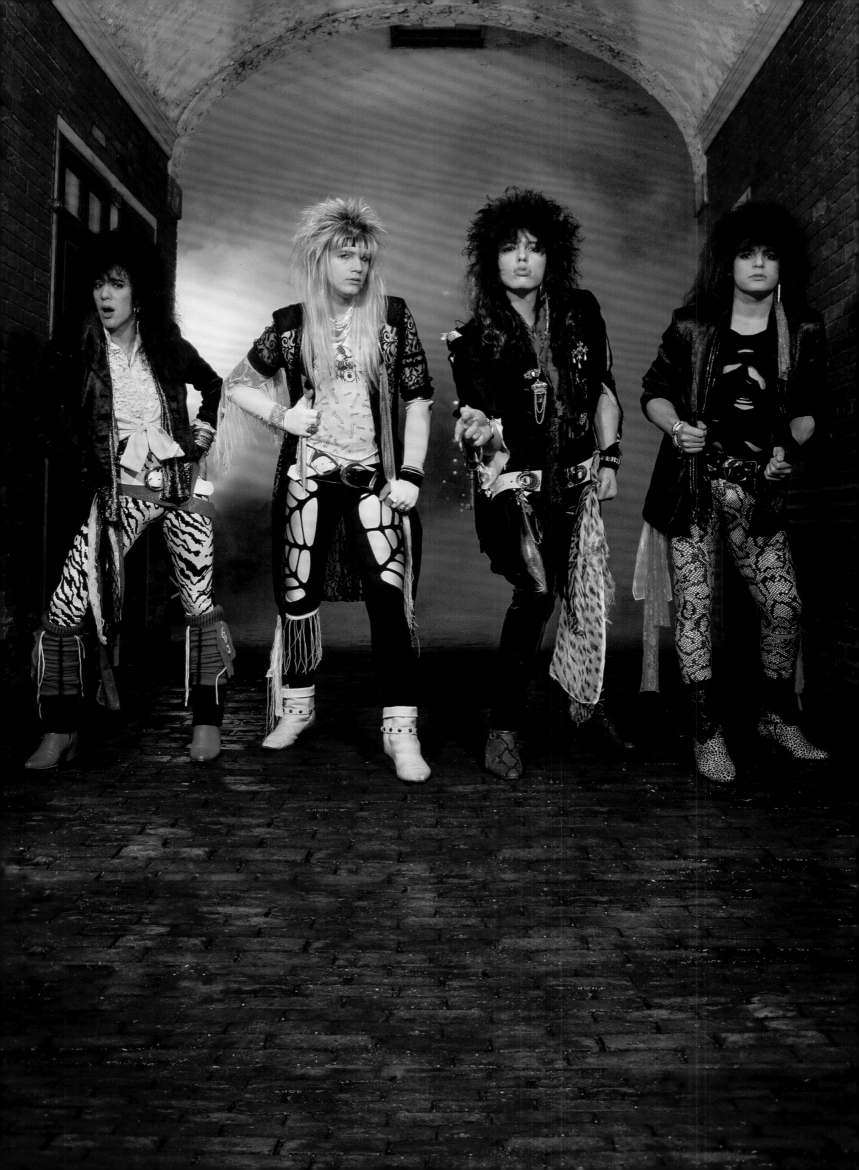

"The cover was shot in the historic district of Philadelphia. But the most interesting thing that I remember is that the album was called *Night Songs* and Mark scheduled the shoot for daytime. I kept saying to him, 'That's not going to look right.' And he said, 'I shoot day for night.' I didn't know what the fuck that meant. I just trusted him because I kind of liked this guy right off the bat. I thought he was a straight-up cat. And sure enough, when we got the pictures back, it looked like it was nighttime. So Mark Weiss is a fucking genius."
—**Tom Keifer (singer and guitarist, Cinderella)**

OPPOSITE: *Night Songs* album cover shoot, Philadelphia **TOP:** Cinderella's Tom Keifer, *Night Songs* tour **BOTTOM:** Tom Keifer with Jon Bon Jovi, opening for Bon Jovi on the *Slippery When Wet* tour

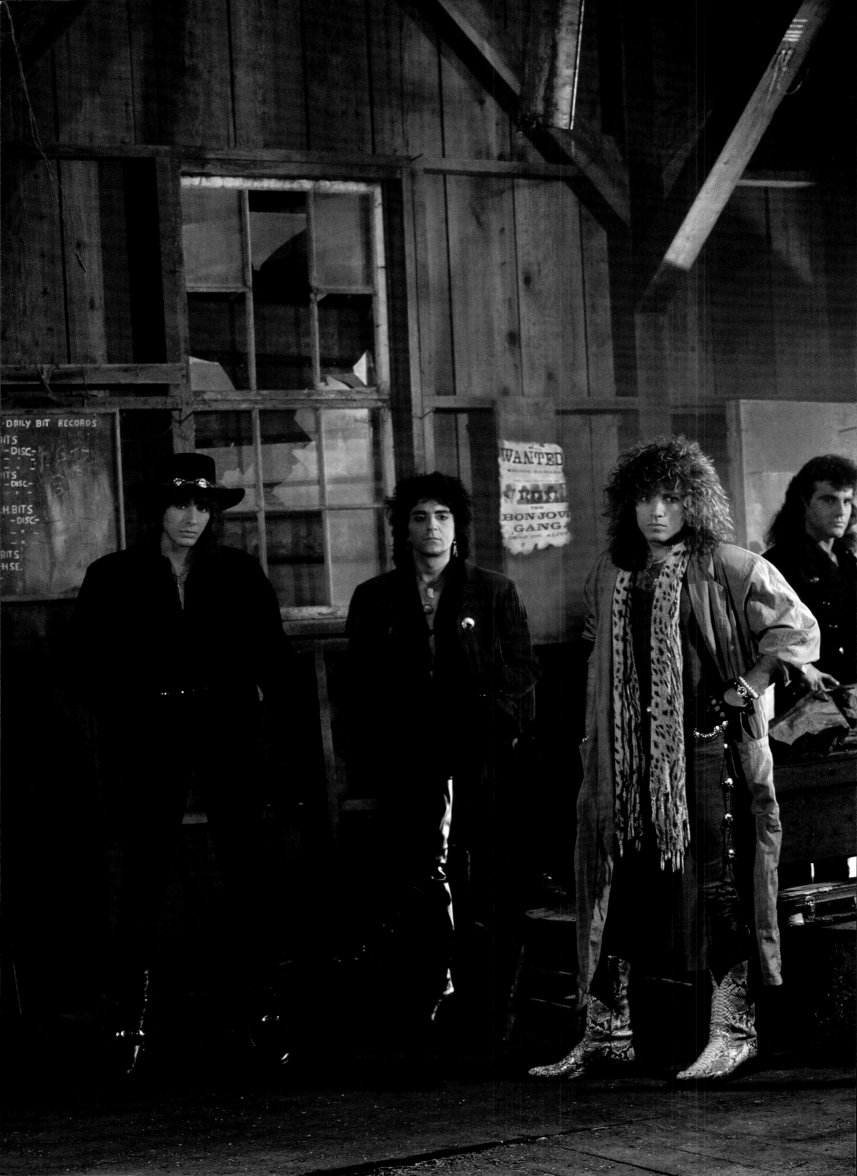

WET AND WANTED

That January, Bon Jovi went to Little Mountain Sound Studios in Vancouver to start work on their third record. I was asked to brainstorm ideas for the album cover. The name they gave me to work with was *Wanted Dead or Alive*. I loved westerns. I came up with what I thought was a no-brainer: I'd have the guys grow beards and put on some cowboy garb, and I used the photos to make up a WANTED poster. The idea was to show the five of them as the Bon Jovi "gang" and have the WANTED poster tacked to the wall where they were "hiding out." Over a three-week period, Richie, David, Alec, Tico, and Jon came to my studio in New York City, one at a time. I would have a good laugh as these formerly clean-shaven guys swaggered in with Billy the Kid looks and attitude. After I shot all of them, I did a sepia print of the solo photos of the guys and glued them to a board and made it look like an authentic WANTED poster, fully weather-beaten and with burnt edges. At this time, they were playing with the idea of putting Jon on the cover of the album, with the band appearing only on the poster in the background. So I spent a very cold day in the dead of winter with Jon, still with beard, in North Jersey, on a set left over from the filming of a western years back.

Then I got a call from the record company. They told me it had been decided that the entire band would be on the cover of the album. I needed to head up to Vancouver, where they were finishing the record. We were still going with the western motif, and I was to find an old abandoned building to use as a background for the shoot. This would be their "hideout," and we'd have the WANTED poster hanging in the background.

OPPOSITE: Bon Jovi, photographed as part of the *Wanted Dead or Alive* album cover shoot. ABOVE: Alternate image from the *Wanted Dead or Alive* shoot. Jon and Mark were driving to the set when they saw the young girl featured in the image playing outside with her father. Jon had an idea to dress her up in cowboy garb and shoot her at the location as a potential cover option. PAGES 228–229: Bon Jovi, individual headshots, *Wanted Dead or Alive* album cover shoot, Mark's studio, New York City

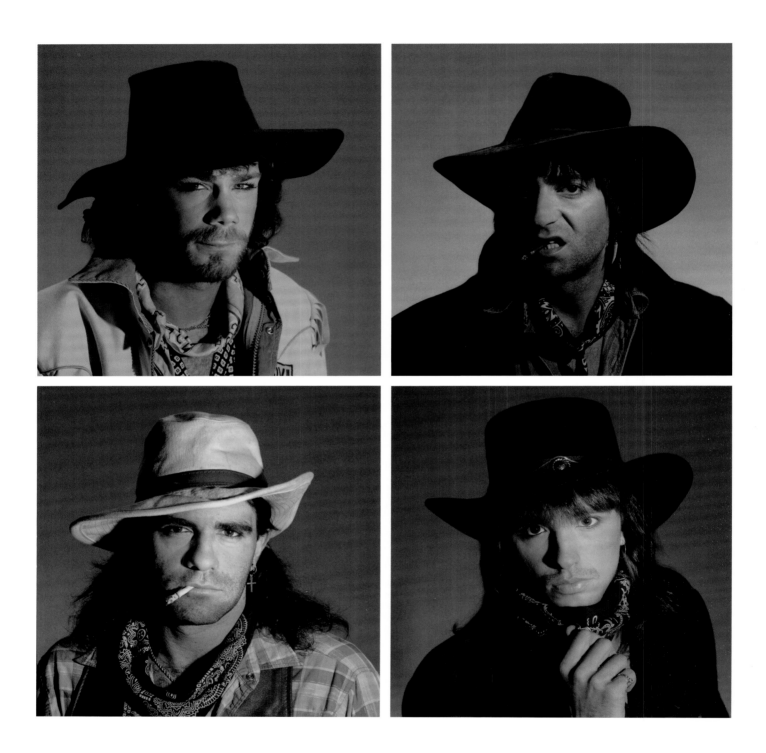

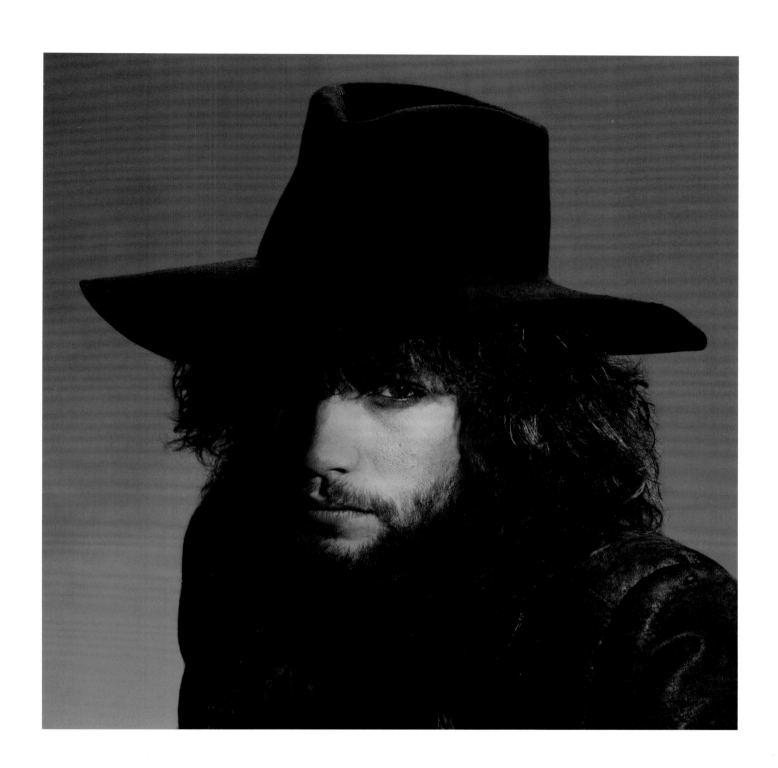

Once in Vancouver, I met the guys at the studio where they were working with producer Bruce Fairbairn. After they were done recording, we headed over to the No. 5 Orange, a local strip club that would later inspire the new title of the album. At this time, however, the title was still *Wanted Dead or Alive*.

After a few days in Vancouver, I found the ideal spot for the shoot: an old abandoned barn at the top of a mountain, about an hour's drive up a long and winding road. There was no electricity, so I rented generators to plug my lights in. We were on the sly, and we had to climb through broken windows just to get in.

We spent hours in this old abandoned barn. It was raining and began to get cold. A few locals saw the flashes from the strobes and came in to see what was going on. I was getting a bit nervous, fearing the police would come and kick us off the premises. I had an assistant act as a lookout man. Finally, after shooting nearly thirty rolls of film, I called it a wrap. Then we quickly packed up and drove 50 miles back to the hotel . . . only to learn that the film I had shot was nowhere to be found. I freaked out on the assistant after he told me he thought I had taken the bag of film. It was 3 a.m., with thunder and lightning, and we could barely keep our eyes open as we drove back up to the barn with flashlights to look for this black film

bag as if it were a sack of gold. About an hour later, I spotted it. Crisis averted! Ironically, on the drive home down the long, winding road, I noticed several signs that read SLIPPERY WHEN WET.

The next day, we had a few drinks at the No. 5 to celebrate the completion of the cover art. Little did we know, the title *Wanted Dead or Alive* was about to be canned. But there would still be another cover idea before Jon resorted to writing *Slippery When Wet* on a garbage bag—one day before the record needed to be shipped.

It was a few months later when I got the news that the title was going to be changed. I was a bit disappointed at first, but when I heard the new title—*Slippery When Wet*—and the concept, I was in. The title was inspired by the No. 5. The girls there would take off their clothes while dancing suggestively in a Plexiglas see-through shower on top of the bar. The idea was to make up a shirt with the words "Slippery When Wet" written on the front in the style of the street sign. Then we'd put it on a voluptuous girl, add a few provocative cutouts, and there you have it—a classic album cover.

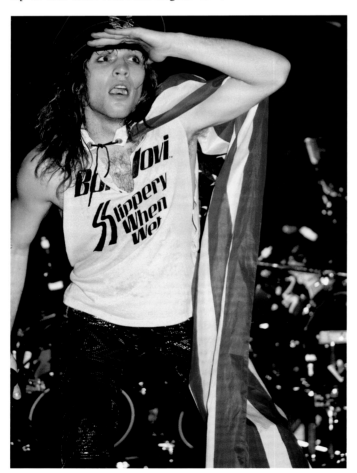

The guys came home after finishing the album, and now we needed to do band photos without their cowboy look. Jon lived right across the street from the ocean in Bradley Beach, New Jersey, and that seemed as perfect a spot as any. All the guys came with their cars, motorcycles, and girls. Even then, we needed a few more girls, so I asked for volunteers to go find some hot Jersey girls. Tico quickly raised his hand and walked across the street to the beach with Danny, my assistant. They came back with just what the doctor ordered: a hot Italian girl named Angela. Immediately, we knew this was going to be the one for the cover. I put her front and center in the band

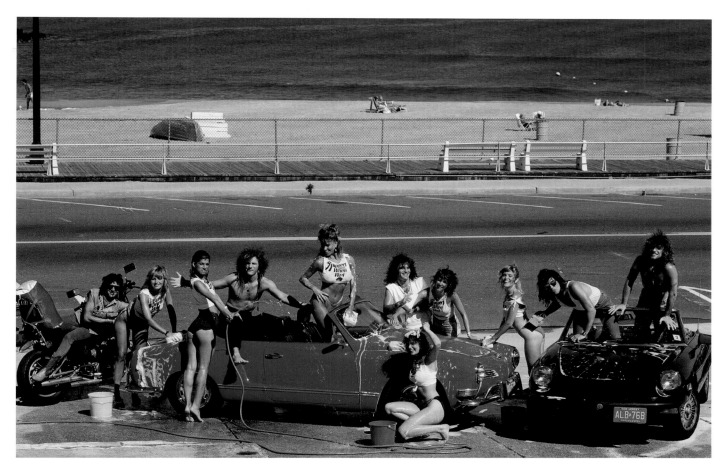

car-wash photo that was used on the inner sleeve of the final album package.

A couple of weeks after that, I did another shoot with Angela at my studio in New York: a blue background, a piece of glass, soapsuds, and some ice were added to perk things up a bit. Angela put on the provocatively cut T-shirt, which was now dyed yellow. Bon Jovi's label loved it, and the new album campaign was set to begin. I had some signs made, and the band and I went around Rumson, another New Jersey town on the coast, and took some shots. We ended up on a dead-end street next to the post office. This was to be the back cover of the album. We also did promo photos at a studio in Red Bank. Three hundred thousand copies, with Angela in her cut-up wet T-shirt clinging to her 34DD breasts, had already been released in Japan. The albums were ready to be distributed in the US.

But this was 1986, and the PMRC was in full swing. Record stores were telling the labels to ease up on the explicit content and imagery or they wouldn't sell the products. PolyGram knew they had a smash album on their hands, and they didn't want to jeopardize that success. They also knew the music stood on its own, so we went back to the drawing board to come up with another cover. Mercury destroyed hundreds of thousands of copies before they ever left the warehouse to be distributed in the US. Jon had issues with the cover as well, but his

issues were more about the color of the border around the photo than the actual photo itself. Recently, he told Howard Stern that his thinking was, "My career is over if we put out a hot pink album cover." Finally, the label's art director had an idea that we all thought was a joke. But we went through the motions and I shot it, as no one had any other ideas. We spent $2,000 on a hand model and $1,000 on a bar of soap with the title carved into it. But it was money thrown down the toilet. There was nothing rock 'n' roll about the image.

After Jon saw the soap cover, he called me to say he was coming over. I asked him what we were going to do, and he replied, "I don't know, but this is our last chance or the album gets held up." Jon arrived at my studio, walked inside, and didn't even say hello. "Garbage bag. Spray bottle," was all he said. I followed orders. I propped up the black garbage bag and sprayed it with an oil and water mixture. Then Jon wrote the words SLIPPERY WHEN WET. As he was leaving, he said, "That's it. That's their cover." He didn't even wait to see the Polaroid. The next day, I delivered the photo, and the rest is history. As Jon later explained on VH1's *Ultimate Albums*, "Don't tell me that red album covers sell, and don't tell me that my picture on the cover sells. I don't want to hear it. Here's your album."

OPPOSITE TOP: Option considered for *Slippery When Wet* album cover
OPPOSITE BOTTOM: Jon Bon Jovi onstage **ABOVE:** Bon Jovi, *Slippery When Wet* album shoot, Bradley Beach, New Jersey

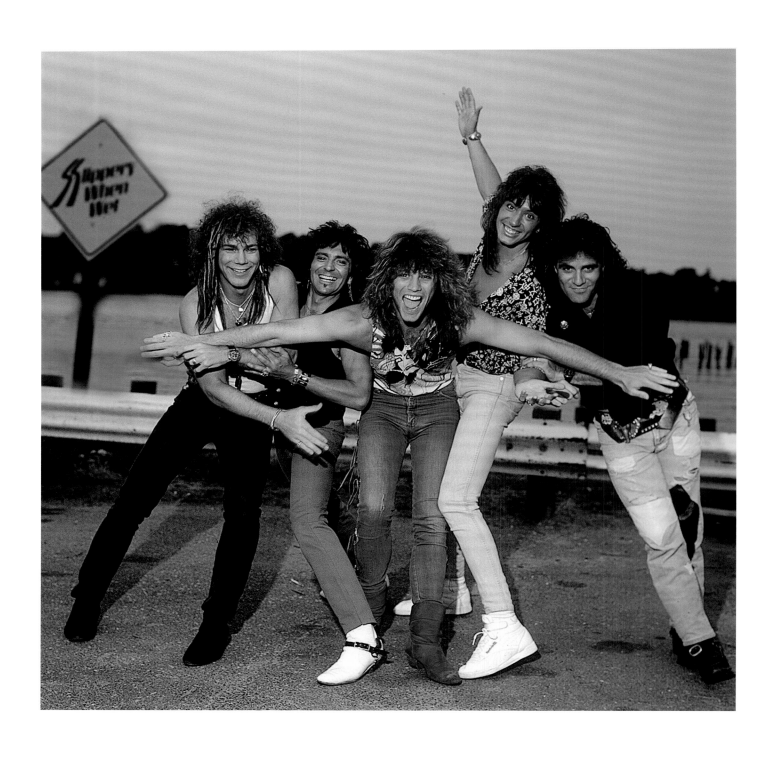

ABOVE: Bon Jovi, *Slippery When Wet* album shoot, Rumson, New Jersey
OPPOSITE: Angela, *Slippery When Wet* album shoot, Mark's studio, New York City

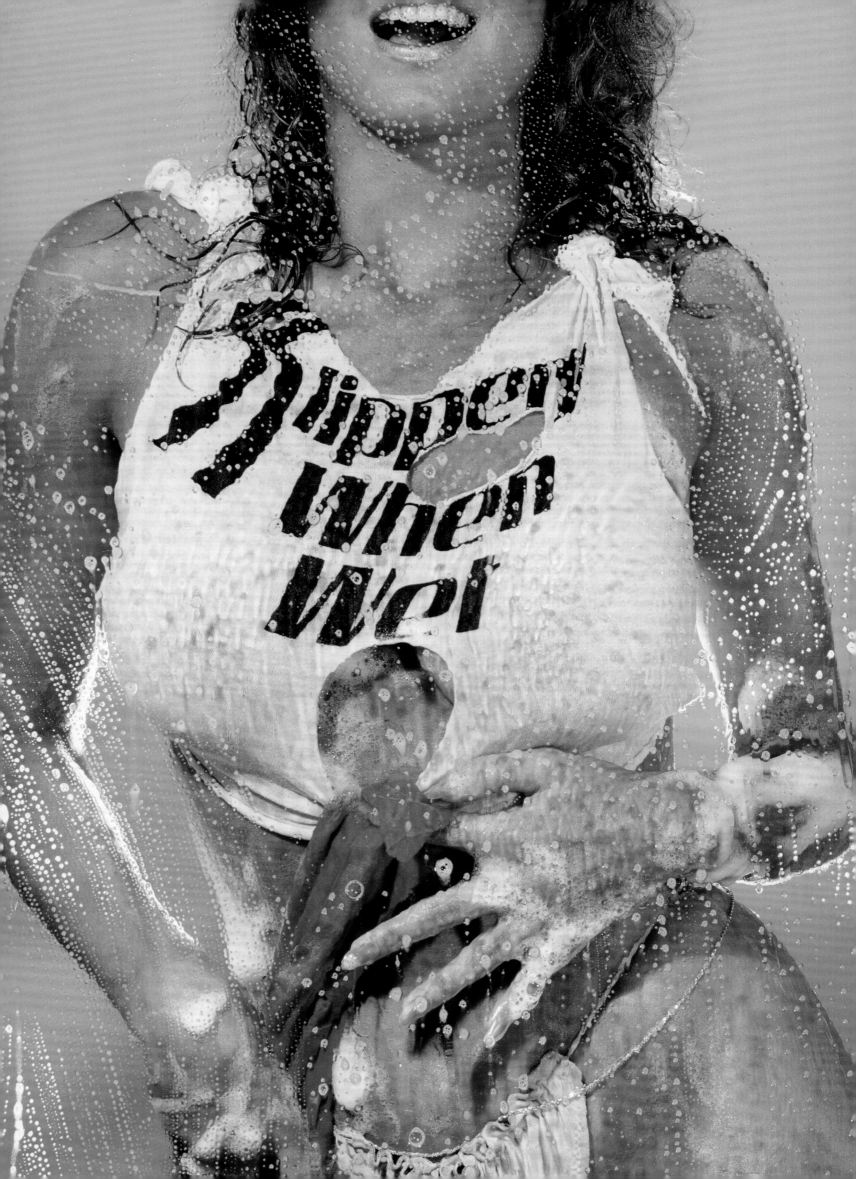

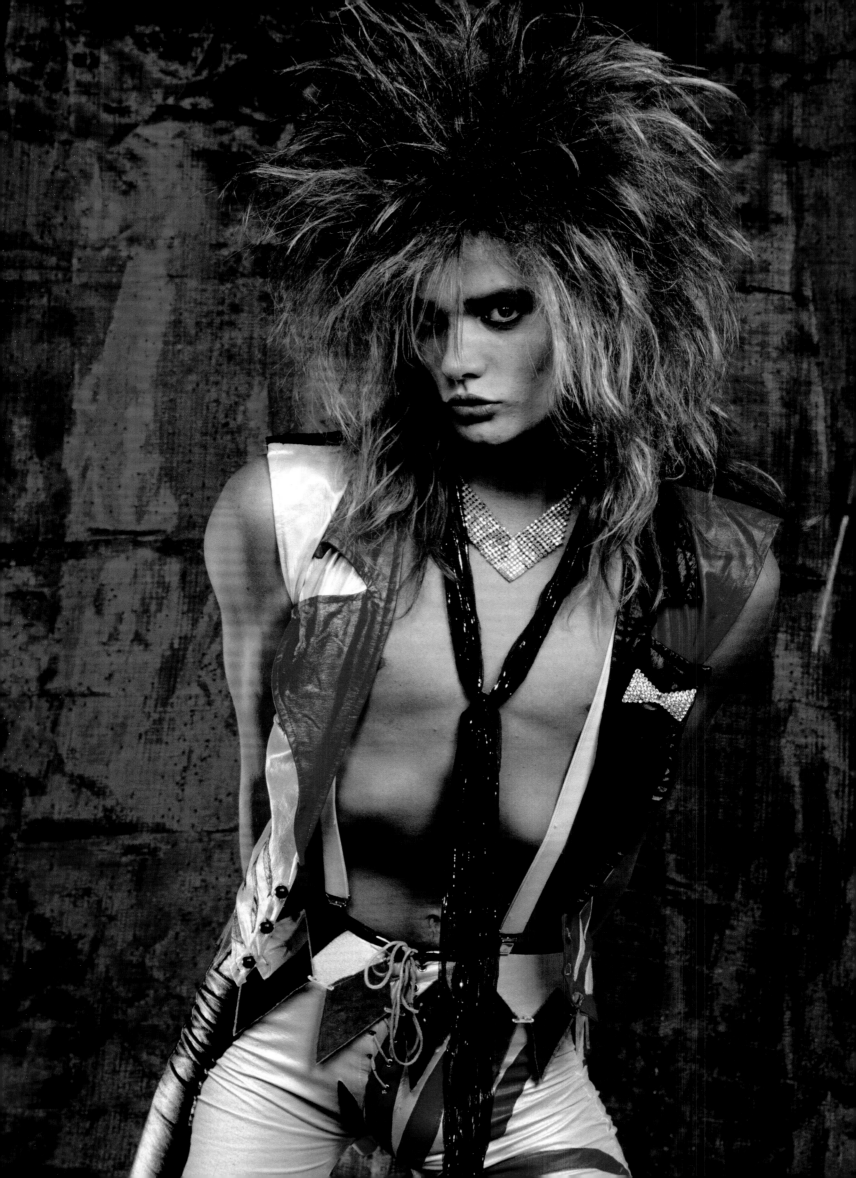

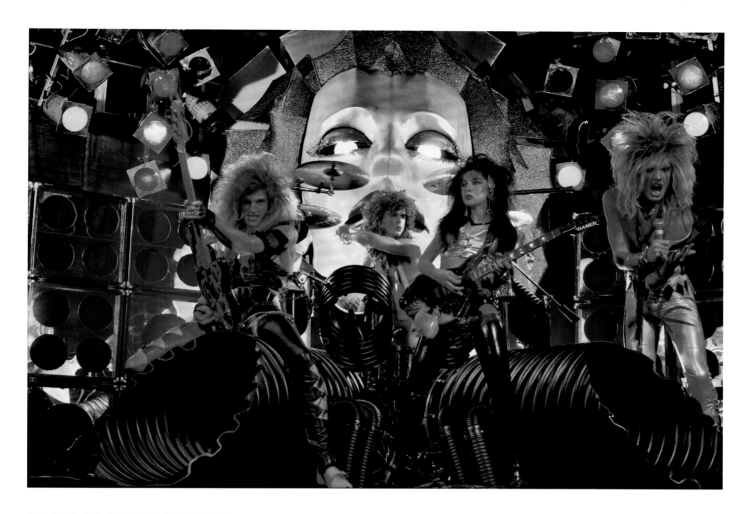

HIGH IN HIGH SCHOOL

A few days before Thanksgiving, I got a call from Maxine Petrucci, the guitar player in Madam X, who I shot the year before. She told me the band had re-formed and I'd be blown away by the new singer. She had an investor in Phoenix who would take care of my hotel, travel, and fee to come do a shoot. I asked them to book me a return flight to Hollywood. I was due for a trip to the West Coast to set up some shoots. When I got to Phoenix, the band was in the middle of dress rehearsals for a local show they had coming up. They stopped what they were doing to say hello, and Sebastian rushed to me, grabbed my hand, and took me backstage. "Check out my girlfriend, Maria—isn't she hot?" Who knew that twenty years later my future wife would be the godmother of their daughter, Sebastiana?

We needed a background for the shoot, and I asked Maxine to take me to a landscaping store that I had seen on the way to the club. They had a shiny black weed-barrier fabric that landscapers used to put under rocks that I thought would be perfect. I bought some of that fabric and then used a little bit of smoke and some colored gels to change the background colors. The fabric became the background for many of my shoots to come. I used it for Guns N' Roses a week later in Hollywood at our first shoot in the fall of '86. They were still working on their debut album, *Appetite for Destruction*, at the time. But the buzz was out. *Hit Parader* editor Andy Secher had seen them play and knew they were the ones to look out for. He had me shoot them for the cover of the magazine. When I first met the guys, they were a bit guarded. They had their own photographer, who was there, and the band didn't want to shoot with anyone but him. But Bryn Bridenthal, who had moved from Elektra to Geffen, was adamant about having me shoot the band. I remember Axl not wanting to look in the camera. I also thought it was peculiar that they were all glammed up, but then on Axl's pants it was written GLAM SUCKS.

By the end of the year, I had started working for *RIP*, a new magazine that was taking rock journalism in a fresh direction, with bold interviews and features on heavier bands as well as conceptual covers. *RIP* contacted me to set up a cover shoot with Ozzy for the premiere issue, which came out at the end of '86.

OPPOSITE: Sebastian Bach with Madam X, Phoenix, Arizona
ABOVE: Madam X performing live, Phoenix, Arizona
PAGE 236: Madam X **PAGE 237:** Madam X's Maxine Petrucci

"I was very excited because I had known about Mark and all the photos he'd taken since *Circus*. And I was very honored to work with a real famous rock 'n' roll photographer. I think he's the first famous, well-known rock photographer who ever shot me!" —**Sebastian Bach**

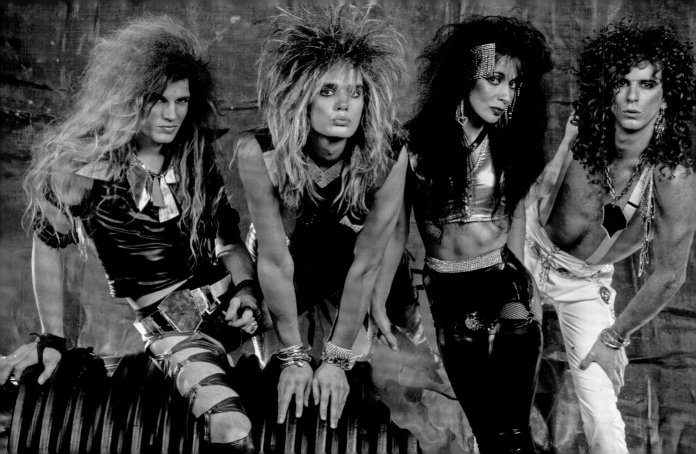

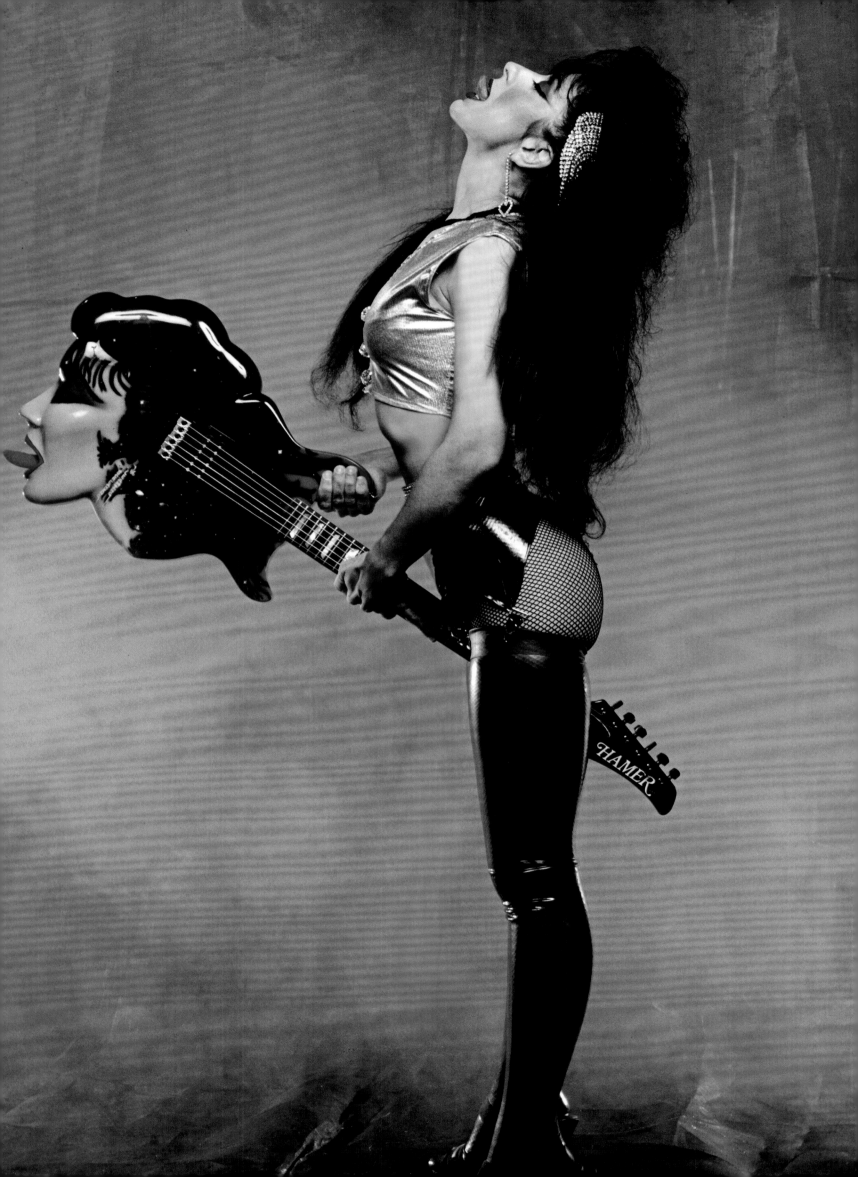

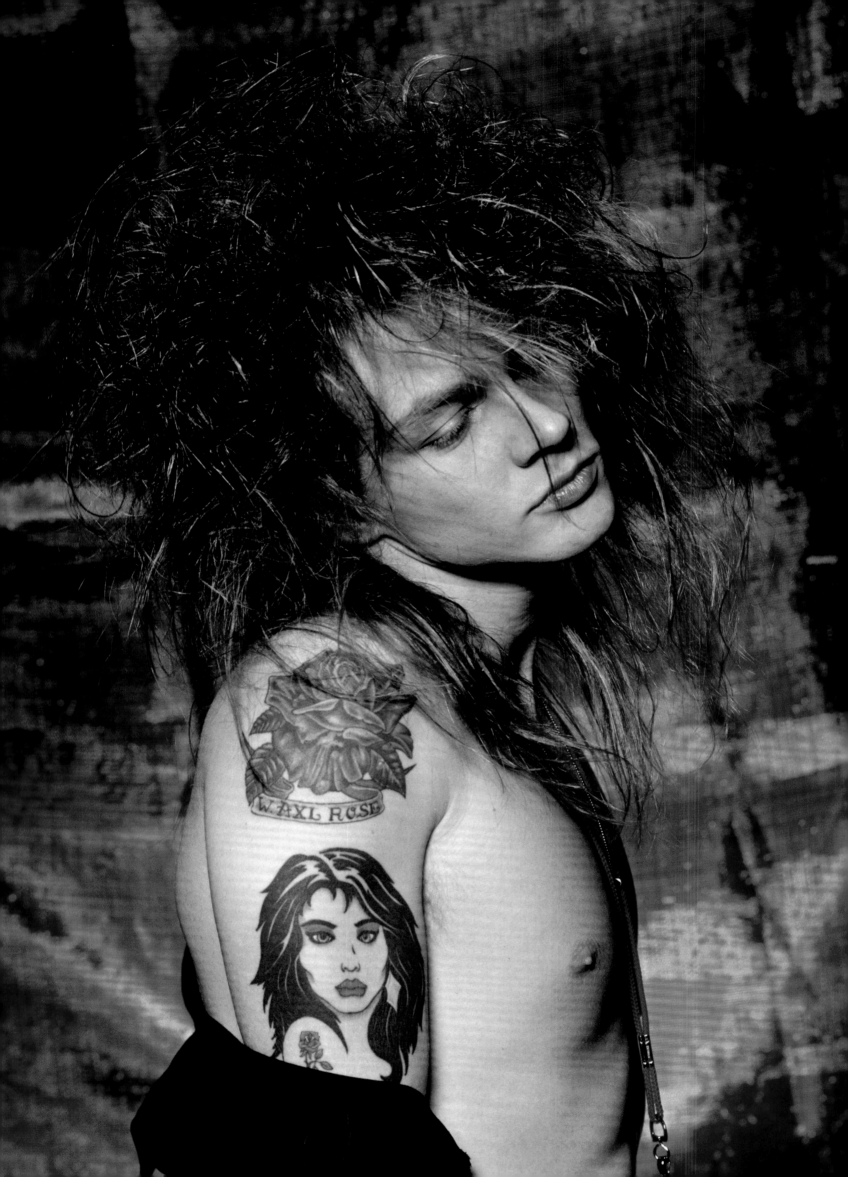

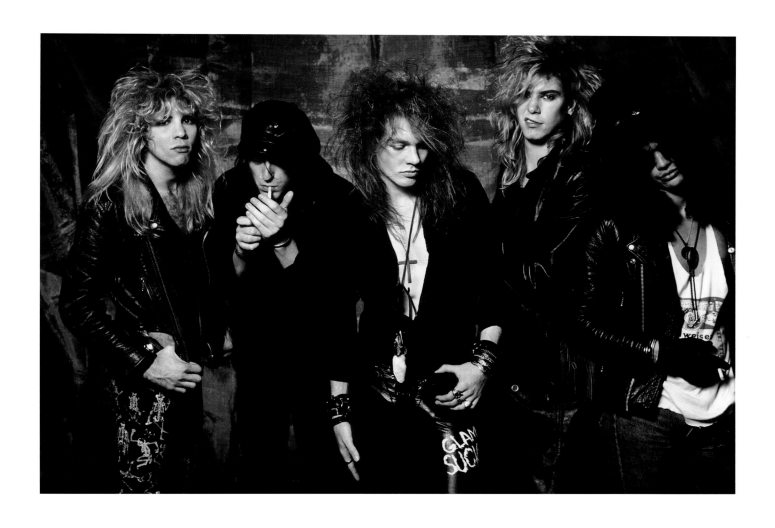

"Mark made all those moments that weren't so pretty look pretty. He had that magic touch. Like Guns N' Roses did when the five of us were together. We could do no wrong. And Mark had that same magic. He always knew the exact moment to push the button." —**Steven Adler (drummer, Guns N' Roses)**

OPPOSITE: Axl Rose of Guns N' Roses, Los Angeles **ABOVE:** Guns N' Roses

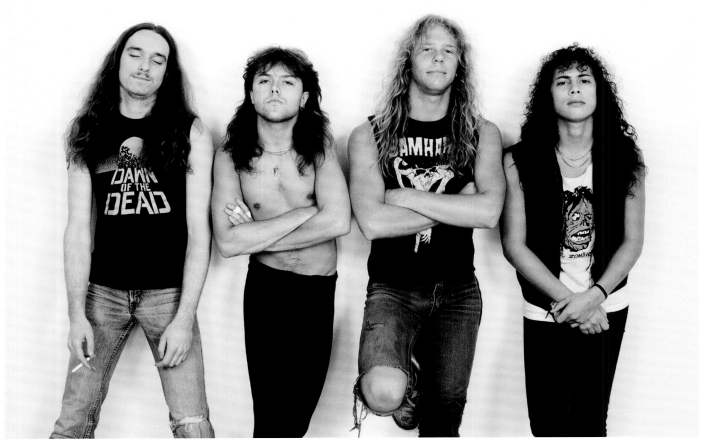

SEEK AND DESTROY

I would go out with Ozzy for a week at a time during his *Ultimate Sin* tour that year. His opening act was Metallica, who had recently released their third album, *Master of Puppets*. The record was getting a lot of buzz, and the magazines started requesting shots of the band. So I introduced myself to the guys in Metallica and asked if it would be cool if I shot the shows. I told them I would be on and off the tour and that I would bring them the photos to approve. They liked what they saw, and soon enough, we began doing shoots before and after the shows as well. That September, the band was on a European tour, traveling from Stockholm to Copenhagen, when their bus flipped over. Tragically, their bassist, Cliff Burton, was killed in the accident. Afterward, the rest of the guys regrouped in San Francisco and eventually began rehearsing with a new bassist, Jason Newsted. My good friend George Dassinger at Elektra Records asked me to come and take their new publicity photographs.

THESE PAGES AND PAGES 242–245: Various images of Metallica on the Damage, Inc. tour: (*above*) Group with bassist Cliff Burton; (*bottom*) Lars Ulrich; (*opposite top left*) Cliff Burton; (*opposite top right*) James Hetfield; (*opposite bottom*) Group with bassist Jason Newsted; (*pages 242–243*) Metallica in their dressing room; (*pages 244–245*) Metallica at the Golden Gate Bridge in San Francisco

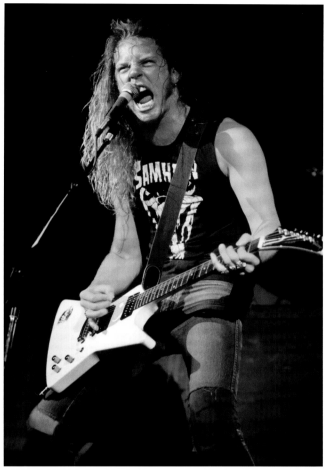

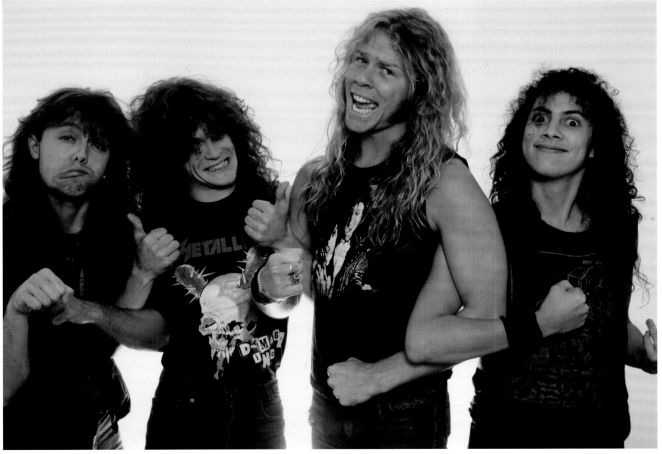

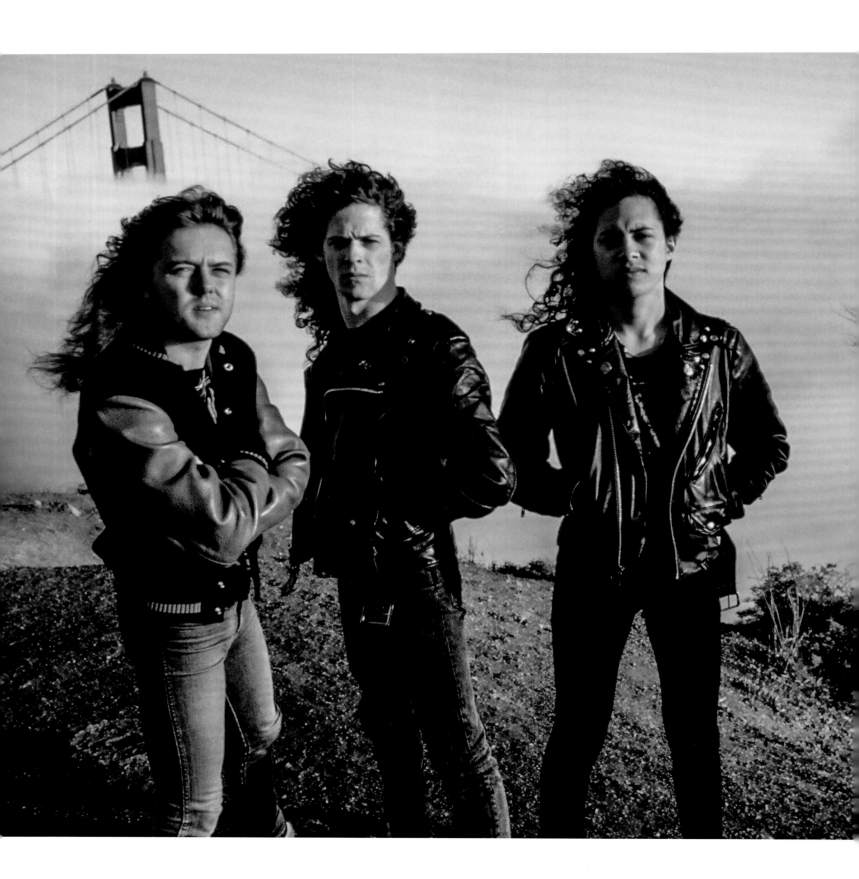

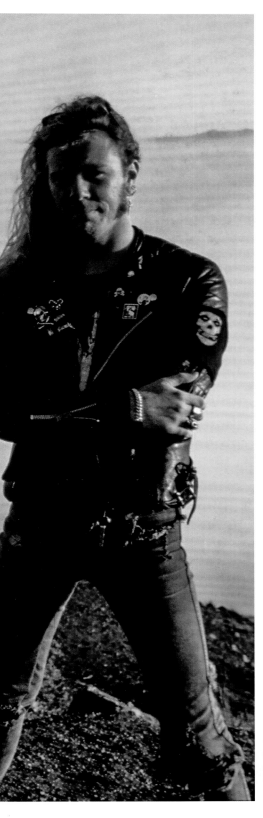

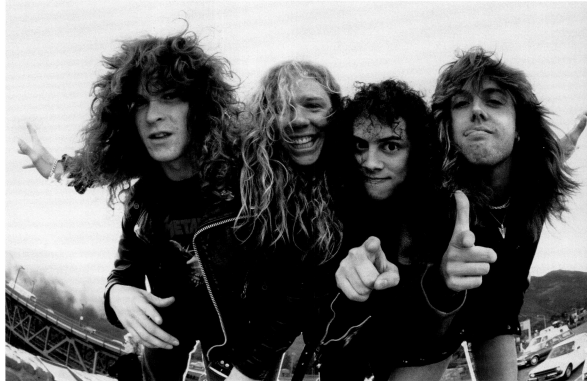

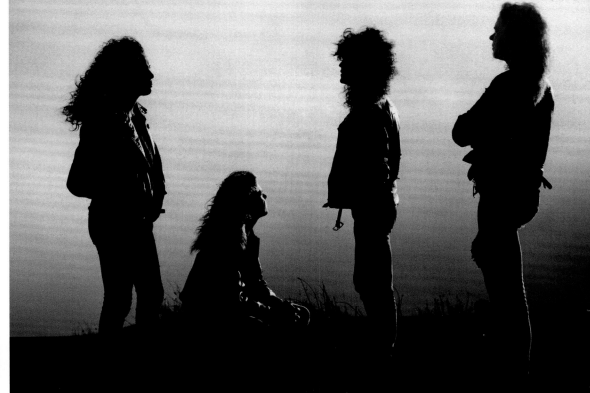

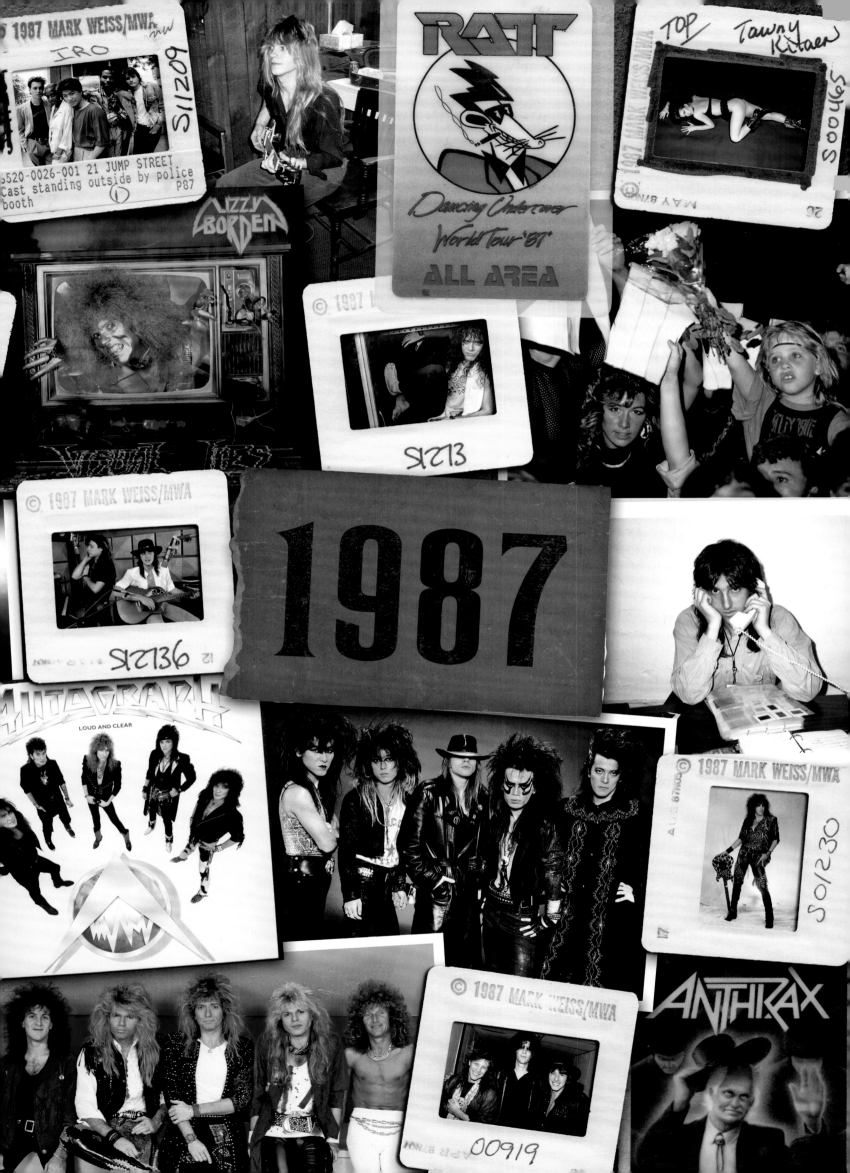

1987

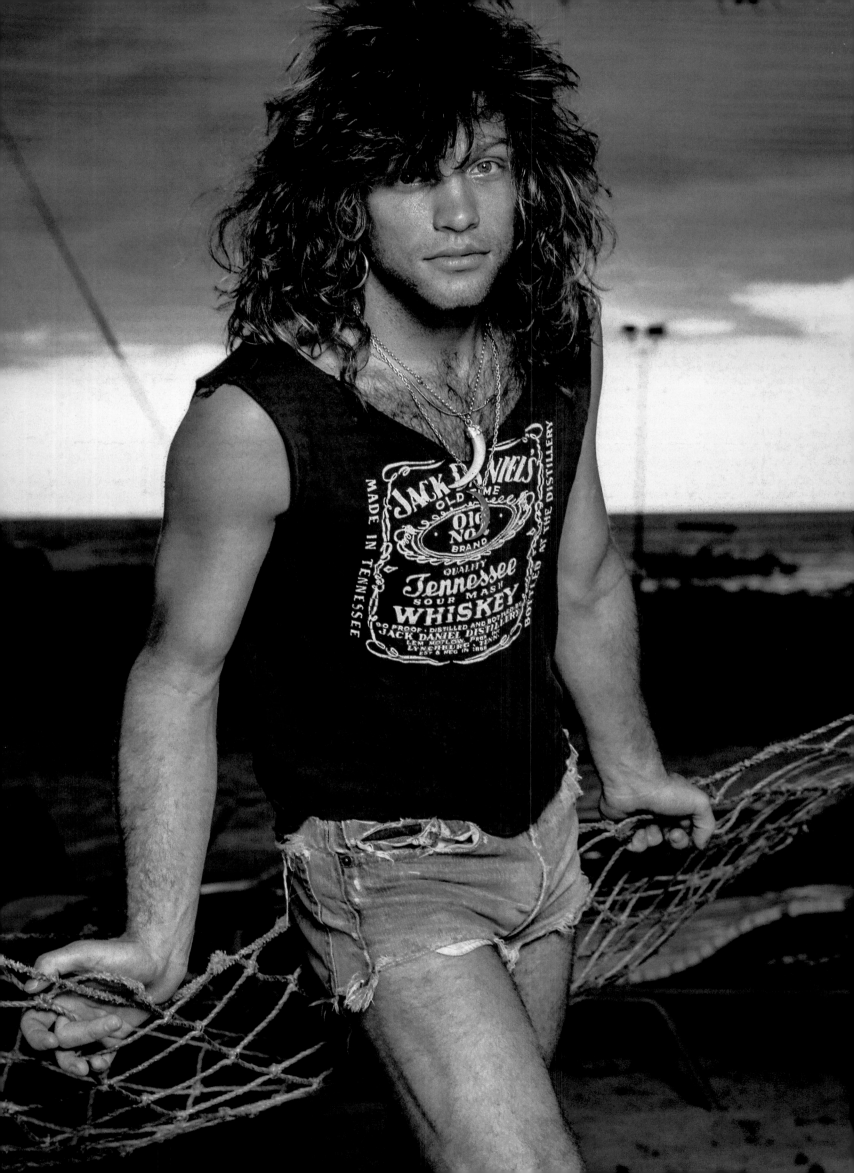

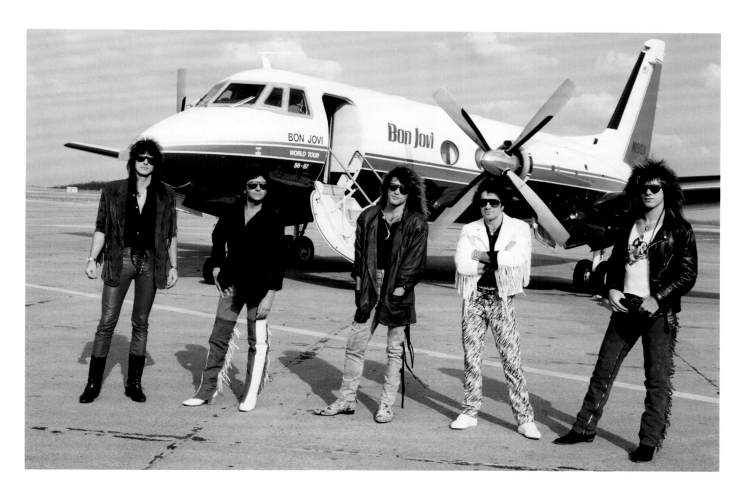

FLYING HIGH AGAIN

Metal music had become mainstream. I had become main-stream right along with it. I never knew where the next job would come from—I even got a call to shoot photos of the cast of a new TV show on Fox. It was titled *21 Jump Street*, and it starred an unknown young actor named Johnny Depp. The '80s were in full swing. Business was good. I was engaged to be married in June, and by the end of the year, I would play a part in rock 'n' roll history, intro-ducing two talented teenagers to the music world. One would grace the cover of *Rolling Stone*, and the other would become a legendary guitarist, touring the world and play-ing sold-out arenas alongside the Prince of Darkness.

I was photographing Guns N' Roses just as they started to take off. Meanwhile, artists such as Bon Jovi, Ozzy, Kiss, and Mötley Crüe were selling out arenas, and I was there, traveling and documenting the tours in between photo shoots at my studio. Doc McGhee made sure his bands traveled in style, and some of them, like Bon Jovi and Mötley Crüe, had their own jets. With the success of the *Slippery When Wet* and *Girls, Girls, Girls* tours, magazines did full issues and specials on them. The photo business was booming, and I was raking in the money.

In February, MTV sponsored a "Hedonism Weekend with Bon Jovi" contest. MTV hired me to tag along with the band to Jamaica to take photos with the winners. Cin-derella's Tom Keifer and Poison's Bret Michaels were both riding high on the success of their bands' debut albums, *Night Songs* and *Look What the Cat Dragged In*. I shot the two front men backstage at the Meadowlands in New Jer-sey, where Cinderella opened for Bon Jovi on New Year's Eve. Tom and Bret proudly showed off my photo for the *Night Songs* album cover on Cinderella's tour laminate.

The '80s were also the heyday of custom guitars. From crazy colors to eye-popping graphics and radical shapes, players wanted the most unique designs they could come up with. Performing and posing with what were essentially pieces of art was another form of artis-tic expression for many guitarists of the era. I was al-ways trying to come up with ways to loosen up my sub-jects before a shoot. One day, I walked into a novelty store and saw some blow-up guitars. I knew they would be perfect—an instant icebreaker. It was a bit corny, but it was all in good fun.

OPPOSITE: Jon Bon Jovi, MTV's "Hedonism Weekend with Bon Jovi," Jamaica **ABOVE:** Bon Jovi in front of tour jet, *Slippery When Wet* tour **PAGES 250–251:** Mötley Crüe about to board their jet during their *Girls, Girls, Girls* '87–'88 world tour

"Bon Jovi took the rock 'n' roll message around to the planet, and we wanted to have that chronicled. And Mark was the guy to do it." —**David Bryan (keyboardist, Bon Jovi)**

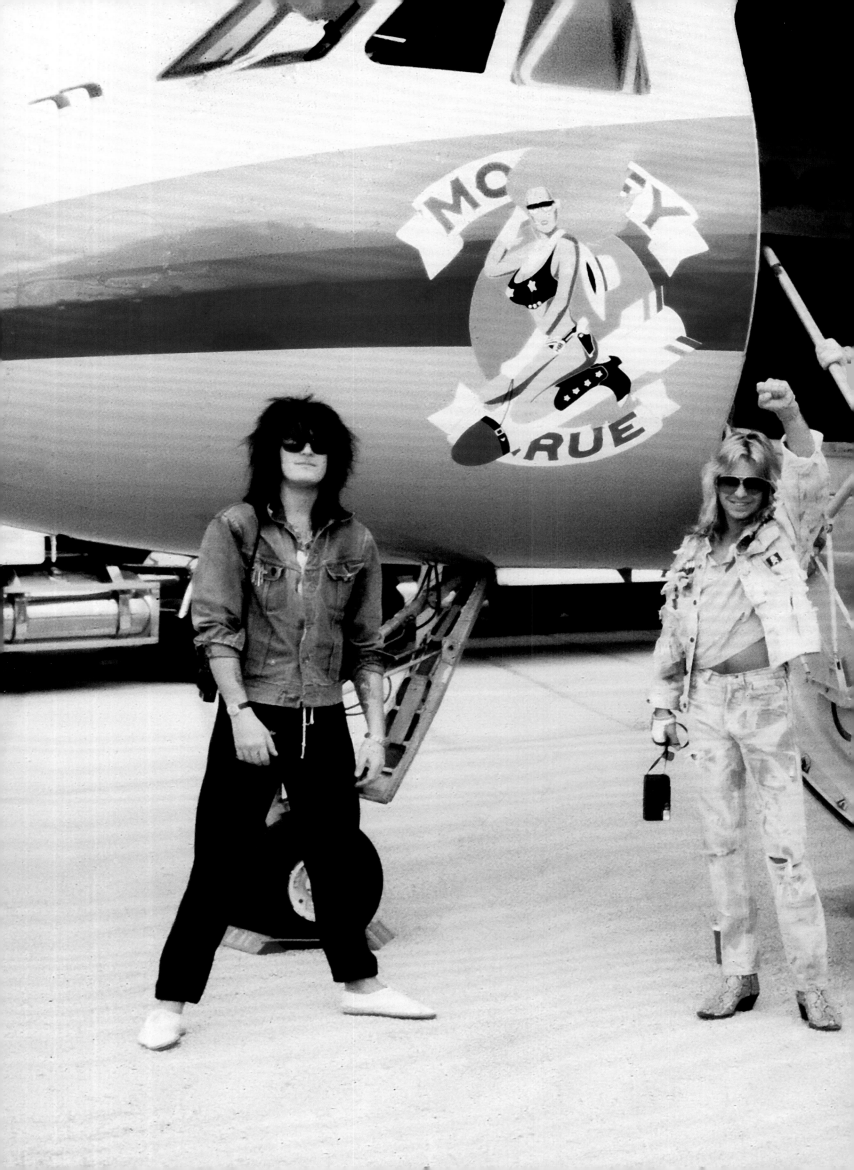

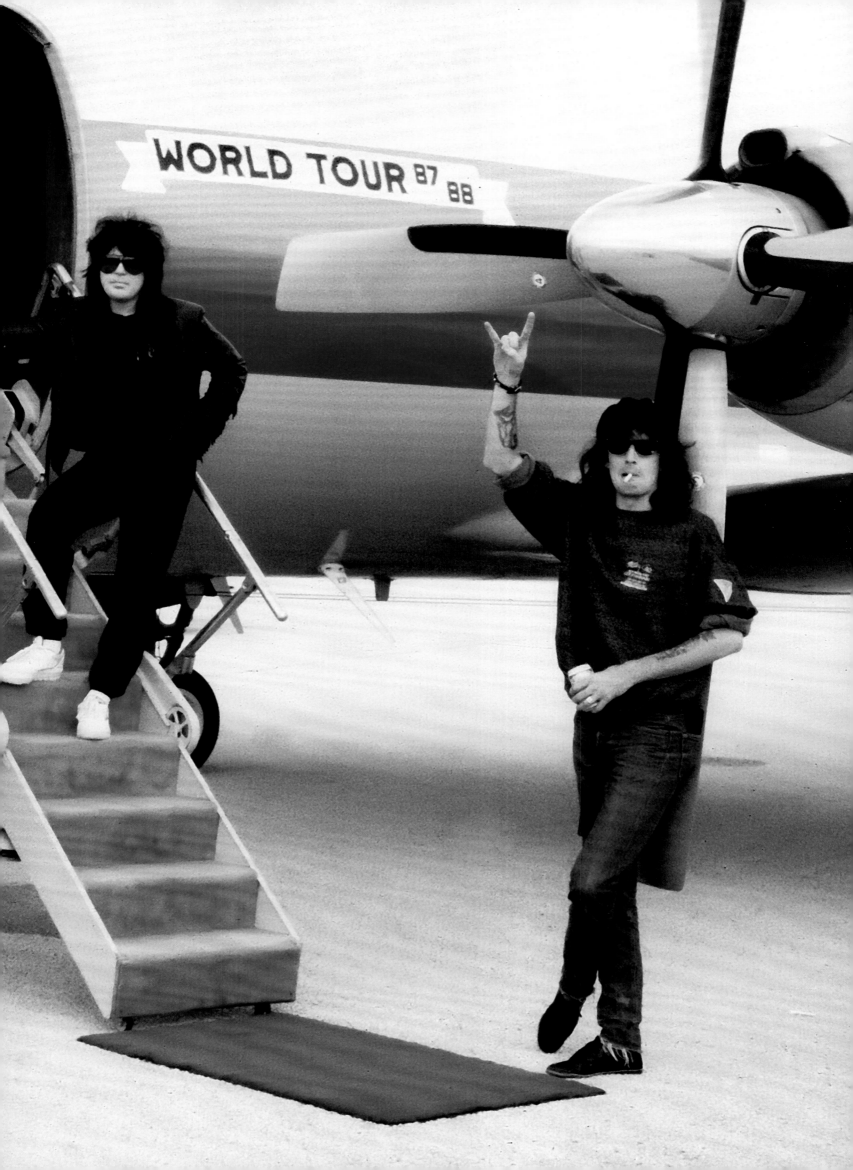

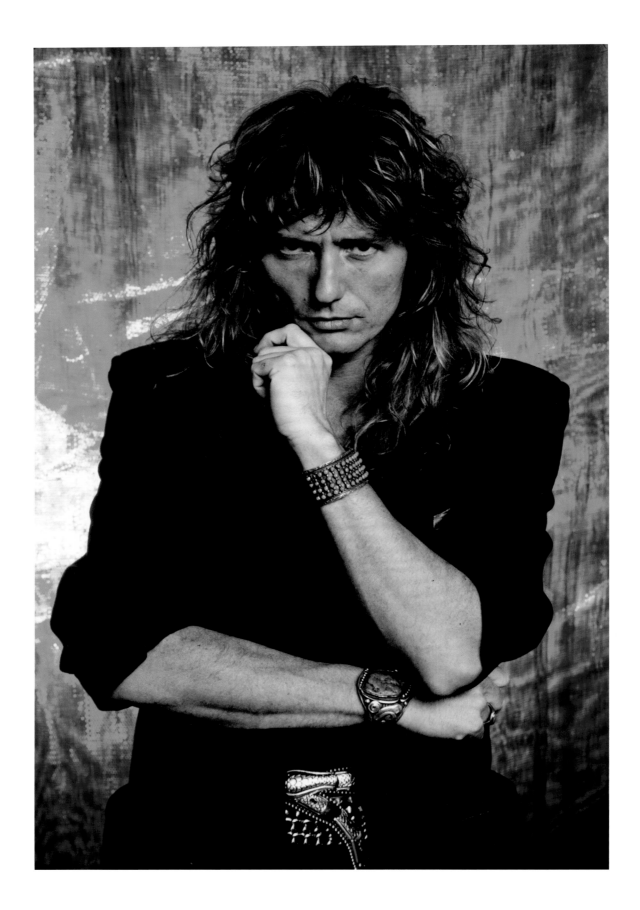

"The rock photogs were fans as well as great assists in helping us get our music across. Mark's work was and remains exemplary. A good guy, too. He never overstepped the boundaries. He was always welcome around us."
—David Coverdale (singer, Whitesnake)

ABOVE: Whitesnake's David Coverdale **OPPOSITE:** Cinderella's Tom Keifer and Poison's Bret Michaels, the Meadowlands

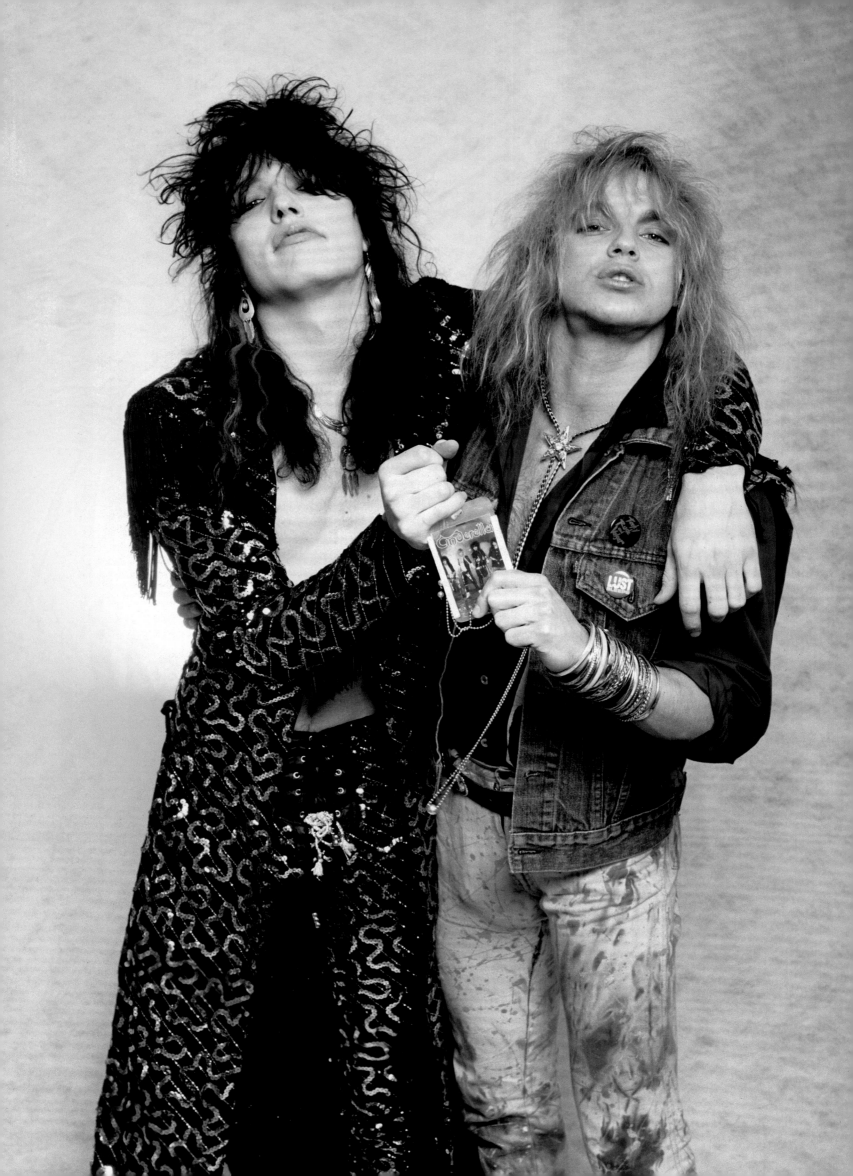

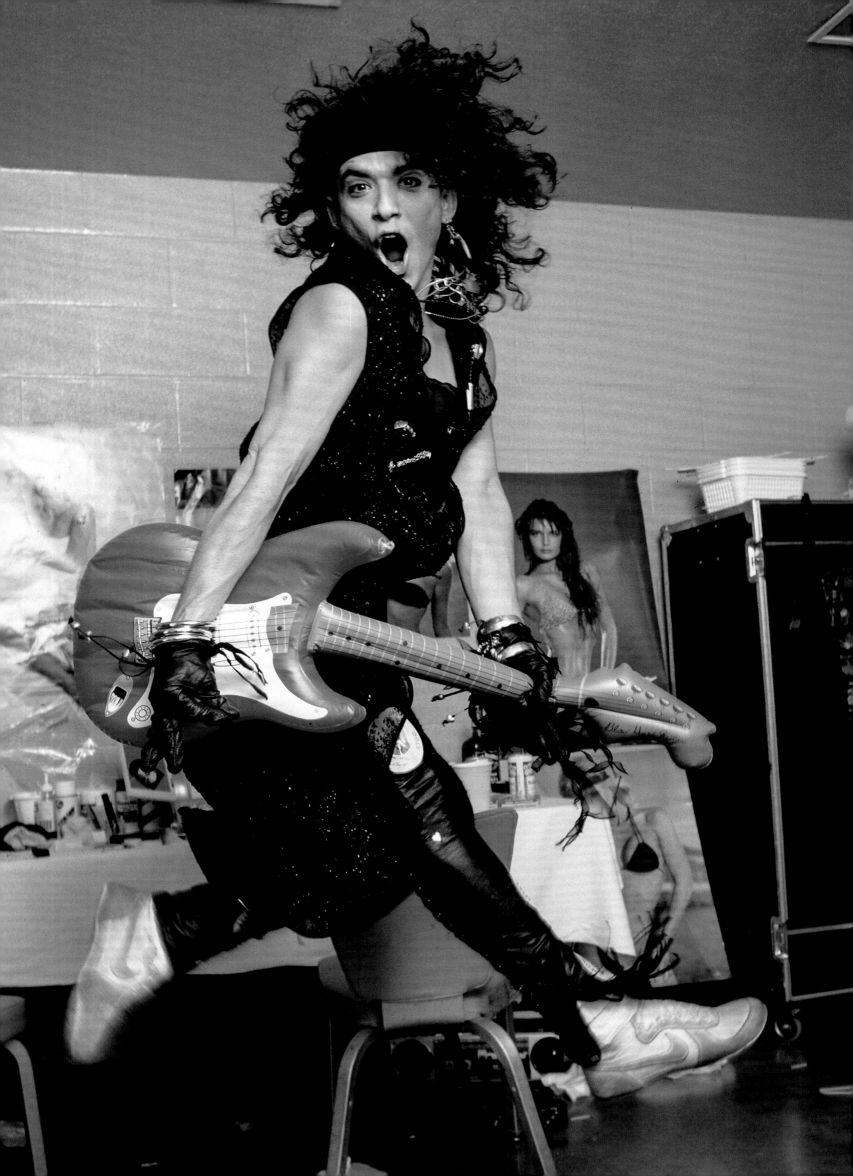

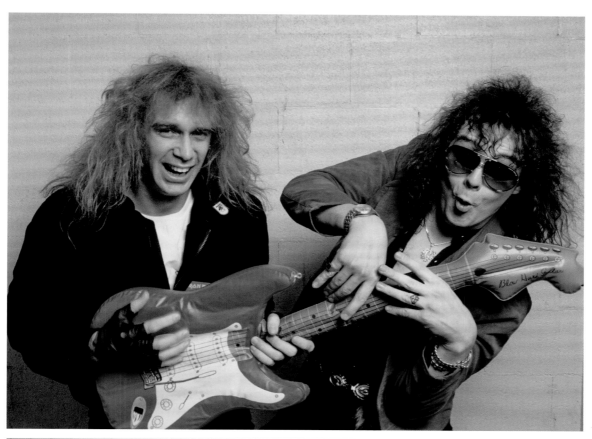

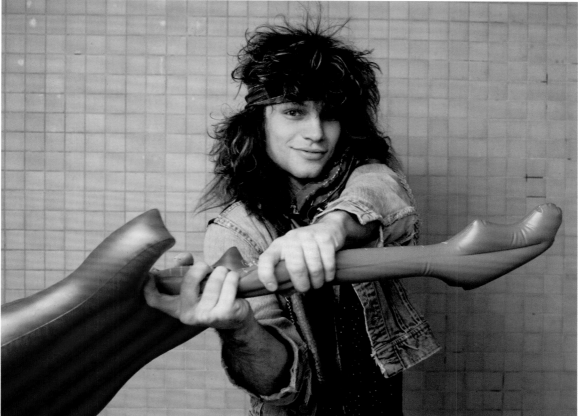

"Ratt's record label told us, "All right, Mark Weiss is going on the road with you for a week. And we were like, 'Fuck, how cool! Now we can get all these cool pictures like I used to see of Zeppelin and Aerosmith and all that stuff.'" —**Stephen Pearcy (singer, Ratt)**

THESE PAGES: Various images with hot air guitars, 1986: (*opposite*) Stephen Pearcy of Ratt; (*above*) Billy Sheehan and Yngwie Malmsteen; (*bottom*) Jon Bon Jovi

FORGIVE ME FOR I HAVE SINNED

The March issue of *RIP* magazine included a special section celebrating rock 'n' roll movies. Dokken wrote "Dream Warriors" as the theme for *A Nightmare on Elm Street 3*. The accompanying video was shot in Boston and featured various scenes from the film as well as a cameo by Freddy Krueger himself. Ozzy had a part in the horror flick *Trick or Treat*, playing a televangelist who denounces heavy metal music. I played off that role by dressing him up in a priest's and a nun's outfit for the shoot.

At the *RIP* shoot, Ozzy mentioned to me that he was looking for a new guitarist. Two months later, I would help him find a teenager named Jeffrey Wielandt, who was going by the name Zakari Wylant at the time. He would soon become known as Zakk Wylde—Ozzy Osbourne's new guitar player. On the day before Zakk first came to my studio, Sharon asked me to join her and Ozzy to go check out a guitar player on Long Island at a club called Sundance. I brought along my friend Dave "Face" Feld. By the time we got to the club, Ozzy had had a few too many drinks and was a bit anxious. I remember him pointing at the guy onstage and saying, "That's him!

That's my new guitar player!" As we were leaving, Sharon pulled me aside and told me, "Keep your eyes open." Clearly, this wasn't their guy. I called Face the next night to let him know that later that night I was going out to a club in Sayreville called Close Encounters, about ten minutes from my parents' house. Face told me he was going to skip it—he was too tired from our night out on Long Island. I kept nagging him to come along, but he refused. Finally, I gave up. But as the night rolled around, I passed out in front of the TV. Face, however, actually listened to me and went to the club—which is where he met Jeffrey Wielandt, whose band, Zyris, was playing that night.

The next day, Face told me all about the guitarist he had seen at the club. I told him I was heading back into the city that day to show Ozzy the photos from a shoot we did earlier in the week, and if he got me a tape of the kid playing, I'd give it to Ozzy and Sharon. When I got to my studio in Manhattan, I had a message from Face on my answering machine: "Weissguy—I got the tape, and it's killer." I told Face to drive in with the cassette and to have Zakk come with his guitar and amp. "When Ozzy

ABOVE: Ozzy Osbourne, photographed for *RIP* magazine, Mark's studio, New York City **OPPOSITE:** George Lynch and Don Dokken with *A Nightmare on Elm Street's* Freddy Krueger on the set of the "Dream Warriors" video shoot, Boston

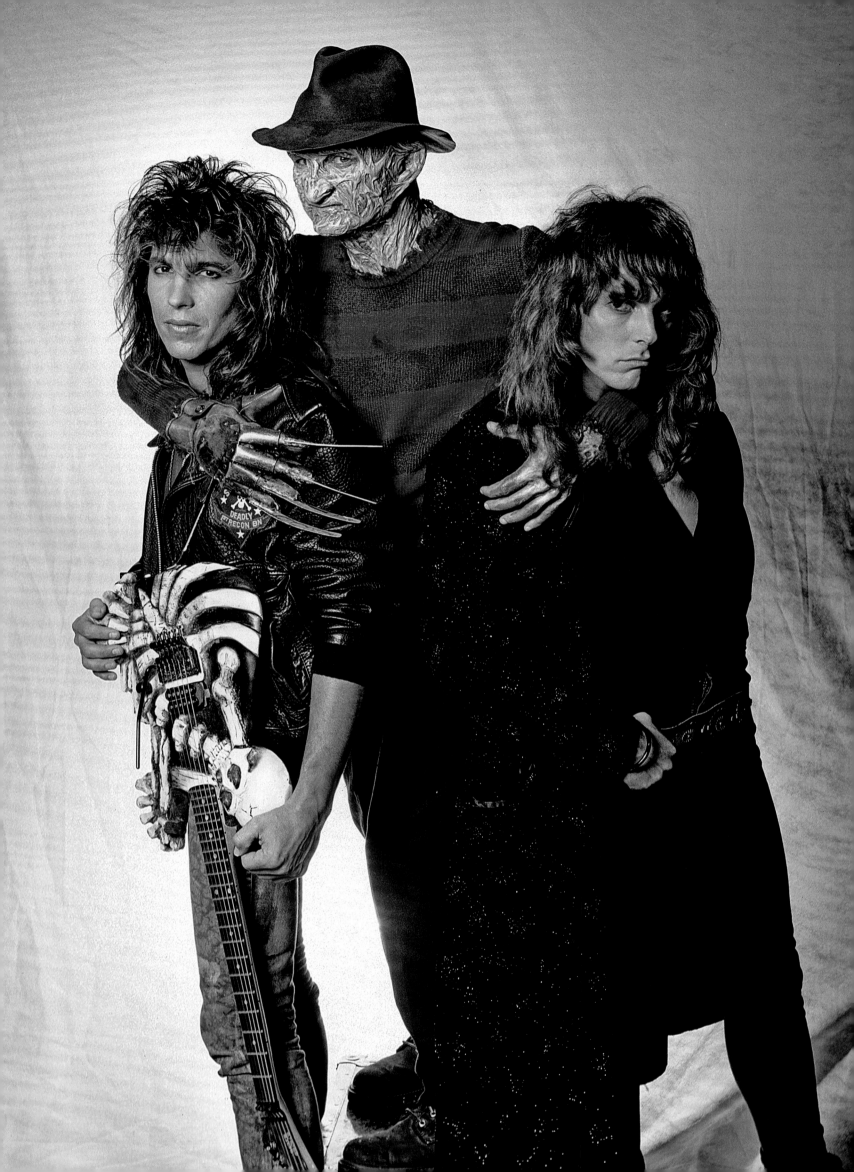

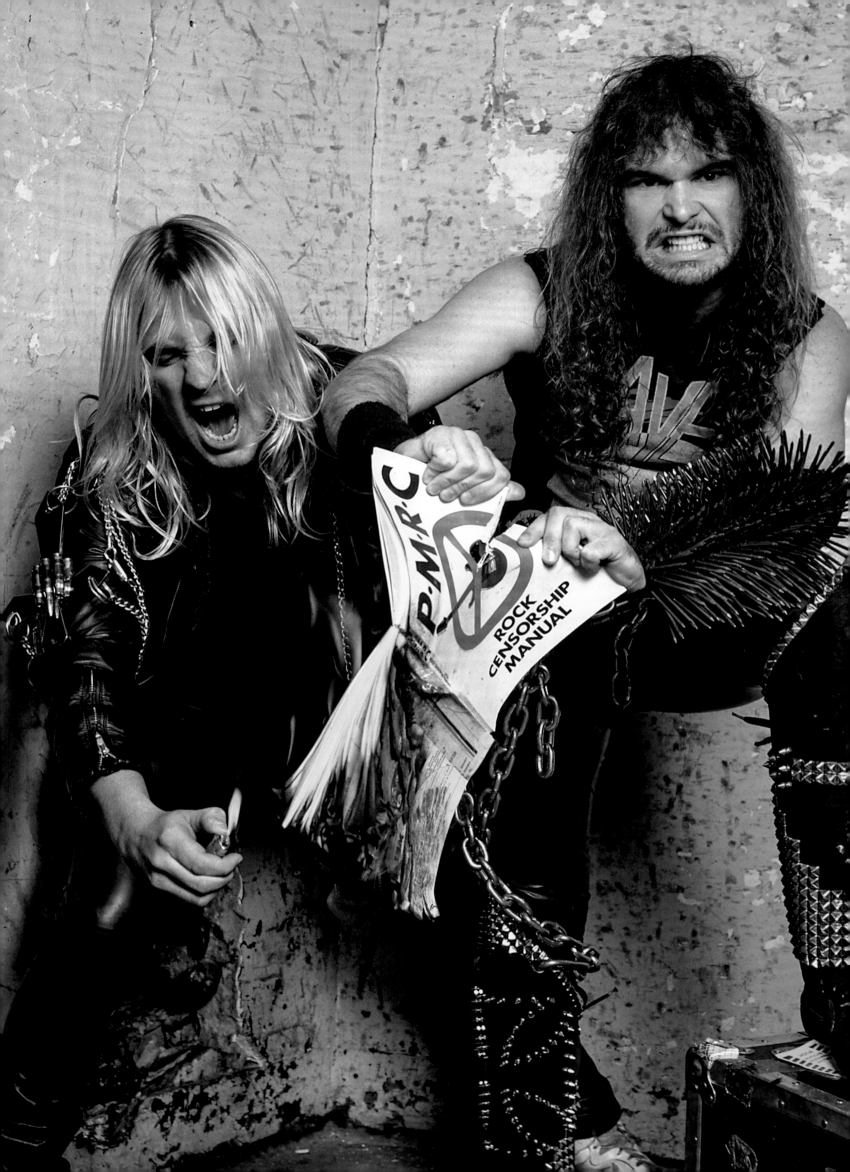

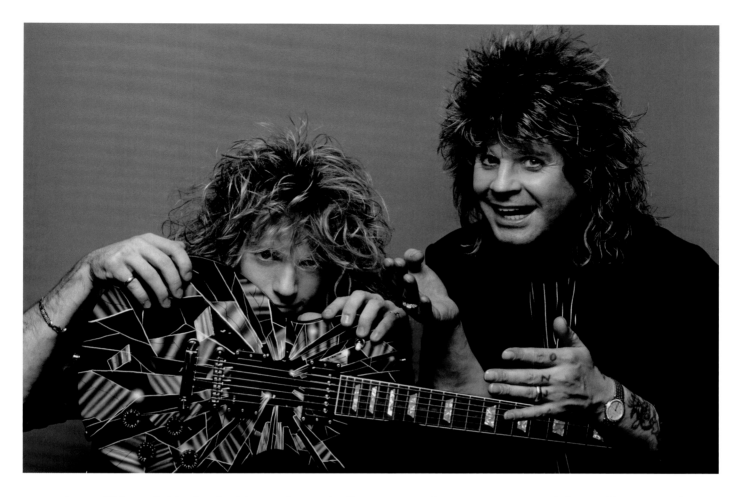

comes by, we'll have Zakk play for him at the studio." I mentioned all this to Sharon, and she said, "Sure, we'll be by after lunch." An hour or so later, Face walked into the studio with Zakk. He definitely had the look. I just thought, If this kid can play, he's got the gig. While I was working in my office, Zakk sat in the makeup room practicing. A couple of hours later, Sharon called to say they were running late but that they would definitely be coming by. While we waited, I did a quick session with Zakk. But as the afternoon turned into the evening, he mostly kept to himself and kept practicing. Finally, the clock struck midnight, and I got another call from Sharon. She was sorry, but Ozzy had drunk André the Giant under the table, and they had to leave in the morning for England—they wouldn't be coming by. She said to leave the tape at their hotel and she would give it a listen on the plane. When I went by to drop off the cassette, I also attached one of the Polaroids from my shoot with Zakk to the case. As soon as Sharon landed in England, she called me: "Bring him to LA for an audition." And the rest, as they say, is history.

Word was getting around that Zakk was Ozzy's new hired gun. By the end of the year the official announcement was made on MTV, with Zakk and Ozzy appearing on *Headbangers Ball*. Around the same time, I took the first official photos of them together, which were published in *Rolling Stone*. A few months later, Zakk was getting ready to begin work on the album that would become *No Rest for the Wicked*. We took some photos around his house. Afterward, we went to a nearby mall in Jackson, where we did a little karaoke. We wound up singing a parody of Steppenwolf's classic "Born to Be Wild," renaming it "Born to Be Zakk Wylde," with lyrics we had written down at lunch that day. We never laughed so hard.

Later on that year, the WWF (now the WWE) invited Alice Cooper to be the special guest for WrestleMania III after Ozzy's cameo the previous year. The event took place at the Pontiac Silverdome in Michigan. Cooper, a Detroit native, was brought in to stand in Jake "The Snake" Roberts's corner during his match with the Honky Tonk Man.

"It was a Saturday night gig, in front of, I don't know, maybe 108 people, nothing too spectacular. And afterward, I'm loading up my gear and this guy named Dave Feld comes up to me and says, 'Have you ever thought about auditioning for Ozzy?' And I'm like, 'Sure, whatever, dude. You know the guys from Zeppelin, too?' But he told me if I put together a demo tape and took some pictures, he could get it to a friend of his, Mark Weiss, who had just finished doing a shoot with Ozzy. Dave said, 'I can't promise you anything, but it's a shot.' Without Mark, I would have never been blessed with having Ozzy in my life. Mark's like family to me. He's like a big brother." —Zakk Wylde (guitarist, Ozzy Osbourne)

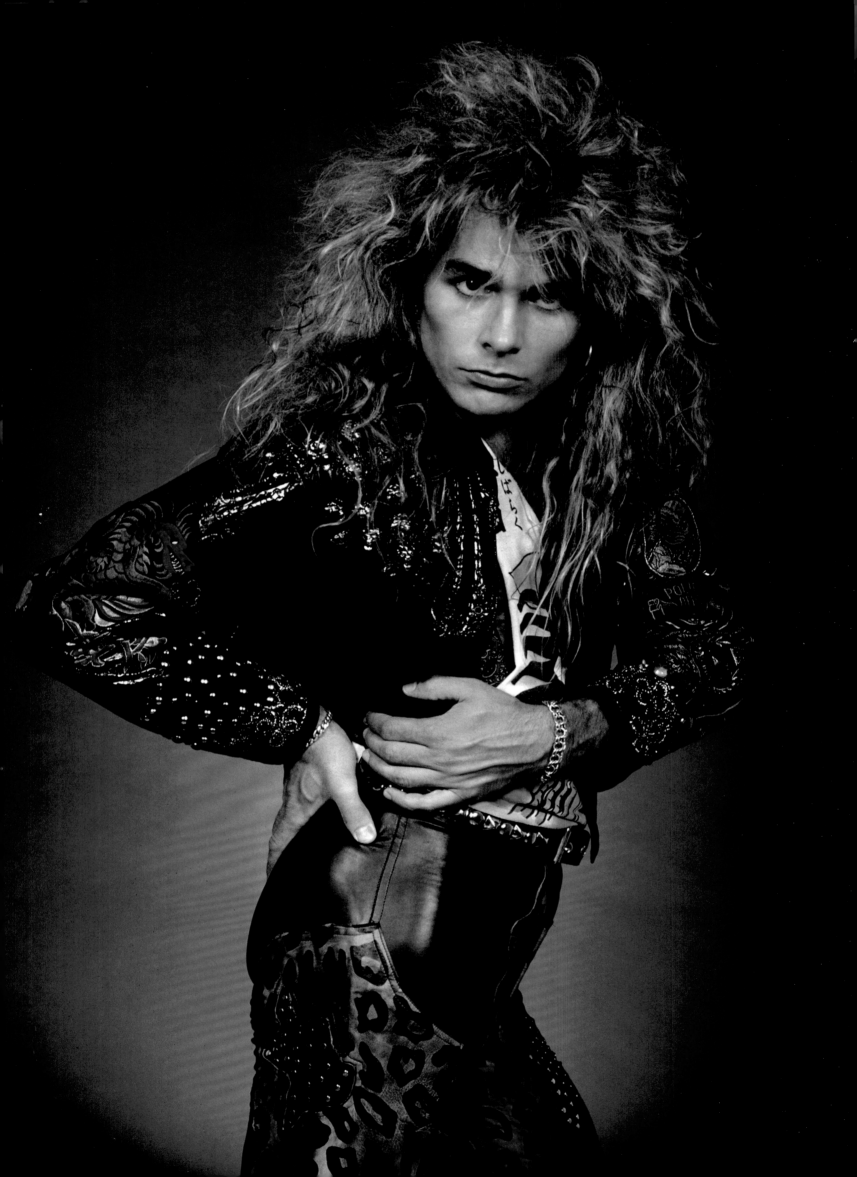

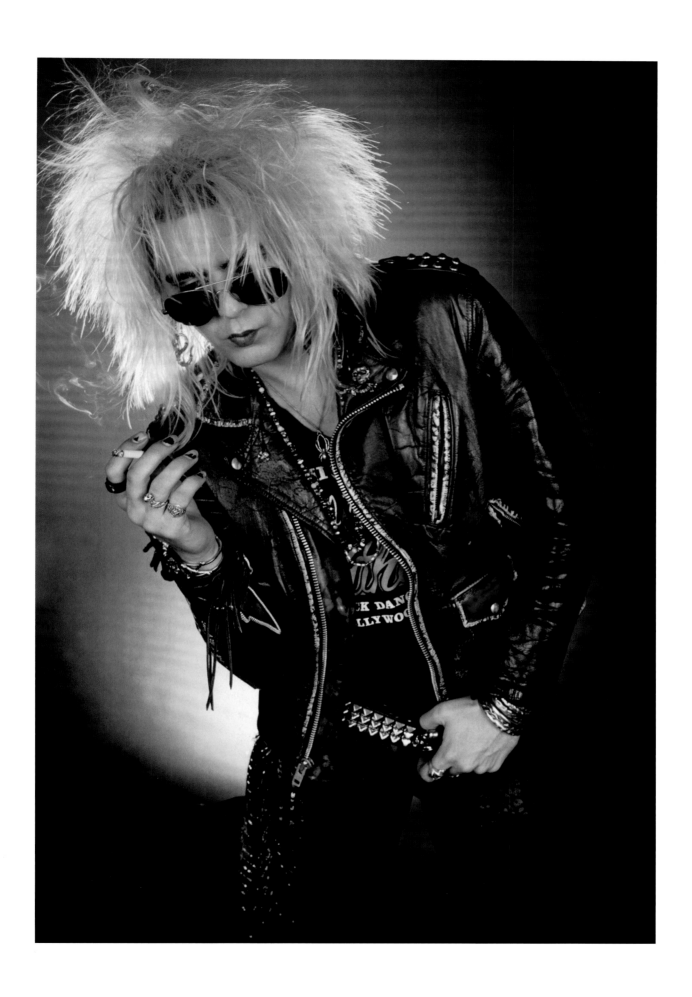

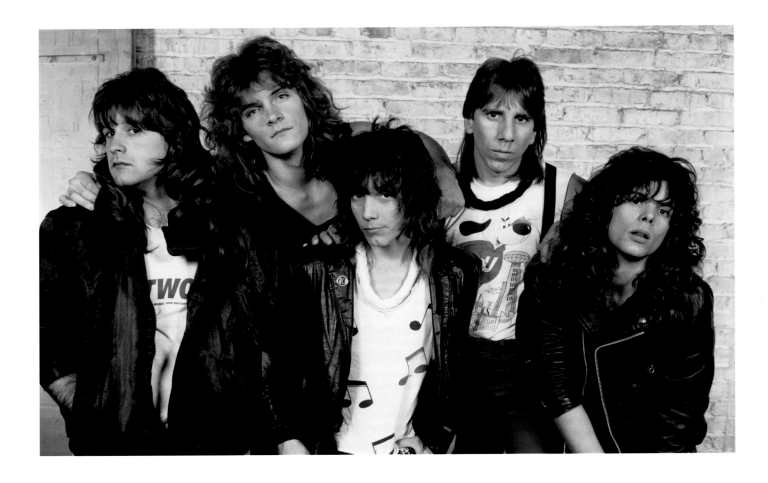

MAKIN' MAGIC

There were not many women rockers in the metal world at the time. Lita Ford had been in the scene as a solo artist since the Runaways broke up in 1979. Lita was about to release her soon-to-be hit song "Close My Eyes Forever" with Ozzy. Coming out of Germany was Warlock, with lead singer Doro Pesch. Her record label hired me to shoot the promo photos for the band's new release, *Triumph and Agony*. She wanted something mystical and moody. I went to the prop house and picked up a few things: a scenic background with a full moon, some trees and bushes and, oh yeah, a wolf, and off we went to Weissguy's imaginary world.

In 1987, Tawny Kitaen appeared in Whitesnake's "Here I Go Again" video, and thanks to her performance dancing on top of two Jaguars, she was probably as recognizable as any guy playing in a band at the time. David Coverdale and Tawny would be married two years later.

That year, I also shot the cover for Anthrax's thrash/rap crossover album *I'm the Man*, as well as covers for Autograph's third album, *Loud and Clear*, and TNT's *Tell No Tales*. The TNT cover is a good example of the style I came to be known for. I would diffuse light through colored gels to change the color of the backdrop or background to complement what the musicians were wearing, as well as add contrast to the photo so that the bands would stand out.

"My manager called me up and said, 'We have a photo session with a very important photographer named Mark Weiss. Bring all your stage clothes, everything you have. He's top-notch.' Shooting with Mark, you knew you were in great hands. He was always working on the set or the lights and getting cool props—like a wolf. It was like building a movie set. It was almost spiritual and very intense, very deep and very soulful. When you were shooting, you were in a different world; you didn't even have to fantasize—you were there."
—Doro Pesch

ABOVE: Tesla photographed on the set of the "Little Suzi" video shoot in Los Angeles **OPPOSITE:** Doro Pesch of Warlock, Mark's studio, New York City **PAGES 264–267:** Kiss, *Crazy Nights* tour book shoot, Los Angeles

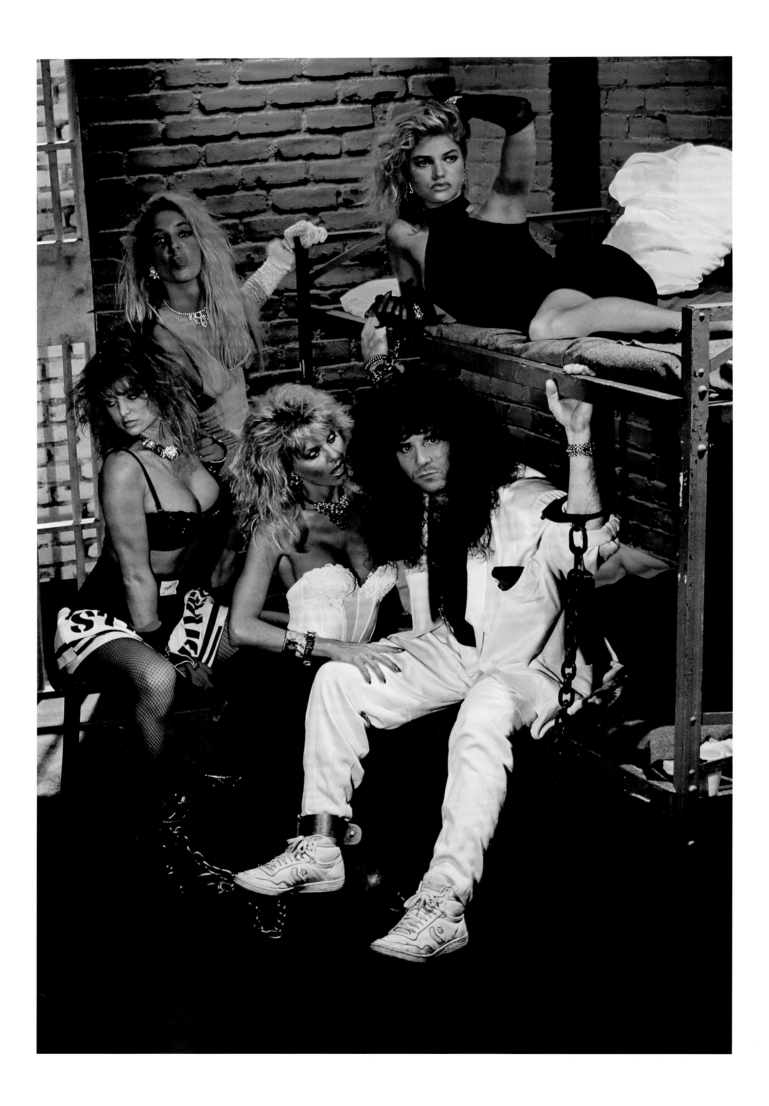

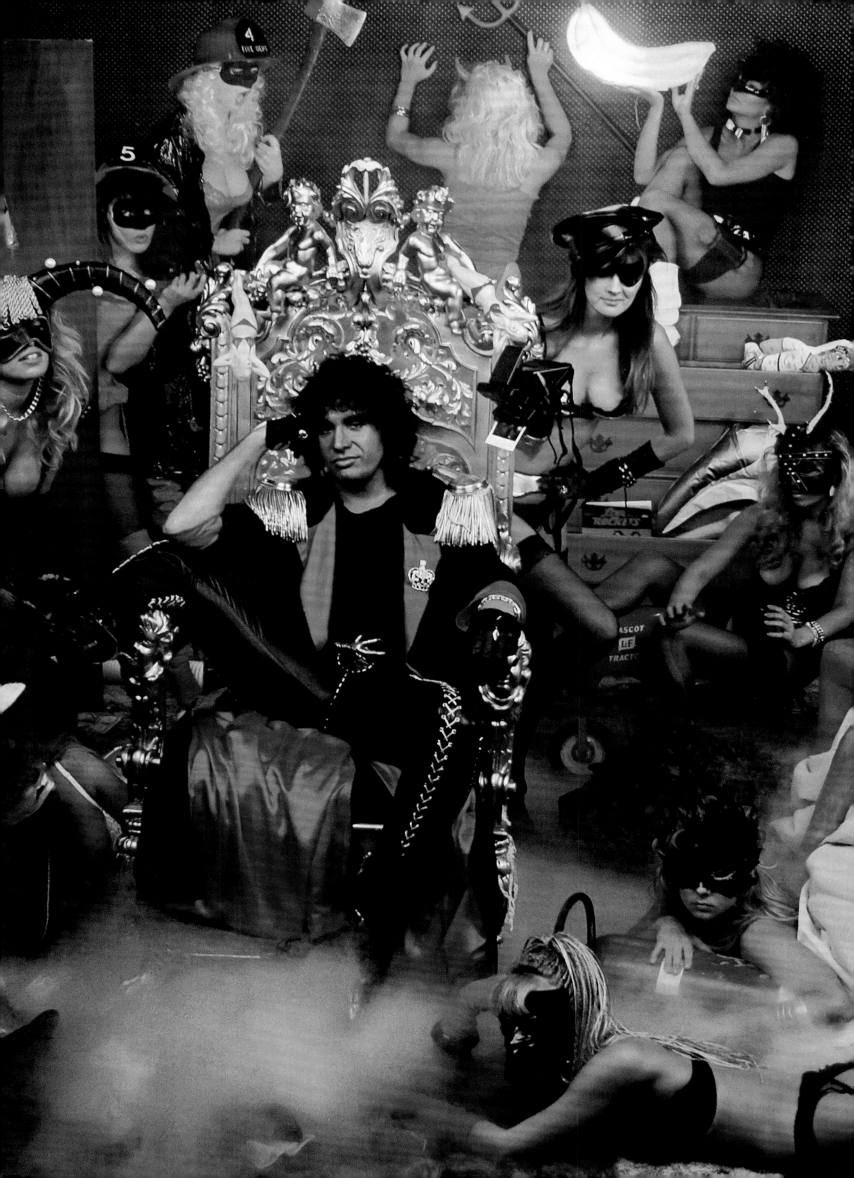

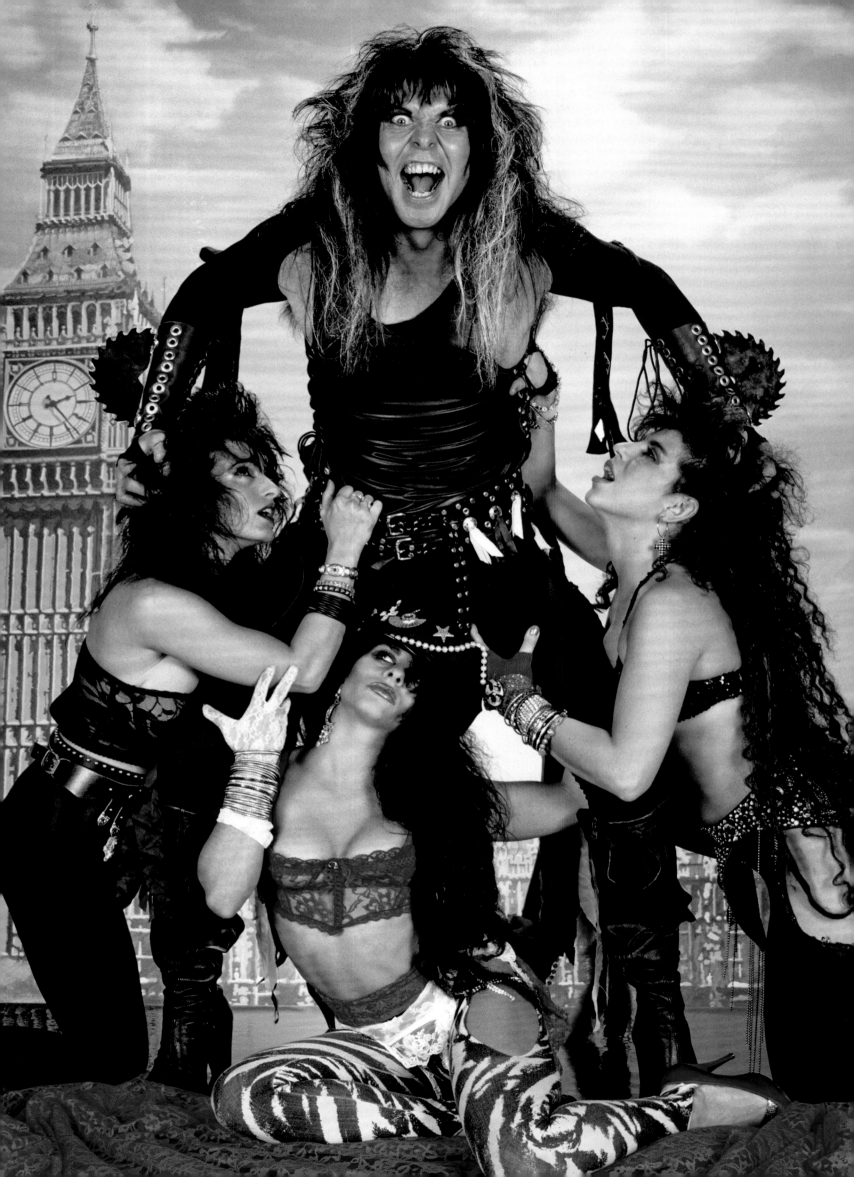

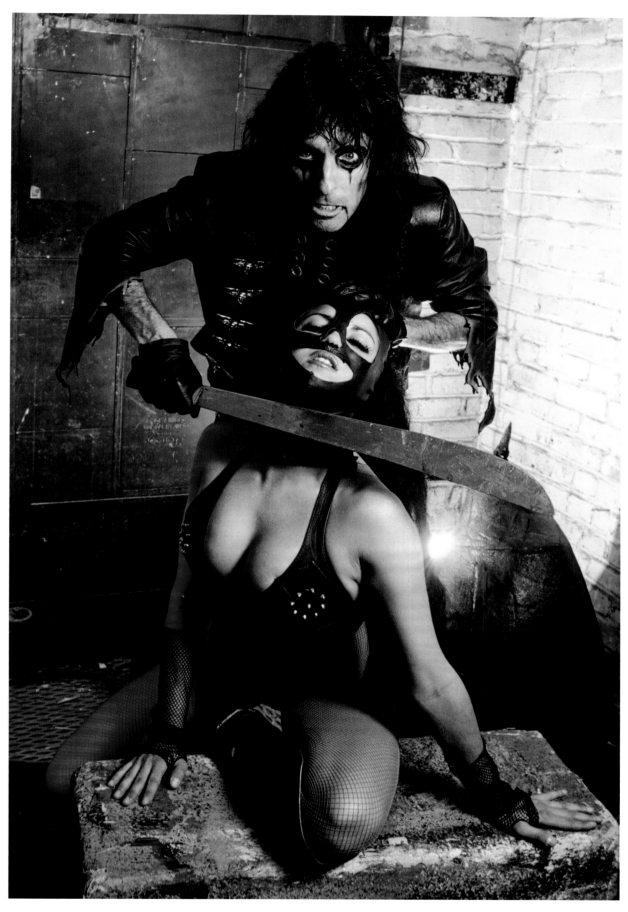

"Mark was a bit of a mainstay there in the '80s and '90s. If you were going to be doing a photo session for a magazine or anything like that, if it was heavy metal or hard rock it was probably going to be Mark Weiss." —**Alice Cooper**

OPPOSITE: W.A.S.P.'s Blackie Lawless, Mark's studio, New York City
ABOVE: Alice Cooper, backstage, Live in the Flesh tour

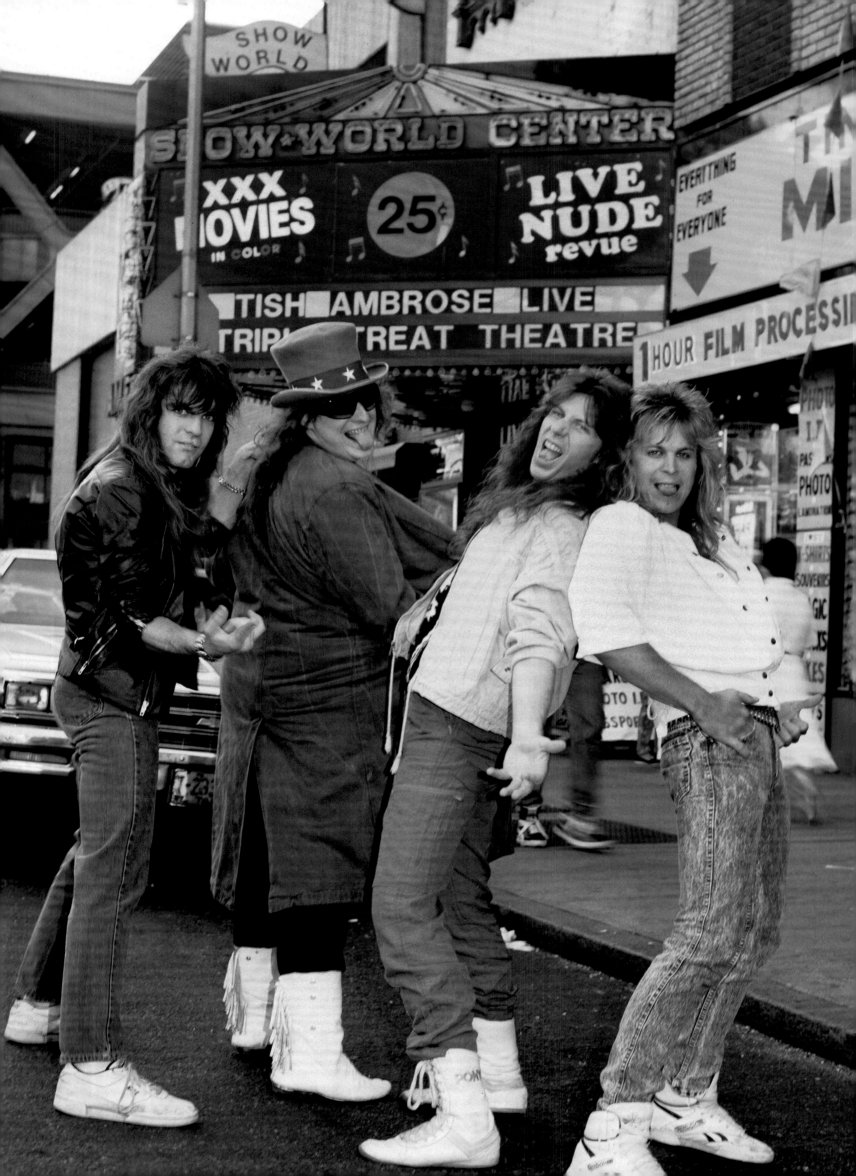

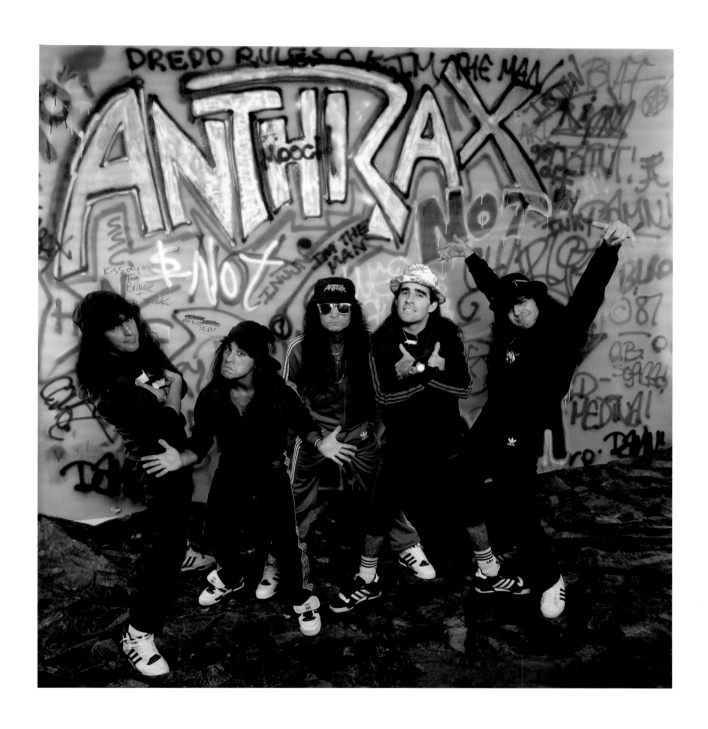

"When we first started working with Mark in the '80s he was already 'Mark Weiss.' So for us as kids it was almost like validation—'Wow, Mark Weiss is working with us!' That actually meant something. He was just a huge part of that era and really captured a time and a place for the world to see. The work he did is so iconic and so great that everybody still wants a piece of him."
—**Scott Ian (guitarist, Anthrax)**

OPPOSITE: Savatage, Times Square, New York City **ABOVE:** Anthrax, outtake from *I'm the Man* album shoot, Mark's studio, New York City

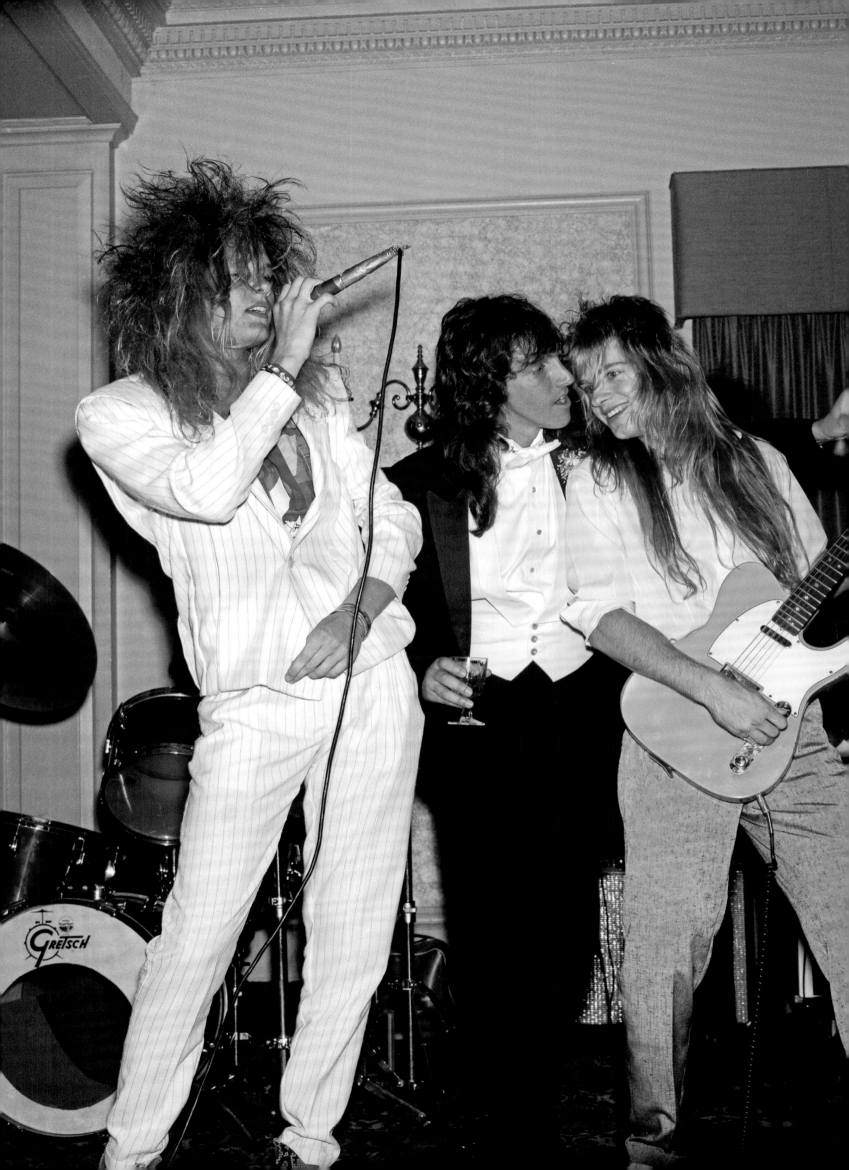

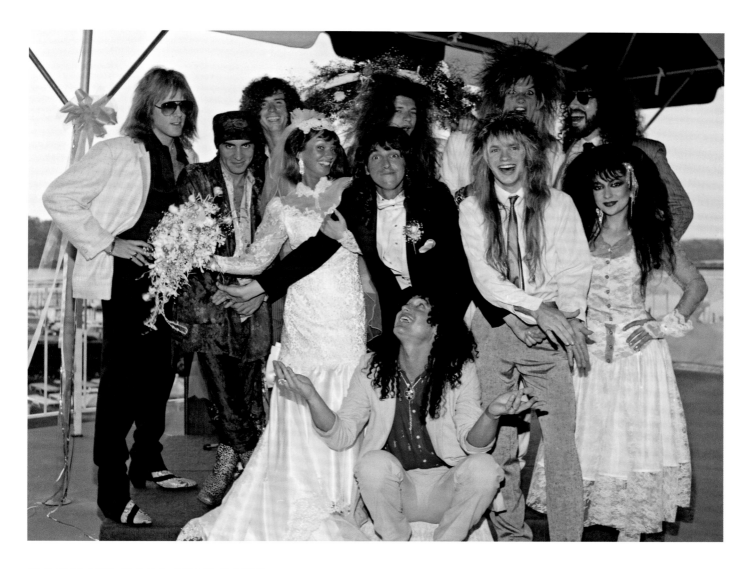

ROCK 'N' ROLL WEDDING

On June 14, I married Suzanne, the girl I had met in the elevator back in 1983. At the last minute, I added two more guests to the wedding invites—Zakk and his girlfriend, Barbaranne. It was a rock 'n' roll wedding, for sure, with members of Twisted Sister and Madam X, Kevin DuBrow, and Steven Van Zandt. Ozzy's daughter, Aimee, was supposed to be our flower girl, but she had to miss the event, as did her mom and dad. Unfortunately, Ozzy came down with an ear infection the night before and the doctor told him he shouldn't fly. In any event, the wedding did indeed rock! At the end of the night, Zakk took the stage with Madam X singer Sebastian Bach for a thirty-minute jam playing Led Zeppelin tunes. Sebastian ended the impromptu set by calling up Kevin DuBrow to sing Quiet Riot's "Bang Your Head."

Soon after bringing Zakk to my studio, Face helped his friend Skid Row guitarist Dave "Snake" Sabo find a new singer for his band. It all happened after Sebastian performed with Zakk at my wedding. After they passed demo tapes back and forth, Sebastian flew out to New Jersey to meet the guys in the band. That first night they got together, Face and I came along, and we all hung out at a club called Mingles in South Amboy. At one point, Sebastian and the Skid Row guys got up on the small stage and jammed out a few tunes. As they were leaving, Sebastian got in a fight with a bouncer, and in true rock 'n' roll fashion, his new bandmates held him back. He officially joined Skid Row as their new lead singer. On one of his next trips out to New Jersey, I did the first official photo shoot with the new lineup. It was as glam as Skid Row would ever get. Needless to say, they lost the pretty boy look at the advice of many close to them, including Jon Bon Jovi and manager Don McGhee.

OPPOSITE: Sebastian Bach, Mark, and Zakk Wylde at Mark's wedding, Molly Pitcher Inn, Red Bank, New Jersey ABOVE: Mark's wedding (left to right): (back row) Twisted Sister's Jay Jay French, Madam X's Mark "Bam-Bam" McConnell and Chris Doliber, Sebastian Bach, Twisted Sister's Mark "The Animal" Mendoza, (middle row) Steven Van Zandt, Suzanne and Mark, Zakk Wylde, Maxine Petrucci, (front row) Kevin DuBrow, Molly Pitcher Inn PAGES 274–275: Skid Row's first photo session, Red Bank, New Jersey

"I used to do this insane scream that was so loud that I can't even tell you. It would wreck my throat, but people couldn't believe this fucking scream that I used to hit. And at the wedding, Zakk was going, 'Do that again, man! Do that fucking scream again!' I was like, 'I can't keep doing it over and over!' But I did. And then, Bon Jovi's parents called me over to their table and said, 'Our son has a friend that has a band, and they're looking for a singer. And we think you'd be great for that band.' Dave Feld was there, and between Dave Feld and Bon Jovi's parents, Skid Row sent me some tapes up in Toronto because I was quitting the band I was in at the time. And that's how I joined Skid Row."
—Sebastian Bach

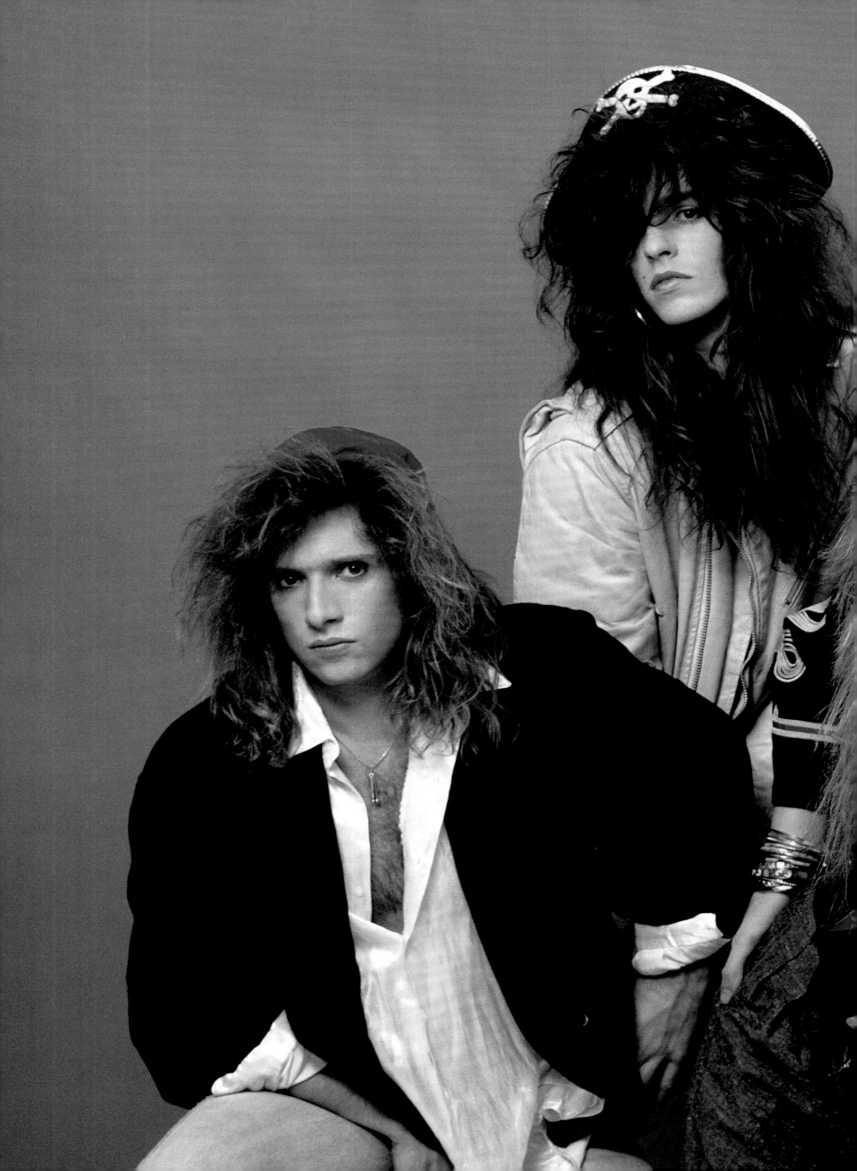

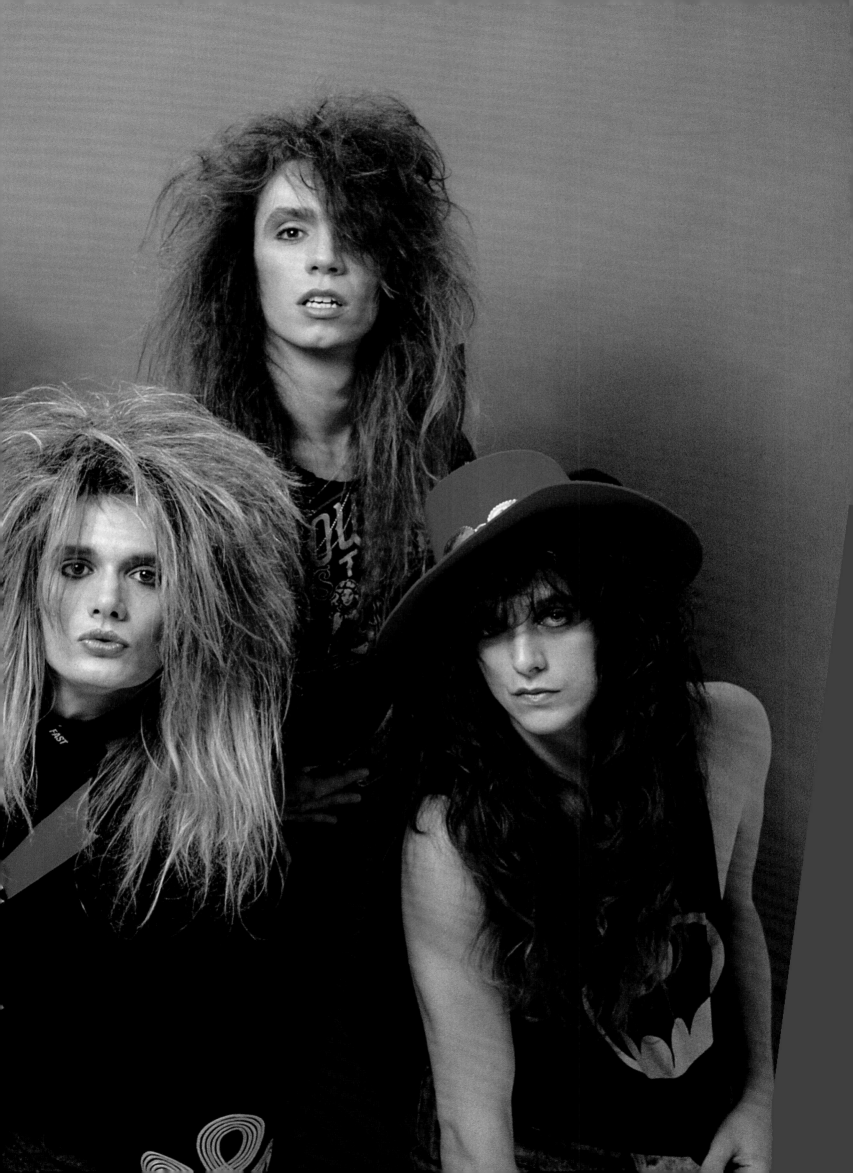

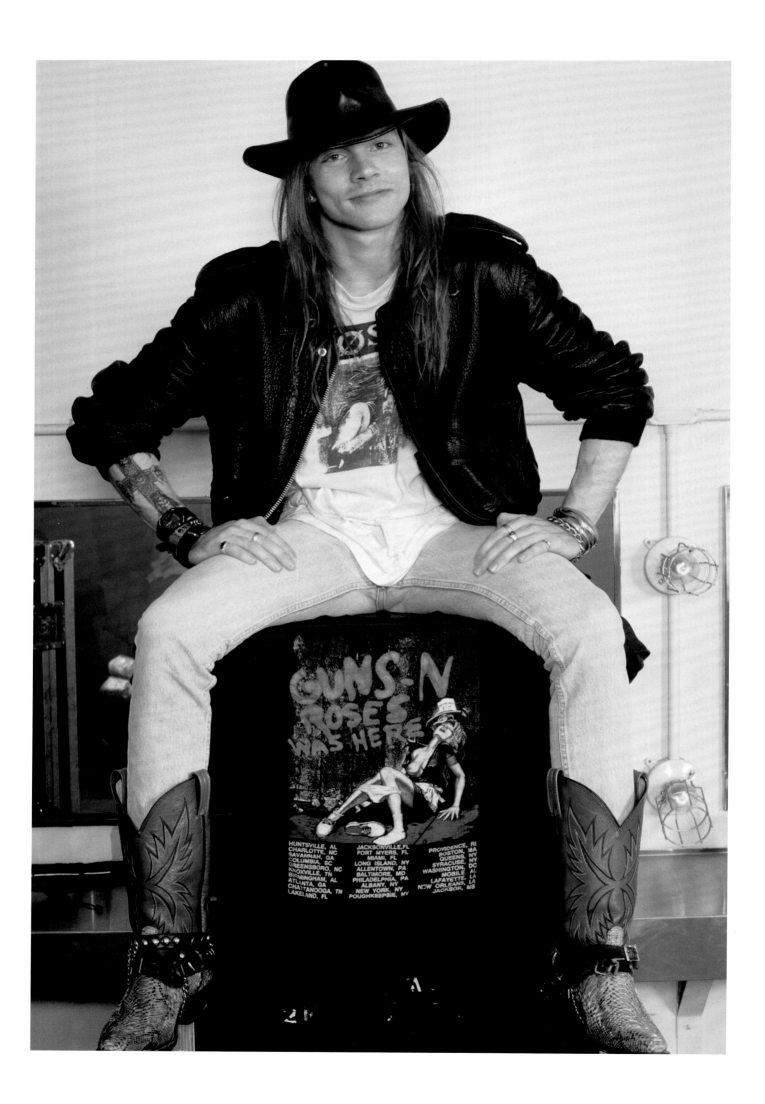

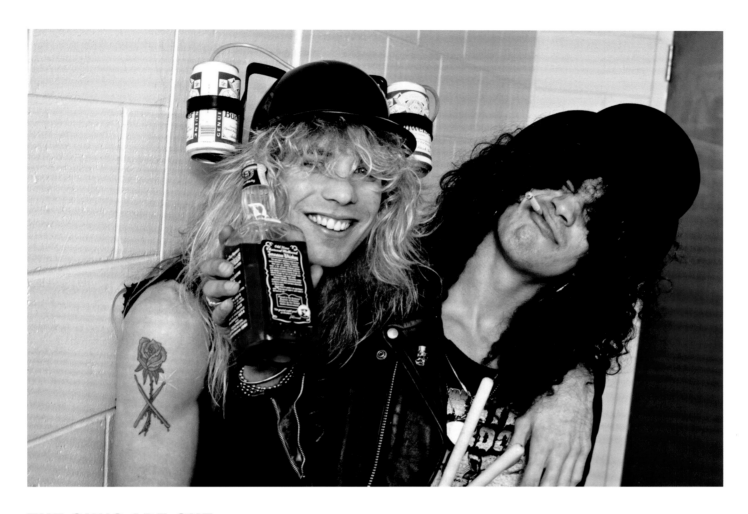

THE GUNS ARE OUT

Guns N' Roses came to New York City to play at the Ritz on October 23. It had been a year since I had shot them in Hollywood, and in the interim, *Appetite for Destruction* had been released. The band was starting to blow up, and all the magazines wanted photos. When I found out they were going to be in town for a week, I arranged a shoot at my studio. Afterward, their publicist, Bryn Bridenthal, asked me to shoot EZO, a band from Japan who were label mates with Guns N' Roses on Geffen. Axl hung around to say hi to them and pose for a few pics.

A week later, Guns came to CBGB for an autograph signing and to play an acoustic set. The guys were in good spirits. I took advantage of the mood and we did some photos around the club. Not long after the CBGB show, I headed down to Florida to spend a few days shooting Mötley Crüe on the *Girls, Girls, Girls* tour—Gn'R were opening for them. When I arrived at the venue, the first guy I saw was Steven Adler. "Hey, Weissguy!" he yelled at the top of his lungs. I asked Steven if he would talk to the guys and see if I could take some photos as the band came offstage all sweaty. When I walked back into the dressing room after the show, Axl was in a towel and cowboy boots. We did some photos, and I went to shoot Mötley's set. Then I came back to take a few more pics of Axl with his clothes on.

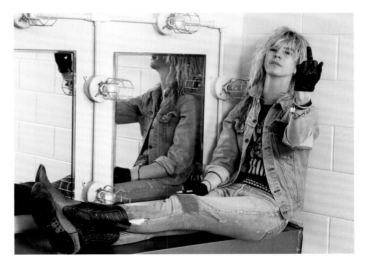

"Life was really exciting at that time. I'd never been to New York before, so those were fun times. It was new, it was fresh, and it's so cool that we're able to have photographs of those moments. And Mark was very cool. He had an edge about him. And if he didn't have that edge, trust me—I'm a happy-go-lucky guy, but the other guys, especially Axl and Slash, if you're not cool, they're gonna beat you down and you're not gonna be able to hang. And they were not able to beat Mark down. He was able to hang." —**STEVEN ADLER (drummer, Guns N' Roses)**

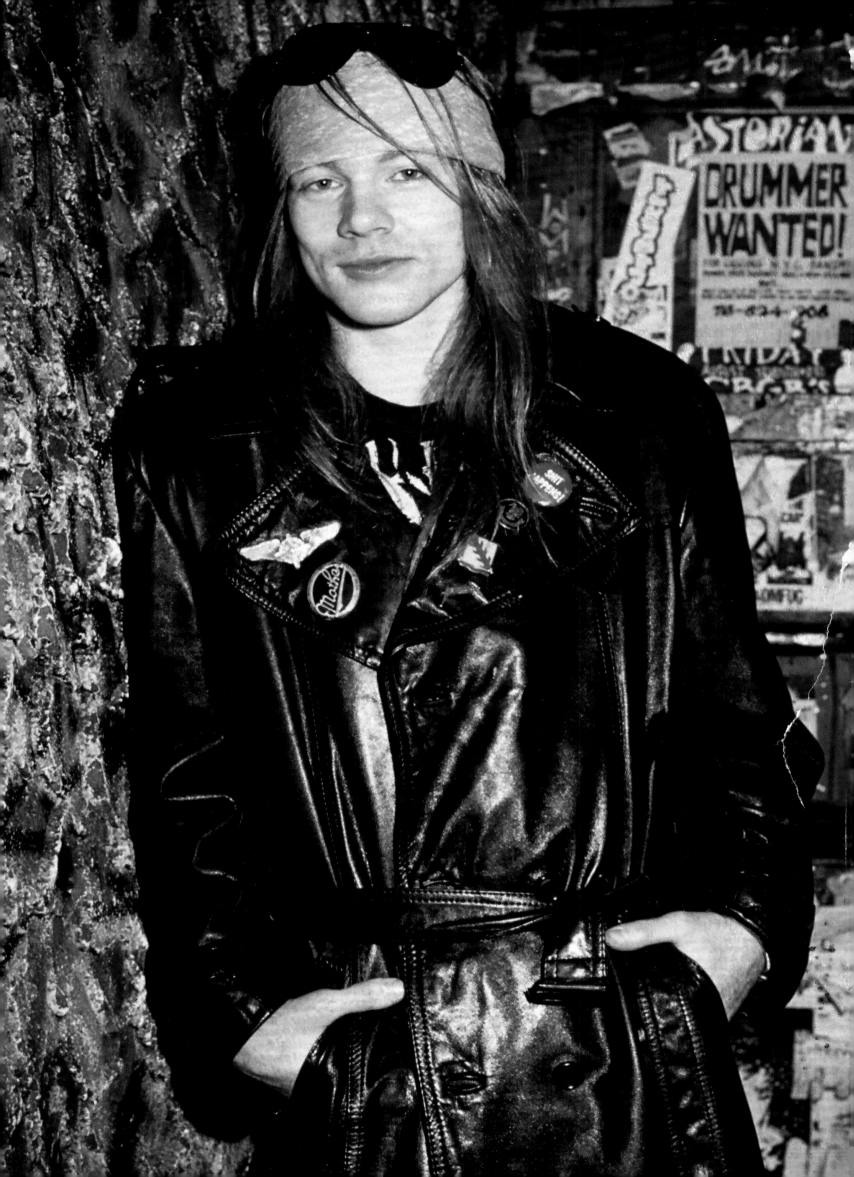

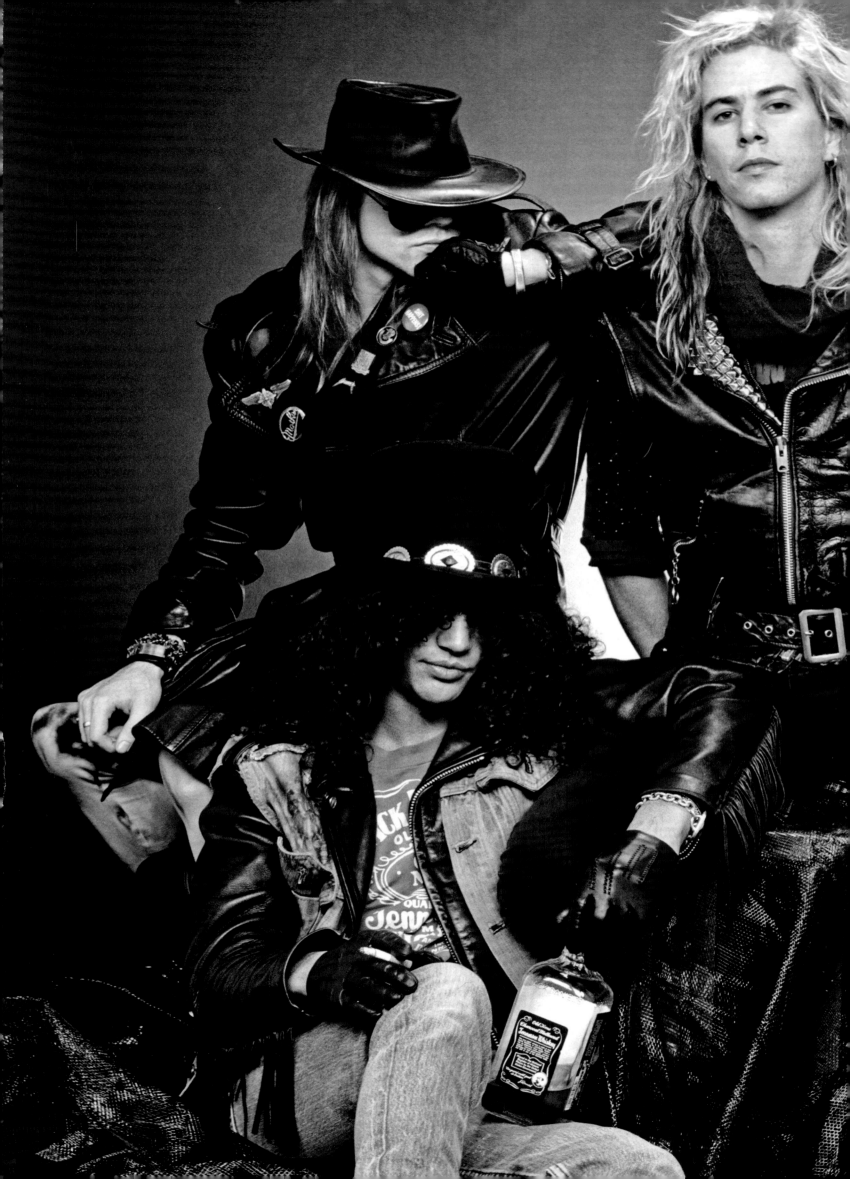

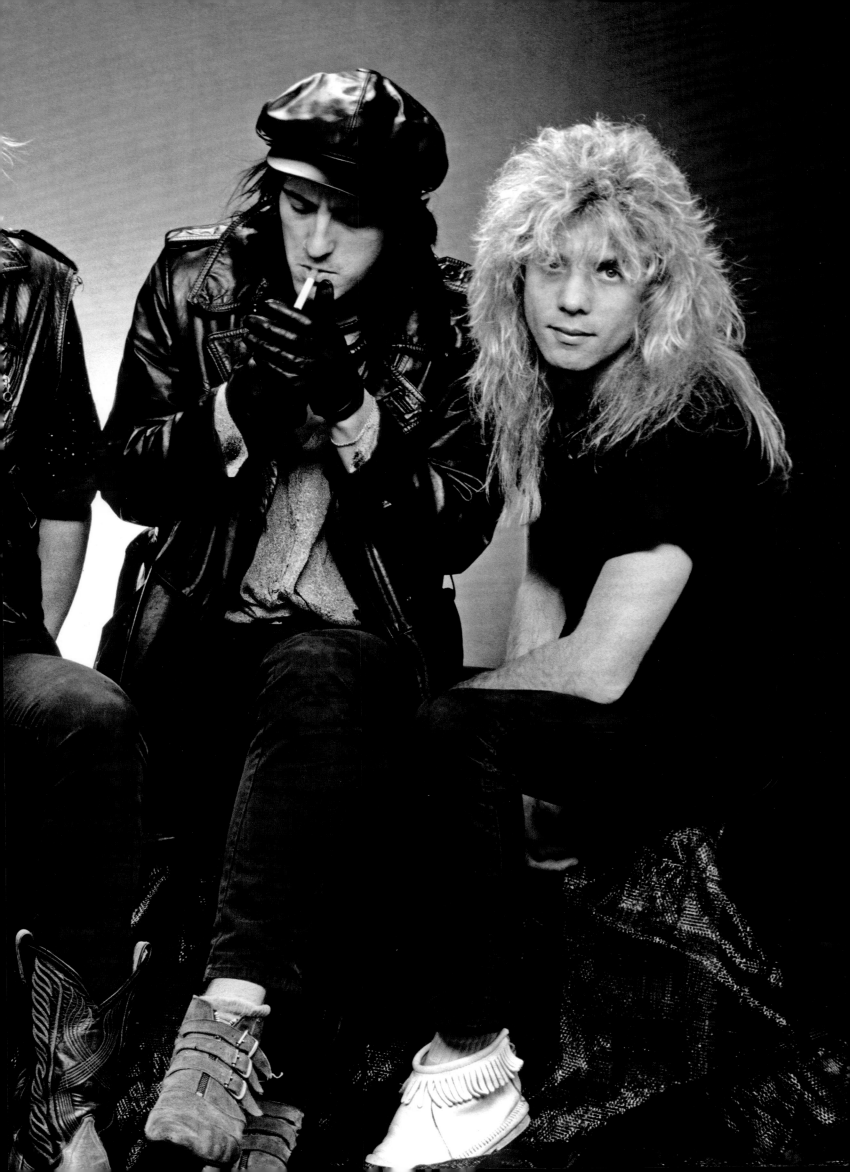

DREAM EVIL?

Ronnie Dio was the nicest, most genuine person I have ever met. At the same time, he always had this dark mystique that would come through in all our shoots together. I would never dare ask him to smile in a photograph, and on the set he always stayed in character. But when it was time to do promo photos for *Dream Evil*, his fifth Dio album, I wanted to try something different. We had developed a trusting relationship, and so I suggested we go to his home and capture the "softer side of Ronnie." I wanted his fans to see the person I knew so well.

OPPOSITE: Ronnie James Dio, *Dream Evil* tour **PAGES 286–287:** Ronnie James Dio at home in Encino, California

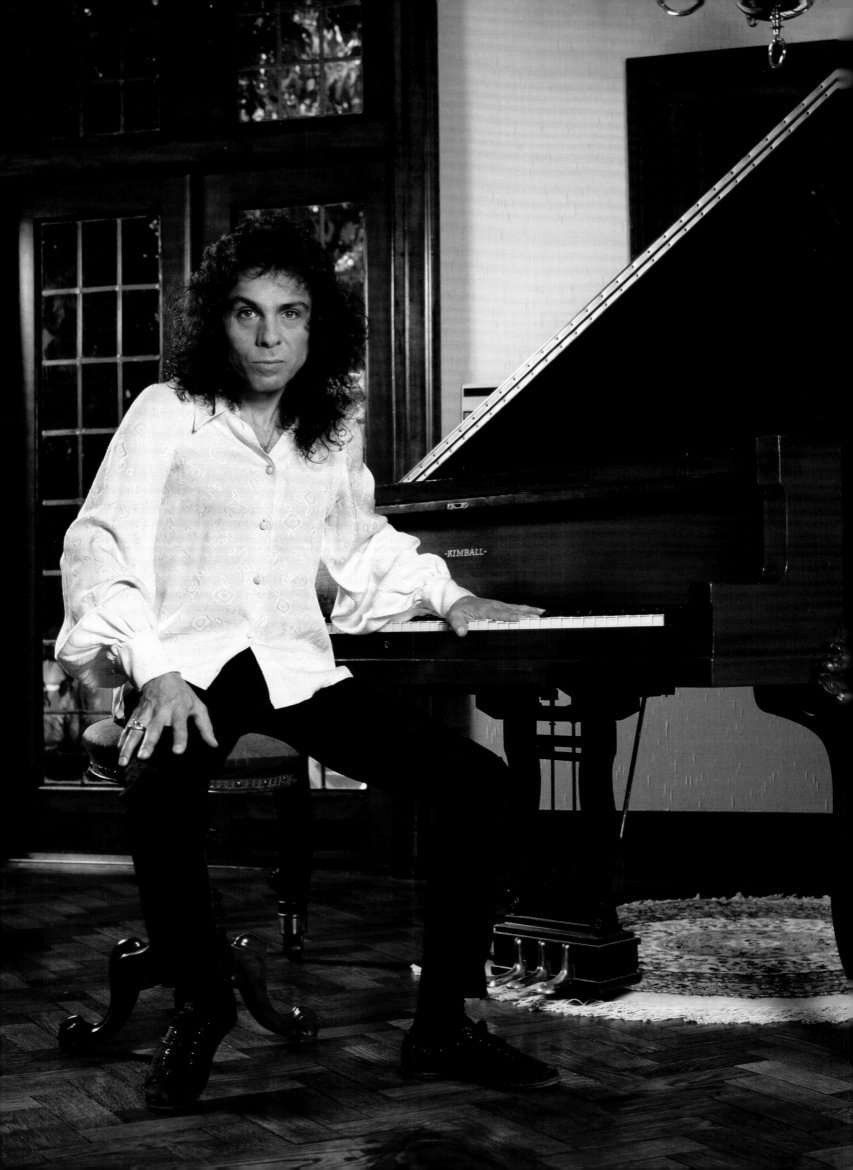

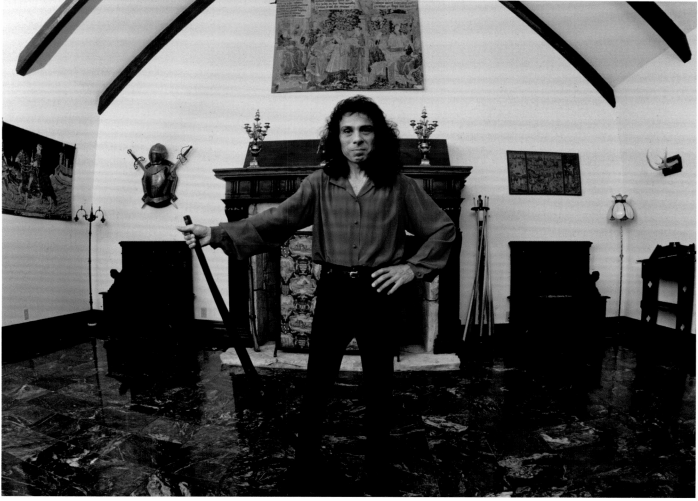

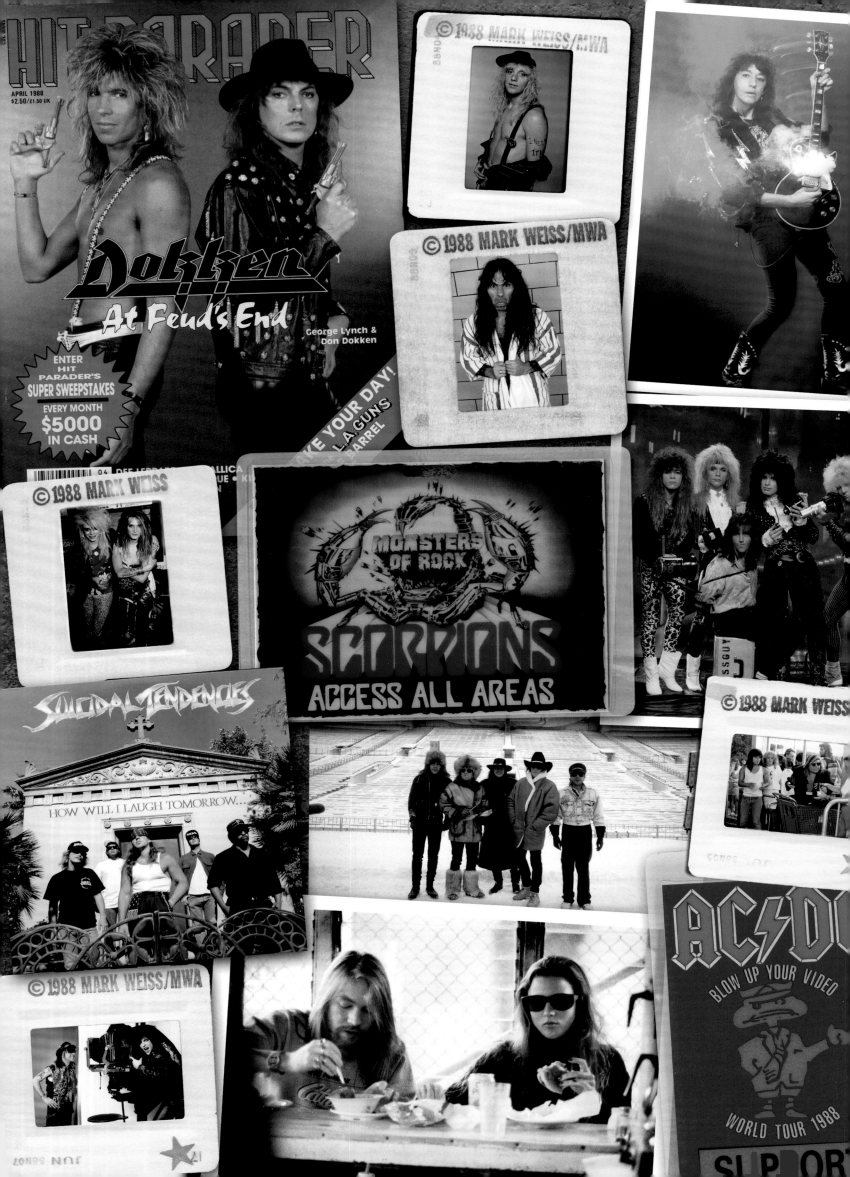

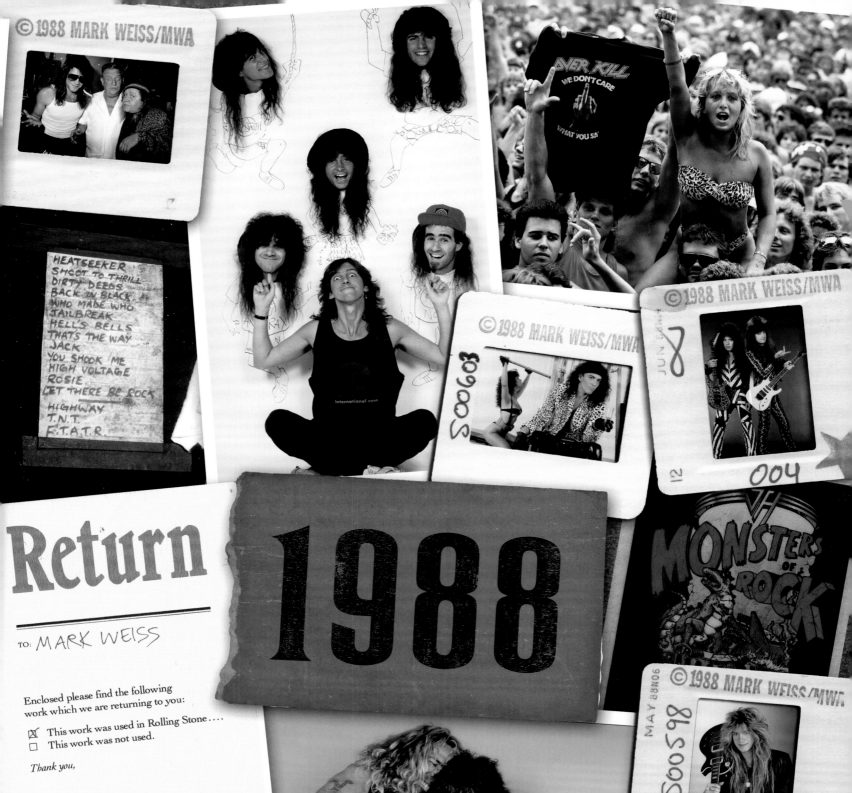

© 1988 MARK WEISS/MWA

HEATSEEKER
SHOOT TO THRILL
DIRTY DEEDS
BACK IN BLACK
WHO MADE WHO
JAILBREAK
HELL'S BELLS
THAT'S THE WAY
JACK
YOU SHOOK ME
HIGH VOLTAGE
ROSIE
LET THERE BE ROCK
HIGHWAY
T.N.T.
F.T.A.T.R.

© 1988 MARK WEISS/MWA

© 1988 MARK WEISS/MWA

S00603

© 1988 MARK WEISS/MWA

JUN 88

12 004

1988

MONSTERS OF ROCK

© 1988 MARK WEISS/MWA

MAY 88N06 S00598

Yngwie J. Malmsteen's
Rising Force

Britny Fox

1988 MARK WEISS/MWA

© 1988 MARK WEISS/MWA

Odyssey

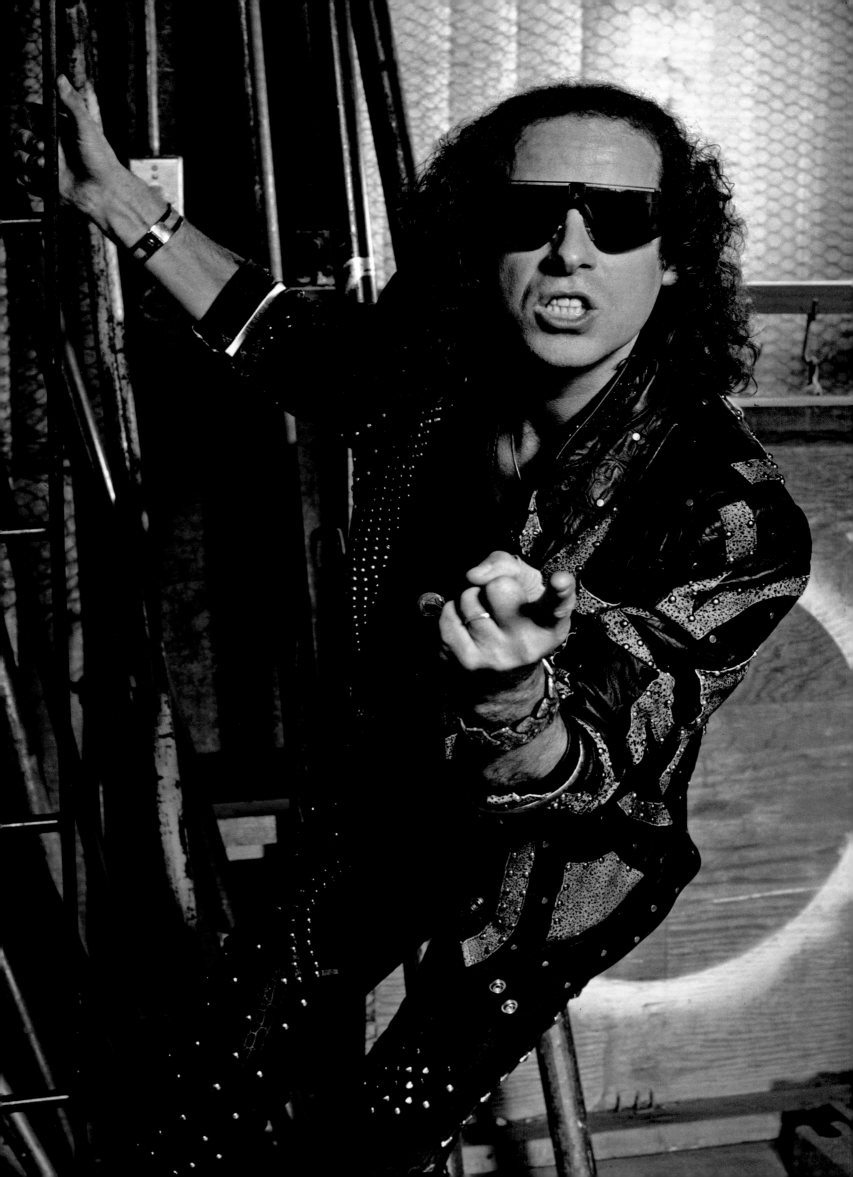

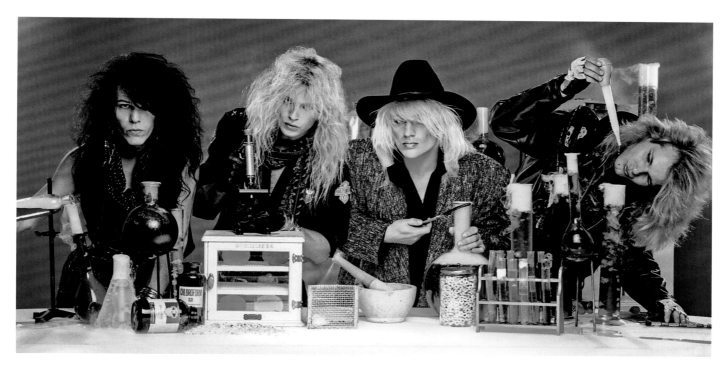

GOLDEN YEARS

By 1988, practically every band I worked with was going gold or platinum. Everyone loved getting the album plaques to hang on the wall, and it was up to the record companies and the bands to decide who would get one. At the end of the day, the bands were the ones paying for them, so they were pretty selective about who made the cut. Eventually, I wound up with a nice collection of gold and platinum records myself. From glam to thrash to the occasional guitar god, the album cover shoots kept on coming. Warrant, Britny Fox, and other newcomers, such as Winger, Kingdom Come, and the all-girl Vixen, would all reach gold status. Bon Jovi, Cinderella, Poison, Scorpions, and Ratt had new releases as well and were taking the young bands out on the road as opening acts on their sold-out arena tours. Record companies kept signing bands and sending them to my studio. It was business as usual, and it never seemed to slow down. The hair kept getting higher, but by the end of the year, bands would be pulling it back to jeans and black leather just like Guns N' Roses and Mötley Crüe.

Dokken had three platinum albums under their belt but never made it to arena status as their record label had anticipated they would. It was well known that guitarist George Lynch and singer Don Dokken had a combative relationship, so in the interest of trying to sell some records, they decided to create a bit of controversy with a tongue-in-cheek photo shoot with toy guns for the cover of *Hit Parader*, along with a tell-all interview about their rivalry.

Meanwhile, a new class of hopefuls were pulling on their spandex pants and leather boots. Bon Jovi did a secret show at a small club called the Raritan Manor, and Skid Row, a freshman act about to go big, opened. Two weeks later, Skid Row played their own show at the Cat Club in New York City. In the fall, Jon Bon Jovi's management told me that he would be making a cameo in Sam Kinison's video for his version of the Troggs's "Wild Thing." Everybody loved Sam, who was quickly becoming a rock star of the comedy world. They were shooting in California with an all-star cast that included Rodney Dangerfield and a who's who of rockers, as well as Jessica Hahn, who had become infamous after being involved in the Jim Bakker sexual assault scandal.

OPPOSITE: Scorpions's Klaus Meine **TOP:** Poison, Hollywood, California
BOTTOM: Ratt's Robbin Crosby at home in Los Angeles

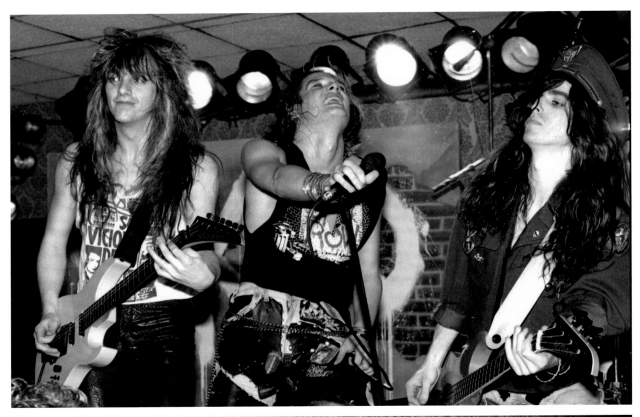

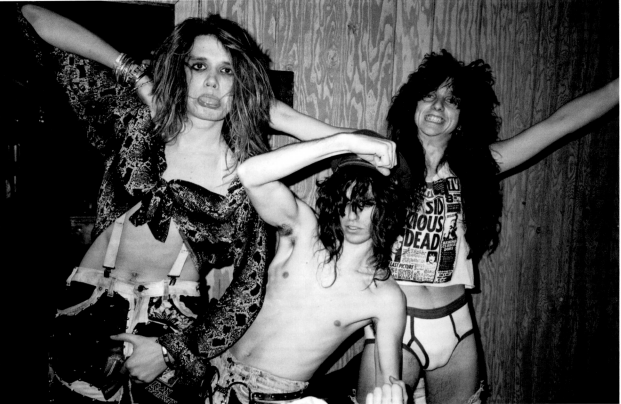

"Mark was a big proponent of this band in the early days. And for a while there, he was the only guy shooting pictures of us. He was the only one who cared."
—Dave "Snake" Sabo (guitarist, Skid Row)

PAGES 292–293: Sebastian Bach, Red Bank, New Jersey **ABOVE:** Skid Row, Raritan Manor, Somerville, New Jersey **OPPOSITE:** Sebastian Bach and Jon Bon Jovi

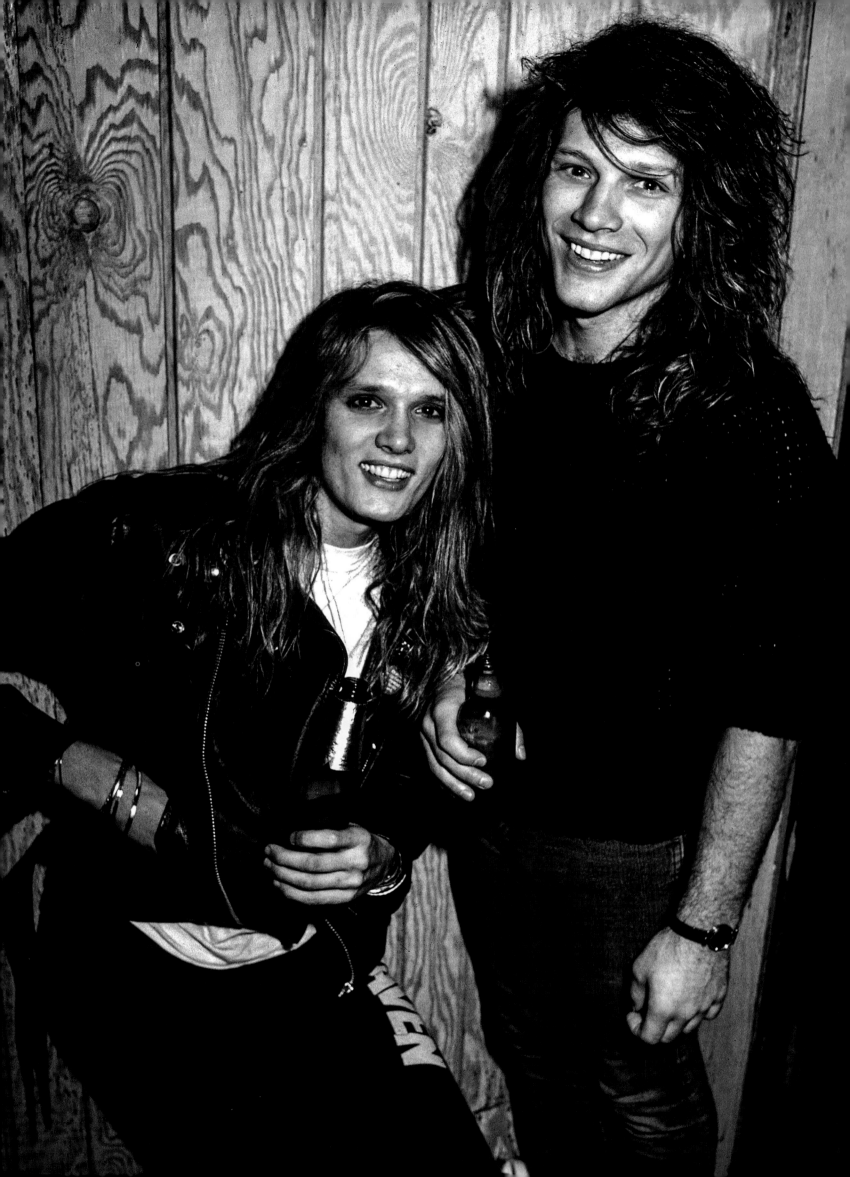

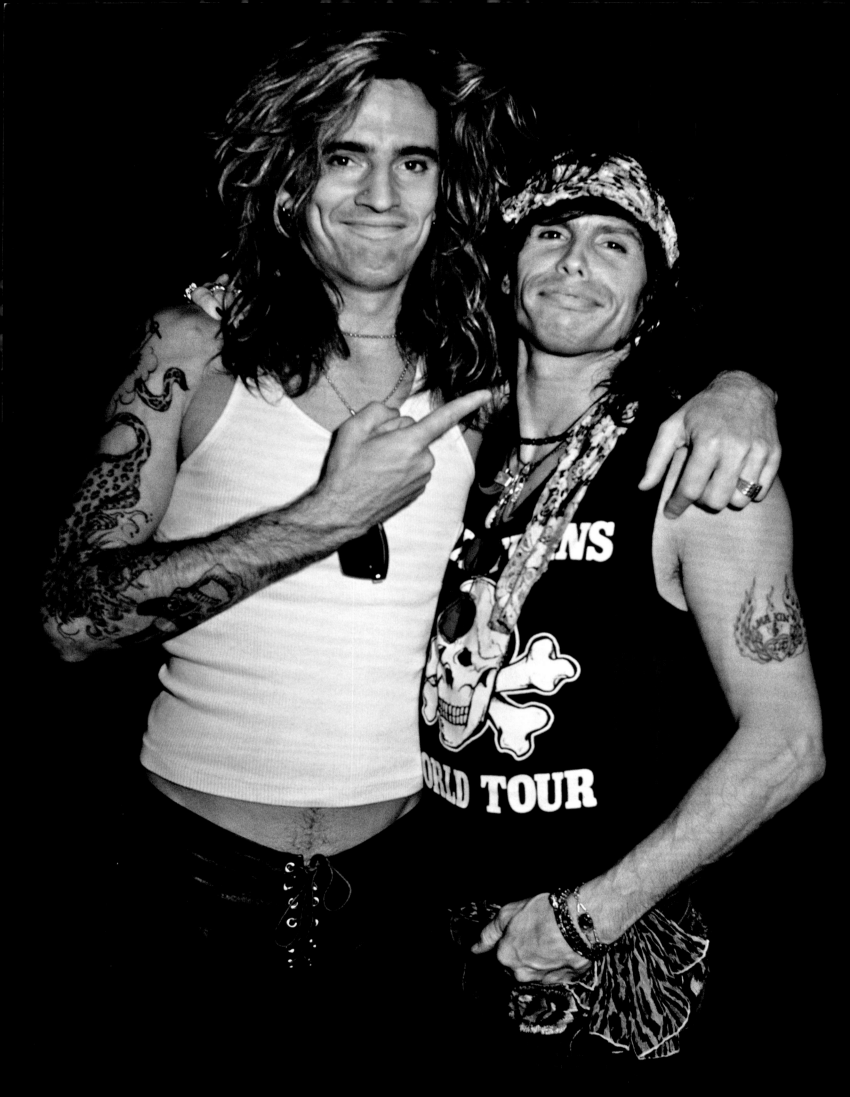

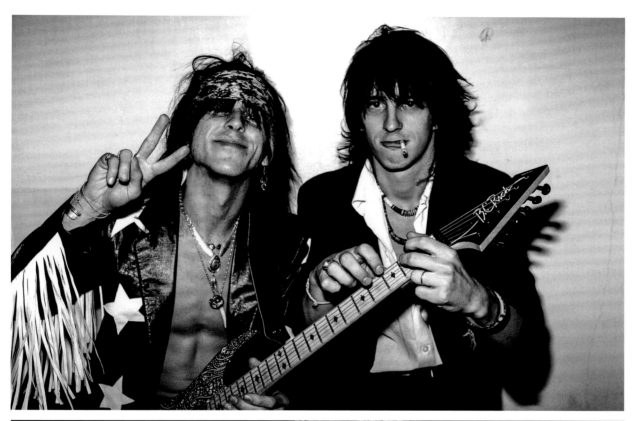

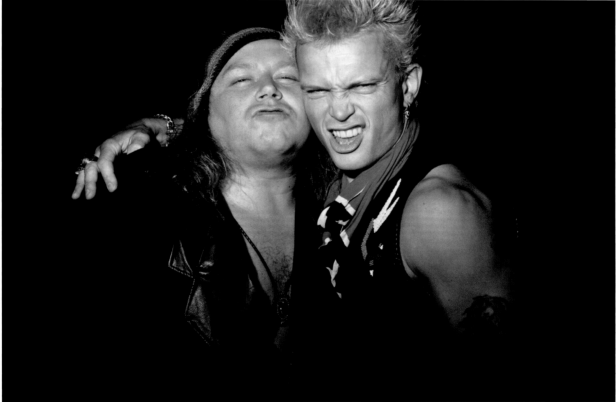

OPPOSITE: Tommy Lee and Steven Tyler, "Wild Thing" video shoot, Los Angeles TOP: L.A. Guns's Tracii Guns and Guns N' Roses's Izzy Stradlin, The Palace, Los Angeles BOTTOM: Sam Kinison and Billy Idol, "Wild Thing" video shoot PAGE 298: Lita Ford on the *Lita* tour PAGE 299: Lemmy Kilmister, Mark's studio, New York City

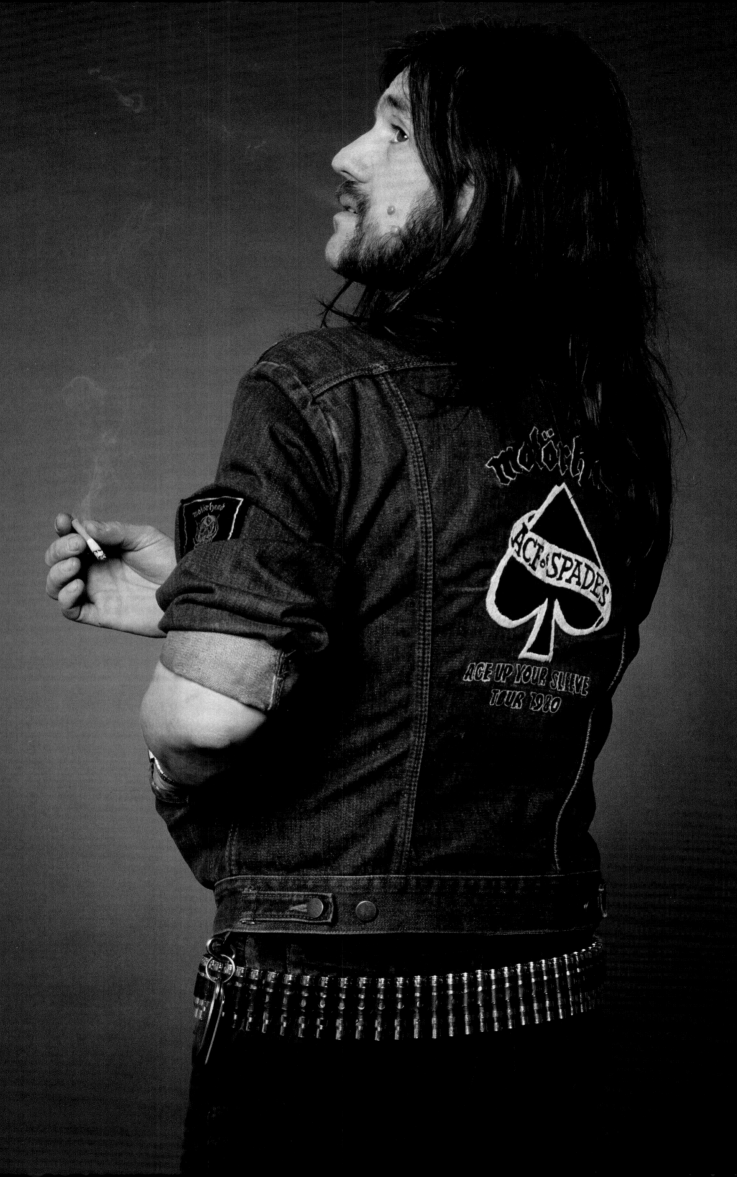

DANZIG IS NOT AMUSED

When the Danzig guys came to my studio, they weren't exactly the friendliest bunch. There was no talking, no kidding around, no small talk. It was apparent they either really didn't like having their picture taken . . . or they just didn't like me. Either way, I had a job to do. I needed to produce a great band shot to be used as a gatefold photo in their album. If they wanted to be tough guys, I decided I'd just make them look like the toughest guys out there.

First, I arranged the members so that Glenn Danzig was the main person in the frame. A band photo is like a puzzle, all different shapes and sizes making one complete image. Once you have the pieces in place, your job as the photographer is to get their vibe across in a way that connects with the fan. Glenn was a bit shorter, so I brought him closer to the camera and shot him at a lower angle, making him appear taller and more dominant than the others. Without talking to him about any of this, I got it—I got him.

As the shoot progressed, I wanted to get a bit more out of the band, but things soon took a turn into more uncomfortable territory. I asked Glenn to pull his head forward and toward me. It was like talking to a brick wall; he wouldn't budge. The other guys followed his lead and began to be uncooperative as well. I proceeded to do what I would usually do—go up to the band members and physically move them, adjusting a shoulder here, a head there. But when I got to Glenn, he said, "Don't touch me. Just take the photos." I finished up the roll of film and said, "Okay, we're done."

To my surprise, Glenn decided he wanted to do one more setup. I never expected what happened next—the whole band came out with their shirts off. The next day, I followed up with the art director. He asked me, "What did you do to piss off Glenn? He loves your photos, but he never wants to shoot with you again." I explained that I had moved the guys around a bit and that Glenn had snapped at me. He told me, "You never should have touched him." I was dumbfounded.

THESE PAGES: Danzig, Mark's studio, New York City

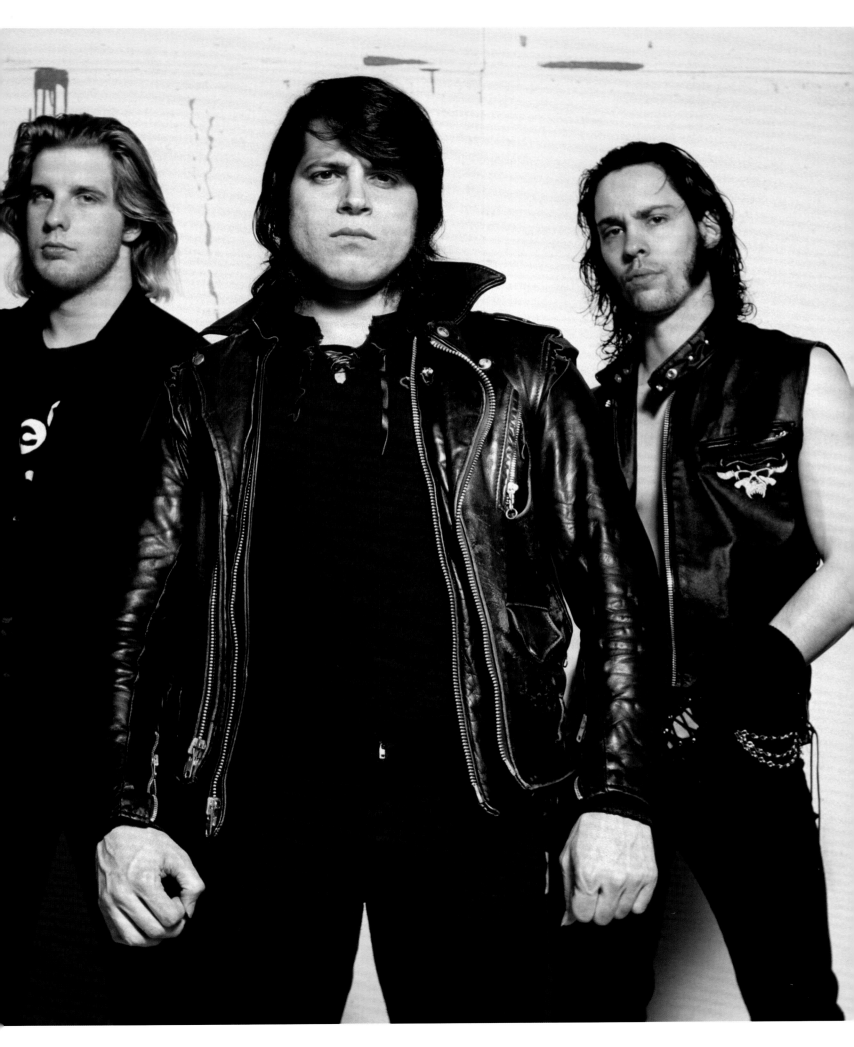

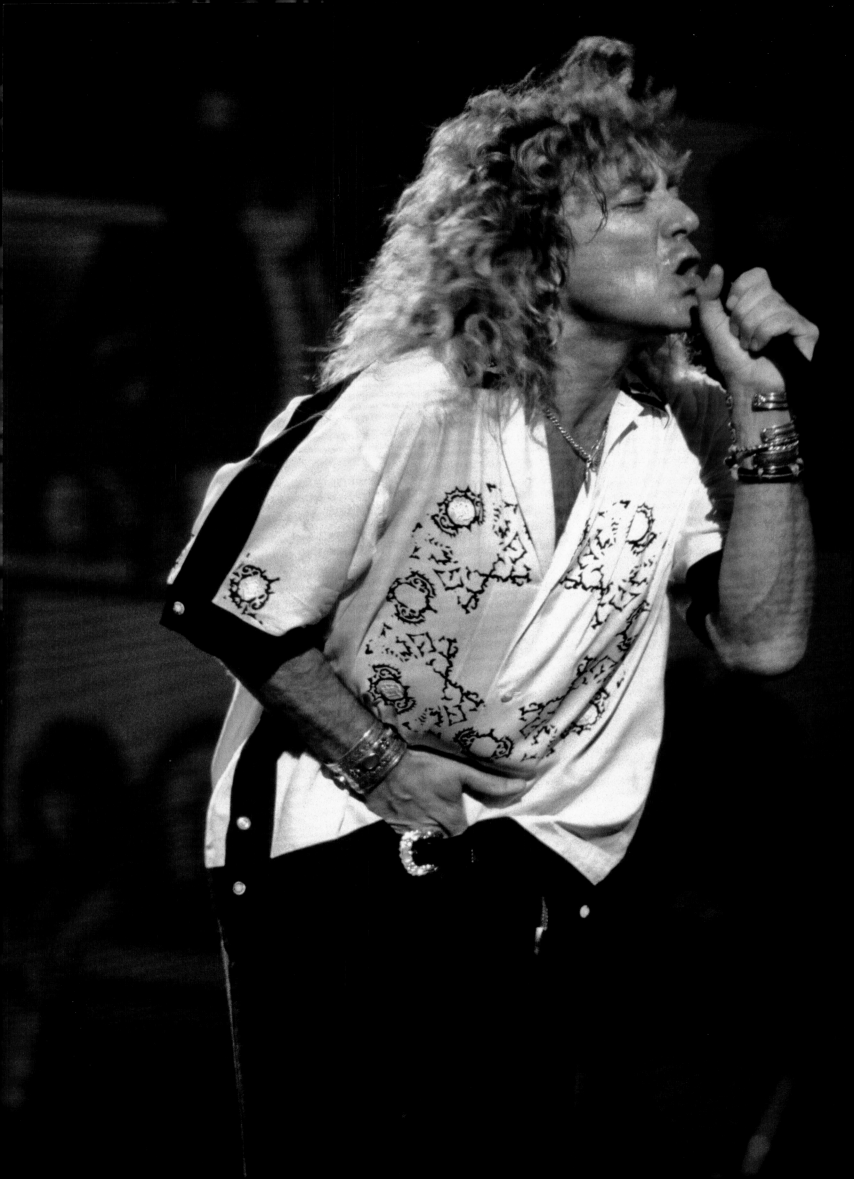

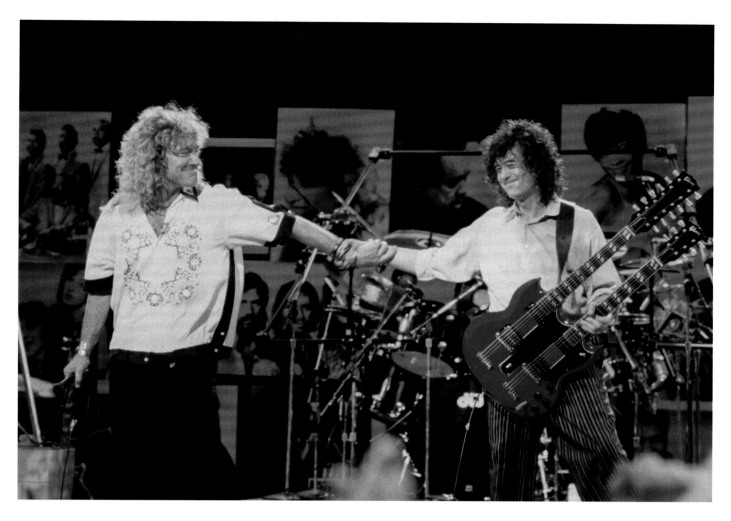

MONSTERS OF ROCK

On May 14, Atlantic Records staged a mega-concert at Madison Square Garden to celebrate the label's fortieth anniversary. Titled "It's Only Rock and Roll," it lasted almost thirteen hours and featured performances from artists ranging from Yes and Genesis to Crosby, Stills & Nash and the Bee Gees. But the main event was a reunion of Robert Plant, Jimmy Page, and John Paul Jones, performing together as Led Zeppelin. A decade earlier, I shot Zeppelin at the same venue; now I was doing it with credentials. They allowed the photographers to shoot one song from the pit, and then I was up to my old tricks and snuck back into the crowd and continued shooting.

Later on that month, Van Halen headed out on the road as the headliners for Monsters of Rock, a massive summer package tour that ran through July and also featured the Scorpions, Dokken, Metallica, and Kingdom Come. The band had just released their second album with Sammy Hagar, *OU812*, and they hired me to shoot new studio and live photos. I joined them on the tour for a few shows, beginning with a press conference that took place

before the first date, in East Troy, Wisconsin, at the Alpine Valley Music Theatre. The rock mags all wanted photos of the monstrous tour, and I had an all-access laminate that gave me the freedom to shoot wherever I wanted.

OPPOSITE: Robert Plant of Led Zeppelin, Atlantic Records' fortieth anniversary, Madison Square Garden **TOP:** Robert Plant and Jimmy Page, Madison Square Garden **BOTTOM:** Monsters of Rock press conference, East Troy, Wisconsin

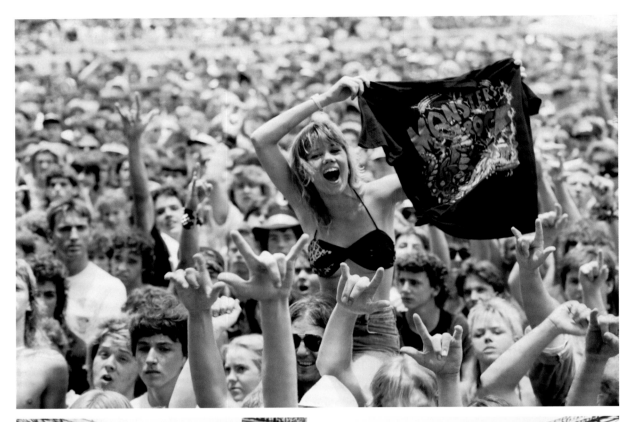

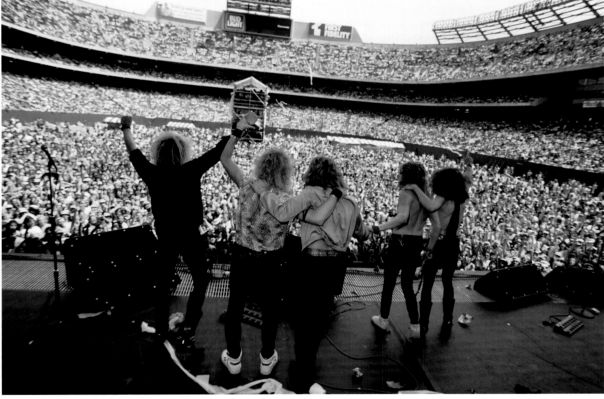

THESE PAGES: Various images from the Monsters of Rock tour:
(*above*) audience; (*bottom*) Kingdom Come onstage;
(*opposite*) Kingdom Come's Lenny Wolf

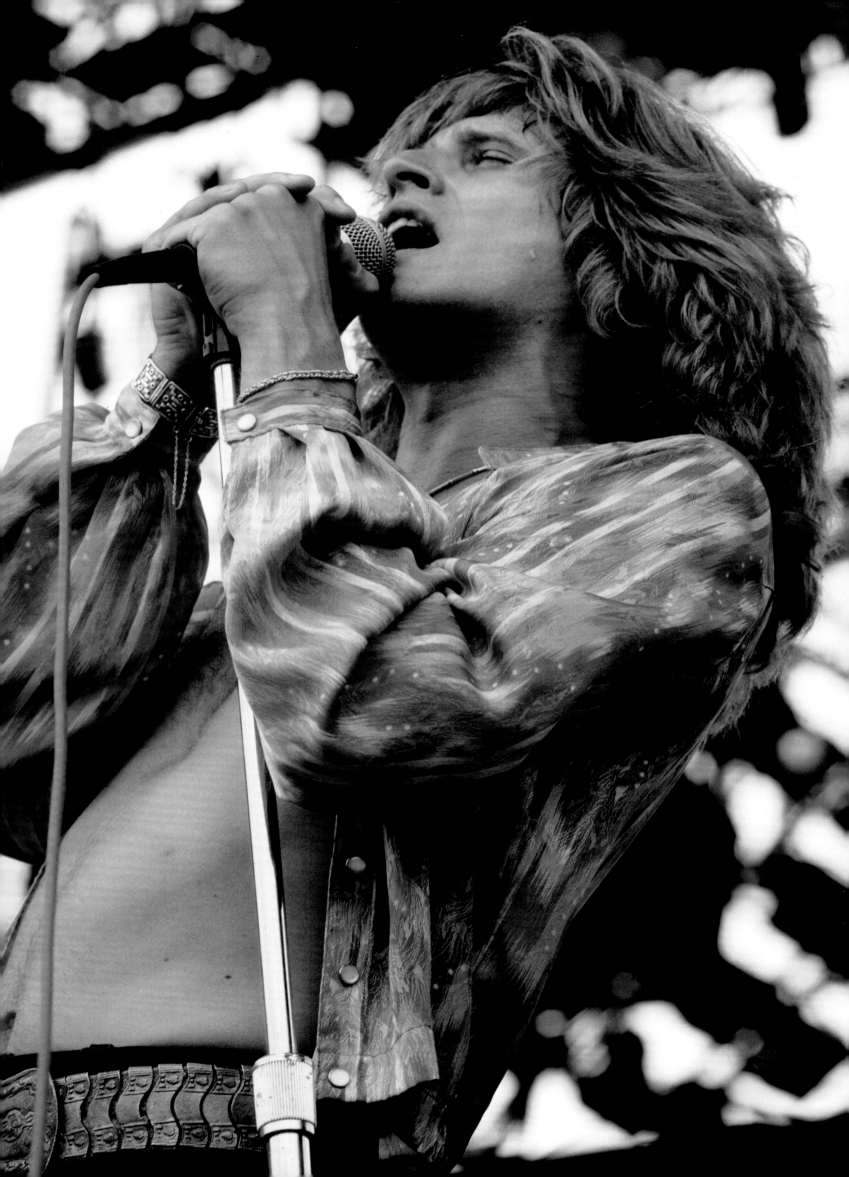

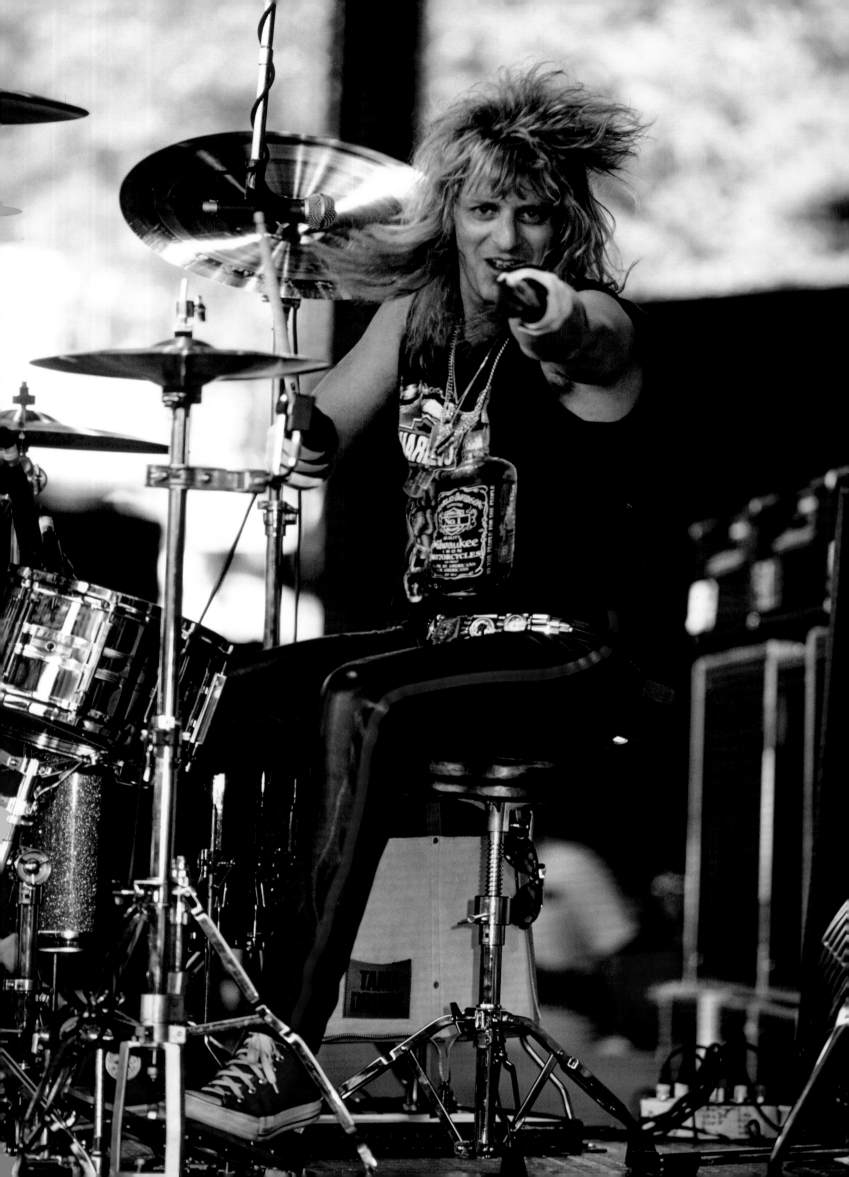

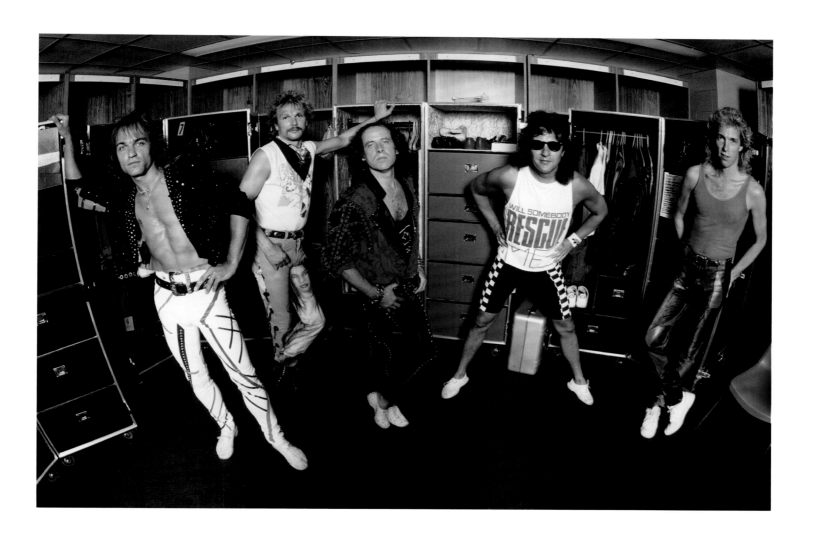

"Monsters of Rock, that was supposed to be our peak, and it was. Here we are, shoved in the middle of five bands— Kingdom Come, Metallica, Scorpions, Van Halen—in that order. We're in the middle. Our manager's like, 'Okay, here you go. This is big time here, play well.'" —"Wild" Mick Brown (drummer, Dokken)

THESE PAGES: Dokken's Mick Brown (*opposite*) and the Scorpions backstage (*above*) during Monsters of Rock **PAGES 308–309:** Images of Van Halen at Monsters of Rock: (*top left*) Sammy Hagar and Eddie Van Halen; (*bottom left*) Van Halen onstage; (*right*) Sammy Hagar

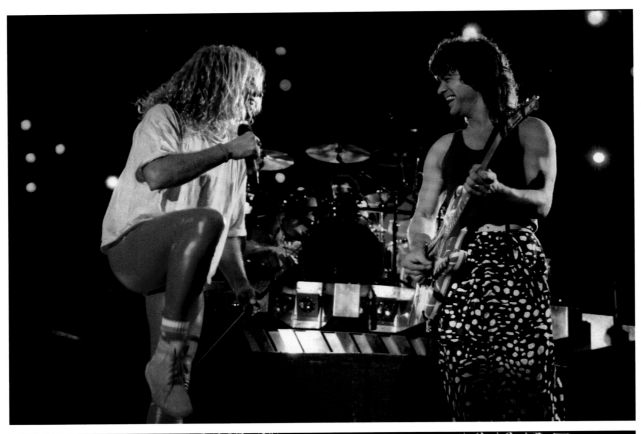

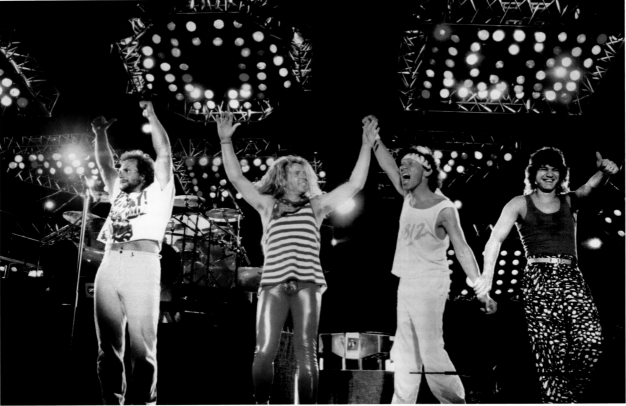

"That era was a photographer's dream. They got to see their work everywhere . . . Mark always had a free pass to do whatever he wanted because I trusted him. He was one of us. He was part of that rock 'n' roll lifestyle." —**Sammy Hagar**

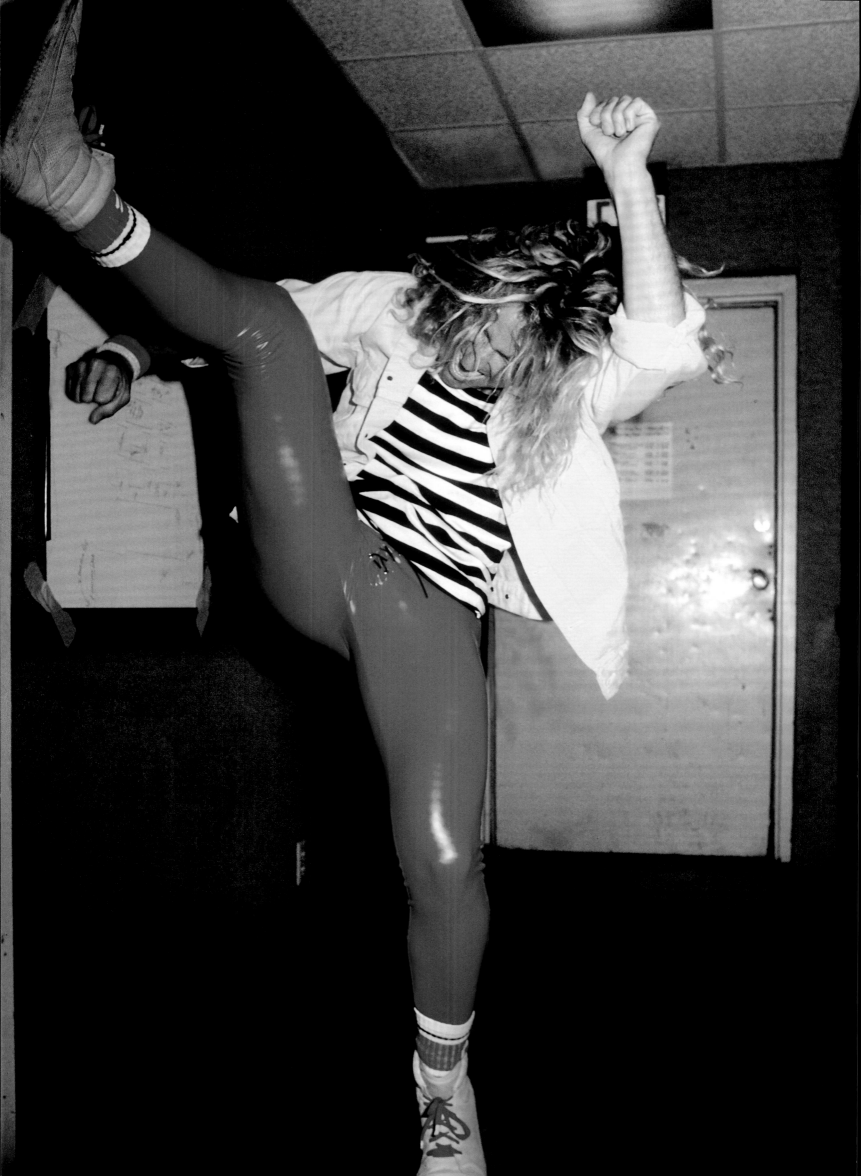

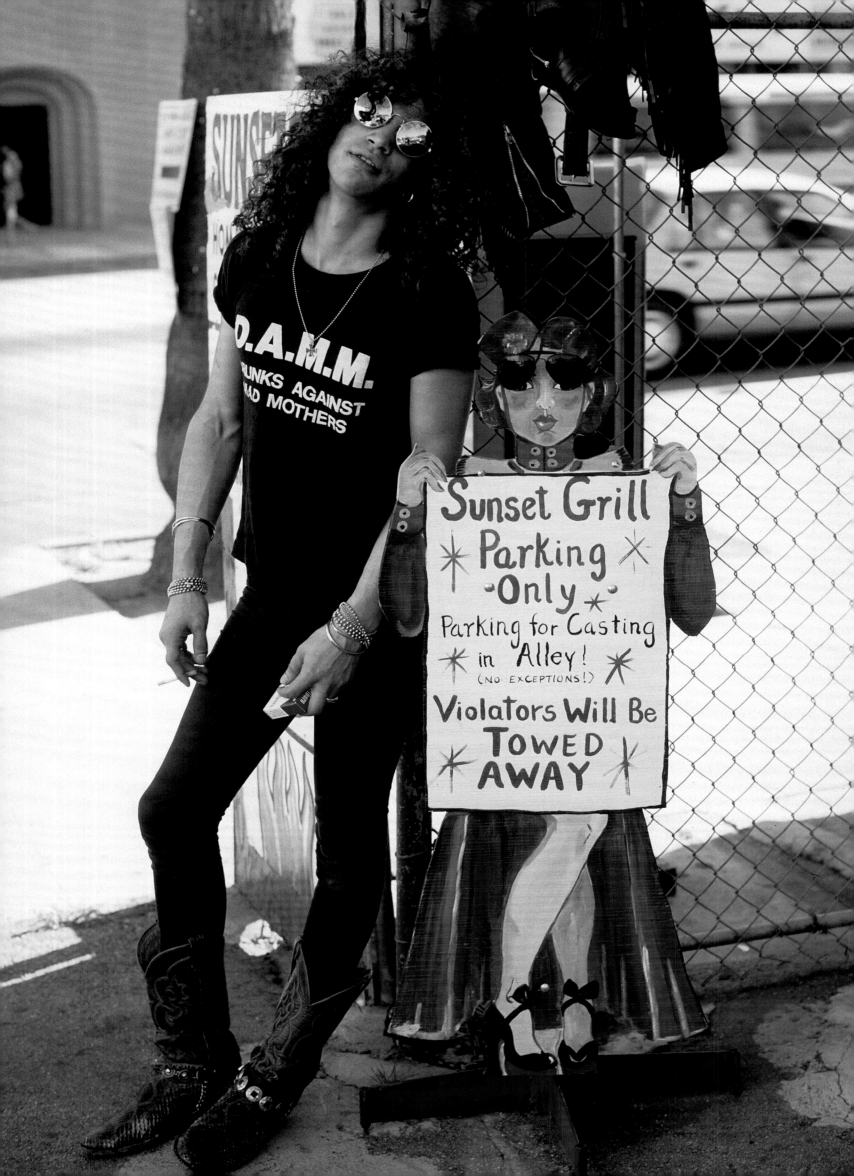

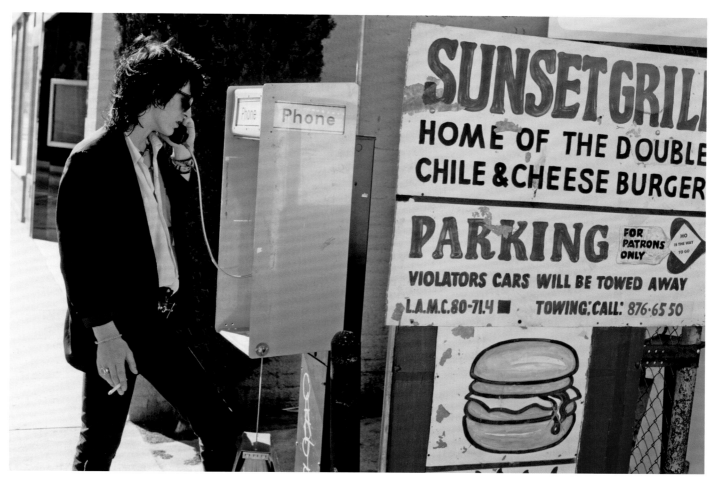

DOWN AT THE SUNSET GRILL

The Sunset Grill was a famous hotspot where musicians would stop in for food after checking out the equipment next door at Guitar Center. While I was in LA with Zakk, who was recording with Ozzy, I reached out to the Guns N' Roses's camp to see if they'd be up for an impromptu photo shoot there. A few days later, we had a plan—or so I thought. Everyone showed up . . . except for Axl. So instead of band shots, I took individuals of the four other guys. The next day, Axl drove up with his girlfriend (and soon-to-be wife) Erin Everly. We had a burger, and he posed for a bit. As he and Erin were leaving, he showed me his new cell phone. He said to me, "Look what I got, Mark! Wanna make a call?" It was the first time I had ever used one.

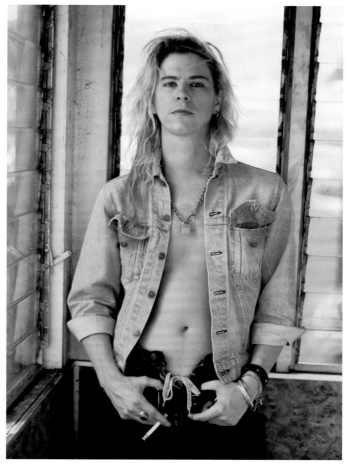

THESE PAGES: Guns N' Roses at the Sunset Grill, Los Angeles: (*opposite*) Slash; (*above*) Izzy Stradlin; (*bottom*) Duff McKagan

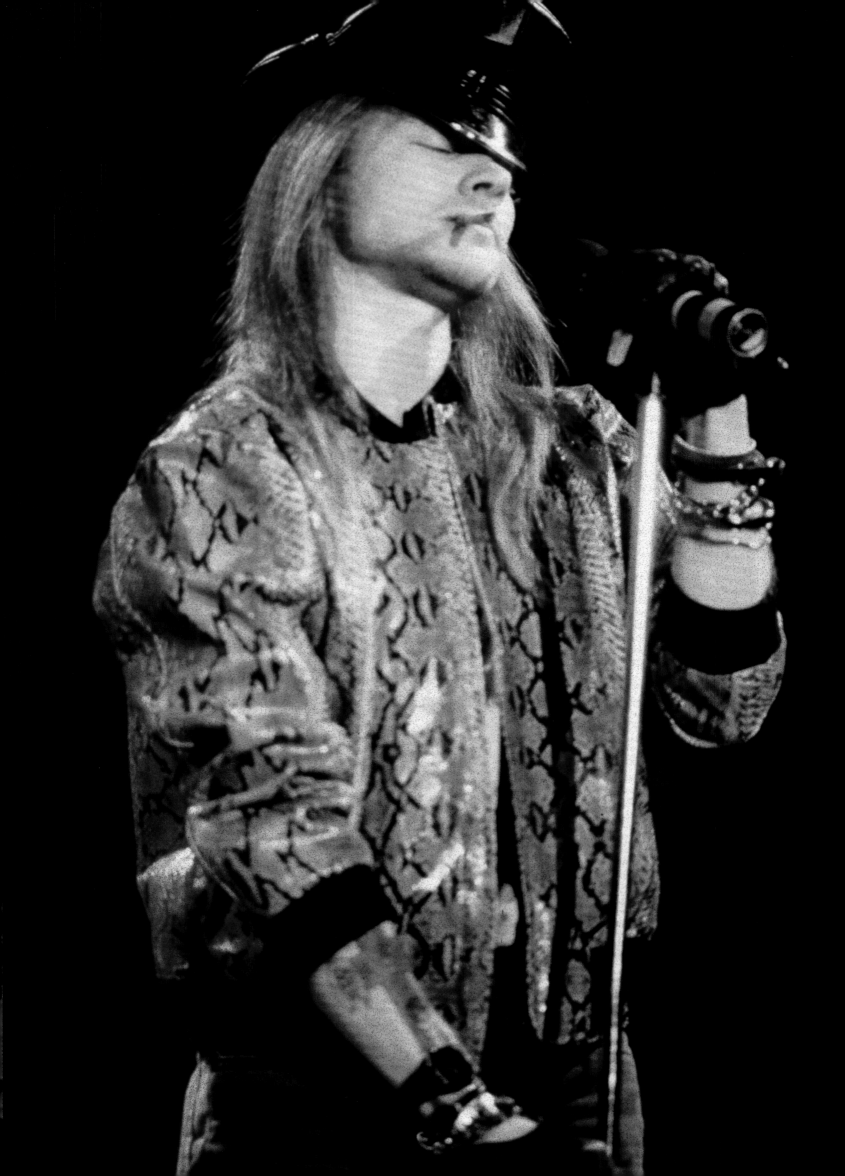

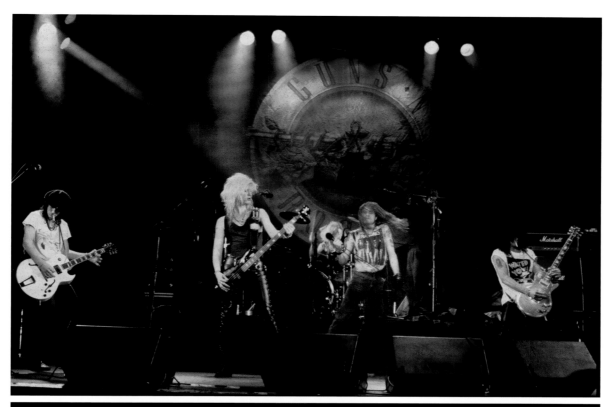

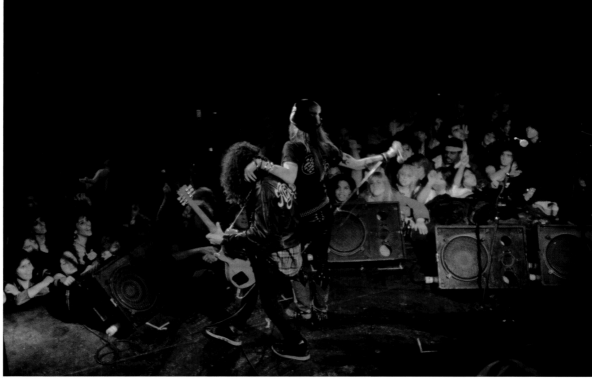

OPPOSITE: Axl Rose, *Appetite for Destruction* tour **TOP:** Guns N' Roses, *Appetite for Destruction* tour **BOTTOM:** Guns N' Roses at the Limelight, New York City

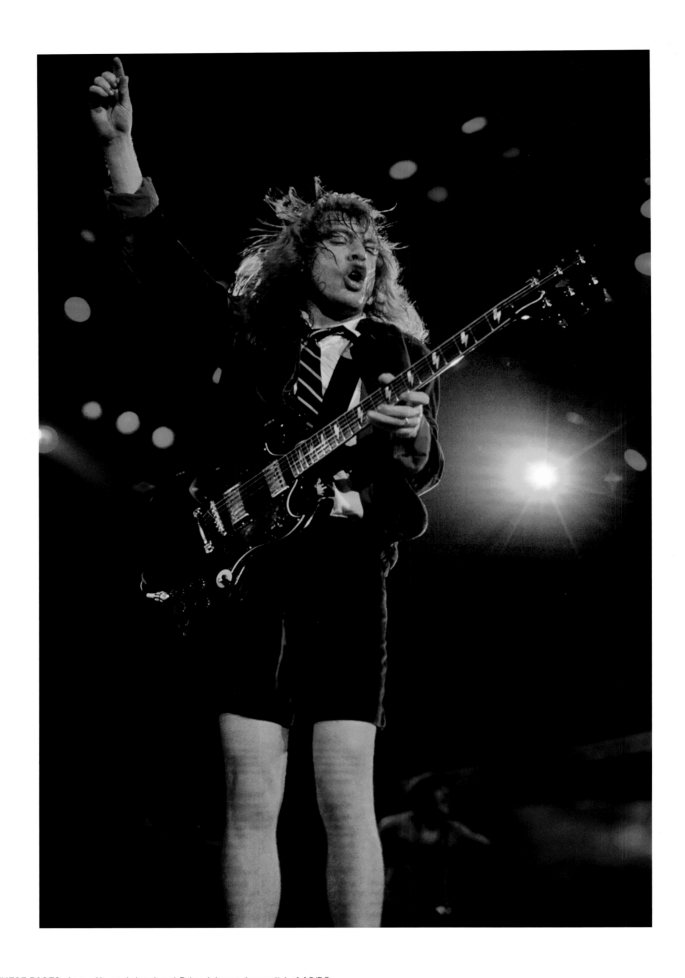

THESE PAGES: Angus Young (*above*) and Brian Johnson (*opposite*) of AC/DC performing live, *Blow Up Your Video* tour.

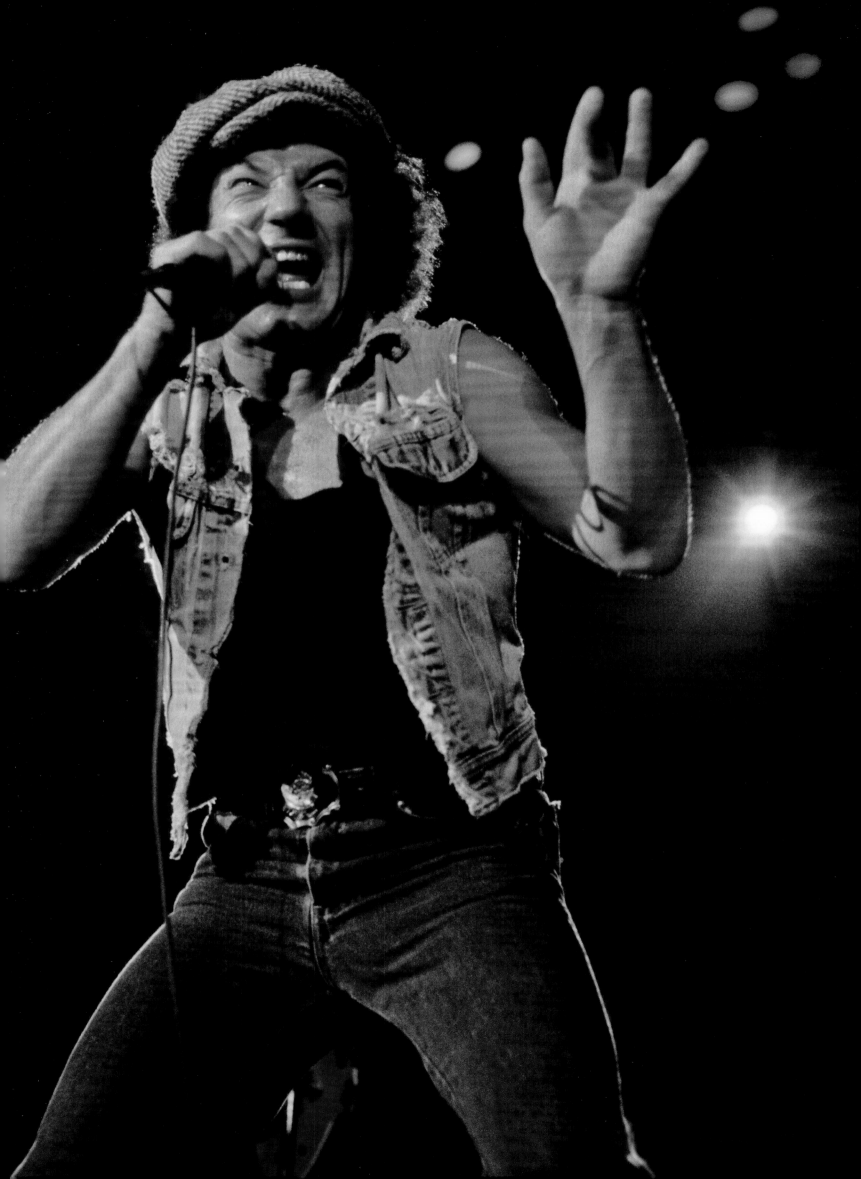

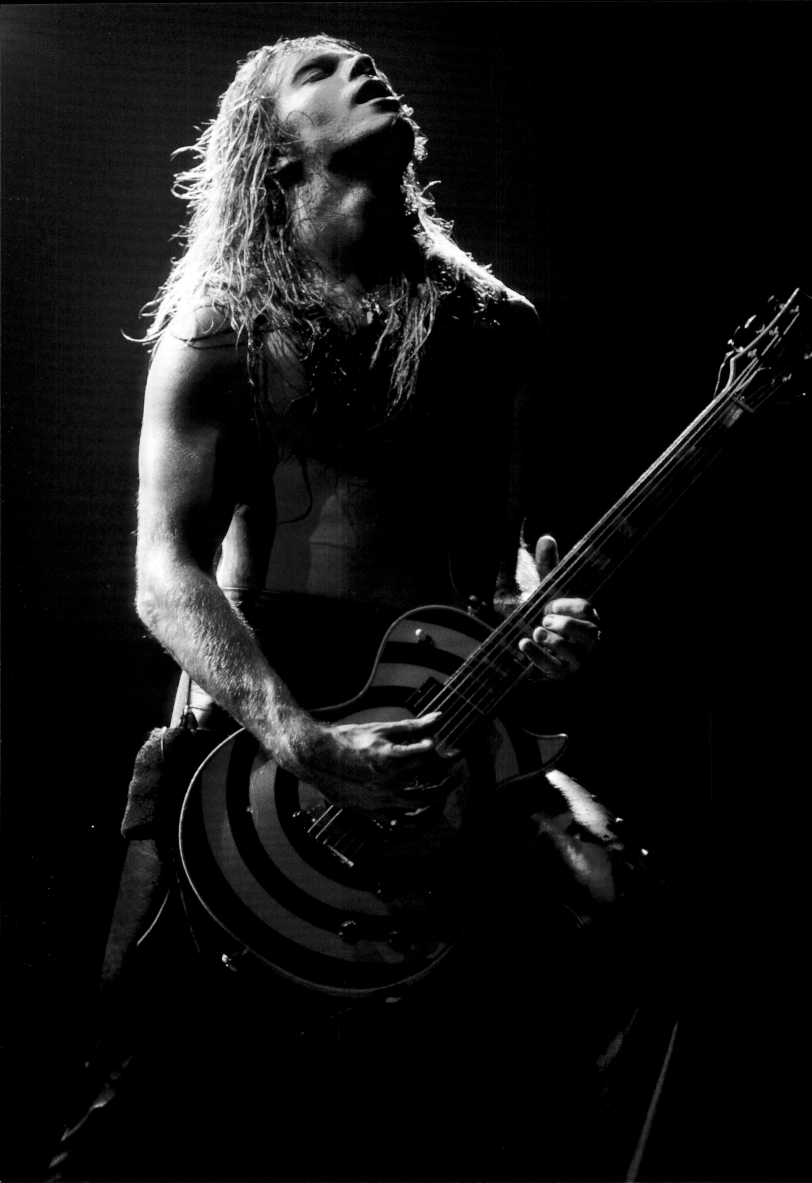

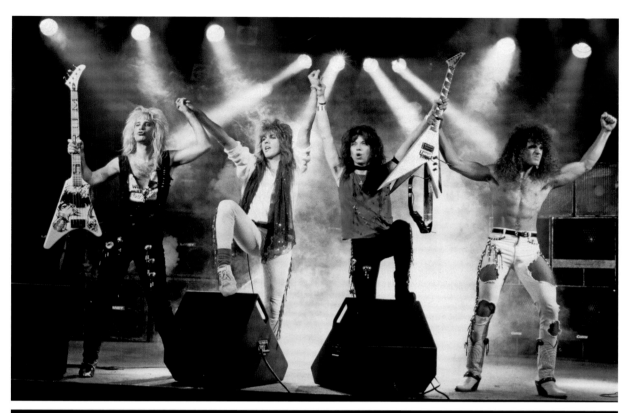

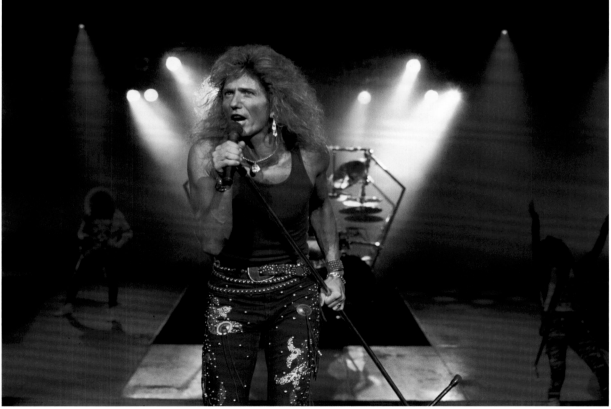

OPPOSITE: Zakk Wylde, *No Rest for the Wicked* tour, 1989 **TOP:** Vinnie Vincent Invasion, 1987 **BOTTOM:** Whitesnake on their 1987–1988 world tour

317

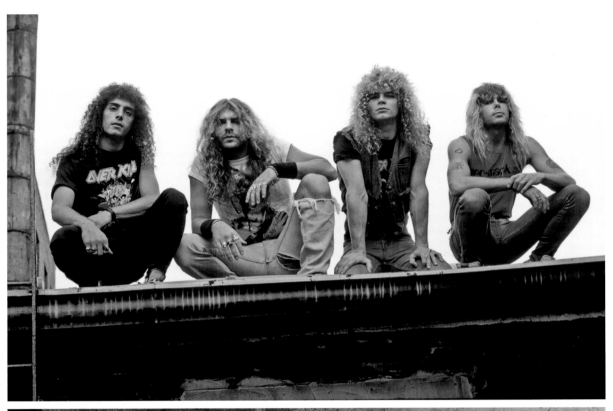

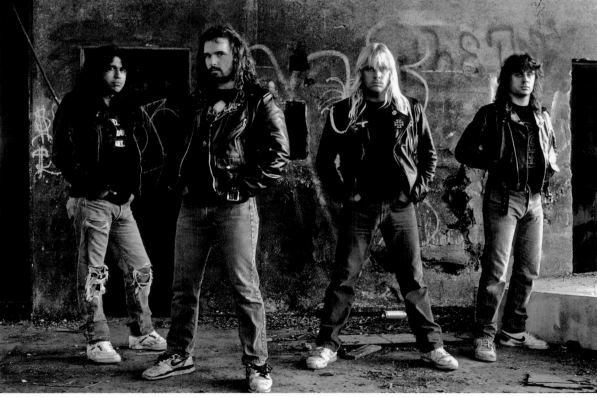

"I think he worked well with us because we were all from the same area, had the same sense of humor—good-standing, card-carrying Jersey boys. There was as much ball-busting going on as flashes! I suppose this is why Mark is a 'Weiss-guy'— it fits, that's for sure." —**Bobby "Blitz" Ellsworth (singer, Overkill)**

TOP: Overkill, Mark's studio, New York City **BOTTOM:** Slayer, Los Angeles
OPPOSITE: Megadeth's Dave Mustaine backstage, *So Far, So Good…So What!* tour

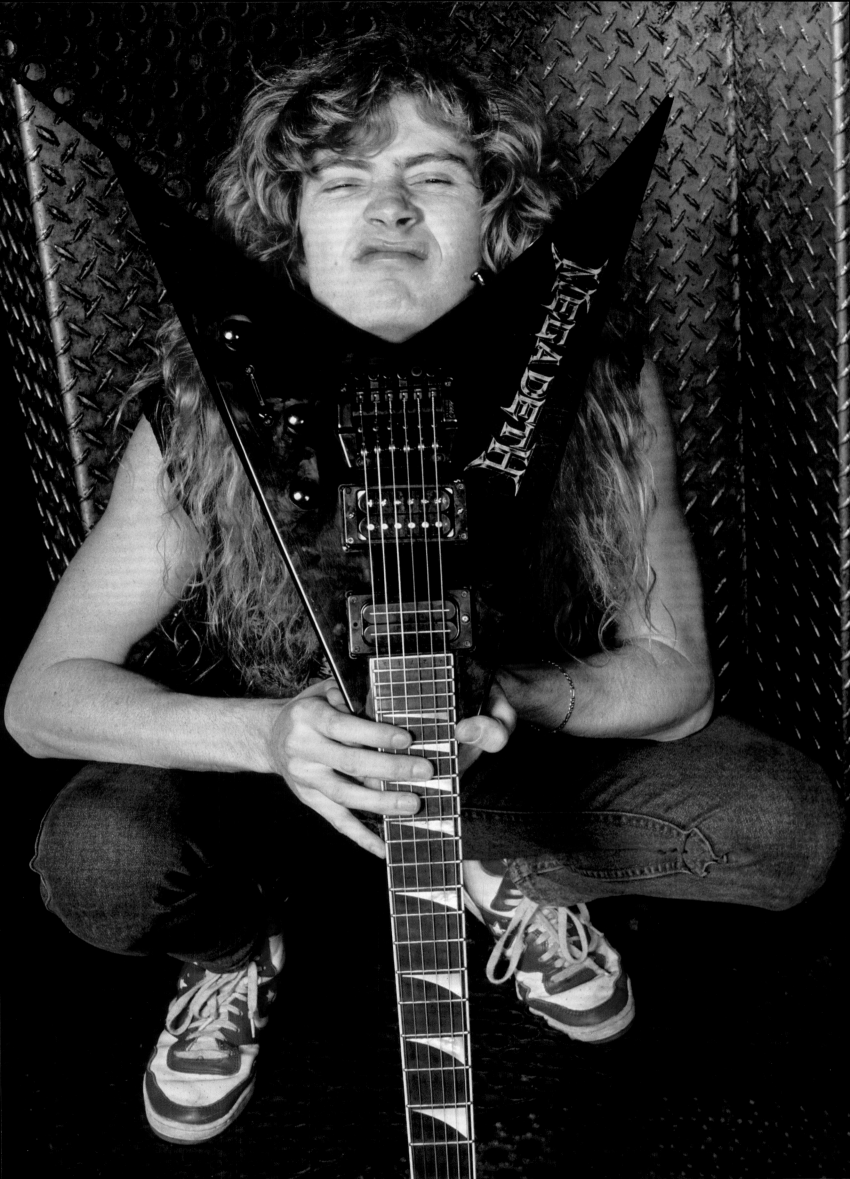

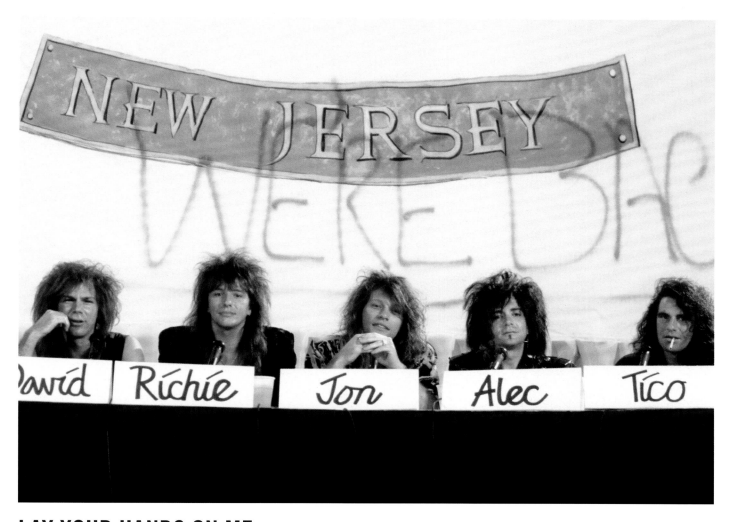

LAY YOUR HANDS ON ME

On August 19, Bon Jovi held a press conference and a record-release party in New York City to celebrate their new album, *New Jersey*. The place was decked out like the Jersey Shore, with a boardwalk beach theme and plenty of hot female lifeguards and hotdog stands to boot. The next month, the band went to California to shoot the video for the album's lead single, "Bad Medicine," with director Wayne Isham. After Jon's cameo in "Wild Thing," Sam Kinison returned the favor by appearing in "Bad Medicine." "We can make a better Bon Jovi video than these guys can!" he screamed, passing out handheld cameras to the crowd of fans and inviting them onstage to help shoot the video.

Later on, as 1988 came to a close, *Rolling Stone* sent me on assignment to photograph Bon Jovi in Moscow, where Doc McGhee was meeting with Russian dignitaries to help orchestrate a concert to be held the following summer. At the time, it was being touted as the "Russian Woodstock." That concert would eventually be known as the Moscow Music Peace Festival.

OPPOSITE: Jessica Hahn and Sam Kinison, on the set of the "Wild Thing" video, Los Angeles TOP: Bon Jovi, *New Jersey* LP press conference, New York City BOTTOM: Doc McGhee and Jon Bon Jovi in Moscow PAGES 322–323: Bon Jovi, Moscow

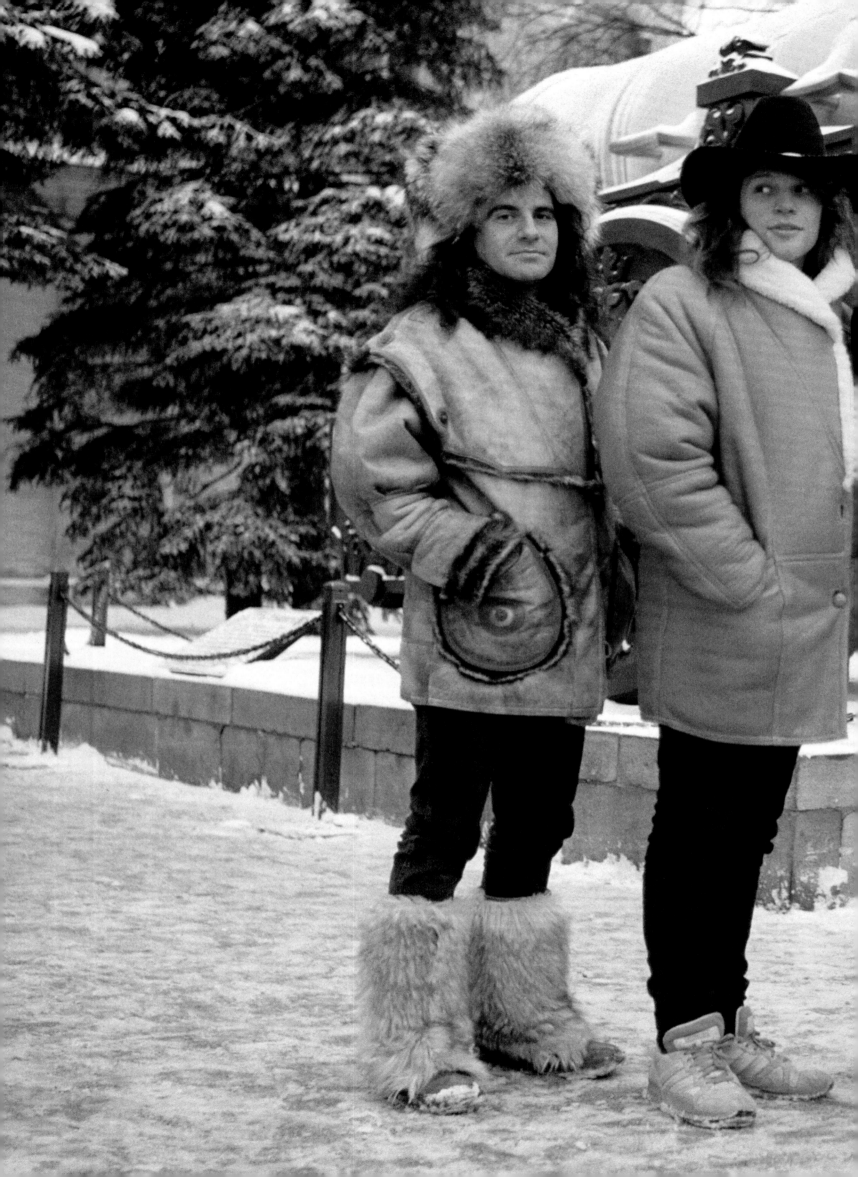

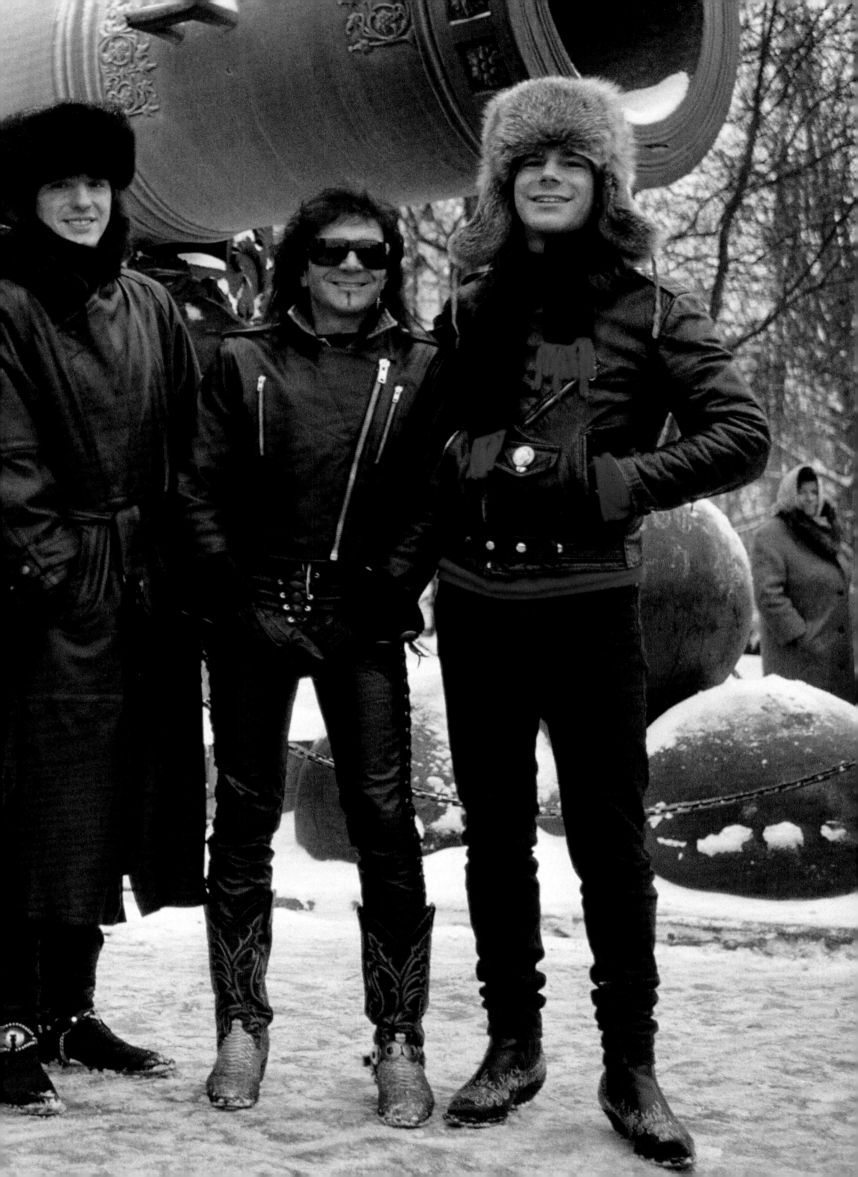

© 1989 MARK WEISS/MWA

7020-0159-001 WHITE LION
Group on couch - white
S89

© 1989 MARK WEISS/M
3340-0724-001 LA GUNS
Group; leopard wall, couch (4

© 1989 MARK WEISS/MWA
S//327

МОСКОВСКИЙ МУЗЫКАЛЬНЫЙ ФЕСТИВАЛЬ МИРА
MOSCOW MUSIC PEACE FESTIVAL
MAKE A DIFFERENCE FOUNDATION
ALL ACCESS
OTTO

© 1989 MARK

© 1989 MARK WEISS
GOOD
Hea
SONGO
S00857

3220-0324-001 KIX
Group (H) standing by garage door
with guitars
S89

© 1989 MARK WEISS/MWA

WE ARE THE YOUTH GONE WILD
SKIDROW
JAPAN TOUR

4:15 - 210
4:30 - WPLJ
4:45-5:00
5:00-6:00 S
6-6:45 CHAN SQUI
6:45-7 SAM
7-8:15 SQUI
8:15-9:00 BONJOVI
9:00- Bon Jovi

90 FINAL COUNT DOWN 91
電話100年記念 NTTスーパーコミュニケーション
BON JOVI
CINDERELLA
SKID ROW
QUIREBOYS
JAPAN
ALL AREAS
PHOTOG

BILKO
(BALL
DROPPED)
BOB
MARTY
DJ
BVZEE

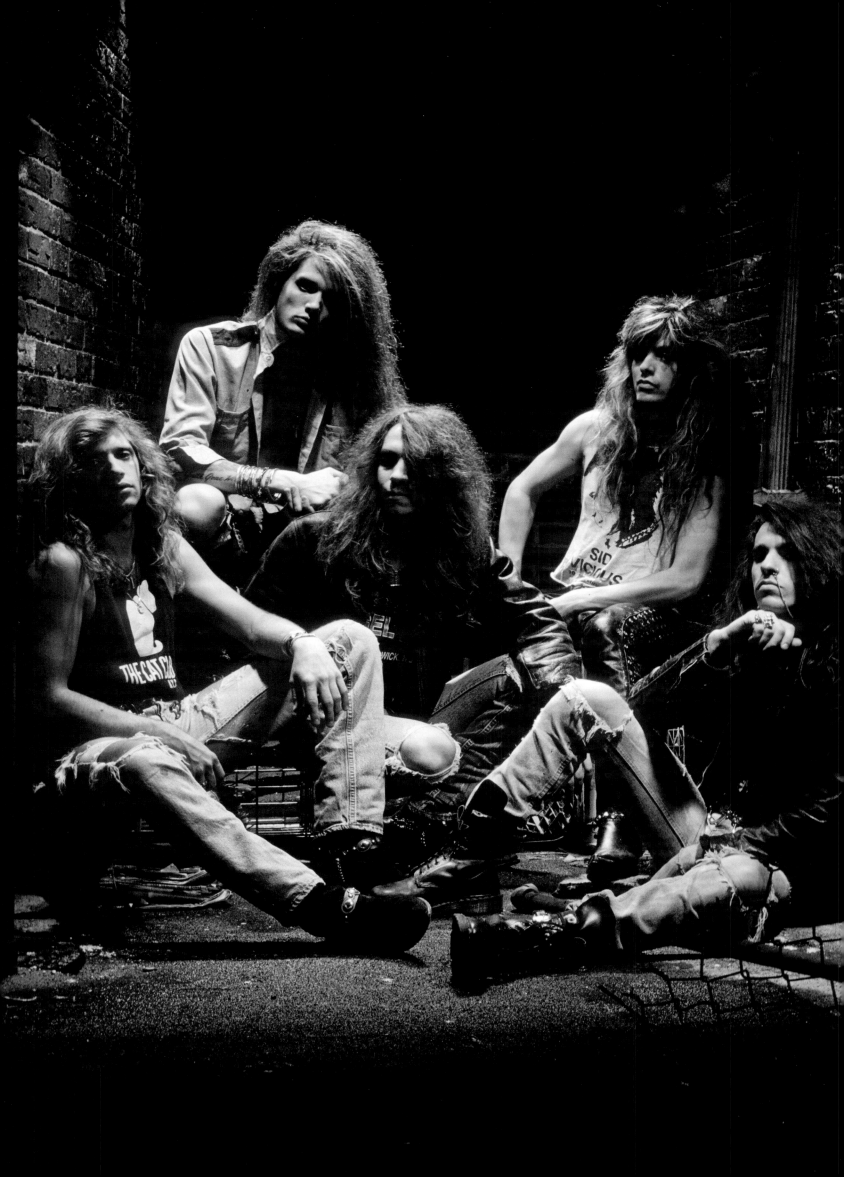

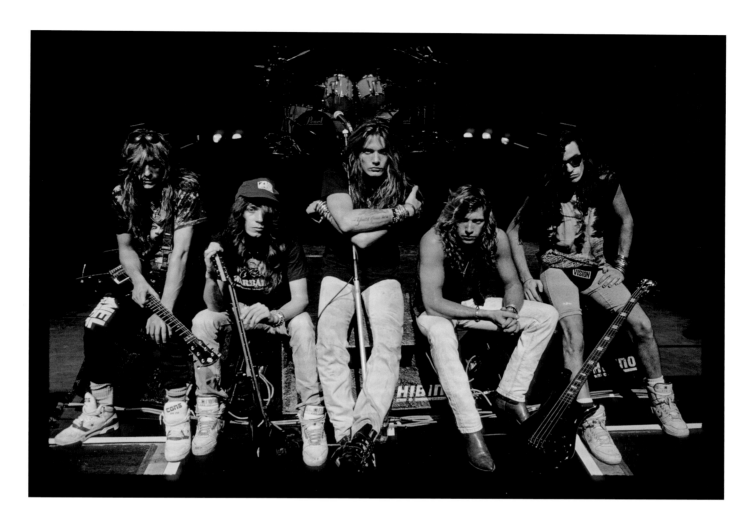

GOTTA GET BACK TO THE GARDEN STATE

As the new year began, I started to think about moving back to New Jersey. I was getting burnt out in New York City and was also traveling more than ever, following bands around the world. I was ready to go back to Jersey, buy a house, and raise a family. I found a great place to rent right on the water in Rumson. It was perfect: a two-car garage that I turned into a studio, an upstairs area that would be my office, a fireplace to chill out in front of, and a dock where I could tie up my boat. I always liked change, and I also loved moving. When I was a kid, I would constantly rearrange my furniture and even switch rooms with my brother and then switch back. I started making plans to move to Rumson by the spring.

On the music side of things, Skid Row had released their self-titled debut at the beginning of the year. I was thrilled for the guys but also a bit disheartened by the album art. Back in the fall of '88, I had heard through the grapevine that the band had shot the cover photo for the record. I felt betrayed. I was responsible for the guys getting together with Sebastian; I thought it was a given that when it came time to do the album cover, I would be

called. But the art director at their label decided to bring in someone who did "artsy black and white." When I found out what had happened, I went to Skid Row's manager, Scott McGhee, and voiced my disappointment. He tried to explain it all away as being the record company's call. But I wasn't going to let it go that easily. Next, I called the guys in the band. They apologized but said the same thing: It was the label's decision. Again, I didn't accept that answer. I asked them to describe the shoot to me, and they told me the setup was a nighttime street scene. Immediately, I started envisioning my own shoot and the set I would build to photograph the band. I decided I wasn't going down without a fight, and the guys understood and seemed to have my back. After some back-and-forth with management, I made a deal, and we went ahead with the shoot. They would pay all expenses, and I wouldn't charge them unless they used the photos.

We scheduled a session at my friend Danny Sanchez's studio in Red Bank—the same place I had done the *Slippery When Wet* shoot with Bon Jovi a few years earlier—and got to work building a set. I brought in some brick

OPPOSITE: Skid Row, *Skid Row* album shoot, Red Bank, New Jersey
ABOVE: Skid Row in Japan

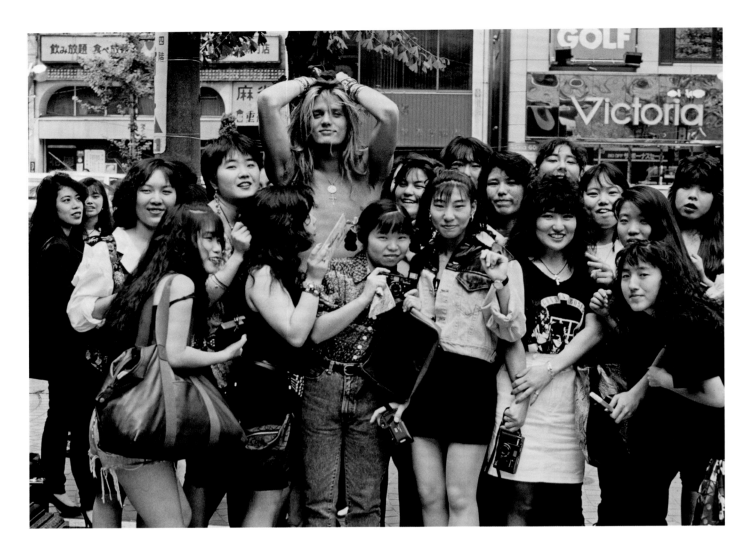

paneling, a fence, a few garbage cans and some trash, and other debris. I weathered the paneling to make it look like the brickwork you would see on a dingy, dead-end street. Finally, I lit the scene as if it were being illuminated by a single streetlight, similar to the cover image I was competing against. I brought the band in, and we shot for twelve hours.

The band was digging the vibe of what I was doing. But the record company didn't even wait to see my shoot; they needed to send out the cover for advance promotion. They were, however, still designing the rest of the package. The inner sleeve, back cover, and single sleeves, as well as promo and merch, used photos from my shoot. Skid Row went on to be a massive success, selling more than five million copies in the US. I was disappointed that I didn't get the cover, but it felt good to know the band had fought for me.

I did my last shoot at my New York City studio in March. It was on the roof with Dirty Looks, for their second major-label album, *Turn of the Screw*. I had developed a good relationship with the art department at Atlantic Records from shooting Twisted Sister covers, and they wanted me to do my magic with another one of their bands.

Skid Row would go on to play in Japan later that summer. Japan was one of those places that held a certain kind of mystique for me. As a teen I had seen larger-than-life photos of Kiss in Tokyo, and those images were embedded in my head. When I was given the opportunity to travel with Skid Row on their tour there, I grabbed it. Their management paid for my travel in exchange for the use of the photographs. Walking through the streets, the band always got swarmed by adoring fans. You could be two blocks away and easily spot a blond, six-foot-three dude in the distance among a crowd of tiny dark-haired girls. Sebastian loved the attention and always had a blast with it.

ABOVE: Sebastian Bach with fans in Japan **OPPOSITE:** Sebastian Bach, Japan

"You can consider him an historian of sorts of an era that had to be lived to be believed. It was the era of excesses, and whomever survived and lived to tell about it has a lifetime of stories." —**Dave "Snake" Sabo**

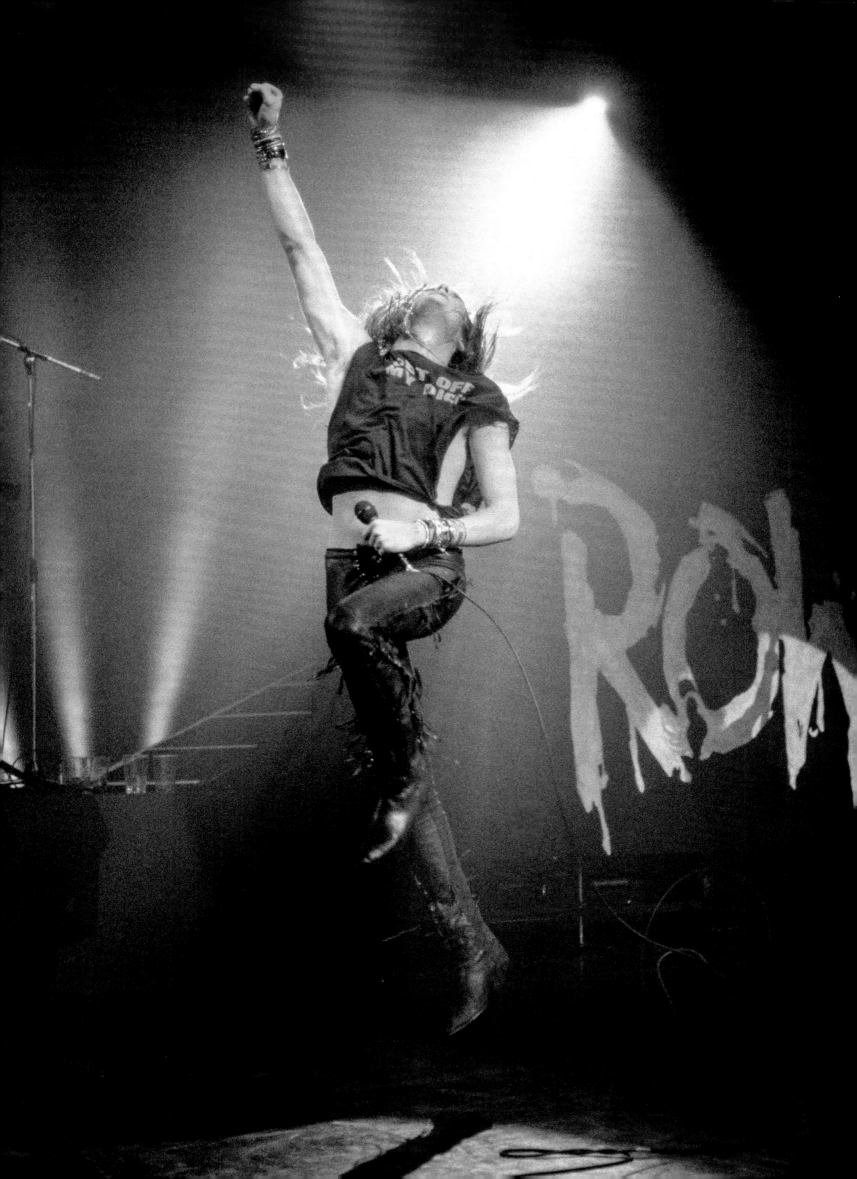

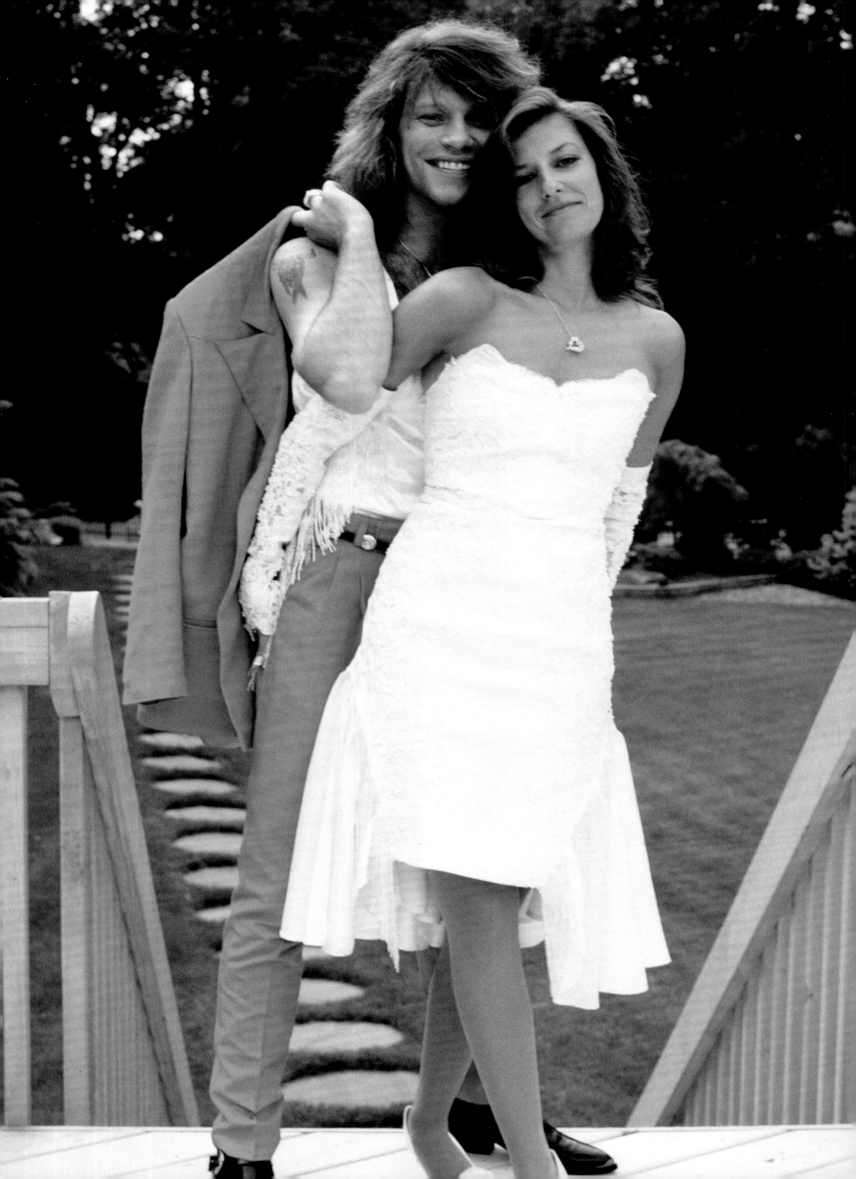

THIS HOUSE IS NOT FOR SALE

On March 30, Jon Bon Jovi gave his childhood home to Jay and Judy Frappier, who had won it in an MTV contest. The Bongiovis had lived at 16 Robinhood Drive in Sayreville, New Jersey, for twenty-four years. They had bought a new house in another town, and it was Jon's younger brother Matt who had suggested a contest giving away the old one on MTV. Not long after, in April, Jon secretly married his high school sweetheart, Dorothea Hurley, at Graceland Wedding Chapel in Las Vegas. After they came home and shared the news, Jon planned a big bash in New York City. As the guests were celebrating there, I joined the newlyweds at their home in Rumson for a private champagne toast before we left in the chopper that was waiting nearby. In March, Alice Cooper, Desmond Child, and Richie Sambora came to Jon's home studio in Rumson. Together they wrote and recorded "Hell Is Living Without You," which appeared on Alice's *Trash* album, released that July. On June 11, Bon Jovi played a massive homecoming show at Giants Stadium. They brought Skid Row, Billy Squier, and Sam Kinison along for the gig. Little Steven performed during the finale. Just as with *Slippery When Wet*, Jon put me to work to find a girl for the event laminate and told me to put her in a cut-up T-shirt. Only this time, appropriately, the shirt was a Giants jersey. It was a great way to christen my brand-new Jersey studio.

OPPOSITE: Jon and Dorothea's wedding photo, taken at Jon's house in Rumson, New Jersey TOP: Jon Bon Jovi's childhood home during the MTV giveaway contest, Sayreville, New Jersey BOTTOM: Mark with model, Mark's house, Rumson, New Jersey

331

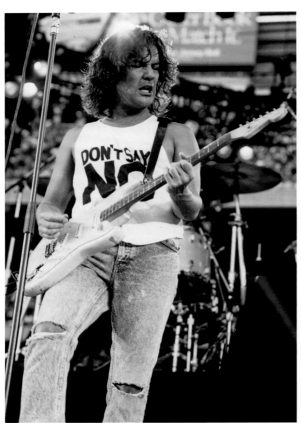
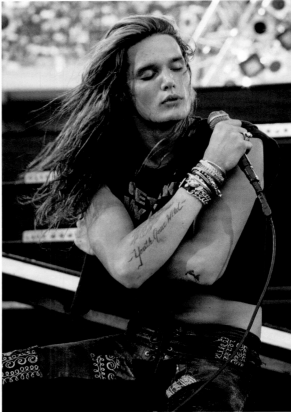
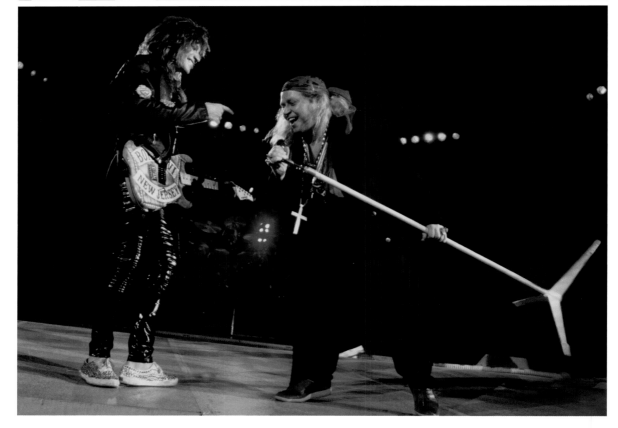

THESE PAGES: Images from Giants Stadium: (*top left*) Billy Squier and (*top right*) Sebastian Bach; (*bottom*) Jon Bon Jovi and Sam Kinison; (*opposite*) Jon Bon Jovi

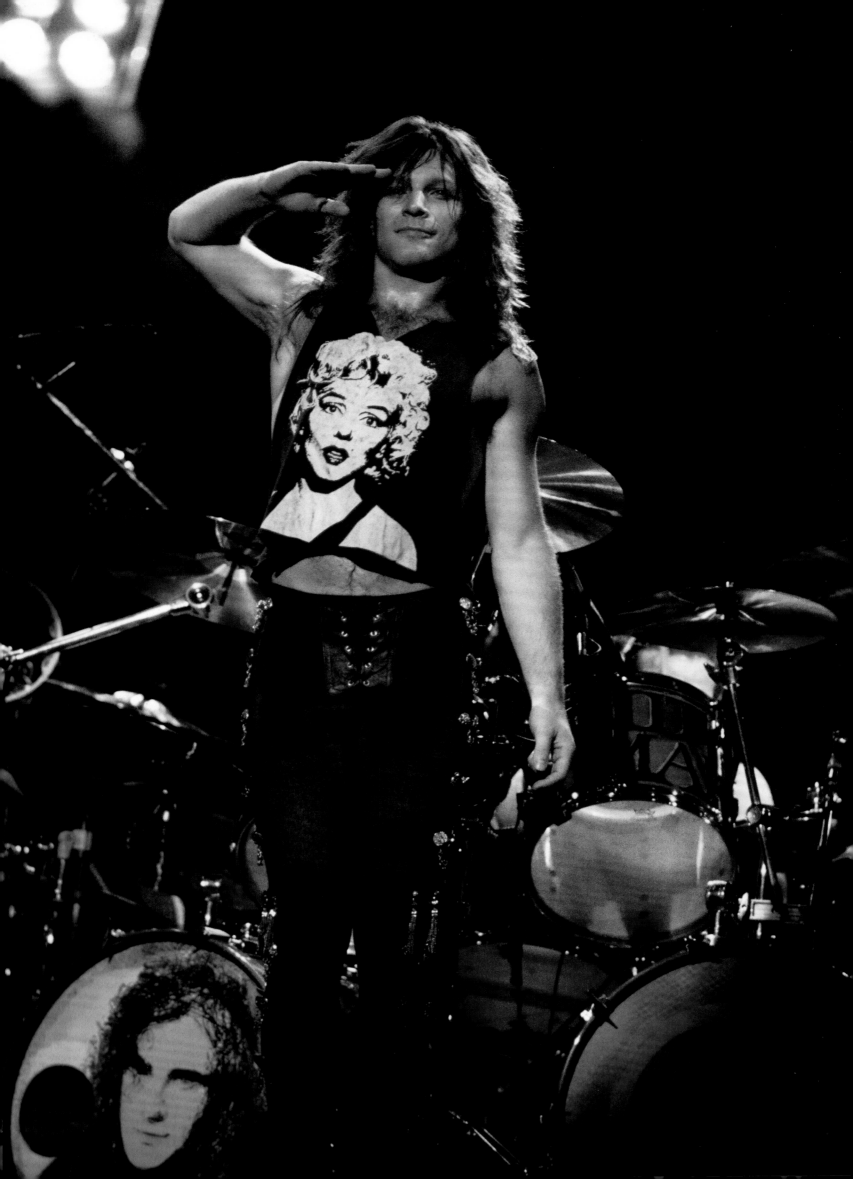

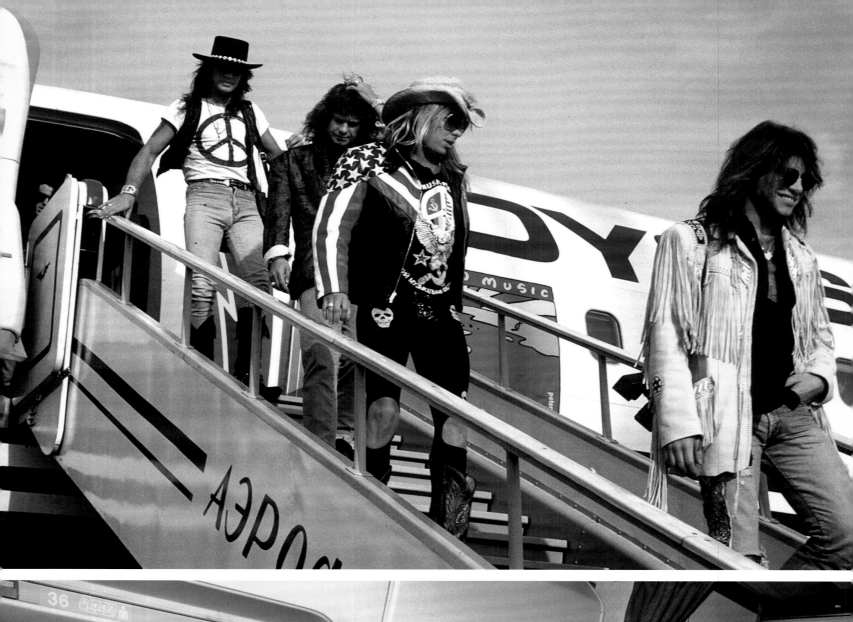

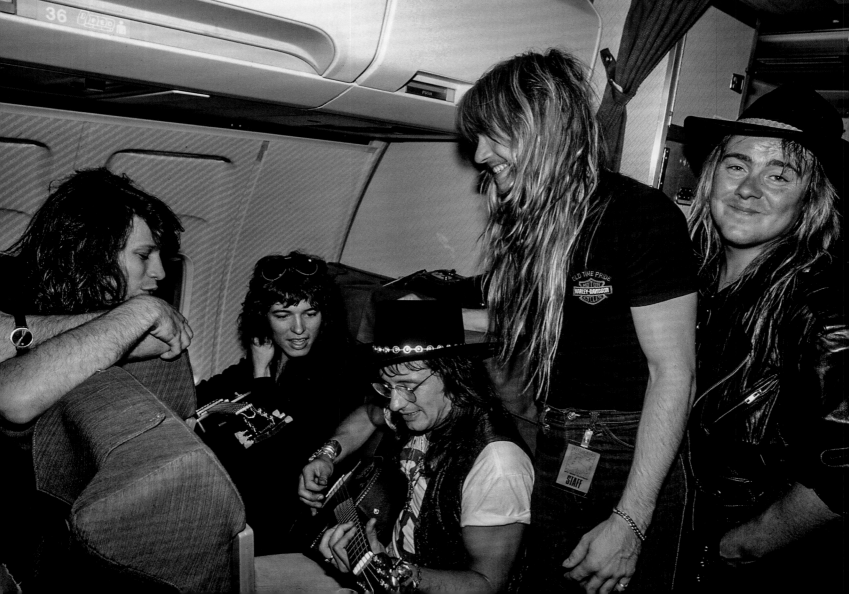

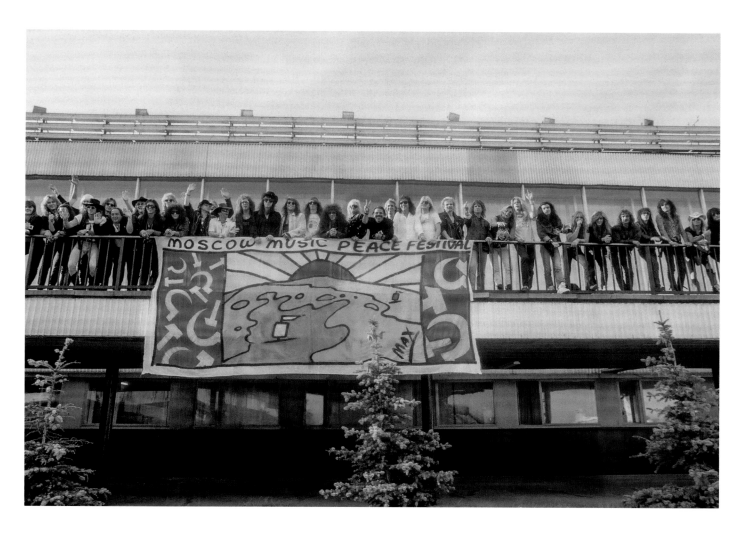

BACK IN THE USSR

That summer was one of the biggest rock events of the decade: the Moscow Music Peace Festival. On August 12 and 13, more than one hundred thousand Russian rock 'n' roll fans came to Lenin Stadium in Moscow for a massive concert featuring Skid Row, Scorpions, Cinderella, Ozzy Osbourne, Mötley Crüe, and Bon Jovi. The event was put together by manager Doc McGhee, with proceeds going to the Make A Difference Foundation, a nonprofit organization that raised money for antidrug and addiction education programs. I had traveled to Russia with Bon Jovi the previous year. Now, we were going back for what would be a historic moment. A few days before the concert, we all boarded a plane we nicknamed the Magic Bus and headed to the USSR. It felt like a class reunion. Actually, forget class reunion—it was more like a family reunion! The flight over was one big party.

When we arrived in Moscow, I wanted to be the first one off the plane so that I could capture the magic moment of so much rock royalty stepping foot onto Russian soil. I remembered being a kid and seeing footage of the Beatles as they arrived in the US for the first time. This felt just as momentous.

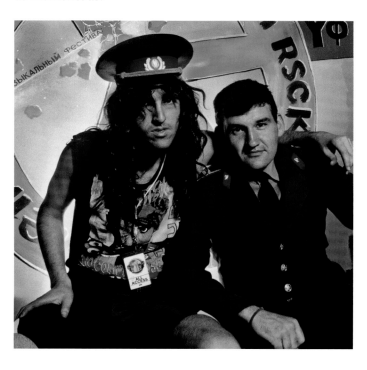

"There was no alcohol served on the plane, so what everybody was doing was going to the duty free and just stocking up on as much booze as possible. It was LAX to Newark, then to Heathrow, where we picked up the Scorpions, and then to Moscow. You could have gotten drunk and sober about twenty-two times on that flight." —**Zakk Wylde**

OPPOSITE TOP: Richie Sambora, Ozzy Osbourne, Vince Neil, and Jon Bon Jovi arriving in Moscow for the Moscow Music Peace Festival **OPPOSITE BOTTOM:** Jon Bon Jovi, Tom Keifer, Richie Sambora, Zakk Wylde, and Jason Bonham aboard the "Magic Bus" plane ride to Moscow **TOP:** Musicians at Moscow Music Peace Festival **BOTTOM:** Mark and a Russian soldier, Moscow

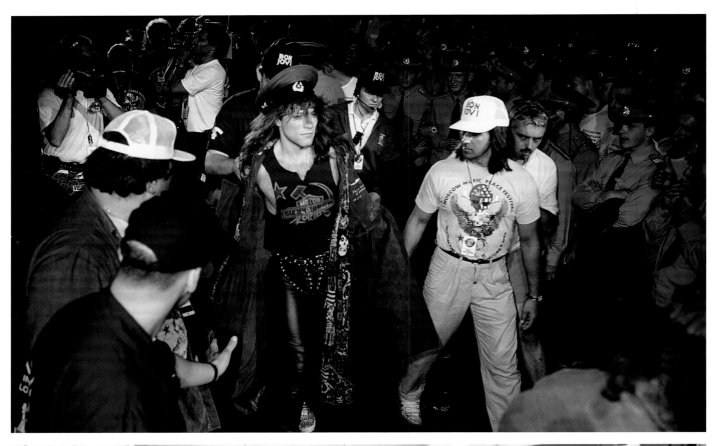

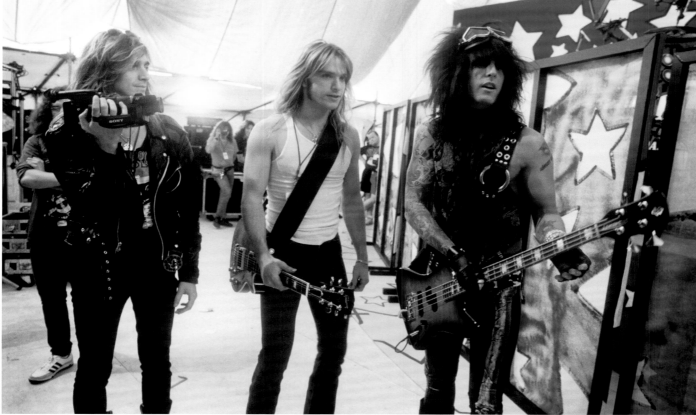

THESE PAGES: Images from the Moscow Music Peace Festival: (*top*) Jon Bon Jovi; (*bottom*) Dave "Snake" Sabo, Zakk Wylde, and Nikki Sixx; (*opposite top*) Mötley Crüe onstage; (*opposite bottom*) musicians backstage.

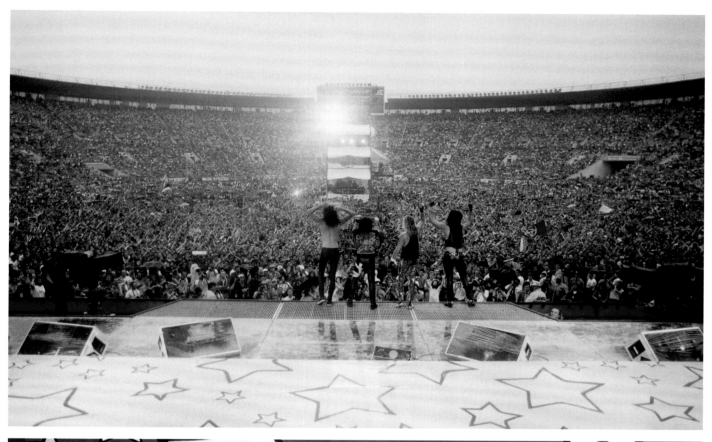

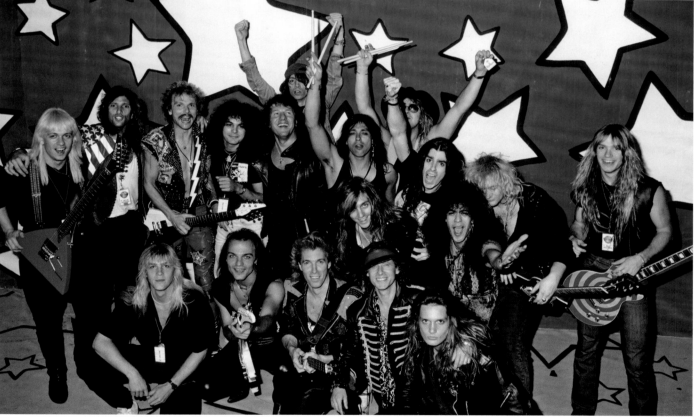

"That's one of those moments where you just never imagine it happening. I mean, shit, it's one thing to tour around America, but to go to Russia and have them sing along to your songs and have, I think it was about forty or sixty thousand people in the stadium going bananas, you're like, 'How the fuck do they even know who we are over here?'" —**Tommy Lee**

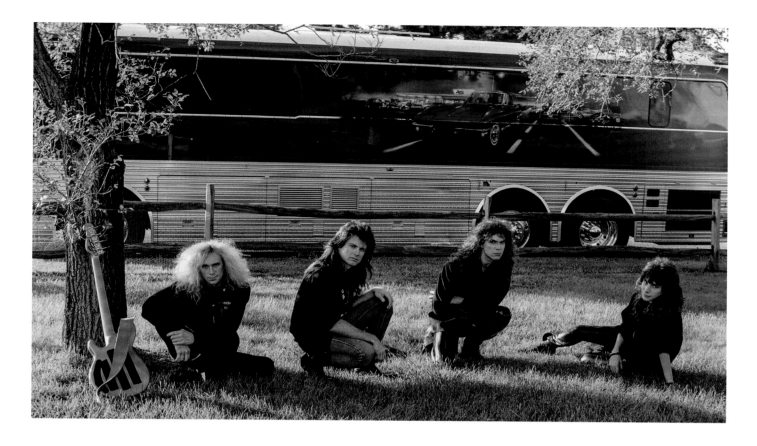

CAMP WEISSGUY

Foundations Forum was created as the world's first hard rock and heavy metal industry convention. The second annual event took place September 21–23 at the Sheraton Universal Hotel in Los Angeles, and the keynote speaker was Kiss's Gene Simmons. By this point, Mötley Crüe, Warrant, and Skid Row were all at the top of the Billboard pop charts, and attendance at the convention had doubled from just one year before. It appeared that this music wasn't going anywhere. The convention was set up by Concrete Marketing executive director Bob Chiappardi, who summed up the purpose of the forum: "The way heavy metal is growing, we want to be careful not to have it blow out. By sitting down and talking about the genre, the good and the bad points, having the indies interacting with the majors, it makes for a healthy industry in general." This was one of hard rock's most defining moments, even if it was also the beginning of the end.

By the summer, I was settled in at my new house at the Jersey Shore. With different surroundings came a different approach to enticing bands to come out to my studio.

Now, instead of the grit and glamour of New York City, it was barbecues and rides on my boat. It was Camp Weissguy. I just made sure not to tell anyone my boat was actually a raft! I started lining up bands to come out to the house. Many would stop by in the tour bus on their way to or from a gig. I had an assortment of colored seamless paper, a white garage door and concrete wall, and plenty of green grass to use as my new backgrounds, not to mention an eighteenth-century church half a block away. I was home. That is, until I moved out a year later . . .

"Mark was shooting Bon Jovi, and he did such a good job that Derek Shulman, the president of ATCO/Atlantic, said, 'I got a guy I want you guys to work with.' So we went out to Mark's house, and we showed up there, we were smoking pot, definitely experimenting at the time. But he understood that. He had a great sense of balance. And we shot pictures all over his pad. Great shots. Did some stuff outside as well. And he had a ton of props and outfits—we dressed up as vampires, we got really got colorful and glammed out."
—**Chip Z'Nuff (bassist, Enuff Z'Nuff)**

OPPOSITE: Enuff Z'Nuff, Mark's home studio, Rumson, New Jersey
TOP: Mr. Big, Mark's home **BOTTOM:** Steve Whiteman of Kix, Mark's home

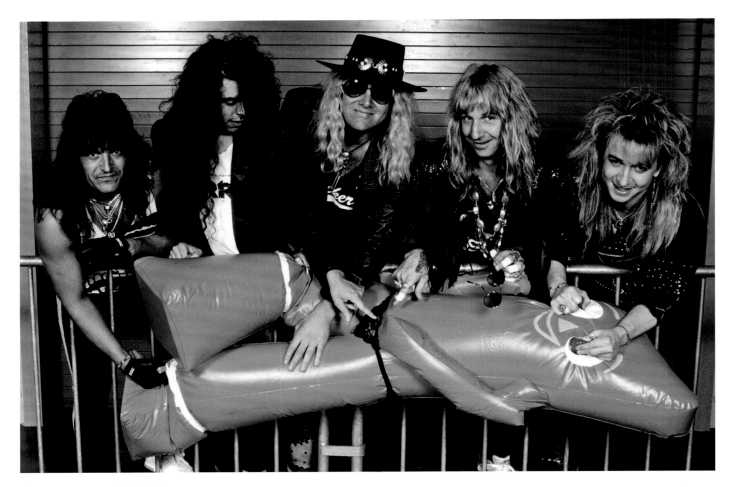

SHARK ATTACK

In April, *RIP* editor Lonn M. Friend whisked me away to Florida for a Great White cover shoot. We ended up at the appropriately named Shark Lounge after their gig at the Ocean Center in Daytona Beach opening up for Ratt. Great White front man Jack Russell was in full shark-at-tack mode as he personally picked out his cover model for the shoot the next day.

Wes Craven's horror flick *Shocker* was released that year, featuring a hard rock and heavy metal soundtrack, with acts such as Dangerous Toys and ex-Plasmatics bass player Jean Beauvoir's new band, Voodoo X. The lead single from the album was Megadeth's version of the Alice Cooper classic "No More Mr. Nice Guy." Alice staged a theatrical electrocution of Megadeth leader Dave Mustaine on the last day of Foundations Forum to promote the soundtrack.

That year, I also had the opportunity to shoot Badlands, which was a new band being produced by Paul O'Neill. I first met Paul at Leber-Krebs. We had both quickly risen in

our careers, and when Paul had a new band he was work-ing with, I would be the one he would call to do the photo shoot. I had previously met singer Ray Gillen and drummer Eric Singer when I shot them with Black Sabbath in 1986. Now, they had joined up with guitarist Jake E. Lee, who had been playing with Ozzy back when they were with Sabbath, to form Badlands. Paul had me photograph the band while they were recording their debut album in New York City. We did some press pics on the NYC streets and then at my studio. Paul was the most loyal guy I knew.

"The Great White road trip to Fort Lauderdale rendered one of the most scan-dalous cover stories of my *RIP* tenure. Witnessing front man Jack Russell in preshow tour bus debauched glory was both eye-opening and quill-rattling. Weissguy suggested the appropriate visual for the feature was a topless pool shoot, which he captured at the hotel the next day. On the road, in the pit, or in the studio, Mark's lens always lassoed the musicians in their natural state. His pics graced many a page in our illustrious bible of bang." —**Lonn M. Friend** (executive editor, *RIP* magazine)

THIS PAGE: Great White, Daytona Beach, Florida
OPPOSITE: Jack Russell of Great White

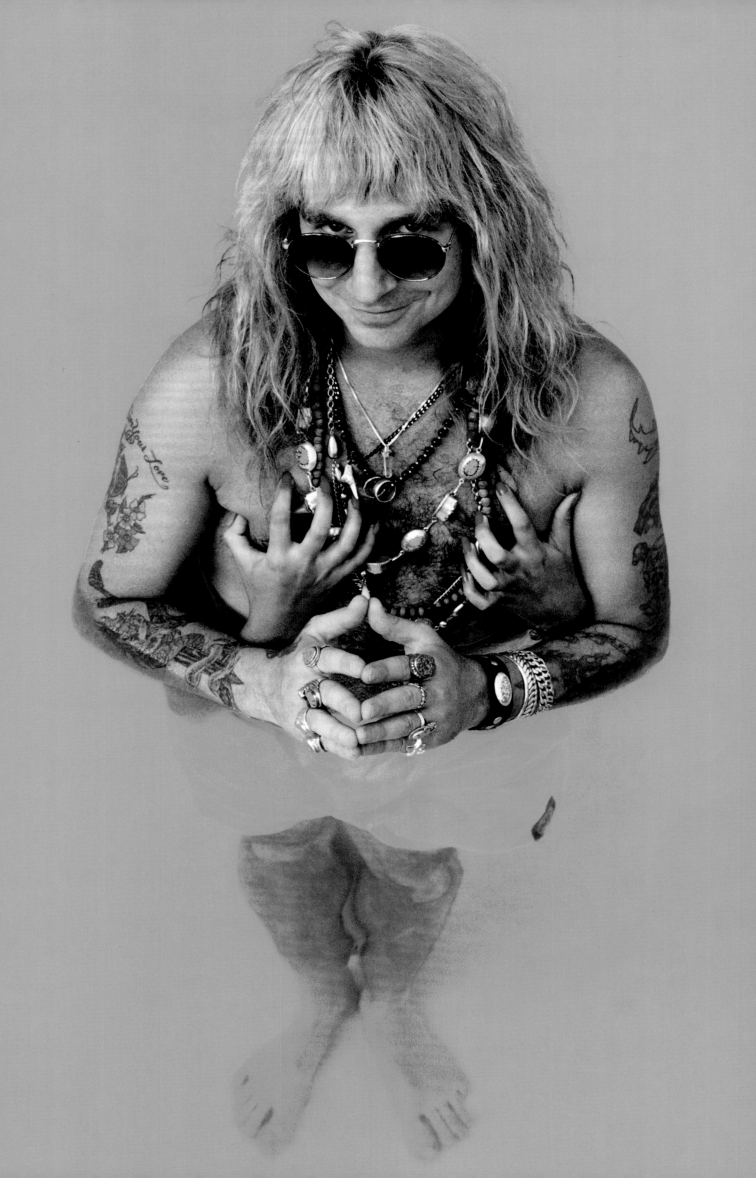

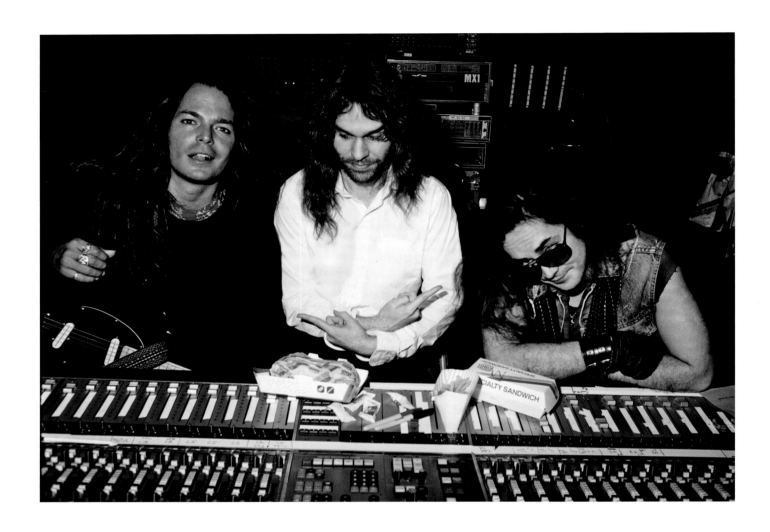

"The thing that I always respected about Mark is that, obviously he shoots all the big bands, but Mark is also out there. There were so many times that I would go to see a baby band, and there's Mark Weiss shooting them. And this is why his house in New Jersey is like a time capsule for the entire history of rock 'n' roll. People like Mark, it's not a job for them—it's a passion. Mark cares about the band; he cares about the music. He finds that individual element to each artist that makes them different, and then he captures their entire history—from when no one knew who they were all the way to the top."
—Paul O'Neill (producer, guitarist)

ABOVE: Ray Gillen, Paul O'Neill, and Jake E. Lee, Badlands recording sessions, Record Plant, New York City **OPPOSITE:** Badlands, Mark's studio, New York City

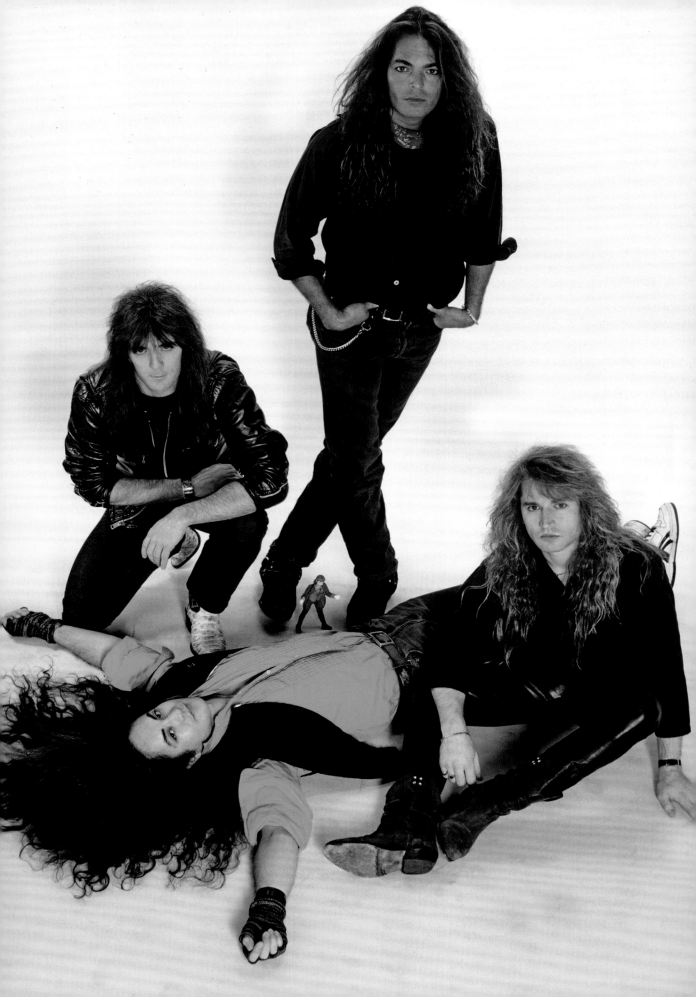

SKiD ROW

OH SAY CAN YOU SCREAM
VIDEO NOW AVAILABLE!

©1990 MARK WEISS / MW.

©1990 MARK WEISS / MWA

SKiD ROW
MAKIN A MESS
OF THE U.S 1990
ALL ACCESS

©1990 MARK WEISS / MWA

1740-0508-001 FASTER PUSSYCAT
Group standing; ivory walls, pink
tile floor $90

©1990 MARK WEISS / MWA

Monmouth Arts Center
DEC 8 2&6 PM NUTCRACKER DEC 9 2 P
15 BLUES JAM SESSION WITH
SONNY RHODES & SPIN DOCTORS 7 P
DEC 23 BON JOVI TICS ON SALE 10 AM DEC 9

WE DIE OR FREEZE FOR BON JOVI

AINMEN

The Cult

T'was the Night Before Christmas

He spoke not a word,
 but went straight to his work.
He filled all their stockings,...

1990

Poison
Flesh & Blood

CITY OF LOS ANGELES
CALIFORNIA

TOM BRADLEY
MAYOR

January 29, 1990

Bill Gazzarri
9039 Sunset Blvd.
Los Angeles, CA 90069

This Bureau has received numerous complaints regarding signs posted on
public property, and our investigation disclosed that your signs have
been illegally posted.

The posting or placement of advertisements of any nature on public or
private property within the public right-of-way is a violation of
Section 28.04(a) of the Los Angeles Municipal code which states:

Very truly yours,

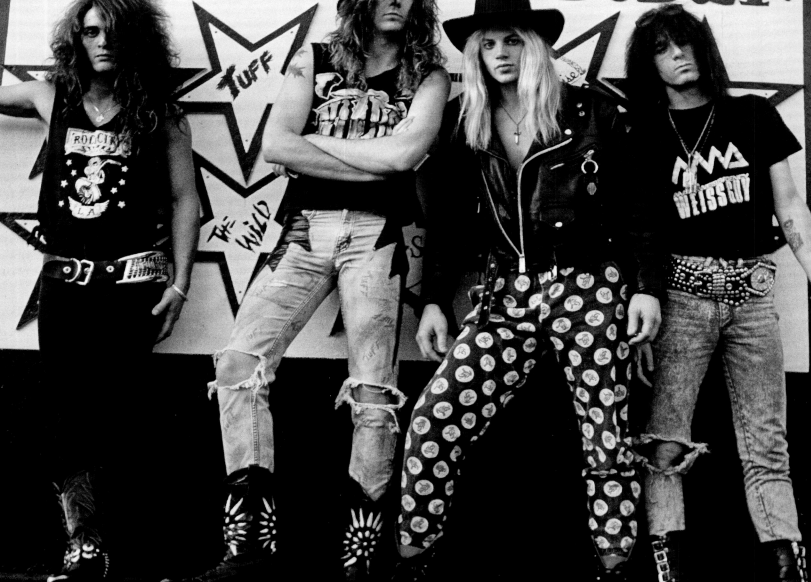

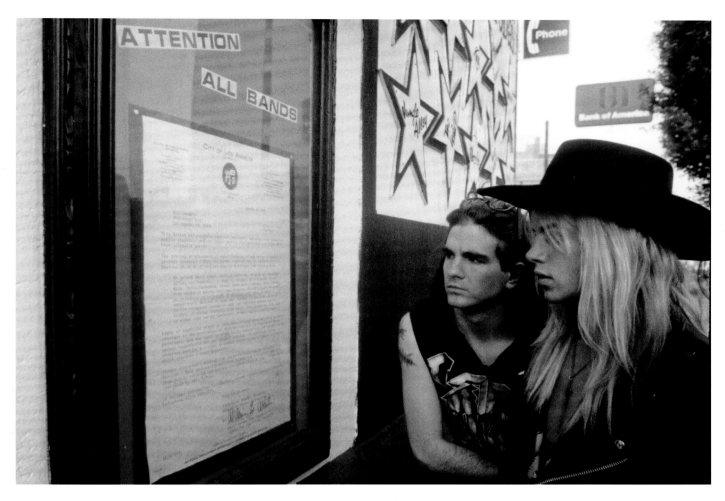

WHERE HAVE ALL THE GOOD TIMES GONE?

Toward the end of '89, I did an all-day shoot with Poison in LA. Afterward, I had a few hours to kill before my flight back to New Jersey, so I met a friend for a bite to eat at Johnny Rockets, on Melrose. I parked my car on a busy street, and as I was walking away, I remember saying to myself, "Where will the film be safer—in the car or on me?" I decided that it would be better off staying with me. I was wrong. The next thing I knew, I was being held up at gunpoint. The two guys pistol-whipped my friend and took the bag of film and my jacket—which also had my wallet, my ID, and my plane ticket. I was stranded. Eventually, everything got sorted out. After the Poison guys found out what had happened, Bret Michaels bought me a new plane ticket and made sure I got back to the East Coast okay.

Then, in February of 1990, I got a call from Bret. He asked how I was doing and wanted to know if I would like to shoot the band photos for the packaging of *Flesh & Blood*, which was scheduled for release in the summer. I went to Vancouver, where they were working on the album. When I got there, they were in jeans and T-shirts—nothing flashy at all. I asked them,

"When will you guys be ready?" They said, "We are." Times were changing.

Change was definitely brewing, but hard rock and metal were still as big as ever. Hollywood's newest glam act, Tuff, had just been signed by Atlantic and were ready to take off. The label needed some new pics to get the campaign started, so I flew out to LA to meet the band. After a quick session, we hit the Strip to take photos at some of the venues where they performed.

Walking down Sunset Boulevard, we spotted a sign outside the famous rock club Gazzarri's. Dated January 24, 1990, it had been sent out from LA mayor Tom Bradley's office to all the clubs on the Strip. Gazzarri's owner, Bill Gazzarri, had posted the notice under glass for everyone to read. Section 28.04 (a) told us all we needed to know: No person shall paint, mark or write on or post or otherwise affix, any hand-bill or sign. . . . It was the end of an era. The Sunset Strip would never be the same.

"It's ironic that we were reading that notice, because on that same day we had been out posting our flyers all over Hollywood. So we were basically breaking the law. We would pick up ten thousand flyers from a printer, and at some point, we would probably go through those and get another shipment. At the height of it, dozens to probably a hundred bands or more per weekend would be out promoting a show. And everybody would be putting up flyers or handing them out. What would happen was, every morning probably around 4 a.m., the city would have to hire some kind of crew to come and clean up the Sunset Strip. Because there was just paper everywhere." —Stevie Rachelle (singer, Tuff)

OPPOSITE: Tuff outside Gazzarri's in West Hollywood, California
ABOVE: Tuff's Stevie Rachelle and Todd Chase

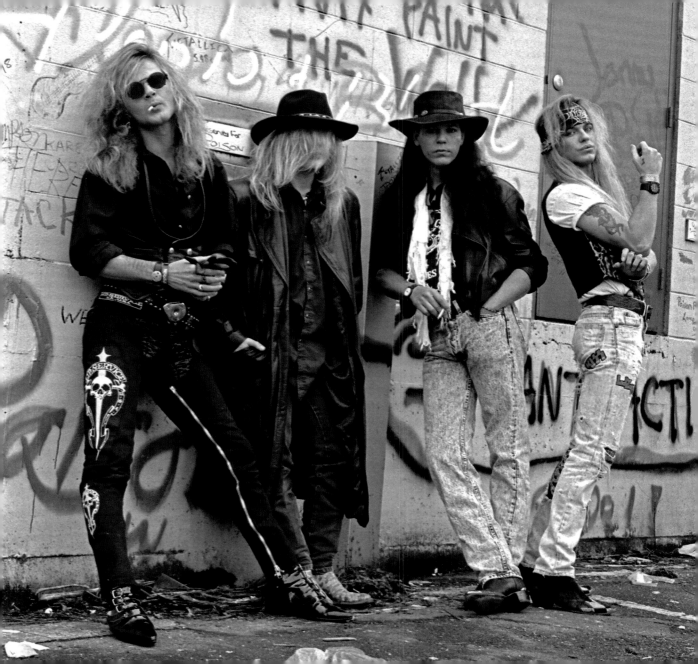

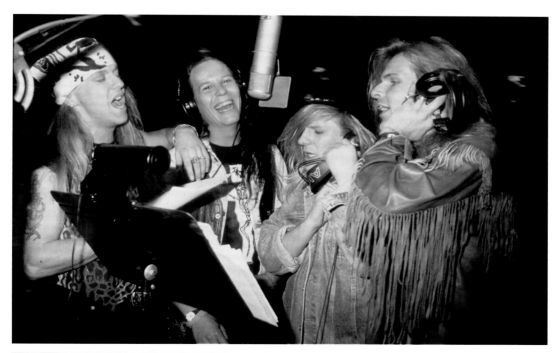

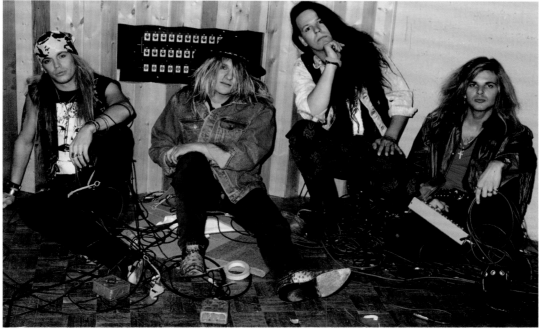

"That was a really freaky time. It's crazy that he got mugged. Number one, I'm glad he lived through it. But number two, we lost all that film! We redid the photo shoot. I remember us going up and standing behind the studio building [where] we were literally recording that day. Mark, beyond being an awesome photographer, he's an incredible friend and incredible part of my life and the legacy of my life." —**Bret Michaels (singer, Poison)**

OPPOSITE: Poison's *Flesh & Blood* album shoot, Little Mountain Sound Studios, Vancouver **THIS PAGE:** Poison, *Flesh & Blood* recording sessions **PAGES 350–351:** Jon Bon Jovi, Christmas card photo shoot, Atlantic Highlands, New Jersey

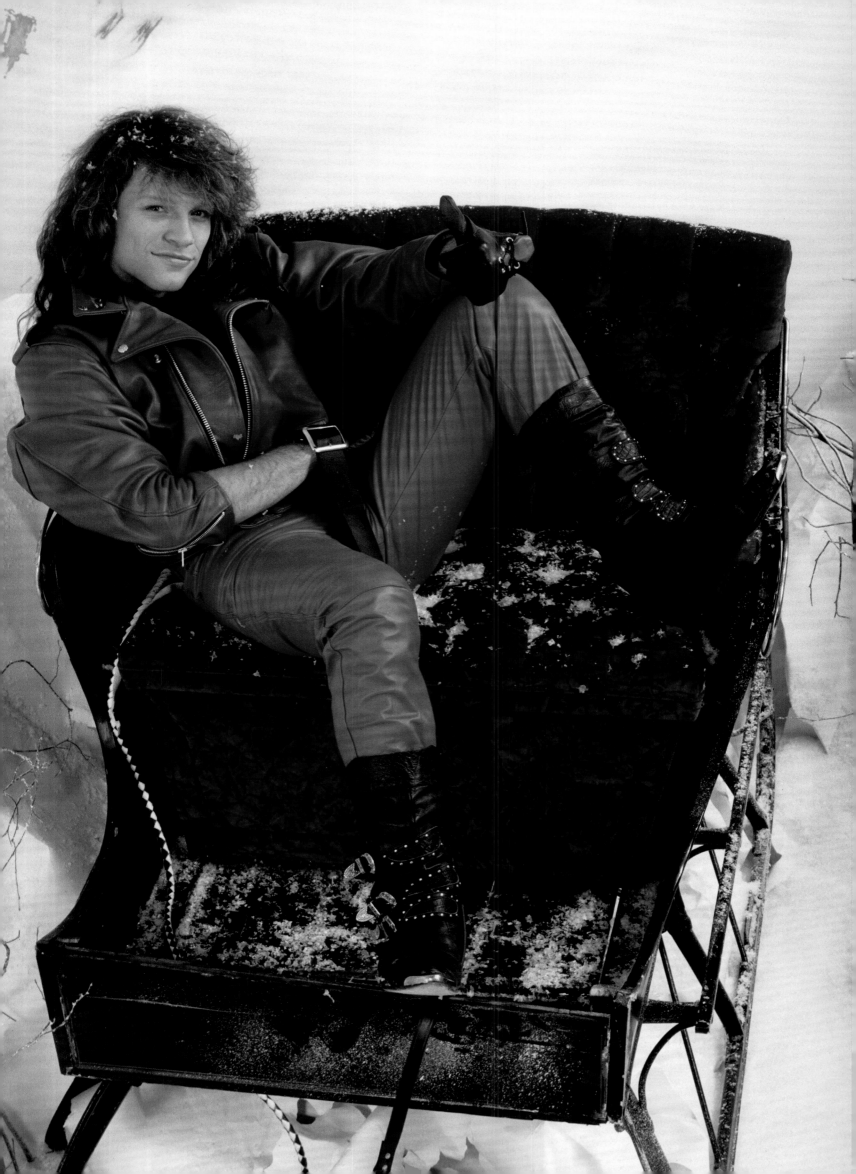

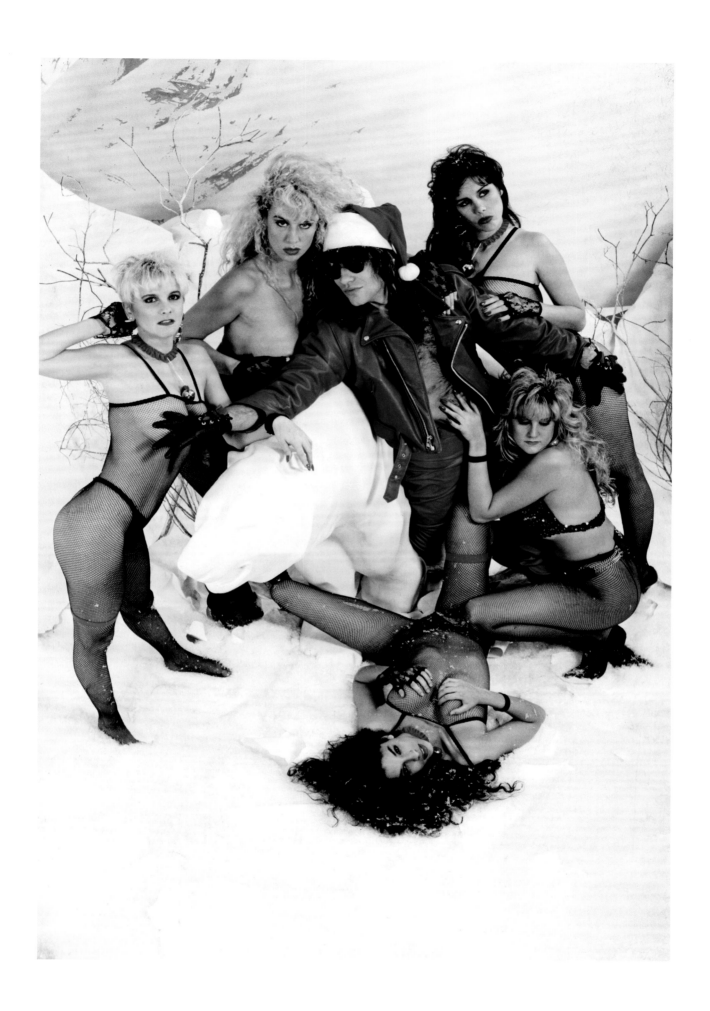

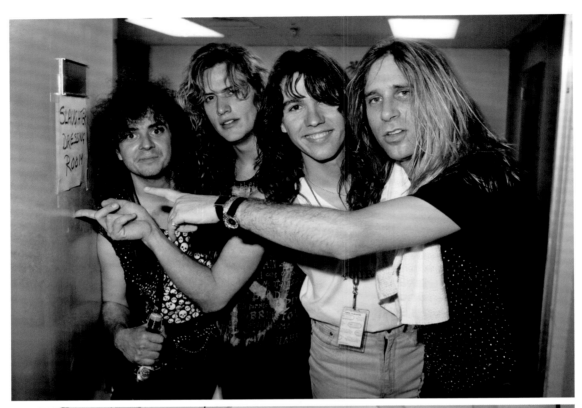

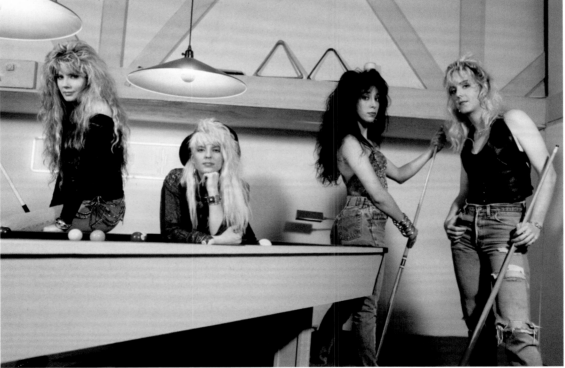

"I was a young kid who loved all of these bands, and I still do to this day. I love music. It's who I am. It's what I grew up with. It's my musical environment. And Mark Weiss's shots were the musical environment in which dreams were set." —**Mark Slaughter (singer, Slaughter)**

TOP: Slaughter, backstage, opening for Kiss on the *Hot in the Shade* tour
BOTTOM: Vixen, Los Angeles **OPPOSITE:** Michael Monroe, New York City

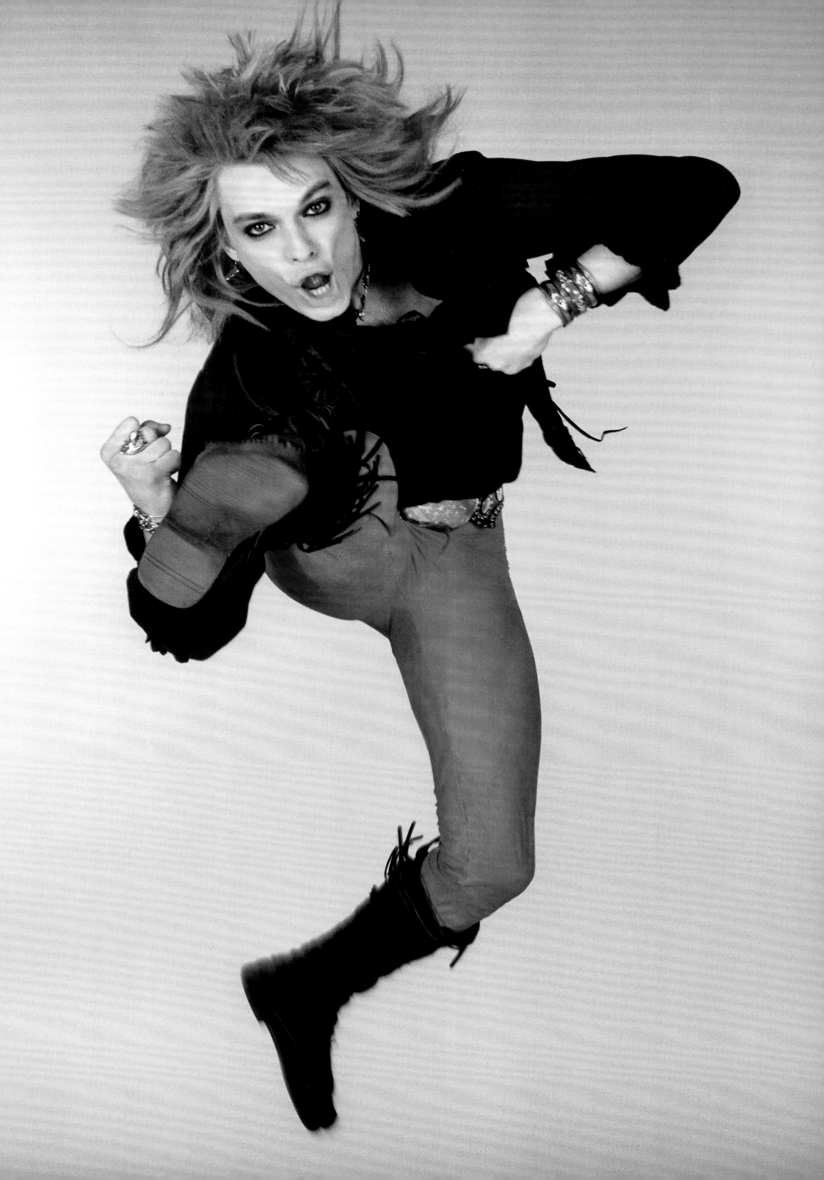

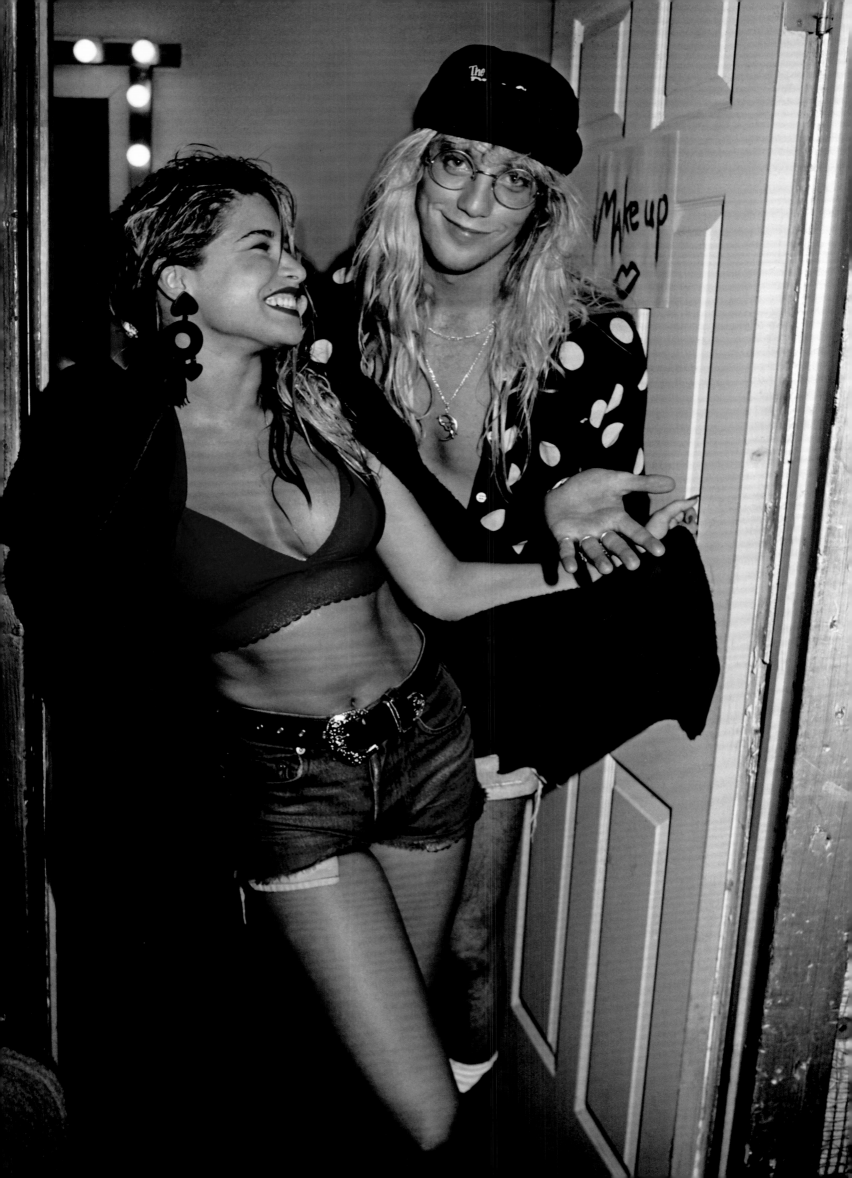

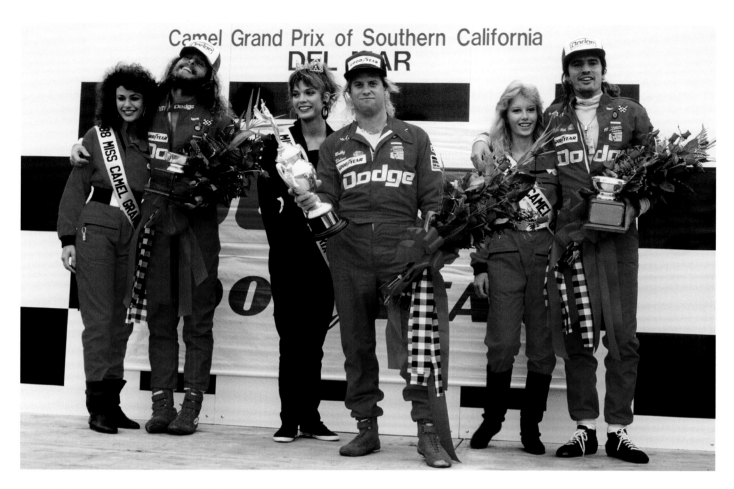

KICKSTART MY HEART

Rock 'n' roll and fast cars go hand-in-hand. It was always a good photo op to take shots of the guys in the bands with their hot rods. Vince Neil even used one of my photos on a racing T-shirt. When he showed me the final product, I thought it looked cool as hell, with flames surrounding my photo of him on the front of the shirt. When I saw him at the race, I asked how the shirt was selling. He smirked and responded with disappointment: "Not well." Apparently, it's bad luck to have flames on a racing shirt. A few years earlier, I had shot some of the guys at the Dodge International Star Challenge, an event meant to raise awareness about the dangers of drinking and driving, at the Del Mar Fairgrounds near San Diego. Bobby Blotzer, Ted Nugent, and Tommy Lee finished in first, second, and third place, respectively, racing around the 1.62-mile course in Dodge Daytona Shelby sports cars.

Later on, in September of that year, Warrant released their sophomore effort, *Cherry Pie*. Jani Lane met model Bobbie Brown during the auditions for the video shoot for the title track. After that, he was all out to get that girl. He left a dozen roses for her when she arrived on set; they got married a year later and had a baby together.

I also reconnected with Billy Squier at Giants Stadium when he opened up for Bon Jovi. I put the seed in his head, letting him know that if he needed a photographer, my hand would be raised high. He smiled and said, "You've got a deal." I got a call from Billy that fall to shoot photos for his next album.

"I met Jani at the audition. They called for me specifically, and basically what he told me was that he saw me on *Star Search* and specifically asked for me to be in the video. He fell in love with that image and wanted to go out and get that girl. When we shot the video, I had no idea how much I would be in it. And I was in it as much—if not more than—the band. And after they premiered the video on MTV, it just blew up. It was such an amazing time." —**Bobbie Brown**

OPPOSITE: Bobbie Brown and Jani Lane, on set of "Cherry Pie" video shoot, Los Angeles **TOP:** Ted Nugent, Bobby Blotzer, and Tommy Lee at the Dodge International Star Challenge, Del Mar, California, 1988 **BOTTOM:** Skid Row's Rachel Bolan, MTV Celebrity Challenge, Texaco/Havoline Grand Prix of Denver, Colorado, 1990 **PAGES 356–357:** Warrant, "Cherry Pie" video shoot

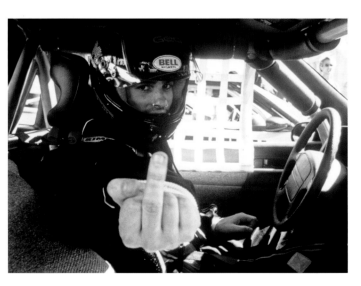

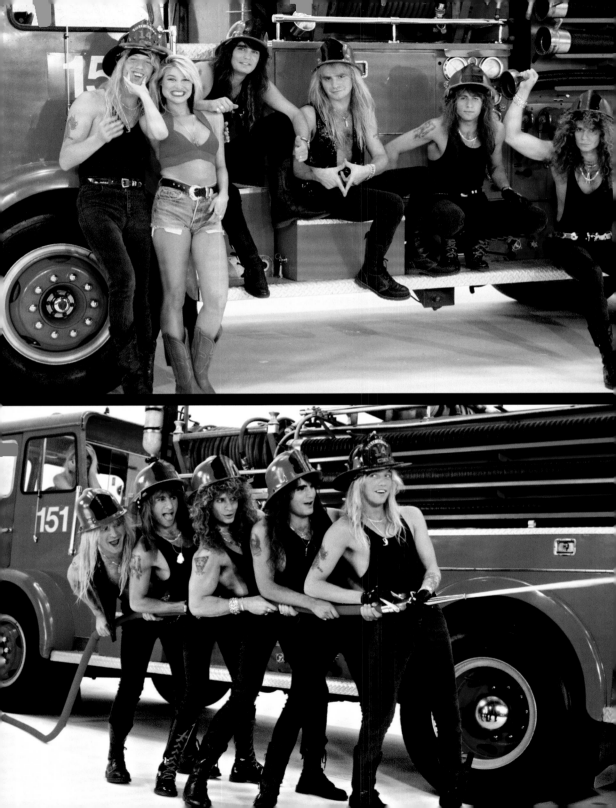

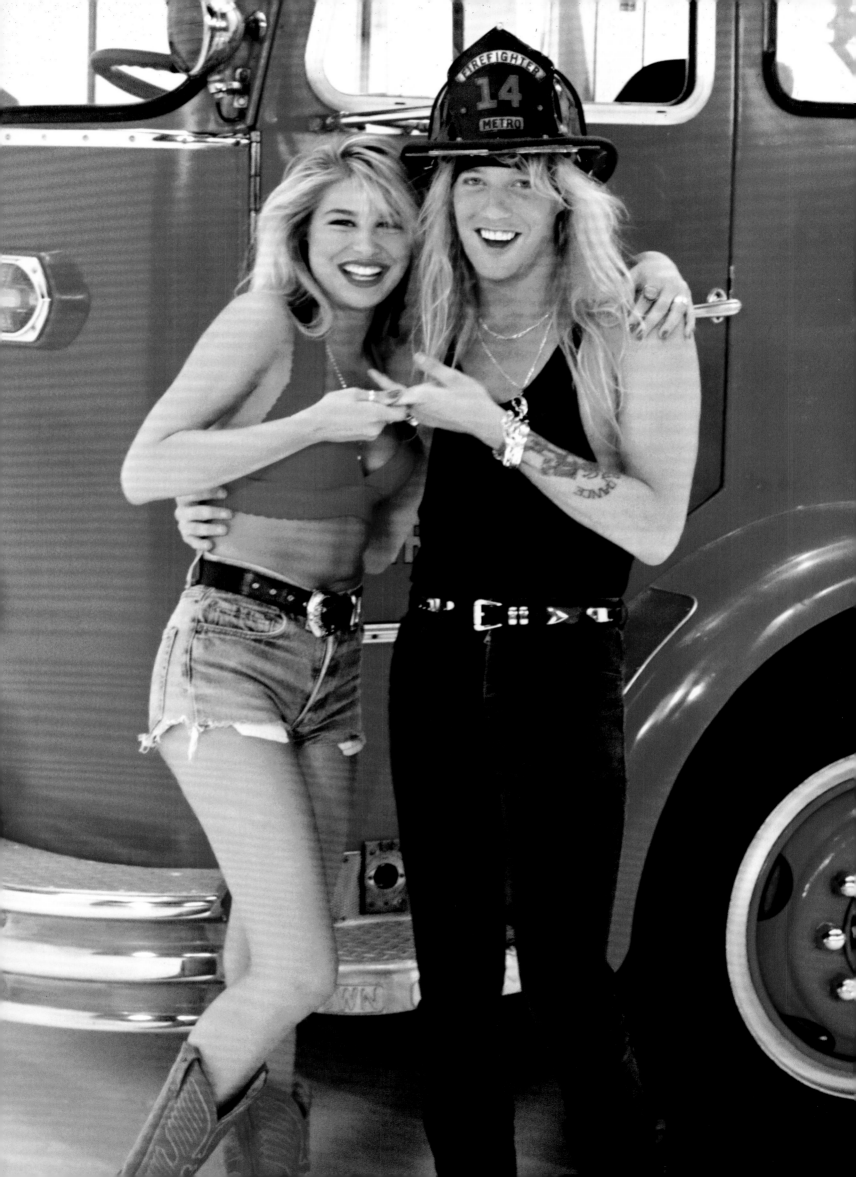

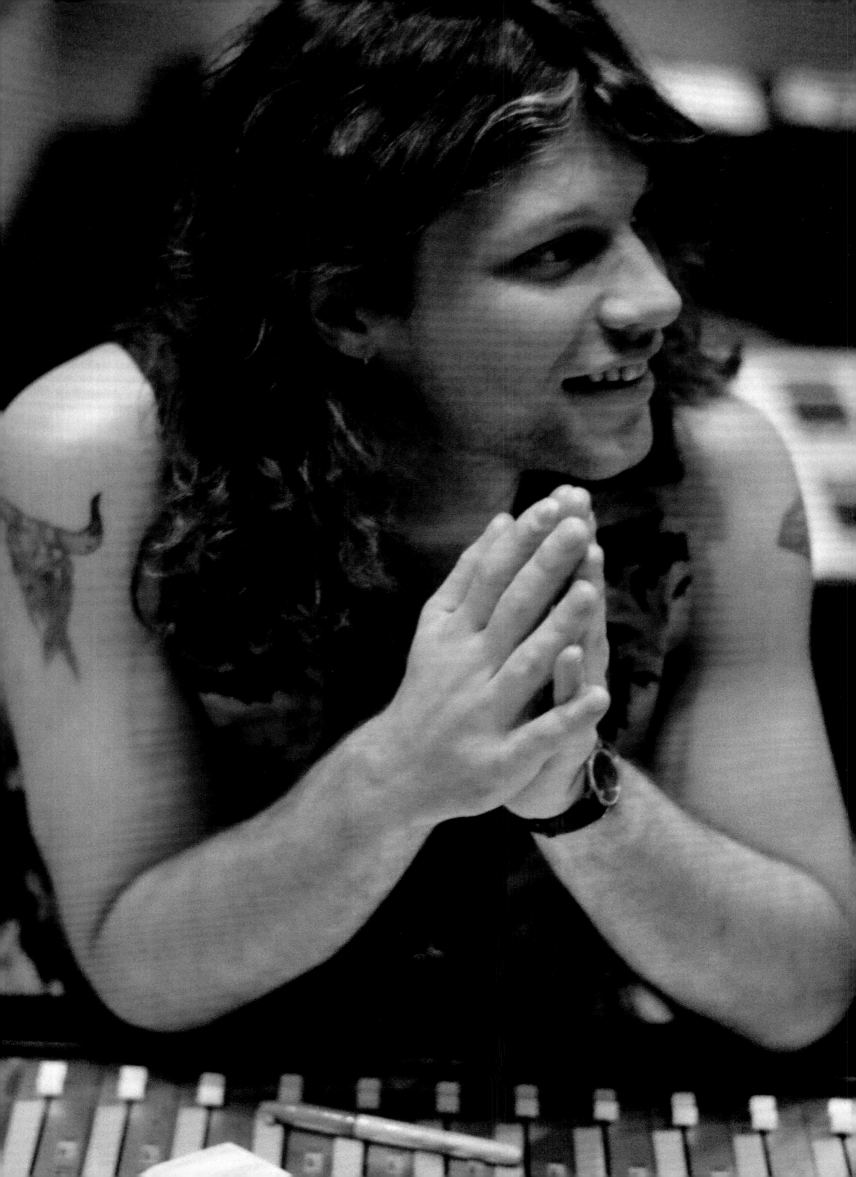

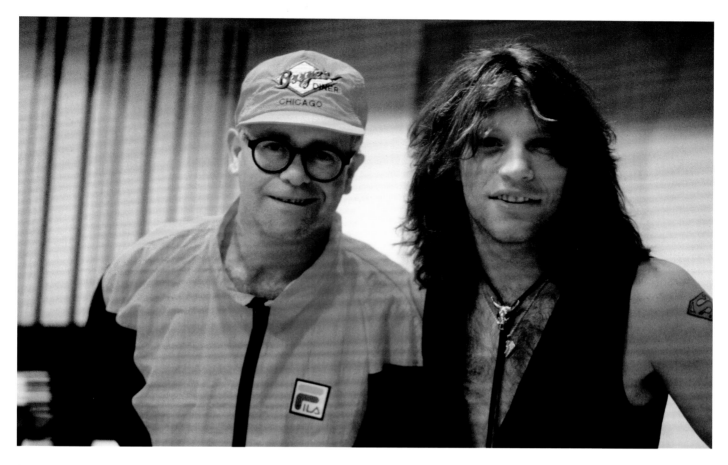

BLAZE OF GLORY

Jon Bon Jovi recorded his first solo album, *Blaze of Glory*, with songs from and inspired by the movie *Young Guns II*. Doc McGhee asked me to come to A&M Studios in LA to take photos of Jon while he recorded with some of the album's guests, such as Little Richard, Jeff Beck, and Elton John. These guys were rock royalty. As a kid, I had been a huge Elton John fan in particular, and to be in such an intimate setting with him was an incredible experience. Wayne Isham shot the video for "Blaze of Glory" in the spring. I went to Utah and flew by helicopter 2,500 feet up to a butte where they were shooting the video. We all camped out there for a few days. One night, I stumbled out of my tent to take a leak—little did I know that I was just a few feet from the end of the butte. That was almost the end of my career—and life.

When I got back to Jersey, I got a call from Jon saying that he wanted to do a 1990 Christmas card. When he first told me about it, I assumed he wanted to do it with Dorothea and send it out to the family. Much to my delight, his request was a bit more rock 'n' roll. He told me he was going to be in red leather from head to toe and wanted to get pulled in a sleigh by a herd of scantily dressed girls. He wanted me to get the photos in every rock magazine I could. I called up a few friends who were more than happy to partake in the reindeer games. The photos were distributed throughout the world. I didn't ask any questions. The message was relayed!

The year ended with Bon Jovi playing the Count Basie Theatre in Red Bank, New Jersey, on December 23. Fans lined up overnight. The two concerts they did benefited the Monmouth Arts Council and Holmdel's Sister of the Good Shepherd. It was a first of many more Christmas concerts to come at the Count Basie.

Kiss closed out the '80s still going strong, playing arenas on their *Hot in the Shade* tour. Within a few years, the original band—Gene, Paul, Ace, and Peter—would be reunited, the makeup would be on again, and they'd be on top of the world. Judas Priest also continued to carry the rock 'n' roll torch. They kicked off the '90s with one of their heaviest albums ever, *Painkiller*.

Music was changing. A new decade, stripped down and grunged out, was emerging. Rock 'n' roll Rome fell. But look around today—Mötley Crüe, Def Leppard, Poison, and Joan Jett are playing stadiums together. Guns N' Roses had one of the most successful tours of all time. Metallica, AC/DC, Ozzy, Judas Priest, Bon Jovi, and so many others are not only thriving, but are bigger than ever. The '80s were the decade that rocked. Here's to many more rockin' decades to come.

OPPOSITE: Jon Bon Jovi, *Blaze of Glory* recording sessions, A&M Studios, Los Angeles **ABOVE:** Elton John and Jon Bon Jovi during the *Blaze of Glory* recording sessions

TOP: Little Richard **BOTTOM:** Elton John **OPPOSITE:** Jon Bon Jovi

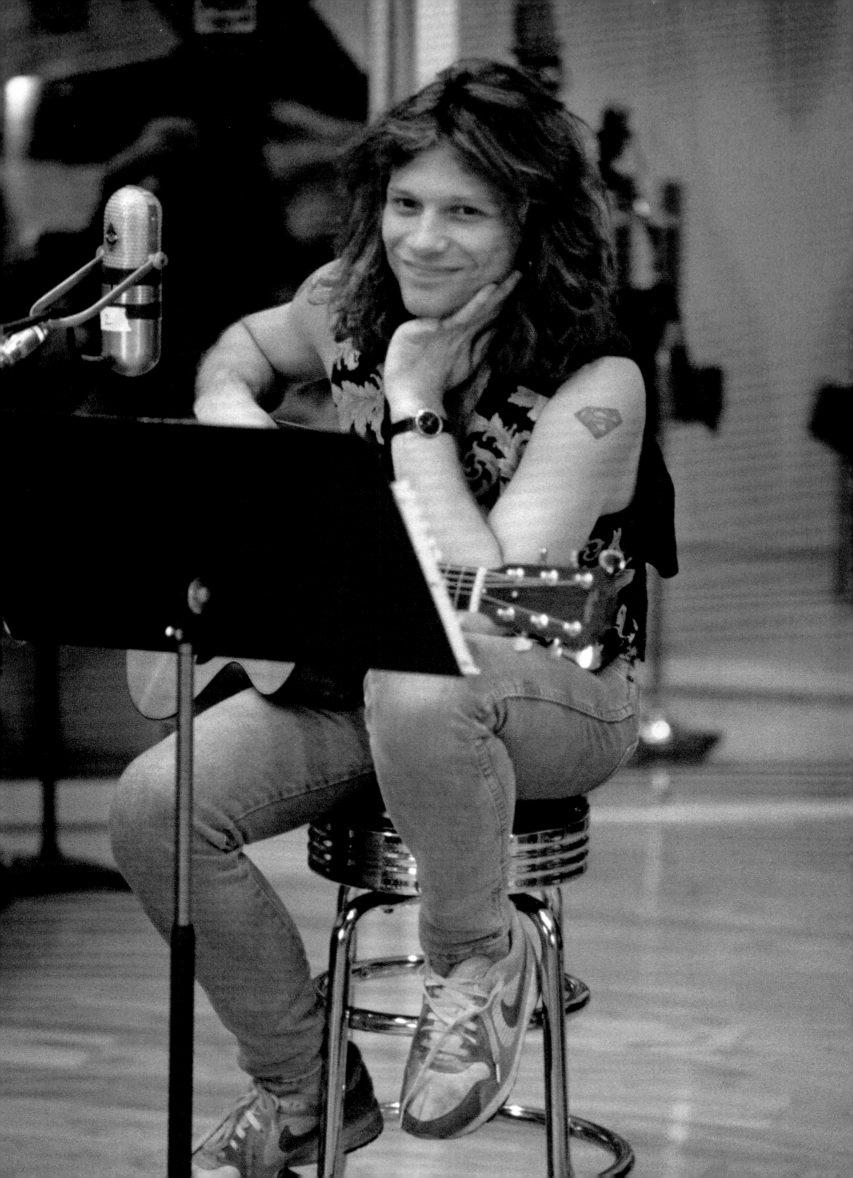

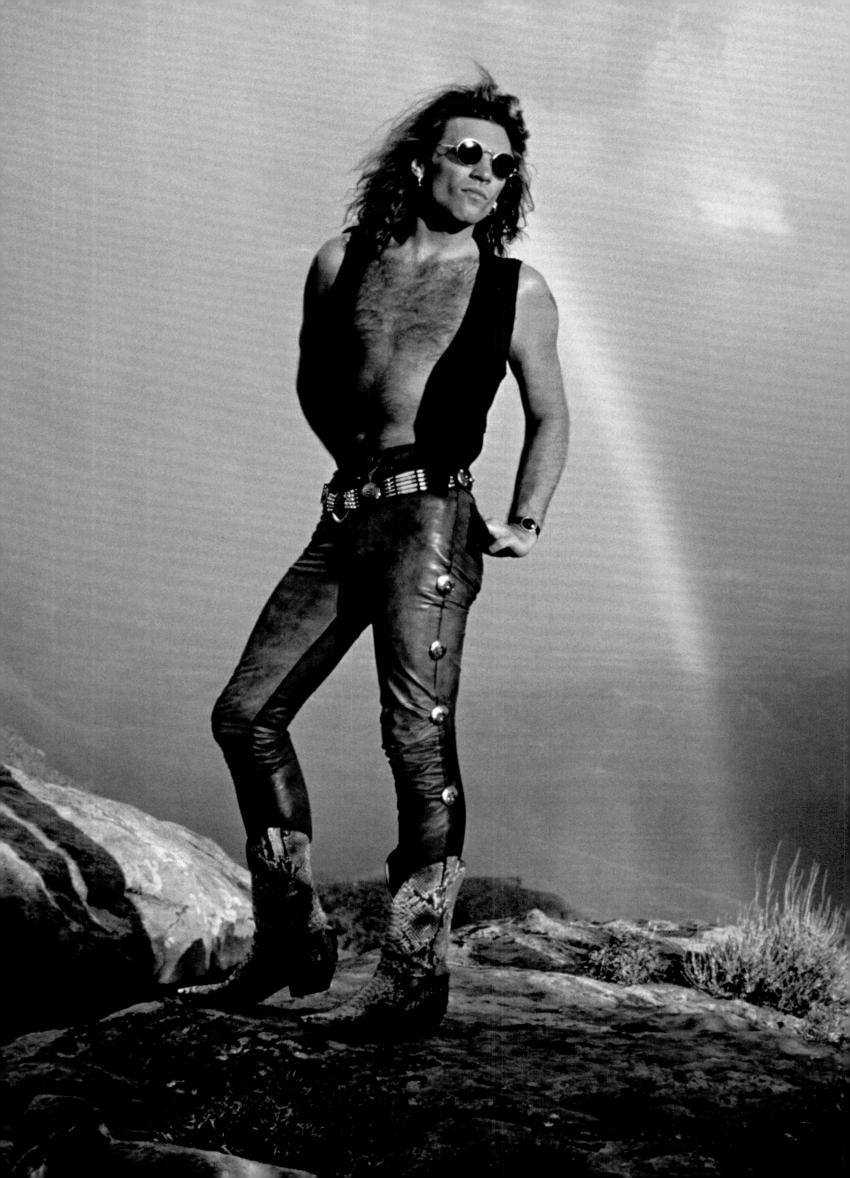

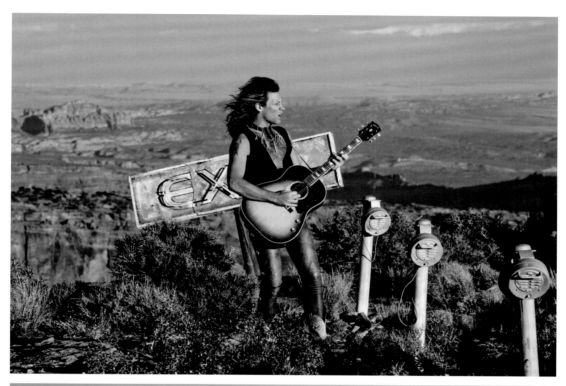

OPPOSITE: Jon Bon Jovi, "Blaze of Glory" video shoot, Utah **TOP:** Jon Bon Jovi filming "Blaze of Glory" **BOTTOM:** Mark in his tent during the "Blaze of Glory" shoot **PAGES 364–365:** Jon Bon Jovi, "Miracle" video shoot, Utah

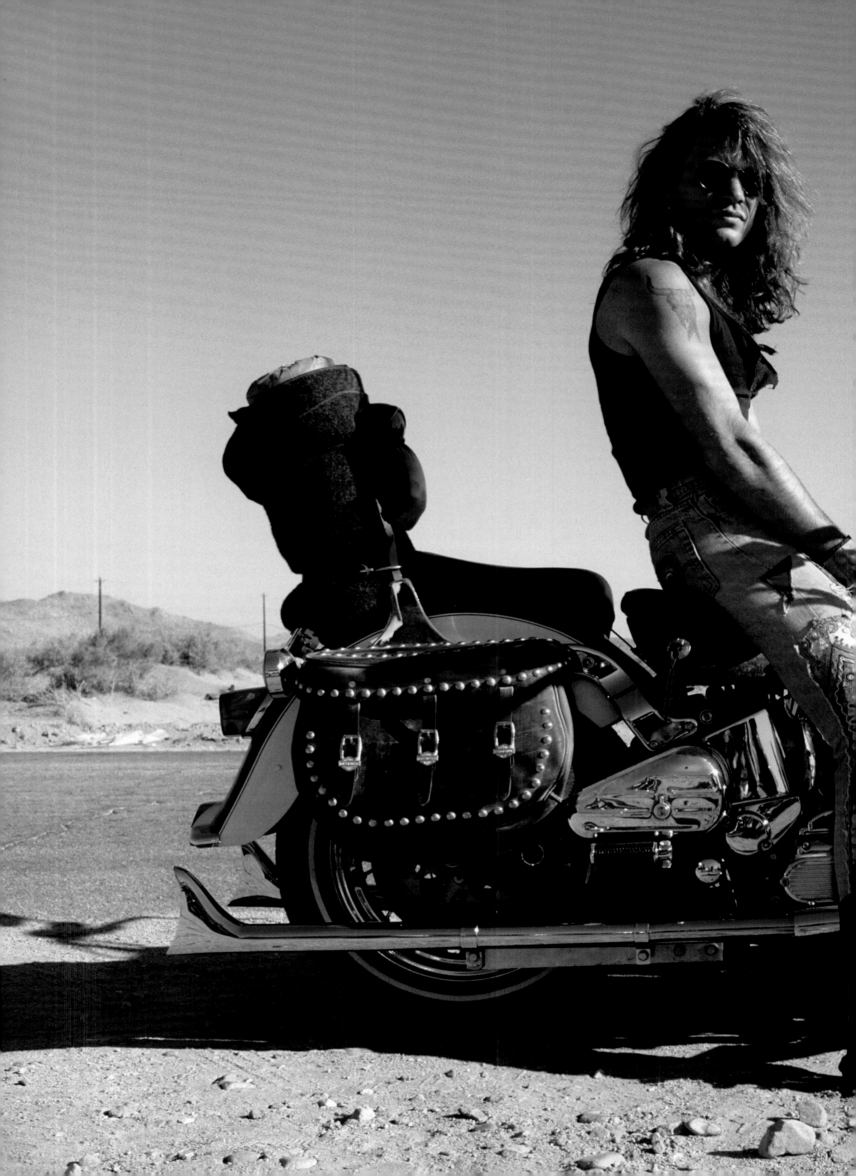

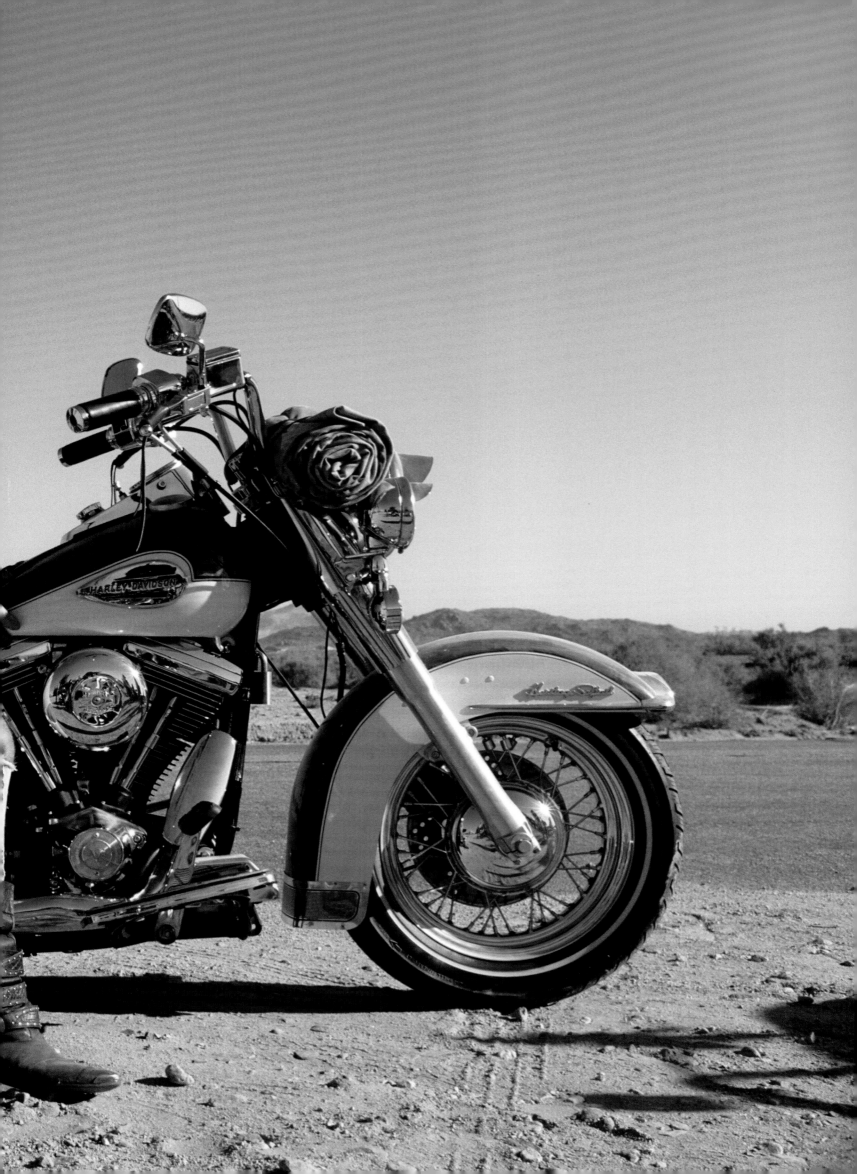

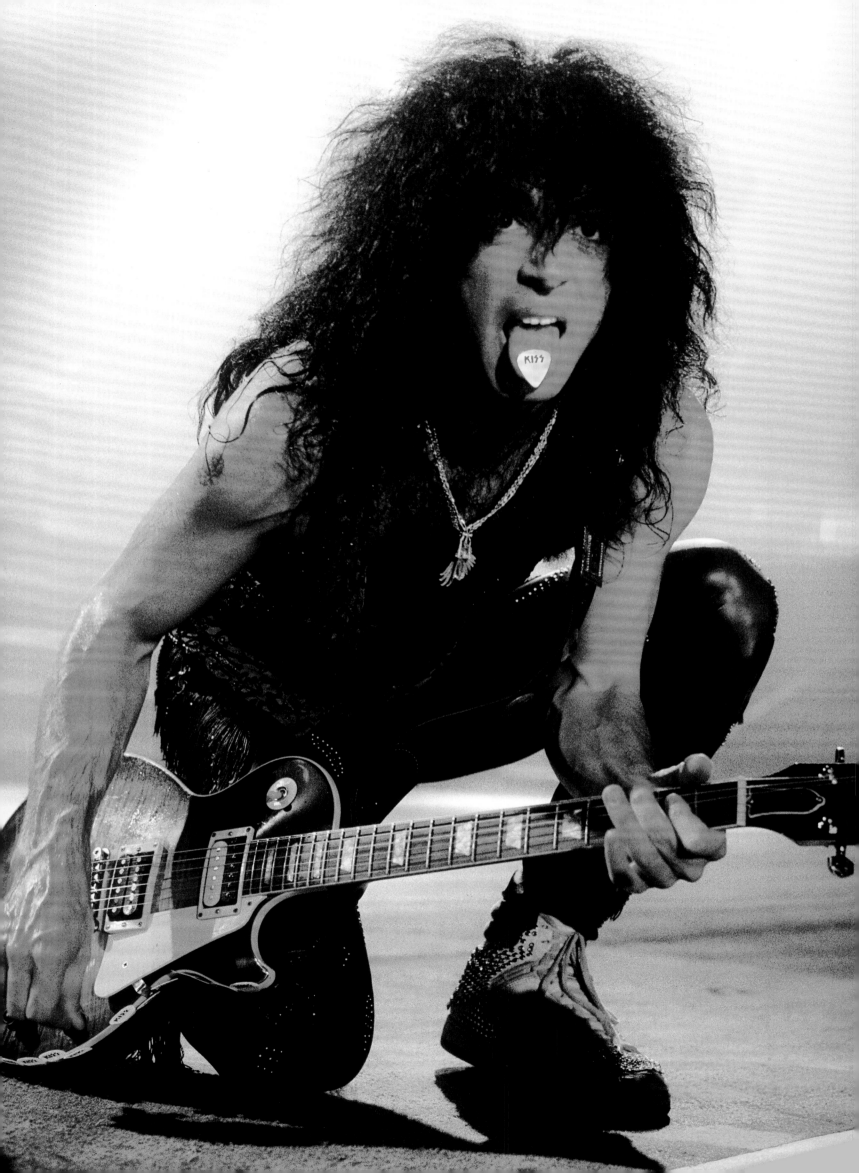

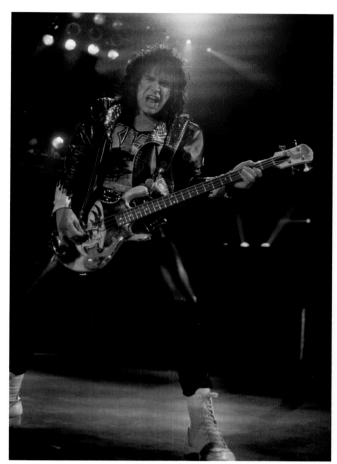

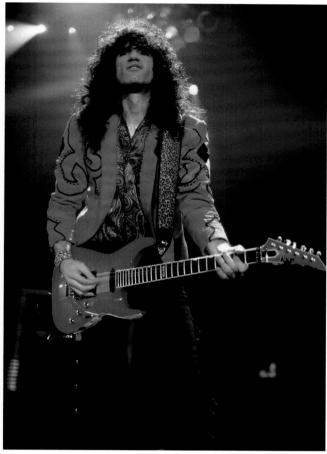

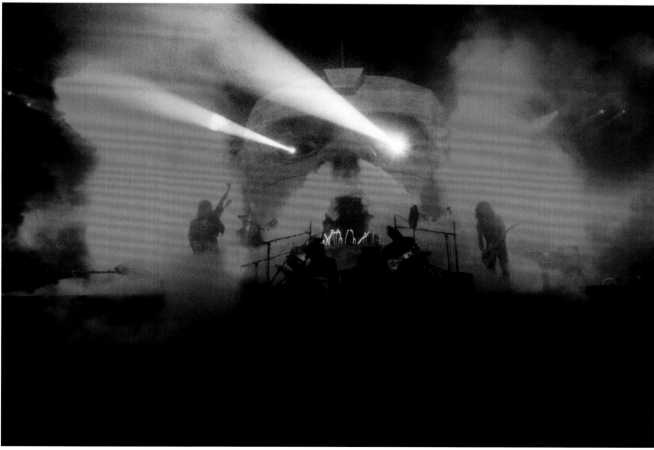

OPPOSITE: Paul Stanley of Kiss, *Hot in the Shade* tour **THIS PAGE AND PAGES 368–369:** Kiss performing live

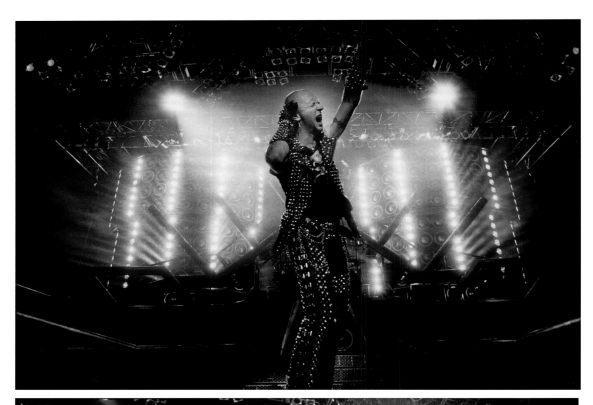

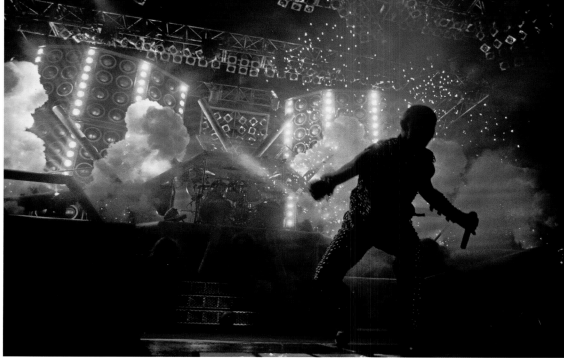

ABOVE: Rob Halford, *Painkiller* tour OPPOSITE: K. K. Downing and Glenn Tipton PAGE 372: Rob Halford

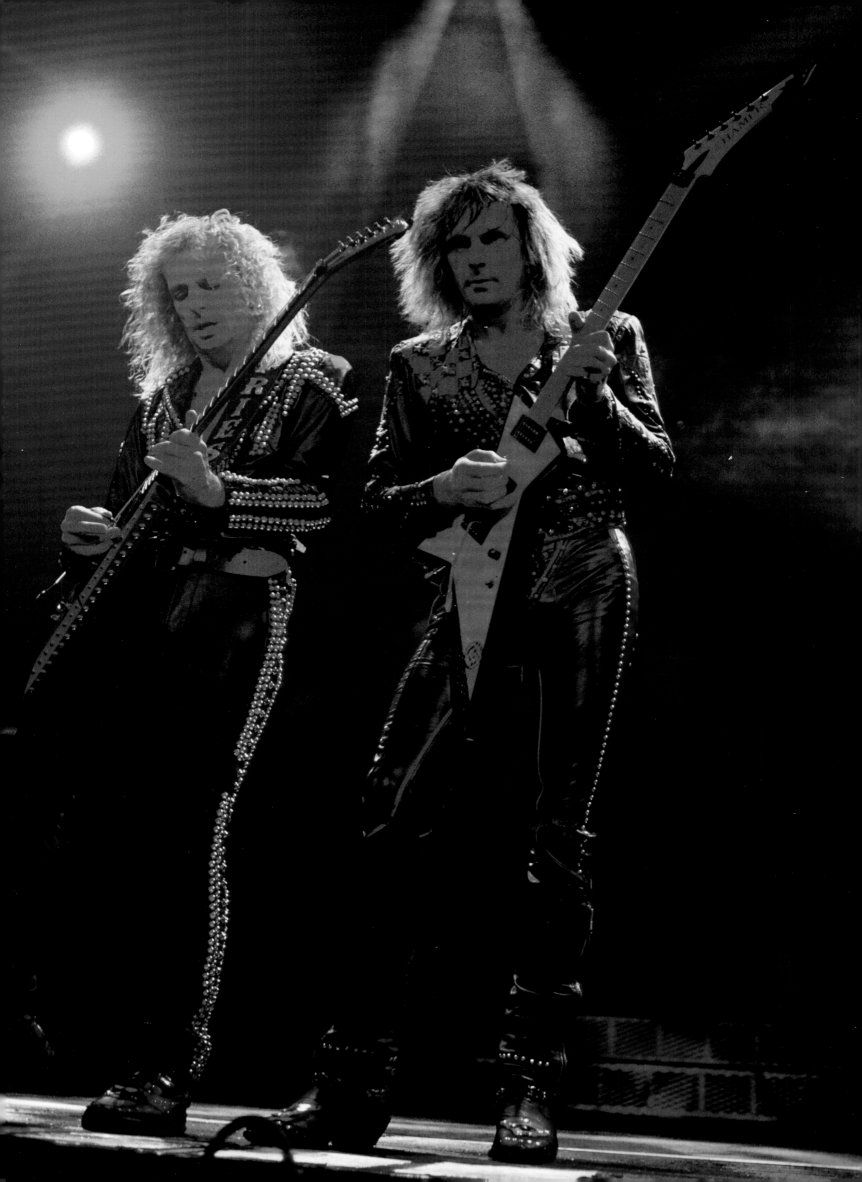

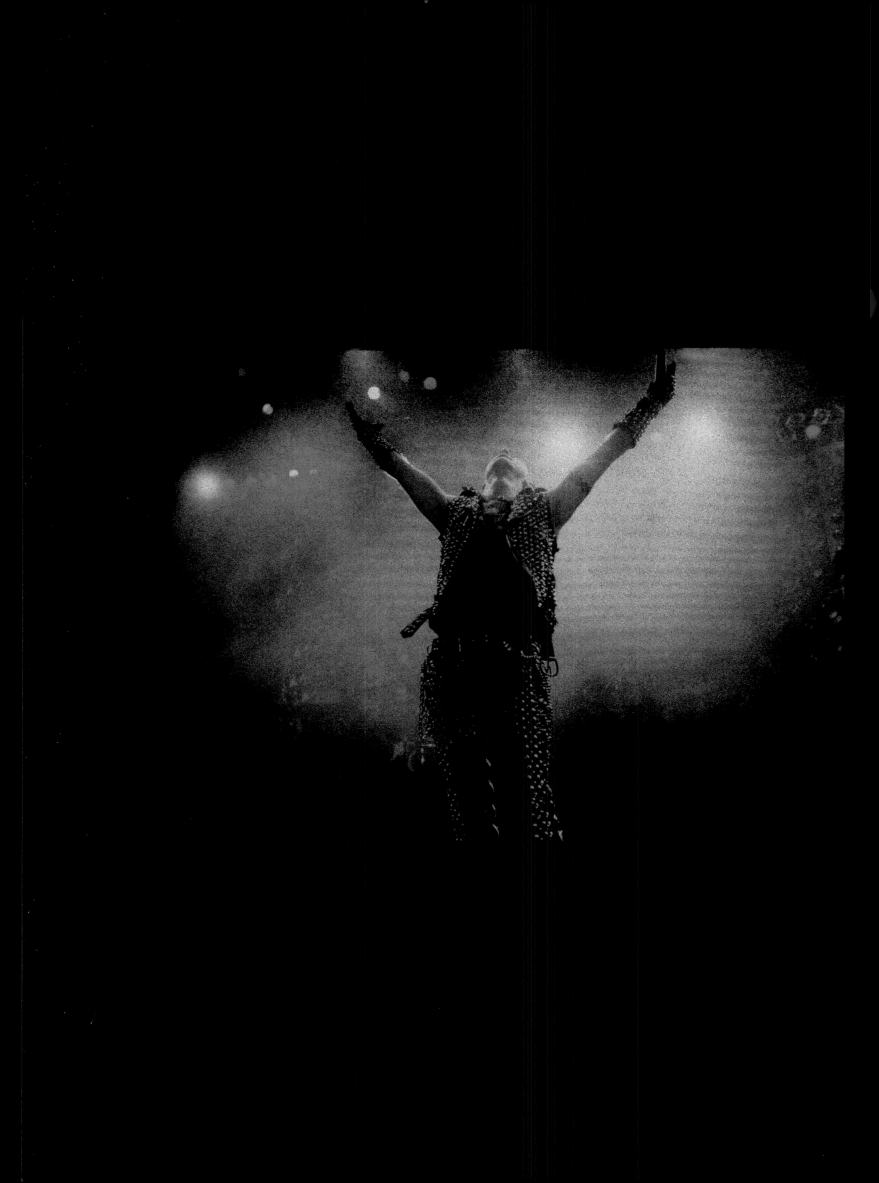

Most bands try to control their destiny, and to some extent, photographers can control that destiny. Because they capture a certain thing that happens onstage, it becomes like a great recording or a great movie. It becomes iconic.

—Rob Halford

May 4, 1987

Dear Mr. Secher,

I just wanted to take the time to write for the first time to the magazine that I've been subscribing to for years. There are many people that play an important role in rock today, and I have a favorite unsung hero that I would like to recognize.

His name is Mark Weiss, known by many as "Weissguy". I have no one else on earth to praise more than this man. He has taken some of the greatest pictures for magazines, posters, and album covers that I have ever seen. I treasure many of them. Mark is truly a professional ranking way out of everyone's league.

If you can, please give Mark Weiss my highest regards & thank him for all of the wonderful photos — I would love to have a picture of Mark himself. He is someone that I would be very proud to meet. Keep it up! — Love, Janine McKavish

AFTERWORD

As a lifelong New Jersey resident and rock fan, I've known Mark Weiss personally for a long time. But even before I actually knew Mark, I knew of him and his work. Not only did I own countless albums that featured his photos, but Mark was also a fixture on the rock scene. At almost every show I went to I'd see this cool-looking guy running around on stages and in photo pits . . . and then also in the audience, in the lobby, in the parking lot, in the front row, at the soundboard, and in the dressing rooms. Mark was everywhere. It got to the point where, as a kid, I had an idea when the band was about to go on because I'd see Mark walk from backstage to his spot in the pit. If Mark was in position to shoot, you knew the lights were going down and the band was hitting the stage.

Once I started out in the record and radio business in the early '80s, I got to know Mark personally. In my days at Megaforce Records he shot many of the acts I worked with, and over the decades we would see each other at so many shows, cruises, and festivals. What's most amazing is that Mark was everywhere then and is still everywhere now. I know so many people in this business who lose their passion and drive and love for rock as they age. To put it bluntly, they just get old. Mark never does.

Mark's work speaks for itself. His incredible images onstage and off capture the iconic artists we love so much in a way that few can. But what's equally impressive is that he still has that youthful passion and energy to do what he does, and at such a high level. What's more, he has a way of doing it where you don't even know it's happening! Some of my personal favorite photos of myself with various artists were taken by Mark, and I didn't even realize he was shooting at the time. He just has a unique way of capturing the moment. Whenever I mention something on my radio show about a concert I was at, minutes later I can count on Mark to send a photo from that exact show.

I've always been a believer that rock 'n' roll keeps you young, and Mark's work and passion is proof of that. What you've had a chance to see in this book is just a small sampling of his decades of commitment to rock photography at the highest level. I can't wait to see what he has up his sleeve going forward. I'll be keeping an eye out for him in the pit!

—Eddie Trunk

OPPOSITE: Fan mail, 1987 **ABOVE:** Eddie Trunk with Skid Row and
Ace Frehley, Brendan Byrne Arena, 1989

ACKNOWLEDGMENTS

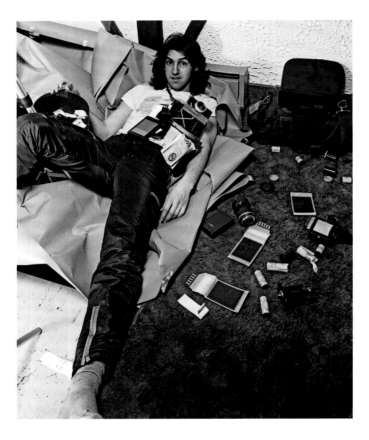

These photographs represent the unforgettable times I had with amazingly talented musicians. We were rock 'n' roll gypsies going from town to town. Bands would play, I would take some photos, we would party with the locals and then off to the next town. It was the '80s—one big party.

A very special thank you to my archivist, Camille Cagno, for her incredible dedication to this project. I would also like to thank everyone who has worked with me over the decades, and those who hired me to work for them. A big thank you to Michael Jensen and Mike Appel, and a special shout-out to my good friends Danny Sanchez, Dave Feld, Mario Frasca, Geoff Blake, Sean Tobin, and Mikael Kirke, and all the fans. An extra big thank you to Michele for her patience during the making of this book, and for keeping me forever young at heart.

This book is dedicated to my parents, Rita and Mike, and my brother Jay—I miss them all so much. It is also dedicated to my children, Guy and Adele, and to my family, George, Gale, Deena, Jeff, Sam, and Susan. Finally, it is dedicated to the newest addition in my life, my grandson Jaxon Mark Weiss—the next generation waiting to discover THE DECADE THAT ROCKED!

— Mark "WEISSGUY" Weiss

Steven Adler	Chuck Fishbein	Rachel Kasuch	Denise Morgan	Gene Simmons
Jayne Andrews	Jason Flom	Carole Kaye	Melody Myers	Daniel Siwek
Sebastian Bach	Lita Ford	Tom Keifer	Ozzy Osbourne	Nikki Sixx
Frankie Banali	Jay Jay French	Simon Kenton	Sharon Osbourne	Terri Smith
Harry Barone	Lonn M. Friend	Jacqui King	Joe Perry	Zack Smith
Jean Beauvoir	Bruce Gallipani	Steve Lacy	Al Pitrelli	Dee Snider
Bryn Bridenthal	Jerry Gaskill	Amy Lasch	Mark Puma	Paul Stanley
Chris Busch	Ellen Zoe Golden	Doreen Lauer	Stevie Rachelle	Dana Strum
Cheri Canner	Lynn Goldsmith	Neon Leon	Walter Reed	Michele Terry
Cedar Ridge HS	Michael Guarracino	Tom Lipsky	Kenny Reff	Eddie Trunk
Warren Croyle	Sammy Hagar	Toby Mamis	Keith Roth	Steven Tyler
Bobby Dall	Rusty Hamilton	Steve Mandel	Gerry Rothberg	Steven Van Zandt
George Dassinger	Margaret Hammel	Larry Mazer	Al Rudolf	Anthony Winters
Wendy Dio	Rick Homan	Doc McGhee	Dave "Snake" Sabo	Barbaranne Wylde
Don Dokken	Byron Hontas	Scott McGhee	Rudy Sarzo	Zakk Wylde
Alistair Duncan	Ioannis	Bret Michaels	Andy Secher	Johnny Zazula
Scott Figman	Wayne Isham	Larry Morand	Pat Shallis	Chip Z'Nuff

I would also like to acknowledge a few of those who are no longer with us:

Bill Aucoin	Randy Castillo	Ronnie James Dio	Laura Kaufman	Paul O'Neill
Eric Carr	Robbin Crosby	Kevin DuBrow	Jani Lane	David Z

"You're just a picture. You're an image caught in time . . . A rainbow in the dark." **—Ronnie James Dio**

ABOVE: Mark in his studio, New York City, 1983 **OPPOSITE:** Dee Snider of Twisted Sister, Hollywood, California, 1985

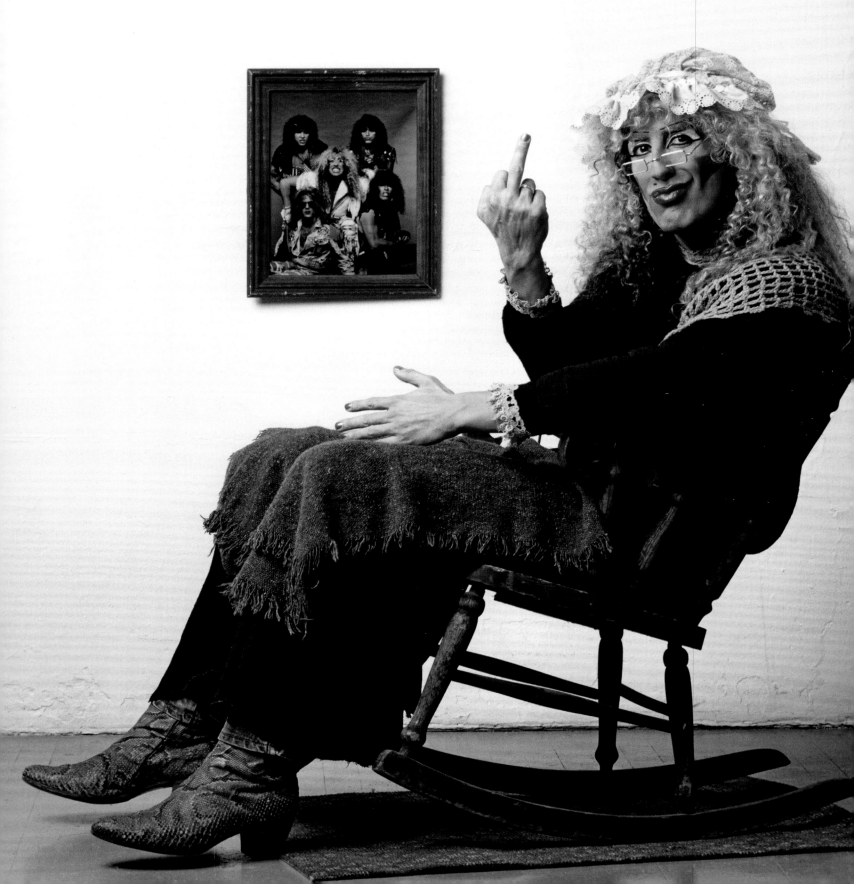

INSIGHT EDITIONS
PO Box 3088
San Rafael, CA 94912
www.insighteditions.com

f Find us on Facebook: www.facebook.com/InsightEditions
🐦 Follow us on Twitter: @insighteditions

Library of Congress Cataloging-in-Publication Data available.

ISBN: 978-1-60887-144-5

PUBLISHER: Raoul Goff
PRESIDENT: Kate Jerome
ASSOCIATE PUBLISHER: Vanessa Lopez
CREATIVE DIRECTOR: Chrissy Kwasnik
VP OF MANUFACTURING: Alix Nicholaeff
DESIGNER: Amy DeGrote
EXECUTIVE EDITOR: Mark Irwin
EDITORIAL ASSISTANTS: Maya Alpert and Holly Fisher
MANAGING EDITOR: Lauren LePera
SENIOR PRODUCTION EDITOR: Elaine Ou
SENIOR PRODUCTION MANAGER: Greg Steffen

A special thank you to Raoul Goff, Vanessa Lopez, and Mark Irwin, Amy DeGrote, and Greg Steffen for their supportive patience and to Richard Bienstock for untangling my words.

Special thanks to the metal god, Rob Halford, and to all the hard rock and metal fans who support this great music. Bang your heads!

ROOTS of PEACE REPLANTED PAPER

Insight Editions, in association with Roots of Peace, will plant two trees for each tree used in the manufacturing of this book. Roots of Peace is an internationally renowned humanitarian organization dedicated to eradicating land mines worldwide and converting war-torn lands into productive farms and wildlife habitats. Roots of Peace will plant two million fruit and nut trees in Afghanistan and provide farmers there with the skills and support necessary for sustainable land use.

Manufactured in China by Insight Editions

10 9 8 7 6 5 4 3 2 1

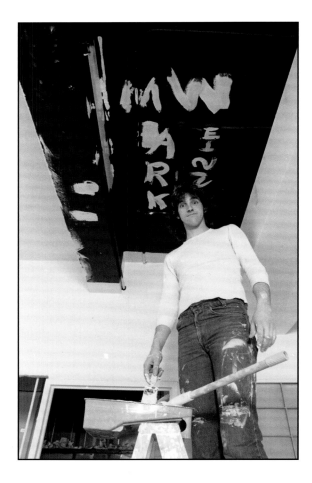

SAYOUNARA

SAY Cheese!!

PHOTO!!

"If you don't go you don't know!"
—weissguy

MarkWeiss.com

f facebook.com/markweissphotography
⊙ Instagram @markweissguy

PAGE 1: David Lee Roth backstage, *Fair Warning* tour, at the Spectrum, 1981; PAGES 2–3: Metallica, Damage, Inc. tour, 1986; PAGE 4: Slash, *Appetite for Destruction* tour, Lakeland Civic Center, Lakeland, Florida, 1987; PAGES 6–7: Dee Snider and Alice Cooper on the set of Twisted Sister's "Be Chrool to Your Scuel" video, 1985; PAGE 8: Ted Nugent and Steven Tyler backstage, Brendan Byrne Arena, 1981; PAGES 10–11: Axl Rose, the Sunset Grill, Hollywood, California, 1988; PAGE 13: Dee Snider, 1985; PAGE 14: Tommy Lee and Ozzy Osbourne, 1984; PAGE 17: Nikki Sixx, 1983; PAGE 18: Judas Priest's Rob Halford, Metal Conqueror tour, the Meadowlands, New Jersey, 1984; PAGES 20–21: Judas Priest audience, World Vengeance tour, the Meadowlands, 1982

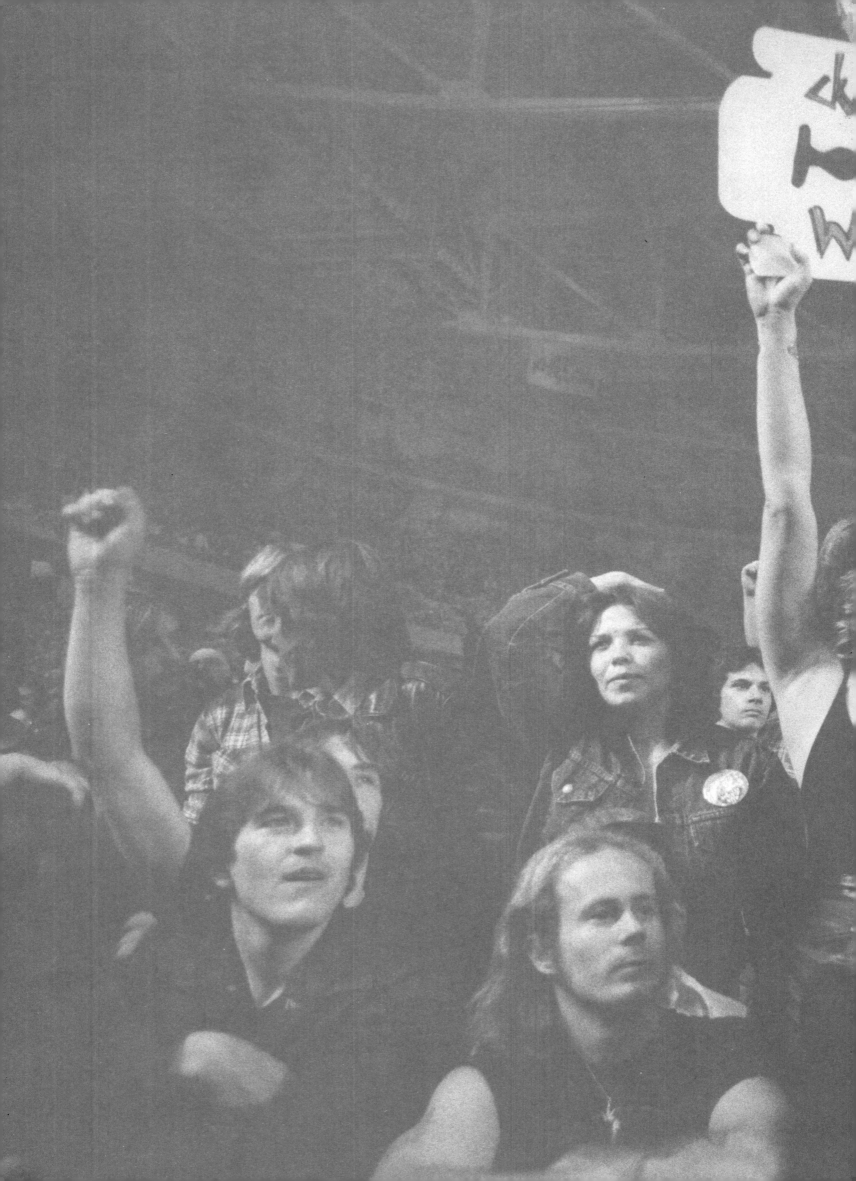